The Museum
of Innocence

The Museum
of Innocence

ORHAN PAMUK

Translated from the Turkish by Maureen Freely

Alfred A. Knopf
New York • Toronto
2009

This Is a Borzoi Book
Published by Alfred A. Knopf
and Alfred A. Knopf Canada

Translation copyright © 2009 by Maureen Freely

Originally published in Turkey as *Masumiyet Müzesi* by İletişim Yayınları,
Istanbul, in 2008. Original Turkish text copyright © 2008 by Orhan Pamuk.

Map by Miray Ozkan

Library of Congress Cataloging-in-Publication Data
Pamuk, Orhan, [date]
[Masumiyet müzesi. English]
The museum of innocence / by Orhan Pamuk ; translated from the Turkish
by Maureen Freely.—1st U.S. ed.
p. cm.
ISBN 978-0-307-26676-7
I. Freely, Maureen, [date] II. Title.
PL248.P34M3713 2009
894'.3533—dc22

Library and Archives Canada Cataloguing in Publication
Pamuk, Orhan, [date]
The museum of innocence / Orhan Pamuk ; translated by Maureen Freely.
Translation of: Masumiyet müzesi.
ISBN 978-0-676-97968-8
I. Freely, Maureen, [date] II. Title.
PL28.9.A68M3813 2009 894'.3533 C2009-902610-4

Manufactured in the United States of America
First North American Edition

To Rüya

These were innocent people, so innocent that they thought poverty a crime that wealth would allow them to forget.

—*from the notebooks of Celâl Salik*

If a man could pass thro' Paradise in a Dream, and have a flower presented to him as a pledge that his Soul had really been there, and found that flower in his hand when he awoke—Aye? and what then?

—*from the notebooks of Samuel Taylor Coleridge*

First I surveyed the little trinkets on the table, her lotions and her perfumes. I picked them up and examined them one by one. I turned her little watch over in my hand. Then I looked at her wardrobe. All those dresses and accessories piled one on top of the other. These things that every woman used to complete herself—they induced in me a painful and desperate loneliness; I felt myself hers, I longed to be hers.

—*from the notebooks of Ahmet Hamdi Tanpınar*

CONTENTS

CONTENTS

CONTENTS

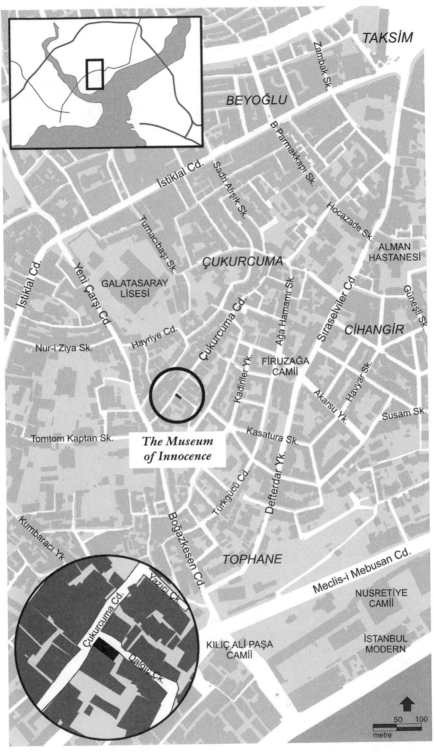

TAKSİM

BEYOĞLU

Zambak Sk.

B.Parmakkapı Sk.

İstiklal Cd.

Sadri Alışık Sk.

Hocazade Sk.

ALMAN
HASTANESİ

Turnacıbaşı Sk.

ÇUKURCUMA

İstiklal Cd.

Yeni Çarşı Cd.

GALATASARAY
LİSESİ

Çukurcuma Cd.

Ağa Hamamı Sk.

Sıraselviler Cd.

CİHANGİR

Güneşli Sk.

Hayriye Cd.

Nur-i Ziya Sk.

Kadiriler Yk.

FİRUZAĞA
CAMİİ

Akarsu Yk.

Havyar Sk.

Susam Sk.

Tomtom Kaptan Sk.

Kasatura Sk.

**The Museum
of Innocence**

Türkgücü Cd.

Defterdar Yk.

Kumbaracı Yk.

Boğazkesen Cd.

TOPHANE

Meclis-i Mebusan Cd.

NUSRETİYE
CAMİİ

Çukurcuma Cd.

Yazıcı Çk.

Dalgıç Çk.

KILIÇ ALİ PAŞA
CAMİİ

İSTANBUL
MODERN

50 100
metre

Camii = Mosque Çk = Cul-de-sac Sk = Street
Cd = Avenue Lisesi = Lycee Yk = Hill

ORHAN PAMUK expresses his gratitude to Sila Okur for ensuring fidelity to the Turkish text; to his editor and friend George Andreou, for his meticulous editing of the translation; and to Kiran Desai for generously giving her time to read the final text, and for her invaluable suggestions and ideas.

The Museum
of Innocence

I

The Happiest Moment of My Life

IT WAS the happiest moment of my life, though I didn't know it. Had
I known, had I cherished this gift, would everything have turned out
differently? Yes, if I had recognized this instant of perfect happiness, I
would have held it fast and never let it slip away. It took a few seconds,
perhaps, for that luminous state to enfold me, suffusing me with the
deepest peace, but it seemed to last hours, even years. In that moment,
on the afternoon of Monday, May 26, 1975, at about a quarter to three,
just as we felt ourselves to be beyond sin and guilt so too did the world
seem to have been released from gravity and time. Kissing Füsun's
shoulder, already moist from the heat of our lovemaking, I gently
entered her from behind, and as I softly bit her ear, her earring must
have come free and, for all we knew, hovered in midair before falling of
its own accord. Our bliss was so profound that we went on kissing,
heedless of the fall of the earring, whose shape I had not even noticed.

Outside the sky was shimmering as it does only in Istanbul in the
spring. In the streets people still in their winter clothes were perspiring,
but inside shops and buildings, and under the linden and chestnut trees,
it was still cool. We felt the same coolness rising from the musty mat-
tress on which we were making love, the way children play, happily
forgetting everything else. A breeze wafted in through the balcony
window, tinged with the sea and linden leaves; it lifted the tulle curtains,
and they billowed down again in slow motion, chilling our naked bod-
ies. From the bed of the back bedroom of the second-floor apartment,
we could see a group of boys playing football in the garden below,
swearing furiously in the May heat, and as it dawned on us that we were
enacting, word for word, exactly those indecencies, we stopped making
love to look into each other's eyes and smile. But so great was our ela-

tion that the joke life had sent us from the back garden was forgotten as quickly as the earring.

When we met the next day, Füsun told me she had lost one of her earrings. Actually, not long after she had left the preceding afternoon, I'd spotted it nestled in the blue sheets, her initial dangling at its tip, and I was about to put it aside when, by a strange compulsion, I slipped it into my pocket. So now I said, "I have it here, darling," as I reached into the right-hand pocket of my jacket hanging on the back of a chair. "Oh, it's gone!" For a moment, I glimpsed a bad omen, a hint of malign fate, but then I remembered that I'd put on a different jacket that morning, because of the warm weather. "It must be in the pocket of my other jacket."

"Please bring it tomorrow. Don't forget," Füsun said, her eyes widening. "It is very dear to me."

"All right."

Füsun was eighteen, a poor distant relation, and before running into her a month ago, I had all but forgotten she existed. I was thirty and about to become engaged to Sibel, who, according to everyone, was the perfect match.

2

The Şanzelize Boutique

THE SERIES of events and coincidences that were to change my entire life had begun a month before on April 27, 1975, when Sibel happened to spot a handbag designed by the famous Jenny Colon in a shop window as we were walking along Valikonağı Avenue, enjoying the cool spring evening. Our formal engagement was not far off; we were tipsy and in high spirits. We'd just been to Fuaye, a posh new restaurant in Nişantaşı; over supper with my parents, we had discussed at length the preparations for the engagement party, which was scheduled for the middle of June so that Nurcihan, Sibel's friend since her days at Notre Dame de Sion Lycée and then her years in Paris, could come from

France to attend. Sibel had long ago arranged for her engagement dress to be made by Silky İsmet, then the most expensive and sought-after dressmaker in Istanbul, and that evening Sibel and my mother discussed how they might sew on the pearls my mother had given her for the dress. It was my future father-in-law's express wish that his only daughter's engagement party be as extravagant as a wedding, and my mother was only too delighted to help fulfill that wish as best as she could. As for my father, he was charmed enough by the prospect of a daughter-in-law who had "studied at the Sorbonne," as was said in those days among the Istanbul bourgeoisie of any girl who had gone to Paris for any kind of study.

It was as I walked Sibel home that evening, my arm wrapped lovingly around her sturdy shoulders, noting to myself with pride how happy and lucky I was, that Sibel said, "Oh what a beautiful bag!" Though my mind was clouded by the wine, I took note of the handbag and the name of the shop, and at noon the next day I went back. In fact I had never been one of those suave, chivalrous playboys always looking for the least excuse to buy women presents or send them flowers, though perhaps I longed to be one. In those days, bored Westernized housewives of the affluent neighborhoods like Şişli, Nişantaşı, and Bebek did not open "art galleries" but boutiques, and stocked them with trinkets and whole ensembles smuggled in luggage from Paris and Milan, or copies of "the latest" dresses featured in imported magazines like *Elle* and *Vogue,* selling these goods at ridiculously inflated prices to other rich housewives who were as bored as they were. As she would remind me when I tracked her down many years later, Şenay Hanım, then proprietress of the Şanzelize (its name a transliteration of the legendary Parisian avenue), was, like Füsun, a very distant relation on my mother's side. The fact that she gave me the shop sign that had once hung on the door as well as any other object connected to Füsun without once questioning the reasons for my excessive interest in the since-shuttered establishment led me to understand that some of the odder details of our story were known to her, and indeed had had a much wider circulation than I had assumed.

When I walked into the Şanzelize at around half past twelve the next day, the small bronze double-knobbed camel bell jingled two notes that can still make my heart pound. It was a warm spring day, and

inside the shop it was cool and dark. At first I thought there was no one there, my eyes still adjusting to the gloom after the noonday sunlight. Then I felt my heart in my throat, with the force of an immense wave about to crash against the shore.

"I'd like to buy the handbag on the mannequin in the window," I managed to say, staggered at the sight of her.

"Do you mean the cream-colored Jenny Colon?"

When we came eye to eye, I immediately remembered her.

"The handbag on the mannequin in the window," I repeated dreamily.

"Oh, right," she said and walked over to the window. In a flash she had slipped off her yellow high-heeled pump, extending her bare foot, whose nails she'd carefully painted red, onto the floor of the display area, stretching her arm toward the mannequin. My eyes traveled from her empty shoe over her long bare legs. It wasn't even May yet, and they were already tanned.

Their length made her lacy yellow skirt seem even shorter. Hooking the bag, she returned to the counter and with her long, dexterous fingers she removed the balls of crumpled cream-colored tissue paper, showing me the inside of the zippered pocket, the two smaller pockets (both empty) as well as the secret compartment, from which she produced a card inscribed JENNY COLON, her whole demeanor suggesting mystery and seriousness, as if she were showing me something very personal.

"Hello, Füsun. You're all grown up! Perhaps you don't recognize me."

"Not at all, Cousin Kemal, I recognized you right away, but when I saw you did not recognize me, I thought it would be better not to disturb you."

There was a silence. I looked again into one of the pockets she had just pointed to inside the bag. Her beauty, or her skirt, which was in fact too short, or something else altogether, had unsettled me, and I couldn't act naturally.

"Well . . . what are you up to these days?"

"I'm studying for my university entrance exams. And I come here every day, too. Here in the shop, I'm meeting lots of new people."

"That's wonderful. So tell me, how much is this handbag?"

Furrowing her brow, she peered at the handwritten price tag on the bottom: "One thousand five hundred lira." (At the time this would have been six months' pay for a junior civil servant.) "But I am sure Şenay Hanım would want to offer you a special price. She's gone home for lunch and must be napping now, so I can't phone her. But if you could come by this evening . . ."

"It's not important," I said, and taking out my wallet—a clumsy gesture that, later, at our secret meeting place, Füsun would often mimic—I counted out the damp bills. Füsun wrapped the bag in paper, carefully but with evident inexperience, and then put it into a plastic bag. Throughout this silence she knew that I was admiring her honey-hued arms, and her quick, elegant gestures. When she politely handed me the shopping bag, I thanked her. "Please give my respects to Aunt Nesibe and your father," I said (having failed to remember Tarık Bey's name in time). For a moment I paused: My ghost had left my body and now, in some corner of heaven, was embracing Füsun and kissing her. I made quickly for the door. What an absurd daydream, especially since Füsun wasn't as beautiful as all that. The bell on the door jingled, and I heard a canary warbling. I went out into the street, glad to feel the heat. I was pleased with my purchase; I loved Sibel very much. I decided to forget this shop, and Füsun.

3

Distant Relations

NEVERTHELESS, AT supper that evening I mentioned to my mother that I had run into our distant relation Füsun while buying a handbag for Sibel.

"Oh, yes, Nesibe's daughter is working in that shop of Şenay's up there, and what a shame it is!" said my mother. "They don't even visit us for the holidays anymore. That beauty contest put them in such an awkward position. I walk past that shop every day, but I can't even bring myself to go inside and say hello to the poor girl—nor in fact

does it even cross my mind. But when she was little, you know, I was very fond of her. When Nesibe came to sew, she'd come too sometimes. I'd get your toys out of the cupboard and while her mother sewed she'd play with them quietly. Nesibe's mother, Aunt Mihriver, may she rest in peace—she was a wonderful person."

"Exactly how are we related?"

Because my father was watching television and paying us no mind, my mother launched into an elaborate story about her father, who was born the same year as Atatürk and later attended Şemsi Efendi School, also just like the founder of the Republic, as you can see in this school photograph I found many years later. It seems that long before he (Ethem Kemal, my grandfather) married my grandmother, he had made a very hasty first marriage at the age of twenty-three. Füsun's great-grandmother, who was of Bosnian extraction, had died during the Balkan Wars, during the evacuation of Edirne. Though the unfortunate woman had not given Ethem Kemal children, she already had a daughter named Mihriver by a poor sheikh, whom she'd married when she was "still a child." So Aunt Mihriver (Füsun's grandmother, who had been brought up by a very odd assortment of people) and her daughter Aunt Nesibe (Füsun's mother) were not strictly speaking relatives; they were more like in-laws, and though my mother had been emphasizing this for years, she had still directed us to call the women from this distant branch of the family "aunts." During their most recent holiday visits, my mother had given these impoverished relations (who lived in the backstreets of Teşvikiye) an unusually chilly reception that led to hurt feelings because two years earlier, Aunt Nesibe, without saying a word, had allowed her sixteen-year-old daughter, then a student at Nişantaşı Lycée for Girls, to enter a beauty contest; and on subsequently learning that Aunt Nesibe had in fact encouraged her daughter, even taking pride in this stunt that should have caused her to feel only shame, my mother had hardened her heart toward Aunt Nesibe, whom she had once so loved and protected.

For her part, Aunt Nesibe had always esteemed my mother, who was twenty years older, and who had been supportive of her when she was a young woman going from house to house in Istanbul's most affluent neighborhoods, in search of work as a seamstress.

"They were desperately poor," my mother said. And lest she exag-

gerate, she added, "Though they were hardly the only ones, my son—all of Turkey was poor in those days." At the time, my mother had recommended Aunt Nesibe to all her friends as "a very good person, and a very good seamstress," and once a year (sometimes twice) she herself would call her to our house to sew a dress for some party or wedding.

Because it was almost always during school hours, I wouldn't see her during these sewing visits. But in 1957, at the end of August, urgently needing a dress for a wedding, my mother had called Nesibe to our summer home in Suadiye. Retiring to the back room on the second floor, overlooking the sea, they set themselves up next to the window from which, peering through the fronds of the palm trees, they might see the rowboats and motorboats, and the boys jumping from the pier. Nesibe having unpacked her sewing box, with the view of Istanbul adorning its lid, they sat surrounded by her scissors, pins, measuring tape, thimbles, and swatches of material and lace, complaining of the heat, the mosquitoes, and the strain of sewing under such pressure, joking like sisters, and staying up half the night to slave away on my mother's Singer sewing machine. I remember Bekri the cook bringing one glass of lemonade after another into that room (the hot air thick with the dust of velvet), because Nesibe, pregnant at twenty, was prone to cravings; when we all sat down to lunch, my mother would tell the cook, half joking, that "whatever a pregnant woman desires, you must let her have, or else the child will turn out ugly!" and with that in mind, I remember looking at Nesibe's small bump with a certain interest. This must have been my first awareness of Füsun's existence, though no one knew yet whether she would be a girl or a boy.

"Nesibe didn't even inform her husband; she just lied about her daughter's age and entered her in that beauty contest," said my mother, fuming at the thought. "Thank God, she didn't win, so they were spared the public disgrace. If the school had gotten wind of it, they would have expelled the girl. . . . She must have finished lycée by now. I don't expect that she'll be doing any further studies, but I'm not up-to-date, since they don't come to visit on holidays anymore. . . . Can there be anyone in this country who doesn't know what kind of girl, what kind of woman, enters a beauty contest? How did she behave with you?"

It was my mother's way of suggesting that Füsun had begun to sleep with men. I'd heard the same from my Nişantaşı playboy friends

when Füsun appeared in a photograph with the other finalists in the newspaper *Milliyet,* but as I found the whole thing embarrassing I tried to show no interest. After we had both fallen silent, my mother wagged her finger at me ominously and said, "Be careful! You're about to become engaged to a very special, very charming, very lovely girl! Why don't you show me this handbag you've bought her. Mümtaz!"—this was my father's name—"Look—Kemal's bought Sibel a handbag!"

"Really?" said my father, his face expressing such contentment as to suggest he had seen and approved the bag as a sign of how happy his son and his sweetheart were, but not once did he take his eyes off the screen.

4

Love at the Office

MY FATHER was looking at a rather flashy commercial that my friend Zaim had made for Meltem, "Turkey's first domestic fruit soda," now sold all over the country. I watched it carefully and liked it. Zaim's father, like mine, had amassed a fortune in the past ten years, and now Zaim was using that money to pursue ventures of his own. I gave him occasional advice, so I was keen to see him succeed.

Once I'd graduated from business school in America and completed my military service, my father had demanded I follow in my brother's footsteps and become a manager in his business, which was growing by leaps and bounds, and so when I was still very young he'd appointed me the general manager of Satsat, his Harbiye-based distribution and export firm. Satsat had an exaggerated operating budget and made hefty profits, thanks not to me but to various accounting tricks by which the profits from his other factories and businesses were funneled into Satsat (which might be translated into English as "Sell-sell"). I spent my days mastering the finer points of the business from worn-out accountants twenty or thirty years my senior and large-breasted lady clerks as old as my mother; and mindful that I would not

have been in charge but for being the owner's son, I tried to show some humility.

At quitting time, while buses and streetcars as old as Satsat's now departed clerks rumbled down the avenue, shaking the building to its foundations, Sibel, my intended, would come to visit, and we would make love in the general manager's office. For all her modern outlook and the feminist notions she had brought back from Europe, Sibel's ideas about secretaries were no different from my mother's: "Let's not make love here. It makes me feel like a secretary!" she'd say sometimes. But as we proceeded to the leather divan in that office, the real reason for her reserve—that Turkish girls, in those days, were afraid of sex before marriage—would become obvious.

Little by little sophisticated girls from wealthy Westernized families who had spent time in Europe were beginning to break this taboo and sleep with their boyfriends before marriage. Sibel, who occasionally boasted of being one of those "brave" girls, had first slept with me eleven months earlier. But she judged this arrangement to have gone on long enough, and thought it was about time we married.

As I sit down so many years later and devote myself heart and soul to the telling of my story, though, I do not want to exaggerate my fiancée's daring or to make light of the sexual oppression of women, because it was only when Sibel saw that my "intentions were serious," when she believed in me as "someone who could be trusted"—in other words, when she was absolutely sure that there would in the end be a wedding—that she gave herself to me. Believing myself a decent and responsible person, I had every intention of marrying her; but even if this hadn't been my wish, there was no question of my having a choice now that she had "given me her virginity." Before long, this heavy responsibility cast a shadow over the common ground between us of which we were so proud—the illusion of being "free and modern" (though of course we would never use such words for ourselves) on account of having made love before marriage, and in a way this, too, brought us closer.

A similar shadow fell over us each time Sibel anxiously hinted that we should marry at once, but there were times, too, when Sibel and I would be very happy making love in the office, and as I wrapped my arms around her in the dark, the noise of traffic and rumbling buses

rising up from Halaskârgazi Avenue, I would tell myself how lucky I was, how content I would be for the rest of my life. Once, after our exertions, as I was stubbing out my cigarette in this ashtray bearing the Satsat logo, Sibel, sitting half naked on my secretary Zeynep Hanım's chair, started rattling the typewriter, and giggling at her best impression of the dumb blonde who featured so prominently in the jokes and humor magazines of the time.

5

Fuaye

NOW, YEARS later, and after a long search, I am exhibiting here an illustrated menu, an advertisement, a matchbook, and a napkin from Fuaye, one of the European-style (imitation French) restaurants most loved by the tiny circle of wealthy people who lived in neighborhoods like Beyoğlu, Şişli, and Nişantaşı (were we to affect the snide tone of gossip columnists, we might call such folk "society"). Because they wished to give their customers a subtler illusion of being in a European city, they shied away from pompous Western names like the Ambassador, the Majestic, or the Royal, preferring others like Kulis (backstage), Merdiven (stairway), and Fuaye (lobby), names that reminded one of being on the edge of Europe, in Istanbul. The next generation of nouveaux riches would prefer gaudy restaurants that offered the same food their grandmothers cooked, combining tradition and ostentation with names such as Hanedan (dynasty), Hünkar (sovereign), Pasha, Vezir (vizier), and Sultan—and under the pressure of their pretensions Fuaye sank into oblivion.

Over dinner at Fuaye on the evening of the day I had bought the handbag, I asked Sibel, "Wouldn't it be better if from now on we met in that flat my mother has in the Merhamet Apartments? It looks out over such a pretty garden."

"Are you expecting some delay in moving to our own house once we've married?" she asked.

"No, darling, I meant nothing of the sort."

"I don't want any more skulking about in secret apartments as if I were your mistress."

"You're right."

"Where did this idea come from, to meet in that apartment?"

"Never mind," I said. I looked at the cheerful crowd around me as I brought out the handbag, still hidden in its plastic bag.

"What's this?" asked Sibel, sensing a present.

"A surprise! Open and see."

"Is it really?" As she opened the plastic bag and saw the handbag, the childish joy on her face gave way first to a quizzical look, and then to a disappointment that she tried to hide.

"Do you remember?" I ventured. "When I was walking you home last night, you saw it in the window of that shop and admired it."

"Oh, yes. How thoughtful of you."

"I'm glad you like it. It will look so elegant on you at our engagement party."

"I hate to say it, but the handbag I'm taking to our engagement party was chosen a long time ago," said Sibel. "Oh, don't look so downcast! It was so thoughtful of you, to go to all the effort of buying this lovely present for me. . . . All right then, just so you don't think I'm being unkind to you, I could never put this handbag on my arm at our engagement party, because this handbag is a fake!"

"What?"

"This is not a genuine Jenny Colon, my dear Kemal. It is an imitation."

"How can you tell?"

"Just by looking at it, dear. See the way the label is stitched to the leather? Now look at the stitching on this real Jenny Colon I bought in Paris. It's not for nothing that it's an exclusive brand in France and all over the world. For one thing, she would never use such cheap thread."

There was a moment, as I looked at the genuine stitching, when I asked myself why my future bride was taking such a triumphal tone. Sibel was the daughter of a retired ambassador who'd long ago sold off the last of his pasha grandfather's land and was now penniless; technically this made her the daughter of a civil servant, and this status sometimes caused her to feel uneasy and insecure. Whenever her anxieties

overtook her, she would talk about her paternal grandmother, who had played the piano, or about her paternal grandfather, who had fought in the War of Independence, or she'd tell me how close her maternal grandfather had been to Sultan Abdülhamit; but her timidity moved me, and I loved her all the more for it. With the expansion of the textiles and exports trade during the early 1970s, and the consequent tripling of Istanbul's population, the price of land had skyrocketed throughout the city and most particularly in neighborhoods like ours. Although, carried on this wave, my father's fortune had grown extravagantly over the past decade, increasing fivefold, our surname (Basmacı, "cloth printer") left no doubt that we owed our wealth to three generations of cloth manufacture. It made me uneasy to be troubled by the "fake" handbag despite three generations of cumulative progress.

When she saw my spirits sink, Sibel caressed my hand. "How much did you pay for the bag?"

"Fifteen hundred lira," I said. "If you don't want it, I can exchange it tomorrow."

"Don't exchange it, darling, ask for your money back, because they really cheated you."

"The owner of the shop is Şenay Hanım, and we're distantly related!" I said, raising my eyebrows in dismay.

Sibel took back the bag, whose interiors I had been quietly exploring. "You're so knowledgeable, darling, so clever and cultured," she said, with a tender smile, "but you have absolutely no idea how easily women can trick you."

6

Füsun's Tears

AT NOON the next day I went back to the Şanzelize Boutique carrying the same plastic bag. The bell rang as I walked in, but once again the shop was so gloomy that at first I thought no one was there. In the

strange silence of the ill-lit shop the canary sang *chik, chik, chik*. Then I made out Füsun's shadow through a screen and between the leaves of a huge vase of cyclamens. She was waiting on a fat lady who was trying on an outfit in the fitting room. This time she was wearing a charming and flattering blouse, a print of hyacinths intertwined with leaves and wildflowers. When she saw me she smiled sweetly.

"You seem busy," I said, indicating the fitting room with my eyes.

"We're just about finished," she said, as if to imply she and her customer were at this point just talking idly.

My eyes flitted from the canary fluttering up and down in its cage, a pile of fashion magazines in the corner, and the assortment of accessories imported from Europe, and I couldn't fix my attention on anything. As much as I wanted to dismiss the feeling as ordinary, I could not deny the startling truth that when looking at Füsun, I saw someone familiar, someone I felt I knew intimately. She resembled me. That same sort of hair that grew curly and dark in childhood only to straighten as I grew older. Now it was a shade of blond that, like her clear complexion, was complemented by her printed blouse. I felt I could easily put myself in her place, could understand her deeply. A painful memory came to me: my friends, referring to her as "something out of *Playboy*." Could she have slept with them? "Return the handbag, take your money and run," I told myself. "You're about to become engaged to a wonderful girl." I turned to look outside, in the direction of Nişantaşı Square, but soon Füsun's reflection appeared ghostlike in the smoky glass.

After the woman in the fitting room had huffed and puffed her way out of a skirt and left without buying anything, Füsun folded up the discarded items and put them back where they belonged. "I saw you walking down the street yesterday evening," she said, turning up her beautiful lips. She was wearing a light pink lipstick, sold under the brand name Misslyn, and though a common Turkish product, on her it looked exotic and alluring.

"When did you see me?" I asked.

"Early in the evening. You were with Sibel Hanım. I was walking down the sidewalk on the other side of the street. Were you going out to eat?"

"Yes."

"You make a handsome couple!" she said, in the way that the elderly do when taking pleasure at the sight of happy young people.

I did not ask her where she knew Sibel from. "There's a small favor we'd like to ask of you." As I took out the bag, I felt both shame and panic. "We'd like to return this bag."

"Certainly. I'd be happy to exchange it for you. You might like these chic new gloves and we have this hat, which has just arrived from Paris. Sibel Hanım didn't like the bag?"

"I'd prefer not to exchange it," I said shamefacedly. "I'd like to ask for my money back."

I saw shock on her face, even a bit of fear. "Why?" she asked.

"Apparently this bag is not a genuine Jenny Colon," I whispered. "It seems that it's a fake."

"What?"

"I don't really understand these things," I said helplessly.

"Nothing like that ever happens here!" she said in a harsh voice. "Do you want your money back right now?"

"Yes!" I blurted out.

She looked deeply pained. Dear God, I thought, why hadn't I just disposed of this bag and told Sibel I'd gotten the money back? "Look, this has nothing to do with you or Şenay Hanım. We Turks, praise God, manage to make imitations of every European fashion," I said, struggling to smile. "For me—or should I have said for us—it's enough for a bag to fulfill its function, to look lovely in a woman's hand. It's not important what the brand is, or who made it, or if it's an original." But she, like me, didn't believe a word I was saying.

"No, I am going to give you your money back," she said in that same harsh voice. I looked down and remained silent, prepared to meet my fate, and ashamed of my brutishness.

As determined as she sounded, I sensed that Füsun could not do what she was supposed to do; there was something strange in the intensely embarrassing moment. She was looking at the till as if someone had put a spell on it, as if it were possessed by demons, so that she couldn't bring herself to touch it. When I saw her face redden and crinkle up, her eyes welling with tears, I panicked and drew two steps closer.

She began to cry softly. I have never worked out exactly how it hap-

pened, but I wrapped my arms around her and she leaned her head against my chest and wept. "Füsun, I'm so sorry," I whispered. I caressed her soft hair and her forehead. "Please, just forget this ever happened. It's a fake handbag, that's all."

Like a child she took a deep breath, sobbed once or twice, and burst into tears again. To touch her body and her lovely long arms, to feel her breasts pressed against my chest, to hold her like that, if only for a moment, made my head spin: Perhaps it was because I was trying to repress the desire, more intense each time I touched her, that I conjured up this illusion that we had known each other for years, that we were already very close. This was my sweet, inconsolable, grief-stricken, beautiful sister! For a moment—and perhaps because I knew we were related, however slightly—her body, with its long limbs, fine bones, and fragile shoulders, reminded me of my own. Had I been a girl, had I been twelve years younger, this is what my body would be like. "There's nothing to be upset about," I said as I caressed the blond hair.

"I can't open the till to give you back your money," she explained. "Because when Şenay Hanım goes home for lunch, she locks it and takes the key with her, I'm ashamed to say." Leaning her head against my chest, she began to cry again, as I continued my careful and compassionate caresses of her hair. "I just work here to meet people and pass the time. It's not for the money," she sobbed.

"Working for money is nothing to be embarrassed about," I said stupidly, heartlessly.

"Yes," she said, like a dejected child. "My father is a retired teacher. . . . I turned eighteen two weeks ago, and I didn't want to be a burden."

Fearful of the sexual beast now threatening to rear its head, I took my hand from her hair. She understood at once and collected herself; we both stepped back.

"Please don't tell anyone I cried," she said after she had rubbed her eyes.

"It's a promise," I said. "A solemn promise between friends, Füsun. We can trust each other with our secrets. . . ."

I saw her smile. "Let me leave the handbag here," I said. "I can come back for the money later."

"Leave the bag if you wish, but you had better not come back here for the money. Şenay Hanım will insist that it isn't a fake and you'll come to regret you ever suggested otherwise."

"Then let's exchange it for something," I said.

"I can no longer do that," she said, sounding like a proud and tetchy girl.

"No really, it's not important," I offered.

"But it is to me," she said firmly. "When she comes back to the shop, I'll get the money for the bag from Şenay Hanım."

"I don't want that woman causing you any more upset," I replied.

"Don't worry, I've just worked out how to do this," she said with the faintest of smiles. "I'm going to say that Sibel Hanım already has exactly the same bag, and that's why she's returning it. Is that all right?"

"Wonderful idea," I said. "But why don't I say the same thing to Şenay Hanım?"

"No, don't you say anything to her," Füsun said emphatically. "Because she'll only try to trick you, to extract personal information from you. Don't come to the shop at all. I can leave the money with Aunt Vecihe."

"Oh please, don't involve my mother in this. She's even nosier."

"Then where shall I leave your money?" Füsun asked, raising her eyebrows.

"At the Merhamet Apartments, 131 Teşvikiye Avenue, where my mother has a flat," I said. "Before I went to America I used it as my hideout—I'd go there to study and listen to music. It's a delightful place that looks out over a garden in the back. . . . I still go there every lunchtime between two and four and shut myself in there to catch up on paperwork."

"Of course. I can bring your money there. What's the apartment number?"

"Four," I whispered. I could barely get out the next three words, which seemed to die in my throat. "Second floor. Good-bye."

My heart had figured it all out and it was beating madly. Before rushing outside, I gathered up all my strength and, pretending nothing unusual had happened, I gave her one last look. Back in the street, my shame and guilt mixed with so many images of bliss amid the unseasonable warmth of that May afternoon that the very sidewalks of

Nişantaşı seemed aglow with a mysterious yellow. My feet chose the shaded path, taking me under the eaves of the buildings and the blue-and-white-striped awnings of the shop windows, and when in one of those windows I saw a yellow jug I felt compelled to go inside and buy it. Unlike any other object acquired so casually, this yellow jug drew no comment from anyone during the twenty years it sat on the table where my mother and father, and later, my mother and I, ate our meals. Every time I touched the handle of that jug, I would remember those days when I first felt the misery that was to turn me in on myself, leaving my mother to watch me in silence at supper, her eyes filled half with sadness, half with reproach.

Arriving home, I greeted my mother with a kiss; though pleased to see me early in the afternoon, she was nevertheless surprised. I told her that I had bought the jug on a whim, adding, "Could you give me the key to the Merhamet Apartments? Sometimes the office gets so noisy I just can't concentrate. I was wondering if I might have better luck at the apartment. It always worked when I was young."

My mother said, "It must be an inch thick with dust," but she went straight to her room to fetch me the key to the building, which was held together with the key to the apartment by a red ribbon. "Do you remember that Kütahya vase with the red flowers?" she asked as she handed me the keys. "I can't find it anywhere in the house, so can you check to see if I took it over there? And don't work so hard. . . . Your father spent his whole life working hard so that you young ones could have some fun in life. You deserve to be happy. Take Sibel out, enjoy the spring air." Then, pressing the keys into my hand, she gave me a strange look and said, "Be careful!" It was that look my mother would give us when we were children, to warn us that life held unsuspected traps that were far deeper and more treacherous than, for instance, any consequence of failing to take proper care of a key.

7

The Merhamet Apartments

MY MOTHER had bought the flat in the Merhamet Apartments twenty years earlier, partly as an investment, and partly as a place where she could retire occasionally for some peace and quiet; but before long she began to use it as a depot for old furniture she deemed to have gone out of fashion and new acquisitions that she immediately found tiresome. As a boy I had liked the back garden, where neighborhood children used to play football in the shade of the giant trees, and I had always loved the story my mother enjoyed telling about the name.

After Atatürk instructed the Turkish people to take surnames for themselves in 1934, it became fashionable to attach one's new name to one's newly constructed apartment building. Since in those days there was no consistent system for street names and numbers, and large, wealthy families tended to live collectively under one roof, just as they had done in the days of the Ottoman Empire, it made sense for the sake of navigating the city that these new apartment buildings be known by the name of the owners. (Many of the rich families I shall mention own eponymous apartment buildings.) Another aspirational fashion was for people to name buildings after high-minded principles; but my mother would say that those who gave their buildings names like Hürriyet (freedom), İnayet (benevolence), or Fazilet (charity) were generally the ones who had spent their entire lives making a mockery of those same virtues. The Merhamet (mercy) Apartments had been built by a rich old man who had controlled the black market in sugar during the First World War and later felt compelled to philanthropy. His two sons (the daughter of one of them was my classmate in primary school), upon discovering that their father planned to turn the apartment house over to a charity, distributing any income it generated to the poor, had their father declared incompetent and put him into a home for the indigent, whereupon they took possession of the building, but

without bothering to change the name that I had found so peculiar as a child.

On the following day, Wednesday, April 30, 1975, I sat in the Merhamet Apartments between 2 and 4 p.m., waiting for Füsun, who never came. I was a little heartbroken and confused; returning to the office, I felt troubled. The next day I went back to the apartment, as if to temper my disquiet, but again Füsun didn't come. Sitting in those airless rooms, surrounded by my mother's old vases and dresses and dusty discarded furniture, going one by one through my father's amateurish snapshots, I recalled moments from my childhood and youth that I hadn't even realized I'd forgotten, and it seemed as if these artifacts had the power to calm my nerves. The next day, while eating lunch at Hacı Arif's Restaurant in Beyoğlu with Abdülkerim, the Kayseri dealer of Satsat (and a friend from my army days), I recalled with shame that I had spent two consecutive afternoons waiting for Füsun in an empty apartment. I was so embarrassed I decided to forget about her, the fake handbag, and everything else. But twenty minutes later, as I glanced at my watch, it occurred to me that Füsun might be walking toward the Merhamet Apartments at that very moment with the refund for the handbag; making up a lie for Abdülkerim, I wolfed down my food and rushed off.

Twenty minutes after I got there, Füsun rang the bell. Or rather, the person who could only be Füsun rang the bell. As I ran to the door I remembered that the previous night I had opened the door to her in a dream.

In her hand was an umbrella. Her hair was dripping wet. She was wearing a yellow pointille dress.

"Well, well, well, I thought you'd forgotten all about me. Come on in."

"I don't want to disturb you. Let me just give you the money and go." In her hand was a worn envelope on which were imprinted the words "Outstanding Achievement Course," but I didn't take it. Taking hold of her shoulder, I pulled her inside and shut the door.

"It's raining hard," I said, although I'd not noticed the rain myself. "Sit for a while. There's no reason why you should rush out into the rain and get wet again so soon. I'm making some tea. At least warm yourself up." I headed for the kitchen.

When I returned, Füsun was looking over my mother's old furniture, her antiques, dusty clocks, hatboxes, and accessories. To make her feel more at home, and to encourage conversation, I told her how my mother had bought all these things on impulse from the most fashionable shops of Beyoğlu and Nişantaşı, pashas' mansions whose furnishings were being sold off, Bosphorus *yalı*s half destroyed by fire, antique dealers, and even vacated dervish lodges, not to mention all the shops she visited on her European travels, but that after using them for a short while she brought them here and forgot all about them. At the same time I was opening trunks packed with clothes reeking of mothballs, and the tricycle that we'd both ridden as children (my mother was in the habit of giving our old ones to poor relations), a chamber pot, and finally the Kütahya vase that my mother had asked me to find for her; then I showed her the hats, box by box.

A crystal sweet bowl reminded us of holiday feasts she had attended. When she'd arrive with her parents for their holiday visit, they'd be offered an assortment of sugar and almond candies, marzipan, sugar-covered coconut "lion bars," and *lokum,* or Turkish delight.

"Once when we came here for the Feast of the Sacrifice, I remember we went out for a ride in the car," said Füsun, her eyes shining.

I remembered that outing. "You were a child then," I said. "Now you have become a very beautiful and enchanting young woman."

"Thank you. I should leave now."

"You haven't even drunk your tea. And the rain hasn't stopped." I pulled her over to the balcony door, gently parting the tulle curtain. She looked out the window; in her eyes was the light that you see only in children arriving at a new place, or in young people still open to new influences, still curious about the world because they have not yet been scarred by life. For a moment I gazed longingly at her neck, the nape of her neck, and her fine complexion, which made her cheeks so beautiful, and the countless freckles on her skin, which were invisible from a distance (hadn't my grandmother had such freckles?). My hand, as if it was someone else's, reached out and took hold of the barrette in her hair. Painted on it were four sprigs of verbena.

"Your hair is very wet."

"Did you tell anyone that I cried in the shop?"

"No. But I'm very curious to know what made you cry."

"Why?"

"I've been spending a lot of time thinking about you," I said. "You're very beautiful, very different from anyone else. I remember so well what a lovely little dark-haired girl you were. But I never imagined you would turn into such a beauty."

She smiled the measured smile of well-mannered beauties accustomed to compliments, but at the same time she raised her eyebrows in suspicion. There was a silence. She took one step back.

"So what did Şenay Hanım say?" I asked, changing the subject. "Did she happen to acknowledge that the handbag was a fake anyway?"

"She was very annoyed when she realized you had demanded your money back, but she didn't want to make a drama about it. She told me just to forget the whole thing. She knew the bag was a fake, I guess. She doesn't know I'm here. I told her that you'd stopped by at lunchtime to collect the money. I really have to go now."

"But you haven't had your tea!"

I brought the tea in from the kitchen. I watched her as she blew lightly on the surface to cool it, before taking careful, hurried sips. I was caught between admiration and shame, tenderness and joy. . . . Again answering its own will, my hand reached out to caress her hair. I brought my face close to hers; seeing that she did not pull away, I gave her a quick delicate kiss on the side of her lips. She blushed. As she was holding the hot teacup with both hands, she couldn't defend herself. She was both angry and confused. I could see this, too.

"I like kissing," she said proudly. "But now, with you, of course it is out of the question."

"Have you done a lot of kissing?" I asked, in a clumsy imitation of a child.

"I've kissed, of course. But that's all."

With a look to suggest that men, alas, were all alike, she cast her eyes around the room one last time, eyeing the furniture, and the bed with blue sheets in the corner, which, with evil intentions, I had contrived to leave half made. She had sized up the situation, but I—perhaps out of shame—could think of no way to keep the game going.

When I'd arrived, I'd found sitting on a chest a fez of the type they make for tourists, and I'd placed it on a coffee table as a sort of ironic statement. Now I could see that when I'd gone to fetch the tea she'd

left the money envelope propped against it. She saw me notice the envelope against the fez but still she said, "I left the money over there."

"You can't leave until you've finished your tea."

"It's getting late," she said, a little more assertively, but she didn't leave.

As we drank our tea, we chatted about our relatives, our childhood years, and our shared memories, and we spoke ill of no one. They had all been afraid of my mother, for whom her mother had a great deal of respect, but who, when Füsun was a child, had been so attentive to her; when her mother came to sew, my mother would lay out our toys for her—our windup animals, the dog and the chicken, which Füsun loved so much but was afraid of breaking. Every year, until the beauty contest, my mother had sent our chauffeur Çetin Efendi over to bring her a present on her birthday: There had been a kaleidoscope, for example, and she still had it. . . . If my mother sent her a dress, she would always get it a few sizes too big lest the girl outgrow it too quickly. So there had been a tartan skirt fastened with a large safety pin that Füsun had been unable to wear for a whole year: She loved it so much that even later, when it was not in fashion, she'd worn it as a miniskirt. I told her that I had seen her in Nişantaşı once wearing that skirt. We changed the subject to avoid mentioning her fine waist and her beautiful legs. There was an uncle Süreyya who was not right in the head. Every time he came from Germany, he would pay ceremonious visits to all the branches of the family, now mostly scattered and out of touch, but thanks to him, they were all kept aware of what the others were doing.

"That time we came to visit you for the Feast of the Sacrifice and you and I went out in the car—Uncle Süreyya was in the house that day, too," said Füsun excitedly. She threw on her raincoat and she began to hunt for her umbrella. She couldn't find it, because on one of my trips to the kitchen I'd thrown it behind the mirrored wardrobe in the entrance hall.

"Do you remember where you left it?" I said as I helped her conduct a thorough search.

"I think I left it here," she said innocently, pointing at the mirrored wardrobe.

As we scoured the apartment, looking even in the most unlikely places, I asked her what she did in her "spare time"—as it was called

in the celebrity magazines. The year before, she had not scored high enough on her university entrance exam to gain admission to the university course of study she had wanted. So now, whatever time she had left over from the Şanzelize Boutique, she spent on the Outstanding Achievement Course. There were only forty-five days left before this year's examination, so she was studying very hard.

"What course do you want to take?"

"I don't know," she said, a bit embarrassed. "What I'd like, actually, is to go to the conservatory to train as an actress."

"Those classes are good for nothing; they're all in it for profit, every last one of them," I said. "If you find you're struggling, especially with mathematics, why don't you come over, since I'm here working every afternoon? I can teach you quickly."

"Do you help other girls with mathematics?" she asked mockingly, raising her eyebrows in that way again.

"There are no other girls."

"Sibel Hanım comes to our shop. She's very beautiful, and very charming, too. When are you getting married?"

"The engagement party is in a month and a half. Will this umbrella suit you?" I said, offering her a parasol my mother had brought back from Nice. She said that of course she could not return to the shop with such an oddity. She wanted to leave now and was prepared to abandon her umbrella. "The rain has stopped," she said joyfully. As she opened the door, I panicked, thinking I might never see her again.

"Please, come again and we'll just drink tea," I said.

"Don't be angry, Kemal, but I don't want to come back. And you know I am not going to. Don't worry, I won't tell anyone you kissed me."

"What about the umbrella?"

"The umbrella belongs to Şenay Hanım but it can stay here," she said, giving me a kiss on the cheek that was hasty but not devoid of emotion.

8

Turkey's First Fruit Soda

HERE I am exhibiting the newspaper advertisements, the commercials, and the bottles of strawberry, peach, orange, and sour cherry flavors of Turkey's first domestic fruit soda, Meltem, in memory of our optimism and the happy-go-lucky spirit of the day. That evening Zaim was celebrating the launch of his new product with an extravagant party in his perfectly situated Ayaspaşa apartment which had a sweeping view of the Bosphorus. Our whole group would be together again. Sibel was happy to be among my rich friends—she enjoyed the yacht trips down the Bosphorus, the surprise birthday parties, and the nights at clubs, which would end with all of us piling into our cars to roam the streets of Istanbul—but she didn't like Zaim. She thought he was a show-off, too much a playboy and rather "coarse"; and his party tricks—like the "surprise" belly dancer at the end of the evening or his habit of lighting girls' cigarettes with a lighter bearing the *Playboy* logo—she found "banal." Sibel was even more disapproving of his dalliances with minor actresses and models (the latter a new phenomenon in Turkey, and still viewed with suspicion), whom he knew of course he would never marry, on account of their being known to have had sex; nor could she bear his misleading the nice girls he also took out with no intention of letting a relationship develop. That is why, when I phoned her to say that I was feeling unwell and unable to attend the party, or to go out at all, I was surprised to find Sibel disappointed.

"They say the German model in the Meltem campaign is going to be there!" Sibel said.

"But I thought you felt that Zaim was a bad influence on me. . . ."

"If you can't even drag yourself to a Zaim party, you really must be sick. Now you have me worried. Shall I come over?"

"There's no need. My mother and Fatma Hanım are looking after me. I should be fine by tomorrow."

As I stretched out on my bed, fully clothed, I thought about Füsun;

I decided once more to forget her, in fact never to see her again for as long as I lived.

9

F

THE NEXT day, May 3, 1975, Füsun arrived at the Merhamet Apartments at half past two in the afternoon and for the first time in her life she made love. I did not go to the apartment that day with the hope of seeing her. As I tell my story so many years later, I wonder how this could be true, but on that day it honestly hadn't occurred to me that she might appear. . . . I'd been thinking about what we'd talked about the day before, and our common childhood possessions, and my mother's antiques, the old clocks, the tricycle, the strange light in the dim apartment, the smell of dust and decay, and I longed to be alone, to gaze down at that back garden. . . . These must have been the thoughts that drew me there. True, I wanted to reflect on our meeting the day before, to relive it, to pick up Füsun's teacups and wash them, to tidy my mother's belongings and forget my transgression. While I was tidying up the room, I found a picture my father had taken from the back room, showing the bed, the window, and the garden, and it struck me how very little the place had changed in all those years. When the doorbell rang, my first thought was "Mother!"

"I came to collect my umbrella," said Füsun.

She wouldn't come in. "Why don't you come in?" I said. For a moment she hesitated. Perhaps deciding it would be rude to stand there at the door, she stepped inside. I shut the door behind her. This is the fuchsia dress in which she appeared to mesmerizing effect that day, with its white buttons and the white belt with the large buckle, which made her waist seem all the more slender. In my youth, I like so many other men had found myself unnerved by girls I found beautiful and mysterious; my way of overcoming this unease was blunt candor, and though I thought I had outgrown this frankness and innocence, I was

wrong: "Your umbrella is here," I said. Reaching behind the mirrored wardrobe, I didn't even ask myself why I hadn't retrieved it beforehand.

"How did it get back there?"

"Actually, I hid it there yesterday, so that you wouldn't leave right away."

For a moment she was not sure whether to smile or scowl. Taking her by the hand, I led her into the kitchen, on the pretext of making tea. It was dark in the kitchen and smelled of dust and damp. Everything speeded up once we were in there; unable to restrain ourselves, we began to kiss. The kisses got longer and more passionate. She gave so much of herself away with those kisses, wrapping her arms around my neck and shutting her eyes so tightly, that I sensed the prospect of "going all the way," as was said.

Since she was a virgin this could not happen, of course. Though as our kissing continued, there was a moment when it dawned on me that Füsun had perhaps made one of the most important decisions of her life in coming here. I quickly reminded myself, however, that such things only happened in foreign films. It seemed strange that a girl would suddenly choose to give herself to me here, of all places. So, perhaps, I reasoned, she wasn't actually a virgin at all. . . .

Kissing still, we left the kitchen and sat down on the edge of the bed, and with scarcely any coyness, though never once looking each other in the eye, we took off most of our clothes and slipped under the blanket. The rough blanket was too heavy and scratched my skin, just as it had done when I was a child, so after a while I pulled it off, and we lay there, half naked. We were both perspiring, and for some reason this relaxed us. The sun filtering through the drawn curtains was a yellowish orange, and that made her moist skin look more tanned than it was. That Füsun could look at my body as I could hers, that she could gaze down at my nether regions so near her without panicking, that, far from finding it strange, she could even look at my sex with calm desire and something akin to tenderness—seemed proof enough that she had seen other men naked in other beds, on divans and car seats, and that made me jealous.

Soon the worried looks we were giving each other betrayed how daunted we both were by the difficult task we'd set ourselves. Füsun removed her earrings (one of which is now the first exhibit in our

museum) and placed them on the side table. She did this as carefully as a nearsighted girl might remove her glasses before swimming, and once again I sensed her determination. In those days it was the style for young people to wear bracelets, necklaces, and rings bearing their names or initials but that afternoon I didn't notice if her earrings were of this kind. But once she had peeled off her outer garments item by item, she removed her little panties in the same purposeful manner and I saw the indisputable evidence of what she was prepared to do. In those days, girls who did not wish to "go all the way" were in the habit of keeping at least their panties on, as Western girls might when trying to sun themselves.

I kissed her shoulders, which smelled of almond, and with my tongue I felt her damp velvety skin, and when I saw that even by May her breasts were one shade lighter than her robust Mediterranean skin, I shivered. If the lycée teachers studying this book in their class are now beginning to get nervous, they can advise the students to skip this page. If there are visitors to my museum who wish to know more, I would suggest that they kindly cast their eyes on the furnishings; the scene will be enough to make them understand that what I had to do I did first and foremost for Füsun, looking at me with such frightened and sorrowful eyes, and second for our common good, and only after all these imperatives were satisfied, just a little for my own pleasure. It was as if we were hoping to overcome an obstacle that life had thrown in our way. So as her eyes stared into mine and as I pressed against her uttering tender words, asking, Does it hurt, darling?, her silence did not alarm me. At the moment when we were closest I felt the fragility of her trembling so deeply (think of sunflowers quivering in a faint breeze) it was as if her pain became mine.

Seeing her eyes slip away to examine the lower regions of her body with a doctor's scrutiny, I understood that she wanted to experience this alone, and I wanted to finish what I was doing, to concentrate on my own satisfaction so that I could emerge from this arduous challenge feeling some relief. By now we both intuitively knew that to savor fully the pleasures that would bind us together meant to savor them in solitude as well; in that merciless embrace, greedy and unsparing, we were using each other for our own pleasure. There was something about the way Füsun pressed her fingers into my back; it made me think of that

innocent, nearsighted girl learning how to swim in the sea, so fearful as she clung to her father who rushed out to save her when she feared she might drown. Ten days later, as she was embracing me with her eyes closed, I asked her what film she might be watching in her mind. "I was watching a field of sunflowers," she told me.

The boys whose joyful shouts and curses and screeches would accompany our lovemaking in the days that followed were there too that first day, playing football in the old garden of Hayrettin Pasha's derelict mansion, cursing and screeching while in the house we made love. When they stopped their chatter for a while, a marvelous silence fell over the room, broken only by a few shy gasps from Füsun, and one or two happy moans that escaped me. In the distance we could hear the policeman's whistle in Nişantaşı Square, and car horns, and a hammer hitting a nail: A child kicked a can, a seagull mewed, a cup broke, the leaves of the plane trees rustled in the breeze.

We were lying in the silent room with our arms around each other, trying to banish thoughts of the bloody sheet, the discarded clothes, our still unaccustomed nakedness—all those primitive social rituals and embarrassing details that anthropologists so like to analyze and classify. Füsun for a while had cried silently. She had paid little attention to my words of consolation, only saying that she would remember this day till the end of her life, before beginning to cry again, and then falling silent once more.

Having become—with the passage of time—the anthropologist of my own experience, I have no wish to disparage those obsessive souls who bring back crockery, artifacts, and utensils from distant lands and put them on display for us, the better to understand the lives of others and our own. Nevertheless, I would caution against paying too much attention to the objects and relics of "first love," for these might distract the viewer from the depth of compassion and gratitude that now arose between us. So it is precisely to illustrate the solicitude in the caresses that my eighteen-year-old lover bestowed upon my thirty-year-old skin as we lay quietly in this room in each other's arms, that I have chosen to exhibit this floral batiste handkerchief, which she had folded so carefully and put in her bag that day but never removed. Let this crystal inkwell and pen set belonging to my mother that Füsun toyed with that afternoon, noticing it on the table while she was smoking a

cigarette, be a relic of the refinement and the fragile tenderness we felt for each other. Let this belt whose oversize buckles that I had seized and fastened with a masculine arrogance that I felt so guilty for afterwards bear witness to our melancholy as we covered our nakedness and cast our eyes about the filth of the world once again.

Before leaving, I told Füsun that if she wanted to win a university place, she was going to have to work very hard during this final month and a half.

"Are you worried I'll be a shopgirl forever?" she said with a smile.

"Of course not . . . But I'd like to tutor you for the exam. . . . We could work here. Which books are you using? Are you studying classical mathematics or modern?"

"At lycée we did classical. But we're doing both in my course. Because the answers are matched in the answer sheet. The whole thing makes my head spin."

We agreed to meet the next day in the same place to work on mathematics. As soon as she was gone I bought the books they used in the lycée and the course from a bookstore in Nişantaşı; once back in the office I leafed through them as I smoked a cigarette, and I saw that I would actually be able to help her. The thought that I might be able to tutor Füsun in mathematics lightened the emotional burden and left me with a feeling of joy and a strange sort of pride. My neck, my nose, my skin, all ached with happiness, an exultation that I could not hide from myself. In one corner of my mind I kept thinking that Füsun and I would be meeting many more times in the Merhamet Apartments to make love. But I understood that the only way I could carry this off would be to act as if nothing out of the ordinary were happening.

10

City Lights and Happiness

THAT EVENING Sibel's old classmate Yeşim was getting engaged at the Pera Palas; everyone was going to be there, so I went. In her shiny

silver dress, over which she had thrown a knitted shawl, Sibel seemed delighted, as if this party were a rehearsal for our own engagement, and she took an interest in every detail, mingling with all the guests, smiling constantly.

By the time Uncle Süreyya's son (whose name I always forget) introduced me to Inge, the German model who'd done the Meltem commercials, I had downed two glasses of *rakı* and felt relaxed.

"How are you finding Turkey?" I asked her in English.

"I've only been in Istanbul," said Inge. "I'm so surprised. I never imagined anything like this."

"What sort of thing *did* you imagine?"

For an awkward moment we stared at each other in silence. This was a wise woman. Having evidently learned how easily she could break a Turk's heart by saying the wrong thing, she smiled, and in broken Turkish, she repeated the Meltem slogan that had captivated the whole country: "You deserve it all!"

"All of Turkey has come to know you in the space of a week. How does that feel?"

"The police recognize me, and so do the taxi drivers, and everyone in the street, too," she said, as gleeful as a child. "There was even a balloon seller who stopped me, gave me a balloon, and said, 'You deserve it all.' It's easy to become famous in a country that has only one television channel."

Did she know how rude she was being even as she struggled to be humble? "So how many channels do you have in Germany?" I asked. Realizing that she had said something wrong, she blushed. I thought there had been no need for me to say that after all. "Every morning on my way to work, I see your picture blown up so large it covers the side of an entire apartment building, and it's lovely," I said, by way of recovery.

"Oh, yes, you Turks are way ahead of Europe as far as advertising is concerned."

These words made me so pleased that for a moment I forgot she was just trying to be polite. I searched the merry, chirping crowd for Zaim. He was across the room, chatting with Sibel. It pleased me to think they might yet become friends. Even all these years later, I can

remember the haze of euphoria that enveloped me. Sibel had coined a private nickname for him: "You-Deserve-It-All Zaim"; she found Meltem's promotional slogan to be selfish and insensitive. In a poor and troubled country like Turkey with young leftists and rightists busy killing each other, it was, she felt, ugly.

A lovely spring breeze was wafting through the balcony's grand doors, carrying the scent of linden trees. The lights of the city shone on the Golden Horn below. Even the slums and shantytowns of Kasımpaşa looked beautiful. I thought how happy I was, even feeling as if this was a prelude to yet greater happiness. The gravity of what had transpired with Füsun confused me, but I told myself that everyone has his secrets, fears, and moments of worry. No one could guess how many of these elegant guests felt similarly uneasy or carried secret spiritual wounds, but it was when we were in crowds like this, surrounded by friends—and having downed a glass of *rakı* or two—that we persuaded ourselves how trivial and transitory those sentiments were.

"You see that nervous man over there?" Sibel said. "He's the famous Cold Suphi. He picks up every matchbox he can lay his hands on and saves them all. Apparently he has rooms and rooms full of them. They say he became that way after his wife left him. Let's not have the waiters wear such weird outfits at our engagement party, promise? Why are you drinking so much? Listen, I have something to tell you."

"What?" I said.

"Mehmet's really smitten with the German model—he won't leave her side—and Zaim is getting jealous. Oh, the one over there, the one who's the son of your uncle Süreyya . . . He's also related to Yeşim. Is there something upsetting you, something I should know about?"

"No, not at all, there's nothing wrong. I'm actually feeling very content."

Even all these years later I remember that Sibel spoke to me sweetly. Sibel was fun, and clever, and sympathetic, and I knew that with her at my side I would be fine, not just then but for the rest of my life. Late that night, after I had taken her home, I walked for a long time through the dark and empty streets, thinking about Füsun. What I couldn't stop thinking about, what perturbed me was not just that Füsun had given

me her virginity; it was that she had shown such resolve in doing so. There had been no coyness, no indecision, not even when she was taking off her clothes.

At home I found our sitting room empty; sometimes I would come home to find that my father, having gotten up in the middle of the night, was sitting out there in his pajamas, and I would enjoy chatting with him before I went to bed; but tonight both he and my mother were asleep—through their bedroom door, I could hear his snores and her sighs. Before going to bed I poured myself another *rakı* and smoked another cigarette. But even so I did not drop off to sleep at once. My head was still swimming with visions of our lovemaking, and these began to mix with the details of the night's engagement party.

I I

The Feast of the Sacrifice

As I was drifting off to sleep I thought about my distant relation Uncle Süreyya, and about his son, whom I'd seen at Yeşim's party and whose name I kept forgetting. Uncle Süreyya had been at the house for one of Füsun's holiday visits—the time we'd gone out for a ride in the car. As I lay in bed, stalking sleep, a few images from that cold, gray morning came back to me. As they paraded before my eyes, they seemed both very familiar and very strange, as memories do when they find their way into dreams: I remembered the tricycle, and I remembered going outside with Füsun, watching silently as a lamb was slaughtered, and then taking a ride in the car.

"We returned that tricycle from our house," said Füsun, who remembered everything much better than I did when we met the next day at the Merhamet Apartments. "After you and your brother outgrew it, your mother gave it to me. But by then I'd grown too old for it as well, so I didn't ride it anymore, and when we went to visit you that year, my mother brought it back."

"And then my mother must have brought it here," I said. "Now I can remember Uncle Süreyya also being there that day."

"Because he was the one who asked for the liqueur," said Füsun.

Füsun's recollection of that impromptu car excursion was likewise better than my own. I would like to pause here to relate the story that came back to me once she'd told it to me. Füsun was twelve and I was twenty-four years old. It was February 27, 1969, the first day of the Feast of the Sacrifice. On that morning, as on all holidays, our home in Nişantaşı was packed with relatives close and distant, all delighted to have been invited for lunch, and dressed up in suits and ties and their finest dresses. The doorbell kept ringing and newcomers arrived, for example, my younger aunt with her bald husband and her nosy but beautifully dressed children, and everyone would stand to shake hands and kiss them on both cheeks. Fatma Hanım and I were passing out sweets when my father took my brother and me to one side.

"Uncle Süreyya's complaining again that we have no liqueurs. Listen, boys, could one of you go down to Alaaddin's shop and buy some peppermint and strawberry liqueur?"

My mother had previously banned the customary serving of peppermint and strawberry liqueur in crystal glasses on a silver tray, because sometimes my father drank too much. She'd done this for his health. But two years earlier, on just such a holiday morning, when Uncle Süreyya had lodged his familiar complaint about there being no liqueur, my mother, hoping to cut the discussion short, had asked, "Why would anyone serve alcohol on a religious holiday?" a question that had paved the way for an endless back-and-forth about religion, civilization, Europe, and the Republic between my mother and my fervently secularist pro-Atatürk uncle.

"Which one of you is going?" my father asked, peeling off a crisp ten-lira note from the wad of cash he'd taken out of the bank to pass out to the janitors and the watchmen and all the children who kissed his hand.

"Let Kemal go!" said my brother.

"No, let Osman go," I said.

"Why don't you go, my boy," my father said to me. "And don't tell your mother what you're up to. . . ."

On my way out of the house I saw Füsun.

"Come out to the store with me, why don't you."

She was a skinny twelve-year-old girl with matchstick legs, the daughter of a distant relation, that was all. Apart from her immaculate clothes and the sparkling white butterfly-shaped bows of ribbon holding her shiny black braids, there was nothing particularly striking about her. All those years later, Füsun reminded me of the uninspired questions I'd asked that young girl in the lift: "What grade are you in?" (The first year of middle school.) "What school do you go to?" (Nişantaşı Girls' Lycée.) "What do you want to be when you grow up?" (Silence!)

We had just left the building and taken a few steps into the cold when I saw that a crowd had gathered around the little linden tree next to a muddy empty lot and they were about to sacrifice a lamb. If my level of understanding had been what it is today, I would have asked myself whether a girl that age might find it upsetting to watch a lamb's throat being slit, and I wouldn't have brought Füsun any closer.

But I was curious, and insensitive, and so we walked on. It was our cook, Bekri Efendi, and our janitor, Saim Efendi, who had rolled up their sleeves and were holding down a lamb whose legs were bound together and whose coat of wool was red with henna. Next to the lamb was a man in an apron, wielding a large butcher's knife, but the lamb was thrashing so violently that he couldn't do the job. After a struggle, the cook and the janitor succeeded in stilling the lamb, leaving behind them a trail of frozen breath. Taking the lamb by its mouth and its sweet nose, the butcher pushed its head roughly to one side and held the knife against the throat. There followed a short silence. "Allah Akbar, Allah Akbar," said the butcher. Swiftly he slid the knife back and forth across the lamb's throat. When the butcher pulled the knife away dark red blood gushed out. The lamb was shuddering and you could see its life ebbing away. Everything was still. Suddenly a gust of wind shook the bare branches of the linden tree. The butcher dragged the lamb by its head across the ground to drain the blood into a hole that had been dug in advance.

In the crowd I saw grimacing children, and our chauffeur, Çetin Efendi, along with an old man who was praying. Füsun had silently taken hold of the sleeve of my jacket. Every now and again, the lamb shuddered, but these were its last throes. The butcher who was now

wiping the knife on his apron was Kazım, whose shop was next to the police station—I'd not recognized him at first. Coming eye to eye with Bekri the cook, I realized that it was our lamb; in those days, we bought sacrificial lambs, and this was the one that had been tied up on a rope in the back garden for a week.

"Come on, let's go," I said to Füsun.

Without speaking, we walked up the street. Was I troubled by my indifference to a little girl's witnessing such a thing? I felt guilty, but I wasn't quite sure why.

Neither my mother nor my father was religious. I never saw either of them pray or keep a fast. Like so many married couples who had grown up during the early years of the Republic, they were not disrespectful of religion; they were just indifferent to it, and like so many of their friends and acquaintances they explained their lack of interest by their love for Atatürk and their faith in the secular republic. Even so, our family, like most other secularist bourgeois families living in Nişantaşı, would sacrifice a lamb for the Feast of the Sacrifice and distribute the meat and the skin to the poor according to custom. But my father would have nothing to do with the sacrifice itself, and neither would anyone else in the family: We left it to the cook and the janitor to distribute the alms. Like my relatives, I had always kept my distance from the annual ritual sacrifice in the empty lot next door.

As Füsun and I, still silent, walked up to Alaaddin's shop a cool wind hit us passing Teşvikiye Mosque and I felt almost as if it was my disquiet that made me shiver.

"Did that frighten you back there?" I asked. "We shouldn't have looked. . . ."

"The poor lamb," she said.

"You know why they sacrifice the lamb, don't you?"

"One day, when we go to heaven, that lamb will take us over the Sırat bridge, which is thin as a hair and sharp as a sword. . . ."

This was the version for children and people with no education.

"There's more to the story," I said, with a teacherly air. "Do you know how it begins?"

"No."

"The prophet Abraham was childless. He prayed to God, saying, 'O Lord, if you give me a child, I'll do anything you ask.' In the end his

prayers were answered, and one day his son Ismail was born. The prophet Abraham was filled with joy. He adored his son; kissing and caressing him all day long, the prophet was exultant and every day he thanked God. One day God came to him in his dream and God said, 'Now slit your son's throat and sacrifice him.' "

"Why did he say that?"

"Listen now. . . . The prophet Abraham did as God instructed. He took out his knife, and just as he was about to slit his son's throat . . . at that very moment, a lamb appeared."

"Why?"

"God showed mercy to Abraham: He sent him the lamb so that he could sacrifice it in his son's place. God saw that Abraham had been obedient."

"If God hadn't sent the lamb, would the prophet Abraham really have slit his son's throat?" asked Füsun.

"He really would have," I said uneasily. "It was because He was sure that Abraham would slit his son's throat that God loved him so much and sent the lamb to spare him terrible grief."

I could see that I had not told the story in such a way as to make it clear to a twelve-year-old girl why a doting father would try to kill his son. My unease was now turning into annoyance at my failure to explain the sacrifice.

"Oh no, Alaaddin's shop is closed!" I said. "Let's go check the shop on the square."

We walked as far as Nişantaşı Square. Reaching the crossroads, we saw that Nurettin's Place, which sold newspapers and cigarettes, was also closed. We turned back, and as we walked silently through the streets, I thought up an interpretation of the story of the prophet Abraham that Füsun might like.

"At the beginning, of course, the prophet Abraham has no idea that a lamb will take the place of his son," I said. "But he believes in God so much, loves Him so much that in the end he trusts no harm can come from Him. . . . If we love someone very much, we know that even if we give him the most valuable thing we have, we know not to expect harm from him. This is what a sacrifice is. Who do you love most in the world?"

"My mother, my father . . ."

We met Çetin the chauffeur on the sidewalk.

"Çetin Efendi, my father wants some liqueur," I said. "All the shops in Nişantaşı are closed, so could you take us to Taksim? And after that maybe we could go for a ride."

"I'm coming too, aren't I?" Füsun asked.

Füsun and I sat in the back of my father's '56 Chevrolet, which was a deep cherry red. Çetin Efendi drove us up and down the hilly, bumpy cobblestone streets as Füsun looked out the window. Passing Maçka, we continued down the hill to Dolmabahçe. Apart from a few people in their holiday best, the streets were empty. But as we passed Dolma-bahçe Stadium, we saw another group performing a sacrifice.

"Oh, please, Çetin Efendi, could you tell the child why we make sac-rifices? I wasn't able to explain it to her properly."

"Oh Kemal Bey, I'm sure you explained it beautifully," said the chauffeur. But he still seemed pleased to be acknowledged as more expert in matters of religion. "We make the sacrifice to show we're as loyal to God as the prophet Abraham was. . . . By this sacrifice we say that we are willing to lose even the thing that is most precious to us. We love God so much, little lady, that for Him we give up even the thing we love most. And we do that without expecting anything in return."

"Isn't there any heaven at the end of it?" I asked slyly.

"As God has so written . . . That will become clear on Judgment Day. We don't make the sacrifice to get into heaven. We make the sacri-fice because we love God, and without expecting anything in return."

"You know a lot about religion, Çetin Efendi."

"Kemal Bey, you're embarrassing me. You're so educated, you know so much more. Anyway, you don't need religion or a mosque to know such things. If there is something we value greatly, something we have lavished with care, and we give it to someone truly out of love, it is without expecting anything in return."

"But wouldn't the person for whom we have performed this selfless act then feel upset?" I said. "They'd worry that we want something from them."

"God is great," said Çetin Efendi. "He sees everything and under-stands everything. . . . And He understands that we expect nothing in return for our love. No one can fool God."

"There's a shop open over there," I said. "Çetin Efendi, could you stop here? I know they sell liqueurs."

In a minute Füsun and I had bought two bottles of the government monopoly's famous liqueurs, one peppermint and one strawberry, and climbed back into the car.

"Çetin Efendi, we still have time, can you take us on a little drive?"

So many years later Füsun was able to remind me of most of the things we talked about during our long drive around the city. In my own memory only one image remained of that cold, gray holiday morning: Istanbul resembled a slaughterhouse. It was not just in the poor areas, or the empty lots in dark and narrow backstreets, or among the ruins and burned-out lots—even on the big avenues and in the richest neighbor-hoods, people had been slaughtering lambs, tens of thousands of them since the early hours of the morning. In some places the sidewalk and the cobblestones were covered in blood. As our car rolled down hills and across bridges and wound its way through the backstreets, we saw lambs that had just been slaughtered, lambs being chopped into pieces, lambs being skinned. We took the Galata Bridge across the Golden Horn. Despite the holiday and the flags and the crowds in their finery, the city looked tired and sad. Beyond the Aqueduct of Valens we turned toward Fatih. There we saw hennaed lambs for sale in an empty lot.

"Are these going to be slaughtered, too?" asked Füsun.

"Maybe not all of them, little lady," said Çetin Efendi. "It's almost noon, and these still haven't been sold. . . . Maybe, if they're not bought by the end of the holiday, these poor animals will be saved. But eventu-ally, the drovers will sell them to butchers, little lady."

"We'll get there before the butchers and buy them, and save them," said Füsun. She wore an elegant red coat and as she smiled, she gave me a courageous wink. "We can rescue the sheep from this man who wants to slaughter his children, can't we?"

"We certainly can," I said.

"You're very clever, little lady," said Çetin Efendi. "Actually the prophet Abraham didn't want to kill his son at all. But the command was from God. If we don't submit to God's every command, then the world will turn upside down, the Judgment Day will be upon us. . . . The foundation of the world is love. The foundation of love is the love we feel for God."

"But how could a child whose father wants to kill him understand this?" I asked.

For a moment I met Çetin Efendi's eyes in the rearview mirror.

"Kemal Bey, I know you are just saying these things to tease me and have a good laugh, just like your father," he said. "Your father loves us very much and we respect him greatly, so we never get upset at his jokes. Your jokes don't upset me either. I'll answer your question with an example. Have you seen the film called *The Prophet Abraham*?"

"No."

"No, of course not—you'd never go to a film like that. But you should see this film and take this little lady with you. You won't be bored. . . . Ekrem Güçlü plays Abraham. We took the whole family— my wife, my mother-in-law, and all our children—and we all cried to our hearts' content. When Abraham took out his knife and looked at his son, we all cried then, too. . . . And when Ismail said, 'Dear Father, do whatever God commands!' just like he does in the Glorious Kuran . . . we cried again. Then, when the sacrificial lamb appeared in the place of the son who was to have been slaughtered, we wept with joy, together with everyone else in the cinema. If we give what we treasure most to a Being we love with all our hearts, if we can do that without expecting anything in return, then the world becomes a beautiful place, and that, little lady, is why we were crying."

I remember going from Fatih to Edirnekapı, and from there we turned right to follow the city walls all the way to the Golden Horn. As we passed the poor neighborhoods, as we advanced along the crumbling city walls, the three of us fell silent, and we remained so for a very long time. As we gazed upon the orchards between the old castle walls, and the empty lots strewn with rubbish, discarded barrels, and debris, and the run-down factories and workshops, we saw the occasional slaughtered lamb, and skins that had been tossed to one side, with their innards and horns, but in the poor neighborhoods, with their un-painted wooden houses, there was less sacrifice, and more festivity. I remember how delighted Füsun and I were to look out over the lots where carousels and swings had been set up for the celebrations, and at the children buying gum with their holiday money, and the Turkish flags set like little horns on the tops of buses, and all the scenes that I would later find in photographs and postcards, and collect so ardently.

As we drove up Şişhane Hill a crowd was milling in the middle of the road and the traffic had come to a standstill. At first I thought it was another holiday gathering, but when the crowd parted before us we found ourselves right beside two vehicles that had crashed only moments ago, and the dying victims. The truck's brakes had failed, and the driver had swerved into the oncoming lane, then mercilessly plowed into a private car.

"God is great!" said Çetin Efendi. "Please, little lady, make sure you do not look."

We caught a glimpse of someone still trapped inside the car, whose front was completely crushed, her head bobbing as she fought for her life. I shall never forget the crunch of shattered glass under our tires as we drove on or the quiet that followed. We hurried on up the hill, and as we sped through the deserted streets from Taksim to Nişantaşı, it was as if in flight from death itself.

"Where have you been all this time?" my father asked. "We were getting worried. Did you get the liqueur?"

"It's in the kitchen!" I said. The sitting room smelled of perfume, cologne, and carpet. As I joined the crowd of relations, I forgot all about little Füsun.

12

Kissing on the Lips

THE FOLLOWING afternoon, Füsun and I reminisced again about our drive around the city on that holiday morning six years earlier, before giving ourselves over to kisses and lovemaking. As the linden-scented breeze rustled through the tulle curtains to lap against her honey-colored skin, I was driven to distraction by the way she clung to me with all her strength, as to a life raft, eyes tightly shut, and I could neither see nor reflect on the deeper meaning of what I was experiencing. Still I concluded that if I was to avoid sinking into the dangerous

depths where guilt and suspicion serve only to induce the helplessness of love, I should seek out the company of other men.

On Saturday morning, after I'd been with Füsun three more times, my brother rang to invite me to the match that Fenerbahçe was to play that afternoon against Giresunspor; if Fenerbahçe won—as the odds-makers expected—it would take the championship. So off we went to the İnönü Stadium, formerly known as the Dolmabahçe Stadium. Apart from its name, it pleased me to note, it was just the same as it had been twenty years ago. The only real difference was that, adopting European convention, they had tried to grow grass on the playing field. But as the seed had taken root only in the corners, the playing field resembled the head of a balding man with just a scattering of hair on the temples and the back. The more affluent spectators in the num-bered stands did the same as they had done in the mid-1950s: When-ever the exhausted players approached the sidelines, especially the less glorious defensemen, they would shower them with abuse, rather as the Roman masters cursed gladiators from the tribunes ("Run, you gutless faggots!"); while from the open stands, the poor, the unemployed, and students echoed the angry curses in unison, hoping to make their voices heard, too. As the sports pages would confirm the next day, it was something of a rout, and when Fenerbahçe scored a goal, I jumped to my feet with the rest of the crowd. In this festive atmosphere, with men on the field and in the stands conjoined in ritual embrace and con-gratulation, in this sudden community I felt my guilt recede, my fear transform into pride. But during the quiet moments of the match, when all thirty thousand of us could hear a player kick the ball, I turned to look at Dolmabahçe Palace, and the Bosphorus glimmering behind the open stands, and as I watched a Soviet ship moving behind the palace, I thought of Füsun. I was profoundly moved that she, hardly knowing me, had yet chosen me, had so deliberately elected to give her-self to me. Her long neck, the dip in her abdomen that was like no other, the blending of sincerity and suspicion in her eyes at the same instant, their melancholic honesty when they looked right into mine as we lay in bed, and our kisses, all played on my mind.

"You seem preoccupied. It's the engagement, I guess," said my brother.

"Yes."

"Are you very much in love?"

"Of course."

With a smile both compassionate and worldly-wise, my brother turned back to watch the ball in midfield. In his hand was a Turkish Marmara cigar—he had taken up this habit two years earlier, "just to be original," he said. The light wind blowing in from Leander's Tower ruffling the teams' great banners as well as the little red corner flags carried the stinging smoke right into my eyes, making them water just as the smoke from my father's cigarettes had done when I was a child.

"Marriage will do you good," said my brother, his eyes still on the ball. "You can have children right away. Don't wait too long and they can be friends with ours. Sibel is a woman with a lot of sense; she has her feet on the ground. While you sometimes get carried away with your ideas, she'll provide a good balance. I hope you don't wear out Sibel's patience the way you did with all those other girls? Hey, what's wrong with this ref? That was a foul!"

When Fenerbahçe scored its second goal, we all leapt up—"Goooal!"—and threw our arms around one another and kissed. When the match was over, we were joined by Kadri the Sieve, an army buddy of my father's, and a number of football-loving lawyers and businessmen. We walked up the hill with the shouting, chanting crowd and went into the Divan Hotel, where we talked football and politics over glasses of *rakı*. And my thoughts turned again to Füsun.

"Your mind is elsewhere, Kemal," said Kadri Bey. "I guess you don't like football as much as your brother."

"I do, but lately . . ."

"Kemal likes football very much, Kadri Bey," said my brother in a mocking tone. "It's just that people don't pass him many good balls."

"As a matter of fact I can give you the whole 1959 Fenerbahçe lineup from memory," I said. "Özcan, Nedim, Basri, Akgün, Naci, Avni, Mikro Mustafa, Can, Yuksel, Lefter, Ergun."

"Seracettin was in there, too," said Kadri the Sieve. "You forgot him."

"No, he never played on that team."

The discussion continued and as always in such situations, led to a wager, Kadri the Sieve betting that Seracettin had played on the 1959

team, and I betting that he hadn't. The loser would buy dinner for the
entire group of *rakı* drinkers at the Divan.

As we walked back to Nişantaşı, I parted from the other men.
Somewhere in the Merhamet Apartments was a box in which I had
kept all the photographs of football players I had collected from the
packs of chewing gum that they used to sell once upon a time. It was
just the sort of item my mother would banish to the apartment. I knew
that if I could find that box, with all those pictures of football players
and film stars that my brother and I had collected, Kadri the Sieve
would be buying dinner for everyone.

But as soon as I entered the apartment I understood that my real
reason for coming again was to dwell on the hours spent there with
Füsun. For a moment I looked at the unmade bed, the unemptied ash-
trays at the head of the bed, and the unwashed teacups. My mother's
accumulated old furniture, the boxes, the stopped clocks, the pots and
pans, the linoleum covering the floor, the smell of dust and rust had
already merged with the shadows in the room to create a little paradise
of the spirit in which my mind could wander. It was getting very dark
outside, but still I could hear the cries and curses of the boys playing
football in the garden.

On that visit to the Merhamet Apartments, on May 10, 1975, I did
indeed find the tin in which I had kept all the pictures of movie stars
from Zambo, but it was empty. The pictures the museum visitor will
view are ones I bought many years later from Hıfzı Bey, during days
whiled away conversing with shivering and miserable collectors in vari-
ous crowded rooms. What's more, on reviewing my collection years
later, I realized that during our visits to the bars frequented by film
people—Ekrem Güçlü (who'd played the prophet Abraham) among
them—we had met quite a few of these actors. My story will revisit all
these episodes, as will the exhibit. Even then I sensed this room myste-
rious with old objects and the joy of our kisses would be at the core of
my imagination for the rest of my life.

Just as for most people in the world at the time, my first sight of two
people kissing on the lips was at the cinema and I was thunderstruck.
This was definitely something I'd want to do with a beautiful girl for
the rest of my life. At the age of thirty, except for one or two chance
encounters in America, I had still seen no couples kissing offscreen. It

was not just when I was a child, though even then, the cinema seemed to be the place to go to watch other people kissing. The story was an excuse for the kissing. When Füsun kissed me, it seemed as if she was imitating the people she had seen kissing in films.

I would now like to say a few things about our kisses, though I have some anxieties about steering clear of trivialities and coarseness. I want to tell my story in a way that does justice to its serious points regarding sex and desire: Füsun's mouth tasted of powdered sugar, owing, I think, to the Zambo Chiclets she so liked. Kissing Füsun was no longer a provocation devised to test and to express our attraction for each other; it was something we did for the pleasure of it, and as we made love we were both amazed to discover love's true essence. It was not just our wet mouths and our tongues that were entwined but our respective memories. So whenever we kissed, I would kiss her first as she stood before me, then as she existed in my recollection. Afterward, I would open my eyes momentarily to kiss the image of her a moment ago and then one of more distant memory, until thoughts of other girls resembling her would commingle with both those memories, and I would kiss them, too, feeling all the more virile for having so many girls at once; from here it was a simple thing to kiss her next as if I were someone else, as the pleasure I took from her childish mouth, wide lips, and playful tongue stirred my confusion and fed ideas heretofore not considered ("This is a child," went one idea—"Yes, but a very womanly one," went another), and the pleasure grew to encompass all the various personae I adopted as I kissed her, and all the remembered Füsuns that were evoked when she kissed me. It was in these first long kisses, in our lovemaking's slow accumulation of particularity and ritual, that I had the first intimations of another way of knowing, another kind of happiness that opened a gate ever so slightly, suggesting a paradise few will ever know in this life. Our kisses delivered us beyond the pleasures of flesh and sexual bliss for what we sensed beyond the moment of the springtime afternoon was as great and wide as Time itself.

Could I be in love with her? The profound happiness I felt made me anxious. I was confused, my soul teetering between the danger of taking this joy too seriously and the crassness of taking it too lightly. That evening Osman came over with his wife, Berrin, and their children to

my parents' place for supper. I remember that while we were eating, I kept thinking of Füsun, and our kisses.

The next day I went to the cinema alone at lunchtime. I had no particular wish to see a film, but I couldn't face eating in the usual little place in Pangaltı with Satsat's aging accountants and the kindhearted, plump secretaries who so enjoyed reminding me what a sweetie I had been as a child. I wanted to be alone. To indulge my thoughts of Füsun and our kisses, longing for two o'clock to come, while joking with my employees, playing the "humble friendly boss" and all the while eating, would have been too much to manage.

As I wandered through Osmanbey, down Cumhuriyet Avenue, gazing at the shop windows, I was drawn into a film by a poster advertising a Hitchcock week. This film too had a kissing scene with Grace Kelly. This cigarette I smoked during the five-minute intermission, this usher's flashlight, and this Alaska Frigo ice cream (which I display as a reminder to all housewives and lazy truants who ever attended a matinee) should imitate the desire and solitude I knew as a youth. I savored the coolness of the cinema after the heat of the spring day, the stale air heavy with mold, the handful of cineastes whispering excitedly, and I loved letting my mind wander as I gazed into the dark corners and the shadows at the edges of the thick velvet curtains; the knowledge that I would soon be seeing Füsun sent wave after wave of delight radiating through my body. After leaving the cinema, I walked through the higgledy-piggledy backstreets of Osmanbey, passing little clothes shops, coffeehouses, hardware stores, and laundries where they starched and ironed shirts, until I reached Teşvikiye Avenue and I remember telling myself as I headed toward our meeting place that this would have to be our last time.

First I would make an honest effort at teaching her mathematics. The way her hair tumbled onto the paper, the way her hand traveled across the table, the way she'd chew and chew a lead pencil, only to slip its eraser between her lips, as if sucking a nipple, the way her bare arm grazed my own from time to time—all this sent my head spinning, but I held myself in check. As she set out to balance an equation, Füsun's face would fill with pride, and all of a sudden she would forget her manners and blow a puff of smoke straight at the book (and some-

times straight into my face), and throwing me a look from the corner of her eye, as if to say, Did you notice how fast I worked that one out?, she managed to ruin the whole thing because of a simple addition mistake. Unable to find her answer in a, b, c, d, or e, she would turn sad, and then upset, and she would make up excuses, like, "It wasn't out of stupidity; it was carelessness!" So that she wouldn't make the same mistake again, I would arrogantly tell her that being careful was a part of being clever, and I would watch the tip of her pencil pecking like the beak of a sparrow as she pounced on a new problem; she would pull at her hair nervously as she simplified an equation with some skill, and I would follow her work anxiously, with the same impatience, the same rising agitation. Then suddenly we would start to kiss, kissing for a long time before we'd make love, and while we made love, we would feel the entire weight of lost virginity, shame, and guilt—this we sensed in each other's every movement. But I also saw in Füsun's eyes her pleasure in sex, her growing amazement at discovering delights that she'd wondered about for so long. She called to mind an adventurer of old who, after years of dreaming of a distant legendary continent, sets out across the seas, and who, having crossed oceans, suffered hardships, and shed blood, finally steps onto its shores, to meet each tree, each stone, each creature with awe and enchantment, drawing from the same elation to savor each flower she smelled, each fruit she put into her mouth, exploring each novelty with a cautious, bedazzled curiosity.

Leaving aside the man's tool, what interested Füsun most was not my body, nor was it the "male body" in general. It was her own form and her own pleasure that most occupied her. She needed my body, my arms, my fingers, my mouth, to find the pleasure spots and potentials of her body, her soft skin. Lacking experience, Füsun was sometimes shocked by the possibilities of what I was teaching her as her eyes turned inward with a lovely haziness, pleasure spreading through her veins to the back of her neck and her head, like a gradually intensifying shiver, and she would follow pleasure's flow with awe, sometimes letting out a blissful cry, then once more await my assistance.

"Do that again, please? Do it like that again!" she whispered now and again.

I was very happy. But this was not an elation I could weigh in my

mind and understand. It was something that I felt on the nape of my neck when I answered the phone, or at the tip of my spine when running up the stairs, or in my nipples when ordering food at a Taksim restaurant with Sibel, to whom I was to become formally engaged in four weeks' time. I would carry this feeling around with me all day, like a scent on my skin, sometimes forgetting it was Füsun who had given it to me, as when, on several occasions, I was in my office after hours, hurriedly making love to Sibel, and it seemed to me I was in the grace of one great, all-consuming beatitude.

13

Love, Courage, Modernity

ONE EVENING, as we were eating at Fuaye, Sibel gave me a fragrance called Spleen that she'd bought for me in Paris; I exhibit it here. Though in fact I didn't like wearing fragrance, I dabbed some on my neck one morning, just out of curiosity, and after we'd made love, Füsun noticed it.

"Was it Sibel Hanım who bought this cologne for you?"

"No. I bought it for myself."

"Did you buy it because you thought Sibel might like it?"

"No, darling, I bought it because I thought *you* might like it."

"You're still making love with Sibel Hanım, aren't you?"

"No."

"Please don't lie to me," said Füsun. An anxious expression formed on her perspiring face. "I would consider it normal. Of course you are having sex with her, aren't you?" She fixed her eyes on mine, like a mother gently steering a child away from his lie.

"No."

"Believe me, lying will hurt me a lot more. Please tell me the truth. So why aren't you making love, then?"

"Sibel and I met last summer in Suadiye," I said, wrapping my arms

around Füsun. "Our winter home was closed for the summer, so we would come to Nişantaşı. Anyway, in the autumn she went to Paris. I visited her there a few times over the winter."

"By plane?"

"Yes. This December, after Sibel finished university and returned from France to marry me, we used the summer house to meet through the winter. But the house in Suadiye would get so cold that after a while it took the pleasure out of sex," I continued.

"So you decided to wait until you had found a warm house?"

"At the beginning of March, two months ago, we went back to the house in Suadiye one night. It was very cold there. While we were trying to light a fire the house filled with smoke, and we had an argument, too. After that Sibel came down with a bad case of the flu. She had a fever, wound up in bed for a week, and we didn't ever want to go back there to make love."

"Which of you didn't want to?" asked Füsun. "Her or you?" As curiosity consumed her, compassion gave way to desperation, and her expression, which a moment ago was saying, Please tell me the truth, now was pleading, Please tell me a lie. Don't hurt me.

"I think Sibel is hoping that if we make love less before we marry, I might prize the engagement, our marriage, and even her, a bit more," I said.

"But you're saying that before all this you did make love."

"You don't understand. This is not about making love for the first time."

"You're right, it isn't," said Füsun, lowering her voice.

"Sibel showed me how much she loved me, and how much she trusted me," I said. "But the idea of making love before marriage still makes her uncomfortable. . . . I understand this. She's studied in Europe, but she's not as modern and courageous as you are. . . ."

There was a very long silence. Having spent years pondering the meaning of this silence, I think I can now summarize it in a balanced way. That last thing I'd said to Füsun had an implied meaning. I had suggested that what Sibel had done before marriage out of love and trust, Füsun had done out of courage and a modern outlook. I have suffered many years of remorse for labeling Füsun as "modern and courageous," for the compliment also said that I would feel no special

obligations to her just because she'd slept with me. If she was "modern," she would not see sex with a man before marriage as a burden, and neither would she worry about being a virgin on her wedding day. Just like those European women we entertained in our fantasies, or those legendary women who were said to wander the streets of Istanbul. How could I have said those words believing Füsun would warm to them?

Though I may not have understood everything quite so clearly during that silence, these thoughts went through my mind as I watched the trees in the back garden slowly swaying in the wind. After making love, as we lay in bed chatting, we would look out the window at those trees, the apartment houses behind them, the random flights of crows among their branches.

"Actually, I'm not modern or courageous!" Füsun said, after a long while.

At the time I took these words to express her unease at discussing this weighty subject, and even humility, and I didn't dwell on them.

"A woman can love a man like crazy for years without once making love to him," Füsun added cautiously.

"Of course," I said. There was another silence.

"Are you telling me that you're not making love at all right now? Why weren't you bringing Sibel here?"

"It never occurred to us," I said, amazed that it hadn't until after I'd met Füsun in the shop. "This used to be the place I'd come to study and listen to music with friends—whatever the reason, it was because of you that I remembered it."

"I can certainly believe that it never occurred to you," said Füsun with skepticism. "But there's a lie in what you said before that. Isn't there? I don't want you to tell me any lies. I can't believe you aren't having sex with her these days. Swear to me, please."

"I swear I'm not making love to her," I said.

"So when were you going to start making love to her again? Will it be when your parents go to Suadiye this summer? When are they due to leave? Tell me the truth. I'm not going to ask you anything else."

"They're moving to Suadiye after the engagement party," I mumbled shamefacedly.

"So did you tell me any lies just now?"

"No."

"Why don't you think it over for a while."

I arranged to look thoughtful and for a brief time I did think. Meanwhile Füsun took my driver's license from my jacket pocket and began to fiddle with it.

"Ethem Bey, I have a middle name, too," she said. "Never mind. Have you thought it over?"

"Yes, I've thought it over. I didn't tell you any lies."

"Just now, or in the recent past?"

"Never," I said. "We're at a stage when there is no need for us to lie to each other."

"How is that?"

I explained that we had no designs on each other, and neither were we connected by work, and though we hid it from the world, we were bound together by the purest and most elemental emotions, and by a passionate sincerity that left no room for deceit.

"You've lied to me—I'm sure of it," said Füsun.

"It hasn't taken you long to lose respect for me."

"Actually, I would have preferred it if you had lied to me . . . because people only tell lies when there is something they are terribly frightened of losing."

"Obviously, I am telling lies *for* you. . . . But I am not lying *to* you. But if you like, I can do the other, too. Let's meet again tomorrow. Can we do that?"

"Fine!" said Füsun.

I embraced her with all my strength and breathed in the scent of her neck. It was a mixture of algae, sea, burnt caramel, and children's biscuits, and every time I inhaled it a surge of optimism would pass through me, yet the hours I spent with Füsun did not change by one iota the course on which my life was set. This may have been because I took my bliss for granted. Still it was not because I fantasized myself to be (like all Turkish men) always in the right, or even that I imagined myself to be continually wronged by others; it was more that I was not yet aware of what I was experiencing.

It was during these days that I first began to feel fissures opening in my soul, wounds of the sort that plunge some men into a deep, dark,

lifelong loneliness for which there is no cure. Already, every evening, before going to bed, I would take the *rakı* from the refrigerator and gaze out the window as I drank a glass alone in silence. Our apartment was at the top of a tall building opposite Teşvikiye Mosque, and our bedroom windows looked out on many other families' bedrooms that resembled ours; since childhood I had found strange comfort in going to my dark bedroom to look into other people's apartments.

As I gazed out on the lights of Nişantaşı, it would occasionally occur to me that if I was to continue my happy, beautiful life in the manner to which I was accustomed, it was essential that I not be in love with Füsun. For this reason I felt it was important to resist befriending her or taking too great an interest in her problems, her jokes, and her humanity. This was not too difficult, as there was so little time left after we had done our math lessons and made love. When, after hours of lovemaking, we quickly dressed and left the apartment, I sometimes thought that Füsun was also taking care not to get "carried away" by her feelings for me. A proper understanding of my story depends, I think, on a full appreciation of the pleasure we took from these sweet shared moments. I am certain that the fire at the heart of my tale is the desire to relive those moments of love, and my attachment to those pleasures. For years, whenever I recalled those moments, seeking to understand the bond I still felt with her, images would form before my eyes, crowding out reason; for example, Füsun would be sitting on my lap, and I would have taken her large left breast into my mouth. . . . Or while drops of perspiration fell from the tip of my chin onto her graceful neck, I'd gaze with awe at her exquisite backside. . . . Or, after crying out rapturously, she would open her eyes for just one second. . . . Or at the heights of our pleasure, the look on Füsun's face . . .

But as I later came to understand, these images were not the reason for my elation, but merely provocative representations of it. Years later, as I struggled to understand why she was so dear to me, I would try to evoke not just our lovemaking but the room in which we made love, and our surroundings, and ordinary objects. Sometimes one of the big crows that lived in the back garden would perch on the balcony to watch us in silence. It was the spitting image of a crow that had perched on our balcony at home when I was a child. Then my mother would

say, "Come on now, go to sleep. Look, the crow is watching you," and that would frighten me. Füsun, too, had had a crow that had frightened her that way.

On some days it was the dust and the chill in the room; on others it was our pallid, soiled, spectral sheets, our bodies, and the many sounds that filtered in from the life outside, from the traffic, from the endless noise of construction work and from the cries of the street vendors that led us to feel our lovemaking belonged not to the realm of dreams but to the real world. Sometimes we could hear a ship's whistle from as far away as Dolmabahçe or Beşiktaş, and together we would try to guess what sort of ship it was, as children might do. As we continued to meet, making love with ever-escalating abandon, I came to locate the source of my happiness not only in that real world outside, but also in the tiny flaws on Füsun's body, the boils, pimples, hairs, and her dark and lovely freckles.

Apart from our measureless lovemaking with childlike abandon, what was it that bound me to her? Or else why was I able to make love to her with such passion? Did the pleasure of satisfying our ever-renewing desire give birth to love, or was this sentiment born of, and nurtured by, other things as well? During those carefree days when Füsun and I met every day in secret, I never asked myself such questions, behaving only like a child greedily gulping one sweet after another.

14

Istanbul's Streets, Bridges, Hills, and Squares

ONCE, WHEN we were talking aimlessly, Füsun happened to mention a teacher she'd liked at lycée, saying, "He wasn't like other men!" and when I asked her what she meant by that, she did not answer. Two days later I asked her once again what she'd meant by his not being "like other men."

"I know you are asking this question in all seriousness," said Füsun. "And I want to give you a serious answer. Shall I try to do that?"

"Of course . . . Why are you getting up?"

"Because I don't want to be naked when I say what I have to say to you."

"Shall I get dressed, too?" I said, and when she didn't answer I too got dressed.

The cigarette packets exhibited alongside this Kütahya ashtray, retrieved from a cupboard elsewhere in the flat and brought to the bedroom, are—like the teacup (Füsun's), the glass, and the seashell that Füsun kept fingering so nervously as she told her stories—assembled here to evoke the room's heavy, draining, crushing atmosphere at that moment. Füsun's girlish hair clip should remind us that the stories she told had happened to a child.

Füsun's first story was about the owner of a little shop on Kuyulu Bostan Street that sold tobacco, toys, and stationery. This Uncle Sleaze was a friend of her father's, and from time to time he and Uncle Sleaze would play backgammon together. When Füsun was between the ages of eight and twelve, and most particularly during the summers, her father often sent her to this man's shop for soft drinks, cigarettes, or beer; every time she went, Uncle Sleaze would say, "I don't have the correct change. Why don't you stay for a while. Let me give you a soft drink," and having used such pretexts to keep her in the shop, when no one was around he'd find some other excuse ("Oh, look, my poor child, you're perspiring") to feel her up.

When she was somewhere between ten and twelve, there was Shithead-with-a-Mustache, the neighbor who visited in the evenings once or twice a week with his fat wife. Her father liked this man very much, and while the two of them were listening to the radio and chatting, drinking tea and eating biscuits, this man would put his arm on her waist, or her shoulder, or the side of her buttocks, or her thigh and leave it, as if he had forgotten it was there, and all this in a way that no one else could see, so that even Füsun had a hard time understanding what exactly was going on. And sometimes this man's hand would "accidentally" plop down on her lap, as a wily fruit might arrange to fall into a basket, and there it would quiver, moist and hot, fingering its way, with Füsun staying as still as if there were a crab crawling between her

buttocks and her legs, this man all the while drinking tea with his other hand and engaging in the conversation in the room.

When she was ten, she would ask her father if she could sit on his lap while he was playing cards, and when he said no ("Stop, my girl, I'm busy, can't you see?"), one of his card-playing friends (Mr. Ugly) invited her onto *his* lap, saying, "Come over here and bring me luck," and he went on to caress her in a way that she would later understand to be far from innocent.

Istanbul's streets, bridges, hills, cinemas, buses, crowded squares, and isolated corners were filled with these shadowy Uncles Sleaze, Shithead, and Ugly, who, though they appeared like dark specters in her dreams, she could not bring herself to hate as individuals ("Perhaps it was because none of them ever really shook me to the core"). What Füsun found hard to reckon was that even though one of every two family visitors quickly turned into an Uncle Sleaze or a Mr. Shithead, her father never noticed them squeezing or touching her in the corridors or the kitchen. When she was thirteen, she was convinced that being a good girl obliged her not to complain about this pack of shifty, sleazy, loathsome men with their restless paws. During those same years, when a lycée "boy" who was in love with her (about which Füsun had no complaints) wrote "I love you" on the street, just in front of the house, her father pulled her to the window by her ear to point at the writing and gave her a smack.

Because so many Shameless Uncles had a penchant for exposing themselves in parks, empty lots, and backstreets, she, like all presentable Istanbul girls, learned to avoid such places. Yet there were inevitably exceptions. One reason that these violations had not strained her optimism was that, even as they all repeated the secret refrain of the same dark music, the malefactors were at the same time eager to reveal their vulnerabilities. There was an army of followers—men who had seen her in the street, caught sight of her at the school gate, in front of the cinema, or on the bus; some would follow her for months on end, and she would pretend she hadn't noticed them, but she never took pity on any of them (I was the one who'd asked if she had). Some of her followers were not so besotted, or patient, or polite: After a certain interval, they would start pestering her ("You're very beautiful. Can we walk together? There's something I'd like to ask you. Excuse me, are you

deaf?"), and before long they'd get angry, saying rude things to her and cursing her. Some would walk about in pairs; some would bring along friends to show them the girl they had been following in recent days and get a second opinion; some would laugh lewdly among themselves as they followed her; some would try to give her letters or presents; some would even cry. Ever since one of her followers had pushed her into a corner and tried to force a kiss on her, she had stopped challenging them the way she occasionally used to do. By the age of fourteen, she knew all the tricks that men played and could read their intentions so men could no longer catch her unawares and touch her, and perhaps she no longer fell into their traps so easily, though the streets were never short of men finding imaginative new ways to touch her, pinch her, squeeze her, or brush her from behind. The men who stretched their arms out through car windows to fondle girls walking down the street, the men who pretended to trip on the stairs in order to press themselves against girls, the men who abruptly started to kiss her in the elevator, the men who took with their change an illicit stroke of her fingers—it had been some time since any of them could surprise her.

Every man in a secret relationship with a beautiful woman is obliged to jealously hear various stories about the various men who were infatuated with, or putting the moves on, his beloved, reports to be greeted with smiles, an abundance of pity, and ultimately contempt. At the Outstanding Achievement Course there was a sweet, gentle, handsome boy her age who was always inviting her to go to the cinema or sit in the tea garden on the corner, and whenever he saw Füsun he was so excited that for the first few minutes he was speechless. One day when she mentioned that she didn't have a pencil he gave her a ballpoint pen, and he was ecstatic to see her using it to take notes in class.

At the same college there was an "administrator"—in his thirties, his hair always slick with brilliantine, edgy, obnoxious, and taciturn. He was ever finding excuses to call Füsun to his office, as in "Your identity papers are not complete," or "One of your answer sheets is missing," and once she was there, he'd begin discussing the meaning of life, the beauty of Istanbul, and the poems he had published until, seeing that Füsun was giving him not a word of encouragement, he would turn his back on her, gazing out the window, and he would hiss, "You may leave."

She would not even discuss the hordes—a woman in one instance—who came to the Şanzelize Boutique and fell in love with her on sight, and went on to buy loads of dresses, accessories, and trinkets from Şenay Hanım. Naturally, I pressed her for more details, and only to placate my curiosity, passing for concern, did she agree to talk about the most ridiculous one, a man in his fifties, short, fat as a jar, with a brush mustache, but stylish and rich. He would chat with Şenay Hanım, now and again pushing long French sentences out of his little mouth, and when he left the shop his cloud of perfume would linger for some time, upsetting Lemon the canary!

As for the suitors found by her mother through a matchmaker (supposedly without Füsun's knowing) there was one man she'd liked, who had been more interested in her than in marriage; she'd gone out with him a few times, liked him, and kissed him. Last year, during a music competition among many schools at the Sports Arena, she'd met a Robert College boy who'd fallen head over heels in love with her. He'd meet her at the school gate, and every day they'd leave together, and they'd kissed two or three times. Hilmi the Bastard, however, despite a flurry of dates, she'd not even kissed, because his sole aim in life seemed to be getting girls into bed. She'd felt close to Hakan Serinkan, the beauty contest emcee, not because he was famous, but because, in this place where everyone was conspiring backstage and being openly unfair to her, he'd gone out of his way to be gentle and kind; and because when it came time for the culture and intelligence questions that made the other girls so nervous, he'd whispered them to her backstage in advance, along with the answers. But later, when this old-style crooner had made insistent phone calls to the house, she'd refused to answer, and, anyway, her mother didn't approve. Rightfully inferring jealousy—though she thought it had to do with the singer's fame—she told me tenderly (but with obvious pleasure) that she had not been in love with anyone since the age of sixteen, and then she made a pronouncement that shocks me still. Although she, like most girls, enjoyed the perpetual celebration of love in magazines and television and songs, she didn't regard the subject fit for idle talk, and was convinced that people exaggerated their feelings just to appear superior. For her, love was something to which one devoted one's entire being at the risk of everything. But this happened only once in a lifetime.

"Have you ever felt anything close to this?" I asked, as I lay down beside her on the bed.

"Not really," she said, but then she thought a bit and with a reserve born of willful scrupulousness, she told me about someone.

There was a man so madly and obsessively in love with her that she had thought she could love him back—he was rich, handsome, a businessman, and "married, of course." In the evenings when she left the shop he would pick her up in his Mustang at the corner of Akkavak Street. They would go to that place next to the Dolmabahçe Clock Tower where people parked and drank tea and looked at the Bosphorus or to that empty lot in front of the Sports Arena, and as they sat there in the dark, and sometimes in the rain, they would kiss for a long time, and then, forgetting his circumstances, this thirty-five-year-old man would ask her to marry him. I could smile over this man's predicament, suppressing my jealousy, much as Füsun intended, even as she told me what kind of car he had, what sort of work he did, and how lovely his large green eyes were; but when Füsun told me his name, I was flooded by an envy that confounded me. This man whom she intimately called Turgay, who had made his fortune in textiles, was a "business associate" and family friend of my father, my brother, and me. I often saw this tall, handsome, ostentatiously hale and hearty man strolling around Nişantaşı with his wife and children, a contented family man. Could my regard for him—as a committed family man, and an honest and hardworking businessman—have somehow inspired this great jealous surge? Füsun recounted how this man had come to the Şanzelize for months on end to "catch" her, and because Şenay Hanım was wise to him, he'd been obliged almost to buy out the entire shop.

Şenay Hanım had pressured her, saying, "Don't cause any heartbreak to my kind customer," and so Füsun had accepted his presents, and then later, when she was sure of his affections, she had started to meet with him "out of curiosity," and even felt "strangely close" to him. One snowy day, at Şenay Hanım's insistence, she'd gone with this man to "help" a friend who'd opened up a boutique in Bebek; on the way back, they'd stopped in Ortaköy for a bite to eat, and after he'd drunk a few too many *rakıs*, "Turgay Bey the playboy factory-owner" began to press her to go with him to his *garçonnière* in a backstreet in Şişli, to "drink some coffee." When Füsun turned him down, that "ele-

gant, sensitive man," losing all sense of proportion, said, "I'd buy you anything!" Thus rebuffed he then drove the Mustang to empty lots and backstreets trying to kiss her like before, until, with Füsun refusing his advances, he'd tried to "possess" her by force. "And all the while he was saying that he was going to give me money," said Füsun. "The next evening, when the shop closed, I didn't meet him. The day after that, he came to the shop, and either he'd forgotten what he'd done or he chose not to remember. He pleaded with me ardently, even leaving a Match-box Mustang for me with Şenay Hanım. But I never got into that Mus-tang again. In retrospect, I should have been stern and told him never to come back again. But he was so in love with me, like a child, really; he was prepared to forget any rejection in the hope of having his love returned, and that moved me, so I couldn't say it. He would come to the shop every day, buying so much and making Şenay Hanım very happy, and if he got me alone for a moment in some corner, his great green eyes almost wet, he would plead with me, saying, 'Can't we just go back to the way we were? I can pick you up every evening. We can drive around in the car. I don't want anything else.' After I met you, I started hiding in the back room every time he visited the shop. Now he doesn't come round so often."

"Those times last winter when you kissed him in the car, why didn't you go further?"

"I wasn't eighteen years old yet," said Füsun, frowning gravely. "I turned eighteen two weeks before you and I met at the shop—on April twelfth."

If the intrinsic evidence of love is to have one's lover or the object of one's affections in mind at all times, then I was truly on the verge of falling in love with Füsun. But inside me was a coolheaded rationalist saying my inability to stop thinking about Füsun was because of all those other men. When it occurred to me that jealousy might be an even more definitive sign of love, my reason (however frantic) con-cluded that this was merely a transitory manifestation. Indeed, after a day or two, I would assimilate Füsun's catalog of the "other men" who had enjoyed her kisses, and even feel some contempt for those who had failed to compel her to go further. But when we made love that day, rather than tumbling into the usual childish bliss, in which playful curiosity mingled with exuberance, I found myself in the grip of what

the newspapers call the urge to "master her," and making my desires plain with ever harsher force, I was surprised by my own behavior.

15

A Few Unpalatable Anthropological Truths

HAVING RAISED the question of "mastery," I would like to return to a matter at the very foundation of my story. Many readers and visitors will already understand it only too well, but in the expectation that much later generations—such as those who will visit our museum after 2100—might find the term opaque, let me now lay aside fears of repeating myself and set down a certain number of harsh—in times past, the preferred word would have been "unpalatable"—truths.

One thousand nine hundred and seventy-five solar years after the birth of Christ, in the Balkans, the Middle East, and the western and southern shores of the Mediterranean, as in Istanbul, the city that was the capital of this region, virginity was still regarded as a treasure that young girls should protect until the day they married. Following the drive to Westernize and modernize, and (even more significantly) the haste to urbanize, it became common practice for girls to defer marriage until they were older, and the practical value of this treasure began to decline in certain parts of Istanbul. Those in favor of Westernization hoped that as Turkey modernized (and in their view, became more civilized) the moral code attending virginity would be forgotten, along with the concept itself. But in those days, even in Istanbul's most affluent Westernized circles, a young girl who surrendered her chastity before marriage could still expect to be judged in certain ways and to face the following consequences:

a) The least severe consequences befell the young people who, as in my story, had already decided to marry. In wealthy

Westernized circles, just as in the case of Sibel and me, there was a general tolerance of young unmarried people who were sleeping together if they had proven themselves "serious," either by formal engagement or another demonstration that they were "destined for marriage." Even so, well-born, well-educated girls who had slept with their prospective husbands before marriage were disinclined to say they had done so out of their trust in these men and their intentions, preferring to claim that they were free and modern enough to disregard tradition.

b) In cases where such trust had yet to be established, or coupledom yet to be socially recognized, should a girl fail to "hold herself back" and instead give away her virginity, perhaps to a man who had forced himself on her, or perhaps because she was passionately in love, or had succumbed to any number of other enemies of prudence—such as alcohol, temerity, or mere stupidity—the traditional code required that any man wishing to protect the girl's honor should marry her. It was after one such accident that Ahmet, the brother of my childhood friend Mehmet, came to marry his wife, Sevda; and though he is now very happy, the union was made in fear of regret.

c) If the man tried to wriggle out of marrying the girl, and the girl in question was under eighteen years of age, an angry father might take the philanderer to court to force him to marry her. Some such cases would attract press attention, and in those days it was the custom for newspapers to run the photographs with black bands over the "violated" girls' eyes, to spare their being identified in this shameful situation. Because the press used the same device in photographs of adulteresses, rape victims, and prostitutes, there were so many photographs of women with black bands over their eyes that to read a Turkish newspaper in those days was like wandering through a masquerade. All in all, Turkish newspapers ran very few photographs of Turkish women without bands over their eyes, unless they were singers, actresses, or beauty contestants (all occupations suggestive of easy virtue, anyway), while in advertisements there was a preference for women and faces that were evidently foreign and non-Muslim.

d) Because no one could conceive of a sensible young girl who gave her virginity under such circumstances to a man who had no intention of marrying her, it was widely believed that anyone who had done such a thing was not sane. The most popular Turkish films of the era included many exemplary tales, painful melodramas of girls at "innocent" dance parties where the lemonade had been spiked with sleeping potions, after which their honor was "soiled" and they were robbed of their "greatest treasure"; in these films the good-hearted girls always died, and the bad ones all became whores.

e) That some girls could be led astray by sexual desire was accepted, of course. But a girl so uncalculating, childish, and passionate that she could not restrain her desires, heedless of the tradition that settled such matters with bloodshed, was regarded as a surreal creature, frightening even her prospective husband, who anticipated that the same sexual appetite might cuckold him after marriage. When an ultraconservative friend from my army days told me that he had separated from his sweetheart because they had "made love too frequently before marriage" (though only with each other) there was a tinge of embarrassment in his voice, and not a little regret.

f) Despite the rigidity of these rules, and all the attendant penalties for breaking them, which ranged from mere ostracism to ritual murder, quite a few of the city's young men believed that there were innumerable young women willing to sleep with a man just for the fun of it. Such beliefs, which social scientists call "urban legends," were so prevalent among the poor, the petite bourgeoisie, and recent immigrants from the provinces, who clung to the notion as fervently as Western children cling to Santa Claus, so readily accepting and rarely disputing them that even modern, Westernized young men in the wealthy neighborhoods of Taksim, Beyoğlu, Şişli, Nişantaşı, and Bebek became susceptible (most especially under circumstances of sexual deprivation). It seemed a universal conviction that these women, who did not cover their heads, wore miniskirts, and made love with men for pleasure ("just like women in Europe"), all lived in places like Nişantaşı (where our story takes place). Young men

like my friend Hilmi the Bastard imagined these women of legend to be rapacious creatures so eager to get to know a rich boy like him, and to climb into his Mercedes, that they would do anything; and on Saturday nights, desperate for sex, after downing a few beers and getting drunk, the Hilmis would prowl Istanbul in their cars, street by street, avenue by avenue, sidewalk by sidewalk, hoping to find one such girl. Ten years earlier, when I was twenty, we spent a winter's night cruising the streets in the Mercedes of Hilmi the Bastard's father (the monicker was affectionate, not technical); after failing to find any women in long skirts or short, we went to a luxury hotel in Bebek, where there were two fun-loving girls who did belly dances for tourists and rich, middle-aged local men, and who, after we had paid their pimps handsomely, were ready to receive us in one of the rooms upstairs. I would like to make clear now that I take no preemptive offense if readers from later, happier centuries disapprove of my conduct. But I would like to defend my friend Hilmi: Despite all his coarse machismo, he did not consider every miniskirted girl to be one of these mythological nymphs who slept with men in simple pursuit of pleasure; on the contrary, if he saw a girl being followed for no reason except that she had bleached her hair or was wearing a miniskirt and makeup, he would defend her from the marauding hordes, slapping and punching them to tutor the unwashed and the unemployed on how women should be treated, and what it meant to be civilized.

Clever readers will have sensed that I have placed this anthropology lesson here to allow myself a chance to cool off from the jealousy that Füsun's love stories provoked, the prime object of which was Turgay Bey. I reasoned that this must be because he was a well-known industrialist living, as I did, in Nişantaşı—and that my jealousy, however overpowering, was natural, and would pass.

16

Jealousy

THAT EVENING, after having heard Füsun boast about Turgay Bey's obsessive love, I went to supper with Sibel and her parents at the old Bosphorus mansion in Anadoluhisarı that they used as their summer home, and after we had eaten I went to sit at Sibel's side for a while.

"Darling, you've had a lot to drink tonight," said Sibel. "Is there something about the preparations you're not happy with?"

"Actually, I'm very glad that we're having the engagement party at the Hilton," I said. "As you know, the person who most wanted such a party was my mother. She's so delighted that—"

"So what's troubling you?"

"Nothing . . . Could I have a look at the invitation list?"

"Your mother gave it to my mother," said Sibel.

I stood up, took three steps, straining, it seemed, the whole dilapidated building, with each floorboard expressing a distinctive creak, and sat down beside my future mother-in-law. "Madam, would you mind if I took a look at the invitation list?"

"Of course not, my child. . . ."

Although I was seeing double from the *rakı,* I found Turgay Bey's name at once and crossed it out with a ballpoint pen, and then, propelled by a sudden sweet compulsion, I put down the names of Füsun and her parents, along with their Kuyulu Bostan Street address, and in a low voice, I said: "My mother doesn't know this, Madam, but the gentleman whose name I crossed out, though a valued family friend, was recently overzealous about a yarn business deal. It saddens me to say that he has knowingly done our family a great wrong."

"Friendship has lost its value, Kemal Bey, as has humanity—in today's world. Those old ties count for nothing," said my future mother-in-law, blinking wisely. "May those people whose names you've added never cause you similar trouble. How many are they?"

"A history teacher and his wife, who's distantly related to my mother

and worked for many years as her seamstress, and their lovely eighteen-year-old daughter."

"Oh good," said my future mother-in-law. "We've invited so many young men that we'd begun to worry that there weren't going to be enough beautiful young girls for them to dance with."

As Çetin Efendi drove us home in my father's '56 Chevrolet, I dozed off, opening my eyes from time to time to contemplate the chaos on the main avenues, which were dark as ever; and the beauty of the old walls covered with cracks, political slogans, mold and moss; the searchlights of the City Line ferries as they lit up the landing stations; and the high branches of the hundred-year-old plane trees receding in the rearview mirror; and all the while I listened to my father, who had been rocked to sleep as the car bumped over the cobblestones, and now softly snored.

My mother beamed with contentment at seeing her wishes coming true. As always on rides home after an evening out, she wasted no time sharing her views of the gathering we had just left and of those in attendance.

"Yes, it was all very good; these are fine people, straight arrows, not lacking in humility, or in elegance either. But what dreadful shape that beautiful mansion is in! Can it be that they can't afford to fix it up? Surely not. But don't misunderstand me, son—I don't believe you could find another girl as charming, graceful, and sensible in all of Istanbul."

After leaving my parents in front of the apartment, I felt like going for a walk, which took me past Alaaddin's shop. This was where my mother had taken my brother and me when we were little, to buy cheap Turkish-made toys, chocolates, balls, water guns, marbles, playing cards, Zambo Chiclets that came with pictures, comics, and so much else. The shop was open. Alaaddin had taken down the newspapers he displayed on the trunk of the chestnut tree outside, and he was just then turning out the lights. With an unexpected warmth he invited me inside, and while he bundled the last of the newspapers he would exchange for the new ones delivered at five in the morning, he tolerated my browsing to pick out this cheap baby doll. I calculated that it would be another fifteen hours before I could give it to Füsun as a present, and wrap my

arms around her and forget all my jealous thoughts; and for the first time I felt pain at being unable to call her on the phone.

It was a burning sensation, from inside me, and it felt like remorse. What was she doing at this moment? My feet were not carrying me home but in just the opposite direction. When I reached Kuyulu Bostan Street, I walked past a coffeehouse where my friends used to play cards and listen to the radio when we were young, and then past the schoolyard where we'd played football. My inner rationalist, though weakened by all the *rakı* I'd drunk, was not yet dead, and now it warned me that it would be Füsun's father who'd open the door and that the consequences might be scandalous. I walked only far enough to be able to see their house in the distance, and the lights in the windows. Just to see the second-floor windows reached by the chestnut tree was enough to make my heart pound.

I commissioned this painting to exhibit right here in our museum, providing the artist with all the necessary details, and while it offers a fine impression of the orangey lamplight cast onto the interior of Füsun's apartment, and the chestnut tree shimmering in the moonlight, and the depth of the dark blue sky beyond the line of rooftops and chimneys of Nişantaşı, does it also, I wonder, convey to the visitor the jealousy I acknowledged as I beheld that view?

As drunk as I was, I was now seeing things clearly—yes, I had come here on this moonlit night to catch a glimpse of Füsun, perchance to kiss her, to speak to her, but in equal part to ensure that she was not spending this evening with someone else. Because now, having gone "all the way" with one man, she might possibly be curious about the experience of making love with one of those other admirers she had enumerated. What fed the ever-growing jealousy festering inside me was that Füsun had embraced the pleasures of lovemaking with the enthusiasm of a child given a wonderful new toy, and that when we made love she was able to give herself over to pleasure completely, in a way I had rarely observed in a woman. I do not remember how long I stood there looking at the windows. It was, I know, quite late by the time I got home, the baby doll present still in my hand, and went to bed.

In the morning, on my way to work, I thought about the things I

had done the night before, taking measure of the jealousy I had been unable to banish from my heart. I was gripped then by the fear that I might be besotted. As she drank from a bottle of Meltem, Inge the model eyed me saucily from the side of an apartment building, warning me to be careful. I considered discussing my secret in jest with friends like Zaim, Mehmet, and Hilmi, so as to release the obsession from the confines of my mind, where it could only intensify. But because my best friends all seemed to like Sibel a great deal—indeed found her very attractive to the point of being envious—I doubted they would give me a sympathetic hearing, or feel much pity. For I knew that as soon as I broached the subject, I would find my calculated and affected mockery crumbling under the weight of my passion, until my longing to speak of Füsun sincerely could no longer be denied, and my friends would conclude that I was indeed undone. And so as the Maçka and Levent buses (the same ones I used to ride with my mother and brother on the way back from Tünel) went rumbling past the windows of my office, I concluded that there was, for now, little I could do to master my desire for Füsun without destroying the chance of the happy marriage that I still wanted very much; and that, rather, I should leave things as they were, avoiding panic, and making the most of all that life had so generously conferred on me.

17

My Whole Life Depends on You Now

BUT WHEN Füsun was ten minutes late for our next rendezvous at the Merhamet Apartments, I immediately forgot my resolutions. I kept glancing at my watch, a present from Sibel, and at the Nacar brand alarm clock Füsun so loved to shake until it jangled, and I peeked continually through the curtains at Teşvikiye Avenue, pacing up and down the creaky parquet floor, unable to take my mind off Turgay Bey. Soon I bolted the apartment and went outside.

I kept a careful eye on both sides of the street, to make sure I didn't

miss Füsun walking toward me, and I proceeded as far as the Şanzelize Boutique. But Füsun wasn't in the shop either.

"Kemal Bey! How can I help you?" said Şenay Hanım.

"We've decided I should buy that Jenny Colon handbag for Sibel Hanım after all."

"So you've changed your mind," said Şenay Hanım. I could see a hint of mockery on her curled lips, but not for long. If I was embarrassed because of Füsun, she must have felt some shame for knowingly selling me a fake. We both fell silent. With torturous slowness, she retrieved the bag that had been restored to the arm of the mannequin in the window, dusting it off with the ritualized care of a seasoned shopkeeper. I directed my attention to Lemon the canary, who was having a dreary day.

After I had paid and was on my way out with my purchase, Şenay Hanım said, "Now that you trust us, perhaps you can grace our shop more often." She took obvious pleasure in her double meaning.

"Of course." If I didn't buy enough from Şenay Hanım, might she plant the seed of suspicion in Sibel, who came into this shop from time to time? It grieved me less to imagine myself falling slowly into this woman's trap than to catch myself making such petty calculations. I imagined that Füsun had gone to the Merhamet Apartments while I was out, and not finding me, had left. In the bright spring day the sidewalks were swarming with housewives out shopping, young girls clomping around in the latest platform shoes paired with ill-fitting short skirts, and pupils swarming out of the schools from which they had just been dismissed. Still searching for Füsun, I cast my eyes over the gypsy flower seller, and the vendor of black market American cigarettes (who everyone said was a plainclothes policeman), and the other denizens of Nişantaşı.

A water tanker with the words LIFE—CLEAN WATER on its side sped by, and Füsun emerged from behind it.

"Where have you been?" we said in unison, joyous smiles coming to our lips.

"The witch stayed in during lunchtime, and she sent me off to a friend's shop. So I got to the apartment late, and you weren't there."

"I got worried, so I went to the shop. Look, I bought the bag as a memento."

Füsun was wearing the earrings of which one is displayed at the entrance to our museum. We walked down the street together. We turned off Valikonağı Avenue into Emlak Avenue, which was not so crowded. We had just passed the apartment that housed the dentist to whom my mother brought me when I was a child (as well as the doctor in whose office I had first felt the unforgettable hardness of the cold tongue depressor shoved into my mouth) when we saw that a crowd had gathered at the foot of the hill; a few others were running down to join it, while others still were coming toward us, their faces contorted by what they had seen.

There had been an accident; the road was closed. Only a few minutes earlier the "Life–Clean Water" tanker had swerved into the left lane while heading down the hill and had crushed a *dolmuş*. The driver of the shared taxi was cowering in a corner, his hands trembling as he smoked a cigarette. The weight of the water tanker had crushed the long nose of a 1940s Plymouth that did the Taksim–Teşvikiye route. All that survived was the taxi meter. Beyond the ever-growing crowd of onlookers, amid the shards of glass and broken car parts, I saw the body of a woman trapped in the front seat, and recognized her as the dark-haired woman I'd passed on my way out of the Şanzelize Boutique. The street was now covered with debris. Taking Füsun by the arm, I said, "Let's go." But she paid me no mind. She stood there silently, staring at the woman pinned inside the wreck, until she had had her fill.

By now the crowd had grown considerably, and I was beginning to feel uneasy, less on account of the dead woman inside the car (yes, she must have been dead by then) than out of fear that I might run into someone I knew, when at last a police car came into view; wordlessly we moved away from the accident. As we walked without speaking up the street where the police station was, straight to the Merhamet Apartments, we were fast approaching the "happiest moment of my life" mentioned at the beginning of this book.

In the coolness of the Merhamet Apartments stairwell, I took her in my arms and kissed her. I kissed her again when we went into the apartment, but there was a certain shyness in her playful lips, a certain reserve in her manner.

"I have something to say to you."

"Then say it."

"I'm afraid you might not take it seriously enough, or that you might react exactly the wrong way."

"Trust me."

"Well, I'm not sure I can, but I'm still going to tell you," she said. She looked as if she'd made up her mind, as if the arrow had already left the bow and there was no longer any point in holding it back. "If you take it the wrong way, I'll die."

"Forget the accident, darling, and please, just tell me."

She began to cry silently, just as she had done that afternoon in the Şanzelize Boutique, when she'd been unable to give me a refund. Her sobs were almost sullen, as those of a child who was furious at being wronged.

"I've fallen in love with you. I'm head over heels in love with you!"

Her voice was both accusatory and unexpectedly gentle. "I think about you all day long. I think about you from morning until night."

She covered her face with her hands and cried.

Let me confess that my first impulse was to grin stupidly. But I didn't. Instead I frowned, assuming a tender expression of concern, until finally I had overcome the force of my own feelings. Here, at one of the deepest, most profound moments of my life, there was something contrived in my demeanor.

"I love you very much, too."

Though I was being utterly sincere, my words were neither as forceful nor as truthful as hers. She'd said it first. Because I'd said it after Füsun, my own truthful declaration of love had taken on a consoling, tactful, echoing tone. Now it didn't matter if my feelings might in fact be stronger than hers, since Füsun had gone first in confessing the fearful dimensions of her sentiments, and so had lost the game. The "sage of love" within me (acquired from who knew what egregious experience) was crowing about Füsun's misstep: By speaking too sincerely, she had lost. From this reaction I deduced that my jealous worries and obsessions would soon subside.

When she began to cry again, she took out of her pocket a crumpled, childish hankie. I embraced her, and while caressing the lovely

velvety skin on her neck and shoulders, I said there could be nothing more ridiculous than the idea of a beautiful girl like her, whom everyone adored, in tears just for having admitted to falling in love.

Still crying, she said, "What do you mean—that beautiful girls never fall in love? If you know so much about everything, then tell me this . . ."

"What?"

"What's going to happen now?"

This was the real question, and she now fixed me with a look as if to say she was not going to be distracted by sweet generalities about love and beauty, and that it was of the utmost importance that I give her the right answer.

I had no answer to give her. But this is how it seems now, so many years later. Sensing that such a question might come between us, I felt an unease for which I secretly blamed her and I began to kiss her.

Driven by desire and helplessness, our kisses grew more passionate. She asked if this was the answer to her question. "Yes," I said. Content with this, she asked, "Weren't we going to do some mathematics?" When I had bestowed another kiss, by way of an answer, she acknowledged it by kissing me back. To embrace, to kiss—it felt so much more genuine than any contemplation of the impasse to which we had come, so full of the irresistible power of the present moment. As she peeled off her clothes, Füsun changed from a fearful girl made sad by helpless passion into a healthy and exuberant woman ready to give herself over to love and sexual bliss. Thus did we enter what I have called the happiest moment of my life.

In fact no one recognizes the happiest moment of their lives as they are living it. It may well be that, in a moment of joy, one might sincerely believe that they are living that golden instant "now," even having lived such a moment before, but whatever they say, in one part of their hearts they still believe in the certainty of a happier moment to come. Because how could anyone, and particularly anyone who is still young, carry on with the belief that everything could only get worse: If a person is happy enough to think he has reached the happiest moment of his life, he will be hopeful enough to believe his future will be just as beautiful, more so.

But when we reach the point when our lives take on their final

shape, as in a novel, we can identify our happiest moment, selecting it in retrospect, as I am doing now. To explain why we have chosen this moment over all others, it is also natural, and necessary, to retell our stories from the beginning, just as in a novel. But to designate this as my happiest moment is to acknowledge that it is far in the past, that it will never return, and that awareness, therefore, of that very moment is painful. We can bear the pain only by possessing something that belongs to that instant. These mementos preserve the colors, textures, images, and delights as they were more faithfully, in fact, than can those who accompanied us through those moments.

We made love for the longest time, somewhere in the middle reaching the point when we were both out of breath; I had just kissed Füsun's moist shoulders and entered her from behind, biting first her neck and then her left ear, and it was at this, the happiest moment of my life, that the earring whose shape I'd failed to notice fell from Füsun's lovely ear onto the blue sheet.

Anyone remotely interested in the politics of civilization will be aware that museums are the repositories of those things from which Western Civilization derives its wealth of knowledge, allowing it to rule the world, and likewise when the true collector, on whose efforts these museums depend, gathers together his first objects, he almost never asks himself what will be the ultimate fate of his hoard. When their first pieces passed into their hands, the first true collectors—who would later exhibit, categorize, and catalog their great collections (in the first catalogs, which were the first encyclopedias)—initially never recognized these objects for what they were.

After what I call the happiest moment of my life had passed, and the time had come for us to part, and the fallen earring unbeknownst to us still nestled between the folds of the sheet, Füsun looked into my eyes.

"My whole life depends on you now," she said in a low voice.

This both pleased and alarmed me.

The next day it was much warmer. When we met at the Merhamet Apartments, I saw as much hope as fear in Füsun's eyes.

"I lost one of those earrings I was wearing," she told me after we had kissed.

So now I said, "I have it here, darling," as I reached into the right-

hand pocket of my jacket hanging on the back of a chair. "Oh, it's gone!" For a moment I glimpsed a bad omen, a hint of malign fate, but then I remembered that I'd put on a different jacket that morning, because of the warm weather. "It must be in the pocket of my other jacket."

"Please bring it tomorrow. Don't forget," Füsun said, her eyes widening. "It is very dear to me."

18

Belkıs's Story

THE ACCIDENT featured prominently in all the papers. Füsun hadn't read them, but Şenay Hanım had talked about the dead woman all morning—until it seemed to Füsun as if people were coming into the shop just to talk about the accident. "Şenay Hanım is going to close the shop tomorrow at lunchtime, so that I can go to the funeral, too," said Füsun. "She's acting as if we all adored that woman. But that was not the case. . . ."

"What was the case?"

"It's true that this woman came to the shop a lot. But she'd take the most expensive dresses—the ones just in from Italy and Paris—and she'd say, 'Let me try out this one and see how it goes,' and after wearing it at some big party she'd bring it back, saying, 'It doesn't fit.' Şenay Hanım would get angry—after everyone had seen the woman wearing that dress at that party, it would be hard to sell. Also this woman drove a hard bargain, so Şenay Hanım was always talking behind her back, but she didn't dare cross her, because she was too well connected. Did you know her?"

"No. But for a while she was the sweetheart of a friend of mine," I said, stopping there because I reckoned I would better enjoy recounting the sordid background details to Sibel, yet I was amazed that this calculation left me feeling deceitful, since less than a week ago it would have caused me no discomfort to hide something from Füsun or even

to tell her a lie—lies, it had seemed to me, were an inevitable and rather enjoyable consequence of the playboy life. I considered whether I could cut the story here and there, adapting it for her consumption, when I realized that this would be impossible. Seeing she had guessed that I was hiding something, I said this: "It's a very sad story. Because this woman had slept with quite a few men, people spoke ill of her."

This wasn't my true impression. That's how recklessly I answered. There was a silence.

"Don't worry," said Füsun, almost in a whisper. "I won't ever sleep with anyone else for the rest of my life."

Returning to my office at Satsat, I felt at peace with myself, and for the first time in ages turning myself over to work, I took pleasure from making money. Together with Kenan, a new clerk who was a bit younger and bolder than I was, I went down the list of our hundred or so debtors, pausing now and again for a bit of levity.

"So what are we going to do with Cömert Eliaçık, Kemal Bey?" he asked, with a smile and his eyebrows raised, seeing as the man's name meant "Generous Open-Hand."

"We'll just have to open his hand a little wider. We can't help it if his name condemns him to loss."

In the evening, on the way home, I walked past the gardens of the old pasha's mansion, which had not yet burned down, and I breathed in the fragrance of lindens, seeking the shadows of the plane trees of Nişantaşı, now in full blossom. As I considered men angrily blowing their horns in the traffic jam I felt content, the love storm had passed, I was no longer racked with jealousy, and everything was back on track. At home I took a shower. As I took a clean ironed shirt out of the wardrobe, I remembered the earring; not finding it in the pocket of the jacket where I thought I'd left it, I searched my wardrobe and every drawer, checked the bowl where Fatma Hanım put stray buttons, collar bands, and any spare change or lighters she found in my pockets, but it wasn't there either.

"Fatma Hanım," I called softly. "Have you seen an earring around here?"

The bright side room where my brother had lived until he married was scented with steam and lavender. Fatma Hanım had spent the

afternoon ironing, and now, as she put away our handkerchiefs, shirts, and towels, she said she hadn't seen "earrings or anything." From the heap of unpaired socks in the basket, she pulled out one sock as if it were a naughty kitten.

"Listen to me, Claw Nails," she said, using one of her nicknames for me when I was a child, "if you don't cut your nails, you won't own a single sock without a hole in it. I'm not darning these for you anymore—that's final."

"All right, Fatma Hanım."

In the sitting room, in the corner that overlooked Teşvikiye Mosque, my father, covered by a spanking white apron, was sitting in a chair, with Basri the barber cutting his hair, and my mother, as always, sitting across from him, bringing him up to date.

"Come on over," she said when she saw me. "I'm reporting the latest gossip."

Basri had been feigning concentration on his work, but stopped trimming and, with a grin that showed his huge teeth, made it clear he'd been listening attentively all along.

"What's the latest?"

"You know how Lerzan's younger son wanted to become a race car driver? Well his father wouldn't let him, and so . . ."

"I know. He crashed his father's Mercedes. Then he rang the police saying it had been stolen."

"All right then. But did you hear what Şaziment did to marry her daughter off to the Karahans' son? Where are you going?"

"I'm not here for supper. I'm picking up Sibel. We're invited out."

"Go tell Bekri so that he doesn't fry the red mullet tonight for nothing. He went all the way to the fish market in Beyoğlu today just for you. Promise you'll come for lunch tomorrow so that we can eat them then."

"I promise!"

The corner of the carpet had been rolled up to protect it from my father's thin, white hair falling strand by strand onto the parquet floor.

I got the car out of the garage and as I bumped over the cobblestone streets I turned on the radio, tapping my fingers on the steering wheel in time with the music. In an hour I had crossed the Bosphorus Bridge and was in Anadoluhisarı. Sibel heard me and ran out to the car

seconds after I had honked the horn for her. The first thing I said was that the woman who had died in the crash the day before had once been Zaim's lover ("You mean 'You-Deserve-It-All Zaim,' " she said with a smile); then I told her the whole story.

"Her name was Belkıs; she was a few years older than me, thirty-two or thirty-three, I guess. She came from a poor family. After she entered society, her enemies began to gossip about her mother's headscarf. In the late 1950s, when Belkıs was a lycée student, she'd met a boy at field day celebrations of the nineteenth of May, and they fell in love. This boy, Faris, was her age, the youngest son of the Kaptanoğlus, who had, as you know, made a fortune in shipping by then, to become one of Istanbul's richest families. This romance between the rich boy and the poor girl was right out of some Turkish film and it went on for years. Their passion was so great or they were so stupid that these teenagers were making love and flaunting it. Certainly they should have married, but the boy's family convinced themselves that the poor girl had surrendered her virtue just to trick him into marriage, and that everyone knew this, so they opposed the match. It's clear that the boy lacked the strength, the cast of mind, and the personal income to stand up to his family, take the girl by the hand, and marry her. So the family's solution was to pack the boy off to Paris with the girl to live out of sight as an unmarried couple. Three years later because of drugs or despair the boy somehow died in Paris. Instead of running off with a Frenchman and never returning to Turkey, as might be expected in such situations, Belkıs returned to Istanbul, and launched herself into affairs with a string of other rich men, enjoying quite a colorful love life, as she drew the silent envy of other society women. Her second lover was Sabih the Bear; when she left him, she had an adventure with the eldest Demirbağ boy, who was then on the rebound from another romance. Because her next lover, Rıfkı, was similarly afflicted, society men began to refer to her as the 'Consoling Angel,' and they all dreamed of having affairs with her. As for all those rich married women who had slept with no one in their lives but their husbands, or at the most taken a lover in shame and secrecy, never with much satisfaction—when they saw this Belkıs openly courting the most eligible bachelors, to say nothing of her secret married lovers, they were so jealous they would have found a way to drown her in a spoonful of water, given the opportu-

nity. But no need. As hard living had already taken a toll on her looks and as she was short of funds it was becoming a struggle to keep herself presentable. So you could say the day of drowning was fast approaching. You could say that the accident put this woman out of her misery."

"It surprises me that not a single one of these men would marry her," said Sibel. "It means that no one ever loved her enough to take the plunge."

"Actually, men fall madly in love with women like that. But marriage—that's something else. If she had been able to marry the Kaptanoğlu boy, Faris, right away, and without having slept with him, people would have been quick to forget how poor her family was. Or if Belkıs had come from a wealthy family, they would have overlooked her not being a virgin when she married. Because she didn't take account of the rules and went on enjoying her sex life, all those society women, envious just a moment ago, began calling her the 'Consoling Whore.' But maybe for that very reason, because she gave herself to the first boy she ever loved, gave herself to her lovers without hiding it from anyone, perhaps we should have some respect for Belkıs, too."

"Do *you* feel respect for her?" asked Sibel.

"No, to be honest, I found the deceased repulsive."

The party—I forget the occasion—was on the long concrete patio of a house on the Suadiye shore. Sixty or seventy people were standing there with drinks in hand, conversing in near whispers as they looked to see who was there, who was just arriving. Most of the women seemed concerned about the length of their skirts, with the ones in short skirts uneasy in the extreme, imagining their legs were too short or too thick. Perhaps this was why, at first sight, they all looked like awkward, surly bar girls. Right next to the patio, on the jetty, a big sewer was emptying into the sea, producing quite a smell for guests as white-gloved waiters wandered among them.

After wandering around a bit myself, I met a "psychiatrist" who had just returned from America and opened an office; he gave me his new card the moment we met, and at the incitement of a vivacious middle-aged woman, he offered up a definition of love to the cluster of guests who were discovering him: When one forsook all other opportunities,

wishing only to make love consistently with the same person, this feeling, which he held to be conducive to happiness, was "love." After the discourse on love, a mother, having introduced me to her beautiful eighteen-year-old daughter, sought my advice about where to send the girl to university, so as to spare her the Turkish universities' continual politically motivated boycotts. The conversation began with a discussion of a report in that day's papers about how, to prevent the theft of the question booklets for the university entrance exams, the printers had been subject to a prolonged sequestration.

Much later, Zaim appeared on the patio. He cut a handsome figure with his long limbs, sculpted chin, and beautiful eyes, and especially with the German model Inge, just as tall and elegant, on his arm. What stung hearts most about Inge, with her blue eyes, long and slender legs, fair skin, and natural blond hair, was the merciless reminder to the women of Istanbul society that even as they bleached their hair, plucked their eyebrows, and scoured boutiques for outfits that might let them feel more European, their darker skin and fuller figures were never entirely redeemed by such efforts. But I was less struck by the woman's northern looks than by her familiar smile that I enjoyed seeing every day in the newspaper ads and on the side of the apartment building in Harbiye—it was like seeing an old friend. Soon enough the inevitable crowd had gathered around her.

On the drive home Sibel broke the silence. "That You-Deserve-It-All Zaim, yes, I can see he is a good egg. But that fourth-rate German model, who looks like she would sleep with any Arab sheikh who asked . . . Wasn't it enough to use her in his ad campaign? Must he parade her around just so everyone knows he's bedded her?"

"I give Zaim credit for making a go of that new soft drink of his. I remember he once told me that Turks relish the taste of a modern Turkish product much more once they've seen Westerners enjoying it, too. . . . You know, it's highly likely that, in her friendly way, this model sees no difference between us and Arab sheikhs."

"When I was at the hairdresser I saw a photo of her with Zaim in *Hafta Sonu,* the centerfold, no less, and there was also an interview plus a very tacky picture of her half-naked."

The silence returned and remained for some time. At last I smiled

and said: "You know that guy who was prattling away in broken German, complimenting her on the ads, and staring at her hair just to avoid looking at her breasts falling out of her dress—that big, bashful guy, Sabih the Bear . . . Well that was Belkıs's second lover."

But as we drove under the Bosphorus Bridge, obscured in the haze, I saw that Sibel had fallen asleep.

19

At the Funeral

THE NEXT day at noon I left Satsat and went home to eat fried red mullet with my mother as promised. As we removed the delicious and brilliant pink membranous skin, and with the care of a surgeon cut away the fine, translucent spine, we discussed the state of arrangements for the engagement party and the latest rumors (my mother's preferred word for gossip). Including those who had contrived to have themselves invited and a few other eager acquaintances whose hearts she couldn't bear to break, the list reached 230; so for that day, the maître d'hôtel of the Hilton had been obliged to take steps to ensure there would be enough "foreign liquor"—the term made it sound like a fetish. For this purpose he had begun to contact colleagues in the other big hotels as well as to cajole liquor importers with whom he'd had dealings. As for Silky İsmet, Şaziye, Left-handed Şermın, Madame Mualla, and all the other seamstresses who catered to society ladies and had once been friends and competitors of Füsun's mother, their order books were full and their apprentices were now working until dawn every night to outfit our guests in the elaborate dresses they had ordered for the engagement party. My mother seemed to have spurred our whole world to action, except for my father, who had been complaining of fatigue and was now dozing in the bedroom. It was not on account of his health, my mother thought, but rather that he was feeling despondent, though she could scarcely imagine what could make him so upset, with his son on the verge of getting engaged, and so she

began probing to see whether I might know the reason. When Bekri, as he had done since my childhood, brought in the pilaf that he invariably served after fish to aid digestion—this was an unbendable household rule—it seemed almost as if the fish had been the source of her high spirits, because once it was cleared away my mother took on a mournful tone.

"I feel so bad about that woman," she said, with genuine sorrow. "She suffered so much, and so many people were jealous of her. In fact she was a very good person. Very."

Without once referring to Belkıs by name, my mother recounted how years ago, when the Demirbağs' eldest son, Demir, had been her lover, my parents had spent time with them in Uludağ; and whenever my father and Demir went off to play poker, my mother and Belkıs would stay up long after midnight, drinking tea and knitting and chatting in the hotel's "rustic bar."

"She suffered so much, the poor woman, first on account of being so poor and then on account of men. Such suffering," my mother said, before turning to Fatma Hanım to say, "Bring my coffee out to the balcony. We're going to watch the funeral."

Except for my years in America, I had spent my whole life in this big apartment whose sitting room and wide balcony overlooked Teşvikiye Mosque, where one or two funerals took place every day, and when I was a child, these spectacles initiated us into the fearful mystery of death. Not just Istanbul's rich but also famous politicians, generals, journalists, singers, and artists had their funeral prayers said at the mosque, considered a prestigious point of departure for the "final journey," whereby the coffin was carried slowly on shoulders to Nişantaşı Square—the procession accompanied, depending on the rank of the deceased, by a military band or the city council ensemble playing Chopin's Funeral March. When my brother and I were little we would put long, heavy bolsters from the divan on our shoulders and Bekri Efendi, Fatma Hanım, Çetin the chauffeur, and others would follow us as we hummed the funeral dirge, swaying slightly, just as the bearers of the dead did, on our way down the corridor. Just before a funeral of broad public interest—if the deceased was a prime minister, a famous tycoon, or a singer—the doorbell would ring and unexpected guests would appear, saying, "I was just passing by, and I thought I'd drop in,"

and though my mother never let her manners lapse, later on she would say, "They didn't come to see us but to see the funeral." And so we began to think of the ceremony not as a comfort against the sting of death or a chance to pay one's last respects to the deceased, but as an amusing diversion.

"Come over to this side, you'll have a better view," my mother said as I joined her at the small table on the balcony. But when she saw me suddenly go pale, with no evident enjoyment at watching the crowd of mourners, she drew the wrong conclusion: "You know, it's not that father of yours napping inside who is keeping me from attending the funeral of this woman I loved dearly. It's the men down there like Rıfkı, like Samim, who are wearing their dark glasses not to hide their tearful eyes, but to hide that they shed no tears. Well, anyway, you can see it much better from here. What *is* wrong with you?"

"Nothing. I'm fine."

Below the gate to the Teşvikiye Mosque courtyard, in the shaded area where women gathered as if by instinct, I'd seen Füsun among the covered women and the society women who, for the occasion, had draped chic, fashionable scarves over their heads, and at that moment, my heart had begun to race. She was wearing an orange scarf. As the crow flies there were seventy, perhaps eighty meters between us. She was breathing, she was frowning, her soft skin was perspiring slightly in the midday heat; annoyed by the crowd of covered women pressing against her, she was biting her lower lip, shifting the weight of her slender body from one foot to the other—of course, I did not just see all these things, I felt them inside me. I longed to cry out to her from the balcony and wave, but as in a dream I had no voice, and my heart continued to pound.

"Mother, I have to go."

"Ah! What's come over you? Your face is deathly white."

On the street I watched her from afar. Şenay Hanım was next to her. As she listened in to her employer's conversation with a potential if not actual customer, a stocky but stylish woman, she ran her fingers over the ends of the scarf she had tied so awkwardly under her chin. The scarf had endowed her with a proud and sacred beauty. The Friday sermon was blaring on loudspeakers in the courtyard, but the sound was so bad that no one could make out what the preacher was saying,

except for a few words about death being the last station and his boor-ish and insistent repetition of the word "Allah," a calculated bit of intimidation, I thought. From time to time, someone would rush into the crowd, as if arriving late to a party, and as all heads turned, a little black-and-white photograph of Belkıs would be pinned onto the late-comer's collar. Füsun carefully eyed everyone around her, as they greeted one another with a wave across the crowd, arms open for embrace, a hug of consolation, and mutual concern.

Like everyone else Füsun was wearing the photograph of Belkıs on her collar. It had become commonplace at funerals following political assassinations (so frequent in those days), and the custom had quickly gained currency among the Istanbul bourgeoisie. Many years later I was able to assemble a small collection of these tokens, and I display them here. When crowds of sighing (but inwardly content) socialites sport-ing sunglasses took to such displays, like so many right- and left-wing militants, these photographs would give an ordinary lighthearted soci-ety funeral intimations of an ideal that might be worth dying for, a hint of common purpose, and a certain gravitas. In imitation of the West-ern conceit, the photograph was framed in black, by which formerly happy images appropriated for death notices assumed the cast of mourning, and the most frivolous images could attain in death the somber dignity usually reserved for victims of political assassination.

I left without coming eye to eye with anyone, rushing off to the Merhamet Apartments, where I impatiently awaited Füsun. Every now and then I glanced at my watch. Much later, and without giving it much thought, I found myself parting the dusty curtains to look through the always closed window that gave onto Teşvikiye Avenue, and I saw Belkıs's coffin pass below slowly in the funeral car.

Some people spend their entire lives in pain, owing to the misfor-tune of being poor, stupid, or outcast from society—this thought passed through me, gliding by with the measured pace of the coffin, then disappeared. Since the age of twenty I had felt myself protected by an invisible armor from all variety of trouble and misery. And so it followed that to spend too much time thinking about other people's misery might make me unhappy, too, and in so doing, pierce my armor.

20

Füsun's Two Conditions

FÜSUN ARRIVED late. This upset me, but she was even more upset than I was. She explained that she had run into her friend Ceyda, but it sounded less like an apology than an accusation. Some of Ceyda's perfume had brushed off on her. Füsun had met Ceyda during the beauty contest. She'd been unfairly treated, too, coming in third. But now Ceyda was very happy because she was going out with the Sedircis' son, and this boy was serious; they were thinking about marriage. "That's wonderful, isn't it?" said Füsun, and as she gazed into my eyes her sincerity was arresting.

I was about to nod when she said there was a problem. Because the Sedircis' son was so "serious," he didn't want Ceyda working as a model.

"For example, now that it's summer, she's booked to do an ad for a swing set. But her boyfriend is very strict, very conservative. So he is forbidding her to appear in a commercial for a covered swing set built for two—forget about wearing a miniskirt, he won't even let her do it if she wears a dress that shows nothing. And Ceyda has completed a professional modeling course. Her picture is already in the papers. The manufacturer of the canopies for the swing sets is willing to use Turkish models, but the boy just won't have it."

"You should warn her that this man could have her under lock and key in no time."

"Ceyda has been ready to marry and become a housewife for ages," said Füsun, annoyed that I had failed to understand what she was talking about. "But her fear is that this serious man might not be so serious about her. I promised to get together and talk about it. What do you think, how can you tell if a man is serious?"

"How would I know?"

"You know exactly how men like this are. . . ."

"I know nothing about rich conservative types from the provinces," I said. "Come on, let's look at your homework."

"I didn't do any homework. Okay?" she said. "Did you find my earring?"

My first impulse was to go through the motions like some sly drunk driver stopped for a police search who knows full well that he has left his license at home, yet searches his pockets, his glove compartment, his bags, in a parody of good faith. But I caught myself in time.

"No, dear, I looked for your earring but couldn't find it," I said. "But don't worry—it will turn up sooner or later."

"I've had enough! I'm leaving and I'm never coming back!"

I understood from the misery on her face as she looked around to gather her things, even as she fumbled, unsure where to put her arms, that this outburst was not just theater. I planted myself in front of the door like a bouncer and begged her not to go, pelting her with professions of how deeply in love with her I was (all true), until I could see, from the hint of a happy smile in the corners of her mouth, and the effort she made to hide her pity—slightly raising her eyebrows—that she was beginning to relent.

"All right, I won't go," she said. "But I have two conditions. First, tell me who you love most in the world."

She saw at once that she had confused me, and that I could not answer with Sibel's name or her own. "Give me the name of a man. . . ." she said.

"My father."

"Fine. My first condition is this. Swear on your father's head that you'll never ever lie to me."

"I swear."

"Not like that. Say the whole sentence."

"I swear on my father's head that I'll never ever lie to you."

"That was too easy for you."

"What's your second condition?"

But before she could announce her second condition, we were kissing and soon gaily making love. We put so much into it this time and our love so intoxicated us that we felt ourselves transported to an imaginary place, a new planet. In my own mind's eye it was an alien surface, a silent, rocky desert island, the first photographs from the moon. Later Füsun would tell me her vision: a dark garden thick with trees, a window overlooking it, and in the distance the sea and a bright yellow

hillside where sunflowers waved in the wind. Such scenes came to us at moments like this when our lovemaking surprised us—for example when I had taken into my mouth Füsun's breast and her ripe nipple, or when Füsun had buried her nose in the place where my neck joined my shoulders and was locking me in her arms with all her might, or when we read in each other's eyes a startling intimacy that neither of us had ever felt before.

"Okay, so now, my second condition," said Füsun, after our lovemaking, her voice full of elation.

"One day you're going to come to my house for supper with my mother and father, and you'll bring my earring and the tricycle I rode when I was little."

"Of course I will," I said, with the lightness that comes after lovemaking. "Except—what are we going to tell them?"

"If you ran into a relative on the street, wouldn't you ask after her mother and father? Wouldn't she invite you over? Or that day you walked into the shop and saw me—might you not have said you wanted to see my mother and father? Is it so unlikely that a relative would offer a girl a little help with her mathematics before the university entrance exam?"

"I certainly will come for a visit one evening, and I'll bring the earring, I promise. But let's not tell anyone about these math lessons."

"Why not?"

"You're very beautiful. They'll know at once that we're lovers."

"In other words, are you saying that this isn't Europe, so men can't be shut up in a room to do math with a girl without it leading to something else?"

"On the contrary, they can. I'm saying that because this is Turkey, everyone will assume they aren't there to do math, but something else. And knowing that everyone is thinking this, they start thinking about it, too. Worried about staining her honor, the girl will begin to say things like, 'Let's keep the door open.' Nevertheless, if a girl remains in that room with him for long, the man will think she's making a pass at him, and even if he hasn't done anything to her yet, he will eventually have to, because otherwise his manhood would be called into question. Before long their minds will be defiled with thoughts of the things everyone thinks they are already doing, and those thoughts will be irre-

sistible. Even if they don't make love, they will begin to feel guilty and lose all confidence that they can stay in that room for long without succumbing to temptation."

There was a silence. With our heads on the pillow, our view was of the radiator pipe, the lidded hole for the stovepipe, the window cornice, the curtain, the lines and corners where the walls met the ceiling, the cracks in the wall, the peeling paint, and the layer of dust. It is to evoke that abiding silence for the museum visitor that, years later, we have re-created this view in such minute detail.

21

My Father's Story: Pearl Earrings

ON A SUNNY Thursday at the beginning of June—nine days before the engagement party—my father and I had a long lunch together at Abdullah Efendi's restaurant in Emirgân, and I knew even then that I would never forget it. My father, whose recent gloom was so troubling to my mother, had invited me, saying, "Before the engagement, let's go out, just the two of us, so that I can give you some advice." As we sat in the '56 Chevrolet, with Çetin Efendi at the wheel, where he had been since I was a child, I listened respectfully to my father's counsel (for instance, that I shouldn't confuse my business associates with my friends), for I assumed this was yet another pre-engagement ritual; and as I listened I opened my mind to the Bosphorus views slipping past the windows, the beauty of the City Line ferries as they rode the currents, and the shadows of the wooded gardens of the *yalıs* on the shores of the Bosphorus: Even at midday they were almost dark as night. Instead of repeating the lectures he'd perhaps heard as a child— instead, that is, of warning against laziness, frivolity, and daydreams, instead of compelling me to shoulder my duties and responsibilities— he reminded me, as the fragrance of the sea and pine trees blew through the open windows, that I needed to make the most of life, because God's gift is fleeting. Here I display the plaster bust by Somtaş

Yontunç (it was Atatürk himself who had given him his name, which means "Solid-Stone Sculptor") created ten years earlier, when, thanks to booming textile exports, and our soaring fortunes, my father had, on the advice of a friend, agreed to pose for this sculptor, who was connected to the Academy. I added the plastic mustache out of contempt for the academician, who rendered my father's whiskers far thinner than they really were, so that he would look more Western. When I was small and he scolded me for idleness, I would watch my father's mustache quiver as he spoke. When he warned me that working too hard might cause me to miss life's great beauties, I took it to mean that my father was satisfied with the innovations I had implemented at Satsat and the other firms. When he asked that in the future I also involve myself with some of the business dealings in which my older brother had recently expressed an interest, and I eagerly agreed, adding that we had all paid dearly for my brother's deeply conservative half measures in every family concern he touched, it wasn't just my father who smiled appreciatively—Çetin the chauffeur smiled, too.

Abdullah Efendi's restaurant had formerly been in Beyoğlu, on the main avenue next to Ağa Mosque. Back in those days it was where the rich and famous would stop for lunch if they were passing through the area or on their way to the cinema, but several years ago, after most of his customers had acquired cars, he had moved to the hills above Emirgân, to a little farm overlooking the Bosphorus. As we walked into the restaurant, my father assumed a jovial smile, shaking hands with the waiters he had known for years from the old Abdullah's and other restaurants. Then he surveyed the large dining room, searching for anyone he knew among the customers. As the headwaiter was guiding us to our table, my father stopped to chat with one party, and waved in the direction of another, and flirted breezily with an elderly lady sitting at a third table with her daughter; this lady remarked how fast I'd grown up, how much I resembled my father, and how handsome I was. Once we had been seated by the headwaiter (who'd called me "little gentleman" throughout my childhood and, at some point, without anyone's quite having noticed, began calling me "Kemal Bey"), my father ordered a few hors d'oeuvres for us to share—pastries, smoked fish, and suchlike—and also *rakı*.

"You do want some, don't you?" he asked me, adding, "You know

you can smoke, too, if you like," as if we had not come to a mutual understanding about my smoking in his presence after I'd returned from America.

"Bring an ashtray for Kemal Bey," he told one of the waiters.

He picked up a few of the cherry tomatoes that came from the restaurant's own greenhouse and sniffed them; as he knocked back his *rakı,* it seemed that there was something specific on his mind, though he had not yet decided how to broach the subject. For a moment we both looked out the window at Çetin Efendi in the distance, chatting with the other drivers waiting outside the entrance.

"Never forget Çetin Efendi's worth," my father said, sounding as if he were dictating his last testament.

"I do know his worth."

"I'm not sure you do. . . . I know he is always telling religious stories, but you should never laugh at them. He's an honest man, Çetin, and he's a gentleman, a thoroughly decent human being. He's been like that for twenty years. If anything should ever happen to me, don't send him away. Don't change cars every two minutes like those nouveau riche upstarts. The Chevrolet's a good car. . . . This is Turkey, look . . . when the state banned the import of new foreign cars ten years ago, it turned Istanbul into a museum for old American cars, but what does it matter; we've ended up with the best repair shops in the world."

"I grew up in that car, Father, so you don't need to worry," I said.

"I'm glad to hear it," said my father, in a tone suggesting he had come to the real subject. "Sibel is very special, a very charming girl," he said, but no, this wasn't what he had brought me here to discuss. "You don't find such a person every day, do you? A woman, a rare flower like her—you must make sure you never break her heart. You must care for her always, and treat her with the utmost tenderness." Suddenly a strange, shameful expression appeared on his face. He began to speak impatiently, as if something had irritated him: "Do you remember that beautiful girl? . . . You know, the one you saw me with once in Beşiktaş. When you first saw her, what did you think?"

"Which girl?"

My father got even more annoyed. "Oh come on now, I'm talking about that very beautiful girl you saw me with in Beşiktaş, in Barbaros Park, you know, ten years ago."

"No, Father, I don't have any memory of this."

"My son, how could you not remember? We came eye to eye. There was a very beautiful girl sitting next to me."

"What happened next?"

"Not wishing to shame your father, you politely averted your eyes. Do you remember now?"

"No, I don't."

"No, you did see us!"

I truly had no such memory, but there was no convincing my father. After a long, awkward discussion, we agreed I must have wanted to forget and succeeded in doing so. Or perhaps he and the girl had merely panicked, thinking I'd seen them. This is how we came to the real subject.

"That girl was my lover for eleven years, and she was very beautiful," said my father, proudly combining the two most important facts into a single sentence.

It was clear that my father had long dreamed of talking to me about this woman's beauty, and the thought that I might not have seen it with my own eyes, or, even worse, that I might have seen her but forgotten how beautiful she was—this had dampened his spirits a little. He pulled a small black-and-white photograph from his pocket. It was of a dark, sorrowful girl—very young—standing on the back deck of a City Line ferry in Karaköy.

"That's her," he said. "It was taken the year we met. It's a shame she's so sad here; you can't see how beautiful she was. She is beautiful, isn't she? Do you remember now?"

I said nothing. It annoyed me to listen to my father talking about an affair, no matter that it was ancient history. Though at that moment, I could not understand what exactly it was that bothered me.

"Look, I don't want you repeating any of what I say here to your brother," my father said, slipping the photo back into his pocket. "He's too stern, he wouldn't understand. You've been to America, and I'm not going to be telling you anything that would shock you. All right?"

"Of course, Father dear."

"So now listen," said my father, and as he took tiny sips of *rakı,* he told his story.

It was "seventeen and a half years ago on a snowy day in January

1958" that he'd first met that girl and was instantly struck by her pure and innocent beauty. The girl was working at Satsat, which my father had only just started. At first it was just a working relationship, but despite the twenty-seven-year difference in their ages it became something more "serious and emotional." One year after the girl had begun relations with her handsome boss (my father, by my instant calculation, would have been forty-seven years old at the time) he forced her to leave Satsat. Again at my father's behest, she did not look for another job; instead she went quietly to live in an apartment in Beşiktaş that my father set up for her, dreaming that one day they would marry.

"She was very good-hearted, very sensitive, and clever—a very special person," said my father. "She wasn't like other women at all. I've had a few escapades in my life, but I never fell for anyone the way I fell for her. My son, I thought a lot about marrying her. . . . But what would have happened to your mother? What would have happened to you and your brother? . . ."

For a time we were silent.

"Don't misunderstand me, my child, I'm not saying I made sacrifices so that you could be happy. In fact, of course, she was the one who really wanted marriage. I kept her dangling for years. I just couldn't imagine life without her, and when I couldn't see her I suffered enormously. But there was no one to share my pain with. Then one day she said, 'Make up your mind!' Either I left your mother and married her, or she was going to leave me. Pour yourself some *rakı*."

There was a silence. "When I refused to leave you boys and your mother, she left me," said my father. To admit this exhausted him, but it also relaxed him. When he looked at my face and saw that he could go on confiding in me, he became more relaxed still.

"I was in pain, great pain. Your brother had married, and you were in America. But of course I tried to hide my anguish from your mother. To steal into a corner like a thief and suffer in secret—that was another agony. Your mother had sensed the existence of this mistress, just as she had with the others; understanding that something serious was going on, she said nothing. Your mother, and Bekri and Fatma Hanım—we lived together like a cast of characters imitating a happy family in a hotel room. I could see that I would find no relief, that if it carried on this way I would go mad, but I couldn't bring myself to do

what was necessary. At the same time, *she*"—my father never said her name—"was suffering just as much. She announced that an engineer had proposed marriage and that if I didn't decide soon, she was going to accept. But I didn't take her seriously. . . . I was the first man she had ever been with. I thought she could not possibly want anyone else, that she must be bluffing. Even when I doubted my reasoning and started to panic, I was still paralyzed. So I tried just not to think about it. You remember that summer when Çetin drove us all to Izmir, to the fair. . . . When we got back I heard that she had got married, but I couldn't believe it. I was convinced she had just put the news out to get my attention, and make me suffer. She refused my every attempt to see her, even to speak with her; she wouldn't answer the phone. She even sold the house I'd bought for her and moved somewhere I couldn't find her. Had she really married? Who was this engineer husband? Had she had children? What was she doing? For four years I couldn't ask anyone these questions. I feared the answers I might get, but to know nothing was agony, too. To imagine her living in another part of Istanbul, opening the papers to read the same news, watching the same TV programs, yet never to see her—it left me desolate. I began to feel as if life itself was futile. Please don't misunderstand me, my son—I certainly felt proud of you, and the factories, and your mother. But this suffering was unimaginable."

Because he'd been using the past tense, I sensed that the story had reached some sort of conclusion, and that my father had found some relief in his confession, but for some reason this displeased me.

"In the end, curiosity got the better of me, and one afternoon I rang her mother. The woman certainly knew all about me, but of course she didn't recognize my voice. I lied to her, passing myself off as the husband of one of her girl's lycée classmates. 'My wife is ill and it would boost her spirits if your daughter could come to see her in the hospital,' I said. Her mother said, 'My daughter is dead,' and began to cry. She'd died of cancer! I hung up at once so that I wouldn't cry, too. I wasn't expecting this, but I knew at once that it was true. She had never married an engineer. . . . How terrifying life can be, how empty it all is!"

When I saw the tears forming in my father's eyes, for a moment I felt utterly helpless. I understood his pain even as I felt anger, and the more I reflected on the story he had told me, the more my mind

became muddled and I behaved as if I were a member of a tribe an old-fashioned anthropologist might describe as "primitive" and unable to think about its own taboos.

"So anyway," my father said, pulling himself together after a short silence, "I didn't bring you here just to upset you with tales of all my woes. But you're about to get engaged, so it's fitting for you to know your father better. But there is something else I want you to know. Can you understand?"

"What is it?"

"What I feel now is only remorse," said my father. "I never paid her enough compliments, and I would give anything to be able to tell her a thousand times over what a charming, precious person she was. She truly had a heart of gold, a lovely, modest, utterly enchanting girl. . . . She wasn't like other beauties I've seen here. She never flaunted it, as if her loveliness were her own doing; she was never demanding, never expected gifts or flattery. You see, it's not just that I lost her; it's also that I know I didn't treat her as she deserved—that's why I still suffer. My son, you must know how important it is to treat women well—but now, not later, not when it is too late."

There was something ceremonial about that last pronouncement, as he reached into his pocket to bring out a faded velvet-covered jewel box. "That time we all went to the Izmir Fair, I bought these for her, so that she wouldn't be angry with me, so that she'd forgive me, but fate did not allow me to give them to her." My father opened the box. "Earrings were very becoming on her. These are pearls, very fine ones. For years I hid them away. But when I'm gone, I don't want your mother finding them. You take them. I've given it some thought; these will look very good on Sibel."

"Father dear, Sibel is not my mistress; she's going to be my wife," I said, looking into the box he'd handed to me.

"Come on, now," said my father. "You won't tell Sibel the story behind the earrings; she will never be the wiser. But when you see her wearing them, you'll remember me. You will never forget the wisdom I've imparted to you today. You'll treat that girl perfectly. . . . Some men always treat women badly, and they're proud of it. Don't ever be one of them. Let my words remain on your ears as the earrings remain on Sibel's."

He closed the box, and with an old-fashioned gesture, pressed it into my hand with his own, as an Ottoman pasha might have pressed a tip into the hand of an inferior. "My boy," he said to the waiter, "why don't you bring us a bit more *rakı* and some ice. What a beautiful day it is, don't you think?" he said to me. "What a beautiful garden they have here. It smells of spring with all the linden trees."

It took me another hour to convince him that I had a meeting I couldn't cancel, and that, no, it wouldn't do for the big boss to phone Satsat and call off his son's appointment.

"So that's what you learned in America," he said. "I'm impressed."

I didn't want to refuse my father his happiness, so I drank another glass of *rakı,* though all the while I kept glancing at my watch, not wanting to be late for my rendezvous with Füsun, on this of all afternoons.

"Don't rush off, my son, let's sit here a little longer. See how easy we are with each other, a lovely conversation between father and son. Give me a moment before you go off to get married and forget us!" my father said.

"Father dear," I said, as we were leaving, "I can see how much you've suffered, and I will never forget this invaluable advice you've given me today."

As he got older, whenever he was overcome by a great emotion my father's lips would quiver at the edges. He took my hand and squeezed it with all his might. When I squeezed his in return, just as hard, it was as if I'd squeezed a sponge hidden in his cheeks, because suddenly his eyes welled.

He quickly composed himself, calling for the bill, and on the way home, as Çetin drove so carefully that the car scarcely rumbled over the cobblestones, he dozed off.

Once at the Merhamet Apartments, I didn't suffer much indecision. After Füsun arrived, we kissed for a very long time, and then I took the velvet box from my pocket, explaining that I smelled of spirits because I'd had lunch with my father.

"Open it," I said.

And she did so, with great care.

"These are not my earrings," she said. "These are pearl."

"Do you like them?"

"Where is *my* earring?"

"It vanished into thin air, and then one morning I looked at my bedside, and there it was, with its mate. I put them both into this velvet box to reunite them with their beautiful owner."

"I'm not a child," said Füsun. "These are not my earrings."

"They are in spirit, darling—as I see it, anyway."

"I want my own earring."

"I'm giving you these as a present," I said.

"I couldn't ever wear these. . . . They're very expensive. Everyone would want to know where they're from. . . ."

"Don't wear them, then. But don't refuse my present."

"But this is something you've given me to replace my earring. . . . If you hadn't lost the one I left behind, you would never have brought me these. I have no way of knowing what you really did with it, if you actually lost it."

"I'm sure it will turn up one day, in some drawer at home."

"One day . . ." said Füsun. "How easily you say that. How irresponsible you are. When do you expect it to turn up exactly? How long will I have to wait?"

"Not very long," I said, scrambling to save the moment. "It will be the day I take that tricycle and come to your house to have supper with your parents."

"I'll be waiting to hear from you, then," said Füsun. Then we kissed. "You reek of drink."

But I went on kissing her, and as we began to make love we forgot all our troubles. As for the earrings my father had bought for his lover—I left them at the flat.

22

The Hand of Rahmi Efendi

As THE day of the engagement party approached, I was so distracted by the preparations that there was no time left to worry about affairs of

the heart. I recall sounding out my friends at the club, whom I'd known since childhood and whose fathers were my father's friends, and had long conversations on how to procure the champagne and other "European" beverages that we hoped to serve to our guests at the Hilton. May I remind visitors entering my museum in the future that in those days the import of foreign alcohol was strictly, one might even say jealously, limited by the state, and that even the state lacked the foreign currency reserves to pay importers for the full quantities allowed under the quotas, with the result that very little champagne, whiskey, or indeed any foreign alcohol came into the country legally. But there was never any shortage of champagne, whiskey, or American cigarettes, for delicatessens in rich neighborhoods were well stocked with black market goods, as were the bars in the city's most fashionable hotels, and likewise the thousands of tombala men who roamed the streets with their bags of black market raffle tickets. Anyone organizing an elaborate party felt compelled to offer "European" drinks, and it was left to the host to hunt down provisions for the hotel. Most head barmen at the larger establishments knew one another and would in such situations depend on colleagues to funnel extra bottles their way, thus ensuring that unusually large functions came off without an embarrassing shortfall. Still one had to be mindful that the society pages enjoyed reporting the day after an event how much "real foreign" alcohol had been served, and how much of it was mere Ankara Viski.

If ever I had a free moment amid all this, Sibel would pick up the phone and we'd be off to see a new house with an enviable view, either in the hills above Bebek and Arnavutköy, or in the then emerging neighborhood of Etiler. Like her, I came to enjoy standing in these unfinished apartments that still smelled of plaster and cement, imagining the bedroom and the dining room, trying to figure out where the long divan we had seen in a Nişantaşı furniture store might be placed to provide the best possible prospect of the Bosphorus. At parties in the evenings Sibel did not rest from her day's calculations and only too happily regaled friends with impressions of the new neighborhoods, discussing our plans with others, apartment locations, their advantages and drawbacks; whereas I, feeling oddly constrained by shame, would change the subject, talk to Zaim about football, the success of Meltem soda, or the new bars, clubs, and restaurants that had just opened for

the summer. My secret bliss with Füsun had made me more subdued in the company of friends, and more and more I preferred to watch the goings-on from the sidelines. Sorrow was slowly consuming me, though at the time I couldn't see it clearly, recognizing it only now, so many years later, as I tell this story. Then I noticed only that I had become more "quiet," as others were noting, too.

"You've been pensive lately," said Sibel late one night as I was taking her home in the car.

"Really?"

"We haven't exchanged a word for half an hour."

"That lunch I had with my father a while ago . . . my mind keeps going back to it. He can deny it, but to me he sounds like a man preparing for death."

On Friday the sixth of June, eight days before the engagement party and nine days before Füsun's university entrance exam, my father, my brother, and I went with Çetin in the Chevrolet to a house between Beyoğlu and Tophane, just below Çukurcuma Hamam, to offer our condolences. The deceased, an old employee from Malatya, had been with my father since he'd first gone into business. This kindly, hulking man was a part of the company family, and he'd been running errands for as long as I could remember. He had an artificial hand, his real one having been crushed in a machine on the factory floor. My father, who had liked this hardworking man a great deal, had transferred him to the office, and that was when we'd gotten to know him. In the beginning, my brother and I were terrified of the artificial hand, but because of Rahmi Efendi's big smile and his unfailing kindness to us, in time he made the hand into a toy for us. Once, I remember Rahmi Efendi going into an empty room, putting his artificial hand to one side, and spreading out his prayer rug; then he knelt down to say his prayers.

Rahmi Efendi had two strapping sons who were as good-hearted as he was. They both kissed my father's hand. His still buxom, pink-skinned, but careworn wife burst into tears the moment she saw my father, wiping her eyes with the edges of her headscarf. As he consoled her with a sincerity that neither my brother nor I could ever have matched, embracing the two sons and kissing their cheeks, he managed, in no time, to make all the other visitors in the room feel as if they shared one soul, one heart. At the same time, however, my brother

and I were each overcome by a crisis of guilt, he speaking in a didactic tone of voice, and I unable to resist reciting memories.

At times like this what matters is not our words but our demeanor, not the magnitude or elegance of our grief but the degree to which we can express fellowship with those around us. I sometimes think that our love of cigarettes owes nothing to the nicotine, and everything to their ability to fill the meaningless void and offer an easy way of feeling as if we are doing something purposeful. My father, my brother, and I each took a cigarette from the packet of Maltepes offered to us by the elder son of the deceased, and once they were all lit with the same burning match that the teenager artfully offered us, there followed a strange moment when all three of us crossed our legs and set about puffing in unison, as if enacting a ritual of transcendental importance.

A kilim hung on the wall in the way Europeans hang a painting. It must have been the unfamiliar taste of the Maltepe that caused me to entertain the illusion that I was having deep thoughts. The most important matter in life is happiness. Some people are happy, and others are not. Of course, most people fall somewhere in the middle. I myself was very happy in those days, but I didn't want to recognize it. Now, all these years later, I think that the best way to preserve happiness may be not to recognize it for what it is. I ignored it then, not out of a wish to protect it, but rather out of a fear of a great misery fast approaching, a fear that I might lose Füsun. Was it this that had made me so touchy and subdued?

As I looked around the small, threadbare, but immaculate room (there was a lovely barometer of the type so fashionable in the 1950s, and a beautifully executed framed calligraphy saying Bismallah), there was a moment when I thought I was going to join with Rahmi Efendi's wife in crying. On top of the television was a handmade doily, and upon that was displayed a china dog. The dog looked as if it was about to cry, too. Nevertheless I remember that I felt comfort at seeing that dog, and thought about Füsun.

23

Silence

As THE day of my engagement party approached, the silences between Füsun and me grew longer and deeper, and though we met every day for at least two hours, making love with ever greater passion, these silences infiltrated us like a poison.

"They've sent my mother an invitation to the engagement party," she said. "My mother was very pleased, and my father said we had to go, and they want me to come, too. Thank God the university exam is the next day, so I won't have to fake an illness to stay home."

"My mother sent the invitation," I said. "Under no account should you come. I don't even want to go myself."

I'd been hoping that Füsun would answer saying, "Then don't go!" but she said nothing. As the day of the engagement party drew near, we would embrace more forcefully, even perspiring more profusely, each wrapping arms and legs around the other, in the manner of longtime lovers who, when reunited, are desperate to close even the least space between them; and then we would lie there, quiet and still, as we watched the tulle curtains flutter in the breeze entering through the door.

Until the day of the engagement party, we met daily at the same time in the Merhamet Apartments. We never discussed our predicament, the engagement, what would happen afterward, instinctively avoiding any subject that called to mind these concerns. But this avoidance could precipitate great silences. We would listen to the shouts and curses of the children playing football outside. Though in the early days we'd also refrained from discussing what was to become of us, there had nevertheless been no end of cheerful chatter, about our relatives in common, and evil men, and everyday Nişantaşı gossip. Now we were saddened to see our carefree days had ended so quickly. We felt the loss, a kind of unspoken misery. But the dreadful ache did not drive us apart—in a strange way it brought us closer together.

I sometimes caught myself thinking that I would be able to continue seeing Füsun after the engagement. This heaven, in which everything would go on as before, slowly evolved from a fantasy (let's call it a dream) into a reasonable hypothesis. If she and I could be this passionate, this generous, making love, then she could not possibly leave me, or so I reckoned. In fact, this was my heart talking, not my reason. I was hiding these thoughts even from myself. But in one part of my mind I was paying close attention to Füsun's words and actions, hoping they might tell me what she was thinking. Because Füsun was well aware of this scrutiny, she gave me no clues, and so the silences grew longer still. At the same time she was watching what I did, and making her own desperate calculations. Sometimes we would stare at each other like spies trying to probe each other's secrets. Here I display Füsun's white panties with her childish white socks and her dirty white sneakers, without comment, to evoke our spells of sad silence.

The day of the engagement party was soon upon us, and all the guessing came to naught. That day there was a champagne and whiskey crisis (one of the dealers had refused to surrender the bottles without cash in hand), and once I had resolved it I went to Taksim to have a hamburger and an *ayran* at the Atlantic, my favorite buffet since childhood, and then on to my childhood barber, Cevat the Chatterbox. In the late 1960s, Cevat had moved shop from Nişantaşı to Beyoğlu, whereupon my father and the rest of us had moved on to another Nişantaşı barber named Basri, but whenever I happened to be in the neighborhood, and in the mood for some fun, I would go to Cevat's place just down the road from Ağa Mosque for a shave. Cevat was overjoyed to hear it was the day of my engagement party, and he went on to give me a "groom's shave," sparing no luxury, using imported shaving foam and a lotion he assured me was odorless, applying it with close attention to every hair and follicle. I walked all the way back to Nişantaşı, to the Merhamet Apartments.

Füsun arrived at the usual time. A few days earlier, I had muttered that we'd better not meet on Saturday, as her exam was on the next day, but after working so hard, she'd wanted to rest her mind. After all, she'd skipped work at the Şanzelize Boutique for two days on the pretext of studying for her exam. The first thing she did when she walked in was to sit down at the table and light a cigarette.

"I think about you so much that there's no room in my mind for mathematics," she said, laughing self-mockingly, as if what she'd said meant nothing, as if it were a stock phrase taken from a film, but then she turned deep red.

Had she not blushed so deeply, and betrayed such sorrow, I would have gone along with the joke. We would have acted as if it hadn't occurred to either of us that this was the day of my engagement party. It wasn't that way, though. An overwhelming and unbearable sorrow weighed down on both of us that no amount of joking and no amount of distracting talk could assuage; we understood that even sharing the misery would not make it lighter, that the only escape from it was making love. But the melancholy inhibited our lovemaking and finally tainted it. At one point Füsun lay stretched out on the bed, as if she were a patient listening to her pain, and watching mournful clouds pass overhead. I stretched out beside her and joined her in looking at the ceiling. The children playing football outside had gone quiet, and all we could hear was the ball being kicked around. Then the birds stopped singing, until there was nothing to hear. Then, in the distance, a ship blew its horn, and then another.

We shared a whiskey in a glass that once belonged to Ethem Kemal—my grandfather, who was her great-grandmother's second husband—and we began to kiss. As I write these words I feel I should take care not to cause undue upset to those concerned souls who have taken an interest in my story, for a novel need not be full of sorrow just because its heroes are suffering. As always, we fiddled with the things in the room—my mother's discarded dresses, hats, and china figurines. As always, we kissed each other gracefully, having become so proficient in this art. Instead of pulling you into our melancholy, let me say that it felt as if Füsun's mouth had melted into mine. As our kisses grew ever longer, a honeyed pool of warm saliva gathered in the great cave that was our mouths combined, sometimes leaking a little down our chins, while before our eyes the sort of dreamscape that is the preserve of childish hope began to take form—and we surveyed it as if through a kaleidoscope. From time to time, one of us would, like a ravenous bird taking a fig into its beak, suck upon the other's upper or lower lip, as if about to swallow it, biting the imprisoned lip, as if to say, "Now you're at my mercy!" and having enjoyed this adventure of lips, and the fris-

son of being at someone else's mercy, and awakening, at that moment, to the thrilling prospect of complete surrender, not just of one's lips but of one's entire body to a lover's mercy, we recognized that the gap between compassion and surrender is love's darkest, deepest region.

After making love we both fell asleep. When a sweet breeze blew in through the balcony, lifting the tulle curtains and dropping them like a silk veil onto our faces, we both awoke with a start.

"I dreamt I was in a field of sunflowers," said Füsun. "And the sunflowers were swaying strangely in the breeze. For some reason they scared me. I wanted to scream, but I couldn't."

"Don't be afraid," I said. "I'm here."

I won't say how we left, how we dressed and reached the door. After telling her to stay calm during her exam, and warning her not to forget her registration card, and assuring her that everything would go well, that she was sure to attain the score she needed, I said the thing that I had been repeating in my mind for days, thousands of times over, trying to make it sound as natural as possible.

"Let's meet at the same time tomorrow, okay?"

As she averted her eyes, Füsun said, "Fine."

I watched with love as she took her leave, and I knew at once that the engagement party would be a great success.

24

The Engagement Party

THESE POSTCARDS of the Istanbul Hilton were acquired some twenty years after the events I describe; I picked up some of them while strolling through small museums and flea markets in this city and elsewhere in Europe, and others I purchased in transactions with Istanbul's foremost collectors in the course of assembling the Museum of Innocence. When, after a lengthy bargaining session with the famously neurotic collector Halit Bey the Invalid, I was able to acquire one of these postcards depicting the hotel's modernist international-style

facade, and granted permission to touch it, I was reminded not just of the evening of my engagement party, but of my entire childhood. When I was ten, my parents attended the opening of the hotel, a very exciting occasion for them, along with all of Istanbul society, as well as the long-forgotten American film star Terry Moore. We could see the new building from our house, and though at first it looked foreign against Istanbul's tired old silhouette, during the years that followed my parents grew accustomed to it, going there whenever they could. Representatives from the foreign firms to whom my father sold goods— they were to a man all interested in "Oriental" dancing—all stayed at the Hilton. On Sunday evenings, when we would go as a family to eat that amazing thing called a hamburger, a delicacy as yet offered by no other restaurant in Turkey, my brother and I would be mesmerized by the pomegranate-colored uniform with gold braids and flashy buttoned epaulettes of the doorman with the handlebar mustache. In those years so many Western innovations made their first appearance in this hotel that the leading newspapers even posted reporters there. If one of my mother's favorite suits got stained, she would send it to the dry cleaner at the Hilton, and she liked to drink tea with her friends at the patisserie in the lobby. Quite a few of my friends and relatives had their weddings in the grand ballroom on the lower level. When it became clear that my future in-laws' dilapidated house in Anadoluhisarı was not quite suitable for the engagement party, the Hilton was everyone's first choice. And it enjoyed one other distinction: The Hilton had been, since the day it opened, one of the few civilized establishments in Turkey where a well-heeled gentleman and a courageous lady could obtain a room without being asked for a marriage certificate.

There was still plenty of time to spare when Çetin Efendi dropped my parents and me at the revolving doors, which were shaded by a canopy in the form of a flying carpet.

"We still have half an hour," said my father, who always cheered up the moment he stepped into this hotel. "Let's go and have something to drink."

After we had chosen a corner of the lobby with a good view of the entrance, my father greeted the elderly waiter, who recognized him, and ordered "quick *rakıs*" for the men and tea for my mother. We enjoyed observing the evening crowds and—as the appointed time grew

closer—watching our guests arrive, and reminiscing about the old days. Acquaintances, curious relations, and other party guests paraded just in front of us one by one in their chic outfits, but the thick leaves of a potted cyclamen shielded us from view.

"Aaah, look how much Rezzan's daughter has grown; she's so sweet," my mother said. "They should ban miniskirts on anyone who doesn't have the legs," she said, frowning at another guest. Then: "It wasn't us who seated the Pamuk family all the way at the back!" she said in answer to a question posed by my father, whereupon she pointed out some other guests: "Look at what's become of Fazıla Hanım. She used to be such a beauty, but nothing remains of it. Oh, I wish they had left her at home, if only I hadn't seen that poor woman like this. . . . Those headscarf people must be relations of Sibel's mother. . . . I've had no use for Hicabi Bey since he left that lovely rose of a wife and his children to marry that coarse woman. I'm going to thrash Nevzat the hairdresser—that shameless man gave Zümrüt exactly the same style as me. Who are these people? Look at the noses on that couple—my God, don't they look just like foxes? . . . Do you have any money on you, my son?"

"What for?" my father said.

"The way he came racing home, changing into his clothes as if he were just dashing off to the club, instead of going to his engagement party. Kemal darling, look at you, did you even remember your wallet?"

"I did."

"Good. Stand up straight when you walk, all right? Everyone's watching you. . . . Come on now, it's time for us to get going."

My father gestured to the waiter to bring him a single *rakı*, and after looking me in the eye, and gathering my own need for one, he repeated the hand gesture, indicating me this time.

"Now, you're not overdoing it, are you?" my mother said to my father. "I thought you'd picked yourself up and shaken off that gloom you've been wearing like an old coat."

"Can't I drink and enjoy myself at my son's engagement party?"

"Oh, how beautiful she looks!" said my mother when she saw Sibel. "And her dress, it's gorgeous; those pearls look perfect. But this girl is such a splendid creature that anything would look wonderful on her.

What a charming sight, how elegant that dress looks on her, don't you think? My son, do you have any idea how lucky you are?"

Sibel was embracing two friends who had walked past us just a few minutes earlier. The girls were taking scrupulous care with the long, thin filtered cigarettes they had just lit, making an exaggerated effort not to muss each other's hair, makeup, or dress; their lovely bright red lips touched nothing as they exchanged kisses, giggling as they looked each other over and showed each other necklaces and bracelets not often removed from their boxes.

"Any intelligent person knows that life is a beautiful thing and that the purpose of life is to be happy," said my father as he watched the three beauties. "But it seems only idiots are ever happy. How can we explain this?"

"Here it is, one of the best days in the boy's life, so why are you spouting such thoughts, Mümtaz?" said my mother. She turned to me. "Go on, my son, what are you waiting for? Go to Sibel. Spend every moment at her side, share her joy!"

I put down my glass, and as I came out from behind the potted plant and walked toward Sibel I saw her face light up. "Where have you been?" I asked as I kissed her.

After Sibel had introduced me to her friends, we both turned around to watch the great revolving door.

"You look so beautiful, my darling," I whispered in her ear. "No one else comes close."

"And you're very handsome. . . . But let's not stand here."

All the same we continued to stand there, and not at my insistence. As people came flowing into the hotel—friends and strangers, guests and a handful of well-dressed tourists—heads kept turning to look at us, and Sibel liked being the center of so much admiring attention.

It is only now, so many years later, as I recall each and every person who came through those revolving doors, that I realize how insular and intimate was this circle of rich, Westernized families, and how familiar we all were with everyone else's business. There was the Halis boy, known to us since the days when my mother would take us to Maçka Park to play with our pails and shovels, and whose family fortune in olive oil and soap from Ayvalık did not prevent him from taking a wife

with the same lantern jaw as everyone else in his clan ("inbreeding!" my mother charged). . . . There was Kadri the Sieve, my father's friend from the army, and mine from football matches, the former goalkeeper and now a car salesman, arriving with his daughters, each glittering with earrings, bracelets, necklaces, and rings. . . . The thick-necked son of a former president, who had gone into business and blackened his good name with corruption, arriving with his elegant wife. . . . And Doctor Barbut, who'd taken out the tonsils of every member of Istanbul society in the days when that operation was still fashionable—it wasn't just me but hundreds of other children as well who went into a panic at the mere sight of his briefcase and camel-hair coat. . . .

"Sibel's still holding on to her tonsils," I said, as the doctor gave me a warm embrace.

"Well, these days modern medicine has more modern ways of scaring beautiful girls into submission," said the doctor, repeating one of his oldest jokes as he gave me a wink.

As Harun Bey, the handsome representative for Siemens in Turkey, passed by, I feared my mother would notice and get annoyed. She judged this serene, mature man to be "an oaf, a disgrace," for undaunted by all the society cries of "Scandal! Calamity!" he had taken as a third wife the daughter of his second wife (in other words, his stepdaughter). With his cool manner and his sweet smile, he had eventually been accepted back into the fold, though he still had to bear the occasional glare. Then there was Cüneyt Bey with his wife, Feyzan. Cüneyt Bey had bought up for next to nothing the factories and other assets of the Greeks and Jews who were sent off to work camps when they were unable to pay the "wealth tax" imposed on minorities during the Second World War. Though his overnight transformation from loan shark to industrialist offended my father, it was more by reason of jealousy than righteousness, and he was still a treasured friend. Their eldest son, Alptekin, had been my classmate in primary school, and when we discovered that their younger daughter, Asena, had been Sibel's, we were all so pleased as to agree the lot of us should get together very soon.

"Don't you think it's time to go downstairs now?" I said.

"You're very handsome, but you must learn to stand up straight," Sibel said, unknowingly parroting my mother.

Our cook, Bekri Efendi, Fatma Hanım, Saim Efendi the janitor, and

his wife and children came through the revolving doors, one behind the other, looking very bashful in their best clothes, and each in turn shook Sibel's hand. Fatma Hanım and Saim Efendi's wife, Macide, had taken the chic scarves my mother had brought them from Paris and fashioned them to look like traditional headscarves. Their pimply sons were in suits and ties, and though they did not stare at her, they could not hide their admiration for Sibel. After that we saw my father's friend Fasih Fahir and his wife, Zarife. My father didn't like it that his dear friend was a Freemason, and at home he would rail against the clandestine network of "influence and privilege" that had infiltrated the world of business, clucking his tongue whenever he pored over the lists of Turkish Masons put out by anti-Semitic publishing houses; but whenever Fasih was expected at the house, my father would hide away all the books with names like *Inside the Masons* and *I Was a Mason* that had so fascinated him.

Just behind him was a woman known to everyone in society, whom at first glance I mistook for one of our guests: Deluxe Şermin, the only female pimp in all of Istanbul (and perhaps the entire Muslim world). Around her neck was the purple scarf that was her trademark (since it concealed a scar from a knife wound, and she could never take it off) and at her side, in impossibly high heels, was one of her beautiful "girls." Walking into the hotel like guests, they headed straight for the patisserie. And here was the strange, bespectacled Faruk the Mouse (as children we used to go to each other's birthdays, because our mothers were friends), and there, behind him, were the Maruf boys, onetime playmates of mine, as our nurses were friends. Their family, whom Sibel knew well from the club Cercle d'Orient, had made a fortune in tobacco.

The aged and rotund former foreign minister, Melikhan, who was to present our rings, came through the revolving doors with my future father-in-law, and because he had known Sibel as a child, he threw his arms around her and kissed her. He looked me over and turned back to her.

"I'm very happy for you!" he said. "And he's handsome! Congratulations, my boy," he said, and he shook my hand.

Sibel's girlfriends, all smiles, came to join us. The former foreign minister took on the air of a playboy, heaping extravagant praise on

them for their dresses, their jewelry, and their upswept hair, in that tongue-in-cheek way that is the preserve of indulged old men, and when he had kissed each one on the cheek he went downstairs, as if never more pleased with himself.

"I've never liked that bastard," said my father, heading down the stairs.

"For God's sake, let it go!" said my mother. "Watch the steps."

"I can see them," said my father. "I'm not blind yet, thank God." When he saw the view from the garden—Dolmabahçe Palace and beyond it the Bosphorus, Üsküdar, and Leander's Tower—and the crowd of chattering guests, he cheered up. I took him by the arm, and as we walked among the waiters offering colorful canapés, we began the long process of greeting our guests, offering each kisses on the cheek and a suitable interval of small talk.

"How proud you must be of your son, Mümtaz Bey. He's the spitting image of you at that age. . . . I feel as if I'm looking at you when you were young."

"I'm still young, madam," said my father. "But I'm afraid I don't recognize you. . . ." Then he turned to me. "Would you mind letting go of me?" he whispered sweetly. "You're holding my arm too tight and I'm not lame."

I discreetly extracted myself. The garden sparkled with beautiful girls. Most were wearing stylish open-toed high heels, and I imagined the expectant and joyful care with which they must have painted their toenails fire engine red. Though they were in sleeveless or backless dresses with plunging necklines, it cheered me to see how much more at ease they were in this fashion than they were in their usual short skirts. Just like Sibel, they were clutching small shimmering handbags with metal clasps.

Sometime later Sibel took me by the hand and introduced me to a large number of relatives, childhood friends, classmates, and other chums I'd never heard of.

"Kemal, I'd like to introduce you to a very dear friend of mine," she said each and every time, her face beaming, and she would go on to praise that person in a voice that, for all its joyous sincerity, still carried the weight of obligation. The joy was most certainly the effect of life having gone her way, exactly the way she planned. She had devoted

such an effort to the perfect placement of every pearl on her dress, made sure every crimp and curl was in impeccable harmony with every curve on her body, and now with the evening proceeding so smoothly, she assumed that she could just as smoothly slip into a happy future. This was why Sibel treated each passing moment, each new face, each embrace, as a fresh cause for jubilation. From time to time she would nestle up to me, and with maternal attentiveness she would use her thumb and her forefinger to pick off an imaginary hair or piece of lint from my shoulders.

Whenever there was a pause in the greeting and joking, I raised my head to survey the guests and the waiters carrying trays of canapés among them and I could tell from the level of laughter and chatter that the drinks were beginning to relax them. All the women were lavishly made up and extravagantly dressed. In their filmy, tight-waisted, sleeveless dresses, they looked as if they would soon be feeling the chill, while the men seemed trussed up in their stylish white suits, buttoned up as tightly as boys in their outgrown holiday best—and ties that were colorful by Turkish standards, aping the wide, loud, patterned "hippie" ties so fashionable three or four years earlier. It was clear that many rich, middle-aged men had either not heard or refused to believe that the rage for big sideburns, Cuban heels, and long hair had finally run its course. The effect of these overlong and now outdated sideburns, kept in deference to fashion, together with the more traditional black mustaches, was to make the men's faces look very dark. As the smells of aftershave and brilliantine (applied with particular liberality on the thinning hair of men over forty), the ladies' heavy perfumes, the clouds of cigarette smoke to which everyone contributed, more out of habit than for pleasure, the odor of cooking oil from the kitchens—as the confluence of odors swirled into the spring breeze, I was reminded of being a child at my parents' parties. Even the elevator music that the orchestra (the Silver Leaves) was playing, half ironically, to set the mood for the evening, whispered to me that I was happy.

By now the guests, especially the elderly, had tired of standing, and hungry people were already looking for their tables, with little children forging ahead ("Granny! I found our place!" "Where? Stop, don't run, you'll fall"). Just then, the former foreign minister came up from behind to take me by the arm. With consummate diplomatic skill he

drew me to one side to remind me that he had known Sibel since she was a child, and to impress on me, at great length, how elegant and refined she was, and what charming, cultured people her parents were, illustrating these points with examples from his own fond memories.

"Old, sophisticated families like theirs are in short supply these days, Kemal Bey," he said. "You are in the world of business, so you know better than I do that we're being swamped by ill-mannered nouveaux riches, and provincials with their headscarf-wearing wives and daughters. Just the other day I saw a man with two wives trailing him, draped in black from head to toe, like Arabs. He'd taken them out for ice cream to Beyoğlu. . . . So tell me, are you ready to marry this girl and do everything to make her happy for the rest of your life?"

"Yes, sir, I am," I said. I could not help noticing that the former minister was disappointed by the lack of jolliness in my reply.

"Engagements are not to be broken. It means that this girl's name will be linked with yours until the end of your lives. Have you given this serious thought?"

The guests were already pouring in and forming a circle around us.

"I have."

"Well then, let's get you engaged so that we can eat. If you would take your place . . ."

I could tell he hadn't warmed to me, but that did not dampen my mood. The former foreign minister began by telling the assembled guests a story from his army days. He, like Turkey itself, had been very poor forty years ago, and he recounted, with genuine feeling, how he and his dear departed wife had become engaged without fanfare or ceremony. He declared his high regard for Sibel and her family. There wasn't much wit in what he said, but even the waiters who had retired to the side holding their trays smiled as if listening to an entertaining story. When Hülya, the sweet, bucktoothed ten-year-old whom Sibel loved dearly (and who was utterly fascinated by her), came forward with the silver tray bearing the rings I display here, the crowd fell silent. Sibel and I were so excited, and the former foreign minister so distracted, that we got into a hopeless muddle about which ring went where. But by now the guests were ready for a laugh, and so when a few people cried out, "Not that finger, it goes on the other hand," a general

titter circulated through the crowd, until the rings finally found their proper places, and then the former foreign minister cut the ribbon binding them, to a spontaneous round of applause sounding like a flock of pigeons taking flight. Even though I had prepared myself for this, the sight of so many people I had known all my life clapping for us and warmly smiling made me as giddy as a child. But this was not what set my heart racing.

For in the back of the crowd, standing next to her mother and father, I'd seen Füsun. A rapturous wave washed over me. As I kissed Sibel's cheeks, as my mother came to our side and I embraced her, and then my father, and my brother, I realized what it was that had made me so joyful, though I still thought I could hide it, not just from the crowd, but from myself, too. Our table was right on the edge of the dance floor. Just before we sat down I saw Füsun sitting with her parents at the very back, right next to the table for the Satsat employees.

"You both look so happy," said my brother's wife, Berrin.

"But we're so tired, too," said Sibel. "If this is what it takes to pull off an engagement party, just imagine how tiring the wedding is going to be."

"You'll be very happy on that day, too," said Berrin.

"How do you define happiness, Berrin?" I asked.

"Goodness, what a question," said Berrin, and she behaved as if she were considering her own happiness, but because even to joke about such a thing made her uncomfortable, she smiled bashfully. Amid the babble of conversation, the guests' chatter, occasional cries, the clink of knives and forks, and the strains of music, we both heard my brother's loud, shrill voice as he regaled someone with a story.

"Family, children, and good company," Berrin said. "Even if you're not happy"—here, she indicated my brother with her eyes—"even when you're having your worst day you live your life as if you are. All sorrows fade away when you're surrounded by your family. You should have children right away. Have lots of children, just like peasants."

"What's going on here?" said my brother, joining us. "Tell me what you're gossiping about."

"I'm telling them to have children," said Berrin. "How many should they have?"

No one was looking, so I downed my half glass of *rakı* in one gulp.

A little later Berrin whispered into my ear: "That man at the end of the table, and that charming girl next to him—who are they?"

"That's Nurcihan, Sibel's dear friend since lycée days—they also went to France together. Sibel has seated her next to my friend Mehmet, hoping to get something started."

"Doesn't look very promising so far!" said Berrin.

Sibel felt a mixture of admiration and compassion for her friend Nurcihan. When they were students in Paris, Nurcihan had had several love affairs, which she'd courageously consummated, even moving in with a few of these men (Sibel had enviously told me all these stories), and all the while keeping this life secret from her wealthy parents in Istanbul; but with time these adventures had left her feeling sad and drained, so now, under Sibel's influence, she was plotting a return to Istanbul. "But for obvious reasons," I added, after telling all this to Berrin, "she'll need to fall in love with someone who appreciates her worth, someone at her level, who won't be troubled by her French past, or her old lovers."

"Well, if you ask me, it's not happening tonight," she whispered. "What sort of business is Mehmet's family in?"

"They have money. His father is a well-known building contractor."

As Berrin saucily raised an eyebrow in snobbish suspicion, I told her that although his family was very religious and conservative, Mehmet was a trusted friend of mine from Robert College, an honest and decent man who had for years refused to let his headscarf-wearing mother arrange a marriage for him to an educated Istanbul girl, because he wanted to marry someone of his own choosing, a girl he could go out with. "But so far he's got nowhere with the modern girls he's found for himself."

"He'll never get anywhere," said Berrin with a knowing air.

"Why not?"

"Just look at him. You can tell that type from a mile off," said Berrin. "Men like him from the heart of Anatolia . . . Girls would rather marry him through a matchmaker because they know if they go gallivanting about town with him too much, a man like this will secretly begin to think of them as whores."

"Mehmet doesn't have that mentality."

"But he's from that mold. That's what his family is like, that's where he comes from. A girl with brains doesn't judge a man by the way he thinks. She looks at his family, at the way he deports himself."

"You do have a point," I said. "I've seen brainy girls like this—no need to mention names—who shy away from Mehmet, even when he's clear he's serious about them, but when they're around other men, even when they're not sure the men would marry them, they're much more relaxed, and much better at getting the ball rolling."

"Exactly," said Berrin proudly. "I can't tell you how many men in this country treat their wives with disrespect even years later, just for having allowed them some intimacy before marriage. Let me tell you something: Your friend Mehmet has never really been in love with any of those girls who did not allow him to approach them. If he had been, those girls would have sensed it, too, and they would have treated him differently. I'm not saying they would have slept with him, of course, but they would have let him get close enough to make marriage a possibility."

"But the reason that Mehmet couldn't fall in love with them was that they wouldn't let him get close enough, because they were conservative and frightened."

"That's not the way it works," said Berrin. "You don't have to sleep with someone to be in love. The sex is not what matters. Love is *Leyla and Mecnun*."

I said something like "Hmmmmm."

"What's going on over there?" my brother shouted from the other end of the table. "Tell us, please! Who's sleeping with whom?"

Berrin gave him a look that said, There are children listening! Then she whispered into my ear. "That's the crux of it," she said. "Why can't this seemingly meek Mehmet of yours fall in love with any of these girls he wants to meet, or start something serious with them?"

Out of respect for Berrin's intelligence, I was tempted for a moment to tell her that Mehmet was an incorrigible patron of whorehouses. He had "girls" he visited regularly in four or five private establishments in Sıraselviler, Cihangir, Bebek, and Nişantaşı. Even as he struggled in vain to form deep attachments with the women he met at work—virgins in their early twenties with lycée diplomas—he'd continued to frequent the high-class brothels for wild all-nighters with girls

impersonating Western movie stars, though when he drank too much it became obvious what a hard time he had keeping up the pace, or even thinking straight. Nevertheless, when we emerged from a party in the wee hours, instead of returning to his house where his father was forever fretting over his worry beads and his mother brooded in her headscarf, and everyone, including his sisters, kept the fast during Ramadan, he would bid us good-bye and head to one of the pricier brothels of Cihangir or Bebek.

"You're drinking rather a lot this evening," said Berrin. "Slow down a little. There are a lot of people here and they're all watching the family."

"Fine," I said, as I lifted my glass with a smile.

"Just look at Osman, how responsible he is," said Berrin. "Then look at you, so mischievous at your own engagement. . . . How could two brothers be so different?"

"Actually," I said, "we're very similar. And anyway, from now on I'm going to be even more serious and responsible than Osman."

"Well, don't go overboard. People can be so boring when they're too serious," Berrin began, and she continued in this half-hectoring vein until, much later, I heard, "You're not even listening to me."

"What? Of course I'm listening."

"All right, then tell me what I just said!"

"You said, 'Love has to be the way it is in the old legends. Like *Leyla and Mecnun.*'"

"I knew you weren't listening to me," said Berrin with a half smile, from which I could see she was worried about me. She turned to Sibel, to see if she had noticed what condition I was in. But Sibel was talking to Mehmet and Nurcihan.

That I'd not been able to put Füsun out of mind all this while; that throughout my conversation with Berrin I'd felt her presence behind me, at her table in the back; that I kept wondering how she was doing and what she must be thinking—I'd been trying to hide this from myself just as I've been keeping it from my readers, but enough! You already know that I failed. So from now on I'll be straight with you.

I found an excuse to leave the table. I can't remember what pretext I came up with. I cast my eyes over the back of the garden, but I couldn't see Füsun. The place was very crowded, and as always, with

everyone talking at once, shouting to be heard, and children shrieking as they played hide-and-seek among the tables, and the clink of knives and forks going on over their heads—a cacophony the orchestra only exacerbated—it added up to quite a roar. I walked through this infernal din toward the back, hoping to catch sight of Füsun.

"Many congratulations, my dear Kemal," I heard someone say. "How much longer till the belly dance?"

This was Selim the Snob, who was sitting at Zaim's table. I laughed, as if he'd said something hilarious.

"You've made an excellent choice, Kemal Bey," a nice matron told me. "You probably don't remember me. I'm your mother's . . ."

But before she could make the connection, a waiter with a tray pushed me aside to make his way between us. By the time I had gathered my bearings, the well-wishing woman had been carried away in the flow of the crowd.

"Let me see your ring!" said a child, roughly twisting my hand.

"Stop, don't be rude!" said the child's fat mother, seizing the child roughly by the arm. She lunged, as if to slap him, but the brat was wise to her ways and wriggled out just in time. "Come here and sit down!" cried his mother. "I'm so sorry . . . and congratulations."

A middle-aged woman I'd never seen before was laughing herself red in the face, but when our eyes met she suddenly became serious. Her husband introduced himself—he was a relation of Sibel's, but apparently we'd both done our military service at the same time in Amasya—and he invited me to sit down with them. I surveyed the tables at the back of the garden, hoping to catch sight of Füsun, but she seemed to have vanished into thin air. Misery spread through my body.

"Are you looking for someone?"

"My fiancée is waiting for me, but of course I'd love to sit down and have a drink with you. . . ."

They were very pleased, and at once they pushed together their chairs to make room for one more. No, I didn't need a place setting, just a little more *rakı*.

"Kemal, my friend, have you ever been introduced to Admiral Erçetin?" the man asked, pointing at the gentleman across the table.

"Yes, of course," I said. In fact I had no memory of him.

"Young man, I am Sibel's father's aunt's sister's husband!" the admiral told me humbly. "I congratulate you."

"Please excuse me, Admiral. I didn't recognize you out of uniform. Sibel speaks highly of you."

In fact, Sibel had told me how a distant cousin of hers had years ago spent the summer in Heybeliada and fallen in love with a handsome naval officer; thinking that this admiral must be one of those grandees that rich families treat so well so as to have someone to pull strings whenever they have dealings with the state, or when they need to arrange the deferment of some son's military service, I hadn't paid particular attention to her tale. I now had a strange urge to ingratiate myself by saying, "When is the army going to step in, sir? How much longer can we be pushed to the brink by communists on the one side and reactionaries on the other?" but I was composed enough to know that if I said these things in my present addled state, I would be judged drunk and disrespectful. Suddenly something prompted me to stand up, and there, in the distance, I saw Füsun.

"I'm afraid I'm neglecting our other guests. I think I'd better get up, gentlemen!"

As always after drinking too much, I felt like my own ghost trying to take its first solo walk outside the body.

Füsun had returned to her table in the back. In a dress with spaghetti straps, her bare shoulders had a healthy glow. She'd had her hair done, too. She was so very beautiful that even from that distance it filled my heart with joy and excitement to catch a glimpse of her.

She acted as if she hadn't seen me. Four tables closer was the fidgety Pamuk family, and so, to close the distance between me and Füsun, I went over to greet Aydın and Gündüz Pamuk, who at some point had done some business with my father. All the while I kept my antennae tuned to Füsun's table, whose proximity to the Satsat table had created the opportunity for my young and ambitious employee Kenan, who could not take his eyes off Füsun, to strike up a conversation with her.

Like so many formerly rich families that had squandered their fortunes, the Pamuks had turned in on themselves and found it upsetting to come face-to-face with new money. Sitting with his beautiful mother, his father, his elder brother, his uncle, and his cousins was the chain-smoking twenty-three-year-old Orhan, nothing special about

him beyond his propensity to act nervous and impatient, affecting a mocking smile.

Rising from the tedious Pamuk table, I walked straight over to Füsun. How to describe the expression on her face when she realized that she couldn't ignore me—that I had been so bold as to approach her with love in my eyes? At once she blushed, her deep pink skin glowing with life. From the looks Aunt Nesibe was giving me, I guessed that Füsun had told her everything. First I shook her hand, which was dry, and then I shook hands with her father, who had long fingers and slender wrists like his daughter's, and he gave no sign of knowing anything. When it was my beloved's turn, I took her hand, and with tenderness and propriety, I kissed her on both cheeks, furtively inhaling the tender spots on her neck and below her ears that had brought me such pleasure only hours ago. The question I couldn't get out of my head— "Why did you come?"—now took the form of "How good of you to come!" She had put on just a bit of eyeliner and some pink lipstick. With her perfume, the makeup gave her an exotic womanly air. But her eyes were red and puffy like a child's, so I knew that after we had parted that afternoon she had gone home and spent the early evening crying; but no sooner had I worked this out than she assumed the demeanor of a confident, well-bred woman who knew her own mind.

"Kemal Bey, I know Sibel Hanım. You've made a very wise choice," she said bravely. "Congratulations."

"Oh, thank you."

"Kemal Bey," her mother said at the same time. "I can only imagine how busy you are. God bless you for giving so much of your time to helping our daughter with her mathematics."

"Her exam is tomorrow, isn't it?" I asked. "She should be heading home early to get plenty of rest."

"I understand you have every right to be concerned," said her mother. "But while she was working with you she got very upset. Give her your permission to have a little fun for an evening."

I gave Füsun a compassionate, teacherly smile. With all the noise from the crowd and the music, it seemed that no one could hear us. I saw in the looks Füsun was giving her mother the same flashes of anger I'd seen during our trysts in the Merhamet Apartments; I took one last look at her beautiful, half-exposed breasts, her wondrous

shoulders, and her childish arms. As I turned away I felt happiness overwhelm me like a giant wave crashing.

The Silver Leaves were playing "An Evening on the Bosphorus," their version of "It's Now or Never." If I didn't believe with all my heart that absolute happiness in this world can only happen while living in the present and in the arms of another, I would have chosen this instant as "the happiest moment of my life." For I had concluded from Füsun's mother's words and her own hurt and angry looks that she could not bring herself to end our relationship, and that even her mother seemed to have resigned herself to this state of affairs, though with certain expectations. If I proceeded with great care and let her know how much I loved her, Füsun, I now understood, would be unable to break off relations with me for as long as I lived! The manly pleasures outside the realm of morality that God granted just a few favored slaves—the happiness that my father and my uncles had had only a taste of, and rarely before their fifties, not before they had suffered terrible torment—it seemed to me now that I was going to be able to enjoy the same good fortune—partaking of all the pleasures of a happy home life with a beautiful, sensible, well-educated woman, and at the same time enjoying the pleasures of an alluring and wild young girl—all this while I was still in my thirties, having scarcely suffered for it, or paid a price. Though not at all religious, I have engraved in my memory what I still regard as a postcard of bliss, sent by God: the image of merry guests, now dispersed to the outer reaches of the garden, and beyond them among the plane trees and the colored lamps, the landscape, the lights of the Bosphorus and the deep blue sky.

"Where have you been?" said Sibel. She'd come out to look for me. "I was worried. Berrin said you had had a bit too much to drink. Are you all right, darling?"

"Yes—I did overdo it in there, but I'm feeling better now, dear. My only problem now is that I'm too happy."

"I'm also very happy, but we have a problem."

"What?"

"It's not working with Nurcihan and Mehmet."

"Well, if it's not to be, it's not to be. What matters tonight is that we're happy."

"No, no, they both want this. If only they could let their guard down

a little, I'm positive they'd be on the road to marriage in no time. But they just can't seem to break the ice. I'm afraid that they'll miss their chance."

I watched Mehmet from a distance. He just couldn't get Nurcihan to warm to him, and when he realized how clumsy he'd been he got angry and damned himself into still further awkwardness.

I motioned to Sibel to sit with me at a small service table piled high with clean plates. "We may be too late for Mehmet. . . . It may not be possible to find him a proper, decent wife."

"Why?"

As her eyes grew large with fear and curiosity, I told Sibel that Mehmet would never find happiness anywhere but in a heavily perfumed room with red lamps. I ordered a *rakı* from the waiter who darted over as soon as we were seated.

"You seem to know quite a bit about these places!" said Sibel. "Did you visit them with him before you knew me?"

"I love you so much," I said, putting my hand on hers, and I didn't mind when the waiter shot an inquisitive glance at our engagement rings. "But Mehmet must surely be wondering if he can ever be deeply in love with any decent girl. In fact he must be panicking."

"Oh, what a pity!" said Sibel. "It's all because of those girls who shied away from him. . . ."

"Well, he shouldn't have scared them off. The girls are right to be careful. What happens to them if they have slept with a man and he doesn't marry them? If word gets out and she's left in the lurch, what is she to do?"

"It's something she just knows," said Sibel carefully.

"What is?"

"Whether she can trust a man or not."

"It's not so simple. Many girls suffer terribly, being unable to make up their minds. Or else they give in to desire but are too afraid to take any pleasure from it. . . . I don't even know if there is any girl out there who can enjoy it for what it is and damn the consequences. And Mehmet, if he hadn't listened to all those stories of sexual freedom in Europe with his mouth watering, he might not have got it into his head that he had to have sex with a girl before marrying her, just to be modern or civilized; he'd probably have been able to make a happy marriage

with a decent girl who loved him. Now look at him, squirming in that chair next to Nurcihan."

"He knows that Nurcihan slept with men in Europe. . . . I know this intrigues him, but it scares him, too," said Sibel. "Come on, let's go give him a hand."

The Silver Leaves were playing "Happiness," a mawkish piece of their own composing. But I was in the mood and it moved me. As I felt my love for Füsun coursing through my veins—such pain, and such bliss—I was nevertheless able to appear paternalistic, lecturing Sibel that Turkey, too, would probably be modern like Europe in a hundred years' time, and that when that day arrived everyone would be free of worries about virginity and what people thought, free to make love and be happy as it is promised one in heaven. But until then most people would continue to agonize over love, and suffer sexual pain.

"No, no," said my beautiful and good-hearted fiancée. "If we can be this happy *today,* then so can they. Because we're definitely going to get Nurcihan and Mehmet married."

"Okay, then, what's the plan?"

"What a fine sight—engaged for only an hour and already off in a corner by yourselves?" This was a portly gentleman neither of us knew. "May I join you, Kemal Bey?" Without waiting for an answer he grabbed a chair from the side and sat down next to us. He was relatively young, perhaps in his forties, to be sporting a white carnation on his lapel and wearing a sickly sweet perfume, for women, and enough of it to make one faint. "When the bride and groom retire to a corner, a wedding loses its joy."

"We're not a bride and groom yet," I said. "We're only engaged."

"But everyone is saying that this splendid engagement party is more sumptuous than the grandest wedding, Kemal Bey. Where might you have the wedding, apart from the Hilton?"

"Excuse me, but with whom have I the pleasure of speaking?"

"Forgive me, Kemal Bey, you have every right. We writers assume that everyone knows who we are. My name is Süreyya Sabır. You may know me by my pen name, 'White Carnation,' in *Akşam.*"

"Yes, of course, there can't be anyone in Istanbul who doesn't read you to find out the latest society gossip," said Sibel. "I always assumed you were a woman—you know so much about fashion and clothes."

Carelessly I interrupted her to ask, "Who invited you?"

"Thank you for the compliment, Sibel Hanım. But in Europe, refined men with a knowledge of fashion are not uncommon. And Kemal Bey, the Turkish press regulations allow journalists to attend gatherings that are open to the public, on condition that we show this press card. By statute, any gathering announced by invitation is 'open to the public.' All the same, I have never once attended a party to which I had not been invited. I am here this lovely evening at the invitation of your esteemed mother. Because of her modern outlook, she knows the value of what you call society gossip, which I prefer to call news, so she invites me to many of her parties. So great is the trust between us that sometimes when I can't attend a particular party we'll speak of it on the phone the next day, and when I sit down to write I quote her word for word. Because—like you, my dear girl—she pays precise attention to everything and never gives false reports. There has never been a mistake in my society news column, Kemal Bey, and there never will be."

Sibel mumbled something like, "I'm afraid you misunderstood Kemal's question. He meant nothing by it."

"Just now there were a number of vipers saying Istanbul's entire supply of black market whiskey and champagne must be in this room. Our country is suffering from a shortage of foreign currency reserves, we don't have the wherewithal to keep our factories going or to buy diesel! There are some, Kemal Bey—jealous enemies of wealth—who would write articles asking, 'Where does all this black market alcohol come from?' just to cast a cloud over this lovely evening. . . . Because I would never dream of trying to upset you, I shall forget your thoughtless words at once, for all eternity. Because we have a free press in Turkey, I shall ask that you answer a single question truthfully."

"Of course, Süreyya Bey."

"Just a moment ago I caught you two wrapped up in a serious discussion, and I was curious. What were you talking about, so soon after your engagement?"

"We were wondering whether the guests had enjoyed their food," I said.

"Sibel Hanım, I have good news for you," said White Carnation in joyous tones. "Your future husband just doesn't know how to tell a lie!"

"Kemal has a very good heart," said Sibel. "What we were talk-

ing about was this: Who knows how many people at this gathering are in anguish over who knows what trouble with love, marriage, or even sex."

"Oooh, yes," said the gossip columnist, at her uttering of the word that had recently been discovered by the press, indeed, had turned into something of a fetish; and because he couldn't decide whether it was better for him to act as if he had just heard an admission worthy of scandal, or whether he might be better advised to show his empathy for the depth of human suffering, for a moment he fell silent. "You, of course, are modern, happy people, at ease in this new age," he said at last. "You've put all this pain behind you." He did not say this sardonically, but with an effortless sincerity cultivated through experience, which taught that in difficult situations the best thing was always to flatter people. Feigning feeling for others not as fortunate as we, he began to tell tales about our guests: the daughter who was hopelessly in love with so-and-so's son; the girl who was being ostracized by good families for being too free in her ways while all the men lusted after her; the mother who had set her cap for a certain rich playboy as her son-in-law; the slovenly son of another wealthy family who had fallen in love, though he was promised to another. Sibel and I could not help but be entertained by his stories, and when White Carnation saw this he relished telling them all the more. He was just explaining that all these "disasters" would be obvious once the dancing had begun, when my mother arrived to tell us we were being very rude, and everyone was looking at us; she ordered us back to our table.

No sooner had I taken my seat next to Berrin than the image of Füsun fired up in my mind's eye with full force, as if a television set had just been plugged in. But this time the light from that image exuded joy, not sadness, illuminating not just this evening but my entire future. For a brief moment I recognized myself among those men whose real source of happiness is their secret lover, but who pretend it is their wives and children—I, too, was acting as if it was Sibel who made me happy, and we weren't even married yet.

After chatting for a while with the gossip columnist, my mother came over to our table. "Take care around these journalists, will you?" she said. "They write all sorts of lies; they do terrible mischief. And then they make threatening calls to your father, asking him to buy more

advertising space. Why don't you two get up and start the dancing. Everyone is waiting for you." She turned to Sibel. "The orchestra is warming up. Oh how sweet you are, how beautiful."

Sibel and I danced to a tango that the Silver Leaves were playing. All the guests were watching, and this gave our happiness the illusion of depth. Sibel draped her arm over my shoulder as if to embrace me, and pressed her face against my chest as close as if we were dancing alone in a dark corner of a discotheque; from time to time she smiled and murmured something, and after we'd made a turn I would look over her shoulder at whatever person she had remarked on a moment ago— the waiter whose heavy tray had not prevented his pausing to smile at our bliss, or her mother weeping for joy, or a lady whose hair resembled a bird's nest, or Nurcihan and Mehmet turning their backs on each other now that we had left them alone, or the ninety-year-old gentle- man who had made his fortune during the Great War and who could no longer eat without the help of his servant, who was wearing a string tie—but I did not once look at the back of the garden, where Füsun was sitting. As Sibel kept up her cheerful chatter, it was better if Füsun didn't see us.

There was a burst of applause; it didn't last long, and we carried on dancing as if nothing had happened. When other couples got up to dance, we returned to our table.

"You did very well. You looked so good together," said Berrin. At that point, I think, Füsun was not yet among the dancers. Sibel was fretting so over Nurcihan and Mehmet's lack of progress that she asked me to speak to Mehmet. "Tell him to come on a little stronger," said Sibel, but I did nothing. Berrin got involved at this point, and in a whisper she told us that forcing the issue was a bad idea; she'd been watching the whole thing from her side of the table and it wasn't just Mehmet; they had both been standoffish, or at least nervous, and if they didn't like each other there was no point in pushing them together. "No," said Sibel, "weddings cast a kind of spell. It's at weddings that many people meet the person they end up marrying. It's not just girls that get into the mood at weddings; it's boys, too. But you have to help them along. . . ." "What are you talking about? Tell me, too," said my brother as he joined the whispering conversation, and once he had been apprised of things, he pointed out in hortatory tones that while

the days of arranged marriages were over, Turkey wasn't Europe, and there weren't many ways couples could get to know each other, with the result that a lot of the burden had fallen on the shoulders of well-meaning informal matchmakers. Then, apparently forgetting that Nurcihan and Mehmet had sparked the debate, he turned to Nurcihan, saying, "I imagine, for example, that you would never consent to a marriage arranged by a matchmaker, am I right?"

"So long as the man is nice, it doesn't matter how you find him, Osman Bey," said Nurcihan with a giggle.

We all laughed as if we'd heard something so outrageous it could only be a joke. But Mehmet turned deep red and looked away.

"Don't you see?" Sibel whispered into my ear a bit later. "She frightened him off. He thought she was making fun of him."

I was not watching the people on the dance floor at all. But when our museum was established, Mr. Orhan Pamuk recalled that Füsun had danced with two people early on. He didn't know or couldn't remember her first dance partner, though I worked out that it must have been Kenan from Satsat. The second, however, was the young man with whom I had exchanged glances a short time earlier while visiting the Pamuk family table—Orhan Pamuk himself, as he proudly told me years later. Those interested in Orhan Bey's own description of how he felt while dancing with Füsun should look at the last chapter, entitled "Happiness."

While Orhan Bey was dancing the dance that he would describe to me with utter frankness many years after the fact, Mehmet decided he had had enough of Nurcihan's giggles and our double entendres about love, marriage, matchmakers, and "modern life" and left the table. At once our spirits dropped.

"That was very rude of us," said Sibel. "We broke the boy's heart."

"Don't say that looking at me," said Nurcihan. "I didn't do any more than you did. You've all had a lot to drink and you're having a good time. Mehmet is the one who is frustrated in life."

"If Kemal brings him back to the table, will you behave nicely, Nurcihan?" asked Sibel. "I know you could make him very happy. And he you. But you have to treat him well."

It seemed to please Nurcihan to see Sibel so openly determined to set her up with Mehmet. "No one's talking about getting married

tomorrow," she said. "He met me, he could have said one or two nice things to me."

"He is trying. He's just not used to talking with a girl as self-possessed as you are," said Sibel; giggling, she whispered the rest of what she had to say into Nurcihan's ear.

"Do you people know why boys in this country never learn how to flirt with girls?" asked my brother. He assumed that charming expression he wore whenever he'd had something to drink. "There's nowhere to flirt. We don't even have our own word for 'flirt.' "

"I remember your idea of flirting," said Berrin. "Before we got engaged, you'd take me to the cinema on Saturday afternoons. . . . You'd bring a portable radio with you, so that you could find out about the Fener match during the five-minute intermission."

"Actually, I didn't bring the radio with me to tune in to the match, but to impress you," said my brother. "I was proud to be the owner of the first transistor radio in Istanbul."

Then Nurcihan admitted that her mother used to brag about being the first person in Turkey to use an electric blender. She went on to tell us how, in the late 1950s, years before canned tomato juice became available, her mother was offering her friends tomato, carrot, celery, beet, and radish juice when they came over to play bridge, and as the ladies were all sipping from crystal glasses, she would proudly take them into the kitchen to show them the first electric blender to arrive in the country. As we listened to light music from that era, we remembered how the Istanbul bourgeoisie had trampled over one another to be the first to own an electric shaver, a can opener, a carving knife, and any number of strange and frightening inventions, lacerating their hands and faces as they struggled to learn how to use them. We talked about all those tape recorders brought back from Europe that usually broke on first use, and the hair dryers that blew the fuses, the coffee grinders that frightened the servant girls, the mayonnaise makers for which no spare parts were to be found in Turkey, but which no one had the heart to throw away and so relegated to a remote corner of the house to gather dust. Meanwhile, as we were laughing about all this, You-Deserve-It-All Zaim sat down in the seat Mehmet had vacated, and within four or five minutes he had managed to enter the swim of the conversation and was whispering into Nurcihan's ear, making her laugh.

"What happened to that German model of yours?" Sibel asked Zaim. "Did you ditch her like all the others?"

"Inge wasn't my lover. She's gone back to Germany." Zaim spoke without losing any of his good humor. "We were just business associates, and I was only taking her out to show her Istanbul by night."

"So you're telling me you were just friends," said Sibel, using one of the expressions newly popularized by the celebrity magazines.

"I saw her today, at the cinema," said Berrin. "She turned up on the screen, sipping that soft drink with that same beckoning smile." She turned to her husband. "I went at lunchtime—the power was out at the hairdresser's. I went to the Site—it was Jean Gabin with Sophia Loren." She turned to Zaim. "I see her everywhere—in every single kiosk in the city; and it's not just children drinking Meltem now, it's everyone. You're to be congratulated."

"We timed it well," said Zaim. "We've been lucky, too."

Seeing the puzzlement in Nurcihan's eyes, and knowing that Zaim would expect me to explain, I quickly informed Nurcihan that my friend was the owner of Şektaş, the company that had recently launched Meltem, and that he'd also introduced us to Inge, a lovely German model who could be seen in the advertisements all over the city.

"Have you had the opportunity to taste our fruit-flavored soft drinks?"

"Of course I have. I especially liked the strawberry," said Nurcihan. "Even the French haven't been able to put out something that good in years."

"Do you live in France?" asked Zaim.

Zaim invited all of us to visit the factory that weekend, also promising a Bosphorus cruise and a picnic in Belgrade Forest just outside the city limits. The entire table watched him and Nurcihan. A short while later they got up to dance.

"Go find Mehmet," said Sibel. "Get him to rescue Nurcihan from Zaim."

"Are we sure she wants to be rescued?"

"I don't want to see my friend swallowed whole by this embarrassing Casanova whose only ambition in life is to lure girls into bed."

"Zaim has a very good heart, and he's honest. He just has a weak-

ness for women. Can't Nurcihan have a bit of fun here as she did in France? Is it absolutely necessary for her to get married?"

"French men don't look down on a woman just because she's slept with a man before marriage," said Sibel. "But here even a little fun can get you a reputation. Besides, I don't want to see Mehmet's heart broken."

"I don't either. But I also don't want other people's love affairs to overshadow our engagement."

"You don't seem to appreciate the pleasures of matchmaking," said Sibel. "If these two get married, just think of it, Nurcihan and Mehmet could be our closest friends for years."

"I doubt Mehmet is going to be able to peel Nurcihan away from Zaim tonight. He shies away from confrontations with other men at parties."

"That's why you have to go have a word with him, tell him not to be scared. I'll handle Nurcihan, don't you worry. Go—go and bring him back here right away." As I stood up she gave me a tender smile. "You're very handsome," she said. "Don't stop and gab. Come back at once and take me off to dance."

It had occurred to me that I might run into Füsun as I made my way from table to table in search of Mehmet, through the crowds of merry, shouting, half-intoxicated revelers, shaking my hand. There were three friends of my mother's who had come to our house every Wednesday during my childhood to play bezique. With the same spontaneity that must have prompted them all to dye their hair the exact same shade of brown, they and their three husbands simultaneously began waving to me from their table, calling "Ke-maaaal" as if summoning a child. Next I saw an importer friend of my father's who ten years later would be notorious for bringing down the minister of customs and excise who'd asked him for an obscenely large bribe, which he'd delivered inside an enormous baklava box packed with stacks of bills with a picture of Antep on the top. He'd later released to the public verbatim the intimate conversation that had ensued, recorded on the tape machine he'd secured under his arm with Gazo brand tape. He is now etched in my memory with his white tuxedo, his gold cuff links, his manicured nails that were doused in the perfume that remained on my hand long after he shook it.

As it was with so many of the faces in the photographs my mother trimmed so meticulously for arrangement in our albums, I found many of the faces in the crowd so familiar, so close, that it made me terribly uneasy when I was unable to work out the relations among them—who was whose husband, or whose sister.

"Kemal darling," said an amiable middle-aged woman at just that moment. "Do you remember proposing to me when you were six years old?" It was only when I saw her stunning eighteen-year-old daughter that I recognized her. "Oh, Aunt Meral, your daughter looks just as you did then!" I said to my mother's second cousin. When the mother told me that they were regretfully obliged to leave early, because the daughter was taking the university exam the next day, I realized that between me and my jovial aunt there were as many years—twelve, to be exact—as between me and her gorgeous daughter, an awareness that produced a momentary stupor, before I yielded to the urge to glance in the very direction I had been avoiding, but Füsun was not visible at the table in the back or on the crowded dance floor. It was shortly thereafter that this photograph was taken of me with "Ship-Sinker Güven," who ran an insurance company. You can't see my face, just my hand in the photo that I acquired years later from a collector whose home was littered with piles and piles of photographs of weddings and other parties from the Hilton. In another that would be taken three seconds later, the gentleman banker in the background would be shaking my hand, having introduced himself as an associate of Sibel's father, this revelation having caused me to remember with some surprise that every time—that is to say, both times—I had been to Harrods in London, I'd seen this gentleman banker lost in thought as he was picking out an appropriately dark suit for himself.

Making my way through the crowd, stopping to pose for souvenir photographs, I marveled at how many brunettes had bleached their hair blond; and how many of the rich, flashy men were wearing almost identical ties, watches, rings, and thick-soled shoes, and how their mustaches and sideburns were trimmed to equally disturbing uniformity, but at the same time I recalled that I knew them all and that we had many fond memories in common, and this was enough to stir a wave of nostalgia, and also wonderment at the blessed life before me, and the unparalleled beauty of the summer evening that carried the scent

of mimosa. I greeted Turkey's first Miss Europe, who had, after the age of forty, and two failed marriages, devoted herself to fund-raising balls sponsored by associations working on behalf of the poor, the disabled, and the orphaned ("Forget idealism, my dear, she takes a percentage," my mother used to say), and who visited my father's office once every two months, seeking his support. I remarked on the beauty of the evening to the lady whose shipping magnate husband had been shot in the eye and killed during a family feud, and who had, ever after, been teary-eyed at family gatherings. It was with great respect that I shook the soft hand of Celâl Salik (I display a column by him here), then Turkey's best-loved, strangest, and most courageous columnist. I sat down for a photograph with the sons, daughter, and grandchildren of the late Cevdet Bey, one of Istanbul's first Muslim businessmen. At another table of some guests invited by Sibel, I entered into a wager about the likely outcome of *The Fugitive,* the television series that had captivated all of Turkey and whose final episode was to be aired the following Wednesday: Dr. Richard Kimble had been hunted down for a crime he didn't commit, and being unable to prove his innocence, would always, always be on the run!

In the end I did find Mehmet comfortably perched on a stool in the bar adjacent to the garden, drinking *rakı* with Tayfun, a classmate of ours.

"Oooh, all the bridegrooms are here at last," said Tayfun as I sat down to join them. It was not just that we were delighted to see each other; his remark brought back happy memories that caused us all to smile. During our last year at Robert College the three of us would often hop into Tayfun's father's Mercedes on an afternoon and head for a glitzy brothel lodged in an old pasha's mansion in the hills above Emirgân, where every time we would sleep with the same charming, lovely girls. These girls, who'd joined us for a spin in the car a few times and for whom we felt a deep affection we were at pains to conceal, charged us much less than they did the aging loan sharks and drunken businessmen they serviced in the evenings. The madam, an old, high-class prostitute, always treated us courteously, as if we were meeting at a society ball at the Cercle d'Orient in Büyükada. But every time she saw us in our school jackets and ties, clearly on our lunch hour, in the hallway where in the evenings her miniskirted girls would sit on divans,

smoking and reading *photoromans* while waiting for customers, the madam would burst out laughing, and call out, "Giii-iirls! Your schoolboy bridegrooms are here!" Thinking it might cheer Mehmet up to recall those happy days, I reminded him of the time when, having drifted off to sleep after making love in those rooms warmed by the spring sun streaming through the closed shutters, we gave as our excuse to the aged schoolmistress: "We were studying biology, madam," and that from then on, "studying biology" was our code word for visiting the brothel. We remembered there was a sign on the front of the mansion, reading CRESCENT HOTEL-RESTAURANT, and that the girls had botanical aliases—Flower, Leaf, Daphne, Rose. Once on an evening visit we'd just retired upstairs with the girls when a famous tycoon turned up with his German partners; knocking on our doors, the madam had quickly extracted her girls and sent them downstairs to belly dance for the foreign guests. As consolation, we were given permission to sit quietly at a table in the back of the restaurant to watch. And as they gyrated in their sparkling, sequined harem outfits, we knew it was us, and not the aging moneybags, whom they were trying to entrance. We spoke with longing of watching them dance, knowing that we'd loved them and that we'd never forget our times in that place.

Whenever I returned from America for summer vacation, my chums Mehmet and Tayfun were always keen to fill me in on the latest bizarre developments, for every time there was a new chief of police, the rules of engagement changed. For example, there was an establishment occupying a seven-story Greek building on Sıraselviler Avenue; for a time the police were raiding it daily, but sealing off only one floor, obliging the girls there to take their admirers to another one that was, nonetheless, adorned with the same furniture and mirrors. . . . In one of the side streets of Nişantaşı there was an old mansion where the bouncers ejected any guest or interested party whom they deemed not rich enough. And then there were the mobile services of Deluxe Şermin, whom I'd seen earlier that evening at the hotel entrance, and who a dozen years ago had been known to cruise around in her finned 1962 Plymouth, making a tour of the Park Hotel, the Divan, and Taksim, stopping occasionally for her two or three girls to be claimed. If you phoned ahead, she would even do "home deliveries." My friends' wistful tones suggested that they had found far greater satisfaction in these

places, and with these girls, than they ever could in the company of "good" girls atremble with worries about their honor and virginity.

I couldn't see Füsun at her table, but her mother and father were still sitting there. I ordered another *rakı* and asked Mehmet about the newest establishments. Tayfun boasted that he had all the most up-to-date information on the newest and most luxurious brothels, and then, as if to prove the point, he presented me with a malicious recitation of famous deputies caught during vice raids, married acquaintances who once spotted in the waiting room would gaze abruptly out the window to avoid his eye, and generals well known for their presidential aspirations who had died of heart attacks in the arms of twenty-year-old Circassian girls in beds overlooking the Bosphorus, though the official story would have them dying in bed beside their wives. As a soft, sweet, melody laden with memories played in the background, I could see that Mehmet balked at Tayfun's venom. I changed the subject, reminding him that Nurcihan had come back to Turkey to marry, adding that she had even told Sibel she liked him.

"She's dancing with Zaim the Sodaman," said Mehmet.

"Only to make you jealous," I said, without once looking at the couple on the dance floor.

After a few moments of coyness, Mehmet admitted that he had found Nurcihan attractive, and that if she "really was serious" then of course he would be glad to sit next to her and whisper sweet nothings, and that if everything worked out, he would be grateful to me for life.

"Then why didn't you treat her well from the very beginning?"

"I don't know, I just couldn't."

"Come on, let's go back to the table, before someone takes your place."

Heading to the table, stopping en route to embrace many guests, I was glancing at the dance floor, scanning it for Nurcihan and Zaim, when I saw Füsun dancing . . . with Satsat's young and handsome new clerk Kenan. . . . Their bodies were far too close. . . . An ache spread through my stomach as I returned to my seat.

"What happened?" asked Sibel. "No matter, it's not going to happen with Nurcihan, she's just mad about Zaim. Just look at the way they're dancing. Oh, don't look so sad. I'm sure you did your best."

"You've got it wrong. Mehmet's willing."

"Then why are you looking so grim?"

"I'm not."

"My darling, it's very clear that the joy has gone out of you," said Sibel with a smile. "It's about time you stopped drinking."

The orchestra going without pause from one number to the next was now playing a slower, more soulful tune. At the table there was a silence, a very long one, and I could feel jealousy's venom mixing with my blood. But I did not wish to acknowledge this. Neither Mehmet nor I was looking at the dance floor, but I could tell from the looks on people's faces that the change in tempo had pushed couples there closer together, to the pleasure of some at the table and the annoyance of others. My brother was talking, and after so many years I can't remember a thing he said, but I do remember trying to pay close attention. Just then the orchestra began to play a number even more syrupy and romantic than the one before, and now even Berrin and Sibel, oblivious a moment ago, were registering reactions to the sight of the dancing couples as they wrapped their arms around each other even tighter. My heart and mind were in utter disarray.

"What were you saying?" I asked Sibel.

"What? I wasn't saying anything. Are you all right?"

"Shall we send the Silver Leaves a note, requesting a short break?"

"Why? Oh, for goodness' sake, let the guests dance," said Sibel. "Look, even the shy ones are dancing with the girls they've had their eyes on all evening. Believe me, half of them will end up marrying these same girls."

I did not look. Neither did I let my eyes meet Mehmet's.

"Look, here they come," said Sibel.

For a moment I thought it was Füsun approaching with Kenan, and my heart began to race. But it was Nurcihan and Zaim who were returning to the table. My heart was still beating madly. I jumped up and took Zaim by the arm.

"Come, let me introduce you to a special drink at the bar," I said, and I took him over there. As we made our way through the crowd, again through a gauntlet of hugs and kisses, Zaim exchanged a few pleasantries with two girls who'd shown interest in him. Seeing how hopelessly one of them gazed at him (she had long black hair and the

Ottoman hooked nose) I remembered hearing gossip about her falling desperately in love a few summers earlier, and attempting suicide.

"All the girls adore you," I said when we sat down. "What's your secret?"

"Believe me, I don't do anything special."

"Did nothing special happen even with the German model?"

Zaim flashed a coy, cool smile. "I'm not at all happy about my reputation," he said. "If I ever found someone as wonderful as Sibel, I'd really want to get married, too. I have to congratulate you—I mean it. Sibel is a fabulous girl. And I can see in your eyes how happy you are."

"Actually I'm not so happy right now. This is what I wanted to talk to you about. I need some help."

"I'd do anything for you, you know that," he said, looking deep into my eyes. "Trust me, and tell me right away."

As the bartender was preparing our *rakı*s, I looked over at the dance floor. Had Füsun, swaying with the sentimental swill, let her head fall onto Kenan's shoulder? That part of the floor was too dark for me to see, and every attempt to catch sight of her refreshed my pain.

"There's a girl who's a distant relation of my mother's," I said. "Her name's Füsun."

"The one who was in the beauty contest? She's dancing over there."

"How do you know?"

"She's too beautiful," said Zaim. "I see her whenever I walk past that boutique in Nişantaşı. Like everyone else, I slow down when I'm passing and look inside. She has the sort of beauty you just can't get out of your head. Everyone knows who she is."

Worrying that Zaim might now say something that would make it awkward for both of us, I said, "She's my lover." I saw a ripple of jealousy cross my friend's face. "Just to see her dancing with someone else causes me pain right now. I might even say I am madly in love with her. I'm trying to think of a way out. I wouldn't want something like this to go on for too long."

"Yes, the girl is wonderful, but the situation couldn't be worse," said Zaim. "And you're right, you can't let something like this go on for too long."

I didn't ask him why. Nor did I ask myself whether it was in fact jeal-

ousy or contempt I saw in my friend's face. But it was clear that I couldn't tell him right away what I wanted him to do. I felt a need to tell him first about the depth and sincerity of this thing between Füsun and me; I wanted him to respect it. But as I began to reveal how I felt for Füsun, it was clear to me that my drunkenness would allow me to express only the most ordinary parts of the story, and that if I attempted emotional candor he would think me feeble and laughable, and even, despite his own dalliances, hold it against me. I suppose that in the end what I really wanted from my friend was his recognition, not of how sincere I was, but how lucky, and how happy. So it seems all these years later, but at the time, I myself could not acknowledge these things at all, and so, while we both watched Füsun dancing, and my head was spinning with drink, I told Zaim my story. I told him that I was the first man Füsun had ever slept with, describing the bliss we had discovered making love, and of our lovers' quarrels and a string of other strange particulars that happened to pop into my head at that moment. "In short," I said, suddenly inspired, "what I want more than anything else in life right now is to hold on to this girl until I die."

"I understand."

When I perceived in him a manly sympathy, free of reproach for my selfishness or moral judgment of my happiness, I relaxed.

"What's upsetting me right now is that she's dancing with Kenan, the young clerk at Satsat. She's putting his job in jeopardy just to make me jealous. . . . Of course, I'm also worried that she'll actually fall for him. For truth be told, Kenan would be an ideal husband for her."

"I understand," said Zaim.

"In a short while I am going to invite Kenan to my father's table. What I would like you to do is to go straight over to Füsun and keep her busy, shadow her every move, like a good football defender, so that I don't die of jealousy tonight—and so that I can get to the end of this evening without succumbing to fantasies of firing Kenan. Füsun and her parents will be leaving soon, as she is taking the university entrance exam tomorrow. And anyway, this impossible love affair of ours must end very soon."

"I can't be sure your girl will take much interest in me tonight," said Zaim. "There's another matter, too."

"What?"

"I can see Sibel is trying to keep me away from Nurcihan," said Zaim. "She wants to get something going between her and Mehmet. But I think Nurcihan likes me. And I like her, a lot. So I'd like you to help me with this a little. I know Mehmet is our friend, but let us compete on a level field."

"What do you want me to do?"

"I couldn't get very far this evening, not with Sibel and Mehmet working against me, and now if I have to defend this girl of yours from the clerk, that will cut into the time I can spend with Nurcihan. So you have to make it up to me. Promise me now that you will bring Nurcihan with you to the picnic at the Meltem factory."

"I promise."

"Why does Sibel want to keep me away from Nurcihan anyway?"

"Well, you do make an impression, with your German models, and your dancers. . . . Sibel doesn't like those things. She wants to marry her friend off to someone she trusts."

"Please tell Sibel that I'm not a bad person."

"I tell her all the time," I said as I stood up. There was a silence. "I appreciate the sacrifices you're making for me," I said. "But when you are minding Füsun, be careful, don't let yourself fall for her. Because she's very sweet."

Zaim's expression, so full of understanding, liberated me from feeling shame for my jealousy. It brought me peace, if only short-lived.

Back at my parents' table I told my father, who had drunk himself into a stupor, that I wanted to introduce a very clever and industrious young clerk named Kenan, who was sitting at the Satsat table. So as not to inflame the other ambitious Satsat employees, I jotted down a note in my father's name and gave it to Mehmet Ali, a waiter who'd known us since the time the hotel had first opened, instructing him to pass it to Kenan at the next pause in the music. At that moment, my mother reached out and tried to grab my father's *rakı,* saying, "You've had enough," and in the tussle, spilled some on his tie. They were serving ice cream in glasses when the Silver Leaves took a break. In those days, we would all enjoy a cigarette before each new course. The bread crumbs, the tumblers smeared with lipstick, the stained napkins, overflowing ashtrays, lighters, dirty plates, and crumpled cigarette packets all fired painful sensations in my muddled mind that the evening's end

was fast approaching. At one point, a little boy, perhaps six or seven years old, climbed onto my lap, and Sibel seized the excuse to come over to sit beside me and play with him. The sight of this moved my mother to remark, "What a lovely way you have with him." People were still dancing. A few moments later my young, handsome, dapper clerk had joined the table and as the former foreign minister rose to his feet, a courtly Kenan told him and my father what an honor it was to meet them both. After the former foreign minister had lumbered off, I explained how Kenan Bey had given considerable thought to Satsat's potential expansion into the provinces, and that he was particularly knowledgeable about Izmir. I praised him at length so that everyone at the table could hear. My father then began to ask him the same questions he asked all the new clerks. "What foreign languages do you speak, my child? Do you read books, do you have any hobbies, are you married?" "He's not married," my mother said. "Just a moment ago he was dancing very nicely with Nesibe's daughter, Füsun." "She's blossomed into quite a beauty," said my father. "Don't let this father and son wear you down with business talk, Kenan Bey," said my mother. "You must want to get back to your friends." "Not at all, madam! The honor of meeting Mümtaz Bey—meeting all of you—is much more important." "Such a courteous, refined young man," my mother whispered, though loud enough for Kenan to hear. "Shall I invite him over one evening?"

When my mother liked or generally approved of someone, she would make sure he heard it when she discreetly told us so, because she enjoyed seeing in his embarrassment proof of her own power. My mother was smiling with this satisfaction when the Silver Leaves resumed with a very slow, sentimental number. I saw Zaim escort Füsun to the dance floor. "Let's talk about Satsat's chances in the provinces now, while my father is here, too," I said. "My son, are you telling me that you are going to talk business now, at your own engagement party?" "Madam," said Kenan to my mother, "you may not be aware of this, but three or four times a week, when everyone else has gone home, your son stays very late and carries on working." "Sometimes Kenan and I work late together," I added. "Yes. Kemal Bey and I enjoy our work," said Kenan. "Sometimes when it's very late we make up expressions that rhyme with the names of the people who owe us money." "That's fine," said my father. "But what do you do with the

bounced checks?" "I would like for us to meet the distributors to discuss this, Father," I said.

As the orchestra played one slow dance after another, our talk ranged from possible innovations at Satsat, to the places of entertainment that my father had frequented in Beyoğlu when he was Kenan's age, to the methods adopted by İzak Bey (my father's first accountant), to whose table we now turned, raising our glasses in what must have seemed to the accountant a puzzling tribute, after which we went on to contemplate what my father hailed as the beauties of youth and of this evening, and, he added in jest, of "love." Despite my father's pressing the matter, Kenan would not be made to admit whether or not he was in love. This did not stop my mother from grilling him about his family, and upon learning that his father was employed by the city council and had for years worked as a streetcar driver, she said with a sigh, "Oh how beautiful they were, those old streetcars!"

More than half the guests had left by now. My father was having a hard time keeping his eyes open.

As my mother and father kissed us each on our cheeks, preparing to take their leave, my mother said, "Don't you stay out too late either, my son," looking into Sibel's eyes, not mine.

Kenan wanted to return to his friends at the Satsat table, but I wouldn't let him go. "Let's find my brother and discuss this shop we might open in Izmir," I said. "It's not often that the three of us are together in one place."

I took it upon myself to introduce Kenan to my brother, and my brother (who had known him for some time) raised an eyebrow in disdain, declaring that I must be seriously drunk. Then he looked at Berrin and Sibel, nodding in the direction of the glass in my hand. Yes, I had downed two glasses of *rakı* at around that time, one after the other, because every time I caught a glance of Zaim dancing with Füsun, the *rakı* was my only relief from a ridiculous jealousy. As my brother talked to Kenan about the logistics of collecting on overdue accounts, everyone at our table, including Kenan, watched Zaim dancing with Füsun. Even Nurcihan, who had her back to them, sensed that Zaim had taken an interest in someone else and she was becoming uneasy. At one point I said to myself, "I am happy." As drunk as I was, I still felt as if everything was going to go my way. On Kenan's face I recognized an all too

familiar species of disquiet, and so I took this long, slender glass (see exhibit) and poured a consoling *rakı* for my ambitious greenhorn friend, who, on account of his bosses having taken a sudden interest in him, had lost the girl he'd been holding in his arms only a few minutes before. At that moment, Mehmet finally asked Nurcihan to dance, and Sibel turned to give me a conspiratorial wink, adding sweetly, "You've had enough, darling. Don't have any more."

Charmed by her solicitude, I took Sibel to the dance floor, and the moment we got there I knew I had made a mistake. The Silver Leaves were playing "A Memory from That Summer," which called to mind the previous summer, when Sibel and I had been so happy, and as the music evoked these memories with arresting force—just as I hope the exhibits in my museum are doing—Sibel embraced me as if for the first time. How I wanted in return to embrace with the same ardor my fiancée, the one with whom I was to share the rest of my life. But I could think only of Füsun. Because I was trying to catch a glimpse of her in the crowd, because I did not want her to see me in a warm embrace with Sibel, I held myself back. I let the other couples distract me. They smiled at me affectionately, as people will at seeing a groom a little worse for wear at the end of his engagement party.

At one point we came shoulder to shoulder with the best-loved columnist of that era dancing with an attractive dark-haired woman: "Celâl Bey, love has nothing in common with a newspaper column, does it?" I said. When Mehmet and Nurcihan came alongside us, I treated them as if they'd been lovers for ages. I slurred an attempt at a quip in French to Zümrüt Hanım, who spoke French whenever she visited my mother, even when there was no one around, supposedly to keep the servants from understanding her. By now Sibel had given up on having a dance she would remember forever, and was whispering into my ear, telling me how sweet I was when I was drunk, apologizing for having forced me into matchmaking, which she'd done, she insisted, only to make our friends happy, and alerting me that the fickle Zaim had moved on from Nurcihan and set his sights on that girl who was my distant relation. Frowning, I told her that Zaim was a very good person, and a trusted friend. I added that Zaim had wanted to know why she was treating him so badly.

"So you were talking about me with Zaim? What did he say?" said

Sibel. During the break between songs, we came alongside Celâl Salik the columnist again. "I've worked out something love has in common with a good newspaper column, Kemal Bey," he said. "What is it?" I asked. "Love, like a newspaper column, has to make us happy *now*. We judge the beauty and power of each by how deep an impression it makes on the soul." "Master, please write that up in your column one day," I said, but he was listening not to me but to his raven-haired dance partner. At that moment I noticed Füsun and Zaim beside us. Füsun had placed her head very close to his neck and was whispering to him, and Zaim was smiling gaily. It seemed to me that they could see us perfectly well, but were pretending not to notice as they spun around the dance floor.

Without losing a beat I maneuvered Sibel in their direction and then, like a pirate ship pursuing a merchant galleon, I caused us to ram Füsun and Zaim from the side.

"Oh, excuse us," I said with a silly laugh. "How are you?" The confused joy on Füsun's face brought me back to my senses and at once I spied in my drunkenness a good excuse for bold action. I turned to Zaim, proferring Sibel's hand. "May I offer you the honor of this dance?" Zaim took his hand off Füsun's waist. "You two are going to have to get to know each other better," I said, "and you might as well start now." Completing my gesture of self-sacrifice, I put my hands on their backs and pushed them together. As Sibel and Zaim began to dance, with obvious reluctance, Füsun and I looked for a moment into each other's eyes. Then I put my hand on her waist and with a few gentle turns, moved her as far away as I could, like any elated suitor preparing to abscond with his sweetheart.

How to describe the peace that came over me the moment I took her in my arms? The noise of the crowd that had so addled me, the ungodly racket that I had taken to be the aggregate of the silverware, the orchestra, and the roar of the city—now I knew what I'd heard was only my disquiet at being far from her. Like a baby who will stop crying only in the arms of one particular person, I felt a deep, soft, velvety bliss of silence spreading through me. From her expression I could see that Füsun felt the same; taking the enveloping silence as our mutual recognition of shared enchantment, I wished that the dance would never end. But soon I realized that her half of the silence meant some-

thing altogether different from mine. Füsun's silence harked back to the question I had brushed off earlier as a joke ("What will become of us?"), and now I had to give an answer. I decided that this was what she had come for. The interest that men had shown her this evening, the admiration that I'd seen even in the eyes of the children—all this had given her confidence, had lightened her suffering. Now she might even be able to view me in perspective, as a "passing fancy." As I began, in my drunkenness, to realize that the night was coming to an end, I was seized by the terrifying thought of losing Füsun.

"When two people love each other as we do, no one can come between them, no one," I said, amazed at the words I was uttering without preparation. "Lovers like us, because they know that nothing can destroy their love, even on the worst days, even when they are heedlessly hurting each other in the cruelest, most deceitful ways, still carry in their hearts a consolation that never abandons them. Trust me that after tonight I'll stop all this, I'll sort this out. Are you listening to me?"

"I'm listening."

When I was sure that no one dancing nearby was looking at us, I said, "We met at an unfortunate time. In the early days neither of us could have known how rare this love was between us. But now I am going to put everything right. Our most immediate concern is your exam tomorrow. This evening you shouldn't waste any more time worrying about us."

"Then tell me, what is going to happen now?"

"Tomorrow, as always" (for a moment, my voice trembled) "at two o'clock, after you've finished your exam, let's meet at the Merhamet Apartments. Then I'll be able to tell you what I plan to do next, without having to rush. If I fail to win your trust, then you never have to see me again."

"No, tell me now, and I'll come."

How sweet it was to imagine in my drunken stupor that she would come to me at two o'clock the next day, that we would make love as always, that we would remain together until the end of my days, and as I touched her wondrous shoulders and her honey-colored arms, I resolved that I would do everything I could, whatever it took.

"No one will ever come between us ever again," I said.

"All right then, I'll come tomorrow after the exam, and you, God

willing, won't have gone back on your word, and you'll tell me how you're going to do this."

While we both remained standing, perfectly straight, with my hand lovingly clamped on her hip, and in time to the music, I tried to tug her closer to me. She resisted, refusing to lean into me, and that excited me all the more. But when it became apparent that my attempt to wrap my arms around her in front of everyone was being viewed not as a sign of love but proof of my drunkenness, I pulled myself together and relented.

"We have to sit down," she said. "I feel as if everyone is looking at me." She was leaving my arms. "Go right home and get some sleep," I whispered. "During the exam, just think about how much I love you."

When I got back to our table there was no one there except for Berrin and Osman, both frowning and bickering with each other. "Are you all right?" said Berrin.

"Perfectly fine," I said, gazing upon the disordered table and the empty chairs.

"Sibel didn't want to dance anymore, and Kenan Bey took her with him to the Satsat table, where they were playing some sort of game."

"It's good that you danced with Füsun," said Osman. "In the end, it was wrong for our mother to give her the cold shoulder. It's important for Füsun and everyone else to know that the family takes an interest in her, that the nonsense with the beauty contest is forgotten, and she can depend on us. I worry for the girl. *She thinks she is too beautiful,*" he said in English. "That dress is too revealing. In six months she's gone from being a child to a woman; she's really bloomed. If she doesn't marry the right sort of man very soon, first she'll get a reputation and that can lead only to misery. What was she telling you?"

"Apparently she is taking her university entrance exam tomorrow."

"And she's still here dancing? It's after midnight." He watched her walk toward her table. "I really did like your Kenan, by the way. I say she should marry *him.*"

"Shall I tell them both?" I shouted, having moved away from him already. I had been doing this since childhood. Whenever my brother began to speak, I would do the opposite of what he asked, and retreat to the most remote corner, ignoring the fact that he was still talking.

In later years I would often reflect on my bliss and joy at that point

in the evening, on my way from our table to the tables in the back where the Satsat employees, Füsun, and her parents were sitting. I had just put everything right, and in thirteen hours and forty-five minutes I would meet Füsun at the Merhamet Apartments. A brilliant future beckoned, and the promise of happiness sparkled like the Bosphorus at our feet. Even as I laughed with the lovely girls now weary of dancing, their dresses in charming (and revealing) disarray, and I joked with the last of the guests, and old friends, and affectionate aunties I'd known for thirty years, a voice inside me warned that if I continued on this path, I'd end up marrying not Sibel but Füsun.

Sibel had joined the untidy Satsat table, where they were holding a mock séance, really just a drunken game based on no particular knowledge of spiritualism. When they were unable to summon any spirits, the group began to disperse. Sibel moved over to the next table, which was empty except for Kenan and Füsun, with whom she immediately struck up a conversation before I could join them. Seeing me approaching, Kenan asked Füsun to dance. Füsun, having seen me, turned him down, saying that her shoes were pinching her toes, and with youthful pride Kenan responded as if the point of it were not Füsun but the dance, and went off as the Silver Leaves played one of the evening's fast numbers to do the latest step with someone else. So now, at the edge of the Satsat table, by now almost empty, a chair awaited me between Füsun and Sibel. So I went and sat down between Füsun and Sibel. How I wish someone had taken a photograph of us that I might have now displayed!

I sat down to discover with contentment that Füsun and Sibel were discussing spiritualism like two Nişantaşı ladies who had been acquainted for years but still maintained a social distance, their language markedly formal, almost ceremonial. Füsun, whom I'd assumed had little religious education, declared that souls certainly existed, "as our religion decrees," but that for us in this world to attempt communication with them was a sin. Here she glanced at her father at the next table. This idea had come from him.

"Three years ago I disobeyed my father and went with some classmates to a séance—just out of curiosity," said Füsun. "I was asked for a name and I remembered a childhood friend who was very dear to me, though I'd lost touch with him, and without pausing to think, I wrote

his name down, just to play along. . . . But this name I'd written down, without really believing, just for the fun of it—well, his spirit did come and I felt *so* guilty."

"Why?"

"I could tell from the way the coffee cup was rattling that my lost friend Necdet was in enormous pain. It was rattling as if it had a life of its own, and I felt that Necdet must be trying to tell me something. Then suddenly the coffee cup went still. . . . Everyone said that this person must have died at that very moment. . . . How could they have known?"

"How *did* they know?" asked Sibel.

"That same night I was at home and looking through my drawers for a missing glove, and I found a handkerchief that Necdet had given me as a present many years before. Maybe it was a coincidence. But I don't think so. I learned a lesson from this. When we lose people we love, we should never disturb their souls, whether living or dead. Instead, we should find consolation in an object that reminds us of them, something . . . I don't know . . . even an earring."

"Füsun, darling, time to go home," said Aunt Nesibe. "You have your exam tomorrow morning, and your father can barely stay awake."

"Just a minute, Mother!" said Füsun in a firm voice.

"I don't believe in séances, either," said Sibel. "But if I'm invited to one, I never pass it up, because I like watching the games people play, and seeing what they fear."

"But if you love someone, and you miss them terribly, which would you do?" asked Füsun. "Would you gather up your friends and try to summon his spirit, or would you look for some old possession of his, like a cigarette box?"

As Sibel groped for a polite answer, Füsun shot up out of her seat and, reaching over to the next table, picked up a handbag, which she placed in front of us. "This handbag reminds me of my embarrassment . . . my shame for having sold you a fake," she said.

When it was on Füsun's arm earlier I had not recognized it as "that" bag. But hadn't I bought it in the Şanzelize Boutique from Şenay Hanım, shortly before the happiest moment in my life, and, after having run into Füsun in the street, hadn't I taken it back with us to the Merhamet Apartments? Just yesterday that talismanic Jenny Colon bag

was still there. How could it be here now? I was like some spectator dumbfounded by a juggler's trick, and my head was spinning.

"It looks very good on you," said Sibel awkwardly. "So lovely with the orange, and your hat, that when I first saw it I felt jealous. I was sorry I'd returned it to you. How beautiful you are!"

It occurred to me that Şenay Hanım must have had more than one fake Jenny Colon bag in stock. Having sold one to me, she might have put another in the window, and even lent a third to Füsun for this evening.

"After you realized that the bag was a fake, you stopped coming to the Şanzelize," said Füsun, smiling graciously at Sibel. "This upset me, because of course you were right." Opening the bag, she showed us the inside. "Our craftsmen make excellent fakes of European products, bless them, but never enough to fool someone with your experienced eye. But now I must say something." She swallowed and fell silent, and I feared she was going to cry. But she pulled herself together, and with a frown she recited the speech that she must have rehearsed at home. "For me, it's not in the least important whether something is or isn't a European product. And it's not in the least important to me either if a thing is genuine or fake. If you ask me, people's dislike of imitations has nothing to do with fake or real, but the fear that others might think they'd 'bought it cheap.' For me, the worst thing is when people care about the brand and not the thing itself. You know how there are some people who don't give importance to their own feelings, and care only about what other people might say"—here she glanced in my direction. "This handbag will always remind me of tonight. I congratulate you. It's been an evening I'll never forget." She rose to her feet, and as she squeezed our hands, my darling girl kissed us each on the cheek. As she turned to leave, she noticed Zaim approaching the next table and she turned back to Sibel. "Zaim Bey is a very good friend of your fiancé, isn't he?" she asked.

"Yes, they're very close," said Sibel. As Füsun took her father's arm, Sibel turned to me and asked, "What did she mean by that question?" but there was no contempt for Füsun in her expression. I saw instead something akin to excitement, even adoration.

As Füsun headed slowly for the stairs, flanked by her mother and father, I watched her from behind with love and pride.

Zaim came and sat down beside me. "You know, at that Satsat table behind us, they've been having quite a laugh at your expense all evening," he said. "As your friend, I thought you should know."

"You must be joking! What exactly could they be laughing about?"

"Well, I didn't hear it directly, of course. Kenan told Füsun. And she told me. . . . And she was quite upset, too. Apparently it's general knowledge at Satsat that every night at quitting time, you and Sibel would meet there for a romp on the divan in the corner office. This is what all the snickering was about."

"What's happened now?" asked Sibel as she came back to us. "You're depressed again, aren't you?"

25

The Agony of Waiting

I DID NOT sleep at all that night. In fact, Sibel and I had been meeting at Satsat only rarely, but this was hardly an extenuating circumstance in the indictment I feared would cost me Füsun. Toward dawn I dozed off briefly. The moment I woke up I shaved and went for a walk. I took the long way back, passing in front of the Technical University's 115-year-old Taşkışla Building, where Füsun was taking her exam. Around the door, through which Ottoman soldiers sporting fezzes and pointed mustaches had once passed on their way to drill, mothers in head-scarves and chain-smoking fathers sat in rows waiting for their children. Some were reading newspapers; others were chatting or looking blankly up at the sky. I could not see Aunt Nesibe among them. Between the windows in the stone facade, sixty-six years on, you could still see the bullet holes left by the Action Army upon the deposition of Sultan Abdülhamit. Fixing my eyes on one of those high windows, I said a prayer, asking God to help Füsun answer the questions, and to send her skipping joyously back to me when the exam was over.

But Füsun did not come to the Merhamet Apartments that day. I told myself her anger would pass. As the strong June sun filtered

through the curtains and the room grew steadily hotter, I waited two hours past our usual meeting time. It hurt to look at the empty bed, so I went out for another walk. As I walked through the park, past soldiers idly killing time and children feeding the pigeons under the gaze of their families, and people reading their newspapers on the benches at the edge of the sea or watching the ships go by, I tried to convince myself that Füsun would come at the usual time the next day. But she did not come the next day, or the four days that followed.

Every day I went to the Merhamet Apartments at the customary hour, to begin my wait. Having realized that getting there early only aggravated my pain, I resolved not to arrive before five minutes to two. I would go into the apartment trembling with impatience, and during the first ten or fifteen minutes hopeful anticipation would ease the pain, an excitement wreathing my head down to the tip of my nose even as my heart ached and my stomach cramped. From time to time I would part the curtains to look down at the street and inspect the rust on the lamppost in front of the entrance, and then I'd tidy the room a bit. I would listen to footsteps passing one floor below, and from time to time I would hear high heels clicking past in that decisive way of hers. But they would continue on without slowing down, and I would realize with pain that the woman who had entered the building, lightly shutting the door behind her in such a familiar way, was in fact someone else.

I have here the clock, and these matchsticks and matchbooks, because the display suggests how I spent the slow ten or fifteen minutes it took me to accept that Füsun was not coming that day. As I paced the rooms, glancing out the windows, stopping in my tracks from time to time, standing motionless, I would listen to the pain sluicing within me. As the clocks in the apartment ticked away, my mind would fixate on the seconds and the minutes to distract itself from the agony. As the appointed hour neared, the sentiment "Today, yes, she's coming, now" would bloom inside me, unbidden, like spring flowers. At such moments I wanted time to flow faster so that I could be reunited with my lovely at once. But those minutes would never pass. For a moment, in a fit of great clarity, I would understand that I was fooling myself, that I did not want the time to flow at all, because Füsun might never come. By two o'clock I was never sure whether to

be happy that the hour had arrived, or sad that with every passing minute her arrival was less likely, and the distance between me and my beloved would grow as that between a passenger on a ship leaving port and the one he had left behind. So I would try to convince myself that not so very many minutes had passed, toward this end I would make little bundles of time in my head. Instead of feeling the pain every second of every minute, I resolved to feel it only once every five! In this way I would take the pain of five discrete minutes and suffer it all in the last. But this too was for naught when I could no longer deny that the first five minutes had passed—when I was forced to accept that she was not coming, the forestalled pain would sink into me like a driven nail. In the subsequent desperation I would repeat the exercise, struggling to tell myself that Füsun had often been ten or fifteen minutes late for our meetings, an assertion I was not really sure of, but which allowed me a respite at least for four-fifths of the next five-minute bundle, and hope would return, as I dreamed that in a moment's time she would ring the bell, that in just a moment she would be there with me, as suddenly as the second time we met. I would imagine what I'd do when she rang the bell—whether I would be angry at her for not having come for so many days, or whether I would forgive her on sight. These fleeting dreams would mix with memories when my eyes lit upon this teacup, from which Füsun drank during our first encounter, or upon this little old vase that she picked up for no reason while impatiently pacing the apartment. After fending off the ever more hopeless awareness that the fourth and fifth five-minute bundles had come and gone, my reason would force me to accept that on that day Füsun would not be coming, and at that moment the agony inside was such that I could do nothing but throw myself like an invalid onto the bed.

26

An Anatomical Chart of Love Pains

THIS DEPICTION of the internal organs of the human body is taken from an advertisement for Paradison, a painkiller on display in the window of every pharmacy in Istanbul at the time, and I use it here to illustrate to the museum visitor where the agony of love first appeared, where it became most pronounced, and how far it spread. Let me explain to readers without access to our museum that the deepest pain was initially felt in the upper left-hand quadrant of my stomach. As the pain increased, it would, as the overlay indicates, radiate to the cavity between my lungs and my stomach. At that point its abdominal presence would no longer be confined to the left side, having spread to the right, feeling rather as if a hot poker or a screwdriver were twisting into me. It was as if first my stomach and then my entire abdomen were filling up with acid, as if sticky, red-hot little starfish were attaching themselves to my organs. As the pain grew more pervasive and intense, I would feel it climb into my forehead, over the back of my neck, my shoulders, my entire body, even invading my dreams to take a smothering hold of me. Sometimes, as diagrammed, a star of pain would form, centered on my navel, shooting shafts of acid to my throat, and my mouth, and I feared it would throttle me. If I hit the wall with my hand, or did a few calisthenics, or otherwise pushed myself as an athlete does, I could briefly block the pain, but at its most muted I could still feel it like an intravenous drip entering my bloodstream, and it was always there in my stomach; that was its epicenter.

Despite all its tangible manifestations, I knew that the pain emanated from my mind, from my soul, but even so I could not bring myself to cleanse my mind and deliver myself from it. Inexperienced in such feeling, I was, like a proud young officer ambushed in his first command, forced into a mental rout. And it only made matters worse that I had hope—with every new day, new dreams, new reasons that

Füsun might appear at the Merhamet Apartments—which by making the agony bearable prolonged it.

In my more lucid moments, I would think that she was scorning me, punishing me, not just for the engagement but for hiding from her my trysts with Sibel at the office, for letting my jealousy get the better of me at the engagement party and playing tricks to keep her away from Kenan, and also, of course, for failing to solve the mystery of the earring. But I also felt, most powerfully, that her denial of the unparalleled happiness we had shared was no less a punishment for her than for me, and that, like me, she would not be able to bear it for long. For I had to endure the pain, face the torment stoically, so that when we met, she might yet feel compelled to acknowledge my suffering. But all such calculation was overshadowed by remorse—having recklessly invited her to the party, and having failed to recover the missing earring or to teach her mathematics properly, or to return her childhood tricycle to her house, and attend the promised supper with her family. The pain of regret was shorter and more contained; it would make itself felt in the back of my legs and in my lungs (see diagram), mysteriously sapping my strength. But it was no less debilitating, leaving me barely able to stay on my feet, longing to collapse onto a bed.

Sometimes I wondered whether this was all happening because her entrance exam had gone badly. Afterward in my guilty dreams I would give her long, exacting math lessons; my pain would abate, especially when the math lessons were over and we would make love. But the dream would end abruptly when I remembered that she had broken the promise made while we danced at the engagement party—to come to me as soon as the exam was over—and when I recalled that she had not even furnished me with an excuse, I would begin to feel angry at her, my resentment fed, too, by her lesser crimes—trying to make me jealous at the party, listening while the Satsat employees joked at my expense. These grievances I would use to distance myself from her, thus answering with my silence her desire to punish me.

By half past two Friday afternoon, and with that day's recognition that she wasn't coming despite my every petty resentment, conjured hope, and self-deceiving trick, I collapsed in defeat. The pain had now become fatal, eating me up like a wild beast without pity for its prey. I

lay like a corpse on the bed, inhaling her fleeting scent on the sheets, remembering how happily we'd made love there, only six days earlier, asking myself how I would live without her, even as jealousy irresistibly mixed with the anger. I imagined Füsun wasting no time taking a new lover. This shameful and debilitating fantasy had come into my head at other times, too, but now I was unable to fend it off, imagining as my rival Kenan, or Turgay Bey, or any number of other admirers, even Zaim, whoever fetched up first. A woman like her, who had taken such pleasure from lovemaking, would certainly not refrain now from seeking the same pleasure with others, particularly with her anger toward me driving her to revenge. Though in one part of my mind I could see these feelings for what they were, I surrendered, nevertheless, allowing this degrading dream to engulf me. Resolving that desire and anger would drive me mad, I rushed out of the apartment and made straight for the Şanzelize Boutique.

I remember my heart pounding with hopeless hope as I raced down Teşvikiye Avenue. Fueled by the certitude that seeing her would restore me, I gave no thought to what I might say. The moment I saw her, my pain would disappear, at least for a time—this I knew. She had to hear me out; there were things I had to say. This wasn't what we'd agreed at the dance—we were to have gone to a patisserie to talk.

The little bell on the door of the Şanzelize Boutique rang and my heart seized up. The canary was gone. I had already worked out that Füsun was not there either, but out of fear and helplessness I tried to convince myself that she was hiding in the back room.

"Kemal Bey, welcome," Şenay Hanım said with a diabolical smile.

"I'd like to take a look at that white embroidered evening bag in the window," I whispered.

"Oh, yes, that's a very nice piece indeed," she said. "You're very discerning. Whenever something beautiful comes to the shop, you're the first to see it, and you snap it up. This just came in from Paris. Note the precious stone in its clip. There's a change purse inside, and a mirror, all made by hand, of course." As she lumbered over to the window to extract the bag, she carried on exaggerating its finer points.

I glanced through the curtains into the back room. Füsun was not there. When the woman brought me this elegant floral bag, I pretended to examine it carefully and accepted without question the exorbitant

price quoted. As the witch was wrapping it up, she spent a very long time telling me how impressed everyone had been by the engagement party. Just to keep the transaction going, I told her to wrap up a pair of cuff links that I happened to notice. Emboldened by the pleasure I saw on her face, I asked, "So what's become of that relation of ours? Hasn't she come in today?"

"Oh dear, didn't you know? Füsun quit suddenly."

"Is that so?"

She'd guessed at once that I'd come looking for Füsun, and deduced from this that we were no longer seeing each other, and now she was eyeing me closely, trying to figure out what had happened.

I managed to contain myself, asking her nothing. Despite my pain, I reached calmly into my pocket, to hide the fact that I was not wearing my engagement ring. As I paid her I noticed her looking at me with a certain compassion: It was as if, having both lost Füsun, we had been drawn closer together. And yet I could not help casting a further incredulous glance in the direction of the back room.

"This is what it's like these days," the woman said. "Today's young people aren't interested in earning their money. They want it all the easy way." It was that last sentiment that hurt in particular.

I managed to hide all this from Sibel. My fiancée registered and was affected by my every expression, my every new gesture, and yet, during the first days following our engagement, she asked me nothing, but on the third day, at supper, when I was twisting with evident discomfort, she remarked, with the sweetest of expressions, that I was knocking back drinks rather quickly, and she asked, "What's going on, darling?" I said that problems at work with my brother were getting the better of me. The following Friday night—with one shaft of pain shooting up from my stomach, and its mate shooting down in the opposite direction, from the nape of my neck into my legs, as I wondered what Füsun might be doing—Sibel repeated her question. I managed to invent a whole skein of details to give credible life to this story about the argument with my brother. (With such symmetry as only God can fashion, these inventions would come true many years later.) "Never mind," said Sibel with a smile. "Shall I tell you what tricks Mehmet and Zaim are hatching to get close to Nurcihan at the picnic this Sunday?"

27

Don't Lean Back That Way, You Might Fall

TO REFLECT the synthesis of traditional pleasures and inspirations drawn from French home and garden magazines favored by Sibel and Nurcihan, the picnic basket displayed here—the thermos filled with tea, stuffed grape leaves in a plastic box, boiled eggs, some Meltem bottles, and this elegant tablecloth passed down to Zaim from his grandmother—evokes our Sunday excursion that may offer the visitor some relief from the oppressive succession of interior settings, as well as my own agony. But neither the reader nor the visitor should on any account think that I could forget my pain even for an instant.

That Sunday morning we went first to the Bosphorus, to the Meltem factory in Büyükdere. On the sides of its buildings were giant pictures of Inge next to leftist slogans that had been painted over. Even as we toured the sterilizing and bottling lines, where silent women wearing headscarves and blue aprons worked under the direction of loud, cheerful supervisors (there were only sixty-four employees in all, despite the countless advertisements Meltem had plastered all over the city), and even as I expressed my distaste for the modish belts, blue jeans, and leather boots that the others in our party had chosen to wear that day—accoutrements that were, like their easy and open demeanor, overly European—I had to muffle my mournful beating heart, pitifully crying, Füsun, Füsun, Füsun.

We piled into two cars and moved on to Belgrade Forest, to a green field overlooking Bentler and offering much the same view as this one painted 170 years ago by the European artist Melling, and here we spread out a *déjeuner sur l'herbe*. I remember lying down on the grass toward noon and gazing up at the bright blue sky. Sibel and Zaim were busy trying to set up an old swing from the Persian gardens with new ropes, and I remember how struck I was by her grace and beauty. At

one point I played the children's game Nine Stones with Nurcihan and Mehmet. As I inhaled the sweet smell of grass and the cool breeze coming from the lake behind Bentler, redolent of pine and roses, I thought that the wondrous life before me was a gift from God, thought how all this beauty had been bequeathed to me unconditionally; how colossally stupid—and perhaps sinful—it was to let it be poisoned by these pangs spreading from my stomach to every part of my body. I still felt shamed that the pain of not seeing Füsun had reduced me to this, and that with my self-confidence undermined, I succumbed to jealousy. As Mehmet, managing to keep immaculate the white shirt and tie he wore with trousers and suspenders, set out the food, and Zaim went off with Nurcihan, supposedly to pick blackberries, I realized that I was happy he was here because it meant he could not be meeting with Füsun. But I could not further assume that Füsun was not with Kenan or someone else. Chatting with my friends, playing ball, watching Sibel swing like a child, even slashing my ring finger as I struggled with a new kind of can opener—at intense moments of this order I was distracted from my pain. I could not stanch the flow from my finger. Was this because love had poisoned my blood? At one point I sat on the swing and began to propel myself with all my strength. When the swing came down so fast it seemed to be in free fall, the pain in my stomach abated slightly. As the ropes creaked, and I described a great arc in the air, throwing my head way back, so that I was almost upside down, my pain almost gave way to true relief.

"Kemal, are you crazy? Stop, don't lean back that way. You might fall!" cried Sibel.

In the noon sun it was hot even in the shade of the trees. I told Sibel that I couldn't stop my finger from bleeding, and that, feeling unwell, I wanted to go to the American Hospital for a few stitches. She was shocked. She opened her eyes wide. Couldn't I wait until evening? She bound my finger tight. I will confess to my readers that I secretly dug into the cut, to exacerbate the flow. "No," I said. "Don't let me ruin this lovely picnic, and, darling, it would cause offense if we both left. You can get a ride back to the city with the others in the evening." As she walked me back to the car, I again saw that shaming question in my lovely fiancée's wise and clouded eyes. "What is wrong with you?" she asked, sensing that my ailment was more serious than the flow of

blood. How I longed to throw my arms around her at the moment, to master my pain, and throw off my obsession, or at the very least, to tell her how I felt! Instead I jumped into the car, swaying like an idiot, panicked by the pounding of my heart, without pausing even to whisper a few sweet nothings to Sibel. Nurcihan and Zaim were still off picking blackberries, but, sensing that something was wrong, they began to walk toward us. If I had to look Zaim in the eye, I was sure he would guess at once where I was going. But I shall not dwell on the expression of genuine concern and sorrow on my fiancée's face as I started up the car—lest readers judge me as heartless.

I drove like a madman through that bright, warm summer afternoon, reaching Nişantaşı in forty-seven minutes flat, all because the moment I put my foot on the accelerator, my heart told me that today, at last, Füsun would come to the Merhamet Apartments. Wouldn't she have waited a few days before making her first visit? Parking the car just fourteen minutes before two o'clock (I'd cut my finger not a moment too soon), I was racing to the Merhamet Apartments when I was stopped in my tracks by a middle-aged woman screeching my name.

"Kemal Bey, Kemal Bey, you are a very lucky man!"

I turned around, saying "What?" as I struggled to remember who she was.

"At your engagement party, you came to our table and we made a bet about the last episode of *The Fugitive* . . . remember? You were right, Kemal Bey! In the end, Dr. Kimble managed to prove his innocence!"

"Oh really?"

"When are you going to collect your winnings?"

"Later," I said, running down the street.

Of course I'd decided that Dr. Kimble's happy ending was a good omen: Today Füsun would come. Joyfully believing that in ten or fifteen minutes we would be making love, I took out the key with trembling hands and let myself into the apartment.

28

The Consolation of Objects

FORTY-FIVE minutes later Füsun still had not come, and I was lying on the bed like a corpse, though in pain and intensely aware of it, like an animal listening helplessly to its last breath. The pain was deeper and harsher than anything I had felt until that day, afflicting every part of me. I felt that I should get out of bed, distract myself, look for a way out of this predicament, or at the very least this room, and these sheets and pillows that still carried her scent, but I just couldn't summon the will.

I now began to regret fleeing the picnic. With a week having passed since we last made love, Sibel was hazily aware that something strange had happened to me, but she couldn't put her finger on it or find a way to ask. I longed for Sibel's compassion, dreaming that my fiancée could distract me. But I couldn't bestir myself, let alone jump back into the car and return to her. So afflicted was I with the pain shooting so violently through my abdomen, my back, my legs, pain so violent it took my breath away—that I couldn't even find the strength to seize relief. Just knowing this exacerbated my desolation, provoking a remorse as fierce and lacerating as the pain of love itself. It was a strange, irrational conviction that took hold: Only by giving over to this pain (like a flower folding its petals shut), by surrendering to its full intensity, then and only then could I come closer to Füsun. In one part of my mind, I knew I might be chasing an illusion, but I had no way of dispelling the weird belief. (Anyway, if I left the apartment now, she might arrive and not find me.)

As I gave myself over to the pain, as acid-filled grenades exploded in my blood and bones, I sorted through my bundle of memories, one by one, distracting myself, briefly and intermittently, sometimes for ten or fifteen seconds, though sometimes for only one or two, until these same memories would propel me even deeper into the void of the present moment, the pain stunning me as if for the first time, a hereto-

fore unknown magnitude of agony. One palliative for this new wave of pain, I discovered, was to seize upon an object of our common memories that bore her essence; to put it into my mouth and taste it brought some relief. There were those nut and currant crescent rolls to be found at all the patisseries of Nişantaşı in those days, which I'd bring to our rendezvous, because Füsun liked them so much. Putting one in my mouth, I would remember the things we'd laughed about when eating them together (like the fact that Hanife Hanım, the wife of the Merhamet Apartments' janitor, still believed that Füsun was a patient of the dentist on the upper floor), and this would cheer me up. The time she took a hand mirror from one of my mother's drawers and used it as a microphone, imitating the famous singer Hakan Serinkan; the way she'd play with my toy Ankara Express train, the same one my mother had given her to play with when her seamstress mother brought her along on house calls; the space gun, another favorite toy of mine— we'd shoot at each other and then mirthfully search the disordered room for the plastic projectile—all of them had the power to console me. The sugar bowl in this exhibit is from the day when a cloud of melancholy darkened our happiness, plunging us into one of our occasional silences, when Füsun, suddenly picking up this same bowl, asked, "Would you be happier if we had met before you met Sibel Hanım?"

Beside my head was the side table on which she had left her watch so carefully the first few times we made love. For a week, I had been aware that in the ashtray now resting there was the butt of a cigarette Füsun had stubbed out. At one moment I picked it up, breathing in its scent of smoke and ash, and placing it between my lips. I was about to light it (imagining perhaps for a moment that by loving her so, I had become her), but I realized that if I did so there would be nothing left of the relic. Instead I picked it up and rubbed the end that had once touched her lips against my cheeks, my forehead, my neck, and the recesses under my eyes, as gently and kindly as a nurse salving a wound. Distant continents appeared before my eyes, sparkling with the promise of happiness, and scenes from heaven; I remembered the tenderness my mother had shown me as a child, and the times I had gone to Teşvikiye Mosque in Fatma Hanım's arms, before pain would rush in again, inundating me.

Toward five o'clock, still in bed, I remembered how, after my grandfather died, my grandmother changed not just her bed, but her bedroom in order to withstand her grief. With all my will, I resolved to extract myself from this bed, this room, and these objects that had aged so beautifully, that were so heavy with the fragrance of happy love, each one murmuring, creaking, rustling of its own accord. But I could not help doing the opposite, and embracing these objects. Either I was discovering the astonishing powers of consolation that objects held, or I was much weaker than my grandmother. The joyful shouts and curses of the children playing football in the back garden bound me to that bed until nightfall. It was only that evening, after I had downed three glasses of *rakı,* and Sibel phoned to ask me about my cut, that I realized it had long since stopped bleeding.

Thus I continued to visit the Merhamet Apartments every day at two o'clock in the afternoon, until the middle of July. As the pain I felt while wondering whether Füsun might come grew less intense each day, I sometimes convinced myself that I was slowly growing accustomed to her absence, but there was no truth to this, none at all. It was simply that I was growing more adept at distracting myself with the happiness I found in objects. A week after the engagement party, she still occupied my every thought, and though these thoughts were not always overwhelmingly urgent, though I sometimes managed to banish them to the back of my mind, the sum total of my agony—to speak arithmetically—was not diminishing; against every hope, it was continuing to grow. It was almost as if I was going to the apartment so as not to lose the habit, or the hope of seeing her.

I would usually spend my two hours in the apartment daydreaming in bed, having selected some object charmed with the illusion of radiating the memories of our happiness—for example, this nutcracker, or this watch with the ballerina, with Füsun's scent on its strap, with which I would stroke my face, my forehead, my neck, to try to transfer the charm and soothe the ache—until two hours had passed, and the time had come when we would have been awakening from the velvet sleep our lovemaking induced, and, depleted, I would try to return to my everyday life.

The light had gone out of my life by now. Having still not managed to make love to Sibel since our engagement (advancing as my excuse

the embarrassment that the people at Satsat knew about our trysts in the manager's office), I realized that my fiancée had come to see my nameless malady as some variety of nonspecific premarital panic, some form of melancholia for which medicine as yet had neither diagnosis nor cure. She accepted this affliction with a solemnity that made me admire her all the more, and because she secretly blamed herself for having failed to pull me out of it, she treated me very well. And I treated her as well in return, taking her to restaurants we'd never visited before, and introducing her to the new friends I managed to make. We continued to attend parties, and to visit the Bosphorus restaurants and clubs where the Istanbul bourgeoisie gathered in the summer of 1975 to display their wealth and happiness. Though I joined her merriment at watching the pleased Nurcihan torn between Mehmet and Zaim, I laughed knowingly. Happiness no longer seemed God's gift to me from birth; no longer was it the right I could claim without effort; it had become a state of grace that only the luckiest, brightest, and most cautious people could attain, and with the most assiduous cultivation. One night, at the newly opened Mehtap, where bodyguards milled about the entrance, I was standing alone at the bar next to the pier extending over the Bosphorus drinking Gazel red wine (Sibel and the others were chatting cheerfully at our table) when I came eye to eye with Turgay Bey, and my heart began to race as fast as if I'd seen Füsun herself, and the tide of jealousy rushed in.

29

By Now There Was Hardly a Moment When I Wasn't Thinking About Her

WHEN TURGAY Bey chose not to give me his customary bland, affable smile, turning his head instead, this wounded me more than I could have anticipated. Reason told me that he had every right to take offense at my not having invited him to the engagement party, but reason was

no match for the paranoid hypothesis—that Füsun might have gone back to him to take revenge on me. I was seized by the urge to run after him and inquire the cause for this snub. Perhaps that very afternoon he had made love with Füsun in his *garçonnière* in Şişli. It would have sent me over the edge if he had so much as seen her, spoken to her. Though my humiliation was mitigated by the knowledge that he had been in love with Füsun before me, and once suffered an agony like mine, for the same reason I had never felt more loathing toward him than now. I knocked back quite a few drinks at the bar. Later on I wrapped my arms around the ever patient and compassionate Sibel, swaying with her as Pepino di Capri sang "Melancholy."

Drinking was my sole defense, albeit temporary, against jealousy. When I woke up the next morning with a headache and my envy refreshed, I realized, with growing panic, that the pain was not abating, and that I felt more helpless than ever. As I walked to Satsat (Inge still smiling saucily at me from the Meltem poster on the side of the apartment), and later that morning, as I tried to bury my thoughts in paperwork, I was forced to acknowledge that the pain was gradually increasing, and that, far from forgetting Füsun as time wore on, I was thinking about her ever more obsessively.

Time had not faded my memories (as I had prayed to God it might), nor had it healed my wounds as it is said always to do. I began each day with the hope that the next day would be better, my recollections a little less pointed, but I would awake to the same pain, as if a black lamp were burning eternally inside me, radiating darkness. How I longed to think about her just a little less, and to believe that I would, in time, forget her! There was hardly a moment when I wasn't thinking about her; in truth, with few exceptions, there was not a single moment. These "happy" interludes of oblivion were fleeting—a second or two—but then the black lamp would be relit, its baleful darkness filling my stomach, my nostrils, my lungs, until I could barely breathe, until merely to live became an ordeal.

As much as I would long for an escape from this suffering, I longed for someone to confide in, to find Füsun and talk to her, but when that longing went unfulfilled I would yearn to pick a fight with someone, anyone to whom I could attribute this damning, furious resentment. For all my willed self-restraint, to see Kenan at the office was to slip

into temporary insanity. Though I had decided that there was nothing between them, I could not forget Kenan's flirtatious attentions at the engagement party, which Füsun might well have enjoyed, and this was reason enough to hate him. By noon I would be concocting pretexts for his termination. Oh, he was a sly one, wasn't he? Lunchtime brought the relative calm of knowing that I would go to the Merhamet Apartments, to wait for Füsun—even a tiny hope sustained me, even when the fear that she would not come was fulfilled. But I understood with fear that when she did not come, the pain of waiting brought to its excruciating climax, the prospect of the next day held out nothing but the same vain hope of the last.

A question likewise debilitating took root in my mind: If I was suffering all this pain, how could she bear it, even if it was half as intense? I had to conclude that she must have found someone else right away, for otherwise she couldn't have stood it. The joys of making love, disclosed to her only seventy-four days earlier—Füsun must now be sharing them with another . . . as I lay every day in agony, a bedridden idiot, a corpse. No, I wasn't an idiot: She had tricked me. We'd known an immense happiness together, and despite the horrible awkwardness of the engagement party, we'd still had our dance together, during which she had promised to come to me the next day, right after her exam. If my engagement had broken her heart, she would have been entirely justified in wanting to end it with me, but then why lie to me? The pain within transmuted into a furious need to remonstrate with her, and lay bare her wrong. I would then prepare myself for an imaginary argument, during which I would be mollified in time, the accusations yielding to the heavenly images of our indelible hours together and the disarming power of her presence. I would all the same rehearse points I wanted to argue, one by one. She would have to tell me to my face that she was leaving me. If the university exam had gone badly I was not to blame. If she was going to leave me I had the right to know. For hadn't she said that she would continue to see me for the rest of her life? Didn't she owe me one last chance—at least to find the earring and bring it to her at once? Did she really believe that other men could love her as I did? With such resolve, I got out of bed and rushed out into the street.

30

Füsun Doesn't Live Here Anymore

I RAN ALL the way to their house. Even before I passed the corner where Alaaddin had his shop, I was euphoric, already imagining how I would feel when I saw her. As I smiled at a cat dozing, shaded from the July sun, I asked myself why it had not occurred to me before simply to go to their house. The pain in the upper left-hand quadrant of my stomach was already abating; the leadenness in my legs and the fatigue in my back were even now gone. As I approached the house, however, the fear of not finding her set in, and so my heart began to race: What would I say to her, what was I going to say if it was her mother who came to the door? At one point I thought of turning back to collect the childhood tricycle. But I knew the moment we saw each other there would be no need for excuses. Like a ghost I entered the cool foyer of the little apartment house on Kuyulu Bostan Street, walked up the steps to the second floor, and rang the bell. Visitors to the museum might wish to press down on the button alongside this exhibit to hear the sound of a chirping bird—so fashionable as a door chime in Istanbul at that time—which I heard as my heart fluttered like a bird, trapped between my mouth and my throat.

It was her mother who answered the door. The foyer was so dark that at first she wrinkled her nose at this tired stranger, as if he might be an annoying salesman. Then she recognized me, and her face lit up. Taking hope from this, the pain in my stomach eased slightly.

"Oh! Kemal Bey! Do come in!"

"I was just passing by, Aunt Nesibe, so I thought I'd drop in," I said, sounding like the earnest neighborhood teenager in a radio play. "I just noticed the other day, Füsun's not working at the shop anymore. So I was wondering; she never dropped by to tell me how she did on the university exam."

"Oh, Kemal Bey, my poor boy, come inside so that we can share our troubles."

Without pausing to register what she might have meant by "sharing our troubles," I went into that dingy backstreet apartment that my mother had never once visited, in spite of all those cozy sewing sessions at our home and all the talk of our being related. Slipcovered armchairs, a table, a buffet holding a candy bowl, a set of crystal tumblers, and a television crowned by a sleeping china dog—I found these things beautiful, because they had all assisted in the making of the wondrous miracle that was Füsun. In a corner I saw a pair of sewing scissors, lengths of cloth, threads of many colors, pins, the pieces of a dress that was being sewn together by hand. So Aunt Nesibe was still working as a seamstress. Was Füsun at home? She didn't seem to be, but here was her mother, standing there waiting, as if about to bargain with me, or present me with a bill, and from this I drew hope.

"Do sit down, Kemal Bey," she said. "Let me make you a coffee. You look pale. You need to relax. Would you like some water from the refrigerator, too?"

"Isn't Füsun here?" asked the bird caught inside my parched throat.

"Noooo. Noooo," said the woman, in a tone to suggest, if only you knew what has happened! "How would you like your coffee?" This time she used the polite word for "you."

"Medium sweet!" I said.

What I now realize, all these years later, is that the woman went into the kitchen not to make me a coffee but to cook up an answer. But at the time, even with my senses on full alert, my mind was whirling from being in a house where the scent of Füsun was everywhere, and dizzy with the hope that I might see her. There, in its cage, was my friend the canary from the Şanzelize Boutique; its impatient twitter was something of a salve on my heart, and this confused me all the more. On the low table in front of me was the Turkish-made, thirty-centimeter wooden ruler with its fine white edge. I had given it to Füsun as a present at our seventh meeting, by my later calculations, for use in her geometry lessons. It was clear that Füsun's mother was now using the ruler for her sewing. I picked it up, brought it to my nose, and as I remembered the scent of Füsun's hand, there, before my eyes, she came to life. As Aunt Nesibe returned from the kitchen, I slipped the ruler into my jacket pocket.

She put the coffee down and sat across from me. She lit a cigarette,

something in the gesture reminding me she was her daughter's mother, and then she said, "Füsun's exam did not go well, Kemal Bey." She had by now worked out how she was going to address me. "She was so upset. She left in tears before she could finish—we haven't even bothered to find out her results. She was in a terrible state. My poor daughter is never going to be able to study at university now. She was so traumatized she gave up her job. Those lessons with you really harmed her. You surely saw how sad she was on the night of your engagement party. . . . It all got to be too much for her. You're not the only one responsible, of course. . . . She's a fragile young girl. She had only just turned eighteen. But she was heartbroken. So her father took her away, far, far away. So very far away. You should forget all about her. She will forget you, too."

Twenty minutes later, as I lay in our bed at the Merhamet Apartments, staring at the ceiling, tears dripping silent and slow onto the pillow, I thought about the ruler. I had used such a ruler as a child, which perhaps explains why I had given Füsun this standard lycée ruler, so it is hardly surprising that it should have become one of the first significant pieces in our collection. It was an object that reminded me of her, the first that agony had provoked me to take from her world. I put the end marked "30 centimeters" into my mouth, keeping it there for the longest time, despite the bitter aftertaste. For two hours I lay in bed, playing around with the ruler, trying to recast the hours it had spent in her hands, which introduced a relief, a happiness almost akin to seeing her.

31

The Streets That Reminded Me of Her

I KNEW by now that if I didn't make a plan to forget her, there would be no continuing my normal daily life. Even the least observant employees at Satsat had noticed the black melancholy that had settled over their boss. My mother, assuming there was some problem between

me and Sibel, kept grilling me, and during the infrequent meals that we ate together she took to warning me against drinking too much, just as she warned my father. The more pain I felt, the more anxious and gloomy Sibel became, and we were fast approaching a dreaded point of explosion. Knowing Sibel's support was crucial if I was ever to be rescued from this quandary, I feared losing her no less than I feared a total breakdown.

I forbade myself from going to the Merhamet Apartments, waiting for Füsun, and caressing the things that reminded me of her. I'd tried to impose these prohibitions before—a regime that took every ounce of my will—but having found any number of ways to evade them (I would, for instance, set out to buy Sibel flowers from a place near the Şanzelize Boutique), I now decided on more drastic measures and removed from my mental map a number of streets and places where I had spent a large part of my life.

Here I display a modified Nişantaşı map that I devised, after considerable effort, the streets or locations marked in red representing regions from which I was absolutely banned. The Şanzelize Boutique, near where Teşvikiye Avenue crosses with Valikonağı Avenue; the Merhamet Apartments, on Teşvikiye Avenue; the police station and the corner where Alaaddin had his shop—on my mental map, they were all restricted areas, marked in red. I banned Kuyulu Bostan Street, where Füsun and her family lived, and the street that was still called Emlak Avenue, though not Abdi İpekçi Avenue or Celâl Salik Street, its official names in later years (although Nişantaşı residents would continue to call it "the street where the police station is"). Even the side streets leading off these main thoroughfares were prohibited. The streets marked in orange I allowed myself entry in the case of absolute necessity, provided I'd had nothing to drink and crossed them at a gallop in under a minute and did not linger. My home and Teşvikiye Mosque were, like so many side streets, marked in orange because I knew that prolonged exposure could inflame my suffering. I had to be careful, too, on all streets marked in yellow. My accustomed path from Satsat to our meetings at the Merhamet Apartments, the road that Füsun had taken every day from the Şanzelize to her home (I kept imagining this journey)—these were full of land mines and snares of recollection that might plunge me into agony. Also marked on the map were other

places that figure in my brief history with Füsun, for example, the empty lot where the devout sacrificed lambs when we were children, and even the corner of the mosque courtyard where she'd stood as I watched her from afar. I kept this map always in my mind, its restrictions inviolable out of belief that only this sort of ascetic regimen would cure, however slowly, my illness.

<div style="text-align: center;">

32

The Shadows and Ghosts
I Mistook for Füsun

</div>

SADLY, IN spite of banishing myself from the streets where I'd lived all my life and keeping far from all objects reminiscent of her, I was unable to forget Füsun. For now I'd begun to see her ghost in crowded streets and at parties.

The first encounter was the most shocking; it happened one evening at the end of July, on a car ferry, as I was going to join my parents in our summer place in Suadiye. It was the ferry connecting Kabataş with Üsküdar, and as we approached the latter, I, like all the other impatient drivers, had started up my engine, when I glanced over at the side entrance for pedestrians and saw Füsun. Since the car ramp had not yet been lowered, I could have reached her only by bolting out of the car and racing after her, thus blocking the vehicles trying to move off the ferry. I jumped out of the car and was about to call to her at the top of my voice when the lower torso came into view and I was pained to notice that I saw it was thicker and coarser than my beloved's, and the face, too, took on the aspect of someone else. But during those eight or ten seconds, my pain became elation, and over the days that followed I lived this moment many times over, being convinced that this was how we would indeed meet.

A few days later I went to the Konak Cinema, just to kill some time, and as I was ascending the long, wide stairs to the ground floor, I saw

her ten steps ahead of me. The sight of her long, bleached blond hair and her slender body sent a jolt first to my heart and then to my legs. I ran toward her ready to cry out, but when I saw it wasn't her I was struck mute, as in a dream.

I was spending more time in Beyoğlu, as there were fewer potential reminders of her there, but one day I had the shock of seeing her image reflected in a shop window. Another time a girl was skipping through a crowd in Beyoğlu, in a way I believe unique to Füsun. I gave chase but couldn't catch up. Uncertain whether this person had been another mirage or my quarry, I went back at the same time for several days in a row to pace back and forth between Ağa Mosque and the Palace Cinema; failing to catch a glimpse of her, I'd take refuge in a beer hall and sit at the window, watching the passing crowds.

Those halcyon moments were so brief. This photograph of Füsun's white shadow in Taksim captures an illusion that lasted only two minutes.

Over time I came to notice how many of our young girls and women shared Füsun's figure, and how many dark Turkish girls bleached their hair blond. The streets of Istanbul were full of Füsun's doubles, who would appear for a second or two and then vanish. But whenever I got a good look at one of these ghostly figures, I would see that she did not resemble my Füsun in the slightest. Once, while playing tennis with Zaim at the Tennis, Fencing, and Mountaineering Club, I spotted her among three giggling young girls, drinking Meltem at one of the tables; my greater surprise was not at seeing her, but at her having been admitted to this club. Another time her specter had just stepped off the Kadıköy ferry onto the Galata Bridge and was trying to hail a shared taxi. It was a while before my heart grew accustomed to these mirages, and then my mind. Once, during the intermission between two films at the Palace Cinema, four rows ahead of me in the balcony I saw her sitting with her sisters, enjoying a chocolate Mirage Ice, and I chose to forget that she had no sisters, for I had learned that until I could harvest the pleasure of an illusion there was no sense in dispelling it, at the expense of my aching heart.

There she was, standing before the Dolmabahçe Clock Tower, or walking through the Beşiktaş Market carrying a macramé bag like a housewife, or most surprising and unsettling, gazing down at the street

from the window of a third-floor apartment in Gümüşsuyu. When she saw me in the street looking up at her, Füsun's ghost stared back at me. When I waved, she waved back. But her manner of waving sufficed to tell me that she wasn't Füsun, so I walked off in shame. Nevertheless, the apparition at the window prompted me to imagine that her father had quickly married her off in shame, perhaps to help her forget me. In my dream she was beginning her new life in that apartment but still wanted to see me.

Discounting the second or two of consolation that the first sightings of these ghosts brought me, I never for long forgot that they were not Füsun but figments of my unhappy imagination. Still, I could not live without the occasional sweet feeling, and so I began to frequent those crowded places where I might see her ghost; and eventually I would mark these places, too, on my mental map of Istanbul. Those places where her ghosts had appeared most often were the ones where I was most regularly to be found. Istanbul was now a galaxy of signs that reminded me of her.

Because I came across her ghost when wandering slowly through the streets, staring into the distance, I took to wandering slowly through the streets, always looking afar. When I was out at a club or a party with Sibel and had drunk too much *rakı,* Füsun would appear dressed in all sorts of outfits, and I would have to remind myself that I was engaged and that rising to the bait of a mirage would imperil the one thing that was real. I have chosen to display these views of the beaches of Kilyos and Şile because it was most often on a summer's afternoon when my guard was down, dulled by heat and fatigue, that I saw her among the crowds of young girls and women so embarrassed to be seen in their maillots and bikinis. Forty-five years after Atatürk's revolution and the founding of the Republic, the Turkish people had still not worked out how to go to the beach in bathing suits without embarrassment, and at times like this, it would occur to me how much Füsun's fragility reflected the bashfulness of the Turkish people.

In these moments of unbearable longing, I would leave Sibel to play ball in the sea with Zaim, and walk off into the distance to lie down in the sand, leaving my awkward body, love-starved into senselessness, to be scorched by the sun. Watching the sand and the shore from the corner of my eye, I would, inevitably, see a girl running toward me and

think that it was her. Why had I not once brought her to Kilyos Beach, knowing how much she'd have wanted to go? How could I not have recognized the value of this great gift God had given me! When was I going to see her? As I lay there in the sun, I wanted to cry, but knowing I was guilty, I couldn't allow myself, and instead I buried my head in the sand, and felt damned.

33

Vulgar Distractions

LIFE HAD receded from me, losing all the flavor and color I'd found in it until that day. The power and authenticity I'd once felt in things (though, sad to say, without fully realizing it) was now lost. Years later, when I took refuge in books, I found, in a work by Gérard de Nerval, the best expression of the crude dullness I was feeling at that time. After understanding that he has lost forever the love of his life, the poet, whose heartbreak eventually leads him to hang himself, writes somewhere in his *Aurélia* that life has left him with nothing but "vulgar distractions." I, too, felt that whatever I did during these days without Füsun, it was vulgar, ordinary, and meaningless, and toward persons and things that had led me to such coarseness I felt only anger. Still, I never stopped believing that I would find Füsun, that I would have another chance to speak to her, or even that I would embrace her; this was what I thought bound my soul to my body still, however tenuously, though when thinking back on these days, I would remorsefully acknowledge that such hope only prolonged my grief.

On one particularly hot July day, my brother rang to tell me, with righteous anger, that Turgay Bey, our partner in so many successful ventures, felt injured at not having been invited to the engagement party, and now wished to withdraw from a big bedsheet contract that we'd jointly bid for and won, a mess for which Osman held me personally responsible (Osman having heard from my mother that it was I

who had scratched his name off the guest list). I calmed him down by promising to put matters right with Turgay Bey tomorrow.

As I sat in the car the next day in the withering heat, on my way to his giant factory in Bahçelievler, I looked out at the hideous neighborhoods of ever uglier new apartment blocks, depots, little factories, and dumping grounds, and the pain of love no longer felt unbearable. This abatement could only be on account of my impending meeting with someone who might give me news of Füsun, someone with whom I might be able to talk about her. But in similar circumstances (when I spoke with Kenan or ran into Şenay Hanım in Taksim) I could not admit the reason for my welcome joy, trying to convince myself that simply pursuing "business" was having a beneficial effect. Indeed, if I hadn't gone to such lengths of self-deception, this visit I had made "only for business" might have gone better.

That I had come all the way from Istanbul to apologize to Turgay Bey had assuaged his pride, and this was quite enough for him to treat me well. He gave me a tour of his weaving operation, through halls where hundreds of girls were working on giant looms and when, behind one of them, I saw Füsun's ghost with her back turned, my real purpose in coming announced itself to me. And so, as I admired the modern new offices and "hygienic" cafeterias, I abandoned my aloof manner, amicably suggesting what a shame it would be if we could not do business with him. Turgay Bey wanted us to eat lunch with the workers, according to his custom, but I, convinced that this would not allow me to apologize properly, told him that a bit of drink not to be found on the premises might help me broach certain "important matters." I looked at him closely—so ordinary looking, with his mustache—and there was nothing in his expression to suggest an awareness that I was alluding to Füsun. Finally I mentioned the engagement party, and he, by now mollified, said proudly, "It was just an oversight, I'm sure. Let's put it behind us." But I continued to insist, forcing this honest and industrious man whose mind scarcely strayed from his work to invite me out to a Bakırköy fish restaurant. In his Mustang I remembered Füsun telling me how many times they had kissed while sitting in those same seats, how their thrashing was reflected in the gauges and the rearview mirror, and I remembered how he had groped her, felt her up,

before she'd even turned eighteen. I wondered again whether Füsun had gone back to him, and, haunted still by all her ghosts, unable to convince myself that this man in all likelihood had no news of her, I remained tightly coiled in readiness.

At the restaurant, as Turgay Bey and I sat across from each other like two old ruffians, as I saw him put the napkin on his lap with his hairy hands, and looked at his great pockmarked nose and his impudent mouth from up close, I had a strong intuition that this would not go well. When he wasn't shouting for the waiter, he was wiping the corners of his mouth with his napkin, an elegant gesture stolen from a Hollywood film. Still I managed to rein myself in, and until the middle of the meal, I remained in control. But soon the *rakı* I drank to escape the evil within me flushed it to the surface. In the most polite way, Turgay Bey allowed that any misunderstanding about the bedsheet contract could be easily settled and that there should be no ill will between us as partners. "We're both going to do very well," he said soothingly, when I blurted, "What matters most is not that our business goes well, but that we be good people."

"Kemal Bey," he said, glancing at the *rakı* glass in my hand, "I have the greatest respect for you, and your father, and your family. We've all had our bad days. Living as we do in this beautiful but impoverished country, we enjoy a good fortune that God bestows only on his most beloved subjects; and let us give thanks for that. Let us not be too proud, and let us remember Him in our prayers—that is the only way to be good."

"I had no idea you were so religious," I said mockingly.

"My dear Kemal Bey, what did I do wrong?"

"Turgay Bey, you broke the heart of a young girl who happens to be a member of my family. You treated her badly. You even offered her money. I'm talking about Füsun of the Şanzelize Boutique—she's a very, very close relation on my mother's side."

His face turned ashen, and he looked down. That was when I realized that I was jealous of Turgay Bey not because he had been Füsun's lover before me, but because, once the affair was over, he'd managed to get over her and return to his normal bourgeois life.

"I had no idea she was related to you," he said with shocking sincerity. "I feel deeply shamed. If your family could not bear to see me, you

had every right not to invite me to the engagement party. Do your father and your older brother feel equally offended? What can we honorably do about this—should we end our partnership?"

"Let's end it," I said, regretting my words even as I uttered them.

"In that case, let us say it is you who have canceled the contract," he said, lighting a Marlboro.

The pain of love was now exacerbated by my shame at having misplayed my hand. Though I was very drunk by now, I drove myself back to the city. Since I'd turned eighteen, driving in Istanbul and especially on the shore road, along the city walls, had brought me huge pleasure, but now, with my sense of impending doom, the ride had become a form of torture. It was as if the city had lost its beauty, as if I could do nothing but put my foot on the accelerator in order to escape this place. Driving through Eminönü, under the pedestrian overpasses in front of the New Mosque, I very nearly ran someone over.

Reaching the office, I decided that the best thing to do was to convince Osman that ending the partnership with Turgay Bey was not such a bad idea. I summoned Kenan, who was well informed about this particular contract, and he listened, very intently, to what I had to say. I summarized the situation thus: "For personal reasons, Turgay Bey is behaving badly and has asked if we might fill this contract on our own," adding that we had no option other than to part ways with Turgay Bey.

"Kemal Bey, if at all possible, let's try and avoid this," said Kenan. He explained that we could not possibly manage alone, and if we failed to fulfill the order in time, it would harm not just Satsat but the prospects of the other firms involved, and subject us to heavy penalties in the New York courts. "Is your brother aware of all this?" he asked. I must have been spouting *rakı* fumes like a chimney, else he wouldn't have questioned his boss so insolently. "The arrow has already left the bow," I said. "We'll have to carry on without Turgay Bey." I knew this was impossible, even if Kenan hadn't said so. But my reason had now shut down altogether, yielding to a troublemaking devil. Kenan remained in front of me, insisting that I needed to speak to Osman.

It goes without saying that I did not then hurl the stapler displayed here, or the accompanying ashtray bearing the Satsat logo, at Kenan's head, however much I longed to do so. I do remember noting that,

however laughable his tie was, it resembled the company ashtray in both ungainly size and coloring. "Kenan Bey," I roared, "you are not working in my brother's firm. You are working for me!"

"Kemal Bey, please don't take offense. Of course I'm aware of this," he said slyly. "But you introduced me to your brother at the engagement party, and since then we've been in touch. If you don't ring him right away to talk about a matter this important, he's going to be very upset. Your brother is aware that you've not been having the easiest time recently, and like everyone else, he only wants to help you."

The words "everyone else" almost detonated my anger. I was tempted to fire him then and there, but I feared his audacity. Suffering like a trapped animal, I became aware that I would only feel better if I could just see Füsun once. To the world I was indifferent, because by now everything was so futile, so very vulgar.

34

Like a Dog in Outer Space

BUT INSTEAD of Füsun I saw Sibel. My pain was now so great, so all-consuming that when the office emptied out, I knew at once that if I remained by myself for too long I would feel as lonely as this dog after the Soviets sent him off in his little spaceship into the dark infinity of outer space. By calling Sibel to the office after hours, I gave her the legitimate expectation that we would be resuming our pre-engagement sex life. My well-intentioned fiancée was wearing Sylvie, a perfume I'd always liked, and these imitation net stockings that, as she knew very well, aroused me, with high-heeled shoes. She arrived elated, thinking that my "sickness" was retreating, and I could not bring myself to tell her that, quite to the contrary, I had called her here to rescue me from the scourge, however briefly; that I longed to embrace her as I had embraced my mother when I was a child. So Sibel did as she had done with such relish in the past: She walked me backward and sat me down on the divan, and proceeded to do her dumb secretary impression,

cheerily peeling off her clothes, layer by layer, until, smiling sweetly, she sat on my lap. Let me not describe how the scent of her hair and her neck made me feel utterly at home, or how relaxed, even restored, I was by that familiar intimacy, because the reasonable reader, like the attentive museum visitor, will then assume that we went on to make love. He would be disappointed, as Sibel was, too. But it felt so good to embrace her that I had soon drifted off into a peaceful, happy sleep, and my dream was of Füsun.

When I woke up, in a sweat, we were still lying there in each other's arms. The room was dark and we dressed in silence, Sibel lost in her own thoughts, and I wallowing in guilt. The headlights of the cars in the avenue and the purple sparks from the trolleybus rods illuminated the office just as they had in the days when we had made careless love.

Without discussion, we repaired to Fuaye, and when we sat down at our sparkling table in the crowded, bustling dining room, I thought once again how charming, beautiful, and understanding Sibel was. I remember that after we had talked about this and that for an hour, and laughed with various tipsy friends who had stopped by our table, we discovered from the waiter that Nurcihan and Mehmet had been in for supper earlier. But there was no avoiding the real issue indefinitely, as our evening was punctuated by longer and longer silences. I ordered a second bottle of Çankaya wine. By now Sibel was drinking a lot, too.

At last she said, "What's going on with you? It's time—"

"If I only knew," I said. "There seems to be a part of my mind that doesn't want to acknowledge the problem, or understand it."

"So you don't understand it either, is that what you're saying?"

"Yes."

"If you ask me, you know a lot more than I do," said Sibel with a smile.

"What do you think I know so much more about than you do?"

"Do you ever worry what I might be thinking about your troubles?" she asked.

"I worry that if I don't snap out of this, I'll lose you."

"Don't worry about that," she said, stroking my hand. "I'm patient and I love you dearly. If you don't want to talk about it, then you don't have to. And don't worry, I don't have any wild theories about all this. We have plenty of time."

"What wild theories?"

"Well, for example, I'm not worried that you might be a homosexual or something," she said, smiling at once, to show that she wanted to reassure me, too.

"Oh, thanks. What else?"

"I don't think it's a sexual illness or some deep childhood trauma, or anything like that. But I still think that it might help to see a psychologist. There's nothing wrong with that. In Europe and America, everyone goes to them. . . . Of course, you'd have to tell this person what you can't tell me. . . . Come on, darling, tell me, don't be afraid. I'll forgive you."

"I *am* afraid," I said with a smile. "Shall we dance?"

"Then you admit there is something you know and I don't."

"Mademoiselle, please don't decline my invitation to dance."

"Oh, monsieur! I am engaged to a troubled man!" she said, and we rose to our feet.

I have recorded these details, and displayed these menus and glasses, to evoke the uncanny intimacy, the private language, and—if that's the right word for it—the deep love that existed between us during those hot July nights when, seeking relief, we'd go to clubs and parties and restaurants and drink with abandon. It was a love fed not by sexual appetite but by a fierce compassion, and on nights when, having both had a lot to drink, we rose to dance, it wasn't so far from physical attraction. As the orchestra in the background played "Lips and Roses," or as the disc jockey (a new fixture in Turkey at that time) spun his 45s, the songs would filter through the leaves of the still and silent trees on humid summer nights and I would take my beloved fiancée in my arms, embracing her no less passionately than on the divan in the office, and however motivated to protect myself, I treasured our camaraderie and common bonds; breathing in the scent of her neck and her hair, I found peace, and I would see how senseless it was to feel as lonely as a canine cosmonaut in space; and assuming that Sibel would always be at my side, I would woozily draw her closer. As we danced under the gaze of other romantic couples, we would sometimes lurch, as if to take a drunken spill onto the floor. Sibel enjoyed these alcoholic trances we fell into, as they transported us from the everyday world. Outside in the streets of Istanbul, communists and nationalists were

gunning each other down, robbing banks, throwing bombs, and spray-
ing coffeehouses with bullets, but we had occasion, and license, to for-
get the entire world, all because of my mysterious ailment, which in
Sibel's mind gave life a certain depth.

Later, when we sat down at our table, Sibel would again drunkenly
broach the subject, now not as something she understood but some-
thing she accepted without fully understanding. Thus, thanks to Sibel's
efforts, my mysterious moods, my melancholy, and my inability to make
love to her amounted to no more than a premarital test of my fiancée's
compassion and commitment, a limited tragedy soon to be forgotten.
It was as if our pain gave us the distinction of standing apart from our
coarse, superficial, rich friends, even as we boarded their speedboats.
We no longer needed to join the careless drunks who jumped from the
pier into the Bosphorus at the end of a party. My pain, and my strange-
ness, had graced us with a degree of difference. It pleased me to see
Sibel embrace my pain with such dignity, and this, too, drew us closer
together. But even amid all this drunken earnestness, if I heard a City
Line ferry blowing its sad whistle in the distance, or if I glanced into
the crowd and in the least likely of places spotted someone I thought
was Füsun, Sibel would notice the strange expression on my face and
intuit painfully that the danger lurking in the shadows was far more
fearsome than she'd thought.

And so it was that by the end of July, Sibel's loving suggestion that I
see a psychiatrist turned into a requirement, and unwilling to lose her
wonderful compassion and companionship I agreed. The famous
Turkish psychoanalyst who the careful reader will recall offering an
analysis of love was at that time recently returned from America and
working hard, with his bow tie and his pipe, to convince a narrow seg-
ment of Istanbul society that they could no longer do without his pro-
fession. Years later, when I was trying to establish my museum, and I
paid him a visit to ask what he remembered of that era (and also to
solicit his donation of that same pipe and bow tie), I discovered that he
had no memory of the troubles I was suffering at the time; what's
more, he'd heard nothing of my painful story, which was by then com-
mon knowledge in Istanbul society. He remembered me as being like
so many of his other patients at that time—perfectly healthy individu-
als who rang his bell only out of curiosity. I shall never forget how Sibel

insisted on coming with me, like a mother taking her ailing child to the doctor, and how she said, "I'll just sit in the waiting room, darling." But I hadn't wanted her to come at all. Sibel, with the felicitous intuition so prevalent in the bourgeoisies of non-Western countries, and most particularly Muslim countries, saw psychoanalysis as a "scientific sharing of confidences" invented for Westerners unaccustomed to the curative traditions of family solidarity and shared secrets. When, after talking about this and that and neatly filling out the necessary forms, I was asked what my "problem" was, I felt compelled to disclose that I had lost the woman I loved and now felt as lonely as a dog sent into outer space. But instead I said that I had been unable to make love to my beautiful and cherished fiancée since our engagement. And he asked me what was the cause of my loss of desire—a surprise since I thought he would be the one to answer this question. Today, so many years later, when I remember the words that came to my mind with God's help, I still smile, but I also see some truth in them: "Perhaps I'm afraid of life, Doctor!"

This would be my last visit to the psychoanalyst, who could do no more than send me off with the words: "Don't be afraid of life, Kemal Bey!"

35

The First Seeds of My Collection

HAVING EVADED the snare of the psychoanalyst, I tricked myself into thinking that I was on the road to recovery, convinced that I was strong enough to return, just for a while, to the streets I had marked in red. It felt so good for the first few minutes, to be walking past Alaaddin's shop, down streets where my mother had taken me shopping as a child, and to breathe in the air in those shops, so good that I came to believe I was not afraid of life and that my illness was abating. These hopeful thoughts emboldened me to think I could walk past the

Şanzelize Boutique without pain—but this was a mistake. Just seeing the shop from a distance was enough to unnerve me.

For the pain was merely dormant, just waiting to be triggered, and in a moment its darkness suffused my heart. Desperate for an instant cure, I told myself that Füsun might be in the shop, and my heart started racing. With my head swimming, and my confidence draining fast, I crossed the street and looked in the window: Füsun was there! For a moment I thought I was going to faint; I ran to the door. I was about to walk in when I realized that it was not Füsun I'd seen but another specter. Someone had been hired to replace her! Suddenly I felt unable to stand. The life of nightclubs, those parties at which I'd taken drunken refuge—they revealed themselves now in all their falsity and banality. There was only one person in the world with whom I could live, only one person whose embraces I craved; the heart of my life was elsewhere, and to try to fool myself for nothing with vulgar distractions was disrespectful both to her and to myself. The regret and the guilt-ridden chaos that had enveloped me since my engagement now grew monstrous with a new realization: I had betrayed Füsun! I had to think only of her. I had to go at once to the place nearest to where she was.

Eight to ten minutes later I was lying on the bed at the Merhamet Apartments, trying to pick up Füsun's scent in the sheets, and it was almost as if I was trying to feel her inside me, almost as if I wanted to become her, but her scent had grown fainter. With all the strength I could muster, I embraced the sheets and then reached out to pick up the glass paperweight on the table, desperate for traces of the scent of her hands. As I inhaled deeply from the glass, I felt instant relief in my nose, my lungs. I lay there holding and sniffing the paperweight, for I don't know how long. According to calculations made later from memory, I had given her this paperweight on June 2, as a present, and as with so many other presents I gave her, she, not wishing to arouse her mother's suspicions, elected not to take it home.

I reported to Sibel that despite the length of my visit to the doctor, it had not moved me to confess anything of interest, and that as the doctor had nothing of his own to offer me, I would not be seeing him again, but that I did feel a bit better.

Unmentioned was that my therapy had consisted of going to the Merhamet Apartments and lying down on that bed, and fondling something she had touched. No matter, since a day and a half later, my agony was as intense as before. Three days on I went back to lie in that bed, holding in my hands another object that Füsun had touched, a brush splattered with oil paints of many colors, and I was sweeping it across my skin, and taking it into my mouth, like an infant examining a new toy. Again, I found relief for a time. In one part of my mind I knew that I had become habituated, addicted to objects that brought me relief, but that my addiction was in no way helping me forget Füsun.

These two-hour visits I made every two or three days to the Merhamet Apartments I hid not just from Sibel—it was as if I was hiding them from myself as well, which may be why I came to believe I was reducing my suffering to a manageable condition. In the beginning, when I looked at the old turban case that had been passed down to us from my grandfather, and the fez Füsun would put on when she was clowning around, or at my mother's discarded shoes (she'd tried these on, too; both were a size 38), it was not with the eyes of a collector. I was a patient taking stock of his medicines. On the one hand I had a longing for any object that reminded me of Füsun; on the other hand, even as my pain abated under therapy, I longed to run away from this house and these objects that had both healed me and reminded me of my affliction, holding out the ever elusive hope that I was beginning to recover. This hope gave me courage, and I began to dream—within pain, but gladly—that I could soon return to my former life, and that I would make love to Sibel, and that we would marry and begin a normal, happy married life.

But these fantasies were short-lived; before a day had passed, the old familiar suffering was again upon me, and again I would be returning to the Merhamet Apartments to take the cure. I would make straight for a teacup, a forgotten hair clip, a ruler, a comb, an eraser, a ballpoint pen—whatever talisman I could find of those blissful days when we sat side by side, or I would rummage through the useless things that my mother had banished here, knowing that Füsun had touched or played with them all, leaving particles of her scent in incalculable measures. To find them was to see all the memories attached to

each thing parade before my eyes, and so my collection loomed ever larger.

36

To Entertain a Small Hope That Might Allay My Heartache

IT WAS during these important days—as I was collecting the first objects for my museum—that I wrote the letter displayed here. It remains in its envelope to keep a long story short, and to spare me a full disclosure of the shame it caused me still, twenty years later, when I was founding the Museum of Innocence. If readers and the visitors to my museum could open the letter, they would find me groveling to Füsun. I abjectly confessed to her my error; I was full of remorse, and suffering terribly; avowing that love was a sacred feeling, I promised that if only she would come back to me, I would leave Sibel. After writing the last words, I felt even more contrite. I knew that in fact what I needed to say was that I had broken off with Sibel for good, but my only hope that night was to drink myself into oblivion, nestling up with Sibel, and so I could not bring myself to take that extreme though necessary measure. When I discovered the letter ten years later in Füsun's drawer, its contents seemed less important than its very existence; it surprised me to see the extent of my self-deception at that time. With one hand I was trying to deny the intensity of my love for Füsun and my own helplessness while conjuring up ridiculous omens to convince myself that we would soon be reunited; with the other hand, I clung to my dreams of a happy family life with Sibel. Should I have broken off my engagement and proposed marriage to Füsun in this letter? I don't think this thought ever crossed my mind until it arose during my meeting with Ceyda, Füsun's dear friend from the beauty contest, and the carrier of my letter.

Knowing that visitors to my museum must by now be sick and tired of my heartache, I display here a lovely news clipping. It features Ceyda's official beauty contest photograph, along with an interview in which she states that her aim in life is a happy marriage with the "ideal man" of her dreams. I would like to take this opportunity to thank Ceyda Hanım, who knew my sad story in full, who respected the love I felt for her friend, and who was generous enough to donate this lovely photograph of herself as a young woman to the museum. Realizing that I could not send my anguished letter to Füsun through the post— lest her mother intercept it—I decided to send it care of Ceyda, whom I tracked down with the help of my secretary, Zeynep Hanım. Füsun had confided to her friend every detail of our liaison from the very beginning, and when I said that I wanted to meet her to discuss a matter of great importance, Ceyda was not at all coy. When we met in Maçka, I noticed at once that I felt no embarrassment in telling Ceyda of my suffering. Perhaps this was because I attributed to her a mature understanding of the matter, or perhaps it was because I could see how happy, how very happy Ceyda was when we met. She was pregnant, and her rich, conservative lover, the Sedirci boy, had decided to marry her. She didn't hide any of this from me, even reporting that the wedding would be soon. Was there a chance I might see Füsun there? Where was Füsun? Ceyda's answers were evasive. Füsun must have warned her. As we walked in the direction of Taşlık Park, she said deep and serious things about how deep and serious love is. As I listened, I fixed my eyes on Dolmabahçe Mosque, shimmering like a dream in the distance, taking me back to childhood.

I could not bring myself to put too much pressure on her, or even ask her how Füsun was. Ceyda, I sensed, hoped that I would break off my engagement to Sibel and marry Füsun, allowing our two families to see each other socially, and it was only when she said all this in as many words that I realized her dreams were also mine. Upon entering Taşlık Park that afternoon, and seeing the view, the beauty of the mouth of the Bosphorus, the mulberry trees before us, the lovers sitting at the tables of the rustic coffeehouse drinking Meltem, the mothers with their baby carriages, the children playing in the sandbox just ahead, the students chatting and laughing as they nibbled on chickpeas and pumpkin seeds, the pigeons picking at the husks, along with two swallows—

everything in this crowded setting reminded me of what I had been on the verge of forgetting: the beauty of ordinary life. And so, when Ceyda opened her eyes wide, saying she would give my letter to Füsun, and she sincerely believed it would be answered—I succumbed to a great hope of which I was never more susceptible.

But there was no reply.

One morning at the beginning of August I was forced to acknowledge that in spite of all my precautions and palliative measures, my pain, far from abating, was still increasing at a steady rate. If I was working in the office or talking on the phone, I did not think any new thought about Füsun, but the pain in my stomach would take on the form of some obsessive thought and race through my brain, silently, like an electric current, until I could think of nothing else. The various things I did to cultivate such small hopes as could allay the pain and distract me for a time were never effective for long.

I began to take an interest in coded messages, mysterious signs, and newspaper horoscopes. I put the most faith in the "Your Sign, Your Day" column in *Son Posta* and the astrologist of *Hayat* magazine. The cleverest astrologers would say to their readers, and most especially to me: "Today you will receive a sign from a loved one!" They said much the same thing to those born under other signs, but that was only right, as it takes two to make such an event happen; and I was so convinced I would read these horoscopes very carefully, but having no systematic belief in the stars, I did not spend hours playing with them, as bored housewives are given to do. My need was urgent. I made my own system of signification: I would say to myself, "If the next person who walks through that door is a female, then I shall be reunited with Füsun, and if it is a man, all will be lost."

The world, life, all reality were swarming with signs sent by God so that we could discern our fortune. I would stand at the Satsat window, counting the cars as they passed, and I would say to myself: "If the first red car moving down the avenue has come from the left, I am going to have news from Füsun, and if from the right, my wait will continue." Or I might divine: "If I am the first person to jump off the ferry when it lands, I'll see Füsun soon." And I would jump before they'd even thrown the rope. Behind me the rope men would cry: "The first person to jump to shore is a donkey!" Then I would hear a ship's whistle, tak-

ing it for an omen, and I would imagine what sort of ship it was. I would tell myself, "If the number of steps in the overpass is an odd number, I'll see Füsun soon." If it turned out to be an even number, my agony would increase, but if the omen augured well I would enjoy a moment of relief.

The worst was the pain that woke me up in the middle of the night and would not let me get back to sleep. In such cases, I would drink *rakı,* and then, out of desperation, chase it with a few glasses of whiskey or wine, trying to silence my mind as if turning down the volume of a relentlessly blaring radio that was robbing me of my peace. Sometimes, with my mother's old deck of cards and a glass of *rakı* in my hand, I would play solitaire, trying to learn my fortune. Some nights I'd pick up the dice that my father played with only rarely and, telling myself that each time was the last, throw them a thousand times over. When I was well and truly drunk I would begin to take a strange satisfaction from my anguish, taking a foolish pride in my predicament, telling myself that it was worthy of a novel, a film, even an opera.

One night, while I was staying at the summer house in Suadiye, I awoke a few hours before dawn; when it became clear that sleep would not return, I tiptoed quietly through the darkness out to the terrace overlooking the sea; lying on a chaise longue, in the fragrant breeze of the pine trees, I gazed at the flickering lights of the Princes' Islands and tried to lull myself to slumber.

"You can't sleep either?" my father whispered. In the darkness I had not noticed him lying on the other chaise longue.

"I've been having some trouble lately," I whispered guiltily.

"Don't worry, it will pass," he said softly. "You're still young. It's still very early for you to be losing sleep over this kind of pain, so don't fret. But when you get to my age, if you have some regrets in life, you'll have to lie here counting the stars until dawn. Beware of doing things that you might regret later."

"All right, Father," I whispered. It was not long before I sensed I might be able to forget my pain, if only for a while, and drift off. Here I display the collar of the pajamas my father was wearing that night, and one of his slippers, just the sight of which makes me sad.

Perhaps because I gave them no importance, or perhaps because I didn't want readers and visitors to my museum to feel too much con-

tempt for me, I have concealed a few habits picked up during this period, but now for the sake of my story's integrity I feel obliged to make a brief confession about one of them. At lunchtime, when my secretary Zeynep Hanım went out with the rest of the office, I would sometimes dial Füsun's number. It was never Füsun who answered, which told me that she had not yet returned from wherever she'd gone, and her father wasn't around either. It was always Aunt Nesibe who picked up the phone, which meant that she was sewing at home, but I persisted in hoping that one day it would be Füsun who answered. Or at least that Aunt Nesibe, as she waited for the caller to speak, would let slip some facts about Füsun. Or that as I waited patiently, without saying a thing, Füsun would say something in the background. When Aunt Nesibe picked up the phone, there was a stretch of time when it was easy to be silent, but the longer and more exasperatedly she spoke, the harder it was to hold back, for Aunt Nesibe would quickly lose her nerve, succumbing to her panic as she writhed in a way that a telephone pervert would love: "Hello? Hello? Who is this? Who am I speaking to? For God's sake, would you please say something? Hello, hello, who are you? Why are you calling?" She would make random arrangements, strings of such phrases, her fear and anger audible in every word, but it never occurred to her to hang up immediately, or at least before I did. Over time I began to feel sorry, even desperate, for this distant relation of mine acting like a trapped rabbit, and so I finally broke the habit.

There was no sign of Füsun.

37

The Empty House

AT THE end of August, as flocks of storks flew over the Bosphorus, the house in Suadiye and the Princes' Islands, leaving Europe to fly for Africa, we decided, at my friends' steady insistence, to go ahead with the end-of-summer party I was in the habit of giving in the empty

apartment in Teşvikiye Avenue just before my parents' return from their summer home. Sibel busied herself with the shopping, shifted the tables around, took the carpets out of mothballs and rolled them out over the parquet floors, and instead of going to help her, I again dialed Füsun's home number for old times' sake. For a few days now it had been ringing and ringing without answer, and that had worried me. This time, when I heard the broken tones that indicated the line was cut off, the pain in my stomach spread to every part of my body, every part of my mind.

Twelve minutes later, having passed through streets I'd been evading studiously since marking them in orange, I found myself walking like a wraith toward Füsun's family's house in Kuyulu Bostan Street. Looking up at the windows from a cautious distance, I could see that the curtains were gone. I rang the doorbell; no one answered. I knocked gently on the door before pounding it, and still no one answered, and I thought I was going to die. "Who's there?" cried the janitor's old wife from the dark basement apartment. "Haaa, the people in number three, they've moved. Those people have left."

I told her I was interested in renting the apartment. Slipping her twenty lira, I used her key to let myself in. Dear God! How can I describe the loneliness of those empty rooms, or the state of the crumbling tiles in that tired and disintegrating kitchen, the dilapidated tub in which my lost love had bathed throughout her life, the mystery of the gas heater that had scared her so, the bare nails in the wall, and the shadows where for twenty years frames and mirrors had hung? The scent of Füsun in the rooms, the shadow falling in a corner, the layout of this house where Füsun had spent her whole life, these rooms that had made her the person she was, the walls and the flaking paint—I lovingly imprinted all these details in my memory. There was this wallpaper, of which I tore off a large piece to take with me. And the handle of the door to the small room I assumed had been hers—thinking about her hand grasping this handle for eighteen years, I pried it off and dropped it into my pocket. The porcelain handle of the toilet chain in the bathroom came loose even more easily.

From the heap of discarded papers and rubbish in the corner, I extracted the arm of a baby doll that had once been Füsun's. I slipped that into my pocket, along with a large mica marble and a few hairpins

that I had no doubt were hers. Imagining the comfort I would eventually extract from these things in privacy, I relaxed. Why, I asked the janitor's wife, had the tenants chosen to leave after so many years? She said they had been haggling with the owner over the rent for ages. "It's not as if rents are lower in other neighborhoods," I said. Money was losing value, and prices were going up.

"So where did these people move to?" "We don't know," said the janitor's wife. "They were cross with us when they left, and with the owner. Imagine, after twenty years, such a falling-out." I felt I would suffocate on the spot.

It was then that I realized how I had always depended on the hope that one day I would come here, ring their doorbell, plead my way in, and see Füsun. Now that I'd been robbed of this chance I had not even realized I was counting on, I didn't know where I would turn next.

Eighteen minutes later I was in the Merhamet Apartments, lying on our bed, finding such relief as I could from the new objects recovered from the empty apartment. Sure enough, these things that Füsun had touched, these objects that had made her who she was—as I caressed them, and gazed at them, and stroked them against my shoulders, my bare chest, and my abdomen—released their analgesic and soothed my soul.

38

The End-of-Summer Party

MUCH LATER, and without first stopping off at the office, I did go to Teşvikiye to help with the preparations. "I was going to ask you what to do about the champagne," said Sibel. "I rang the office a few times, but every time they said you weren't there."

Offering her no explanation, I went directly to my bedroom. I remember lying on my bed, and thinking how unhappy I was, and feeling the party was doomed. By dreaming of Füsun, by conjuring with her things and taking consolation in them, I had sacrificed my self-

respect, even as my distracted dreaming opened the door to another world that I wanted to explore more fully. The party that Sibel was so vigorously preparing required a rich, intelligent, cheerful, healthy man as host, one who knew how to take his pleasures, but I was in no condition to play that role. And there was no getting away with playing the sullen twenty-year-old, scowling and contemptuous, at a party in my own house. Sibel might be prepared to tolerate the effects of my nameless illness, but I could not expect such indulgence from our guests, eager for fun at the last party of summer.

At seven that evening I ushered the first guests to the bar we had set up—it was fully stocked with all the requisite foreign liquor bought under the counter from the city's delicatessens—and like a good host, I offered them drinks. I remember occupying myself with the music for a time, and that I played *Sergeant Pepper*—I liked the cover—and Simon and Garfunkel. I danced—and laughed—with Sibel and Nurcihan. In the end, Nurcihan had chosen Mehmet over Zaim, but Zaim didn't seem to mind. When Sibel told me, with a frown, that she thought Nurcihan had slept with Zaim, I could not understand why my fiancée was so upset by that, but I didn't even try. There was beauty to behold in the world, that was all there was to it: the summer night was cooled by the north wind blowing off the Bosphorus, rustling the leaves of the plane trees in the courtyard of the Teşvikiye Mosque, and causing them to whisper in that lovely soft way I remembered from childhood; and at nightfall the swallows were screeching as they swooped over the dome of the mosque and the rooftops of the 1930s apartment buildings. As the sky grew darker still, I could begin to see the flickering lights of television sets in the homes of those who had not fled the city for the summer, among them a bored girl on one balcony and, sometime later, on another balcony, an unhappy father, gazing absently at the traffic in the avenue below. But as I watched all this listlessness, I felt as if I were watching my own feelings, and I was frightened by the thought that I might never be able to forget Füsun. As I sat there on our balcony, enjoying the cool evening, listening to the vivacious chatter of those who joined me from time to time, I drank like a fish.

Zaim had arrived with a lovely girl who was in high spirits because she had scored very high on the university entrance exam. Her name was Ayşe; I made pleasant conversation with her. I drank with a friend

of Sibel's—a shy fellow who worked as a leather exporter and could really hold his *rakı*. Long after the sky had turned a velvety black, Sibel said, "You're being rude. Come inside for a while." Wrapping our arms around each other, embracing each other with all our strength, we danced that hopeless dance of ours, which to others looked so romantic. We'd turned off a few lights, so that it was dim in the sitting room, giving the apartment, in which I had spent my entire childhood, and indeed most of my life, the aspect and colors of a very different place; with this image came the idea of an entire world snatched away from me, and I embraced Sibel even more desperately as we continued dancing. Because so much of my misery that summer had infected my lovely fiancée—along with my drinking habits—she was as unsteady as I was.

In the parlance favored by the gossip columnists of the day, "as the evening progressed, under the effect of alcohol," the party got out of hand. Glasses and bottles were broken, 45s and 33s destroyed, some couples who had fallen under the influence of European magazines began to kiss openly, or went into my or my brother's bedroom, allegedly to make love, but possibly to pass out, and it was as if this group of young rich friends was in a collective panic, afraid that their youth, and their aspirations to be modern, would soon come to an end. Eight or ten years earlier, when I'd begun giving these end-of-summer parties, they'd been anarchic affairs, fueled by anger toward our parents; my friends would fiddle with our pricey kitchen appliances, often breaking them; they would go through my parents' cupboards, pulling out old hats, perfume spray bottles, electric shoe buffers, bow ties, and dresses, convinced all the while that their destructive energy was political, and so enjoying it all the more.

In the years that followed, only two members of this large crowd took to politics in a serious way; one would be tortured by the police in the aftermath of the 1971 coup, and remain in prison until the 1974 amnesty; and it is likely that both of them dismissed the rest of us as "irresponsible, spoiled, and bourgeois," but for whatever reason, they cooled to our company and lost touch.

Now, as dawn approached, and Nurcihan went through my mother's drawers, it was not out of anarchic anger, but a womanly curiosity, expressed with refinement and no small degree of respect.

"We're going to Kilyos for a swim," she told me solemnly. "I was just checking to see if your mother had a swimsuit." Suddenly flooded with intense remorse and pain for never having taken Füsun to Kilyos, where she had so longed to go, it was all I could do to collapse onto my parents' bed. From where I lay, I could see drunken Nurcihan pretend to look for a swimsuit as she covetously fingered my mother's embroidered stockings from the 1950s, the elegant umber lace-up corsets, and the hats and scarves that she had not exiled to the Merhamet Apartments. Also passing through Nurcihan's appreciative hands were the titles for all the houses, apartments, and lots that we owned, and that my mother kept in a drawstring pouch in her stockings drawer, because she didn't trust the bank's safe deposit box, and piles and piles of keys to locks unknown, apartments that had been sold or rented out. There was also a thirty-six-year-old clipping from a gossip column, featuring my parents' wedding, and another from the society pages of *Hayat* magazine, dated twelve years later, with my mother looking very chic and attractive at a party. "How lovely your mother was, she was such an interesting woman," Nurcihan said. "She's still alive," I said, still lying like a corpse on the bed, and thinking how wonderful it would be to spend the rest of my life with Füsun in this room. Nurcihan let out a sweet and happy laugh, and it was this, I think, that drew Sibel into the room, followed soon after by Mehmet. Sibel and Nurcihan went through the rest of my mother's things with drunken ceremony, while Mehmet sat on the bed (in just the place where my father would sit in the morning, staring absently at his toes before putting on his slippers), gazing at Nurcihan with love and admiration. He was so very happy, having, for the first time in years, fallen head over heels in love with a woman he could marry, and it seemed to come as a shock to him, as if he were ashamed of being that happy. But I did not envy him, because I sensed an overwhelming fear of being deceived—the ever-lurking possibility that things would come to a bad and degrading end—and regret.

Here I display a number of the items Sibel and Nurcihan were extracting from my mother's drawers with such care. From time to time they laughed, reminding each other that they were meant to be searching for swimsuits.

The search for swimsuits and the discussions about going to the

beach went on until first light. In fact no one was sober enough to drive. I knew that drink and sleeplessness, together with my anguish about Füsun, would overwhelm me at Kilyos, so I wasn't about to go. Promising that Sibel and I would follow afterward, I dragged my feet until the others were ready to leave. At sunrise I went out to the balcony where my mother drank coffee and watched funerals, and I waved and shouted down to my friends below. Standing on the street were Zaim and his new girlfriend, Nurcihan and Mehmet, and a few others, all drunkenly carousing, tossing around a shiny red plastic ball, running after it whenever it escaped their grasp, making enough noise to wake up all of Teşvikiye. When the doors of Mehmet's car finally slammed shut, I saw the old people walking slowly toward Teşvikiye Mosque for morning prayer. Among them was the janitor from the apartment across the street, who dressed up as Father Christmas on New Year's and sold lottery tickets. Just then, Mehmet's car took off, its tires squealing, before skidding to an abrupt halt, going into reverse, and stopping again; the door opened, and Nurcihan stepped out of the car, calling up to us on the sixth floor that she had left behind her silk scarf. Sibel ran inside, and in no time brought the scarf out to the balcony, and threw it down to the street. I shall never forget standing there with Sibel on my mother's balcony, watching the purple scarf's slow descent, as it swayed like a kite in the light breeze, opening and closing, puffing up and twisting. This is my last happy memory of my fiancée.

39

Confession

WE HAVE now come to the confession scene. It was my express desire that all the frames, backgrounds, everything in this part of my museum be painted a cold yellow. Yet it wasn't long after our friends had left for Kilyos, and I had returned to my parents' bed, that a giant sun rose from behind the hills of Üsküdar, casting a deep orange glow over the spacious bedroom. The echo of a ship's horn rose from the Bosphorus.

"Come on," said Sibel, sensing my lack of enthusiasm, "let's not stay here forever. Let's try to catch up with them." But seeing how I lay there, she knew I was not fit to go to the beach (though it had not crossed her mind that I was too drunk to drive); and that was not all: She sensed that my mysterious illness had brought us to the point of no return. I could tell that she wanted to avoid discussing it, because she kept averting her eyes from mine. But in the way that people will sometimes confront their worst fears without forethought (some call this courage), she was the one to broach the subject.

"Where were you actually, yesterday afternoon?" she asked. But she regretted the question at once, adding sweetly, "If you think this is going to be embarrassing for you later on, if you don't want to tell me, then don't."

She lay down next to me on the bed, pawing me like an affectionate kitten, with such compassion but trepidation, too; sensing that I was about to break her heart, I felt ashamed. But the djinn of love had escaped Aladdin's lamp and was prodding me, telling me that I could no longer keep this secret to myself.

"Do you remember that evening in early spring, darling, when we went to Fuaye?" I began with these harmless, careful words. "You saw that Jenny Colon bag in a shop window, and as we passed you said you liked it. We both stopped to look at it."

My darling fiancée knew at once that this was about more than a handbag—that I was about to speak of something real and serious; as her eyes widened, I told her the story that readers will recall and visitors to the museum have known since viewing the very first object on exhibit. Nevertheless, displayed here is a series of small pictures of the most important objects; it will, I hope, serve as an aide-mémoire for visitors making their way through the extensive collection, or for those who are so impetuous as not to start at the beginning.

I told Sibel the story in careful chronological order. As I launched into the painful tale of my first encounter with Füsun, and the relationship that followed, my remorse was palpable, as was the aura of atonement; this endowed my lapse with the gravity of a great sin. But I may well have been the one to add these colors to my story, so as to lighten the tone of my rather ordinary crime, and to suggest I was talking about something from the distant past. Having, of course, omitted the

details of sexual bliss at the heart of my tale, I made it sound like a typical Turkish man's silly indiscretion on the eve of his marriage. I could not, seeing Sibel's tears, continue with my original aim—to be straight with her—and I was sorry for having brought it up at all.

"You're a disgusting person, and it's only now I can see it," said Sibel. Picking up an old bag of my mother's—rose-printed, and full of her loose change—Sibel hurled it at me, and next came one of my father's summer spectator shoes. Neither projectile hit its mark. The loose change went flying across the floor like broken glass. Tears were streaming from Sibel's eyes.

"I broke this off ages ago," I said. "But I was destroyed by what I did. . . . This feeling has nothing to do with this girl or anyone else."

"This is the girl whose table we visited at the engagement party, am I right?" Sibel asked, too afraid to mention her by name.

"Yes."

"She's a common shopgirl. She's disgusting! Are you still seeing her?"

"Of course I'm not. . . . Once we were engaged, I broke it off. And she has gone missing. I hear she married someone else." (Even now, I am shocked that I could throw out this lie.) "This was why I was so withdrawn after the engagement, but that's all over now."

Sibel would cry a little, and then she would wash her face, pull herself together, and ask me more questions.

"So you can't get over her, is that it?" This was how my clever fiancée summed up the truth in her own words.

What man with a heart could answer this question in the affirmative? "No," I said reluctantly. "You don't understand. To have treated a girl so badly, to have deceived you and broken our trust, to carry all this in my conscience, it wore me down. It took all the joy out of life."

Neither of us believed what I was saying.

"Where were you after lunch yesterday?"

How I longed to tell someone—someone who would understand, someone other than Sibel—of having taken mementos of her into my mouth, how I had rubbed them against my skin, and how, as I did so, I conjured up images of her and burst into tears. All the same I was sure that if Sibel left me, I would lose my mind. What I needed to say was, Let's get married right away. There were countless solid marriages—

marriages that were the bedrock of our society—that had been made in an effort to forget stormy and unhappy love affairs.

"I wanted to play around with some of my childhood toys before we got married. I had a space gun, for example. . . . It was still working. I guess you could call it a strange sort of nostalgia. That's what I was doing there."

"You are never to go back to that apartment again!" said Sibel. "Did you meet her there often?"

Before I could answer, she started sobbing. When I took her in my arms and caressed her, she cried even harder. As I embraced my fiancée I felt a deep gratitude—and an amity that was deeper than love; I treasured our closeness. After Sibel had cried for a very long while and dropped off to sleep in my arms, I, too, nodded off.

It was almost noon when I awoke; Sibel had been up for a good while, had showered and put on her makeup and even prepared my breakfast in the kitchen.

"If you want you can go buy some bread from the shop across the street," she said in a cool voice. "But if you don't have the energy, I can slice the stale bread and toast it."

"No, I can go," I said.

We had breakfast in the sitting room, which after the party looked like a war zone, at the table where my parents had sat across from each other for more than thirty years. Here I display an exact replica of the loaf I bought from the grocery store across the street. Its function is sentimental, but also documentary, a reminder that millions of people in Istanbul ate no other bread for half a century (though its weight did vary) and also that life is a series of repeated instances that we later assign—without mercy—to oblivion.

That morning Sibel was strong and decisive in a way that shocks me even today. "This thing you thought was love—it was just a passing obsession," she said. "I'll look after you. I'll rescue you from this nonsense you got mixed up in."

She'd used a lot of powder to conceal the puffiness under her eyes. To see her choosing her words so carefully, so as not to hurt me, even though she was in terrible pain herself—to feel her compassion—made me trust her all the more, and so certain was I that only Sibel could deliver me from my agony, that I decided then and there to agree

to whatever she said. And so it was while we ate our breakfast of fresh bread, white cheese, olives, and strawberry jam that we agreed to leave this house and to stay away from Nişantaşı, these neighborhoods and streets, for a long while. The orange zone and red zone prohibitions were now in full force.

Sibel's parents had by now returned to their house in Ankara for the winter, and so the *yalı* in Anadoluhisarı was empty. They would turn a blind eye on our staying there alone together now that we were engaged, of this she was certain. I was going to move there with her at once, abandoning all the habits that had kept me in thrall to my obsession. As I packed my bags, I felt sad but also hopeful of recovery, like a lovesick girl dispatched to Europe. I remember that when Sibel said, "Take these, too," throwing a pair of winter socks into my suitcase, I was struck by the painful thought that my cure might take a very long time.

40

The Consolations of Life in a Yalı

I WAS EXUBERANT at the thought of beginning anew, and greatly soothed by the consolations of life in a *yalı*, so much so that during the first few days I convinced myself that a rapid recovery was in prospect. No matter what amusements we'd partaken in on the previous evening, no matter how late we'd come back, and no matter how much I'd had to drink, in the morning, as soon as the light began to stream through the gaps in the shutters, casting its strange reflections of Bosphorus waves onto the ceiling, I would arise to throw open the shutters, each time amazed at the beauty that rushed in, that almost exploded, through the window. There was, in my amazement, the elation that comes only from a reawakening, a discovery of life's forgotten beauties—or so I wished to believe. The ever-perspicacious Sibel, sensing that mood, would come to my side in her silk nightgown, the wooden floorboards creaking lightly under her bare feet, and together we would admire the

beauty of the Bosphorus, and the red fishing boat bobbing in the waves as it passed by, and the mist rising above the dark wooded hills on the opposite shore, and the way the first ferry of the morning listed in the current as it cut through the water, hissing like a ghost.

Sibel, too, became a believer in the idea that the pleasures of *yalı* life would be curative. As we sat at the bay window overlooking the water, eating our evening meal like a couple who were able to live on nothing but love, the City Line ferry named *Kalender* would leave the Anadoluhisarı landing stage, and there at the wheel we would see the mustached captain with his cap; so close that he could see the crackling mackerel at our table, and the eggplant purée and fritters, the white cheese, the melon and *rakı,* he would cry, "Good appetite," which Sibel took for yet another charming ritual bound to advance my cure and make us happy. In the morning, as soon as we awoke, my fiancée and I would jump into the cool waters of the Bosphorus; we would go to the Ferry Station Coffeehouse for tea with *simit*s—sesame rolls—and to read the paper; we would cultivate the peppers and tomatoes in the garden; toward noon we would rush over to the fishing boats just returned with fresh fish to buy gray mullet and sea bream, and on very warm September evenings when not a leaf would rustle, when, one by one, the moths flew too close to the lights, we would splash once again in the sea now sparkling phosphorescent. Sibel's faith that these rituals would heal me was clear when, in bed at night, she would gently drape her fragrant body around me as if changing the dressing on a wound. When the shooting pains in my stomach stopped me from making love to Sibel, I would awkwardly laugh it off, saying, "We're not married yet, dear," and my darling fiancée would laugh along to soothe my unease.

Sometimes, after whiling away the night alone in a chaise longue on the terrace, or gorging on a boiled cob of corn bought from a vendor in a rowboat, or having planted two kisses on Sibel's cheeks like any young husband getting into the car in the morning on the way to work, I could see in Sibel's eyes a certain contempt, a budding hatred. Certainly my failure to make love to her was a cause, but there were more frightening reasons: Could Sibel have been thinking that her extraordinary show of love and restraint in the hope of "making me better" had come to nothing, or even worse, that, once cured, I would continue to see Füsun after our marriage? In my worst moments, I, too, wanted to

believe in this last possibility, dreaming that one day I would receive news of Füsun, which would permit an immediate return to the happy routine of old. Our daily meetings in the Merhamet Apartments, while furnishing the ultimate remedy for the pain of love, would, of course, enable me also to make love to Sibel as before, in which state we would go on to marry and have children, enjoying the full blessings of normal family life.

But it was only when I had lifted my spirits by drinking heavily or when a beautiful morning inspired hope that I could entertain such dreams, and even then rarely so. More typically she crowded out every other thought in my mind, and by now the pain of love was caused not so much by Füsun's absence but by the more abstract prospect of agony without end.

41

Swimming on My Back

TO BE SURE, those painful September days had their dark beauty, and as the month wore on I discovered an important new way of making them bearable: If I swam on my back, the pain would ease. To make this happen, I had to throw my head very far back to the point where I could see all the way to the bottom of the Bosphorus, but upside down, and I had to carry on swimming in this attitude for some time without coming up for air. As I backstroked through the current and the waves, I would open my eyes to see the inverted Bosphorus changing colors, fading into a blackness that awakened me to a vastness altogether different from the boundless pain of love—offering me a glimpse of a world without end.

Because the Bosphorus is so deep so close to the shore, there were times when I could see the bottom and times I couldn't, but to glimpse this brilliantly colored realm, albeit upside down, was to see a great, mysterious whole, at whose sight one could not but rejoice to be alive, humbled at the thought of being part of something greater. Gazing

down at the rusty cans, the bottle caps, the gaping mussels, and even the ghosts of ancient ships, I would contemplate the vastness of history and time, and my own insignificance. At times like these I would notice that I could enjoy concentrating on my love and being absorbed by it. Exposed, and grieving ever more deeply, I could cleanse my soul.

What mattered was not my pain, but my connection with this mysterious infinity shimmering beneath me. As the waters of the Bosphorus poured into my mouth, my throat, my ears, my nostrils, I could tell that the djinns inside me, governing equilibrium and happiness, were well pleased. A sort of sea drunkenness would overtake me as I propelled myself backward, stroke after stroke, until there was no pain in my stomach at all. I would feel a deep compassion for Füsun welling up inside me at that same moment, and this reminded me of how much anger I felt, too.

Seeing me racing backward toward a Soviet oil tanker or a City Line ferry anxiously tooting its horn, Sibel would jump up and down on the shore, frantically calling to me, but most of the time I would not hear her cries. In this habit of swimming so dangerously close to the steady procession of City Line ferries, international oil tankers, cargo ships laden down with coal, passenger boats, and barges distributing beer and Meltem to the Bosphorus restaurants, almost as a challenge to those vessels great and small, Sibel saw an unhealthy impulse and in her heart she wanted me to stop bobbing backward in the Bosphorus in front of the house, but knowing what good it did chasing away the pain, she didn't insist. Rather, sometimes she would suggest I take myself to a secluded beach, or on windless days, when the sea was calm, to Şile Beach on the Black Sea, or else go with her to one of the empty coves beyond Beykoz, and without taking my head out of the water, I could swim as far as my thoughts would take me, with no end in sight. Later, when I had swum back to shore and lay exhausted under the sun with my eyes closed, I would entertain the hopeful thought that all serious and honorable men who happened to fall passionately in love went through the same things as I did.

Still, there was one unsettling difference: The mere passage of time brought me none of the healing it seemed to offer everyone else. Despite Sibel's tireless encouragement during our silent nights together (when all that could be heard was the gentle putter of a barge passing in

the distance), we were both daunted by the awareness that my pain would not simply ebb away. Sometimes I sought escape by willing myself to see this agony as a figment of my imagination or as proof of spiritual frailty, but to be cast in this light, as helplessly dependent on the mercy of a redeeming mother-angel-lover, was itself unbearable, so most of the time I could do nothing but continue to master the pain in the only way I knew, by swimming on my back, though I knew full well that I was deceiving myself.

During the month of September I went three times to the Merhamet Apartments, hiding each visit from Sibel and, in a way, from myself, each time lying on the bed and touching things Füsun had touched, enacting the consolatory rituals already known to my readers. I could not forget her.

42

The Melancholy of Autumn

IN THE early days of autumn, after a storm had blown in from the north, the fast-moving waters of the Bosphorus were too cold for swimming, and my melancholy had soon darkened beyond the point at which I could still hide it. Night was falling earlier each day, and all at once the shore and the back garden were carpeted with leaves; the *yalı* apartments that served as summer homes fell empty; rowboats were pulled out of the sea, and after the first days of rain, overturned bicycles littered the suddenly empty streets, and for us a deep autumn gloom set in. With growing panic, I sensed that Sibel would soon be unable to bear my apathy or the misery that could no longer be concealed or consoled, or the consequence that I was now drinking like a fish.

By the end of October, Sibel had had her fill of the rusty water that poured from the old taps, the dankness of the ramshackle kitchen, the *yalı*'s leaks and drafty cracks, and the icy north wind. Gone were the friends who had dropped by on hot September evenings, getting drunk

and giddily jumping into the sea from the dark landing, now that there was more fun to be had in the autumn in the city. Here I display the damp and broken stones of the back garden and the shells of snails that crawled over them, along with our solitary friend, the panicky lizard (now petrified), who disappeared during the rains—all represent the abandonment of *yalı* life by the nouveaux riches with the approach of winter, and the attendant melancholy of the season.

It was clear by now that any decision to stay on in the *yalı* with Sibel for the winter depended on my proving to her sexually that I had forgotten Füsun, but as the weather grew colder, we struggled to heat the high-ceilinged bedroom, we each grew more withdrawn and hopeless, and on the few nights when we were moved to embrace, it was only in camaraderie and compassion. Despite our express contempt in ordinary days for those who used electric heaters in wooden *yalıs*—those irresponsible philistines who subjected combustible historical buildings to risk—every evening, when we began to feel cold, we would plug that infernal device into the deadly socket. At the beginning of November, when we knew the heat had come on in our winter homes, we grew curious about the autumn parties we might be missing in town, and the new nightclub launches, and the old haunts that had been renovated, and the crowds gathering outside cinemas, so we began to make excuses for returning to Beyoğlu, and even Nişantaşı, and the streets from which I was banned.

One evening, while in Nişantaşı for no good reason, we decided to stop off at Fuaye. We ordered *rakı* on the rocks, which we drank on empty stomachs, and exchanged greetings with the waiters we knew, speaking at length with Haydar and the headwaiter, Sadi, and like everyone else we complained about the ultranationalist gangs and leftist militants who were throwing bombs right, left, and center, bringing the country to the brink of disaster. As always, the elderly waiters were much more circumspect than we were about enlarging on politics. As we saw people we knew coming into the restaurant, we gave them welcoming looks, but no one came over. In a mocking tone Sibel asked why my mood had suddenly dropped again. Without having to exaggerate too much, I explained that my brother had patched things up with Turgay Bey, and that they were starting up a new business, with room for Kenan—how I regretted never having found a way to fire

him—and this lucrative new enterprise taken together with my reaction to Turgay Bey would now furnish a pretext to exclude me.

"Kenan—is he the Kenan who was such a good dancer at the engagement party?" Sibel, I knew, was using the words "good dancer" as a way to allude obliquely to Füsun without mentioning her name. Both of us recalled the engagement party with some pain, and being unable to find an excuse to change the subject, we fell silent. This was a change. During the early days, when the reasons for my "illness" had first come to light, Sibel, even at the worst moments, had shown a lively and robust talent for changing the subject.

"Is this Kenan now to be the director of the new firm?" asked Sibel in the sarcastic voice that she'd slowly been cultivating. As I looked sadly at her hands, which were trembling, and at her heavily made-up face, it occurred to me that Sibel had changed from a healthy Turkish girl with the veneer of a French education into a cynical Turkish house-wife who had taken to drink after becoming engaged to a difficult man. Was she needling me because she knew I was still jealous of Kenan on account of Füsun? A month ago, such a suspicion would not have crossed my mind.

"They're resorting to trickery just to make a bit of loose change," I said. "It's not worth thinking about."

"There's more than a bit of loose change at stake—this could be quite lucrative, you know, or your brother wouldn't bother. You shouldn't sit by and let them exclude you, or deny you your share. You have to stand up to them, challenge them."

"I don't care what they do."

"I don't like this attitude," said Sibel. "You're letting everything go, you're withdrawing from life; it's almost as if you enjoy being ground down. You have to be stronger."

"Should we order two more?" I said, lifting my glass with a smile.

As we waited for the drinks to arrive, we stayed silent. Between Sibel's eyebrows appeared a furrow that always reminded me of a ques-tion mark, and told me she was annoyed or angry.

"Why don't you ring Nurcihan and company?" I said. "Maybe they'd like to join us."

"I just checked, but the pay phone here is broken," said Sibel in an angry voice.

"So, what did you do today? Let's see what you bought," I said. "Open those packages of yours. Let's have a little fun."

But Sibel was not in the mood for opening packages.

"I am quite sure that you could not be as in love with her now as you were," she said, with a startling airiness. "Your problem is not that you're in love with another woman—it's that you are not in love with me."

"If that were so, then why am I always at your side?" I said, taking her hand. "Why is it that I don't want to go through a day without you? Why am I always here, holding your hand?"

It wasn't the first time we'd had this discussion. But this time I saw a strange light in Sibel's eyes, and I feared that she would say: "Because you know that left alone you wouldn't be able to bear the pain of losing Füsun, and that it might even kill you!" But luckily Sibel still didn't realize that the situation was quite that bad.

"It's not love that keeps you close to me; it just allows you to continue believing you have survived a disaster."

"Why would I need that?"

"You've come to enjoy being the sort of man who is always in pain and turns his nose up at everything. But the time has come for you to pull yourself together, darling."

I made my usual solemn assurances—that these difficult days would pass, that in addition to two sons, I was hoping we'd have three daughters who would look just like her. We were going to have a big, wonderful, happy family; we would have years and years of laughter, and lose none of the pleasures of life. To see her radiant face, to listen to her thoughtful words, to hear her working in the kitchen—these things gave me no end of joy, I told her, and made me glad to be alive. "Please don't cry," I said.

"At this point, it doesn't seem to me as if any of these things could ever come true," said Sibel as the tears began to flow faster. She let go of my hand, picked up her handkerchief, and wiped her eyes and her nose; then she took out her compact and dabbed a great deal of powder under her eyes.

"Why have you lost faith in me?" I asked.

"Maybe because I've lost faith in myself," she said. "I've even lost my looks—that's what I think now sometimes."

I was squeezing her hand and telling her how beautiful she was when a voice said, "Hello, young lovers!" It was Tayfun. "Everyone's talking about you—did you know that? Oh dear, what's wrong?"

"What are people saying about us?"

Tayfun had come to visit us at the *yalı* many times in September. When he saw Sibel had been crying, all the jolliness left his face. He wanted to leave the table, too, but seeing Sibel's expression, he was paralyzed.

"The daughter of a close friend died in a traffic accident," said Sibel.

"So what was it everyone was saying about us?" I asked mockingly.

"My condolences," said Tayfun, looking left and right in search of an escape, and finally shouting in an overloud voice at someone who had just walked in. Before peeling himself away, he said, "People have been saying that you are so in love it's got you worried that marriage might kill it, as happens with so many Europeans, and that, because of this, you're thinking of not getting married. If you ask me, you should just get married. Everyone is just jealous of you. There are even people saying this *yalı* of yours is unlucky."

As soon as he was gone we ordered more *rakı*. All summer long Sibel had ably masked my "illness" from others with invented excuses, but there was no way forward. Our decision to live together before marriage had become fodder for gossip. It had been noted, too, that Sibel had begun needling me and making jokes at my expense and that I'd begun to swim great distances on my back, and, of course, there was the ridicule of my low spirits for some to savor.

"Are we going to call Nurcihan and company and ask them to join us, or should we order our food?"

Sibel seemed anxious. "You go find a telephone somewhere and call them. Do you have a token?"

Among those taking an interest in this story fifty or a hundred years on, there might be a temptation to turn up their noses at Istanbul circa 1975, when there was still a shortage of running water (obliging even the richest neighborhoods to be supplied water by private trucks), and where the phones rarely worked. In an effort to elicit reflective sympathy rather than reflexive disdain, I have displayed a telephone token with serrated edges that could be bought in those days at any tobac-

conist's. During the years when my story begins, there were very few phone booths in the streets of Istanbul, and even if they had not been vandalized, they were usually out of order. I do not recall being even once able to make a call from a PTT phone booth during that entire period. (Such success was only managed, it seemed, in Turkish films, whose stars copied what they saw done in Western films.) However, one clever entrepreneur had managed to sell metered phones to grocery stores, coffeehouses, and other outlets; it was by using these that our needs were met. I offer these details as explanation of why I was obliged to go from shop to shop in the streets of Nişantaşı. Finally, in a lottery ticket outlet, I found a phone not in use. But Nurcihan's phone was busy, and the man wouldn't let me make a second attempt to call, and some time had passed before I was able to ring Mehmet from a phone in a florist's. I found him at the house with Nurcihan, and he said they would join us at Fuaye in half an hour.

By going from store to store, I had arrived at the heart of Nişantaşı. It occurred to me that being this close to the Merhamet Apartments, I might as well see if I could do myself some good by dropping in for a brief while. I had the key with me.

As soon as I entered the apartment, I washed my face and hands, and carefully removed my jacket, like a doctor preparing for an operation. Sitting shirtless on the edge of the bed where I had made love to Füsun forty-four times, and surrounded by all those memory-laden things (three of which I display herewith), I spent a happy hour caressing them lovingly.

By the time I got back to Fuaye, Zaim was there as well as Nurcihan and Mehmet. As I gazed upon the genial chatter of Istanbul society, and all the bottles, ashtrays, plates, and glasses on the table, I remember thinking how happy I was, and how much I loved my life.

"Friends, please excuse me for the delay. You'll never guess what happened to me," I said, as I tried to think up a good lie.

"Never mind," said Zaim sweetly. "Sit down. Forget the whole thing. Come and be happy with us."

"I'm already happy, actually."

When I came eye to eye with the fiancée I was about to lose, I saw at once that, drunk as she was, she knew exactly what I'd been up to and had finally decided I was never going to recover. Though furious, Sibel

was in no condition to do anything about it. And even when she sobered up, she would not make a scene—because she still loved me, and because the prospect of losing me still terrified her, as did the socially disastrous consequences of breaking off the engagement. This might explain why I felt even then a strong bond with her, although perhaps there were other reasons that I still did not understand. Perhaps, I reasoned, this enduring attachment would restore her faith in me, and she would return to believing in my eventual recovery. For that night, however, I felt that her optimism had run out.

For a while I danced with Nurcihan.

"You've broken Sibel's heart. She's very angry at you," she said as we danced. "You shouldn't leave her sitting alone in restaurants. She's so in love with you. She's also very sensitive."

"Without thorns, the rose of love has no fragrance. When are you two getting married?"

"Mehmet wants us to marry right away," said Nurcihan. "But I just want to get engaged first as you two did—and have a chance to enjoy love a bit before we settle into marriage."

"You shouldn't use us as your model, not to that extent, anyway. . . ."

"Why—are there things I don't know?" said Nurcihan, trying to hide her curiosity behind a fake smile.

But I paid her no mind. The *rakı* was easing my obsession from a strong, steady ache into an intermittent specter. I remember that at a certain point in the evening, Sibel and I were dancing, and, like a teenage lover, I made her promise never to leave me, and she, impressed by the ardor of my pleas, tried sincerely to allay my fears. Many friends and acquaintances stopped by our table, inviting us to join them elsewhere when we had tired of Fuaye. Some wanted to play it safe and drive out to the Bosphorus for tea, others were saying we should go to the tripe restaurant in Kasımpaşa, there were even those proposing we all go to a nightclub to listen to Turkish classical music. There was a moment when Nurcihan and Mehmet wrapped their arms around each other with exaggerated abandon and amused everyone as an instantly recognizable impression of the romantic dance that Sibel and I were given to dancing. At daybreak, and in spite of pleas from a friend leaving Fuaye with us, I insisted on driving. Seeing how I was

drifting back and forth across the road, Sibel began to scream, so we took a car ferry to the other side. At dawn, as the ferry approached Üsküdar, we both fell asleep in the car. A sailor woke us by pounding on the window, because we were blocking food trucks and buses. We made our way along the shore, under ghostly plane trees shedding their red leaves, reaching the *yalı* without incident, and, as we always did following our all-night adventures, we wrapped our arms tightly around each other and drifted off to sleep.

43

Cold and Lonely November Days

IN THE days that followed, Sibel didn't even ask where in Nişantaşı I'd spent the hour and a half that I'd gone missing, but there was little room for doubt. After that night we had both become resigned to the fact that I was never going to get over my obsession. It was clear that strict regimens and prohibitions had been useless, though we still enjoyed living together in this once grand, now crumbling *yalı.* However hopeless our situation, there was something about this decrepit house that bound us together and made our pain bearable by endowing it with a strange beauty. The *yalı* added gravity and historical depth to this doomed love of ours; our sorrow and defeat were so great that the vestigial presence of a vanished Ottoman culture could furnish what we had lost as old lovers, as a newly engaged couple. The world evoked protected us somehow from the pain we felt at being unable to make love.

If, of an evening, we set up our table beside the sea—and, resting our arms and our elbows against the iron balcony rail, drank Yeni Rakı together and found our spirits lifting—I would sense from the way Sibel looked at me that in the absence of sex the only thing that could bind us together was marriage. Weren't there plenty of happy married couples—not just in our parents' generation but in our own—who led chaste lives together, as if everything were normal? After our third or

fourth glass, we would play guessing games about young and old couples we knew—sometimes from a distance, sometimes more intimately—asking each other, "Do you think they still do?" and giving the question half-serious consideration. Our mockery, which now seems so very painful to me, owed a great deal, no doubt, to a dubious supposition that we would soon be returning to a satisfying love life. In our strange complicity and in these conversations that walled us off from the outside world, there was the veiled aim of convincing ourselves that we could marry in this condition, and peacefully await the return of that sex life of which we had once been so proud. At least Sibel would come to believe this, even on her most pessimistic days; swayed by my teasing, my jokes, and my compassion, she would grow hopeful, and content, even sitting on my lap, as if to trigger a reaction. In my more hopeful moments I, too, would feel the thing I thought Sibel was feeling, and it would occur to me to say that we must marry at once, but I held back, fearing that she might decline my proposal quickly and definitively, and then abandon me. For it seemed to me that Sibel was waiting for an opportunity to end our relationship with a retaliatory blow that would also restore her self-respect. Unable to accept that she had lost the lifetime of marital bliss that had stretched out before us only four months ago—that enviable, unsullied existence, rich with children, friends, and diverse amusements—she could not bring herself to strike first. In this way, we both derived emotional utility from the strange love that still bound us and for the time being, whenever in the middle of the night despair awoke us from the slumber that only drink can induce, we would continue the custom of wrapping our arms around each other, ignoring the pain as best we could.

From mid-November onward, whenever we awoke on a windless night—raw from misery, or thirst, because we'd had so much to drink—we began to hear a fisherman splashing around in his rowboat, just beyond our closed shutters, moving through the still waters of the Bosphorus, casting his net. Sometimes the boat would drift beneath our bedroom. Accompanying this quiet, soft-spoken fisherman was a slim little boy whose voice was sweet and who did everything his father asked. As the lamp hanging from their boat filtered through our shutters, casting a lovely glow on the ceiling, we could hear the sounds of their oars cutting into the silent water, and the water cascading through

their net as they lifted it from the sea, and at times only the boy's cough-
ing as the two went wordlessly about their work. We would wake up to
their arrival and clinging to each other we listened to them rowing five
or six meters from our bed, little knowing that we were in here listen-
ing; we heard them throw stones into the sea, to scare the fish into the
net, and on rare occasions they spoke: "Hold it tight, my son," the fish-
erman would say, or, "Pick up the basket," or, "Now backwater." Much
later, in the midst of the deepest silence, the son would say in his sweet
voice, "There's another one over there!" and Sibel and I lying enfolded
would wonder what the child was pointing at. Was it a fish, or a danger-
ous spike, or some sea creature we could only imagine from our bed? I
do not remember ever talking about the fisherman and his son during
the waking hours that followed. But at night we wafted between sleep
and wakefulness, sometimes hearing the fishing boat drift away after its
night's work and sometimes missing it we would nevertheless enjoy
without fail a precious interval of immense peace, as if there was noth-
ing to fear as long as we'd been visited by the fisherman and his son.

With every passing day, Sibel would resent me a bit more, entertain
a few more painful doubts about her beauty; each day her eyes would
well up more frequently, as our altercations and little tiffs and skir-
mishes became more unpleasant. It typically happened that Sibel would
give herself over to a gesture to make me happy, by baking a cake, per-
haps, or finding at a great price some marvelous coffee table for the
house, but when I, sitting there with a *rakı* in my hand, dreaming of
Füsun, would not respond in the way she had hoped, she would leave
and slam the door in fury; though I would sit where she had left me,
cursing myself for the shame that kept me from going after her to
apologize—and when I finally did, I would see that she was too far lost
to resentment.

If she broke off the engagement, society, noting how long we had
"lived together" without marrying, would look askance at Sibel. Sibel
knew full well that no matter how high she held her head, no matter
how "European" her friends were in their outlook, this affair would
not be seen as a love story if we did not marry. It would become the
story of a woman whose honor had been stained. Of course, we didn't
discuss these things, but she knew each passing day worked against her.

With the occasional visit to the Merhamet Apartments to lie down

on the bed and distract myself with Füsun's things, I sometimes felt better, and then I would fool myself into believing that my pain might pass and that this might give Sibel hope, too. There continued as well the evening outings, parties, and get-togethers with friends, which revived Sibel's spirits, if not mine, but none of it could revoke the invidious truth that, apart from the hours we spent very drunk, or the minutes we spent listening to the fisherman and his son, Sibel and I were very unhappy. It was during this time that—desperate to discover where Füsun was, and how she was—I pleaded with Ceyda, then about to give birth; I even offered her bribes, but she would only report that Füsun was somewhere in Istanbul. Would I have to search the city street by street?

At the beginning of winter, on one of our particularly cold and bleak days at the *yalı,* Sibel said she was mulling over a trip to Paris with Nurcihan. Nurcihan wanted to go at Christmastime to do some shopping and tie up loose ends before becoming formally engaged (and then married) to Mehmet. When Sibel showed an interest in going, I encouraged her, planning, once she had left, to move heaven and earth to find Füsun; I would search every corner of Istanbul, and if I failed, I would throw off this pain, this remorse that was breaking my will, and when Sibel returned, I would marry her. Sibel met my encouragement with due suspicion, but I told her that a change of scene and rhythm would do us both good, adding that when she returned we would pick up where we'd left off at the *yalı;* in the course of saying all this, I used the word "marriage" once or twice, though without too much emphasis.

In truth, I still assumed that I would marry Sibel, who was now ready to pin her hopes on the chance that a trial separation might restore us both to health by the time of her return. We drove out to the airport with Nurcihan and Mehmet, and, having arrived early, sat down at a little table in the new terminal to drink Meltem sodas, as recommended by Inge on the poster that was there. When I embraced Sibel in farewell and saw tears in her eyes, I became afraid, thinking that there would be no return to our old life after this, sensing I would not see her again for a very long time, and then I chided myself for taking such a dark view of things. On the way back in the car, Mehmet, for whom this would be the first separation from Nurcihan in many

months, broke the long silence: "Life is just so empty, isn't it, without the girls."

That night the *yalı* indeed felt so empty and sad that I couldn't bear it. It wasn't just the creaking floorboards: Now that I was alone, I discovered that the sea itself was invading the old frame, each time moaning a new tune. The waves crashing against the concrete terrace made a very different noise than those that hit the rocks, and the murmuring currents hissed past the boats tethered below. Toward morning, with the north wind blowing into every corner of the house, as I lay in bed in a drunken stupor, it occurred to me that it had been a very long while since the fisherman had last come in his boat with his son. There was still one part of my mind sound enough to see things clearly, and it was telling me that a chapter of my life was now coming to a close, but the greater part of me was still too anxious and fearful of being alone to let me accept this truth.

44

Fatih Hotel

THE NEXT day I met with Ceyda. In exchange for her agreeing to carry my letters, I had found work for a relative of hers in the accounting department of Satsat. I knew though that if I spoke a bit harshly she could be cowed into giving me Füsun's address. But Ceyda responded to my demands by falling into a mysterious mood and speaking elliptically. She hinted that I would not be so glad to see Füsun, for life, love, and happiness were difficult things, and people did what they had to do in this mortal world, seizing what chance for happiness they could! It was strange coming from someone who, as she spoke, kept touching her bump, by now very large, and who had a husband who did everything she wished.

I couldn't find it in myself to push Ceyda too hard. And as there were still no private detective bureaus of the type one saw in American films (it would be another thirty years before they arrived), I could not

hire someone to tail her. Earlier on I had gone to Ramiz, who handled my father's less savory business dealings and also, for a time, his security (in the old days we would have called him a bodyguard); telling Ramiz that we were making discreet inquiries into a robbery, I sent him off on a secret mission to find Füsun, her father, and Aunt Nesibe, but he'd come back empty-handed. Even our friend Selami Bey, the retired police commissioner who had helped Satsat when problems arose with Customs or the Ministry of Finance, was of no help: After making a few inquiries at registry offices, police stations, and council offices, he told me that as the person I was seeking—Füsun's father—had no criminal record, it would be next to impossible to find him. Masquerading as a grateful student wishing to kiss the hand of his former teacher, I paid visits to Vefa and Haydarpaşa Lycées, the two schools at which Füsun's father had taught history before his retirement, but to no avail. And so I tried hunting down Aunt Nesibe among the Nişantaşı and Şişli households she sewed for. Of course, I could not ask my own mother. But Zaim discovered from his mother that almost no one did that kind of work anymore. She put out feelers to see whether anyone knew where to find Nesibe Hanım the seamstress, but no one did. These disappointments exacerbated my pain. I would spend my lunch hours at the Merhamet Apartments, sometimes returning to the office afterward, and sometimes taking the car out for an aimless drive around the city, hoping to find Füsun by chance.

As I scoured every neighborhood, every street of the city, it never crossed my mind that I would recall the hours I spent hunting for her as happy ones. When Füsun's ghost began to appear in the poor neighborhoods of the old city—Vefa, Zeyrek, Fatih, Kocamustafapaşa—I concentrated on that side of the Golden Horn. I would be driving through their narrow backstreets, smoking a cigarette as the car rumbled over the cobblestones and potholes, when suddenly Füsun's ghost would dash out in front of me, impelling me to park the car at once, and luxuriate in a deep affection for her beautiful and impoverished neighborhood. With all my heart I would bless these streets with their tired aunties in headscarves, and young toughs staring at the strangers roaming the neighborhood in search of the ghosts, and the old people and the unemployed idling in the coffeehouses, reading newspapers in air thick with coal smoke. When a careful study of an apparition in the

distance proved it was not Füsun, I would not leave the neighborhood right away; rather I would continue wandering around, convinced by some irrational logic that if a double had appeared here, the true Füsun must be close at hand. And so I came upon a broken marble fountain, 220 years old, sitting in the middle of a cat-infested square, and the sight of slogans and death threats scratched on every visible surface, scrawled by "factions" of the various left- and right-wing parties, brought me no disquiet. With my heart convinced that Füsun was somewhere nearby, these defaced streets were for me enchanted. I resolved that I needed to spend more time walking through these streets, more time in these coffeehouses, drinking tea, gazing out the window, and waiting for her to walk by; that if I was to get closer to her and her family, I needed also to live more like them.

Shortly thereafter, I stopped frequenting the newest restaurants of Nişantaşı and Bebek; I lost interest in the society amusements that had once consumed my nights. I had already tired of meeting up every evening with Mehmet, who saw it as our common fate to spend hours discussing what "our girls" were buying in Paris. Even if I managed to shake him off, Mehmet would track me down at whatever club I went to afterward, and his eyes shining, he would go on and on about what Nurcihan had said to him that day on the phone. When Sibel rang me, I would panic, for I had nothing to say to her. There were times, I admit, when I longed for the consolation of Sibel's embrace, but I was so guilt-ridden, so worn down by my evil duplicity, that ultimately her absence was a comfort. Relieved of the pretenses that our situation demanded, I became convinced that I had returned to my old self. As my old self, though troubled, I would wander through the city's old neighborhoods, looking for Füsun, cursing myself for having neglected to seek out these charming streets, these old neighborhoods, much sooner. And I regretted not having broken off with Sibel before our engagement, or not finding a way to break off the engagement afterward, before it got to be too late.

In mid-January, two weeks before Sibel was due to return from Paris, I packed my bags, left the *yalı,* and moved to a hotel between Fatih and Karagümrük. Displayed here is one of its keys, on which you can see its insignia, likewise on its headed stationery from my room, and a replica of its little sign, which I found many years later. The day

before, I'd spent the afternoon exploring the neighborhoods between Fatih and the Golden Horn, looking in every street, and every shop, peering into the windows of each and every family living in the neglected stone houses and the teetering unpainted wooden houses left behind by the Greeks who had fled the city, when, having had my fill of their joy, noise, misery, and crowded poverty, I had stepped into the hotel to escape the rain. By that time night had fallen, and unwilling to wait until I had crossed the Golden Horn to have my first drink, I walked up the hill, entering a new beer hall near the main drag. Chasing vodka with beer, I sat there with the other men watching television, and before long—it wasn't even nine o'clock—I was paralytic. When I went outside I could not even remember where I'd parked my car. I walked for a long time in the rain, thinking more about Füsun, and my life, than about my car, and I remember that as I walked these dark and muddy streets, my dreams of Füsun, painful as they were, still brought me happiness. So it was that in the middle of the night I found myself back at the Fatih Hotel; having secured a room, I was soon asleep.

For the first time in months I slept soundly. I would continue to sleep soundly in that same hotel during the nights that followed. This took me by surprise. Sometimes, toward morning, I would be visited in my dreams by a sunny memory from my childhood or early youth. I would awake with a shudder, just as I had done when I'd heard the fisherman and his son, and my only wish was to go right back to sleep in that hotel bed, to return to the same sunny dream.

After the first restful night I had gone back to the *yalı* to pack up my clothes, my woolen winter socks and my other belongings, and determined to avoid the worried looks and anxious questions of my parents, I moved into the hotel rather than going home. I went to Satsat early as usual, but left the office early to run back to the streets of Istanbul. My hunt for Füsun was a boundless joy, and in the evening I would go content to beer halls to rest my weary legs. But as with so many chapters of my life, I would realize only much later that my days at the Fatih Hotel, far from being painful, as I then imagined, were in fact full of happiness. Every lunch hour I would go to the Merhamet Apartments for the distraction and consolation drawn from things; every day I would remember more of them, cherishing each newly found object; in the evenings I would drink and take long walks, my mind fogged by drink

as I prowled the backstreets of Fatih, Karagümrük, and Balat, peering through parted curtains on the good fortune of families eating their evening meal, telling myself over and over that "Füsun must be in one of them," and finding ever fresh comfort in the thought.

Sometimes I felt that my happiness issued not from the possibility that Füsun was near, but from something less tangible. I felt as if I could see the very essence of life in these poor neighborhoods, with their empty lots, their muddy cobblestone streets, their cars, rubbish bins, and sidewalks, and the children playing with a half-inflated football under the streetlamps. My father's expanding business, his factories, his growing fortune, and the attendant obligation to live the "elegant European" life that befit this wealth—it all now seemed to have deprived me of simple essences. As I walked these streets, it was as if I was seeking out my own center. As I meandered drunkenly up and down these narrow ways, the muddy hills and curving alleys that turned abruptly into steps, the world would suddenly seem uninhabited except by dogs, and a chill would pass through me, and I would gaze admiringly at the yellow lamplight filtering through drawn curtains, the thin funnels of blue smoke rising from chimneys, the reflected glow of televisions in windows and shop fronts. So the next night, when I was sitting with Zaim at a tavern inside the Beşiktaş Market, drinking *rakı* and eating fish, these dark scenes would return, their protection beckoning me from the world into which Zaim's stories might pull me.

It was his usual conversational fare, reports of parties and dances, gossip about people at the club, and the growing popularity of Meltem, no one subject dwelt on for long. He knew I'd moved out of the *yalı* and was not at my parents' in Nişantaşı, but to avoid triggering my gloom he refrained from asking about Füsun or my broken heart, though from time to time I tried to lead us in that direction, for I longed to know what he knew about her past. When it was clear that he was disinclined or unable to feed my obsession, regarding the complexity as too reckless or simply a bore, I assumed the air of a self-possessed man, and made sure he knew that I was going to the office every day and working hard.

It was snowing in late January when Sibel rang the office from Paris; in some agitation she told me that she'd heard from the neighbors and

the gardener that I had moved out of the *yalı*. It had been a long time since we'd spoken on the phone, and certainly this was an indication of our estrangement, but in those days it wasn't easy to make international calls. The line would crackle with strange noises, and one had to shout into the receiver. Daunted by the prospect of proclaiming my love to Sibel at the top of my lungs (and without meaning a word of it) for the entire office to hear, I kept finding reasons not to talk to her.

"You've moved out of the *yalı*, but I hear you're not at your parents'!" she said.

"Yes, that's right."

I did not remind her that we had decided together that returning to my parents in Nişantaşı would exacerbate my illness. Neither could I ask who had told her I was not spending my nights at home. My secretary Zeynep Hanım had jumped from her seat to close the door between us, so that I could speak to my fiancée in private, but I still had to shout for Sibel to hear me.

"What are you doing? Where are you staying?" she asked.

No one but Zaim knew I was staying in a hotel in Fatih, I now remembered. But I didn't want to shout this either, for the whole office to hear.

"Have you gone back to her?" asked Sibel. "You have to be straight with me, Kemal."

"No!" I said, but I wasn't able to shout it loud enough.

"I can't hear you, Kemal."

"No," I said, louder this time. But still my response was muffled in the whoosh of the international line, whose sound was that of a seashell held to the ear.

"Kemal, Kemal, I can't hear you, please. . . ." Sibel shouted.

"I'm here!" I was shouting as loud as I could.

"Let me have it straight."

"There's nothing to tell you!" I said, shouting even louder.

"I understand!" said Sibel.

A strange sea sound came down the line, then a crackle, before the line went dead and the voice of the operator cut in. "The line to Paris has been disconnected, sir. Would you like me to try to connect you again?"

"No thank you, my girl," I said. It was my father's habit to address

all female clerks, no matter their age, as "my girl." It shocked me to notice how soon I was taking on my father's habits. It shocked me to hear Sibel sounding so sure of herself. . . . But I was tired of telling lies. Sibel did not ring me from Paris again.

45

A Holiday on Uludağ

I HEARD of Sibel's return in February, at the start of the fifteen-day school holiday when families went to Uludağ to ski. Zaim, too, had called me at the office, suggesting we meet for lunch. As we sat together at Fuaye, eating lentil soup, Zaim fixed me with an affectionate gaze.

"You've run away from life. Every day I see you turning into a sadder and more troubled man, so I'm worried about you."

"Don't worry about me," I said. "I'm fine. . . ."

"You do not look fine," he said. "Try to be happy."

"You think the point of life is to be happy," I said. "That's why you believe I'm not happy and have run away from life. . . . I'm on the threshold of another life that will bring me peace."

"Fine . . . Then tell us about this life, too. We're genuinely curious."

"Who are 'we'?"

"Don't do that, Kemal," he said. "How is any of this my fault? Am I not your best friend?"

"You are."

"We . . . Mehmet, Nurcihan, myself, and Sibel . . . We're going to Uludağ in three days' time. Why don't you come, too. Nurcihan was planning to keep an eye on her niece, and so we decided to make it a group excursion. It will be fun."

"So Sibel is back."

"It has been ten days now. She came back the Monday before last. She wants you to come to Uludağ." Zaim smiled, his face shining with

goodness. "But she doesn't want you to know it. . . . I'm telling you all this without her knowledge, so whatever you do, don't make any mistakes in Uludağ."

"I won't—I'm not coming."

"Come, it will do you good. This business will be over soon, and you'll forget all about it."

"Who knows? Do Nurcihan and Mehmet know?"

"Sibel knows, of course," said Zaim. "She and I talked about this. She understands very well how someone as caring as you could get pulled into something like this, and she wants to help you out of it."

"Is that so?"

"You've taken a wrong turn, Kemal. We all fall for the wrong people sometimes. We all fall in love. But in the end we all pull ourselves out of it before we ruin our lives."

"Then what about all those love stories, all those films?"

"I love romantic films," said Zaim. "But I've never seen one that justifies a case like yours. Six months ago, you had that huge engagement party. You and Sibel stood in front of everyone and exchanged rings. What a lovely evening that was. You moved in together, before you even were married. You even had parties at your house. We all thought, How elegant, how civilized. And because everyone knew you were getting married, everyone accepted it, not a soul took offense. I even heard people saying it was so chic, they wanted to do the same. But now you've moved out of the *yalı,* and you're on your own. Are you leaving Sibel? Why are you running away from her? You're not explaining yourself. You're acting like a child."

"Sibel knows. . . ."

"No, she doesn't," said Zaim. "She has no idea how to explain the situation. How is she going to face people? What can she say? 'My fiancé fell in love with a shopgirl, so we've separated'? She's very upset, she's heartbroken. You have to speak to her. In Uludağ you could patch things up, put all this behind you. I guarantee you, Sibel is ready to go on as if this never happened. Nurcihan and Sibel will be staying in a room together at the Grand Hotel. Mehmet and I have taken the corner room on the second floor. There's a third bed in that room. You know, you can see the misty mountaintop from there. You can stay with

us. We can stay up all night ragging one another just like we did when we were young. Mehmet is so smitten with Nurcihan he's burning up. Think of the fun we could have with him."

"Actually the person you'd be having fun with would be me," I said. "And anyway, Mehmet and Nurcihan are already a couple."

"Believe me, I would never joke at your expense," Zaim said, somewhat hurt. "Nor would I let anyone else."

From his words it was clear that already Istanbul society—or at least the people in our own circle—had begun to make jokes about my obsession. But I had already guessed this.

I was full of admiration for Zaim's delicacy in setting up this trip to Uludağ, just to help me. When I was young, my family would go to Uludağ every winter, along with most of my father's business associates, his friends from the club, and so many other wealthy Nişantaşı families. I had so loved those vacations—when everyone knew or would come to know everyone, and you could make new friends, and play at matchmaking, as even the shiest girls danced the night away— that even years later, if I happened on an old mitten of my father's at the back of a drawer, or the goggles that my brother had used and then passed on to me, my spine would tingle. During my time in America, whenever I looked at the postcards my mother sent me from the Grand Hotel, I felt a wave of happy longing.

I thanked Zaim but said, "I'm not coming. It would be too painful. But you're right. I need to talk to Sibel."

"She's not at the *yalı*. She's staying with Nurcihan," said Zaim. Turning his head to survey the other diners, who were in high spirits—and like him, getting richer by the day—he was able for a moment to forget my troubles and smile.

46

Is It Normal to Leave Your Fiancée in the Lurch?

I COULDN'T bring myself to call Sibel until the end of February, when she was back from Uludağ. I was afraid that the dreaded talk might end in unpleasantness, anger, tears, and reproach, and hoping she might take the initiative and send back the ring with a fully justified excuse. But one day I could bear the tension no longer, so I picked up the phone and rang her at Nurcihan's house; we agreed to meet for supper.

I'd thought it would be good to go to Fuaye because neither of us was likely to succumb to sentimentality, anger, or excess surrounded by people we knew. And so it was in the beginning. At the tables around us were Hilmi the Bastard with his new wife, Neslihan, and Tayfun, and Güven the Ship Sinker with his family, and (at a very crowded table) Yeşim and her husband. Hilmi and his wife even came over to our table and said how very pleased they were to see us.

Over mezes and Yakut red wine, she talked about her trip to Paris, describing Nurcihan's French friends, and telling me how beautiful that city was at Christmas.

"How are your parents?" I asked.

"They're fine," she said. "They have heard nothing about our situation as yet."

"Don't worry about that," I said. "We don't have to say anything to anyone."

"I don't," said Sibel, and then she fell silent, with a look as if to ask, So what's going to happen now?

Changing the subject, I told her that my father seemed to be withdrawing from the world a little more every day. Sibel told me about her mother's new habit of hiding away her old clothes and other belongings. I told her how my mother was even more radical about banishing

all her discarded things to another apartment. But this was a dangerous subject, so we fell silent again. Sibel's expression told me she inferred no malice in my having brought it up just to keep the conversation going, but she also understood that my avoiding the real subject meant I had nothing new to say to her.

So she got to the point herself, saying, "I see you've come to accept your condition."

"What do you mean?"

"For months now we've been waiting for your illness to pass. But after all this waiting, there are no signs of recovery—and instead you seem to greet your illness with open arms. It's very painful to see, Kemal. In Paris I prayed for your recovery."

"I'm not ill," I said. I looked at the jolly crowd of diners around us. "These people might see it that way. But you shouldn't."

"When we were at the *yalı*," Sibel said, "didn't we both agree it was an illness?"

"We did."

"So what has changed now? Is it normal to leave your fiancée in the lurch like this?"

"What?"

"For a shopgirl . . ."

"Why are you mixing things up like that? This has nothing to do with shops, or wealth, or poverty."

"It has everything to do with it," said Sibel, with the determination that attends having given something a great deal of thought and reached a painful conclusion. "It's because she was a poor, ambitious girl that you were able to start something with her so easily. If she hadn't been a shopgirl, maybe you could have married her without causing yourself embarrassment. So that's what made you ill, in the end. You couldn't marry her. You couldn't find the courage."

Believing that Sibel was saying these things to me to make me angry, I got angry. But this is not to say that the fury owed nothing to my partial awareness that she was right.

"It isn't normal, darling, for someone like you to do all these bizarre things for the sake of a shopgirl, to go to live in a hotel in Fatih. . . . If you want to get better, you have to concede that I have a point."

"First of all, I'm not in love with that girl the way you think I am," I

said. "But just for the sake of argument, don't people ever fall in love with people who are poorer than they are? Don't rich and poor ever fall in love?"

"The art of love is in finding a balance of equals," Sibel said. "As there is with you and me. Have you ever seen a rich girl fall in love with Ahmet Efendi the janitor, or Hasan Usta, the construction worker, just for his good looks? Outside Turkish films, I mean."

Sadi, the headwaiter, was walking toward us, his face beaming at the sight of us, but when he saw how intently we were talking, he broke off the approach. I indicated with my head that he had been right to do so and turned back to Sibel.

"I believe in Turkish films," I said.

"Kemal, in all these years I have never seen you go to a Turkish film, not even once. You don't even go with your friends to the summer cinemas, just for a laugh."

"Life at the Fatih Hotel is just like a Turkish film, believe me," I said. "At night, before I go to sleep, I walk around those desolate and impoverished streets. It does me good."

"In the beginning I thought this whole business with the shopgirl was Zaim's fault," she said pointedly. "I thought you were aping *La Dolce Vita*. I thought you wanted to have some fun with dancers, and bar girls, and German models before you got married. I discussed this with Zaim. But now I've decided you're suffering from some sort of complex"—this word had just come into fashion—"some sort of complex about being rich in a poor country. Of course, this is a lot deeper than some little fling with a shopgirl."

"You may be right," I said.

"In Europe the rich are refined enough to act as if they're not wealthy. That is how civilized people behave. If you ask me, being cultured and civilized is not about everyone being free and equal; it's about everyone being refined enough to act as if they were. Then no one has to feel guilty."

"Hmmmmm. I see your time at the Sorbonne was not a waste," I said. "Shall we order our fish now?"

Sadi now came to our table, and after we'd asked him how he was ("Extremely well, praise be to God!") and how business was going ("We're a family, Kemal Bey. It's the same people every night!"), we

talked about the general state of affairs ("Ah, with all this terrorism between leftists and rightists, it's almost impossible for a decent citizen to go out into the street!") and the comings and goings of the regulars ("Everyone's back from Uludağ now!"). I'd known Sadi since childhood. Before Fuaye opened, he'd worked at Abdullah Efendi's in Beyoğlu, where my father had eaten all the time. He'd come to Istanbul thirty years earlier, at the age of nineteen, never having seen the sea before, and quickly learned the intricacies of picking and preparing fish from the old Greek tavern owners and the city's most famous Greek waiters. He brought us a tray of red mullet, large, oily bluefish, and sea bass that he'd bought with his own hands at the fish market that morning. We smelled the fish, looked at the brightness of the eyes, and the redness of the gills, and confirmed that it was fresh. Then we complained about how polluted the Sea of Marmara was getting. Sadi told us that Fuaye had a private company deliver a tanker full of water every day because of the cuts in the water supply. They had not yet ordered a generator to cope with the power cuts, but the guests seemed to like the atmosphere on those evenings when they had to depend on candles and gas lamps. After topping off our wineglasses, Sadi went on his way.

"There was that fisherman with his son," I said. "We used to listen to them in the *yalı*. Not long after you left for Paris, they disappeared, too. After that the *yalı* got even colder and lonelier, until I couldn't bear it anymore."

Sibel heard the note of apology in my voice as I spoke of this development, hoping to redirect the conversation. (My father's pearl earrings crossed my mind.) "This father and his son were probably going after the schools of bonito or bluefish." There had been plenty of both this year, I told her; even in the backstreets of Fatih, I'd seen them sold from horse-drawn carts, followed everywhere by cats. As we ate our fish, Sadi told us that the price of turbot had gone up dramatically, because they'd arrested those Turkish fishermen who'd gone into Russian and Bulgarian waters to fish turbot. As we were discussing this story, I saw that Sibel was looking more distressed than ever. She knew I was talking about all these things so as not to speak of our predicament, about which I had nothing new to say and no hope to offer. I did want to find an easy way to talk about it, but I couldn't think of any.

Now, seeing her sad face, I knew I couldn't lie to her, and that made me frantic.

"Look, Hilmi and his wife are getting up to leave," I said. "Shall we invite them to join us?" Before Sibel could say anything, I waved at them, but they didn't see me.

"Don't ask them to join us," said Sibel.

"Why? Hilmi's a very nice boy. And I thought you liked his wife, what's her name?"

"What's going to happen to us?"

"I don't know."

"When I was in Paris, I talked to Leclerq." This was Sibel's economics professor, whom she admired greatly. "He thinks I should do a dissertation."

"So you're going to Paris?"

"I'm not happy here."

"Shall I come, too?" I asked. "Though I have a lot of work here."

Sibel did not answer. It was clear that she'd already made up her mind about this meeting, and also about our future, but I sensed that she had one more thing to say.

"Go to Paris, then," I said, tiring of the halting discussion. "I can see to things here and come later."

"There's one more thing I have to say. I apologize for bringing it up, but there's the question of virginity, Kemal. Perhaps you feel some obligation to this shopgirl. But I think virginity is not important enough to justify what you've done."

"What do you mean?"

"If we're really meant to be modern in our outlook, if we're really European, as I said, it has no importance. If, on the other hand, we're still tied to tradition, and virginity matters to you, as something you want everyone to respect, then everyone's should be considered in the same way!"

At first I frowned, because I wasn't sure what Sibel was trying to say. Then I remembered that I had been her first lover. "It's not the same burden for you as for her," I wanted to say. "You're rich and modern!" But instead I looked down in shame.

"And there's something else that I'm never going to be able to for-

give, Kemal. If you weren't going to be able to break it off with her, then why did we get engaged? Why didn't you break off the engagement?" Her voice trembled with bitterness. "If it was going to come to this, why did we move to the *yalı*? Why did we give parties? Why, in a country like this, did we live openly as a couple without being married?"

"The innocent, sincere companionship I shared with you in the *yalı*—I've never known such a thing with anyone else."

I could see how angry my answers were making her. She was so angry and miserable that she was about to cry.

"I'm sorry," I said. "I'm so very sorry."

There was a terrible silence. To keep Sibel from crying, to keep this from going any further, I waved frantically at Tayfun and his wife, who were still waiting for a table. They were glad to see us. When I insisted, they sat down at our table.

"Do you know, I've already begun to miss the *yalı*!" said Tayfun.

They had come to visit us a lot during the summer. Tayfun had strolled up and down the wharf and through the house as if they belonged to him, he'd opened up the refrigerator to get drinks for himself and others, sometimes he'd feel inspired to spend hours in the kitchen cooking, while consumed by the need to hold forth on the particularities of the Soviet and Romanian tankers steaming by.

"Do you remember that evening when I passed out in the garden?" he said, reminiscing fondly. Seeing Sibel sitting there listening to Tayfun, saying jovial things in reply, without betraying a hint of her inner feelings, I could not help but feel something akin to admiration.

"So then, when are you two getting married?" asked Tayfun's wife, Figen.

Was it possible that she had not heard the gossip about us?

"In May," said Sibel. "At the Hilton again. You'll all have to promise to wear white, as in *The Great Gatsby*. Have you seen it yet?" Suddenly she looked at her watch. "Oh no, I have to meet my mother at the corner of Nişantaşı in five minutes." In fact her parents were in Ankara.

She jumped up and kissed first Tayfun and Figen, and then me, on both cheeks. After sitting for a while with Tayfun and Figen, I, too, left Fuaye and went to the Merhamet Apartments to find my customary consolation. A week later, Sibel returned her engagement ring to me,

via Zaim. Although news of her came to me from all directions, I would not see her again for thirty-one years.

47

My Father's Death

THE NEWS of my broken engagement spread fast; Osman came to the office one day to berate me; he was ready to intervene and mollify Sibel's heart. Meanwhile, a wide variety of rumors reached my ears: I'd gone soft in the head; I'd become a creature of the night; I'd joined a secret Sufi sect in Fatih; there were even those who said I'd become a communist and, like so many militants, gone to live in a shantytown— but none of this upset me much. On the contrary, I hoped that when Füsun heard I had broken my engagement, she would be impressed and send word from wherever she was hiding. By now I had given up all hope of recovery; instead of seeking to relieve it, I made the most of my pain. I took to wandering aimlessly through those forbidden streets of orange light, and four or five times a week I would repair to the Merhamet Apartments for the peace of my memories and the therapeutic comfort of the things I kept there. With Sibel out of my life, I could have gone back as a bachelor to my old bedroom in my parents' house in Nişantaşı, but my mother, herself unable to accept the broken engagement, had concealed the bad news from my father, whom she described as "listless and weak," and as she was unwilling to discuss this dangerous subject openly, there would be long silences at the table when I went to have lunch with them, which I did frequently, though I never stayed the night. In fact, my stomachaches worsened whenever I was in the Nişantaşı house.

But when my father died at the beginning of March, I went home to stay. It was Osman who came to the Fatih Hotel in the Chevrolet to bring me the bad news. I would never have wanted him to come up to my room and see the strange objects I'd bought during my walks through the poor neighborhoods, from junk dealers, grocers, and sta-

tioners, all of them hoarded in my shamefully ramshackle room. Refraining from his customary scolding, this time he just looked at me sadly, embracing me with tender sincerity, and no reproach; half an hour later I had packed up my things, paid the bill, and left the Fatih Hotel. Teary-eyed Çetin Efendi looked so distraught, and I remembered that my father had entrusted both him and the car to my care. It was a gloomy, leaden winter's day, and as Çetin Efendi drove us over the Atatürk Bridge, I looked at the Golden Horn, its icy aquamarine swirling with oil slicks, its coldness chiming with my loneliness.

My father had died of heart failure, a few minutes after seven, as the morning prayers were being sung; my mother had awoken thinking her husband was still asleep beside her; when she realized what had happened, she became hysterical, so they had given her a Paradison tablet to calm her down. Now seated in the sitting room in her usual chair, across from my father's, she would from time to time begin to cry, and gesture toward the empty seat. She brightened when she saw me. We threw our arms around each other; neither of us spoke.

I went in to see my father. He was lying in his pajamas on the walnut bed he had shared with my mother for almost forty years; though still in a sleeping position, he was rigid, and the expression on his pallid face suggested not a slumberous peace but deep distress. He had awoken to see death before him; his eyes were wide with panic, frozen on his face a look of fear and awe, the sort you would expect on someone helpless in the path of fast-approaching traffic. His wrinkled hands gripping the blankets, their scent of cologne, their crooked curves, their hairs and moles; these hands had caressed my hair, my back, my arms thousands of times when I was a child, making me so happy; these were hands I knew. But now their whiteness scared me; and I could not bring myself to kiss them. I wanted to pull off the blanket and see his whole body in those blue-and-white-striped silk pajamas he always wore, but the blanket was stuck somewhere.

While I was pulling at it, his left foot poked out. I felt compelled to look at his toe. My father's big toe was absolutely identical to my own, and as one will gather from this detail of an old photograph that I've had enlarged, his toes had a unique shape. Ever since my father's old friend Cüneyt had first noticed this strange resemblance twelve years earlier when we were sitting in our swimsuits on the Suadiye shore, he

would greet us with the same old joke whenever he saw us together: "How are the father-and-son toes doing?"

I locked the bedroom door and sat down, preparing to take the opportunity to cry over Füsun for a very long time while thinking about my father, but the tears wouldn't come. Instead I gazed with new eyes at the bedroom where my father had spent so many years with my mother, this intimate chamber of my childhood still entirely redolent of cologne, carpet dust, floor polish, old wood, curtains, my mother's perfume, and the oil from our hands that clung to the barometer that my father would take me on his lap to show me. It was as if the center of my life had dissolved, as if the earth had swallowed up my past. Opening up his cupboard, I took out the outmoded ties and belts, and one of the pairs of shoes that were still occasionally shined, though he hadn't worn them in years. When I heard footsteps in the corridor, I felt the same tinge of guilt I'd felt when rummaging through this wardrobe as a boy, and I quickly shut its creaking door. On my father's bedside table were medicines, crossword puzzles, folded newspapers, a much loved photograph from his army days, taken when he'd been drinking *rakı* with the officers, his reading glasses, and also his false teeth, in a glass. The false teeth I took from the glass, wrapping them in my handkerchief, and put them in my pocket; then I went to be with my mother in the front room, taking my father's chair.

"Mother dear, don't worry—I took Father's false teeth," I said.

She nodded, as if to say, Fine, you know best. By noon the house had filled with relatives, friends, acquaintances, and neighbors. They all kissed my mother's hand and embraced her. The front door was open and the lift in constant use. Before long there were so many people that I could not help but remember the holiday feasts we'd had here. I felt that I loved this crowd of people, these sounds of family life, and the warmth; surrounded by all these relatives, all these cousins with the same potato noses and wide foreheads, I felt happy. For a while I sat with Berrin on the divan, gossiping amiably about the cousins. It pleased me that Berrin followed them all so closely, that she knew the family news better than I did. Like everyone else, I whispered the occasional little joke, I talked about the latest football match, which I'd watched in the lobby of the Fatih Hotel (Fenerbahçe 2–Boluspor 0), and I sat down at the table set by Bekri, who, despite his pain, was fry-

ing up more cheese pastries; and I went often to the bedroom in the back to look in on my father's pajama-clad body. Yes, he was perfectly still. From time to time I opened up his drawers, to touch the things that carried so many of my early memories. My father's death had turned these familiar props of childhood into objects of immeasurable value, each one the vessel of a lost past. I opened the bedside table drawer, and as I breathed in the fumes of cedar and my father's sugary cough syrup, I gazed for a long time at the old phone bills, the telegrams, my father's aspirins and medicines, as if I were looking at a complicated picture. I remember, too, that before leaving with Çetin to make the funeral arrangements, I stood on the balcony at length, gazing down at Teşvikiye Avenue. With the death of my father, it wasn't just the objects of everyday life that had changed; even the most ordinary street scenes had become irreplaceable mementos of a lost world whose every detail figured in the meaning of the whole. Because coming home now meant a return to the center of that world, there was a happiness I could not hide from myself, and my guilt was even deeper than that of a man whose father has just died. In the refrigerator I found the little bottle of Yeni Rakı that my father had half finished the last night of his life; after all the guests had left and I was sitting with my mother and older brother, I drank what was left.

"Did you see what your father did to me?" said my mother. "Even when he was dying, he didn't let me know."

That afternoon, my father's corpse had been taken to the morgue at Sinan Pasha Mosque in Beşiktaş. My mother, wishing to fall asleep immersed in my father's scent, had not wanted the sheets or pillowcases to be changed. It was late when my brother and I gave our mother a sleeping pill and put her to bed. My mother smelled the pillowcases and the sheets for a time, and cried a little, and fell asleep. When Osman, too, had left, I went to my own bed, thinking that in the end—as I had so often longed would happen, and dreamed of happening, when I was a child—I had been left alone in this house with my mother.

But it was not this that filled me with excitement; it was (as I in my heart could not deny) the possibility that Füsun might come to the funeral. For this express reason I had included all the names of that distant branch of the family in the death announcements in the papers.

I kept thinking that Füsun and her parents would read one of these announcements, somewhere in Istanbul, and come to the funeral. Which newspaper might they read? Of course, they might also hear the news from other relatives mentioned in the death notices. My mother read through all the newspaper death notices over breakfast. From time to time she would grumble: "Sıdıka and Saffet are related both to me and to your dear departed father, so their names should have come just after Perran and her husband. Şükrü Pasha's daughters, Nigân, Türkan, and Şükran, have also been put in the wrong order. There was no need to include Uncle Zekeriya's first wife, Melike the Arab. After all, she couldn't have been married to your uncle for more than three months. That poor little baby of your great-aunt Nesime, who died when she was two months, her name wasn't Gül, it was Ayşegül. Who did you go to for your information when you were writing these up?"

"They're just typographical errors, Mother dear. You know what our newspapers are like," said Osman. Every other minute, my mother was glancing out the window down at the courtyard of Teşvikiye Mosque, fretting about what she was going to wear, and we realized that on an icy, snowy day like this, she should not go outside at all. "You can't wear that fur as if you were off to a party at the Hilton, and even in that you won't be warm enough."

"I am not going to stay at home on the day of your father's funeral, even if it kills me."

But as she watched the bearers carry my father's coffin from the mosque morgue to the funeral stone, my mother began crying so hard that we immediately knew she would not make it down the stairs and across the street to join the funeral. In spite of all the tranquilizers we'd given her, when she went out to the balcony in her Astrakhan fur, propped up by Bekri on one side and Fatma Hanım on the other, to watch the crowd lift the coffin into the funeral hearse, she fainted. There was a harsh north wind blowing; there were swirls of snowflakes small enough to get into your eyes. Almost no one in the crowd noticed my mother. After Bekri and Fatma had taken her back inside, I too gave my attention to the crowd. These were the same people who had come to our engagement party at the Hilton. As it seemed so often on the streets of Istanbul in winter, the pretty girls I'd noticed during the summer had disappeared; the women had grown uglier, the men, too,

darker and more threatening. Just as I had done at the engagement party, I shook hundreds of people's hands, embracing many well-wishers, and every time I met a new shadow in the crowd I felt a pang, because we were burying my father, and because that shadow was not Füsun. When I was sure that neither she nor her parents had come to the funeral or the interment, and that they were not going to come, I felt as if I was being buried under the cold earth along with my father.

The cold seemed to bring the family closer, and after the ceremony was over they wanted to remain together, but I fled them, taking a taxi straight to the Merhamet Apartments. Even the smell of the apartment brought me peace as I inhaled it from the threshold; I knew from experience that Füsun's lead pencil had the greatest consolatory power of all the things in the apartment, with her teacup, which I had not washed since her disappearance, coming in a close second; I took these things into bed with me. After touching them and stroking my skin with them for a short time, I was able at last to relax.

To readers and museum visitors who are curious to know whether the pain I endured that day was owing to the death of my father or to Füsun's absence, I would like to say that the pain of love is indivisible. The pains of true love reside at the heart of our existence; they catch hold of our most vulnerable point, rooting themselves deeper than the root of any other pain, and branching to every part of our bodies and our lives. For the hopelessly in love, the pain can be triggered by anything, whether as profound as the death of a father or as mundane as a piece of bad luck, like losing a key; such elemental pain can be flamed by any sort of spark. People whose lives have, like mine, been turned upside down by love can become convinced that all other problems will be resolved once the pain of love is gone, but in ignoring these problems they only allow them to fester.

Sitting in the taxi on the day we buried my father, I was able to think these thoughts clearly, but to my regret I could not act accordingly. The anguish of love had disciplined me—brought me to maturity—but in ruling my mind, it gave me scant latitude to use the reason that maturity had brought me. A man like me, too long captive to a destructive passion, will continue on the course his reason tells him is wrong, even if he knows it will bring him to sorrow; in time, he'll see only more and more clearly how wrong was his path. In such situations there is an

interesting phenomenon rarely remarked upon: Even on our worst days, our reason does not stop speaking to us; even if unequal to the power of our passion, it continues to whisper with merciless candor that our actions will serve no purpose but to heighten our love, and therefore our pain. During the first nine months after I lost Füsun, my reason continued to whisper to me, ever more urgently, giving me the hope that one day it would usurp control of my mind and rescue me. But love mingled with such hope (even the simpler hope that I would one day live without pain) gave me the strength to carry on in the face of my agony, while at the same time prolonging it.

As I lay in the Merhamet Apartments, soothing myself with Füsun's things (the loss of my father having now merged with the loss of my love in an amalgam of being alone and unloved), I began to understand why Füsun and her family had not come to the funeral. Still I struggled to accept that Aunt Nesibe and her husband, who had always attached such importance to their relations with my mother and the family, had stayed away because of me. For this conclusion meant inexorably that Füsun and her family were determined to escape me forever. The prospect that I might never see her again for the rest of my life was so unbearable that I could not entertain it for long; I needed to find some way to have hope of seeing Füsun in the near future.

48

The Most Important Thing in Life Is to Be Happy

"I HEAR you're blaming Kenan for Satsat's going off the rails," Osman whispered into my ear one evening. He came often to visit our mother in the evenings, sometimes with Berrin and the children, but mostly he came by himself to make a threesome at supper.

"Where did you hear that?"

"I hear things," said Osman. My mother was in the other room; he

gestured in her direction. "You've disgraced yourself in society, but at least don't embarrass yourself at the firm," he said mercilessly. (This despite the fact that he hated the word "society" as much as I did.) "It's your fault you lost out on the sheet business," he added.

"What's going on, what are you talking about?" said my mother. "Please don't have another argument!"

"We're not," said Osman. "I was just saying how good it is that Kemal's returned. Don't you agree, Mother?"

"Oh, yes, my son, it's wonderful. Whatever anybody says, the most important thing in life is to be happy. This city is full of beautiful girls; we'll find one who is even kinder and more beautiful, and more understanding. After all, a woman who doesn't love cats is never going to make a man happy. None of us should waste any more time dwelling on what happened. Just promise me you'll never go back to living in a hotel."

"On one condition!" I said, childishly repeating Füsun's ploy of nine months earlier. "I want to take over my father's car, and Çetin with it."

"Fine," said Osman. "If Çetin is happy with that, then I am, too. But you have to stop messing with Kenan and the new business. I don't want any more mudslinging."

"I don't want you two arguing in front of everyone, ever!" my mother said.

After separating from Sibel, I grew more distant from Nurcihan; and once I distanced myself from her, I began to see much less of Mehmet, who was as ever madly in love with her. Zaim, meanwhile, was spending more time with them, so when he and I met it would be just the two of us, and slowly I removed myself from the group. For a brief time I took to going out with Hilmi the Bastard and Tayfun and a few others who, despite being married, engaged, or as good as engaged, still had a taste for the naughtier side of nightlife, and liked to visit the city's priciest brothels, or I'd go out with friends who knew which hotel lobbies were favored by the slightly more educated and refined girls that we mockingly called the "coeds"; I was not really looking for fun; what I was hoping for was a cure for my illness, but my love for Füsun had emerged from the shadows to claim my entire body. Although it was amusing to be among friends, I was not able to lose myself and for-

get my troubles. And so most evenings I stayed at home, sitting next to my mother, a glass of *rakı* in my hand, watching whatever was on the single state-controlled channel.

My mother did just as she'd done when my father was alive: a merciless critique of whatever was on the screen; at least once a night, she would tell me not to drink so much, just as she used to tell my father, and then she would fall asleep in her chair. Fatma Hanım, the maid, and I would then be obliged to whisper about whatever was on television. Unlike the maids who worked for the rich families we saw in Western films, Fatma Hanım did not have a television in her room. For four years now, ever since the broadcasting service had begun and we'd bought our first television set, Fatma Hanım would come into the sitting room every evening to perch tentatively on the bar stool at the far end of the room—by now we had come to think of it as "her chair"— and from this distance she would watch along with us, fiddling with the knot in her scarf at moments of high drama, and sometimes venturing into the conversation. After my father's death, it fell to her to respond to my mother's endless monologues, and so lately we'd been hearing more from her. One night, after my mother had dozed off, there was a live broadcast of a skating competition; as we watched the long-legged Soviets and Norwegians, just as ignorant of the competition rules as the rest of Turkey, Fatma Hanım and I chatted about the warm weather, the political street killings, my mother's health, the futility of politics, and about her son, who, after working with my father, had immigrated to Duisburg, Germany, to open a *döner* restaurant—in other words, we were talking about the sweetness of life, when she brought the subject round to me.

"Clawnails, you're not poking holes in your socks anymore, and this is a good thing. I noticed that you're cutting your nails now, and very nicely, too. So I'm going to give you a present."

"A pair of nail clippers?"

"No, there are already two pairs of nail clippers in the house. Three, counting your father's. This is something else."

"What is it?"

"Come inside," said Fatma Hanım.

From her manner I guessed it was something special, so I followed. Stepping into her room, she picked something up; then she led me into

my room and turned on the light; she opened her palm like someone doing a magic trick for a child.

"What's this?" I said, before my heart began to pound.

"It's an earring. What is this—a butterfly with a letter? Isn't it strange?"

"It's mine."

"I know it's yours. Months and months ago I found it in the pocket of your jacket. I set it aside, to give it to you. But your mother saw it and took it. She must have thought your dear departed father had bought it for someone else, and she would spoil his fun, or something like that. Anyway, she had a secret velvet pouch where she hid things from your father"—she smiled—"stole from your father and then hid from him. After your father died, she emptied it out and laid all the contents on top of his bureau, and when I saw this, I recognized it right away, so I grabbed it for you. There is also a photograph I found in one of your father's jackets. Take that, too, before your mother sees it. Did I do well?"

"You did very well, Fatma Hanım," I said. "You are very clever, very wise, and truly wonderful."

With a happy smile, she handed me her gifts. The photograph was the one my father had shown me at Abdullah's Restaurant: a picture of his deceased sweetheart. Looking at this sad girl now, and the ships and the sea in the background, I suddenly saw shades of Füsun.

The next day I called Ceyda. Two days later, we met again in Maçka and walked to Taşlık Park. Her hair was in a bun, and she was radiating with the happiness one sees uniquely in new mothers, and I soon saw she had acquired the confidence that comes of having to grow up quickly. During the past two days, and without much strain, I had written four or five letters to Füsun, finally putting the most moderate and coolheaded of these into a yellow Satsat envelope. As I had planned in advance, I frowned as I handed Ceyda the letter, telling her there had been a very important development, and that she had to make sure Füsun received this letter. My plan was to tell Ceyda nothing of the letter's contents, creating an air of a mystery of such importance that she could not take responsibility for failing to deliver it. Ceyda's sane, mature, accepting manner disarmed me, and it was with great excitement that I confessed to Ceyda that the letter pertained to a matter that

had made Füsun very angry at me, and that when Füsun received the news I was sending her, she would be very glad, as I was, and that apart from lost time, our troubles were over. As I said my good-byes to Ceyda, who was rushing home to nurse her baby, I told her that as soon as Füsun and I married, we would have a child who would be friends with her boy, and that we would laugh one day at these troubles and the contortions it had taken to find true love. I asked her what she had named her child.

"Ömer," said Ceyda. "But life never turns out the way we want, Kemal Bey."

When weeks had passed without an answer from Füsun, Ceyda's parting words came back to me often, but I never doubted that Füsun would answer my letter, for Ceyda had confirmed that Füsun was aware I had broken off the engagement. In my letter I had said that her earring had turned up in a box of my father's, and that I wanted to bring it back to her, along with the other earrings of my father's that I had tried to give her, and the tricycle. The time had come for the evening we had planned so long ago, when I would come for a meal with her parents.

In the middle of May, on a busy day, I was at the office reading correspondence from our distributorships in the provinces, along with other letters, personal and professional, offering friendship, thanks, complaint, apologies, and threats. Most had been written by hand, and I was struggling with some of them, because I couldn't read the script—and then I came upon a very short letter, which I devoured with my heart pounding:

Cousin Kemal,

We too would very much like to see you. We await your company at supper on May 19.

Our phone line has not yet been connected. If you are unable to join us, send Çetin Efendi to let us know.

With our love and respects,

Füsun

Address: Dalgıç Street, No. 24, Çukurcuma

There was no date on the letter, but from the postmark I could tell it had been sent from Galatasaray Post Office on May 10. The nine-

THE MUSEUM OF INNOCENCE

teenth was more than two days hence, and though I longed to bolt straight to that Çukurcuma address, I restrained myself. If my aim was to marry Füsun in the end, and to bind her to me ever after, I should take care not to seem too anxious, I told myself.

49

I Was Going to Ask Her to Marry Me

ON WEDNESDAY, May 19, 1976, at half past seven, I set out for Füsun's family's house in Çukurcuma, telling Çetin Efendi only that we were going over to return a child's tricycle to Aunt Nesibe. I gave him the address and I sat back in my seat, watching rain pour down on the streets, as if someone had upended a giant glass. Not once during my thousands of dreams of our reunion had I imagined such a deluge, or even a light drizzle.

Stopping at the Merhamet Apartments to pick up the tricycle and the pearl earrings that my father had given me in a box, I got completely soaked. Still entirely contrary to my expectations, I felt the deepest peace in my heart. It was as if I had forgotten all the pain I had endured since last seeing her at the Hilton Hotel 339 days earlier. I remember even feeling thankful for every minute I had spent writhing in agony, because it had brought me to this happy ending. I blamed nothing and no one.

I saw stretching out before me the same wondrous life I'd seen at the beginning of my story. Stopping off at a florist on Sıraselviler Avenue, I had them make me a huge bouquet of red roses that was as beautiful as that prospect. To calm myself, I'd had a half glass of *rakı* before leaving home. Should I have stopped off for one more at a *meyhane*—one of the taverns in the side streets leading up to Beyoğlu? Impatience, like the pain, had taken hold of me. "Be careful!" warned a voice inside. "This time you can make no mistakes!" As we passed the Çukurcuma Hamam shrouded in rain, I suddenly realized what a good lesson Füsun had taught me with these 339 days of agony: She had

won. I was ready to do whatever she wanted, to avoid the punishment of never being able to see her again. Once I had recovered from the initial excitement, once I was sure that Füsun was at my side, I was going to ask her to marry me.

As Çetin Efendi peered through the rain, trying to read the house numbers, I conjured up the proposal scene, which I had already imagined somewhere in my mind, hiding it from my consciousness: After entering the house, handing over the tricycle, making a few jokes, taking a seat and settling in—was I up to doing all this?—I would sip the coffee Füsun brought me, and then, summoning my courage, I would look straight into her father's eyes and say point-blank that I had come to ask for his daughter's hand in marriage. The tricycle was just an excuse. We would laugh about it, like so many jokes we would use to keep from ever talking about the agonies, or the sorrows that had caused them. As I drank the Yeni Rakı her father would naturally serve me at the table, I would look into Füsun's eyes and feast on the happiness that my decision had brought me. We could discuss the details of the engagement and the marriage at another time.

The car stopped in front of an old building; the rain made it impossible to see what sort of structure it was. My heart racing, I knocked on the door. Almost at once Aunt Nesibe answered. As I carried the tricycle inside, I remember how impressed she was by the sight of Çetin Efendi, who stood behind me holding an umbrella, and how delighted she was by the roses. I sensed unease in her expression, but I was not the least deterred, because I was climbing the stairs, and with every step, I was drawing closer to Füsun.

Füsun's father was waiting on the landing. "Welcome, Kemal Bey." I'd forgotten I'd seen him a year earlier at the engagement party, somehow imagining that we hadn't embraced since the last of the old family meals at the Feast of the Sacrifice. Age had not made him less handsome, as is so often the case; it had simply made him less visible.

Then I thought I must be seeing Füsun's sister, because there, standing behind her father in the doorway, I saw not Füsun, but a dark-haired beauty who resembled her. But even as I was thinking this, I realized that this was Füsun. It was a tremendous shock. Her hair was jet-black. "Her natural color, of course!" I told myself, as I tried to calm my nerves. I went inside. My plan had been to ignore her parents,

hand her the flowers, and throw my arms around her, but I could tell from the look on her face, and her discomfort as she approached me, that she didn't want me to embrace her.

We shook hands.

"Oh, what lovely roses!" she said, without taking them from my hands.

Yes, of course, she was very beautiful; she had matured. She could tell how distressed I was that our reunion was turning out so differently from what I'd imagined.

"Aren't they lovely?" she said, now addressing someone else in the room.

I came eye to eye with the person she had indicated. The first thought to cross my mind was: "Couldn't they have found another evening to invite over this sweet, fat adolescent neighbor?" But once again, even as the thought passed through my mind, I knew I was wrong.

"Cousin Kemal, let me introduce you, this is my husband, Feridun," she said, trying to sound as if she'd just recalled a detail of minor significance.

I stared at this man called Feridun, not as a real person but as if he were an obscure memory I could not quite place.

"We married five months ago," said Füsun, raising her eyebrows as if waiting for the penny to drop.

I could tell, from the way this fatso shook my hand, that he knew nothing. "Oh, I'm so pleased to meet you!" I said to him, and smiling at Füsun, now hiding behind her husband, I said, "You're a very lucky man, too, Feridun Bey. Not only have you married a wonderful girl, but this girl is now in possession of a nifty tricycle."

"Kemal Bey, we so wanted to invite you to the wedding," said her mother. "But we'd heard your father was ill. My girl, instead of hiding behind your husband, why don't you find a vase for those beautiful roses Kemal Bey is holding in his hands."

My beloved, who had never once been absent from my dreams all year, took the roses from my hands with a small, elegant gesture, first bringing herself close enough for me to see the blush of her cheeks, her ever-inviting lips, her velvet skin, and her neck, and I would have done anything at that moment, just to know I could spend the rest of

my life this close. I inhaled the fragrance of her exposed bosom before she drew back. I was dumbstruck, amazed at her reality, as one is amazed at the reality of the natural world.

"Put the roses in a vase," said her mother.

"Kemal Bey, you'll have a *rakı,* won't you?" said her father.

"Tweet tweet tweet," said her canary.

"Oh, yes, I'd love one, yes, I'll have a *rakı.*"

They gave me two *rakı*s on the rocks and I knocked them both back, on an empty stomach, hoping they would take immediate effect. I remember speaking for a time about the tricycle I'd brought with me, and a few childhood memories, before we sat down to eat. But alas, I was still sober enough to know that because she was married, I could show none of that lovely brotherly feeling that I'd hoped the tricycle would evoke.

Füsun sat across from me, as if by chance (she'd asked her mother where she should sit), but she would not look me in the eye. During these first minutes I was shocked enough to believe she had no interest in me. I, in turn, tried to look as if I had no interest in her, as if I were a well-meaning, wealthy cousin, here to give a wedding present to a poor relation, while many more important things weighed on my mind.

"Soooo, when can we expect children?" I asked, still playing this role, looking Feridun in the eye first, but failing then to address Füsun.

"We're not thinking of having children right away," said Feridun. "Perhaps after we've moved into our own house."

"Feridun is very young, but he is one of the most sought-after screenwriters in Istanbul today," said Aunt Nesibe. "He's the one who wrote *The Old Lady Who Sells* Simits."

All night I struggled to get it through my skull—as people say. At intervals all evening I conjured up the hopeful dream that this wedding story was a joke, that they'd gotten some neighbor's fat son to masquerade as a childhood sweetheart, dressing him up as her husband, a final lesson to me that they would, at evening's end, own up to. Eventually, as I learned more about the couple, I did accept that they were married, but then it was the various details of that reality that, as they were disclosed, I found unacceptable: Feridun Bey, this son-in-law who was living with his wife's family, was twenty-two years old, and interested in film and literature; though he wasn't making much money yet,

in addition to screenplays for Yeşilçam, he wrote poetry. I discovered that as a distant relation on her father's side, he'd played with Füsun as a child, and that, when he was a child, he had even ridden on the tricycle I'd brought back to the house. Hearing all this, I felt my very soul shriveling up inside me, irritated by the *rakı* that Tarık Bey poured so solicitously into my glass. Whenever I entered a new house, I would always feel uncomfortable until I knew how many rooms it had, and which backstreet the balcony looked out on, and why a table had been positioned in a particular way, but now there were no such questions in my mind.

The only consolation was to sit across from her, to admire her, like a painting. Her hands were always moving, just as I remembered. Although married, she still didn't smoke in front of her father, and that, alas, meant that I could not watch her light her cigarette in that lovely way of hers. But twice, she pulled back her hair the way she used to, and three times, when she was trying to join the conversation, she took a deep breath—like those she had always drawn when we quarreled—and raised her shoulders just slightly, as if waiting for her chance. Each time I saw her smile, hope and joy rose up inside me with the force of blooming sunflowers. I was reminded by her beauty, and by her gestures, which were so dear to me, and by her luminous skin, that the center of the world, the center to which I must travel, was at her side. All other people, places, and pastimes were nothing but "vulgar distractions." It wasn't just in my mind that I knew this, it was in my body; and so sitting across from her I longed to stand up and throw my arms around her. But when I tried to contemplate my situation, and what would happen next, I felt such an ache in my heart that I could think no more, and then it was not just for the benefit of the others that I played the part of the relative come to congratulate the young couple: It was also for my sake. Though our eyes hardly met during that meal, Füsun caught on at once, and as I carried on acting, she did everything one would expect from a happy young newlywed entertaining a wealthy distant relation come to call in his chauffeur-driven car, teasing her husband, feeding him spoonfuls of fava beans. All this made the eerie silence in my head echo.

The rain that had been pelting down ever faster on the way to the house showed no signs of abating. Tarık Bey had already told me, at the

very beginning of the meal, that the neighborhood of Çukurcuma was, as the name implied, a topographical bowl, and that only after buying the house last summer did they learn it had flooded many times in the past, and so I went with him to the bay window to watch the torrent pouring down the hill. Many of their neighbors were out there, with their trousers rolled up and barefoot, using zinc buckets and plastic washtubs to bail out the water rushing over the curbs right into their houses, and arranging piles of stones and rags into makeshift levees. As two barefoot men struggled to clear a blocked grate with their hands, two women, one wearing a green and the other a purple headscarf, were pointing insistently at something in the torrent and shouting. At the table Tarık Bey had commented mysteriously that the sewers dating back to Ottoman times could no longer cope. Whenever the drumming of the rain increased, someone would say something like, "The heavens have opened up," or "It's the flood!" or "May God protect us," and then rise from the table to gaze anxiously through the window at the floodwaters and the neighborhood, now transfigured in the pale lamplight. I, too, felt compelled to rise, in solidarity with their fears of flood, but I was so drunk I was afraid of being unable to stay on my feet, and knocking over tables and chairs.

"I wonder how your driver is doing out there?" said Aunt Nesibe as she gazed out the window.

"Should we get him something to eat?" asked the bridegroom.

"I could take it down," said Füsun.

But Aunt Nesibe, sensing that I might not like this, changed the subject. For a moment I felt myself to be a lonely drunk under the suspicious scrutiny of the family standing by the bay window. So I faced them and smiled. Just then there was a clatter in the street below—a barrel had overturned—and we heard someone cry in pain. Füsun and I came eye to eye. But she immediately looked away.

How could she manage to show so little interest? This was what I wanted to ask her. But I wasn't asking this question like some addled abandoned lover, who, when asked why he won't leave his beloved alone, claims, I just wanted to ask her something! Well, all right, I was.

She'd seen me sitting here alone, so why didn't she come and sit beside me? Why didn't she seize this perfect opportunity to explain everything? Again we exchanged glances and again she looked away.

Now Füsun will come to sit at your side, said an optimistic voice inside me. And if she came, it would be a sign that one day she would give up on this misalliance, divorce her husband, and be mine.

The sky rumbled. Füsun drew away from the window and taking five steps floated to the table like a feather to sit across from me in silence.

"I beg you to forgive me," she said in a whisper that pierced my heart. "I wasn't able to come to your father's funeral."

The blue glare of a lightning bolt flashed between us like a swath of silk in the wind.

"I was waiting for you," I said.

"I guessed that, but I would never have been able to come," she said.

"That illegal awning over the grocery shop has been blown off— did you see?" said her husband, Feridun, as he returned to the table.

"We saw that, and it's a shame," I said.

"Not a shame at all," said the father, returning from the window.

Seeing his daughter with her hands over her face, like a girl in tears, he first glanced anxiously at his son-in-law, and then at me.

"I still feel so bad about missing Uncle Mümtaz's funeral," said Füsun in a quivering voice. "I loved him so dearly. I was so upset."

"Füsun loved your father very much," said Tarık Bey. Passing his daughter, he kissed her head, and when he sat down he raised his eyebrow with a smile and poured me another *rakı*. Then he offered me a handful of cherries.

I was still drunkenly imagining the moment when I would remove from my pocket my father's velvet box with the pearl earrings, and then the single earring that belonged to Füsun, but that moment never seemed at hand. Churning up inside, I rose to my feet. But I could not stand up to offer her the earrings formally; on the contrary, I had to remain seated. From the way that father and daughter were looking at me, I knew that they, too, were waiting for something. Maybe they wanted me to go, but no, somehow the atmosphere in the room spoke of a deeper sort of anticipation. I dreamed this scene so many times, but in my dreams, of course, Füsun was not married, and just before I offered my presents, I had asked her mother and father for her hand.

Now my intoxicated mind could not decide what to do with the earrings in this unforeseen situation.

I told myself that I couldn't take out the boxes because of my cherry-stained fingers. "May I wash my hands?" I asked. Füsun could no longer ignore the storm raging within me. Feeling her father's prodding gaze, which said, Show him where to go, daughter! she jumped to her feet in a panic. Seeing her standing before me, my memories of all our rendezvous a year earlier came to full life.

I wanted to embrace her.

We all know how the mind will work on two distinct planes when we're drunk. On the first plane I was embracing Füsun as in a dream, as if we were meeting in a place beyond time and space. But on the second plane, we were around that table in the house in Çukurcuma, and a voice minding the second plane warned I must not embrace her, that to do so would be disastrous. But because of the *rakı,* this voice was delayed; instead of coinciding with my dream of embracing Füsun, it came five, six seconds later. During those five, six seconds, my will was free, and precisely for that reason I did not panic, but followed her up the stairs.

The closeness of our bodies, the way we walked upstairs—these too were like things from a dream out of time, and so they would remain in my memory for many years. I saw understanding and disquiet in her glances and I felt grateful to her for the way she expressed her feelings with her eyes. There, once again, it was clear that Füsun and I were made for each other. I had undergone all this anguish on account of this awareness and it did not matter in the least that she was married; just to feel as happy as I did now, climbing up the stairs with her, I was ready to undergo any further torment. To the visitor stubbornly wed to "realism" who cannot suppress a smile at this, having noticed how small that Çukurcuma house is, with the distance between that table and the upstairs bathroom being perhaps four and a half paces, not counting the seventeen steps, let me state with categorical and liberal-minded clarity that I would have readily sacrificed my very life for the happiness I felt during that brief interlude.

After closing the door to the bathroom on the top floor, I decided that my life was no longer in my control, that my connection to Füsun

had shaped it into something beyond my free will. Only by believing this could I be happy, could I indeed bear to live. On the little tray before the mirror bearing Füsun's, Aunt Nesibe's, and Uncle Tarık's toothbrushes, as well as shaving soap, brush, and razor, I saw Füsun's lipstick. I picked it up and sniffed it, then put it into my pocket. I efficiently sniffed the towels hanging on the rack but detected nothing as I remembered it: Clean ones had evidently been put out in expectation of my visit. As I surveyed the small toilet, searching for one other object that might offer me consolation during the difficult days awaiting me after I'd left this place, I saw myself in the mirror, and from my expression I had a shocking intimation of the rift between my body and my soul. Whereas my face was drained by defeat and shock, inside my head was another universe: I now understood as an elemental fact of life that while I was here, inside my body was a soul, a meaning, that all things were made of desire, touch, and love, that what I was suffering was composed of the same elements. Between the howling of the rain and the gurgling of the water pipes, I heard one of the old Turkish songs that, in my childhood, would make my grandmother so happy whenever she heard it. There had to be a radio nearby. Between the low moan of the lute and the joyous chatter of the kanun was a tired but hopeful female voice, coming to me through the bathroom's half-open window, saying, "It's love, it's love, the reason for everything in the universe." With the help of this singer, I thus lived through one of my life's most profoundly spiritual moments standing in front of the bathroom mirror; the universe was one, and one with all inside it. It wasn't just all the objects in the world—the mirror in front of me, the plate of cherries, the bathroom's bolt (which I display here), and Füsun's hairpin (which I thankfully noticed and dropped into my pocket)—all humanity was one, too. To understand the meaning of this life, one first had to be compelled to see this unity by the force of love.

It was in this good-natured spirit that I took out Füsun's orphaned earring and put it where her lipstick had been. Before taking out my father's pearl earrings, the same music reminded me of the streets of old Istanbul, the stormy loves recounted by aging couples as they sat in their wooden houses listening to the radio, and the reckless lovers who ruin their lives because of passion. Inspired by the melancholy song on the radio, I understood that, as I had become engaged to another,

Füsun was perfectly justified and indeed had had no choice but to save herself by marrying. I found myself verbalizing all this, as I peered in the mirror. I recognized in my eyes something of the innocence and playfulness I'd had as a child, and when I experimented with my reflection, I made a shocking discovery: By imitating Füsun, I could escape my own being by the strength of my love; I could consider—and even feel—all that passed through her heart and mind; I could speak through her mouth, understand how she felt a thing even as she felt it herself—for I was she.

The shock of my discovery must have kept me in the bathroom for an unusually long time. Someone coughed discreetly outside the door, I think. Or knocked: I can't quite remember which, because "the reel had snapped." That was how we'd put it when we were young, and blacked out at parties from too much drink, referring to those maddening interruptions at the cinema, when the projectionist's life was in danger. How I left the bathroom, how I regained my seat, with what excuse Çetin had come upstairs and coaxed me through the door, of these things I have no recollection. There was also a silence at the table; I so remember that, but whether it was owing to the rain having eased up, or to my embarrassment, which could no longer be hidden or ignored, or simply to the defeat that was fast destroying me, with the pain that had become tangible—this I cannot say.

Far from being unnerved by the silence, the son-in-law was enthusing about the film business—perhaps I'd actually said my reel had snapped and he'd taken his cue from this—with a mixture of love and loathing, saying how bad Turkish films were, and how especially bad the films made at Yeşilçam, though the Turkish people were crazy about the cinema. These were perfectly ordinary opinions at the time. Amazing films could be made, if only one could secure a backer who was serious, resolute, and not overly greedy; he had written a screenplay in which he intended to cast Füsun, but what a shame it was that he could find no one to produce it. What concerned me was not that Füsun's husband needed money and wasn't shy about saying so; what preoccupied me was that Füsun would one day become a "Turkish film star."

On the way home, semiconscious in the backseat while Çetin drove, I remember dreaming Füsun had become a famous actress. No matter

how drunk we might be, there are moments when the leaden clouds of our pain and confusion disperse, when for a moment we see the reality we believe, or suspect, that everyone else knows: so here, as Çetin drove and I sat in the backseat, gazing out at the dark, flooded avenues, there was a moment of sudden recognition, and I understood that Füsun and her husband saw me as a rich relative who might help with their dreams of making movies. This was why they had invited me to supper. But deadened as I was by the *rakı,* I felt no resentment; instead I continued wafting off into dreams about Füsun the actress so famous she was known all over Turkey, no ordinary actress but a glamorous film star: At the premiere of her first film, at the Palace Cinema, she would walk on my arm through the applauding crowd toward the stage. And the car was passing right through Beyoğlu at that moment, right in front of the Palace Cinema!

50

This Is the Last Time I'll Ever See Her!

IN THE morning I saw things as they really were. The night before, at the hands of those householders, my pride had been shattered, I had been ridiculed, even degraded, but I had myself abetted in the humiliation, I now saw, by getting so drunk. Though they knew how much in love I was with their daughter, Füsun's parents must have been in on this plan, having condoned inviting me to supper, for no other purpose but to pander to their son-in-law's childish, stupid dreams of becoming a filmmaker. I would never see these people again. When I felt my father's pearl earrings in my jacket pocket, I was glad. I had given Füsun her own earring back, but I had not allowed my father's valuable gift to be taken by these people who had designs on my money. After a year of suffering, it had also been salubrious to see Füsun one last time: The love I felt for her was owing not to her beauty or her personality; it was nothing more than a subconscious reaction to Sibel and the prospect of marriage. Though never having read a word of Freud, I recall

appropriating the concept of the subconscious, widely bandied about in newspapers, to make sense of my life at that time. Our forebears had djinns that drove them to action against their will. And I had my "subconscious," which had driven me not just into a year of such suffering on account of Füsun, but also now to embarrassment in ways I could never have imagined. I could no longer be its dupe; I needed to turn over a new leaf in my life, and forget everything to do with Füsun.

My first defiant act was to take her letter of invitation from my breast pocket and rip this letter so carefully preserved in its envelope into tiny pieces. The next morning I stayed in bed until noon, determined at last to forbid this obsession that my subconscious had sent me. Giving a new name to my pain and degradation gave me a new strength with which to fight it. My mother, seeing me hungover from the night before, disinclined even to get out of bed, had sent Fatma Hanım to Pangaltı to buy prawns for lunch; she had them cooked in a casserole with garlic just the way I liked them, and for the vegetable some artichokes with olive oil and lots of lemon. Calmed by my decision never to see Füsun and her family again, I was savoring my lunch, enjoying every bite, even having a glass of white wine, as my mother did. She told me that Billur, the youngest daughter of the Dağdelen family, who had made their original fortune in railroads, had finished lycée in Switzerland and had just last week turned eighteen. The family, having since gone into construction, was now in difficult straits, and, being unable to repay various bank loans procured by pulling who knew what strings and paying heaven knew what bribes, the Dağdelens were now keen to marry off their daughter before these difficulties became public: It seemed bankruptcies were imminent. "Apparently the girl is very beautiful!" she then said, with an encouraging air. "If you want I can go and have a look at her. I can't just sit around and watch you spend every night drinking with your men friends, like a gang of officers in the provinces."

"You go and take a look at this girl, Mother dear," I said, without smiling. "I've tried my luck with a modern girl I chose for myself—I spent time with her and took time to know her, but it didn't work out. Let's try matchmaking this time."

"Oh my darling son, if only you knew how happy I am to hear you say this," said my mother. "Of course, you could still get to know each

other, and go out together. . . . You have a beautiful summer before you; it's so lovely, you're both young. Look, I want you to treat this one right. Shall I tell you why it didn't work out with Sibel?"

At that moment I realized that my mother knew all about Füsun, but that she wanted to find some other way of explaining a painful occurrence—just as our ancestors had blamed djinns rather than themselves. Seeing this, I was deeply touched.

"She was very ambitious, very haughty, very proud, that girl," said my mother, looking straight into my eyes. She added, as if giving away a secret, "Anyway, from the time I heard she didn't like cats, I had my doubts."

I had no memory of Sibel's hatred of cats, but this was the second time my mother had used this as a reason to rail against her. I changed the subject. We drank our coffees together on the balcony, watching a small funeral below. Though she still shed a few tears now and again, saying, "Oh, your poor, dear father," my mother was in good health; she had pulled herself together and her faculties were sound. She told me that the person in the coffin set on the funeral stone was one of the owners of the famous Bereket Apartments. As she located it for me, two buildings down from the Atlas Cinema, I found myself daydreaming about a premiere at the Atlas Cinema of a film starring Füsun. After lunch I left for Satsat, where, convinced that I could recover the "normal" life I'd had before Füsun, before Sibel, I threw myself into my work.

Seeing Füsun had alleviated much of the pain I had suffered for so many months. As I worked in the office, part of me was thinking, in all sincerity, that I was lucky to have recovered from my lovesickness, and in this thought was a great serenity. As I carried on shuffling papers, I checked myself periodically, and I was glad to note that indeed I had no desire to see her. There was no longer any question of my returning to that dreadful house in Çukurcuma, that rat's nest with its mud and its floods. My disdain was fueled less by love for Füsun than by resentment of her conniving family and that fatso they called their son-in-law. But I grew angry for feeling enmity for a mere boy, just as I cursed my stupidity in enduring a year of agony on account of this "love." But was I really angry at myself? I wanted to believe that I had embarked on a new life, and that my heartache was over; these powerful new dark

feelings were necessary proof my life had changed, and as such I needed them, genuine or not. So I resolved to see the old friends I had been shunning, to have fun, to go to parties, though for some time I kept my distance from Zaim and Mehmet, lest they bring back memories of Füsun and Sibel. Sometimes, after midnight, having had a lot to drink at a nightclub or a party, I would see my rage directed not at society's idiocies, its tedious conventions, nor my own foolishness in succumbing to my obsession; my anger was directed at Füsun; in a walled-off corner of my mind, I would fretfully acknowledge that I was in perpetual argument with her, at times thinking secretly that she had chosen to reject the pleasant life I could have given her, in favor of this flooded rat's nest in Çukurcuma, and so she was to blame for my natural inability to continue caring about someone who would bury herself alive in such a stupid marriage.

I had a friend from my army days, Abdülkerim, the son of a wealthy Kayseri landowner. After our military service had ended, he had kept in touch with holiday and New Year's cards, which he signed in a careful floral script, and so I had made him the Kayseri distributor for Satsat. Because I'd thought Sibel would find him far too "à la Turca" I had not spared him much time during his visits to Istanbul over the last few years, but four days after my visit to Füsun's family, I took him to a new restaurant named Garaj that had found immediate favor with Istanbul society. As we reminisced, it was almost as if I were seeing my life through his eyes; to make myself feel better, I told him stories about the wealthy patrons entering and leaving the restaurant, sometimes even just before or after they had visited our table to offer us polite and affable handshakes. Before long it was clear that Abdülkerim was less interested in stories of ordinary human frailty, pain, and transgression than in the sex lives, scandals, and domestic peccadillos of rich Istanbullus whom he hardly knew; one by one he focused on each girl rumored to have had sex before marriage, or even before her engagement, and I did not like this. Perhaps this is why, by the end of the evening, having fallen into a contrarian frame of mind, I told Abdülkerim my own story, describing the love I'd felt for Füsun, but telling it as if it had all happened to some other rich idiot. As I told the story of the young rich man, much admired in society, who had fallen so madly in love with a "shopgirl," only for her, in the end, to marry someone

else, I was so anxious to keep Abdülkerim from suspecting that "he" was me that I pointed out a young man sitting at a distant table.

"Well, no harm done. This promiscuous girl has been married off, so the poor man is off the hook," said Abdülkerim.

"Actually, when I think of what that man risked for love, I can't help feeling a lot of respect for him," I said. "He broke off his engagement for this girl. . . ."

For a moment Abdülkerim's face lit up with gentle understanding; but then he turned to look covetously at Hicri Bey, the tobacco magnate, with his wife and two swanlike daughters, making their way toward the exit. "Who are those people?" he asked without looking at me. The younger of Hicri Bey's two dark-haired daughters—her name was Neslişah, I think—had bleached her hair. I did not like the way Abdülkerim looked at them, half mocking, and half admiring.

"It's late. Shall we go?" I said.

I asked for the bill. We said nothing to each other until we had left the restaurant and were saying our good-byes.

I did not walk straight home to Nişantaşı; instead I headed for Taksim. I had returned Füsun's orphaned earring to her, but not formally—in my stupor, I had merely left it in the bathroom. This was demeaning, both for them and for me. My pride demanded that I make it clear to them that this had been no mistake but something I'd done deliberately, intending she would find it. So I would have to apologize, and being secure in the knowledge that I would never see her again, I could smile at Füsun and say one last indifferent good-bye. As I walked through the door, Füsun would understand that this was to be her last glimpse of me, and perhaps she would panic, but I would elude her in a deep silence, as she had done to me for the past year. I would not even say that we would never see each other again, but I would wish her well in such a way that she could not conclude otherwise and would thus be undone.

As I slowly made my way toward Çukurcuma through the backstreets of Beyoğlu, it crossed my mind that there was a chance Füsun might not be undone at all; it was possible she was perfectly happy, living in that house with her husband. But if that was the case, if she loved that dullard so much that she would choose to live penuriously in that rickety house, then I would surely have no wish to see her again

anyway. Along the narrow streets, uneven sidewalks, and stairs, I looked through the half-drawn curtains to see families turning off their television sets and preparing for bed, or poor, elderly couples sitting across from each other, smoking their last cigarettes of the day, and it struck me on this spring evening, in the pale lamplight, that the people living in these silent backstreets were happy.

I rang the doorbell. A bay window on the second floor swung open. "Who is it?" Füsun's father called out into the darkness.

"It's me."

"Who?"

As I stood there, wondering if I should run away, her mother opened the door.

"Aunt Nesibe, I am sorry to disturb you at such a late hour."

"Never mind, Kemal Bey. Do come in."

As I followed her up the stairs, just as I had done on my first visit, I told myself, "Don't be bashful! This is the last time you'll see Füsun!" I went inside, fortified by my resolve never to let myself be degraded that way again, but as soon as I saw her, my heart began to pound and I felt embarrassed. She was sitting in front of the television with her father. When they saw me, they both jumped to their feet in a surprised confusion that softened apologetically when they noticed my furrowed brow and the liquor on my breath. During the first four or five minutes, which I do not like to remember, not at all, I told them laboriously how very sorry I was to have disturbed them, but that I had just been passing by and had something on my mind that I wished to discuss with them. In that interval I had discovered that her husband was not at home ("Feridun went out with his film friends"), but I couldn't find a way to broach my subject. Her mother went into the kitchen to make tea. After her father got up without excusing himself, we found ourselves alone.

"I'm very sorry," I said, as we both kept our eyes on the television. "I meant no harm. It was because I was drunk that I left your earring next to the toothbrushes that evening, though I meant to hand it back to you properly."

"There wasn't any earring near the toothbrushes," she said with a frown.

As we looked at each other, struggling to make some sense of this,

her father came in holding a bowl of semolina and fruit *helva,* which he said was just for me. After taking one spoonful, I praised the *helva* to the skies. For a moment we were silent, as if it were for the *helva* that I had come here in the middle of the night. That was when I realized, as drunk as I was, that the earring had been an excuse: I had come here to see Füsun. And now she was teasing me, telling me she had not found the earring. During that silent interlude I remarked to myself that the pain of not seeing Füsun had been far more soul-destroying than the shame I had suffered in order to see her. I also knew at that moment that I was prepared to endure more situations like this to be spared the pain of not seeing her, though I was more defenseless in the face of shame than in that of longing. Caught now between the fear of humiliation and the fear of suffering her absence, I had no idea what to do, so I stood up.

There, right across from me, I saw my old friend Lemon. I took one step toward its cage, coming eye to eye with the bird. Füsun and her parents had stood up with me, perhaps relieved to see me go. Again I was delivered to the dreadful awareness that had driven me from this wretched house the last time. Füsun was married now; I would not be able to lure her away. Remembering, too, what conclusion I had drawn following the last visit—that she was after my money—I resolved once more that this was the last time I'd ever see her. I was never going to set foot in this house again.

Then the doorbell rang. This oil painting captures that moment when Lemon and I were staring at each other, while Füsun and her parents were staring at me and the canary from behind, just before the doorbell rang and we all turned to look at the door: I commissioned it many years after these events. Because the point of view is that of Lemon the canary, with whom I had identified in some strange way at that moment, none of our faces are depicted. It portrays the love of my life, viewed from the back, just as I remembered, and every time I see it, this painting brings me to tears; and let me add with pride that the artist has caught the night peeking through the parted curtains, the dark neighborhood of Çukurcuma in the background, and the room's interior with perfect fidelity to my descriptions.

Füsun's father went over to the bay window to look down at the mirror that was mounted in such a way as to reflect the front and,

announcing that it was one of the neighbors' children ringing the bell, he went downstairs. There was a silence. I went to the door. As I put on my coat I lowered my head and stayed silent. As I opened the door, it occurred to me that all was not lost: This could be the "revenge" scene I had been preparing for a year now, but keeping this fact to myself, I simply said, "Good-bye."

"Kemal Bey," said Aunt Nesibe. "We cannot begin to tell you how glad we were that you rang our bell as you were passing by." She glanced at Füsun. "Don't pay any attention to her pouting. She's afraid of her father. If she weren't, she'd have shown herself as happy as we were to see you."

"Oh, Mother, please," said my beloved.

It did cross my mind to begin the parting ritual with some pronouncement along the lines of Well, I can't bear her hair being black, but I knew these words would ring false: I was willing to suffer all the pain in the world for her, and what's more I knew that willingness would be the death of me.

"No, no, she looks fine," I said, looking meaningfully into Füsun's eyes. "Seeing how happy you are has made me happy, too."

"It was seeing you that made us happy, too," said Aunt Nesibe. "Now that your feet know how to get here, we hope you'll visit us often."

"Aunt Nesibe, this is the last time I'll be visiting you," I said.

"Why? Don't you like our new neighborhood?"

"It's our turn now," I said with fake jocularity. "I'm going to talk to my mother and ask her to invite you over." There was, I'd like to say, a certain indifference in the way I walked down the stairs, not once looking back at them.

"Good-night, my son," said Tarık Bey softly when I met him at the door. The neighbor's child had given him a package, saying, "This is from my mother!"

As I felt the fresh air cool my face, I thought how I would never again see Füsun, and for a moment I believed I had an untroubled, carefree, happy life before me. I imagined that Billur, the Dağdelens' daughter, whom my mother was going to visit, would be charming. But with every step I took, farther from Füsun, I felt as if I were leaving a piece of my heart behind. As I walked up Çukurcuma Hill, I could feel

my soul quivering in my bones, straining to return to the place I'd just left, but I still believed it was only a matter of letting this fever break and then I'd be over it.

I'd come a long way. What I needed now was to find ways to distract myself, to remain strong. I went into one of the *meyhane*s that was about to shut, and sitting in the atmosphere of thick blue cigarette smoke I drank two glasses of *raki* with a slice of melon. When I went back out into the street, my soul was telling my body we had not gone far from Füsun's house. At this point I must have lost my way. In a narrow street I came across a familiar shadow that sent an electric shock through me.

"Oh, hello!" he said. It was Füsun's husband, Feridun.

"What a coincidence," I said. "I'm just coming back from your house."

"Is that so?"

Once again I was shocked to see how young this husband was—how childish, in fact.

"Ever since my last visit, I've been thinking about this film business," I said. "You're right. We have to make art films in Turkey, too, just as they do in Europe. . . . But since you weren't there, I didn't have a chance to talk about all this. Shall we get together some evening?"

I could sense an immediate confusion in his evidently tipsy mind (by the whiff of him, he'd had at least as much to drink that evening as I had).

"Why don't I come and pick you up on Tuesday evening at seven?" I said.

"Füsun can come too, right?"

"Of course, if we are to make a European-style art film, we must have Füsun play the lead!"

For a moment we smiled at each other like two old friends who, having shared the long, trying years of school and military service, had at last seen their ship come in. In the lamplight I looked probingly into Feridun Bey's eyes, each of us imagining he'd gotten the better of the other, and we parted in silence.

51

Happiness Means Being Close to the One You Love, That's All

I REMEMBER that when I reached Beyoğlu, its shop windows were glittering and I was glad to walk among the crowds streaming out of the cinemas. My happiness—the joy I could take in life—was impossible to deny. That Füsun and her husband had invited me to their house so that I would invest in their preposterous film dreams should perhaps have caused me only shame and humiliation, but so great was the happiness in my heart that I felt no embarrassment whatsoever. That night my mind was fixed on one fantasy: the film premiere, and Füsun holding the microphone, speaking to the admiring audience at the Palace Cinema—or was the New Angel Cinema a better choice?—thanking me first and foremost. When I came on stage, those attuned to the latest gossip would whisper that during the filming the young star had fallen in love with the producer and left her husband. The photograph of Füsun kissing me on the cheek would appear in all the newspapers.

There is no need to dwell on the dreams my imagination was churning out, much as the rare safsa flowers that secrete their own opiated elixir and fall off to sleep. Like most Turkish men of my world who entered into this predicament, I never paused to wonder what might be going on in the mind of the woman with whom I was madly in love, and what her dreams might be; I only fantasized about her. Two days later, when I went to collect her and Feridun in the Chevrolet, with Çetin Efendi at the wheel, I saw, as soon as my eyes met hers, that our evening would in no way resemble the conjurings of my imagination, but being happy just to see her, I lost none of my enthusiasm.

I invited the newlyweds to sit in the backseat, while I sat in the front beside Çetin, and as we passed through streets darkened by the city's shadows, and through dusty, disorderly squares, I tried to lighten the mood by turning my head around continually to make jokes. Füsun was

wearing a dress the color of blood oranges and fire. To expose her skin to the exquisite fragrance of the Bosphorus breeze, she had left the top three buttons undone. I remember that as the car bumped over the cobblestones on the Bosphorus roads, every time I turned around to address them, happiness flamed up in me. That first night we went to Andon's Restaurant in Büyükdere, and—as would become the rule whenever we met to discuss our film project—I soon realized that I was the one who was the most animated of our party.

We had just selected our mezes from the tray that the old Greek waiters brought to us, when Feridun, whose self-confidence I almost envied, said, "For me, Kemal Bey, cinema is the only thing in life that matters. I say this so that my age does not undermine your confidence in me. For three years now I've been working in the heart of Yeşilçam, our own Hollywood. I'm very lucky, I've met everyone. I've worked as a set hand, carrying lights and props, and I've worked as an assistant director. I've also written eleven screenplays."

"And all of them were shot, and they did very well," said Füsun.

"I'd really like to see those films, Feridun Bey."

"Of course, Kemal Bey, we could go and see them. Most of them are still playing at summer cinemas, and some are still showing in Beyoğlu. But I'm not happy with those films. If I were content to produce work of that caliber, the people at Konak Films say that I'd be ready to start directing. But I don't want to make that sort of film."

"What sort of film would that be?"

"Commercial, melodramatic, mass audience stuff. Don't you ever go to Turkish films?"

"Very rarely."

"The rich of our country who have been to Europe only go to Turkish films to laugh at them. When I was twenty I thought that way, too. But I don't look down on Turkish films the way I used to. Füsun now likes Turkish films very much."

"Teach me, too, for God's sake, so I, too, may love them as much," I said.

"I'd be happy to teach you," said Mr. Son-in-law, smiling sincerely. "But the film we make with your help won't be at all like those, have no fear. For example, we won't make a film in which Füsun leaves the vil-

lage for the city, and three days later, thanks to her French nanny, becomes a lady."

"Anyway, I'd be fighting with that nanny from the very beginning," said Füsun.

"And you won't see her playing Cinderella, despised by her rich relatives because she's poor," Feridun continued.

"Actually, I wouldn't mind playing a despised poor relation," said Füsun.

Although I didn't believe she was mocking me, I felt in her words a buoyancy, a lightheartedness, that pained me all the same. It was in the same blithe spirit that we shared family memories; after recalling how we'd long ago toured Istanbul in the Chevrolet, with Çetin at the wheel, we discussed recent and imminent deaths of distant relations living in the narrow streets of distant neighborhoods, and much else. Our discussion of how to make stuffed mussels ended with the extremely pale Greek chef coming all the way from the kitchen to tell us, with a smile, that a dash of cinnamon was required. The son-in-law, whose innocence and optimism were beginning to win me over, was not overbearing as he promoted his screenplay and his film ambitions. When I dropped them off at the house, we agreed to meet again four days later.

During the summer of 1976 we dined together at many Bosphorus restaurants. Even years later, every time I looked out at the Bosphorus through the windows of those restaurants, I would remember being caught between my elation at sitting across from Füsun and the cool I needed to maintain to win her back, and would feel the same confusion that had beset me. At these meals I would listen respectfully to her husband holding forth on his dreams, on Yeşilçam films and Turkish audiences, keeping my doubts to myself; it was, after all, not my aim to offer the Turkish filmgoer "the gift of an art film in the Western sense of the term," and so I would discreetly create difficulties; for example, asking to see the finished screenplay, only to express my excitement about another story before the first script came to hand.

Once, after Feridun (whom I had discovered to be cleverer and more adroit than many Satsat employees) had engaged me in a conversation about the cost of a "good and proper" Turkish film, I worked out that the cost of making Füsun a star would be roughly half that of

a small apartment in the backstreets of Nişantaşı, but if we were unable to accomplish this purpose, it was not because this figure was unacceptable; it was because I had realized that seeing Füsun twice a week on the pretense of making a film was enough to assuage my pain, at least for now. After suffering so much I was content with what I now had. Even to wish for more was too daunting. It was as if, having endured such agony, I needed to give myself a little rest.

If, after our meal, Çetin drove us to İstinye for chicken breast pudding with lots of cinnamon on top, or he took us to Emirgân for a stroll, to laugh and talk as we ate paper *helva* and ice cream sandwiches and gazed into the dark waters of the Bosphorus, it would seem to me that there could be no deeper happiness in all the world. One evening, when I had placated the djinns of love and found peace in Yani's Place, just by sitting across from Füsun, I recall being struck by the simple, ineluctable formula: Happiness means being close to the one you love, that's all. (Taking immediate possession is not necessary.) Just before acknowledging this enigmatic mantra, I had looked out the restaurant window at the opposite shore; seeing the twinkling lights of the *yalı* where Sibel and I had spent the previous summer together, I realized that love was no longer lacerating my stomach.

It was not just that the searing pains of love would disappear the moment I sat down at the same table with Füsun; I would immediately forget that until just now, this same pain had brought me to thoughts of suicide. So, at Füsun's side, with the agony having subsided, I would forget my wretched undoing; convincing myself that I had been restored to "normal," I returned to my old self; I would succumb to the illusion that I was strong, decisive, even free. But after our first three outings I came to notice that such ecstasy was inevitably followed by the familiar despair, and so, as I sat across from her, thinking how soon I would miss her, foreseeing the pain of the days to come, I would discreetly pilfer various objects from the table as reminders of the happiness I'd felt there and then—and to fortify myself later when I was alone. This little tin spoon, for example: One evening, at Aleko's Place in Yeniköy, I had a short conversation with her husband about football—it was fortunate we were both Fenerbahçe supporters, which spared us shallow arguments—when Füsun, getting bored, put this spoon into her mouth, toying with it for some time. This saltshaker:

Just as she picked it up a rusty Soviet tanker rumbled past the window, the violence of its propeller shaking the bottles and glasses on our table, and she held it for a good long time. On our fourth meeting, we went to Zeynel in İstinye, and as we all strolled, I was just behind her, Füsun cast off this half-eaten cone, which I retrieved from the ground and pocketed in a flash. Returning home, I would gaze drunkenly at these objects; a day or two later, not wishing my mother to see them, I would take them over to the Merhamet Apartments to arrange them among similarly precious artifacts, and as the agonies of love set in, I would conjure my relief with them.

During that spring and summer my mother and I grew closer—our camaraderie now resembled nothing we had known before. The reason, no doubt, was that she had lost my father, just as I had lost Füsun. Loss had brought us both greater maturity, and made us more indulgent. But how much did my mother know of my grief? Were she to find the spoons and ice cream cones I brought home with me, what would she think? If she had interrogated Çetin, how much would she have learned of my movements? Sometimes, in moments of misery, I would worry about such things; on no account did I want my mother to grieve for me; I did not want her thinking of me in the grip of an intolerable obsession driving me to mistakes I might "regret for a lifetime."

Sometimes I would feign being in higher spirits than she was; I could never tell her, even in jest, that her attempts to arrange a marriage for me were pointless, and so I would still listen intently to her detailed reports on the girls she had investigated on my behalf. One of these was the Dağdelens' youngest daughter, Billur; according to my mother, the spate of bankruptcies that had now come to pass had not arrested their "life of dissipation," complete with cooks and servants; though she conceded that the girl had a pretty face, she added that she was very short, and when I said I was not prepared to marry a dwarf, she closed the case file. (From our earliest youth, our mother had been telling us, "Don't you take any girl under 1 meter 65 centimeters, please; I don't want you marrying a dwarf.") As for the Mengerlis' middle daughter, whom I had met with Sibel and Zaim at the Cercle d'Orient in Büyükada early the previous summer, my mother decided that she wasn't suitable either: The girl had been very recently left in the lurch by the eldest Avunduk son, with whom she had been madly in love, and

whom she hoped to marry—a state of affairs that, as my mother had only lately discovered, had been scrutinized by all Istanbul society. My mother continued her search all summer long, and always with my blessing, sometimes because I actually hoped that her efforts might somehow produce a joyous outcome, and sometimes because I hoped this project would bring her out of the reclusiveness she had entered after my father's death. On any given afternoon, my mother might call the office from her house in Suadiye to tell me of a girl she really wanted me to see: She had been coming in the Işıkçıs' motorboat to spend her evenings on our neighbor Esat Bey's wharf, and if I came over to the other side before it got dark and went down to the shore, I could have a look and if I wished, I could meet her—this intelligence all relayed as dutifully as a peasant might do when leading hunters to the place where the partridges had gathered.

At least twice a day my mother would find an excuse to ring me at the office, and after telling me how long she had cried after coming across some possession of my father's at the back of a wardrobe—his black-and-white summer spectator shoes, for example, one of which I respectfully display here—she would say, "Don't leave me alone, please!" and would go on to remind me that I shouldn't stay in Nişantaşı, that it wasn't good for me to be alone either, and that she was definitely expecting me for supper in Suadiye.

Sometimes my brother would come with his wife and his children. After supper—while my mother and Berrin discussed children, relatives, old habits, new shops and fashions, the ever-spiraling prices, and the latest gossip—Osman and I would sit under the palm tree, where my father had once sat alone in his chaise longue, gazing at the islands and the stars and dreaming of his secret lovers. Here we would discuss the business and the settlement of my father's affairs. My brother would do as he always did in those days, urging me to come in on this business with Turgay Bey, but never insisting too much; and then he would tell me, again, what a good thing it had been promoting Kenan to the managerial ranks; he would go on to denounce the difficulties I'd made with Kenan, and my refusal to be part of this new venture; after warning me that this was my last chance to change my mind, and muttering that I would live to regret losing this opportunity, he would com-

plain that I seemed to be avoiding him, and all our mutual friends, indeed, running away from success and happiness, both in private life and at work. "What's eating you?" he would ask with a frown.

My answer would be that I was worn out after the loss of our father and the awkward ending of my engagement to Sibel—and left feeling a bit introverted. It was a very hot July evening when I told him that I wished to be alone with my grief, and I could see from Osman's face that he saw this as a form of madness. It seemed to me that, for now at least, my brother was willing to tolerate this as a species of severe depression; but if my affliction got any worse, he would find himself caught between embarrassment and the agreeable prospect of seizing permanent control of our business dealings through the pretext of my incapacity. But I was only afflicted by such anxieties if I'd seen Füsun very recently; if a longer time had elapsed since I'd last seen her, and I was racked with the pain of her absence, my thoughts would be only of her. My mother could sense my obsession, and the darkness inside me, but although it worried her, she did not truly want to know the details. After every meeting with Füsun I was overcome by the innocent wish to convince myself that the love I felt was of no great importance; in much the same way, I tried to persuade my mother, without quite putting it into words, that the obsession more and more evidently ruining my life was nothing to worry about. To prove to my mother that I didn't have a "complex," I told her that I had taken Füsun, the daughter of Aunt Nesibe the seamstress, along with her husband, out to eat on the Bosphorus, also mentioning that, at the young husband's insistence, we had all gone to see one of the films of which he was the screenwriter—such diversions as an obsessive could hardly afford to entertain!

"Goodness," said my mother. "I'm glad they're doing well. I'd heard how the child was spending time with film people, Yeşilçam people, and it made me very sorry. What can you expect for a girl who enters beauty contests! But if you say they're all right . . ."

"He seems to be a reasonable boy."

"You are going to the movies with them? You should still be careful. Nesibe has a very good heart, and she's very good company, but she's a conniver." Then, changing course, she said, "There's going to be a

party on Esat Bey's wharf this evening; they sent a man over with an invitation. Why don't you go—I can have them put my chair under the fig tree, and I can watch you from here."

52

A Film About Life and Agony
Should Be Sincere

FROM THE middle of June 1976 to the beginning of October, we went to see more than fifty films at the summer cinemas, whose ticket stubs I display here, along with the lobby photographs and advertisements I was able to acquire in subsequent years from Istanbul's collectors. Toward nightfall I would go with Çetin to the house in Çukurcuma to collect Füsun and her husband in the Chevrolet, just as I had done on evenings when we went out to eat along the Bosphorus. In the morning Feridun would have discovered from managers and distributors he knew where the film we wished to see was showing, noting the neighborhood and the district on a piece of paper, and under his direction, we would try to find our way. Istanbul had grown wildly over the previous ten years while fires and new buildings had changed its face, and the narrow streets were so packed with fresh arrivals that we often lost our way. Only by frequently stopping to ask directions did we eventually find the cinema, and even then we were obliged to run, often arriving to find the garden already in darkness, and so we would have no idea what sort of place it was until the lights came on during the five-minute intermission.

In later years these cinema gardens would disappear—the mulberry and plane trees would be chopped down, replaced with apartment buildings or turned into parking lots, or mini football fields covered with AstroTurf; but in those days, each time I set eyes on these mournful places—surrounded by whitewashed walls, little factories, teetering old wooden houses, and two- or three-story apartments with too many

balconies and windows to count—I was shocked by how crowded they were. Intermingled in my mind with the drama on the screen was the lively humanity I sensed in all those big families, the mothers in their headscarves, the chain-smoking fathers, the soda-sipping children, the single men, the barely suppressed fidgetiness of these people munching disconsolately on their pumpkin seeds as we watched the film, almost always a melodrama.

It was on one such screen in a gigantic open-air cinema that I first saw Orhan Gencebay, who with his songs and his movies, his records and his posters, was becoming a fixture in the lives of the entire Turkish public at that time—the king, in fact, of music and domestic film. The cinema was on a hill behind the new shantytowns between Pendik and Kartal, overlooking the Sea of Marmara, the sparkling Princes' Islands, the factories, large and small, whose walls were covered with leftist slogans. The smoke, which looked even whiter by night, rising like puffs of cotton from the chimneys of the Yunus Cement Factory in Kartal had covered the entire area in white ash, and together with the plaster dust falling onto the audience produced an effect like snow in a fairy tale.

In this film Orhan Gencebay played a poor young fisherman named Orhan. There was a rich, evil man who was his patron, to whom he felt indebted. This patron's spoiled son was even worse, and when the boy and his friends happened upon the girl played by Müjde Ar (who was just making her first films at the time) and raped her, mercilessly and at length, tearing off her clothes to give us a better view, the audience fell silent. Under pressure from his patron, to whom he felt so indebted, Orhan was then obliged to whitewash the whole affair by marrying Müjde. At this point, Gencebay cried out, "Down with the world, down with everything!" and once again he would sing the song he had made famous throughout Turkey.

During the film's most affecting scenes, we would hear nothing but a rustling noise coming from the hundreds of people seated around us, munching pumpkin seeds (the first time I heard this, I thought it was coming from some machine in a nearby factory). Whenever I heard this sound, I felt as if we had all been abandoned to sorrows gathering up within us for many years. But the film's ambience, the jostling of people who had come out to have a bit of fun, the wisecrackers in the sec-

tion for single men at the front, and, of course, the implausible plot elements all hindered my ability to let myself go and luxuriate in my suppressed fears. But when Orhan Gencebay cried out in anger, "All is darkness, where is humanity?" I was very happy to be sitting in that cinema, among the trees and under the stars, with Füsun at my side. While I kept one eye on the screen, with my other I watched how Füsun squirmed in her blue jeans, in her wooden chair, how her chest rose and fell with each breath, and how, as Orhan Gencebay cried, "My destiny be damned!" she crossed those legs. I watched her smoke, and wondered how much she shared in the passions on-screen. When Orhan was forced to marry Müjde, and his angry song took on rebellious tones, I turned to Füsun, smiling with a look both impassioned and arch. But, caught up in the film, she didn't even turn to look at me.

Because his wife had been raped, Orhan the fisherman did not make love with her—he kept his distance. When she understood that her pain would not be assuaged by this marriage, Müjde attempted suicide; Orhan took her to the hospital and saved her. The most emotional scene was on the way back from the hospital, when he told his wife to take his arm, and Müjde turned to him and asked, "Are you ashamed of me?" It was then that I finally felt an intimation of the shame that had remained buried inside me. The crowd had fallen into a deathly silence, aghast at the shame of marrying and walking arm in arm with a woman who had been raped, her virginity stolen.

My own shame was compounded by anger. Was I embarrassed that virginity and chastity were being discussed so openly, or because I was watching this with Füsun? As these thoughts passed through my mind, I could feel Füsun fidgeting in her chair. The children sitting in their mothers' laps had fallen asleep, and the angry youths in the front row had stopped making wisecracks at the heroes and had grown quiet, and Füsun, seated next to me, put her right arm behind her chair—how I longed to hold it!

The second feature gave the shame inside me a new shape, casting it as the ailment that afflicted the entire country, and even the stars in the sky: the pain of love. This time Orhan Gencebay had dark, sweet Perihan Savaş at his side. In the face of unbearable pain, he showed no anger, rather availing himself of those other, greater weapons that we

all possess—humility and forbearance—summarizing his feelings, and the film, in this song, which the museum visitor can have the pleasure of listening to:

Once you were my sweetheart
I yearned for you even when you were near
Now you've found another love
May happiness be yours
And mine the trials and troubles
Let life be yours, be yours.

By now all the children were asleep on their parents' laps, and the rowdy, soda-swilling, chickpea-throwing boys in the front rows had fallen silent—was it owing to the lateness of the hour or to the respect they felt for Orhan Gencebay in transforming the pain of fear with sacrifice? Could I do likewise and live without further misery or humiliation, just by wishing for Füsun's happiness? If I did all that was necessary for her to star in a Turkish film, would I find peace?

Füsun's arm was no longer close to me. When Orhan Gencebay told his sweetheart, "May happiness be yours, and may the memories be mine!" someone at the front yelled "You fool!" but almost no one laughed approval. We were all silent. That was when it occurred to me that the lesson this country had learned or yearned to learn, above all others, the skill we most wanted to master and pass along, was that of gracefully accepting defeat. The film had been shot in a Bosphorus *yalı,* and perhaps because it awakened memories of last summer, and last autumn, for a brief time I felt a lump in my throat. Just off the coast of Dragos a white ship was slowly advancing across the Sea of Marmara toward the sparkling lights of the Princes' Islands where happy people were summering. Lighting a cigarette, I crossed my legs and gazed at the stars, dazzled by the beauty of the universe. I had been drawn into this film, coarse as it was, by the audience's hushed response. If I had been watching the film at home alone on television, it would not have affected me so, and had I been sitting with my mother, I would not have watched it to the end. It was only because I was sitting next to Füsun that I felt the bond of fellowship with the rest of the audience.

When the lights went up we were as quiet as the mothers and fathers bearing sleeping children in their arms; not once did we break this silence on our return journey. As Füsun dozed in the backseat, her head resting on her husband's chest, I smoked a cigarette and gazed through the window at the somber streets, the little factories, the shantytowns, the youths defacing walls with leftist slogans under cover of darkness, the trees that looked so much older at night, the aimless packs of dogs, and the tea gardens about to close, while Feridun whispered to me his good-natured analysis of the film's key moments, which I never once turned my head to acknowledge.

One warm evening we went to the Yeni İpek Cinema, located in a long and narrow garden squeezed between the shanties near İhlamur Palace and the backstreets of Nişantaşı, where we sat under the mulberry trees to watch *The Agony of Love Ends with Death* and a second melodrama, *Listen to My Crying Heart,* featuring the child star Papatya. As we sat holding our soft drinks during the intermission, Feridun mentioned that the tough guy with the thin mustache playing the crooked accountant in the first film was a friend of his, and was willing to play a similar role in our film. This was the point I realized it would be very difficult for me to enter the Yeşilçam film world purely for the sake of being close to Füsun.

My evasive eyes lit on one of the balconies overlooking the cinema garden, and from the black curtains obscuring its door I realized that this old wooden house was one of Nişantaşı's two most secret and exclusive backstreet brothels. The girls there loved to joke about how, on summer nights, as they lay with their rich gentleman clients, their cries of love would mingle with the music on the sound track, and the clashing of swords, and actors declaring, "I can see, I can see" in melodramas featuring a pair of sightless eyes suddenly opened. The house had once belonged to a famous Jewish merchant, and his former parlor now served as a waiting room, so whenever the high-spirited, miniskirted girls got bored, they could go up to one of the empty rooms in the back and watch the film from the balcony.

At the little Yıldız Garden Cinema in Şehzadebaşı, overflowing balconies surrounded the garden on all three sides, in a way that recalled boxes at La Scala. Once, during a scene from *My Love and My Pride,* a father was castigating his son ("If you marry that good-for-nothing

shopgirl I will cut you out of my will and disown you!"), while an argument broke out on one of the balconies, causing some of us to confuse the two disputes. In the Yaz Çiçek Cinema Garden, just next to the wintertime Çiçek Cinema in Karagümrük, we watched *The Old Lady Who Sells* Simits, whose screenplay was written by son-in-law Feridun, based, he told us, on a new adaptation of the novel *The Bread Seller Woman* by Xavier de Montépin. This time it was not Türkan Şoray in the leading role but Fatma Girik, and just above us there was a fatso father unhappy with this state of affairs, so as he sat there in his underwear on the balcony, surrounded by his family, drinking his *rakı* and eating his mezes, he kept saying, "Now would Türkan ever have deigned to play the part like this? Not on your life, brother, what a travesty!" To make matters worse, having seen the film the previous evening, he kept sarcastically announcing what was about to happen, in a voice loud enough for the entire audience to hear. When drawn into a shouting match with those below who pleaded, "Shhh, shut up so we can watch the film," he scorned the film all the more, picking fights with the audience. Füsun, doubtless thinking that all this was upsetting her husband, nestled up to him, and I burned up inside.

On the way back, as she joined the conversation or dozed off in the backseat, she would rest her head on her husband's shoulder or his belly, or wrap her arms around him, which I had no wish to see. In the car, with Çetin driving slowly and carefully, I was directing my attention to the warm and humid night, our way lit by fireflies, listening to crickets, breathing in the fragrance of honeysuckle, rust, and dust blowing in the backstreets through the half-open windows, and gazing out into the darkness. But when we were watching a film and I sensed that they were nestling up against each other, as happened, for example, at the Incirli Cinema in Bakırköy, where we saw two thrillers inspired by American films and set in Istanbul's backstreets, a black mood would instantly swamp me. And sometimes, like the fierce hero of *Caught in the Crossfire* who swallowed his grief, I would seal my lips tight. Sometimes it would seem to me that Füsun was leaning on her husband's shoulder just to make me jealous, and in my mind she and I were dueling to see which of us could make the other feel worse. Then I would act as if I had not even noticed the newlyweds whispering to each other and giggling, and I would pretend I was immersed in the film, enjoying

it tremendously; just to prove it, I would laugh at something only the most obtuse person in the audience would find funny. Or I would snigger as if, having noticed a bizarre inconsistency everyone else had missed, and, like so many intellectuals being uneasy at having come to see a Turkish film, I couldn't help railing against such nonsense. But I didn't like this cynical mood of mine. If at an emotionally charged moment her husband draped his arm around Füsun, something he did only rarely, I did not feel at all uncomfortable, but if Füsun took such a moment to rest her head lightly on Feridun's shoulder, I felt utterly crushed and couldn't prevent myself from feeling that Füsun was heartless and trying to hurt me, and I would get angry.

At the end of August, when the first flocks of storks had flown over Istanbul, en route from the Balkans to the south, to Africa (it didn't even cross my mind that Sibel and I had given an end-of-summer party at just this time the previous year), and the weather had turned cool and rainy, we went one evening to see a film at the large garden inside the Beşiktaş Market that was known as the Hunchback's Place and served as the summer venue for the Yumurcak Cinema, and as we sat there, watching *I Loved a Penniless Girl,* I sensed that underneath the pullover that she had draped over her lap the two were holding hands. I took the same measures as I had at other times, in other cinemas, when I was overcome by this same jealousy, and just after I had convinced myself that I had put it out of my mind, I crossed my legs and lit a cigarette so that I could take another look and see if the happy couple were indeed holding hands beneath that pullover. Bearing in mind that they were married, and shared a bed, and had so many other opportunities to touch each other, I had to wonder why they were doing so now, in front of me.

Whenever my mood plummeted, it would seem to me that the film on the screen (like all the others we had seen over the past few weeks) was perversely awful, preposterously shallow, and deplorably disconnected from the real world. I'd had my fill of half-witted lovers, continually bursting into song, of those headscarfed servant girls with painted lips who became chanteuses overnight. I didn't care for those plots about bands of sergeants that were "rip-offs of a French adaptation" of *The Three Musketeers,* as Feridun would tell me with a smile, nor

did I like watching other bands of ruffians who proved themselves men by taunting girls in the street. We saw *The Kasımpaşa Trio* and *The Three Fearless Musketeers* with its black-shirted heroes at the Desire Cinema in Feriköy, where competition had forced the managers to show three badly cut and therefore incomprehensible films every evening. All those lionhearted lovers ("Stop! Stop! Tanju is innocent; the one you want is me!" as Hülya Koçyiğit declares in *Under the Acacias,* which we were unable to see to the end because of a rainstorm); and those mothers who would sacrifice everything so that their blind children could have the operation (as in *Broken Heart,* shown in the Üsküdar People's Garden Cinema, where a troupe of acrobats entertained us between features); those friends who said, "Keep running, my lion, while I distract them" (Erol Taş, who Feridun said had promised to appear in our film, was once to speak those immortal lines); I found them no less tiring than the honorable and selfless neighborhood boys who refused happiness saying: "But you are my friend's sweetheart." At a gloomy, hopeless moment like this, even the heroines who said, "I am a penniless shopgirl, while you are the son of a wealthy factory owner"—even the miserable wretch who went to see his beloved in a chauffeur-driven car on the pretext of visiting distant relatives couldn't stir my sympathies.

The pleasures of sitting beside Füsun, the fleeting happiness of being at one with the audience as I watched the film, if chilled by a wind of jealousy, could produce a darkness benighting everything under the sun. But on some transcendent occasions the whole world seemed illumined: When, for instance, amid the misery of heroes forever losing their sight, my arm would brush against the velvet skin of her arm, and, not wishing the wondrous sensation to end, I would hold my arm still, continuing to watch the film without following the action, until I could believe that she had actually let her arm brush against me, I would almost faint from happiness. At the end of the summer, in the Arnavutköy Çampark Cinema, while watching *Little Lady,* about a spoiled rich girl's adventures with the chauffeur who brings her to her senses, our arms brushed against each other that way, and remained intensely in contact as the fire of her skin ignited mine, and until my body reacted with an entirely unexpected elation. So transported was I

by the dizzying sensation that for a time I paid no attention to arresting my body's impudence, and so when the lights came on, and the five-minute intermission began, I was obliged to hide my shame by draping my navy pullover over my lap.

"Shall we get some soda?" said Füsun. At the interval she usually went with her husband to buy soda and pumpkin seeds.

"Sure, but give me a moment, would you?" I said. "I just had a thought I'm trying to remember."

Just as I had done as a lycée student, whenever I needed to hide my body's importune excitement from my classmates, I raced through memories of my grandmother's death, the real and imaginary funeral rites of my childhood, the times when my father had scolded me, and then I imagined my own funeral, the grave terrifyingly dark, my eyes filled with earth. Half a minute later I was ready to stand up without betraying myself.

Walking together toward the soda vendor, I noticed as if for the first time how tall she was and how fine her posture. How pleasant it was to walk among families, chairs, running children without worry of being seen. . . . I liked to observe the notice she attracted in the crowd, and it made me so happy to imagine that they saw us as a couple, husband and wife. That this short walk together was worth all the pain I had suffered, that I was living through a moment unlike any other, that this walk was one of the happiest moments in my life, seemed certain even as it was happening.

As always, there was no queue for the soda vendor, only a crowd of children and adults all shouting at once. So we took our place behind them and began to wait.

"So what was this serious thought you were trying to remember just now?" Füsun asked.

"I liked the film," I said. "I was wondering how it was I could now enjoy all these films that I used to laugh at in the old days, or just ignore. At that moment it seemed to me the answer was on the tip of my tongue if I could only concentrate."

"Do you really like these films? Or do you like coming with us to see them?"

"Of course I like them. They make me so very happy. Most of the

ones we've seen this summer, they speak to a sorrow inside me, and I find them consoling."

"But life is not as simple as these films, actually," said Füsun, as if disturbed to see me so fanciful. "But I am enjoying myself. I'm glad you've come with us."

For a moment we were silent. What I wanted to say was, It is enough for me to sit beside you. Had it been by chance that our arms had stayed pressed together for so long? How excruciating it was, longing to express these hidden thoughts, knowing that the crowds at the cinema like the whole world in which we lived would not allow it. Through the loudspeakers hanging from the trees we heard Orhan Gencebay's song from the film we'd seen two months ago in the hills of Pendik, overlooking the Sea of Marmara. "Once you were my sweetheart. . . ." It summoned all my memories of the summer, now passing before my eyes like a picture show, those sublime moments of sitting in Bosphorus restaurants drunkenly admiring Füsun and the moon on the sea.

"I've been very happy this summer," I said. "These films have taught me how. The important thing in life is not to be rich. . . . What a pity it is . . . all this agony . . . this suffering. . . . Don't you think?"

"A film about life and agony," said my beauty, as her face clouded, "should be sincere."

When one of the children squirting soda at one another came hurtling toward her, I took Füsun by the waist and pulled her toward me. A bit of the soda had splashed on her.

"You sons of donkeys!" said one old man as he slapped one of them on the neck. He looked to us for approval, and his eyes fell on my hand, still on Füsun's waist.

How close we were to each other in that cinema garden, not just physically but spiritually! Füsun, fearful of the way I was looking at her, backed away, walking through the crowd of brats to reach for the soda bottles sitting arranged in the laundry basin; she had already broken my heart.

"Let's buy one for Çetin Efendi, too," said Füsun. She had two bottles opened.

I paid for the sodas and then I took one over to Çetin Efendi, who

would never join us in the "family section" when we went to films, but sat alone in the section for single men.

"You shouldn't have, Kemal Bey," he said with a smile.

When I turned around I saw a child staring in awe as Füsun drank straight from her soda bottle. The child was bold enough to approach us.

"Are you an actress, sister?"

"No."

Because the fashion has now passed, let me remind my readers that in those days this question was a way of telling girls they were pretty, and served as a popular pickup line for playboys wishing to approach well-groomed girls in outfits slightly more revealing than the norm, and who were not exactly upper-class. But this child, who looked to be about ten years old, had no such motives. He insisted: "But I've seen you in a film."

"Which one?" asked Füsun.

"*Autumn Butterflies,* and you were wearing the same dress, you know. . . ."

"What part was I playing?" Füsun asked, smiling with pleasure at this child's fantasy.

But the child, now realizing his mistake, fell silent.

"Let me ask my husband now," she said to spare the little boy's feelings. "He knows all these films."

You will have understood that when Füsun said "husband," and looked across the chairs to pick him out in the crowd, and the child realized I was not the man in question, I felt wounded. But spurred on by the joy of being so close to her, drinking soda with her, I said this: "The child must have sensed that we'll be making a film soon that will make you a star."

"So you're saying that you really are going to shell out the money to make this film? Please don't take offense, Cousin Kemal, but Feridun is too embarrassed even to bring up the subject, but let me tell you, we're sick and tired of waiting."

"Is that so?" I said. I was dumbstruck.

53

An Indignant and Broken Heart Is of No Use to Anyone

I DID not say another word all night. Because so many languages describe the condition I was in as "heartbreak," let the broken porcelain heart I display here suffice to convey my plight at that moment to all who visit my museum. The pain of love no longer manifested itself as panic, hopelessness, or anger, as it had done the previous summer. By now it had become a more viscous substance that coursed through my veins. Because I had been seeing Füsun every other day if not every day, the heartache of absence had lessened, and I had developed new habits to cope with the new milder pain of her presence; after a summer of careful practice these habits had become second nature, making me a new man. I no longer spent my days battling with my pain; instead I could suppress it, veil it, or act as if there were nothing wrong with me.

The new pain, the pain of presence, was in fact the pain of humiliation. It seemed that Füsun did take care to spare me pain of that kind, shying away from subjects and situations that might wound my pride. But in the face of those crude last words of hers, I finally realized that to pretend nothing was amiss was no longer possible.

I had tried at first pretending not to hear them reverberating in my mind: "shell out the money . . . We're sick and tired of waiting." But my feeble mumbled rejoinder ("Is that so?") was proof that I had heard her. I could not, therefore, act as if no offense had been taken; and, anyway, who could have missed my grim expression, which spoke of spirits plummeting and utter humiliation. Her insult ringing in my head, I went back to my chair and sat down, still clutching my soda bottle. It was hard for me to move. The worst part was not even those cutting words, but Füsun's evident awareness of my humiliation and the upset it caused me.

I forced myself to think of something else, ordinary matters. I remember asking the same question I would ask myself in my youth whenever I thought I would explode from boredom, surrendering to metaphysical musing, as in: "What am I thinking now? Am I thinking that I'm thinking?" After repeating this sentence silently many times over, I turned to Füsun in a decisive way and said, "They want us to return the empties," and, taking the empty bottle from her hand, I stood up and walked away. In my other hand was my own bottle. There was still some soda in it. No one was looking, so I poured my soda into Füsun's bottle, handing mine, now empty, back to the boys selling the sodas. So I was able to return to my seat with Füsun's bottle, which I display here.

Füsun was talking to her husband; they didn't notice me. I cannot recall a single thing about the film we watched next. This is because the bottle that had touched Füsun's lips only a few moments earlier was now in my trembling hands. I had no interest in anything else. I wanted to return to my own world, to my own things. This bottle would remain for many years on the bedside table at the Merhamet Apartments, meticulously preserved. Visitors will recognize it by its shape as a bottle of Meltem soda, the soda launched at the time our story begins, and now available throughout the country, but the soda inside was not Zaim's highly praised recipe. For already very poor imitations of our first great national soda brand were turning up everywhere. There were little local pirate soda plants operating underground that would collect empty Meltem bottles, fill them with the cheap counterfeit, and distribute them to unsuspecting or indifferent vendors. When he noticed me with the bottle against my lips as we drove back in the car, Feridun, quite unaware of my conversation with his wife, said, "This Meltem soda is great stuff, isn't it, brother?" I told him that the soda wasn't "genuine" Meltem, from which he deduced the scheme and felt compelled to comment: "In the backstreets of Bakırköy there's a secret propane-filling depot. They fill Aygaz canisters with cheap cooking gas. We bought it, too, once. Brother Kemal, please believe me when I tell you—the fake burned better than the real thing."

I brushed the bottle against my lips with care. "This one tastes better, too," I said.

As the car rumbled over the silent backstreets, passing through

pools of pale lamplight and shuddering gently over the cobblestones, the shadows of trees and leaves flickered on the windshield as they do in dreams. Sitting in the front next to Çetin the chauffeur as always, I could feel my heart swelling painfully, so I did not turn around to look at them, even when the usual talk about the films began. Çetin Efendi was not inclined to join these conversations we had on the way home, and it was perhaps because the silence was making even him uncomfortable that he ventured to observe how certain parts of the film were not credible. An Istanbul chauffeur would never scold the young lady he worked for, not even politely, as in the film, he insisted.

"But he's not really a chauffeur," said Feridun the son-in-law. "He's the famous actor Ayhan Işık."

"You're right, sir," said Çetin. "And that's why I liked it. In a way, it was educational. . . . As entertaining as the films we've seen this summer have been, I love them more for offering lessons about life."

Füsun was silent, as was I. When I heard Çetin Efendi say "this summer," my pain grew sharper. For his words reminded me that these lovely summer nights were drawing to a close: No longer would we be coming to these cinema gardens to see films; the joy I'd known sitting beside Füsun under the stars would soon be a memory, and I was ready to talk about anything that might have popped into my head, just to hide my distress from her, but my lips remained pressed so tightly shut one couldn't have pried them open with a knife. I was sinking into a bitterness that would, I suspected, last a very long time.

I didn't want to see Füsun at all, or indeed anyone who would have befriended me just to help her husband make a film—in other words, just for money. It was a bald fact and in a way thrilling that she would not even bother to conceal her venal purpose, thrilling because I knew I could never be attracted to such a person, and in this recognition I could glimpse an easy break.

That night, when I dropped them off in the car, contrary to custom, I appointed no date for the next trip to a cinema. For three days I did not get in touch. It was during this period that I began to exhibit (first in the recesses of my mind, but gradually in a more pronounced way) a new manner of brooding. I thought of it as "diplomatic pique," for it derived less from the pain of heartbreak than from a sense of protocol: Abuse of friendship must be answered accordingly so as to decry such

behavior and preserve our pride. Obviously the retribution I had in mind for Füsun was a refusal to back her husband's film, and with it the death of her dreams of becoming a movie star. "Let's see what happens," I told myself, "if this film doesn't get made!" Having come to feel my previously formal pique viscerally I began, on the second day, to imagine in some detail the ways in which Füsun might be suffering in reaction to her punishment. Unfortunately in my imagination it was the dimming of her as yet unrisen star that upset Füsun and not the prospect of no longer seeing me. Perhaps this was not an illusion, but the truth.

The pleasure of imagining Füsun remorseful had, by the second day, overwhelmed my visceral pique. By the evening of that day, as I sat eating silently with my mother in Suadiye, I realized I had begun to miss Füsun. My viscera having healed, I knew that I could only maintain my pique for the sake of punishing her. As I ate my supper I tried to put myself in Füsun's place and adopt a cruel pragmatism. I imagined the agony and remorse I'd be feeling if I were a beautiful young woman, on the verge of starring in a film directed by my husband, when with a thoughtless remark I had shattered the feelings of the wealthy producer, and with them, the hope of becoming a star. But for my mother's continued interruptions ("Why didn't you finish your meat? Are you going out this evening? Summer's almost over. We don't have to wait until the end of the month—we can go back to Nişantaşı tomorrow. How many glasses does that make for you tonight?") I might have succeeded in putting myself in Füsun's place.

In the course of my drunken struggle to guess what Füsun might be thinking, the possibility occurred to me that from the moment I'd heard the ugly words ("So you're saying that you really are going to shell out the money. . . .") provoking my "diplomatic pique," a vengefulness in me had been exposed. I wanted to take revenge on Füsun, but because it both frightened and shamed me to entertain such a wish, I instead convinced myself that I "never wanted to see her again." This was the more honorable way, as it would allow me to take my revenge with a clear conscience, whereas exaggerating my visceral pique could only serve to excuse the sin by cloaking my desire to punish her in a victim's innocence. Realizing this, I decided to forgive Füsun and go to see her, and having so decided, I began to see everything in a more positive

light. Still, before I could go see them again, I would have to engage in more thinking, as well as self-deception.

After supper I went out to Baghdad Avenue, where, years ago, when I was young, I had so often "promenaded" with my friends, and as I walked down the wide sidewalks, I again tried as hard as I could to put myself in Füsun's shoes, to figure out precisely how Füsun would interpret the situation were I to stop punishing her. In a blinding flash it came to me: A beautiful woman like her, a woman with brains who knew what she wanted, would have no trouble finding another producer to back her husband's film. A scorching and jealous regret overtook me. The next day I sent Çetin off to find out what was playing in the open-air cinemas of Beşiktaş, which investigation led me to decide that there was "an important film not to be missed." Sitting in my office at Satsat with the receiver pressed to my ear, listening to the phone ringing in Füsun's house, my heart began to pound as I realized that, whoever answered, I would be unable to speak naturally.

As nothing natural could come of trying to satisfy the conflicting demands of visceral and diplomatic pique, I felt compelled at least to prolong the latter for as long as no apology was forthcoming. So it was that we passed our last summer evenings in Istanbul's cinema gardens, our dignity chastened, having little fun, speaking even less, feigning mutual indignation. My grimace was infectious—and of course Füsun responded in kind. I resented her obliging me to make this pretense, and now this in turn would make me genuinely indignant. Over time, the persona I assumed in her presence came to supplant my true self. It must have been then I first came to realize that for most people life was not a joy to be embraced with a full heart but a miserable charade to be endured with a false smile, a narrow path of lies, punishment, and repression.

While these Turkish films kept telling us that one could find "the truth" leaving behind this "world of lies," by now I could no longer believe in the films we saw in the open-air cinemas, with ever dwindling audiences. I could no longer submit to that sentimental realm. By the end of summer, the Star Cinema in Beşiktaş was so empty that it would have looked strange for me to sit too close to Füsun, so I left a seat empty between us, and as the winds grew colder, my contrived sulking hardened into icy remorse. Four days later we went to the Club Cinema

in Feriköy, but instead of a film, there were beds with penniless boys tended by headscarf-wearing aunties, and it amused us when we realized that the city council had organized a circumcision ceremony, complete with acrobats, magicians, and dancers, for families who couldn't afford their own rite. But when the good-hearted mustached mayor saw how pleased we were and asked us to join them, Füsun and I, both so determined to present each other a cold shoulder, declined. It was infuriating to see her responding to my diplomatic pique with her own no less contained version while also keeping the pantomime subtle enough for her husband not to notice.

I managed not to call them for six days. It bothered me that neither Füsun nor her husband had ever once called me. If we were not going to make this film, what excuse could I have for calling them? If I wanted to carry on seeing them, I would have to give them some money, an unbearable truth, one I couldn't accept.

The last film we went to was at the Majestic Garden Cinema in Pangaltı at the beginning of October. It was a warm night, and there were some others in attendance. I was hoping that on this beautiful evening, probably the last of the summer, our recriminations, the diplomatic standoff, might end. But before we took our seats, something happened: I ran into Cemile Hanım, the mother of a childhood friend. She had also been one of my mother's bezique partners in those days, but it was as if she grew ever poorer with age. We exchanged looks, as if to say, What are *you* doing here? in the manner of people who come from old money and feel ashamed and guilty at the loss of their fortunes.

"I was curious to see Mükerrem Hanım's house," said Cemile Hanım, as if making a confession.

I did not understand what she meant. I assumed that some interesting person named Mükerrem Hanım lived in one of the old wooden houses whose interiors you could see from the cinema garden, and so I sat down next to Cemile Hanım, that we might look into this house together. Füsun and her husband went to sit six or seven rows in front of us. When the film began I realized that it was the house in the film she was referring to as Mükerrem Hanım's. This was the princely abode in Erenköy of a prominent aristocratic family—I used to ride past it on my bicycle when I was a child. After falling on hard times, they (like so

many old families of my mother's acquaintance) had taken to renting out their villas to Yeşilçam Films as sets. Cemile Hanım was not here to cry her eyes out watching a film called *More Bitter Than Love,* but to see the wood-inlaid rooms of an old pasha's house serving fictively as the home of an evil family who were evidently new money. I should have stood up and gone to sit next to Füsun. But I couldn't, for a strange shame had immobilized me. I was like a teenager refusing to sit with his parents at the cinema, but also unwilling to acknowledge the source of his shame.

This shame, mingling with my affected pique, which I remain reluctant to acknowledge even so many years later, made it easier to sustain the pretense of being offended. When the film was over, I rejoined Füsun and her husband, whom Cemile Hanım gave a careful look up and down. Füsun was sulking even more than before, and I had no recourse but to respond in kind. On the way back, the silence in the car was hard to bear, and so I fantasized about throwing off this role in which I had cast myself with an unexpected joke, bursting into mad laughter, or getting drunk—but all in vain.

For five days I didn't call them. I survived on elaborate and delicious fantasies of a contrite Füsun preparing to ask my forgiveness. In my dreams I answered her regretful pleas by blaming her, and when I had listed her faults one by one, I had so fully persuaded myself of her anguish that before long I was as genuinely angry as anyone who had been dealt a terrible injustice.

The days I didn't see her became harder and harder to endure. Once again I was in thrall to the dark, dense anguish that had held me captive for a year. I was terrified of making a mistake for which my punishment would be never to see Füsun again. To keep this from happening, I had to ensure that Füsun did not see the extent of my visceral pique. So now the weapon I'd fashioned of my anger was turned inward, punishing me alone. An indignant and broken heart is of no use to anyone. By continuing to take offense, I was hurting only myself. One night, while thinking about all this, walking alone amid the falling autumn leaves of Nişantaşı, I realized that the happiest resolution—and therefore the most hopeful—would be to see Füsun three or four times a week (and never less than twice). Only then could I return to my old equilibrium without again falling into the bilious black abyss of love.

Now I knew I could no longer endure not seeing Füsun—no matter whether out of wanting to protect myself or to injure her. To avoid the hell of the preceding year, I would have to keep the promise I had made in my letter to Füsun sent via Ceyda: I would have to bring her my father's pearl earrings.

The next day, when I went out to Beyoğlu for lunch, the pearl earrings were in my pocket, nestling in the box my father had given me. It was October 12, 1976, a bright, sunny day with a hint of summer's glare. The shop windows were brilliant with color. As I ate my lunch at Hacı Salih, I was candid with myself: I could admit that I had come here on purpose, and if it "happened to cross my mind to do so" there was no harm in nipping straight down to Çukurcuma to spend half an hour with Aunt Nesibe. It was a six- or seven-minute walk from the restaurant table where I was sitting. On my way here I'd glanced into the Palace Cinema and noticed that the next show started at 1:45. After lunch, if I chose, I could lose myself in that darkness that smelled of mold and damp, or at least enter a different world, and find peace. But by 1:40, having got up and paid my bill, I found myself walking down Çukurcuma Hill. There was food in my stomach, sun on the back of my neck, love on my mind, panic in my soul, and an ache in my heart.

It was her mother who answered the door.

"No, Aunt Nesibe, there's no need for me to come up," I said, reaching into my pocket. "This is for Füsun. . . . It's a present from my father. I thought I would drop it off on my way by."

"Why don't I make you a quick coffee, Kemal. There are a few things I'd like to tell you before Füsun gets back."

She said this in such a furtive way that I relented and followed her up the stairs. The house was flooded with sunlight, Lemon the canary rattling about happily in his cage. I saw that Aunt Nesibe's sewing things—her scissors, her pieces of cut cloth—were spread all over the room.

"Nowadays I never make house calls, but these people were so insistent I couldn't say no, so we're putting together an evening gown as a rush job. Füsun's helping me, too. She should be back soon."

She served me coffee and got straight to the point. "There have been needless heartbreaks, and silent recriminations—all this I under-

stand," she said. "Kemal Bey, she went through a lot of pain, my girl did. Her heart was very badly broken. You need to be patient with her moods, and indulge her. . . ."

"Yes, of course," I said, as if I did know all this.

"You know far better than I do how to do it. Indulge her, do what you think best, so that she can step off this wrong path she has taken."

I gave her an inquiring look, hoping to learn what wrong path Füsun had taken; then I raised my eyebrows.

"Before you got engaged, and on the day of your engagement, and even after the engagement—for months and months, she suffered terribly—oh, how she cried," she said. "She stopped eating, and drinking, she wouldn't go out, she cut herself off from everything. This boy came to see her every day and tried to console her."

"Do you mean Feridun?"

"Yes, but don't worry. He knows nothing about you."

She went on to explain that the girl was in such great pain and distress that she had no idea what she was doing, that Tarık Bey had been the first to propose the idea of marriage as a cure, and that in the end she had agreed to marrying off Füsun to "this child." Feridun had known Füsun since she was fourteen. In those days he was madly in love with her, but Füsun had paid him no attention; she had almost destroyed him with her lack of interest. These days Feridun was not so much in love with Füsun—she raised her eyebrows slightly and smiled, as if saying, This is good news for you, too. Feridun was seldom at home in the evenings, being utterly immersed in the film world and preoccupied with his film-world friends. You might almost think that he had left his dormitory in Kadırga not to marry Füsun, but to be closer to the Beyoğlu cafés where his film friends waste their time. Of course, the two had eventually developed feelings for each other, as healthy young couples entering arranged marriages had always done in the past, but I was not to credit this overmuch. After the ordeal she had suffered, it had seemed only prudent to them that Füsun should marry at once, and so they had no regrets. . . .

By their "ordeal," she left me in no doubt that she was referring not to Füsun's love for me, or the debacle of the university exam: It was clear from her eyes that the heart of the crisis was Füsun's having slept

with me before marriage, and now she took evident pleasure in holding me to account. Only by marrying at once could Füsun save herself from this stain, and, of course, I was responsible for this, too!

"We know—we all know—that Feridun has no real prospects, that he is in no position to give her a good life. But he's Füsun's husband!" said Aunt Nesibe. "He wants to make his wife a movie star. He's an honest and well-meaning boy! If you love my daughter, you'll help them. We thought it would be better to marry Füsun to Feridun than to some rich old goat who would look down on her because of her stained virtue. The boy will introduce her to film people. And you, Kemal, you can protect her."

"Of course, Aunt Nesibe."

If she knew that her mother had been spilling family secrets, Füsun would punish us severely (Aunt Nesibe smiled faintly, as if only slightly exaggerating). "Of course, Füsun was deeply affected by the news that you had broken off your engagement to Sibel, just as she was sorry to hear that you had suffered so much, Kemal. This film-loving boy she has married has a heart of gold, but it won't be long before Füsun sees how inept he is, and when she does, she'll leave him. . . . Until then, you can be at her side, bolstering her confidence."

"All I want, Aunt Nesibe, is to repair the damage I've done, the heartbreak. Please help me win Füsun back," I said, taking out the box with my father's earrings and giving it to her. "This is for Füsun," I said.

"Thank you. . . ." she said, and took the box.

"Aunt Nesibe . . . there's something else. . . . On the first night I came here, I brought back an earring of hers. But it never reached her hands. Do you know anything about this?"

"This is the first I've heard of it. You can give her your present yourself, if you want."

"No, no . . . Anyway, that earring was not a present; it belongs to her."

"Which earring?" asked Aunt Nesibe. When she saw that I was having trouble making up my mind, she said, "If only everything could be sorted out with a pair of earrings. . . . When Füsun was feeling poorly, Feridun came to see us, too. When my daughter was so weak from sorrow that she could barely walk, he would take her by the arm and walk her all the way to Beyoğlu to see a film. Every evening, before he went

off to the coffeehouse to see his film friends, he would come and sit with us, and eat with us, watch television with us, he paid Füsun such loving attention. . . ."

"I can do a great deal more than that, Aunt Nesibe."

"If God is willing, Kemal Bey. You are always welcome. Come any evening! Give my best to your mother, but please don't cause her any upset."

As she glanced at the door, so as to warn me that I needed to leave before Füsun caught me there, I left the house at once, feeling at peace as I walked up Çukurcuma Hill to Beyoğlu, freed from indignation, from pique of either kind.

54

Time

FOR SEVEN years and ten months exactly I made regular visits to Çukurcuma for supper to see Füsun. If we bear in mind that my first visit was on Saturday, October 23, 1976—eleven days after Aunt Nesibe's open-ended welcome ("Come any evening!")—and that my last night in Çukurcuma with Füsun and Aunt Nesibe was on Sunday, August 26, 1984, we can see that there were 2,864 days intervening. According to my notes, during the 409 weeks that my story will now describe, I went there for supper 1,593 times. From this we can deduce that I went four times a week on average, but that does not mean I went there four times a week as a matter of course.

There were weeks when I saw them every day, and others when— growing indignant again and again convincing myself that I could for- get Füsun—I stayed away. But never did more than ten days go by without Füsun (that is, without my seeing her), because after ten days I would be reduced to those levels of misery that I had endured during the autumn of 1975, which had precipitated the current regime, so it would be correct to say that I saw Füsun and her family (the Keskins) on a regular basis. They, for their part, expected me on a regular basis,

and they could always guess when I was likely to turn up. However it happened, before long they had grown accustomed to seeing me at the supper table, as I had grown accustomed to the idea that they were expecting me.

The Keskins never needed to formally invite me to supper, because they always kept a place for me at the table. This provoked a great deal of hand-wringing on my part, when I was not altogether inclined to go and struggled over the decision. I sometimes thought that if I went one more time, I might be imposing on them; and if I didn't go, I not only would face the pain of not seeing Füsun that evening, but might "cause offense" or succumb to fears that my absence might be taken amiss.

I was most preoccupied by such anxieties during my first visits to Çukurcuma, when I was still getting used to the house, Füsun's regular presence, and the domestic routines. I hoped that Füsun would know from the way I looked into her eyes that I was trying to say, Here I am. This was my chief sentiment during my first visit. For the first few minutes after my arrival, I congratulated myself on conquering my shame and disquiet to be there. After all, if it made me this happy to be near Füsun, then why should I make such a fuss over my visits? And here was Füsun, smiling sweetly, as if there was nothing unusual about my being there, as if she was truly happy I had come.

What a pity that we only rarely found ourselves alone during those first visits. Still, I seized every opportunity to whisper things like "I've missed you terribly!" or "It seems I've missed you terribly!" and Füsun would answer, if only with her eyes, seeming to say that she had warmed to my words. There was no possibility of getting any closer than that.

For the sake of any readers who are amazed that I could visit Füsun and her family (it seems so clinical to call them the Keskins) for eight years, and who wonder how I can speak so breezily about such a long interval—thousands of days—I would like to say a few words about the illusion that is time, as there is one sort of time we can call our own, and another—shall we call it "official" time?—that we share with all others. It is important to elaborate this distinction, first to gain the respect of those readers who might think me a strange, obsessed, and even frightening person, on account of my having spent eight lovelorn years trudging in and out of Füsun's house, but also to describe what life was like in that household.

Let me begin with the big clock on the wall: It was German-made, cased in wood and glass, with a pendulum and a chime. It hung on the wall right next to the door, and it was there not to measure time, but to be a constant reminder to the whole family of time's continuity, and to bear witness to the "official" world outside. Because television had taken over the job of keeping time in recent years, and did so more entertainingly than did the radio, this clock (like hundreds of thousands of other wall clocks in Istanbul) was losing its importance.

Wall clocks first came into fashion in Istanbul at the end of the nineteenth century, when Westernized pashas and wealthy non-Muslims began to furnish their homes with large wall clocks much more ornate than these, with weights and pendulums and winders. In the early years of the twentieth century, and after the founding of the Republic, when the country was aspiring westward, such clocks rapidly gained favor with the city's middle classes. There was a clock like this in my own home when I was a child, and all the other houses that were then part of my life had identical or even larger ones, with even more exquisite woodwork, and by and large you would find them in the entryway or the hall, though people hardly looked at them, since by the 1950s "everyone," even children, had wristwatches, and each house had a radio that was always playing. Until television sets came to dominate the sound track of domesticity, changing the way people ate, drank, and sat—until the mid-1970s, when our story begins—these wall clocks continued to tick away, as they had done for so long, even though the householders scarcely paid them any attention. In our house you could not hear the ticking or the chimes on the hour and half hour if you were in the sitting room or any of the bedrooms, so the clock never disturbed us. And so for years no one even thought about stopping the clock, and one would indeed continue to stand on chairs to wind it! Some nights, when out of love for Füsun I had drunk a great deal, and misery awoke me, and I arose from my bed to go to have a cigarette in the sitting room, I would hear the clock in the corridor chiming the hour, and it would warm my heart.

In Füsun's house there were times when the clock was ticking and times when it had stopped: It was during the first month that I noticed this difference, and I grew accustomed to it at once. Late in the evening we'd be sitting together watching a Turkish film or a seductive

chanteuse crooning an old song, or something about ancient Rome with gladiators and lions, which we'd tuned in to halfway through, and which had such bad subtitles, or such bad dubbing, that we'd immediately begin to joke about it until we could barely follow the action, and were each left to drift off into his own dreams—just then a moment would arrive when by some enchantment a silence would envelop the television set, and the clock hanging right next to the door, whose existence we'd forgotten, would begin to chime. One of us—usually Aunt Nesibe, and sometimes Füsun, too—would turn to the clock with a meaningful look, and Tarık Bey would say, "Who wound it up again, I wonder?"

Sometimes the clock was wound, and sometimes it was forgotten. Even when it had been wound and was ticking away, the chime would remain silent for months at a time; sometimes it would chime only once, on the half hour; sometimes it would surrender to the ambient silence and let weeks pass before it made another sound. That was when I'd realize, as a chill passed through me, how frightening everything must be when no one was home. Whether or not it was ticking, whether or not the chime sounded, no one looked at the clock to know the time, but they did spend a lot of time talking about whether it had been wound or not, and about how a frozen pendulum might be set in motion again just by touching it once. "Let it be, let it tick, it's not hurting anyone," Tarık Bey would sometimes say to his wife. "It reminds us that this house is a house." I think I would agree, as would Füsun, Feridun, and even the odd visitor. So the wall clock was not there to remind us of the time, or to warn us that things were changing; it was there to persuade us that nothing whatsoever had changed.

During those first months I dared not even dream that nothing would or could change—that I would spend eight years eating supper in Çukurcuma, watching television, and chatting amiably without purpose. During my first visits every word Füsun uttered, every feeling that registered on her face, the way she paced up and down the room— all of it seemed new and different to me, and whether the clock was ticking or not, I paid it no mind. What mattered was to be at the same table with her, to watch her, to feel happy and remain perfectly still as my ghost left my body to kiss her.

Even without our being aware of it, the clock always ticked in the

same way, and when we sat at the table, eating our supper, it brought us the peace of knowing we hadn't changed, that all would stay the same with us. That the clock served to make us forget the time, even as it continually brought us back to the present, reminding us of our relations with others—this paradox was the cause of the cold war that flared up from time to time between Aunt Nesibe and Tarık Bey. "Who wound that clock again, to wake us in the middle of the night?" said Aunt Nesibe, if during a silence she noticed that the clock was working again. "If it wasn't ticking, it would feel as if there was something missing in this house," said Tarık Bey one windy evening in December 1979. He added, "It used to chime in the other house, too." "So then, are you trying to tell me you still haven't become accustomed to Çukurcuma, Tarık Bey?" said Aunt Nesibe, with a much gentler smile than her words implied (she sometimes addressed her husband with the honorific "Bey").

Such measured quips, aspersions, and perfectly timed digs—the couple had honed their craft over many years, and whenever we heard the clock's tick at an unexpected moment or the gong began to chime, the discord would become more intense. "You wound this clock so that I wouldn't get any sleep either, Tarık Bey," Aunt Nesibe would say. "Füsun, dear, could you make it stop?" If you used your finger to still the pendulum in the middle, then no matter how much someone had wound it, the clock would stop, but Füsun would only smile and look at her father; sometimes Tarık Bey would give her a look that meant, All right then, go ahead and stop it! and sometimes he would stubbornly refuse. "I didn't touch it. The clock started on its own, so let it stop itself!" he'd say. Sometimes, when they saw that such mysterious pronouncements made an impression on the neighbors or the children who came to visit on rare occasions, Tarık Bey and Aunt Nesibe would begin an argument of double entendres. "The djinns have got our clock working again," Aunt Nesibe would say. "Don't touch it, you could get hurt," Tarık Bey would say in a menacing voice as he frowned. "I don't care if there's a djinn ticking inside it," Aunt Nesibe would reply. "I just don't want it waking me up at night like a drunken church bell ringer who can't tell morning from night." "Don't fret so, and, anyway, if you forget the time you'll feel better," Tarık Bey would say. Here he was using "time" to mean "the modern world" or "the age

in which we live." This "time" was an ever-changing thing, and with the help of the clock's perpetual ticking, we tried to keep it at bay.

The device by which the Keskin family actually kept time was the television, which, like our radio during the fifties and sixties, was always on. In the days of radio, no matter what the broadcast—a piece of music, a discussion, a mathematics lesson, whatever—you would hear a soft blip on the hour and the half hour, for the benefit of those who cared to know. In the evenings, when we watched television, there was no need for such a signal, as most people had no need to know the time unless they were trying to find out what was on television.

Every evening at seven o'clock, when the enormous clock appeared on the screen a minute before TRT, the country's only television station, began its news program, Füsun would look at her wristwatch (displayed here) as Tarık Bey looked at one of the many pocket watches I saw him use over that eight-year period—either to confirm they had the correct time or to adjust their watches to it. They would do this. It was deeply satisfying to watch Füsun sitting at the supper table, gazing at the enormous clock on the screen and squinting, pressing her tongue against the inside of her cheek as she calibrated her watch with the seriousness of a child copying her father. From my very first visits, Füsun was aware how much I enjoyed this spectacle. When she adjusted her watch, she knew I was observing her lovingly, and when she got the time right, she would look at me and smile. "Do you have the time right now?" I would ask her just then. "Yes, I've got it!" she would say to me, with a smile that was even warmer.

As I would slowly come to understand over the eight years, it was not merely to see Füsun that I went to the Keskin house but to live for a time in the world whose air she breathed. This realm's defining property was its timelessness. And so it was that Tarık Bey advised his wife to "forget time." When people come to visit my museum and view all the Keskins' old possessions—especially all these broken, rusting clocks and watches that haven't worked for years—I want them to notice how strange they are, how they seem to exist out of time, how they have created among themselves a time that is theirs alone. This is the timeless world whose air I inhaled during my years with Füsun and her family.

Beyond this timeless space was the "official" time outside, with

which we kept in touch through television, radio, and the call to prayer; when we talked about finding out what time it was, we were organizing our relations with the outside world, or so I felt.

Füsun did not adjust her watch because life as she lived it called for a clock that was accurate to the second, so that she could be punctual for work or some meetings; like her father, the retired civil servant, she did so as a way of acceding to a directive signaled to her straight from Ankara and the state, or so it seemed to me. We looked at the clock that appeared on the screen before the news much as we looked at the flag that appeared on the screen, while the national anthem was playing at the end of the broadcasting day: As we sat in our patch of the world, preparing to eat supper or bring the evening to a close by turning off the television, we felt the presence of millions of other families, all doing likewise, and the throng that was the nation, and the power of what we called the state, and our own insignificance. It was when we were watching flags, Atatürk programs, and the official clock (once in a while, the radio would refer to the "national time") that we were most keenly aware that our messy and disordered domestic lives existed outside the official realm.

In *Physics* Aristotle makes a distinction between Time and the single moments he describes as the "present." Single moments are—like Aristotle's atoms—indivisible, unbreakable things. But Time is the line that links these indivisible moments. Though Tarık Bey asked us to forget Time—that line connecting one present moment to the next—no one except for idiots and amnesiacs can succeed in forgetting it altogether. A person can only try to be happy and forget Time, and this we all do. If there are readers who sneer at the things my love for Füsun taught me, at these observations that arise from my experiences during the eight years at the house in Çukurcuma, I would like to ask them please to be careful not to confuse forgetting about Time with forgetting about clocks or calendars. Clocks and calendars do not exist to remind us of the Time we've forgotten but to regulate our relations with others and indeed all of society, and this is how we use them. When looking at the black-and-white clock that appeared on the screen every evening, just before the news, it was not Time we remembered but other families, other people, and the clocks that regulated our business with them. It was for this reason that Füsun studied the clock on

the television screen to check if she'd adjusted her watch "perfectly," and perhaps it was because I was looking at her with love that she smiled so happily—and not because she'd remembered Time.

My life has taught me that remembering Time—that line connecting all the moments that Aristotle called the present—is for most of us a rather painful business. When we try to conjure up the line connecting these moments, or, as in our museum, the line connecting all the objects that carry those moments inside them, we are forced to remember that the line comes to an end, and to contemplate death. As we get older and come to the painful realization that this line per se has no real meaning—a sense that comes to us cumulatively in intimations we struggle to ignore—we are brought to sorrow. But sometimes these moments we call the "present" can bring us enough happiness to last a century, as they did if Füsun smiled, in the days when I was going to Çukurcuma for supper. I knew from the beginning that I was going to the Keskin house hoping to harvest enough happiness to last me the rest of my life, and it was to preserve these happy moments for the future that I picked up so many objects large and small that Füsun had touched, and took them away with me.

Late one evening, during the second of the eight years, when the television stopped broadcasting for the night, I listened to Tarık Bey's memories of his time as a young teacher in Kars Lycée. If he had fond memories of these unhappy years, when he was alone and scraping by on a low salary, suffering many misfortunes, it was not because bad memories grow rosier with the passage of time, as most people believe, but because he enjoyed talking about the good moments (the particles of Now) from that troubled phase of his life (beads inevitably strung on that evil line, Time). It was after he had noted this paradox one evening that he remembered for some reason the "East-West" watch he'd bought while in Kars, which he brought out to show me had two faces, one in Arabic numerals, and the other in Roman.

Let me elaborate this theme with another timepiece: when I see this slender Buren wristwatch that Füsun began to wear in April 1982, what appears before my eyes is the moment when I gave it to Füsun on her twenty-fifth birthday, and the moment when, after she had taken it out of its now lost box, with her parents elsewhere (and Feridun not at home), she kissed me on the cheek, behind the open kitchen door, and

the moment when we were all sitting together and she joyously showed the watch to her parents, and the moment when her parents, having long accepted me as an eccentric member of the family, each thanked me in turn. For me, happiness is in reliving those unforgettable moments. If we can learn to stop thinking of our lives as a line corresponding to Aristotle's Time, treasuring our time instead for its deepest moments, each in turn, then waiting eight years at your beloved's dinner table no longer seems such a strange and laughable obsession but rather (as I would discover much later) assumes the reality of 1,593 happy nights at Füsun's dinner table. Today I remember each and every evening I went to supper in Çukurcuma—even the most difficult, most hopeless, most humiliating evenings—as happiness.

55

Come Again Tomorrow, and We Can Sit Together Again

FOR EIGHT years, assuming no flood or snow had closed the roads, and he was not ill or on holiday, and the car was in good repair Çetin Efendi drove me to Füsun's house in my father's Chevrolet. I was careful not to break that rule. After the first few months he'd made friends in the local teahouses and coffeehouses. He would never leave the car right in front of the Keskins' house, parking instead near those places with names like the Black Sea Coffeehouse or the Evening Teahouse; he'd go into one of these establishments and as he watched the same television program that we were watching at Füsun's house, he would read the paper, join in the conversation and sometimes a game of backgammon, or watch the men playing a card game known as Konken. After the first few months, everyone in the neighborhood knew us both on sight, and unless Çetin Efendi was exaggerating, they thought of me as a humble man who faithfully visited his poor distant relations just for the pleasure of their company, and for the love they felt for him.

Over the eight years there were of course those who claimed I had dark and evil designs. There was idle gossip not worthy of serious consideration: I was there to buy all the ruined houses in the neighborhood for next to nothing, only to demolish them and build apartments; I was looking for unskilled laborers to work for a pittance in my factories; I was a deserter from the army; or I was Tarık Bey's illegitimate child (which would make me Füsun's older half brother). But the reasonable majority had deduced, from the bits of information that Aunt Nesibe judiciously dispensed now and again, that I was a distant relation of Füsun's, involved in a film project with her husband that would make her a movie star. From what Çetin told me over the years, I understood that there was nothing unacceptable about these circumstances, and that even if the Çukurcuma neighborhood did not have any particular affection for me, as a rule they looked favorably on me. In any event, by the second year they had come to see me almost as one of their own.

It was a mixed neighborhood: Galata dockworkers, clerks and owners of small shops in the backstreets of Beyoğlu, Romany families who had moved there from Tophane, Kurdish Alevi families from Tunceli, the impoverished children and grandchildren of the Italians and Levantines who had once worked as clerks in Beyoğlu or Bank Street, a handful of the old Greek families who, like them, still could not find it in them to leave Istanbul, and various employees of bakeries and depots, taxi drivers, postmen, grocers, and penniless university students. This multitude did not coalesce into the sort of united community one saw in the traditional Muslim neighborhoods of Fatih, Vefa, and Kocamustafapaşa. But from the help I was continually offered, from the interest the young men took in any unusual or expensive cars that cruised its streets, from the speed with which news and gossip spread through the neighborhood, I inferred a sort of connectedness, a tentative solidarity, or at the very least the buzz of shared experience.

The house in which Füsun's family, the Keskins, lived was on the corner of Çukurcuma Avenue (popularly known as Çukurcuma Hill) and the narrow lane known as Dalgıç Street. As you can tell from the map, it was a ten-minute walk through the neighborhood's steep and winding streets to Beyoğlu and İstiklal Avenue. Some evenings, on our way home, Çetin would take those winding streets up to Beyoğlu, and sitting in the backseat smoking a cigarette I would gaze inside the

houses and the shops and at the people on the sidewalks. Lining these narrow streets were dilapidated wooden houses, overhanging the sidewalks as if on the verge of collapse, and vacant buildings abandoned by the latest wave of Greeks immigrating to Greece; these, and the stovepipes that the impoverished Kurdish squatters in those same buildings stuck through their windows, gave night a fearsome guise. Even at midnight, neighborhoods near Beyoğlu were still alive with small, dark bars, *meyhanes*, cheap nightclubs that described themselves as "drinking establishments," snack bars, grocery shops that sold sandwiches, lottery shops, tobacconists where you could also buy narcotics, black market cigarettes, or whiskey, and even music shops selling records and cassettes, and though all these places were in miserable condition, they struck me as cheerful and lively. Of course, I would only feel this way if I had left Füsun's house in a peaceful frame of mind. There were many nights when I left the Keskin household thinking that I would never go back again, and, revolted by the ugliness of the hurly-burly street, as Çetin drove the car I would lie down miserably on the backseat, as if passed out. Most unhappy evenings of this order date back to the early years.

Çetin would pick me up from Nişantaşı a little before seven in the evening; we'd run into a bit of traffic in Harbiye, Taksim, and Sıraselviler, and then wind our way through the backstreets of Cihangir and Firuzağa, passing in front of the historic Çukurcuma Hamam as we rolled down the hill. Somewhere along the way I would ask Çetin to stop the car and buy a package of food or a bunch of flowers. Not every time I visited, but on average every other time, I would bring a funny little present for Füsun—some Zambo Chiclets, a brooch or a barrette decorated with butterflies that I had found in Beyoğlu or the Covered Bazaar—and I would give it to her very lightheartedly, as if it were half a joke.

Some evenings, to avoid the traffic, we would go via Dolmabahçe and Tophane, turning right onto Boğazkesen Avenue. Without fail throughout that eight-year period, every time we turned onto the Keskins' street, my heart would begin to race just as it had done when as a child I turned in to the street where my school was, and I felt a disquiet in which joy mingled with panic.

Having tired of paying rent for an apartment in Nişantaşı, Tarık Bey

had used his savings to buy the building in Çukurcuma. The Keskins' apartment entrance was on the first floor. They also owned the little ground-floor apartment, and over the eight years a series of tenant families drifted in and out like ghosts, never involving themselves in our story. The entrance of this small apartment (which would later become a part of the Museum of Innocence) was on the side street—Dalgıç Street—and so I rarely crossed paths with the people who lived there. I did hear that Füsun had befriended one of the tenants—a girl named Ayla, who shared the apartment with her widowed mother while her fiancé was doing his military service—and that they'd go together to the cinema in Beyoğlu, but Füsun hid her neighborhood friends from me.

During the first months, when I rang the doorbell at Çukurcuma Hill, it was always Aunt Nesibe who would descend the flight of stairs to let me in. In all other instances, even if the doorbell rang in the evening, she would always send Füsun down. This was her way of making it clear to me that from my very first visit everyone knew why I was there, and for that purpose she was my natural mediator. But there were times when I felt as if Feridun really didn't suspect a thing. As for Tarık Bey, living as he did in a world of his own, he never gave me much cause for concern.

In the same spirit, Aunt Nesibe always took it upon herself to say something to make my presence seem natural as soon as she opened the door. Her conversation starters were usually inspired by whatever they were watching on television: "A plane was hijacked. Did you hear about it?" "They're showing pictures of the bus crash and they've left out none of the horror." "We're watching the prime minister's visit to Egypt." If I arrived before the news, Aunt Nesibe would always say with the same conviction: "Oh wonderful, you're just in time. The news is just beginning!" And sometimes she'd add, "We've made those cheese pastries you like so much," or "This morning Füsun and I made some lovely vine-leaf *dolma*s, you're going to love them." If her chatter to diffuse the situation seemed too forced, I would feel ashamed and remain silent. But most of the time I would cheerily reply, "Is that so?" or "Oh wonderful, just in the nick of time," and go upstairs repeating the rejoinder with exaggerated enthusiasm when I saw Füsun, hoping to hide the shame and joy I felt at that moment.

"Oh dear, I hope I didn't miss the plane crash, too," I said once.

"The plane crash was yesterday, Cousin Kemal," Füsun replied.

In the winter, I could say things like "How cold it is!" or "Are we having lentil soup?" as I was taking off my coat. After February 1977, when the installation of a buzzer allowed them to admit me without coming downstairs, I had to make my opening gambit as I was walking into the apartment, and that was harder. If Aunt Nesibe saw me struggling to find a way into the domestic routine, she'd draw me in at once: "Oh, Kemal Bey, don't just stand there, sit right down, before your pastry gets cold"; if not she'd make a more typical reference to current events: "The man shot up an entire coffeehouse and now he's bragging about it."

I would frown and take my seat straightaway. My presents also helped me with awkward first moments after my arrival. During the early years, I'd bring pistachio baklava, Füsun's favorite, or water pastries from Latif, the renowned bakery in Nişantaşı, or hors d'oeuvres like salted bonito and taramasalata. Always handing whatever it was to Aunt Nesibe, and without much fanfare. "Oh, you shouldn't have gone to so much trouble!" Aunt Nesibe would say. Then I would give Füsun her special present or leave it somewhere for her to find later, diverting attention by offering Aunt Nesibe a jolly reply: "I was just passing by the shop, and the pastries smelled so good I couldn't resist!," adding a few words of praise for whatever Nişantaşı patisserie I had visited. Then I would take my place discreetly, very much like a pupil who has come to class late, and suddenly my mood would lift. After sitting at the table for some time, I would eventually come eye to eye with Füsun. These were the sublime moments that repaid any amount of trouble I had gone to.

I treasured that moment when our eyes first met—not on first arrival, but while we were sitting down at the table—not only because it warmed my heart but because it spoke of what sort of evening lay ahead. If I saw some contentment, some tranquillity in Füsun's expression, even if it were a frown, the rest of the evening would assume that tone. If, however, she was unhappy or uneasy and so didn't smile, I wouldn't smile much either; during the first months I wouldn't under such conditions even try to make her laugh, but just sit there drawing as little attention to myself as I could.

My place at the table was between Tarık Bey and Füsun, on the side facing the television, and across from Aunt Nesibe. If he was at home, Feridun would be next to me, as would the occasional guest. At the beginning of the meal it suited Aunt Nesibe to sit with her back to the television, so that she could slip easily in and out of the kitchen, but by the middle of supper, when she had less to do, she would come to sit on my left, between me and Füsun, so that she could watch television more comfortably. For eight years I sat here elbow to elbow with Aunt Nesibe. Sometimes, when he came home late in the evening, Feridun would take a seat along the side of the table Aunt Nesibe had left vacant. And then Füsun would go to her husband's side, and Aunt Nesibe would take her daughter's old seat. Then it became difficult to watch television, but by then the broadcast day would be over anyway, and the television set was turned off.

When something important was on television while there was still something cooking on the stove, Aunt Nesibe would send Füsun in to check it in her place. As Füsun darted between the kitchen and the dining area, which was just next door, carrying plates and pots, she would pass right between me and the television screen. As her mother and father lost themselves in some film, or quiz show, or weather report, or the tirade by some angry general of ours who had just staged a coup, or the Balkan Wrestling Championship, or the Manisa Mastic Festival, or the ceremony marking the sixtieth anniversary of the liberation of Akşehir, I would watch my beauty pass back and forth in front of me, as though she was not, as her parents might have seen it, blocking the view, but rather was the view itself.

During my 1,593 visits to the Keskin household, I spent a good part of the evening sitting at the dinner table watching television. But I cannot so easily tally the length of individual visits. Out of shame, I would always try to convince myself that I'd gone home far earlier than I had done. It was, without doubt, when the broadcast ended that we remembered the time. The closing ceremony, watched in all the country's coffeehouses and gambling clubs, lasted four minutes: soldiers marching in step, saluting the flag as it was raised up the pole, and the national anthem playing in the background. Considering I usually arrived at around seven o'clock, and left soon after this nightly ceremony around midnight, I suppose I must concede I spent an average of five hours at

Füsun's house on each visit, but clearly there were times when I stayed longer.

In September 1980, four years after I began my visits to the Keskin household, there was another military coup; martial law was imposed and with it ten o'clock curfews. These obliged me to leave the house at a quarter to ten, long before my heart had satisfied its hunger. During the last minutes before the curfew, as Çetin drove quickly through the dark and fast-emptying streets, the torment of insufficiency would feel as keen as that of total deprivation. I would feel the pain of not having seen enough of Füsun. Even now, all these years later, whenever I read in the papers of the military's displeasure with the state of the nation, the evil of military coups I remember most vividly is that of rushing home denied my due ration of Füsun.

My relations with the Keskin family went through their vicissitudes over the years: the meanings of our conversations, our respective expectations and silences were forever changing shape in our minds. Of course, what never changed for me was my reason for going, which was to see Füsun, and I assumed this pleased her and her parents. But because the reason could never be spoken openly, we all had recourse to some form of euphemism. I was there as a "guest," though this term was ambiguous and not altogether convincing in the circumstances, we collectively agreed on an alternative expression that made us less uncomfortable. I went to the Keskins' four times a week to "sit."

Aunt Nesibe was particularly fond of this formulation, familiar to Turkish readers, which foreign guests to our museum might not readily understand, due to its manifold applications—"to pay a visit," "to drop by," or "to spend some time with someone"—not to be found in the dictionary. When I left at the end of an evening, Aunt Nesibe would always bid me farewell with the same gracious words: "Come again tomorrow, Kemal Bey, and we can sit together again."

In so saying she did not imply that we did nothing but sit at the table, of course. We would also watch television, sometimes falling silent for long stretches, and sometimes conversing amicably about this and that, as well as eating and drinking *rakı*. During the early years, to impress upon me how welcome I was, Aunt Nesibe would make particular mention of these other activities. She would say, "Do come again tomorrow, Kemal Bey, we're having those stuffed zucchini you love so

much for supper," or, "Tomorrow we can watch the ice-skating com-
petition, which they'll broadcast live." When she said these things, I
would glance at Füsun, hoping for some sign of approval, ideally a
smile; if Aunt Nesibe said, "Come, we'll sit," and Füsun seemed to
approve, I could let myself believe that there was no deceit in her
words, that we were indeed gathering in the same place, as people do, to
sit together. Touching in the most innocent way upon my main reason
for being there—my desire to be in the same place as Füsun—the word
"sit" suited me perfectly. Unlike those intellectuals who deem it a
solemn duty to deride the people and who believe that the millions of
people in Turkey who talked of "sitting together" every evening were
congregating to do nothing, I, to the contrary, cherished the desire
expressed in the words "to sit together" as a social necessity amongst
those bound by family ties or friendship, or even between people with
whom they feel a deep bond, though they might not understand its
meaning.

Here I display a model of Füsun's apartment in Çukurcuma (this
being the second floor of the building as a whole), which will, I hope,
serve as an introduction to the eight-year span of my story. On the
floor above the living room was the bedroom that Aunt Nesibe shared
with Tarık Bey, and the one Füsun shared with her husband; between
them was a bathroom.

A close look at the model will reveal that my place at the dinner
table is marked. For those unable to visit our museum, let me explain: I
sat across from the television, which was slightly to my left, and with
the kitchen just to my right. Behind me was a sideboard, and some-
times, if I tipped back my chair, I would knock against it. Then the
crystal glasses inside would shudder along with the porcelain and the
silver sugar bowls, the liqueur sets, the never-used coffee cups, the old
clock, the silver lighter that no longer worked, the little glass vase with
the spiraling floral pattern whose likeness one could see displayed on
the buffet of any middle-class family in the city, other assorted orna-
mental pieces, and finally the buffet's glass shelves.

Like everyone else at the table, I sat watching television year in and
year out, but casting my eyes slightly to my left, I could see Füsun quite
well without needing to turn toward her or move in the least. This
meant that while I was watching television I was able to look at Füsun

for extended periods without anyone noticing, simply by moving my eyes. The temptation was, of course, irresistible, and the more I performed this feat, the more expert I became at it.

If we were watching a film that had reached its climax, or some news story that we found particularly gripping, I took great pleasure in tracking Füsun's expressions; in the subsequent days and months my memory of the images on the screen would merge with that of the expression on her face. Sometimes at home I would first recall Füsun's expression before the affecting scene that had provoked it (an indication that I missed Füsun and had gone too long without coming to supper). The deepest, strangest, and most stirring memories of scenes watched during the eight years at the Keskins' dinner table are indelibly marked with corresponding images of Füsun. My fluency at reading her expressions reached the point where I could look at her from the corner of my eye and deduce with remarkable accuracy what was happening on television, even if I had been paying no attention to the screen.

On the table, next to the place where Aunt Nesibe would come to sit later in the evening, after the food was served, there was a lamp with clawed feet and a shade that was always askew, and next to it was an L-shaped divan. Some evenings, if the eating, drinking, laughing, and talking had proved particularly exhausting, Aunt Nesibe would say, "Come on, everyone, let's sit on the divan," or "Go relax and I'll bring you coffee!" and then I would sit on the end of the divan closest to the sideboard, while Aunt Nesibe sat on the other end, and Tarık Bey took his place next to the bay windows, on the chair closest to the hill. For a good view of the screen from our new places, it was necessary to pivot the television set, and this Füsun would do, from her place at the table, where she would remain. Although sometimes, having changed the angle of the television, she would take a seat at the far end of the divan, beside her mother, the two nestling together as they watched. Sometimes Aunt Nesibe would stroke her daughter's hair and her back, and, like Lemon the canary, who would be watching us with interest from his cage, I took great pleasure in the spectacle through the corner of my eye.

Late at night, when I had sunk into the cushions on the L-shaped divan, the *rakı* I had drunk with Tarık Bey would make itself felt, and I

could almost drop off to sleep, watching the television screen with one eye open, and with the other it was as if I were looking into the depths of my soul; I would feel the shame I had at other times succeeded in banishing, the shame that life had brought me to such a strange place, and an anger would well up urging me to get on my feet and leave the house. It was not uncommon for me to feel this way on those dark, dire nights when Füsun's expressions had displeased me, when she had offered hardly a smile, and even less if I brushed against her, intending nothing, but having done so, requiring a sign of assurance.

At such moments I would stand up and go to the bay window, where Lemon the canary was slowly aging in his cage, and I would peek through the curtains over the middle or right-hand panes at Çukur-cuma Hill. On wet days you could see the light of the streetlamps reflected on the cobblestones. Without taking their eyes off the screen, Aunt Nesibe and Tarık Bey would be prompted to say: "Has he eaten his food?" "Shall we change his water?" "He's not very happy today."

There was one more room on the first floor; it was at the back and had a narrow balcony. Used mostly in the daytime, it was where Aunt Nesibe did her sewing and Tarık Bey read his newspaper. After the first six months, whenever I felt uncomfortable at the table, perhaps wanting to pace nervously for a while, I would often go into this room if the light was on, to look through the balcony window: I enjoyed standing there surrounded by the sewing machine, the shears, the old newspapers and magazines, the open drawer with an array of ornaments, and before leaving I would often pocket something to soothe me later on if I was pining for Füsun.

Through this balcony window I could see a reflection of the room in which we were eating overlaying the prospect of a row of destitute houses in the narrow lane behind the house. On a few nights I spent a long time watching a woman who lived in one of these houses. Every night it was her habit, after putting on her woolen nightdress and before going to sleep, to take one pill from a box of medicine, and with it the crumpled instructions, which she would read with great care. It was only when Füsun came to stand beside me in the back room one night that I realized this was the widow of Rahmi Efendi, the man with the artificial hand who had worked in my father's factory for so many years.

Füsun whispered that she had followed me into the room to find out what I was up to back there. Her casual curiosity moved me, and for a time we stood together in the dark, side-by-side at the window, looking out at the street. At that moment I came close to grasping what it was that kept me coming to the Keskin house for eight years: I was driven by the very question that lay at the heart of what it meant to be a man or a woman in our part of the world.

In my view, Füsun left the table that evening because she wanted to be close to me. This was clear from the way she stood by me in silence, gazing at what was to her a very ordinary view. But for me, as I cast my eyes upon the roof tiles, and the tin roofs, and the smoke puffing gently from the chimneys, as I peered through lit windows, catching glimpses of families moving about their homes—it all seemed extraordinarily poetic, simply because Füsun was at my side, and the desire was great to put my hand on her shoulder, to wrap my arms around her, or just to touch her.

But my experience at the Çukurcuma house during the first weeks was enough for me to tell that Füsun's response would be severe, perhaps even as cold as if I had tried to molest her; she would push me away and leave the room abruptly, causing extravagant pain, and launching us into our twinned indignation (the game that we would slowly perfect over the years) with the ultimate result that for a time I would not even go to the Keskins' for supper. Even having reasoned this through, the urge to touch her, kiss her, or, at the least, brush against her side persisted. The *rakı* played some part in this. But even if I'd had nothing to drink, this dilemma would have afflicted me nonetheless.

If I held myself back, kept myself from touching her (as I was becoming a master at doing), Füsun would come even closer; she might brush against me, and perhaps she would say a few sweet things. Or (as she had a few days earlier) she might ask, "Is something bothering you?" In fact, that evening Füsun said, "I love how quiet it is at night. I love watching the cats wandering over the roofs." And again I would be gored by the same painful dilemma. Could I touch her, hold her, kiss her? How I longed to do so. It is possible that during the first weeks, the first months (as I would come to believe afterward, for many years) that she was making no kind of overture at all, but only saying the

polite and civilized things that an intelligent, well-mannered girl with a high school diploma was obliged to say to a distant relation who was rich and lovelorn.

During those eight years the dilemma preoccupied me, and damned me. The view you can see in the picture displayed here is the one we beheld standing at the window for at most two or two and a half minutes. I would like the museum visitor in contemplating it to please reflect on my dilemma as he looks at this view, bearing in mind, too, how delicate and refined was Füsun's behavior at this moment.

"I find this view so beautiful, because you are at my side," I finally said.

"Let's go, my parents will begin to wonder what we're up to."

"With you at my side, I could be happy looking at a view like this for years," I said.

"Your food is getting cold," said Füsun, and she went back to the table.

She knew how cold her words were. For it was not long after I had returned to the table that Füsun stopped frowning, giving me two sweet, compassionate smiles as she passed me the saltshaker (later to be added to my collection) and allowing her fingers to brush rather boldly against my hand; with that she made everything right again.

56

Lemon Films Inc.

ON FIRST discovering that his daughter had entered a beauty contest with the support and approval of her mother, Tarık Bey had been beside himself with fury, but loving his daughter dearly as he did, he could not resist her supplications when she burst into tears; afterward, though, when he heard what people said about her, he would regret tolerating the disgrace. There had been beauty contests during the first years of the Republic during Atatürk's reign, and when girls walked down the catwalk in black swimsuits, they were, in Tarık Bey's view,

both manifesting their interest in Turkish history and culture, and also showing the entire world how modern they were, which was all to the good. But by the seventies, the contests had become the province of girls with no culture or manners and coarse hopes of becoming singers and models, and so the significance of beauty contests became something else altogether. The hosts of the old contests would ask the contestants, oh so politely, what sort of man they dreamed of marrying, as a refined way of clarifying that the girls were virgins. And while today's hosts asked girls, "What do you look for in a man?" (the correct answer being "character"), they would grin and smirk like Hakan Serinkan. So Tarık Bey was adamant with his filmmaker son-in-law that while he and Füsun were living under his roof, his daughter was to have no further adventures of this nature.

Out of fear that her father might consider becoming a film star likewise objectionable and thwart her plans in various overt and covert ways, we continued to discuss the "art film" Feridun planned only in hushed tones. In my view, Tarık Bey pretended not to hear our whispering because he looked favorably on my interest in his family and enjoyed drinking and talking with me. And as the art film provided a plausible pretext for my visiting the Keskin family four times a week, it served only too well to conceal the real purpose of my appearances, so well known to Aunt Nesibe. During the first few months, whenever I looked at Feridun's sweet and guileless face, it seemed to me that he knew nothing, but later I would begin to think that he was in on a counterplot, but trusted me with his wife, seeing me as no kind of threat—indeed someone to be made fun of behind my back—and in his desperate need for my backing, simply played along with the deception.

Toward the end of November, after much coaxing from Füsun, Feridun finished the final draft of his screenplay, and one evening after supper, while standing on the landing at the top of the stairs, and under Füsun's frowning gaze, he ceremoniously handed the typescript over to me, as prospective producer, to solicit my decision.

"Kemal, I want you to read this carefully," said Füsun. "I believe in this screenplay and I trust you. Don't let me down."

"I'd never let you down, my dear girl!" I pointed at the typescript in my hand. "Tell me, do you esteem the screenplay so highly because

you're meant to star in it, or is it because it's meant to be an 'art film'?" (A new concept in 1970s Turkey.)

"Both."

"Then consider the film made."

The screenplay was entitled *Blue Rain,* and there was nothing in it remotely to suggest an awareness of Füsun, or me, or our romance, or our story. Over the summer I had come to have respect for Feridun's intelligence and his understanding of film; discussing cultivated and highly educated Turkish filmmakers longing to make art films in the manner of the West, he had very astutely identified their typical mistakes (imitation, artificiality, moralism, vulgarity, melodrama, and commercial populism, etc.), so why had he fallen into all the same traps? As I was reading this vexing screenplay, I realized that the longing for art, like the longing for love, is a malady that blinds us, and makes us forget the things we already know, obscuring reality. Even the three scenes, motivated by commercial considerations, in which Füsun's character would appear nude (once making love, once pensively smoking a cigarette in a bubble bath, in the style of the French New Wave, and once wandering through a heavenly garden in a dream) were arty, insipid, and gratuitous!

My confidence in this project was never more than a pose, but after reading these scenes I was even more resolutely and angrily opposed than Tarık Bey would have been. But realizing that I had to keep the project alive for a while longer, I lavishly praised the script to both Füsun and her husband, going so far as to tell them that "as the producer" I was now ready to begin tryouts for actors and technicians, a zealousness for which I gently mocked myself, in the interest of making it more credible.

So with the onset of winter, Feridun, Füsun, and I delayed not a moment in visiting the backstreet haunts, the prospective production offices, and the coffeehouses where second-class actors, would-be film stars, bit players, and set workers played cards, as well as the bars where producers, directors, and semifamous actors were usually to be found from early evening, eating and drinking until the late hours. All these places were a ten-minute walk up the hill, and whenever I took this route I would remember how Aunt Nesibe had told me that Feridun had married Füsun in order to live within walking distance of such

establishments. Some evenings I would collect them at the door, and some evenings we three—Feridun, with Füsun on his arm, and I— would walk together up to Beyoğlu, having had our supper with her parents.

Our most frequent destination was the Pelür Bar, popular with film stars and men with new money hoping to mingle with girls who hoped to become starlets, and the children of Anatolian landowners, now cast into the Istanbul business world by day and letting off steam in the evening, and moderately renowned journalists, film critics, and gossip columnists. All winter long we met many actors who'd played support-ing roles in the films we'd seen that summer (including that mustached friend of Feridun's who had played the crooked accountant), and we became part of that society of spirited, bitter, but ever hopeful souls who whiled away the evenings exchanging vicious gossip, recounting their life stories, and describing their ideas for films, and who couldn't get through a day without the company of those like them.

They were very fond of Feridun, and because he held some of them in high esteem, had assisted some others, and wanted to ingratiate him-self with the rest, he would go off to their tables, sitting with them for hours, leaving Füsun and me alone, though never happily on my part. When Feridun was with us, Füsun would address me as "Cousin Kemal," only very rarely dropping this half-innocent pretense; if she did deign to speak to me sincerely, I read her change of register as a warning—about the men who came and went from our table, and her future life in the film world—that I ignored at my peril.

One evening after too much *rakı,* I found myself left alone with her again, and having tired of her aspirational fantasies and the pettiness of this milieu, I suddenly became convinced of the rightness of my next comment and of her receptiveness to it. "Take my arm, darling, let's get up and leave this dreadful place together right now," I said. "We could go to Paris, or Patagonia, to the other end of the world—it doesn't matter so long as we forget all these people, and live happily ever after, just the two of us."

"Cousin Kemal, how can you even say such a thing? Our lives are what they have become," said Füsun.

After we'd been coming to the bar for several months, the drunken lot that gathered there every night (an "it" crowd in their own minds)

didn't bother us, having accepted Füsun as the young and beautiful bride and having pegged me with derisive suspicion as the "well-meaning idiot millionaire" who wanted to make an art film. But there were inevitably those who didn't know us, or drunks who knew us but leered at Füsun anyway, or who had caught a glimpse of her from a distance while barhopping, or who nurtured an irrepressible longing to narrate their own life stories (this was an enormous crowd), and collectively they hardly left us alone. While I enjoyed it when a stranger joined us with a glass of *rakı* in his hand, having taken me for Füsun's husband, she would straightaway smile and correct them with an insistence that broke my heart every time, saying, "My husband is the fatso over there," and emboldened the stranger to ignore me and attempt to make a pass at her.

Each attempt took a different form. Some claimed they were looking for a "dark-haired innocent-looking Turkish beauty" just like her to use in a *photoroman;* some would immediately offer her the lead in some new film on the prophet Abraham, headed imminently into production; some would gaze longingly into her eyes for hours saying nothing; while others would discourse on life's little beauties and all the subtle wonders that no one paused to notice in this materialistic world, where only money mattered; then there were the ones who sat at remote tables reading the work of long-suffering imprisoned poets, poems about love, longing, and the nation; others from distant tables would either pay our tab or send us a plate of fruit. By the end of the winter we were frequenting these Beyoğlu haunts less, but every time we did go, we would inevitably see the same great hulking woman who often played the diabolical prison matron or the leading villainess's bulky sidekick. She would invite Füsun to dance parties at her house, promising "lots of cultivated, well-schooled girls" like her. And there was always an old, squat little critic who wore bow ties and girded his enormous belly with suspenders; he would plant his ugly hand like a scorpion on Füsun's shoulder, foretelling the "great fame" awaiting her, perhaps as the first Turkish actress to gain international renown, provided she gave careful consideration to every step she took.

Füsun would indeed give serious consideration to each and every film, *photoroman,* and modeling offer, however unsuitable or trivial; she would also remember the names of everyone she met, and in the case

of film actors, no matter how obscure, she would shower them with outsize, even vulgar compliments, a want of proportion that I couldn't help tracing back to her days as a shopgirl. Even as she tried to flatter and beguile everyone, she was also determined to achieve the often contradictory purpose of making herself seem interesting. Toward these ends she was ever more often pressing us to visit these places, and if I counseled against giving her phone number to everyone who made her an offer—"What would your father say?"—she would only snap at me that she knew what she was doing, even declaring that she needed options in the event that Feridun's film failed to get made. I took deep offense at the implication and moved to another table, but then she would come over with Feridun and say, "Why don't we three go out for supper, just like we did last summer?"

I had made two new friends among the hard-drinking film crowd of which I was slowly becoming a somewhat embarrassed fixture. One of them was a middle-aged actress named Sühendan Yıldız, who owed her fame as the "evil woman" entirely to her nose, which had been broken by one of Turkey's first cosmetic surgeons and reconstructed in a hideous new shape. The other was a character actor named Salih Sarılı, who having for years played authority figures like army officers and policemen, was now obliged to earn his keep by dubbing semi-legitimate domestic porn films, the absurdities of which enterprise he could be relied upon to recount in a chesty voice, often interrupted by a laugh and a hacking cough.

In a few years' time I would discover that it was not just Salih Sarılı working in the domestic porn industry, but most of the actors we had befriended in the Pelür Bar, and this startled me as if I'd discovered that all my friends belonged to a secret society. Well-mannered middle-aged actresses and actors of strong types like Salih Bey would get by dubbing foreign films that were only moderately obscene, and during the sex scenes, moaning and screaming to suggest the details of the action that the film didn't show. Most of these actors were married with children and admired for their gravitas; they would tell their friends that they had been forced to take on such work during the economic decline so as not to be entirely cut off from the film world, though at first they hid it from everyone, and especially their families. Even so, their ardent fans, particularly those in the provinces, would

recognize their voices and write them letters of hatred or admiration. At the same time, far bolder, greedier actors and producers, most of them regulars at the Pelür, were involved in domestic productions that must go down in history as "the first Islamic porn films." The "love scenes" in their films mixed sex with slapstick, as the gasping and moaning proceeded with ludicrous exaggeration, as the actors assumed all the positions that could be learned from European sex manuals bought on the black market, though all involved, male and female alike, would never remove their underpants.

At the Pelür, as Füsun headed off with Feridun, alighting at every table, meeting everyone she could, I would sit and listen to my two new middle-aged friends, more often the courteous Sühendan Hanım, dispense words of caution. I was, for example, to keep Füsun at all costs away from that producer over there, who looked respectable enough with his yellow tie, crisply ironed shirt, and little brush mustache, but whose greatest claim to fame was trapping women under thirty in his office above the Atlas Cinema where he had no qualms about locking the door and raping them, and afterward he would silence the crying girls with the offer of the lead in one of his films, which role, when the filming began, would turn out to be a bit part—that of the scheming German nanny who upsets the peaceful home of a rich Turkish man with a golden heart. I was to be likewise wary of Muzaffer the producer, also Feridun's old boss, at whose side Feridun still spent so much time, laughing slavishly at every joke, hoping to win this man's technical assistance for the art film. Not long ago, less than a fortnight, this scoundrel had been sharing a table with the owner of two medium-size production companies with whom he was in constant competition, and he had bet his rival a bottle of black market champagne that he could seduce Feridun's wife within the month. (The films of that era offer copious examples of our fetish for that Western infidel luxury.) As I sat chatting with this renowned film star who had for so many years played the ordinary vixen (never the true she-devil), and who on account of the celebrity magazines was known to the entire Turkish nation as Conniving Sühendan, she would be knitting a tricolored woolen pullover for her beloved three-year-old grandson, and showing me the picture in *Burda* from which she was copying it. If anyone mocked her for sitting

in the corner of the bar with balls of red, yellow, and navy blue wool on her lap, she would say, "At least I'm keeping busy while waiting for my next job, which is more than you drunks can say," and if circumstances warranted she would discard her ladylike manners with some ease and launch into foul-mouthed invective.

The intellectuals, filmmakers, and pouting starlets frequenting places like the Pelür would be drunk by eight in the evening: Seeing how scandalized I was by the ensuing vulgarities, my world-weary friend Salih Sarılı gazed across the room with a romantic expression that recalled the noble, idealist policeman roles that he had personified for so many years, and, fixing his eyes on Füsun, who was sitting at a distant table, laughing with someone I didn't know, he allowed that were he a rich businessman, he wouldn't be bringing a beautiful relation to bars like this for the purpose of her becoming a star. This broke my heart. I was now obliged to add my actor-dubber friend to my list of "men who looked at Füsun in the wrong way." Conniving Sühendan made a more oblique comment one day that I would never forget: My beautiful relative Füsun, she said, was a sweet and good and lovely girl, just the right age to become a very good mother, like the one who had given birth to the grandson for whom she was knitting the red, yellow, and navy blue pullover. But what were we doing here?

I, too, would eventually succumb to such anxieties. For every week Füsun was making new acquaintances in the film bars of Beyoğlu, admirers who were continually proposing to use her in this *photoroman* or that commercial. And so at the beginning of 1977 I signaled to Feridun that the time had come to decide on his technical team. From her friendly smiles and the way she touched me when she whispered funny stories into my ear, Füsun had led me to believe she would leave Feridun soon. As I was planning to marry her the "very next" moment, I told myself that it would be better for her, too, not to become too involved in this sordid world. We could make her an actress without cozying up to such people. It was at about this time that the three of us decided that our joint venture was better managed from an office than in the Pelür Bar. The moment had come to set up a company to finance Feridun's films.

It was at Füsun's jolly suggestion that we agreed to name the com-

pany after Lemon the canary. As one can gather from our business card, bearing the likeness of the charming bird, Lemon Films was located next door to the New Angel Cinema.

I arranged for 1,200 Turkish lira to be deposited every month in a personal account at the Beyoğlu branch of the Agricultural Bank. This sum was slightly more than the salaries I paid my two top managers at Satsat: Half would pay Feridun's salary as the firm's managing director, while the rest would cover the rent and the production costs.

57

On Being Unable to Stand Up and Leave

ONCE I had begun to pay Feridun through Lemon Films, growing more convinced with each passing day that there was no need to rush into production, I felt much better, even about going to Füsun's for supper. Or more truthfully, some nights, when my desire to see Füsun was too strong to resist, and my heart would be seized by a shame no less powerful, I would tell myself that somehow because I was now giving them money there was no longer cause for shame. The need to see Füsun had so fogged my mind that I never examined the logic by which the payments expunged the disgrace. But I remember sitting with my mother in front of the television in Nişantaşı around suppertime one evening in the spring of 1977, yet again caught between desire and shame, doubled up in my father's chair (now mine), paralyzed by indecision, for half an hour, unable to move.

My mother said what she always said now on seeing me at home in the evening. "Why don't you stay in for a change, and we can eat something together."

"No, Mother dear, I'm going out."

"Goodness, I had no idea there were so many diversions in this city. You can't stay away from it for a single night."

"My friends insisted, Mother dear."

"I wish I were your friend instead of your mother, left alone in life. . . . Look, Bekri could run down to Kazım's and buy some lamb chops; he could grill them for you. Sit down and have supper with me. You can eat your lamb chops and then go see your friends."

"I could go down to the butcher right now," Bekri called out from the kitchen.

"No, Mother, this is an important party," I said. "The Karahans' son is hosting it."

"Then why haven't I heard about it?" my mother said, rightfully suspicious. What did my mother or Osman or anyone else know about the frequency of my visits to Füsun's? I didn't want to think about this. On the nights I went to Füsun's house, I would sometimes have supper with my mother first, just to allay her suspicions, and then go and eat again at Füsun's. On nights like this, Aunt Nesibe would notice at once my lack of interest in the food, and she'd say, "You have no appetite this evening, Kemal; didn't you like the vegetable stew?"

There were times when I would eat supper with my mother, thinking that if I could survive those hours when I missed Füsun most intensely, I would have the strength to stay at home, but one hour and two glasses of *rakı* later, my longing would grow to such proportions that even my mother could not fail to notice.

"Look at you with your legs twitching again. Why don't you walk off your nervousness and come back," she'd say. "But please, don't go far, I beg you, not with the streets as dangerous as they are these days."

I have no desire to interrupt my story with descriptions of the street clashes between fervent nationalists and fervent communists at that time, except to say what we were witnessing was an extension of the Cold War. In those years people were being murdered in the streets continually; coffeehouses would be machine-gunned in the middle of the night, and every other day there were university takeovers or boycotts, bombs going off, and banks being raided by militants. Slogans had been written over slogans on every wall in the city, and in every color. Like most people in Istanbul, I had no interest in politics, and it seemed to help no one that this war was being waged in the streets by an assortment of ruthless factions, none of which had anything in common with the rest of us. When I told Çetin, who'd been waiting for

me outside, to drive carefully, I was speaking as if politics were as natural a cataclysm as an earthquake or a flood, and there was nothing we ordinary citizens could do except try our best to stay out of its way.

If I was unable to stay at home, as on most evenings, I didn't always go to the Keskins'. Sometimes I'd go to a party, hopeful of meeting a nice girl who would help me forget Füsun; sometimes I would go out for a few drinks with old friends and chat. If Zaim had taken me to a party, or, finding myself in the home of some distant relation recently come into society, I ran into Nurcihan and Mehmet, or if, late at night, Tayfun had driven me to a nightclub and, bumping into long-lost friends, we ordered a bottle of whiskey and sat together listening to Turkish pop songs (mostly rip-offs of French and Italian pop songs), I would alight upon the mistaken notion that I was slowly returning to my former healthy life.

It was not the shame and indecision I felt in advance of going to Füsun's that bespoke the gravity of my affliction, but rather the indecisive inertia that overtook me when, having sat with them for hours, eating supper and watching television, the time to go home had come. Besides the shame of ordinary inertia, there was in the extreme instance the shame I felt when I was literally unable to summon the will to leave the Çukurcuma house at all.

The television broadcast would end every evening between half past eleven and midnight, and the images of the flag, Atatürk's mausoleum, and "our boys" in the army would be replaced by a snowfall of blurry dots, which we would also watch for a while, as if some further program might come on by mistake, until Tarık Bey said, "Füsun, my girl, let's turn this thing off now," or else Füsun did so unbidden, with a single touch. And so would begin the particular misery I now wish to analyze. The feeling that if I did not stand up at once and leave there would ensue great discomfort in everyone. I couldn't reckon how apt it was to worry about this. I would just think, I'll be getting up soon. Having heard them speak ill of guests who dashed off the moment the broadcast ended, with scarcely a "good-night," and of neighbors without televisions of their own who did likewise, I deluded myself, imagining I was merely being polite.

Certainly they knew that I did not come calling to watch television, but to be near Füsun, but sometimes to finesse this imperative I would

phone ahead, saying to Aunt Nesibe, "Why don't I come over this evening. They're showing *Pages from History*!" But having seized on such a pretext, I had locked myself into a need to be off once the program was over. So at that moment, the television having been turned off, I would sit for a casual while longer, before telling myself, more force-fully now, that I needed to stand up and get going, but my legs would not obey me. In this motionless state I would remain, whether at the table, or on the L-shaped divan, like a figure in a painting, and as I felt the perspiration beading on my brow, many Aristotelian moments would pass, the ticking of the clock punctuating my discomfort, as I exhorted myself, saying, "I'm standing up now!" forty times over, but still to no avail.

Even all these years later this inertia baffles me somewhat, just as I cannot fully comprehend the love that so afflicted me, though I can adduce, perfectly, any number of discrete reasons for my apparent loss of will:

1. Every time I said, "I must get going now," Tarık Bey or Aunt Nesibe would say with sincerity, "Oh, please stay a little longer, Kemal Bey, we were sitting so nicely!"

2. If they did not, Füsun might give me an enchanting smile, with such a mysterious air that I would be all the more confused.

3. Then someone would begin telling a new story, or bring up a new subject. To get up now, before this new story was told, would be rude, I told myself, and so I would sit there, however uneasily, for twenty minutes more.

4. Coming eye to eye with Füsun I would lose all sense of time, until finally glancing at my watch I'd see that forty, not twenty, minutes had passed, and then I'd say, "Oh, look at the time," but I still wouldn't go: I'd just sit there, cursing myself for being so weak, my inertia and shame growing ever deeper, until the moment arrived when it became too heavy to bear.

5. I would search my mind for an excuse to sit there just a bit longer, to give myself a little respite from that burden before going.

6. Tarık Bey might have poured himself another *rakı,* in which case courtesy perhaps required that I should join him.

7. I would try to ease my departure by using the feeble excuse of waiting for midnight, and then saying, "Oh, it's midnight already, I really should be going."

8. I would tell myself that Çetin was perhaps in the middle of some conversation at the coffeehouse, and that he might not be ready either.

9. And anyway, down in the street, just beyond the door, a group of neighborhood youths were gathered, smoking and blabbing, so to leave just then would make me the object of their idle gossip. (It was not a fantasy: Whenever I ran into the neighborhood youths on my way in or out of the Keskin house, they would fall silent, and for years that disturbed me, though seeing me on such good terms with Feridun, they could never as "defenders of the neighborhood" challenge me.)

Feridun's absence also made me uneasy, oddly more than his presence. I knew already from the way Füsun looked at him that the situation was difficult. But the thought that Feridun might trust his wife implicitly led me to the excruciating conclusion that they might somehow be happily married.

It was far more comforting to explain Feridun's lack of concern by reference to taboos and traditions. Living as we did in a country where it was unthinkable to show interest in a married woman in front of her parents, and where especially among the poor, and in the provinces, even a sidelong glance could lead to death, it would have been virtually inconceivable to Feridun that it might cross my mind to flirt with Füsun every night as we sat watching television like a happy family. The love I felt, like the dinner table at which we ate, was ringed with so many refinements and prohibitions that even if every fiber in me shouted that I was madly in love with Füsun, we would all be obliged nevertheless to act "as if" there was an absolute certainty that such a love could simply not exist. At times when this occurred to me I would understand that I was able to see Füsun not in spite of all these exquisite customs and proscriptions, but because of them.

Let me offer a counterexample by way of elucidation, as it is central to my story: Had we been living in a modern Western

society with more candid relations between men and women, and with the sexes not living in separate realms, my going to the Keskin household four or five times a week would, of course, force everyone eventually to accept that I was coming to see Füsun. The husband would have to be jealous and would be obliged to stop me. And so in such a country my visits could never be so frequent, and neither could my love for Füsun have taken this shape.

On nights when Feridun stayed home, it was less difficult for me to stand up and leave at a suitable time. If, however, Feridun was with his film friends, it could get quite late, the broadcasting having ended, and someone having uttered one of those nightly pleas made out of politeness—"Won't you have another cup of tea before you go?" or "Sit a little longer, Kemal Bey, please!"— because I would sometimes resolve to time my departure around his return. But not once during those eight years could I decide whether it was better to leave just before he got back or just after.

During the first months it seemed far preferable to depart before Feridun returned. Because in those first moments after he walked in and we came eye to eye, I would feel very, and I mean very, bad. I would have to down at least three more glasses of *rakı* after returning to Nişantaşı just so I could sleep. What is more, getting up the moment Feridun arrived was as good as suggesting that I disliked him and, even worse, as revealing that I was there for Füsun. Hence the habit of my remaining at least half an hour after Feridun's return, despite magnifying both my inhibitions and shame. Better to suffer these feelings than to expose my guilt by avoiding him. I wouldn't follow those dastardly Casanovas in European novels who openly court the countess and scamper out of the castle moments before the count's return! Of course, as an alternative to leaving before Feridun got back, I could have allowed a longish interval between my departure and his arrival. But this would have meant leaving the Keskin house early. And that I could not do. I had trouble leaving late. I had trouble leaving early.

10. If I did wait for Feridun, we might have a chat about this

screenplay business. In fact, I tried this a few times; when Feridun got home, I tried to talk to him.

"There's now a faster way of getting cleared by the board of censors, Feridun. Have you heard?" I said once. If I didn't use those exact words, I said something similar, leading to an icy silence at the table.

"There was a meeting with the Erler Films people at Panayot's coffeehouse," said Feridun.

Then he kissed Füsun in the half-heartfelt, half-routine way that husbands in American films kiss their wives when they get home from work. Sometimes I would see from the way Füsun greeted his embrace with her own that these kisses were genuine, and it would hit me very hard.

Some nights Feridun would sit with us and have supper, but most evenings found him at the cafés with the writers, draftsmen, stagehands, and cameramen of the film world, or visiting them at home. He had been drawn into a communal life with noisy, gossipy people who lacked inner calm and were never without a reason to argue with one another. Feridun had in fact come to attach disproportionate importance to the dreams and disputes of these associates with whom he drank and dined so often, so that while his film friends' passing pleasures brought him instant happiness, their lingering despair left him no less instantly grief-stricken. When he was so afflicted I put my mind at ease and would not worry that my evening visits were keeping Füsun from going out with her husband and enjoying life. Ordinarily, profiting from the nights when I wasn't visiting, Füsun would go out to Beyoğlu once or twice a week, radiant in a chic blouse and adorned with one of the butterfly brooches I had bought her, and with her husband she would sit for hours in a place like the Pelür or Perde, a detailed report of which would come to me from Feridun on the very next visit.

Feridun and I both knew that Aunt Nesibe, too, was keen for Füsun to find the shortest way into the film business. Tarık Bey was secretly on "our" side of reluctance, but we knew that he could never be drawn out into the open in this matter. Still, I wanted Tarık Bey to know that I was his son-in-law's backer. It would be a year after the founding of Lemon Films before I heard from Feridun that his father-in-law was aware of my help.

During that year, I cultivated Feridun as colleague and friend outside the Keskin household. I could not deny he was affable, sensible, and very sincere. From time to time we would meet at the office of Lemon Films to review the status of the screenplay, our application with the board of censors, and the search for Füsun's male lead.

Two quite famous and handsome actors had already expressed an interest in Feridun's art film, but he and I both regarded them with suspicion. These black-mustached braggarts, who specialized in historic films wherein they would kill Byzantine priests and take down forty thieves with one blow, were sure to set their lecherous sights on Füsun. Their standard repertoire included talking lasciviously about their female costars, even those under eighteen, and their loaded remarks would lead to headlines like "The Kisses in the Film Come True" or "The Forbidden Love That Flowered on the Set." In fairness, such scandal was part of the film business, because it made actors into stars and drew in the crowds, but it was an advantage that Feridun and I were determined to forgo where Füsun was concerned. Knowing that to protect her in this manner could be costly to Feridun, I would order Satsat to remit more funds and expand Lemon's budget.

But that I could not buy my way out of every anxiety attending Füsun's entry into the film world around this time did worry me deeply. One evening when I went to the house in Çukurcuma, Aunt Nesibe told me, most apologetically, that Füsun had gone out with Feridun to Beyoğlu. I kept a neutral expression, hiding my misery as I sat down with Tarık Bey and Aunt Nesibe to watch television. Two weeks later, when the same thing happened again, I invited Feridun to lunch, to warn him that if Füsun became too involved with this drunken film crowd, it could undermine the integrity of our art film. He should use my visits, I advised, as a way of obliging her to spend her evenings at home. A lengthy explanation ensued as to why I thought this would be for the good of both the family and our film.

It troubled me that my advice would be so little heeded. Arriving on yet another evening to find Feridun and Füsun gone out to some place like the Pelür, I again found myself sitting with Aunt Nesibe and Tarık Bey, silently watching television. I stayed until Füsun and Feridun returned at two in the morning, passing the time—whose passing I affected not to notice—by telling stories of America as I had come to

know it during my years at university: Americans were very hardworking, well-meaning, and at the same time very naïve; they went to bed early; and even the richest children were obliged by their fathers to go from door to door on their bicycles delivering newspapers early in the morning. They smiled as they listened, as if I were joking, but they were also curious. Tarık Bey asked me to explain something he had wondered about: When phones rang in American films, they sounded different from ours. Did all phones in America ring like that, or just the phones ringing in films? Suddenly I was confused, and I realized that I had forgotten what phones sounded like in America. Long after midnight this awareness gave me the impression that I had left behind my youth, reminding me of the freedom I'd felt in America. Tarık Bey did an impression of a telephone in a typical American film, and a different impression of a phone ringing in a thriller, an even shriller sound. It was after two o'clock and we were still drinking tea together, and smoking, and laughing.

Did I stay so long to discourage Füsun from going out on the evenings of my visits, or did I stay because it would cause me such distress to leave without having seen her? Even all these years later I still don't know. But finally, after one more serious heart-to-heart with Feridun about the perils of Füsun's keeping such louche company, she did stop going out when I was expected for supper.

It was around this time that Feridun and I began to consider whether we should raise funds for the art film in which Füsun would star by first doing a commercial film. It is possible that talk of this prospective interim venture, in which Füsun would play no part, was what inspired Füsun to stay at home, though she did not neglect to communicate her resentment, and on some nights bounded vengefully upstairs to bed before I'd left. Still she clung to her dream, and so the next time I came she would be warmer than ever, asking after my mother, or spooning a bit more pilaf onto my plate unbidden; and then it would be impossible for me to go.

For even as my friendship with Feridun progressed, I remained afflicted by attacks of inertia that kept me from taking my leave. The moment Feridun walked through the door, I would at once feel superfluous, out of place in this world, like something I'd seen in a dream, but unable to give up my stubborn wish to belong to it. I shall never

forget Feridun's expression one night in March 1977, when the late news on television had been an endless succession of stories about bombs detonated at political meetings and coffeehouses and leaders of the opposition shot in cold blood; it was very late (in my shame I'd stopped looking at my watch), and he arrived to find me sitting there. It was the sad look of a good man who felt genuine concern for me, but also tinged with an element of his nature that so mystified me—an innocence, so light and good and hopeful as to accept everything as normal.

After the 1980 coup, the ten o'clock curfew constrained my intervals of inertia. But martial law could not cure my affliction; indeed squeezing my relief into a shorter parcel of time made the suffering more intense. During the curfew hours, the crisis of immobility would intensify from half past nine, and I would be unable to stand, no matter how furiously I told myself, "Up now!" As the countdown continued relentlessly my panic would become impossible to bear by twenty to ten.

When I finally managed to propel myself downstairs and into the Chevrolet, Çetin and I would panic as we wondered whether we would make it to the house by the curfew; invariably we were four or five minutes late. In those first minutes of the curfew (which was later extended to eleven o'clock) the soldiers would never stop the last few stragglers racing down the avenues. On the way home, we'd see cars that had crashed in Taksim Square and Harbiye and Dolmabahçe in their haste to beat the clock, and the drivers were no less quick to get out of their cars and pummel each other. One night a drunken gentleman emerged with his dog from a Plymouth, its exhaust pipe still spewing smoke, and it reminded me of another occasion when after a head-on collision in Taksim, a taxi's broken radiator was producing more steam than the Cağaloğlu Hamam. One night, having navigated the macabre darkness and the deserted, half-lit avenues, I reached home safely, and after I had poured myself one last *rakı* before heading for bed, I pleaded to God to return me to normal life. I cannot say if I really wanted this prayer to be answered.

Any kind word I heard before I left the house, any gentle or positive remark Füsun or the others offered me, however ambiguous, was enough to sustain hope, to revive the conviction that I would win

Füsun back one day, that all these visits had not been in vain. In such a gladly deluded state I could take my leave relatively untroubled.

A pleasant comment from Füsun at the dinner table at an unexpected moment—for instance, "You went to the barber, I see. He took off a lot but it looks good" (May 16, 1977), or turning to her mother, "He enjoys his meatballs like a little boy, doesn't he?" (February 17, 1980), or on a snowy evening a year later, when I had just walked in, "We haven't sat down to eat yet, Kemal. We were just saying how much we all hoped you'd be joining us"—and I would feel so happy, however dark the thoughts I'd brought with me, however discouraging the signs I read as we watched television, that when the time came to leave, I could rise from my chair decisively, retrieving my coat from the hook beside the door, and say, "With your permission, sir, I'll be off!" Leaving the house in this way I would feel serene as Çetin drove me home early, and I could even think not about Füsun, but about the next day's work.

A day or two following such a triumph, when I next went to their house for supper and saw Füsun, I would understand with great clarity two of the things that drew me there:

1. When I was far from Füsun, the world troubled me; it was a puzzle whose pieces were all out of place. The moment I saw her, they all fit back together, reminding me that the world was a beautiful, meaningful whole where I could relax.

2. Anytime I entered the house of an evening and our eyes met, it was like a conquest. In spite of everything, and no matter what had happened to dash my hopes and my pride, there was the glory of being here once more, and most of the time I saw the light of the same happiness in Füsun's eyes. Or so I would believe, and, convinced that my stubbornness, my resolve had made an impression on her, I would find my life's beauty was restored.

58

Tombala

I SPENT New Year's Eve 1976 playing tombala with the Keskins. Perhaps I remembered this now because I've just been speaking about the beauty I'd found in my life. But it is also important, because celebrating the New Year with the Keskins was proof that my life had changed irrevocably. Having broken off with Sibel, I had been obliged to stay away from our circle of mutual friends, and now, visiting the Keskins four or five times a week, I had mostly abandoned my old habits, but until that New Year's Eve, I would still have myself and those around me believe that I was continuing my old life, or at least that I could return to it whenever I chose.

As for the acquaintances I no longer saw—so as to keep a distance from Sibel, avoid upsetting people with bad memories, and save myself the bother of explaining why I'd disappeared—it was Zaim who kept me abreast of their news. Zaim and I would meet at Fuaye or Garaj or some other society restaurant that had just opened, and there we'd sit having long, pleasant conversations about life and what everyone was up to as intensely as two men discussing business.

Zaim had lost interest in his young girlfriend, Ayşe, who was the same age as Füsun. He told me she was too much of a child, and he couldn't relate to her troubles or anxieties, nor had she managed to fit in with our group; when I pressed him, he insisted that he had no other girlfriend, or even anyone he was interested in. From what he said, it was clear that Zaim and Ayşe had done no more than kiss, and that the girl would continue to be cautious and prudent so long as her uncertainty about Zaim persisted.

"Why are you smiling?" said Zaim.

"I'm not."

"Yes, you are," said Zaim. "But I don't mind. Let me tell you something you will enjoy even more. Nurcihan and Mehmet meet every day of the week without fail and go from restaurant to restaurant, club to

club. Mehmet even takes Nurcihan to *gazinos* and makes her listen to Ottoman music, all the old songs. They've made friends in these places with singers who used to sing on the radio and are now in their seventies and eighties."

"Are you serious? . . . I never saw Nurcihan as someone who would go for that sort of thing."

"All because she fell in love with Mehmet. Actually, Mehmet doesn't know much about these old singers either. He's trying to learn it all, just to impress Nurcihan. They go to the Sahaflar Market together to buy old books, and then they trot off to the flea market looking for old records. In the evenings they go to Maksim and the Bebek Gazino to listen to Müzeyyen Senar. But they never get around to listening to the records together."

"What do you mean?"

"Well, every evening they're out at the *gazinos*," Zaim said carefully. "But they never go anywhere to be alone and make love."

"How do you know that?"

"Where could they possibly go? Mehmet still lives with his parents."

"He used to have a place where he took women, in the backstreets of Maçka."

"He had me over there, for a whiskey," said Zaim. "It's a typical *garçonnière*. Nurcihan is too clever to go near that hideous place; she knows that if she did Mehmet would immediately see it as reason not to marry her. Even I felt strange there: The neighbors were peering through the peephole, to see if this guy had brought back another prostitute."

"So what should Mehmet do? Do you think it's easy for a single man to rent an apartment in this city?"

"They could go to the Hilton," said Zaim. "Or he could buy himself an apartment in a decent neighborhood."

"Mehmet loves living with his family."

"You do, too," said Zaim. "May I say something to you as a friend? But promise me you won't get angry."

"I won't get angry."

"Instead of meeting secretly at the office, as if you were doing something wrong, you should have taken Sibel to the Merhamet Apartments, where you took Füsun; then you two would still be together."

"Did Sibel say that?"

"No, my friend. Sibel doesn't talk about such things with just any-one," said Zaim. "Don't worry."

For a time we were silent. We'd been having so much fun gossiping, but then suddenly it upset me to have my life discussed as if I'd suf-fered some sort of catastrophe. Zaim noticed that my spirits had fallen, so he told me about how he'd run into Mehmet, Nurcihan, Tayfun, and Faruk the Mouse all sitting together at a soup shop in Beyoğlu late one night.

Zaim may have been recounting this in the hope of luring me back into my old life, but he also enjoyed reporting all the fun he was having; I listened to him go on in detail, often exaggerating, but I didn't pay it much mind until later in the evening, when I was at the Keskins' and I caught myself reflecting fondly on such outings. But let no one imagine that I was grieving my lost friends or my days of prowling the city. It was just that sometimes at the Keskins' dinner table it would suddenly seem to me that nothing was happening in the world, or if something was happening we were far away—that's all.

On the night we ushered in 1977 I must have succumbed to such a feeling, because I remember a point when I wondered what Zaim, Sibel, Mehmet, Tayfun, Faruk the Mouse, and all the rest were doing. (Zaim had installed electric heaters in his summer house and had dis-patched the caretaker to light a fire for a big party to which he had invited "everyone.")

"Look, Kemal, twenty-seven's come up, and you have one on your card!" said Füsun. When she saw I wasn't paying attention, she put a dried bean on the 27 on my tombala card, and smiled. "Stop messing around and play the game!" she said, for a moment looking into my eyes with concern, anxiety, and even tenderness.

It was for just this sort of attention from Füsun that I was going to the Keskin house. I felt an extraordinary happiness, but it hadn't been easy to achieve. Not wanting to upset my mother and my brother, I hid my plans for spending New Year's Eve at the Keskins' by eating supper at home with them. Afterward Osman's sons—my nephews—had cried, "Come on, Grandmother, let's play tombala!" so I was obliged to play a round with them. While we were all playing, I came eye to eye with Berrin, and perhaps she, too, was struck by the pretense of this

happy family tableau, because I remember that she raised her eye-
brows, as if to say, "Nothing wrong, I hope?"

"Nothing," I whispered. "We're having fun, can't you see?"

Later, rushing toward the door on the pretext of going to Zaim's
party, I caught another look from Berrin, who was not fooled. But I
didn't respond.

As Çetin rushed me over to the Keskin house, I was anxious but
happy. The first thing I did after running up the stairs and entering—
and, of course, savoring the joy of meeting Füsun's eyes—was to take
out from the plastic bag some of the presents my mother had prepared
for the tombala winners at our house, and to set them out at the end
of the table, crying, "For the tombala winners!" Aunt Nesibe, too,
had prepared her own little presents for tombala, just as my mother had
done every New Year's since I was a child, and we mingled her presents
with my mother's. The fun we had playing tombala that night would
be repeated every New Year's for the next eight years, and Aunt
Nesibe's presents would be thrown together with the ones I had
brought with me.

Here I display the tombala set that we used for eight consecutive
New Years at Füsun's house. For forty years, from the late 1950s to the
late 1990s, my mother used a similar set to amuse first my brother, my
cousins and me, and later, her grandchildren. When the New Year's
Eve party had come to an end, the game was over, the presents distrib-
uted, and the children and the neighbors had begun to yawn and doze
off, Aunt Nesibe, like my mother, would carefully gather up the pieces,
fill the velvet pouch bag, and count the numbered wooden tiles (there
were ninety in all). After also making a deck of all the numbered cards,
and tying it with a ribbon, she would collect the dried beans we'd used
to mark the numbers and put them into a plastic bag for the next New
Year's Eve.

Now, all these years later, as I undertake to explain my love as sin-
cerely as I can, explicating each object in turn, it seems to me that
tombala captures the strange and mysterious spirit of those days.
Invented in Naples, and still played by Italian families at Christmas, the
game passed, like so many other New Year's rituals and customs, from
the Italian and Levantine families of Istanbul into the general popula-

tion after Atatürk's calendar reform, in no time becoming a New Year's ritual.

Every year Aunt Nesibe would include among her presents a child's handkerchief. Was this to remind us of the old wisdom that "To play tombala on New Year's makes children happy, and so grown-ups should be mindful of being as happy as children on that evening"? When I was a child and an elderly guest won a present intended for a child, they would say without fail, "Oh, this is just the sort of handkerchief I needed!" My father and his friends would then wink at one another, suggesting there was a second meaning beyond our childish reach. Seeing them do this I would feel as if the grown-ups were not taking the game seriously with their sarcasm. In 1982, on a rainy New Year's Eve, when I managed to complete the top line of my tombala card first and cry "Chinko!" like a child, Aunt Nesibe said, "Congratulations, Kemal Bey," and handed me this handkerchief. And, yes, I said, "This is just the sort of handkerchief I needed!"

"It's one of Füsun's childhood handkerchiefs," said Aunt Nesibe, perfectly earnest.

My mother would include a few pairs of children's socks among the presents, as if to imply no lavish indulgence, only the furnishing of a few household essentials. Making the presents feel less like presents did allow us to see our socks, our handkerchiefs, the mortar we used for pounding walnuts in the kitchen, or a cheap comb from Alaaddin's as objects of greater value, if only for a short time. Over at the Keskin household, everyone, even the children, would rejoice not on account of winning socks, but because they had won the game. Now, years later, it seems to me that this was so because none of the Keskins' possessions belonged strictly to a particular family member, but, like this sock, to the entire household and the whole family, while I had always imagined a room upstairs that Füsun shared with her husband, and in it a wardrobe, with her own belongings; I had many tormented dreams about this room and her clothes and the other things in it.

It was on New Year's Eve 1980 that I brought a surprise tombala present—a memento of my grandfather, Ethem Kemal: the antique glass from which Füsun and I had drunk whiskey at our last rendezvous, on the day of my engagement. Beginning in 1979 the Keskins

had detected my habit of pocketing various belongings of theirs and replacing them with more valuable and expensive things, but like my love for Füsun, it was never discussed; so there was nothing remotely strange to them about a fancy glass such as one saw in Rafi Portakal's antique shop turning up among the pencils, socks, and bars of soap. What broke my heart was that when Tarık Bey won, and Aunt Nesibe produced the presents, Füsun did not even begin to recognize it as the crystal glass from the saddest day of our affair.

Every time Tarık Bey used it as his *rakı* glass over the three and a half years that followed, I would want to recall the happiness of the last time Füsun and I had made love, but like a child conditioned by some taboo to drive a certain thought from mind, I could not entertain this memory properly while sitting at the table with Tarık Bey.

The power of things inheres in the memories they gather up inside them, and also in the vicissitudes of our imagination, and our memory—of this there is no doubt. At some other time I would have had no interest in the bars of Edirne soap in this basket, and might even have found them tawdry, but having served as tombala presents on New Year's Eve, these soaps formed in the shape of apricots, quinces, grapes, and strawberries remind me of the slow and humble rhythm of the routines that ruled our lives. It is my devout, and uncalculating, belief that such sentiments belong not just to me, and that, seeing these objects, visitors to my museum many years later will know them, too.

With the same conviction, I display here a number of New Year's lottery tickets from the period. Like my mother, Aunt Nesibe would buy a ticket for the grand drawing on December 31, to serve as one of the tombala presents. To whomever won the ticket, the others at the Keskin table, as at our home, would say almost in unison: "Oh, look at that, you're lucky tonight. . . . You're sure to win the ticket for the grand drawing, too."

By some strange coincidence, Füsun won the lottery ticket every year between 1977 and 1984. But when the winning ticket was announced on the radio and television a short while later, by an equally strange coincidence, she never won a prize, not even a refund.

At our house as at the Keskin table, the old saw about poker, love, and life was oft repeated, especially when Tarık Bey was playing cards with guests.

"Unlucky at cards, lucky at love."

Everybody said it compulsively, and so in 1981, on New Year's Eve, after we had watched the live broadcast of the grand drawing, supervised by the First Notary Public of Ankara, after it was clear that Füsun had won nothing, I drunkenly, thoughtlessly, uttered it too.

"Seeing as you've lost the lottery, Miss Füsun," I said, imitating the English gentleman hero we watched on television, "you are bound to be a winner at love!"

"I have no doubt about *that,* Kemal Bey!" said Füsun, without missing a beat, just like the clever, elegant heroines of the same films.

Conservative newspapers like *Milli Gazete, Tercüman,* and *Hergün* were forever fulminating against New Year's Eve, which, thanks to tombala, the National Lottery, all this card playing, and the ubiquitous promotions for restaurants and nightclubs, was slowly turning into an orgy of drinking and gambling. When some rich Muslim families in Şişli and Nişantaşı began buying pine trees to decorate and display in windows the way Christians did in films, I remember that even my mother felt uneasy, but because these were people she knew, she refrained from calling them "degenerates" or "infidels" as the religious press would, dismissing them rather as "harebrained."

In the run-up to New Year's there would be thousands of vendors selling tickets for the National Lottery in the streets of Istanbul, and some would go dressed as Santa Claus into the wealthy neighborhoods. One evening in December 1980, when I was choosing what tombala presents to take to Füsun's house, I saw a small mixed group of lycée students deriding one such Santa Claus, pulling his beard of cotton wool and laughing. When I drew closer I saw that this man was the janitor of the apartment house across the street; as the teenagers tugged at his cotton wool mustache, Haydar Efendi stood there silently, holding his tickets, his eyes downcast. A few years later the conservatives' anger at the drinking and gambling during the celebration overflowed when Islamists set off a bomb in the Marmara Hotel on Taksim Square, in the patisserie that had been decorated for New Year's with an enormous pine tree. At the Keskin dinner table, I recall, the bombing was, of course, an urgent topic, but it was nothing compared to what happened to the belly dancer who was expected to appear on a New Year's Eve telecast. When Sertap, the most famous belly dancer of the day,

appeared on television in 1981 despite the angry diatribes in the conservative press, we were dumbfounded, along with almost everyone else in the country. The TRT management had draped the beautiful and curvaceous Sertap in so many layers that not only were her "world-famous" belly and breasts covered, but even her legs.

"They might as well have veiled her, the disgraceful buffoons!" said Tarık Bey. Actually he hardly ever got angry at the television, and no matter how much he'd had to drink, he never shouted at the screen the way the rest of us did when sufficiently annoyed.

For some years, I'd been buying a *Saatlı Maarif Takvimi,* the calendar indicating the prayer times, from Alaaddin's shop to take to Aunt Nesibe's as a tombala present. On New Year's Eve, 1981, it was Füsun who won it, and at my insistence she tacked it on the wall between the television and the kitchen, but no one would pay attention to the pages on days when I wasn't there, despite there being a poem of the day, a daily note about the historical events whose anniversary it was, and a picture of a clock face, so that those who could not read and write might know the prayer times, as well as recommended recipes, historical anecdotes, and a bit of wisdom.

"Aunt Nesibe, you've forgotten to pull the page off the calendar again," I would say at the end of the evening, when the soldiers would be saluting the flag as they goose-stepped across the screen, and we would have polished off a lot of *rakı.*

"Another day is over," Tarık Bey would say. "Thank God we are not hungry or without shelter, that our stomachs are full, that we are sitting in a warm house—what more could a person want in life?"

For some reason it lifted my heart to hear Tarık Bey say these homely words as the evening wound down, and so—even though I'd noticed on my arrival that they'd forgotten to pull the page off the calendar—I would omit to mention it until the moment I was about to leave, when I was ready to hear this thanksgiving.

"The most important thing is that we're here all together, with our loved ones," Aunt Nesibe would add. As she said this, she would lean over to kiss Füsun, and if Füsun was not at her side, she would call out, "Come here, my little storm cloud, so that I can give you a kiss."

Sometimes Füsun would assume a little girl's expression and sit on

her mother's lap, allowing Aunt Nesibe to spend a long time caressing her, kissing her arms, her neck, her cheeks. No matter how mother and daughter were getting along, they kept up this ritual through the eight years. As they laughed and kissed and hugged, Füsun knew full well that I was watching her, but she never looked back at me directly.

There were times, too, when, after Aunt Nesibe pronounced her wisdom about "loved ones," Füsun would not go to her mother's lap, but instead would take a neighbor's child, a fast-growing boy called Ali, onto her lap, and after caressing him and showering him with kisses, she would say, "Time for you to go home now, or else your parents will get angry at us for keeping you." Finally, there were the occasions when Füsun was in a bad mood, because she and her mother had argued that morning, and at Aunt Nesibe's plea, "Come over here, my girl," she would say, "Oh, Mother, please!" leaving Aunt Nesibe to say, "Then at least pull the page off the calendar, so we don't get our days confused."

This would leave Füsun all smiles suddenly, and after getting up to pull the page off the *Saath Maarif Takvimi*, she would read out the day's poem and the recipe in a loud semitheatrical voice and laugh. Aunt Nesibe would comment, "Oh, what a good idea, let's make quince and raisin compote, it's been ages," or, "Yes, they're suggesting artichokes, but you can't pick artichokes when they're still small enough to fit in the palm of your hand." Sometimes she would ask a question that unsettled me: "If I made a spinach pastry, would you eat it?"

If Tarık Bey didn't hear her or was too gloomy to answer, then Füsun would turn to scrutinize me in silence, with a sadistic curiosity based on the expectation that I would not dare presume the prerogative of a full member of the family by telling Aunt Nesibe what to cook.

I knew how to rescue myself from this difficult bind, saying, "Füsun loves savory pastries, Aunt Nesibe, so you should definitely make it!"

Sometimes Tarık Bey would ask his daughter about the important historical dates on the page she'd torn off the *Saath Maarif Takvimi*, and she'd read aloud: "On September 3, 1658, the Ottoman army began its siege of Doppio Castle." Or "On August 26, 1071, after the Battle of Malazgirt, Anatolia opened its doors to the Turks."

"Hmmmm, let's have a look at that," Tarık Bey would say. "They've misspelled 'Doppio.' Here, take it back, and read us the saying of the day."

"Home is where the heart is, and where we fill our stomachs," Füsun said, reading in a mocking voice until our eyes met and she turned serious.

Suddenly we all fell silent, as if each was pondering the deeper meaning of those words. After Füsun had finished reading and had put the leaf from the calendar to one side, I picked it up, pretending I wanted to read it for myself, and when no one was looking, I put it into my pocket.

Of course, the pilfering wasn't always so easy, but I have no wish to make myself more risible by going into the full details of my difficulties in acquiring so many objects of such varying size and preciousness from the Keskin household. Let an example from the end of New Year's Eve 1982 suffice: Before I left the house with the little handkerchief I'd won at tombala, little Ali, the neighbor's boy, who grew more in awe of Füsun with every day, came up to me and in a manner quite unlike his usual naughty self he said, "Kemal Bey, you know that handkerchief you won . . ."

"Yes?"

"That's Füsun's hankie from when she was a child. May I see it again?"

"Oh, I have no idea where I put it, Ali, my boy."

"But I know," the brat replied. "You put it in this pocket, so it must be there."

He almost managed to invade my pocket with his hand, but I took a step backward. The rain was pelting down outside, and everyone had gathered at the window, so no one else heard what the child said.

"Ali, my boy, it's getting very late, and you're still here," I said. "Your parents will blame us."

"I'm going, Kemal Bey. But are you going to give me Füsun's hankie?"

"No," I whispered with a frown. "I need it."

59

Getting Past the Censors

I'd known for years, from the stories in the news, that all films, domestic and foreign, had to clear the state censors before theatrical release, but before setting up Lemon Films I had no notion of their power in the film business. The papers mentioned the censors only when they banned films much esteemed in the West, as with *Lawrence of Arabia,* categorically banned for insulting Turkishness, and *Last Tango in Paris,* trimmed of its sex scenes to make the film more artistic, and more boring than the original.

There was one partner of the Pelür Bar who'd been working at the board of censors for many years; Hayal Hayati Bey was a frequent visitor to our table, and one evening he told us that, actually, he believed in democracy and freedom of expression more fervently than any European, but that he could not allow those who would deceive our innocent and well-meaning nation to exploit the cinematic arts toward that foul end. Like so many other Pelür habitués, Hayal Hayati also worked as a director and a producer, and said he'd accepted the board position so as "to drive the others crazy!"—a claim he punctuated as he did every joke, by giving Füsun a wink. Hayal Hayati got his nickname (meaning "Dream") from the Pelür crowd because he used that term so often when making his rounds of the tables, talking about the films he was going to make. Every time he came to ours he would look soulfully into Füsun's eyes, and he would tell her about one of his dream films, asking her each time for an "immediate and sincere" appraisal devoid of "commercial considerations."

"That's a beautiful idea for a film," Füsun would say each time.

"When we make it you're going to have to agree to star in it," Hayal Hayati would reply, in the manner of a man who always acted instinctively and from the heart. We were discovering that it would take some time for us to get our first film off the ground.

According to Hayal Hayati, the Turkish film industry was free to do more or less what it liked, provided that films did not include lewdness or sex scenes, or unacceptable interpretations of Islam, Atatürk, the Turkish army, the president, religious figures, Kurds, Armenians, Jews, or Greeks. Of course, he'd smile when he said it, because for half a century the members of the board of censors did not just obey the dictates of the state, banning any subject that made those in power uneasy, but had gotten into the habit of acting on their own agendas, banning whatever happened to annoy or offend them, and like Hayal Hayati, deriving considerable pleasure when using their power arbitrarily.

Hayati Bey told stories about the films he had banned during his time on the board with the relish of a hunter bragging of the bears he'd caught in his traps. We laughed at his stories as much as anyone. For example, he'd banned one film about the adventures of a hapless security guard on the grounds that it "degraded Turkish security guards"; and a film about a wife and mother falling in love with another man because it "insulted the institution of motherhood"; and a film about the happy adventures of a little truant was prohibited for "alienating children from school." Unfortunately the first film Hayati Bey made after his term on the board ended was itself also banned, "and, sadly, it was a capricious decision motivated by personal matters." Hayati Bey would get very angry whenever it was mentioned. The film, which had been very costly to make, was banned in its entirety on account of a dinner scene in which a man became enraged at the family dinner table because there was no vinegar in the salad, and the censors felt called to "protect the family, the foundation of society."

As he sat with us explaining how this scene and two other family quarrels, likewise offensive to the censors, had been taken in all innocence from his own life, it became clear that what had really upset Hayal Hayati was being betrayed by his old friends at the board of censors when they banned his film. If we were to believe what we were told, one night he'd gone out on a bender with them and ended up brawling in an alleyway with his oldest friend on the board, ostensibly over a girl. When the police picked them up off the muddy street and carted them to Beyoğlu Police Station, neither lodged a complaint, and so were encouraged by the police to kiss and make up. But subsequently, to win approval for theatrical release and save himself from

bankruptcy, Hayal Hayati, having still influence enough to win a second consideration, was obliged to remove every quarrel remotely demeaning to the institution of the family, with the exception of the one in which the brute of a son beat up his younger sister at the behest of his devout mother; with this editing, the film passed the board of censors.

Hayal Hayati remained convinced that it was "a relatively good thing in the end" if censorship led only to the cutting of scenes deemed objectionable by the state. For even a heavily cut film could be shown in the cinema, and if it still made sense, then you could make back your investment. The worst possible outcome was an outright ban. To prevent this disaster, the state was prevailed upon kindly to divide the censorship process into two stages.

In this first phase one would send the screenplay to the board for approval of the subject and the content of the scenes. As was typical of all situations involving work for which citizens had to seek "permission" from the state, a complex bureaucracy of permits and bribery had developed, which in turn gave rise to a network of agents and agencies offering to guide a citizen's application. I myself recall many times during the spring of 1977, sitting across from Feridun in the offices of Lemon Films, smoking cigarettes as we considered at length which agent was right for *Blue Rain*.

There was a hardworking, well-liked Istanbul Greek known as Daktilo Demir, or Demir the Typewriter. His manner of inoculating a screenplay so as not to offend the censors was to rewrite it, on his own famous typewriter, and in his own style. This hulk of a man, a former boxer (he'd once worn the uniform of the Kurtuluş team), was in fact a very refined man possessed of an elegant soul. He knew better than anyone how to make a script acceptable, rounding off its sharp corners, softening into innocence the harsh divisions between rich and poor, worker and boss, rapist and victim, virtue and evil, and offsetting the effect of any harsh or critical pronouncement that the hero might make at the end of the film—words likely to offend the censors but delight the audience—by the addition of a few bromides about the flag, the nation, Atatürk, and Allah. His greatest gift was his flair for taking the sting out of the most vulgar and extreme moments in the screenplay: He would always find a light and witty way of returning it to the innocent charm of everyday life. Even the big firms that gave regu-

lar bribes to the board of censors would entrust their screenplays to Daktilo Demir, even in the absence of unsuitable material, just so that he could inject into them the sweet aura of childish magic that was his trademark.

When we discovered how much we owed to Daktilo Demir for the most lyrical moments in those films that had so affected us the previous summer, the three of us—Feridun thought Füsun should come, too—decided to pay a call on the "Screenplay Doctor's" home in Kurtuluş. In a room filled with the ticking of an enormous wall clock, we saw the old Remington on which he had earned his legendary name, and we felt the same distinct magical aura as in the films he'd rewritten. Demir Bey welcomed us graciously, saying that he would be delighted if we left our screenplay with him, so that if he liked it he could recast it on his typewriter into a version sure to pass the censors. Showing us the stack of project files between the plates of kebab and fruit he had set out, he went on to disclose that the process would not be quick considering his vast workload; gesturing at his twenty-something twin daughters, sitting at the end of the enormous dining table, gazing myopically through their owlish glasses at the screenplays their father couldn't find time for, he allowed, with paternal pride, that they had become "even better" than he was at getting scripts into shape. Füsun was very pleased when the more buxom of the twins remembered her as one of the finalists in the Milliyet National Beauty Contest from years earlier. What a shame it was that so few others did.

The same girl would deliver us back the screenplay, rewritten and polished specially for Füsun, and accompanied by kind words of admiration ("My father says this is a real European art film"), but by then three more months had passed. Füsun met the delay with pouts and occasionally cross words, compelling me to remind her that her husband's work had been just as slow.

Few opportunities to speak to Füsun privately, away from the table, occurred during my evening visits to Çukurcuma. But toward the end of each evening we would go together to Lemon's cage to make sure the bird had enough food and water and some squid cartilage to peck on (I bought this in the Mısır Çarşısı, or Spice Bazaar). But this was hardly ideal, and we had to whisper.

From time to time an easier opportunity would present itself: When

she wasn't spending time with the neighborhood friends she hid from me (mostly unmarried girls or newlyweds), or going with Feridun to film haunts, or doing the housework, or helping her mother with the sewing work Aunt Nesibe still took in, she would go by herself to paint birds. She put it so prosaically, but I sensed the passion behind this amateur's nonchalance, and her paintings made me love her all the more.

This hobby began when a crow landed on the ironwork balcony of the back room on the lower floor, a crow just like those that had landed on the balcony in the Merhamet Apartments: When Füsun approached it, the bird had not flown away. The crow returned on other occasions, and again instead of flying off it just sat there, staring at Füsun from the corners of its bright, scary eyes to the point of intimidating her. One day Feridun took a picture of the crow, a small black-and-white photograph I display here, which Füsun had enlarged for use as her model for a painstaking watercolor that I liked very much. She continued with a pigeon that came to perch on the same iron balcony, and then a sparrow.

On nights when Feridun was not at home, before supper or during a long commercial break, I would ask Füsun, "How's your painting coming along?"

If she was in a good mood, she'd say, "Let's go and have a look at it," and we would go into the back room, which would be strewn with Aunt Nesibe's sewing things, her cloth, and her scissors, and in the pale light of the chandelier we would study the picture together.

"It's truly beautiful, very beautiful," I'd say. My words were no less sincere for the unbearable longing I felt to touch her back, or just her hand. I'd been buying gorgeous "European-made" paper, notebooks, and watercolor sets from a stationery store in Sirkeci as offerings to her.

"I'm going to paint all the birds of Istanbul," Füsun would say. "Feridun's taken a picture of a sparrow. That's next. I'm just doing this for myself, you know. Do you think an owl might ever perch on the balcony?"

"You should definitely mount an exhibition someday," I said once.

"Actually, what I'd like to do is go to Paris and look at the pictures in the museums there," said Füsun.

Sometimes she was irritable and downcast. "I haven't been able to paint for the last few days, Kemal," she'd say.

It was always clear that her low spirits were owing to the film's delay: Not only had we failed to start filming; we'd not even managed to get an acceptable screenplay. Sometimes, having added almost nothing to a picture since the last viewing, Füsun would lead me into the back room to talk about the film.

"Feridun is so unhappy with Daktilo Demir's rewrite, he's doing it all over," she said one night. "I told him myself, but you have to tell him, too: He can't take too long on this. We just have to get this film of mine started."

"I'll tell him."

Three weeks later we had again gone into the back room. Füsun had finished her crow and was now slowly painting the sparrow.

"It's really coming along," I said after admiring it for a long time.

"Kemal, I finally realize that it's going to be months before we can start shooting Feridun's art film," said Füsun. "The censors don't just wave that sort of film through; they're slow and suspicious. The other day at the Pelür, Muzaffer Bey offered me a role. Did Feridun tell you?"

"No. So you've been going to the Pelür? Be careful, Füsun, those men are wolves, every last one of them."

"Don't worry, Feridun is careful about that, we both are. But this is a very serious offer."

"Have you read the screenplay? Is this really something you want?"

"Of course I haven't read the screenplay. If I agree, they'll have a screenplay written for me. They want to meet me."

"What's the plot?"

"What difference does that make, Kemal? We're talking about one of Muzaffer's romantic melodramas. I'm thinking of accepting."

"Don't rush into this, Füsun. These are bad people. Feridun should go talk to them for you. They could have evil intentions."

"What sort of evil intentions?"

I didn't want to continue this conversation; I went back to the table.

I could easily imagine a skilled director like Muzaffer Bey using Füsun as the main attraction in a commercial melodrama and making her famous from Edirne to Diyarbakır. With her beauty and kindness, she was sure to enchant audiences—the truants, the unemployed, the

60

Evenings on the Bosphorus, at the Huzur Restaurant

SOMETIMES THE things we were obliged to do to keep Füsun away from the wolves and jackals besieging her on our every visit to the Pelür were less a source of distress than of mirth and even of moral uplift. When, for instance, we had heard that the White Carnation, the gossip columnist readers will remember from my engagement party at the Hilton, planned to write a piece about Füsun, in the "a star is born" genre, we concocted copious evidence of what a cad he was, and so she conspired with us to avoid him like a leper. When a journalist and self-described poet sat down at our table to inscribe a poem that had welled up from his innermost parts, and sweetly dedicated the inspiration to Füsun, I managed to ensure the timeless ode would not outlive that moment or have a single other reader by furtively instructing the elderly waiter Tayyar to toss it in the trash. Later, when Feridun, Füsun, and I would find ourselves alone after such episodes, we would merrily compare notes, and, although each of us withheld details according to his or her purposes, we would laugh in genuine complicity.

After a few drinks, most of the film people and journalists and artists who frequented bars and taverns like the Pelür were given to weepy self-pity, but after only two drinks Füsun would become as cheerful as a child, as chirpy as a flighty girl, and on our visits to summer cinemas and Bosphorus restaurants, I sometimes imagined that the reason for her happiness was that the three of us were together. Having long tired of all the gossip and wisecracks at the Pelür, I now seldom went there, and when I did it was to spy on those surrounding Füsun, and if possible, before the evening's end, to extract Füsun and Feridun from the bar to drive with Çetin on a dinner excursion to the Bosphorus. Füsun would sulk over leaving the Pelür early, but once in the car she'd have such a good time chatting with Çetin and the rest of

daydreaming housewives, and the sex-starved single men—who packed into the airless cinemas that stank of the coal stoves heating them. It was not long before it occurred to me that if her dream came true and she became a star, she would take to abusing not just me but Feridun, too, possibly even leaving us both. I couldn't bear to imagine her as the sort of woman who would ruthlessly manipulate magazine writers in pursuit of fame and fortune. But in the looks of the Pelür crowd, I saw a lot of people who would do anything to part "us"—and I use that word because it was the first to enter my mind. If Füsun became a famous film star, it would only magnify my love for her, and with it my fear of losing her.

Füsun's cross looks persisted to the end of the meal, and knowing my lovely was thinking not about me or even her husband, I became anxious, then frantic. I had long since calculated that if Füsun were to run off with some director or famous actor she met at one of these bars, abandoning me and her husband, my pain would be astronomically greater than anything I'd suffered in the summer of 1975.

How much did Feridun understand the danger besetting us both? He must have been at least vaguely aware of the commercial producers plotting to carry her off to a distant, depraved world, the hazards of which I was at pains to remind him—in veiled language—while hinting that the art film would cease to have meaning for me were Füsun to degrade herself by playing in some dreadful melodrama. Back at home, drinking *rakı* alone, in my father's chair, I would wonder anxiously whether I had revealed too much.

At the beginning of May, as outdoor weather and the filming season approached, Hayal Hayati came to Lemon Films to tell us that a semi-famous young actress lay in the hospital following a beating at the hands of her lover, and that this unfortunate development also proposed a wonderful opportunity for a beautiful and cultivated girl like Füsun, but Feridun, now well aware of my misgivings, courteously declined the offer, and I don't think he ever even mentioned it to Füsun.

us that I'd decide, just as I had in the summer of 1976, that going out to eat together more often would do us all good. But first I had to persuade Feridun. It was out of the question for Füsun and me to go gallivanting to any restaurant on our own, like lovers. As Feridun resisted being dragged away from his film friends, I enlisted Aunt Nesibe to join the party and prevail on Füsun and her husband to come eat fish at Urcan in Sariyer.

In the summer of 1977 we cajoled Tarık Bey into joining us as well, and as he warmed to the idea, the entire team of television-watching Keskins would head out to eat on the Bosphorus, with Çetin at the wheel. I would like every visitor to our museum to find these outings as pleasant as I did, so I shall go into some detail here. After all, isn't the purpose of the novel, or of a museum, for that matter, to relate our memories with such sincerity as to transform individual happiness into a happiness all can share? That summer these excursions to the *meyhane*s of the Bosphorus fast became a custom we all relished. In the years that followed, whether it was winter or summer, we would, at least once a month, get into the car, as excited as wedding guests, and go off to a restaurant or one of the large, famous *gazino*s, to listen to the melodies and aged crooners that Tarık Bey enjoyed so much. There were, of course, intervals when we'd fail to relish our pleasures—moments of tension or confusion between me and Füsun, anxiety that our film work would never begin—and these joyless spells would last for months until unexpectedly we would be driving around in the car together, and we would notice how delighted we actually were to be together, how close we had become and how much we loved each other.

In those days, the most popular place along the Bosphorus was Tarabya, with its line of crowded restaurants spilling across the sidewalks, and the tombala men wandering among the tables, along with the mussel vendors, the fresh almond vendors, the photographers who took your picture and brought back the developed shots within the hour, the ice cream men, the bands of musicians playing Ottoman music and the traditional singers who performed in most of the restaurants. (Back then you wouldn't see a single tourist.) I remember how Aunt Nesibe laughed admiringly at the speed and daring of the waiters as they darted across the narrow road that divided the restaurants from

the tables, weaving their way through the traffic with their heavy trays laden with food.

On our first excursion together we went to a relatively modest restaurant called Huzur (peace), which happened to have a free table, and which Tarık Bey had instantly taken to, because of its proximity to the flashy Mücevher Gazino next door, which meant that one could sit in the restaurant and hear the old Turkish songs being sung "from a distance and for free." The next time, when I proposed that we could better hear the singers if we were actually sitting in the Mücevher itself, Tarık Bey said, "Oh no, Kemal Bey! Why pay to hear that awful band, and that woman who sounds like a crow?" but for the rest of the meal, he gave all his attention, sometimes joyful and sometimes angry, to the music blaring from the *gazino.* He would correct the "tuneless, tone-deaf" singers in a loud voice, and finish their lines before they could, just to prove he knew the lyrics, and after the third glass of *rakı* he would close his eyes and his head would sway to the music with deep spiritual rapture.

On our Bosphorus excursions from the house in Çukurcuma, to some extent we threw off the roles we played indoors, and that made me relish our trips. Füsun would sit right next to me in the car and at the restaurant, as she never did at the house. And as we sat surrounded by tables, no one noticed if my arm pressed up against her, and as her father listened to the music with his eyes shut and her mother watched the shimmering lights of the Bosphorus in the vaporous darkness, we would whisper to each other over the din, chatting about it didn't matter what—the food, the beauty of the evening, how endearing her father was—as tentatively as two bashful young people who had just met and only recently discovered how a boy might flirt with a girl, or form a relationship with her, as they did in Europe. Füsun was otherwise liberated, too; while ordinarily averse to smoking in front of her father, in Bosphorus restaurants she would puff away on her cigarettes like some formidable European career woman. I remember once, having decided to try our luck, we bought a ticket from a rascally tombala man in dark glasses, and when we didn't win a prize, we glanced at each other and both said, "Unlucky at cards . . . ," inducing in both of us a terrible embarrassment and then elation.

Much as this happiness derived simply from being out of the house,

and the twin joys (extolled by many an Ottoman court poet) of drinking wine and sitting beside one's beloved, there was also the diversion of the street crowds, as traffic jams on the road between the restaurants and the tables provoked quarrels between the people at the tables and the people in the cars: "Why don't you look at the road instead of the girl," someone would say, or "Why did you flick your cigarette at me?" As the evening progressed, drunken revelers would begin to sing, and tables would exchange applause and lusty cries. Suddenly a besequined "oriental" dancer would dash from one restaurant to the next, on her way to do a show, and as her costume and bronzed skin caught the car lights, drivers would lean ecstatically on their horns, like ships blowing their whistles on November 10 to mark the moment of Atatürk's death. On a warm night the wind might suddenly change direction, and all at once the dust and dirt overlaying the rubbish strewn on the cobblestone sidewalk along the shore—the nuts and shells and watermelon rinds and wastepaper and newspapers and soda caps and corncobs and seagull and pigeon droppings and plastic bags—would come to life, and all at once the trees across the street would begin to rustle, and Aunt Nesibe would say, "Beware, the dust has kicked up, children, don't let it get on your food!" and she'd shield the plates with her hands. Then the wind would suddenly change direction again and rush in from the northeast, bringing us cool air that smelled of iodine.

Toward the end of the evening, when people started arguing with the waiters, challenging their bills, and there was singing at every table, Füsun and I would press our arms and legs and hands together even closer, so close sometimes that I thought I would faint. Sometimes in such happiness I couldn't resist stopping a photographer to have him take our picture, or a gypsy woman to tell our fortune as if we had only just met. As I sat there pressed against Füsun, I would imagine the day we married, I would gaze at the moon and lose myself in dreams, but no sooner had I drunk another *rakı* on the rocks than I would notice that I had grown hard just as in a dream, but now trembling with pleasure I would not panic, for I felt as if I—we—had become like our ancestors in heaven, souls cleansed of guilt and sin, and I would abandon myself to my dreams, my delights, and the bliss of sitting next to Füsun.

I cannot say why we were able to get so much closer outside the

house, in the middle of a crowd and under the nose of her parents, than we could at the house in Çukurcuma. But it was during those evenings that I was able to imagine us as a couple living in harmony, and to see that—in the parlance of magazine writers—we "looked good together." It was not pure imagining. I remember with utter contentment how once, as we were talking, she asked, "Would you like a taste of this?" and with my fork I sampled the little dark meatballs on her plate, and how, on another evening, again at her encouragement, I tasted her olives, whose pits I display here. On another evening we turned our chairs around to have a long and friendly conversation with a young couple at the next table (to whom we were attracted, I believe, because they resembled us: the man in his thirties with brown hair, the girl twenty, dark-haired, and fair-skinned).

At the end of that same evening I ran into Nurcihan and Mehmet, coming out of Mücevher Gazino, and without mention of our mutual friends we at once launched into a serious discussion of "which Bosphorus ice cream parlors still open at this hour" was best. As I said my good-nights, I pointed in the direction of Füsun, now getting into the Chevrolet with her mother and father, for whom Çetin held the door, and I said that I had taken some distant relatives out for a tour of the Bosphorus. Let me take this opportunity to remind those who visit my museum in later years that during the fifties and sixties there were very few private cars, and that those rich enough to import cars from America and Europe often took their relatives and acquaintances on tours of the city. (When I was a child, I remember my mother sometimes turning to my father to say, "Saadet Hanım wants to go out in the car with her husband and children. Would you like to come, too, or shall I just take them out with Çetin?" Sometimes she would just say "the chauffeur." My father's stock response was, "God no! You can take them out. I'm busy.")

On our way back in the car we were in the habit of singing all together, and it was always Tarık Bey who got us started. First he would hum an old tune, and as he tried to remember the words, he'd ask for the radio to be turned on, and as I searched for a familiar song he would begin to sing some old melody that had drifted over to us from the Mücevher Gazino that evening. Sometimes, as I was searching for a station, we would hear voices from distant countries speaking in strange

tongues, and for a moment we would be silent. "Radio Moscow," Tarık Bey would say then, in an enigmatic tone. Then as it came back to him, he would sing the first words of a song, and before long Aunt Nesibe and Füsun would join him. As we sped under the dark shadows and great plane trees of the Bosphorus road, I listened to the concert in the backseat, and, turning around, I would try to harmonize as they sang "Old Friends" by Gültekin Çeki, though—to my embarrassment—some of the words eluded me.

Whenever we were singing together in the car, or laughing and dining together in a Bosphorus restaurant, the happiest among us was in fact Füsun, and yet whenever a chance presented itself she still yearned to see her film friends from the Pelür. For this reason I would continue to depend first on persuading Aunt Nesibe. For her part she never wanted to miss an opportunity to throw Füsun and me together. Another ploy was to entice Feridun, once even including Yani, a cameraman friend that Feridun was loath to leave behind. Feridun was using the Lemon Film facilities to make a few commercials with Yani, and I didn't object, thinking it prudent to let them make a little money, though I did sometimes ask myself how I would manage to see Füsun if one day Feridun actually made a lot of money, and moved out of his in-laws' house, and went off with his wife to live elsewhere. Sometimes I would realize with shame that this consideration underpinned my desire to get along with Feridun.

Aunt Nesibe and Tarık Bey did not come with us to Tarabya that night, so there was no listening to the singers in the *gazino* next door, and no singing on the way home. Füsun sat next to her husband, not me, and immersed herself in film world gossip.

It was the memory of that miserable evening that prompted me, on another occasion, when I was leaving the Pelür with Füsun and Feridun, to tell a friend of Feridun's that there was no room in the car, as we would be picking up Füsun's parents for dinner. I may have phrased it a bit brusquely. The man had a large, handsome forehead; I saw surprise, even fury, in his dark green eyes, but I swept him from my mind. Afterward, having arrived in Çukurcuma, I was able to bring Aunt Nesibe and Tarık Bey around to the idea, with a few words and a little help from Füsun, and then off we went to the Huzur Restaurant in Tarabya.

We had been sitting there eating and drinking for some time, I remember, when I realized there was not peace at that table, for Füsun's tense demeanor had set the tone for the evening, which would bring me no pleasure. I had just turned around to see whether there might be any tombala men to amuse us, or hawkers of fresh shelled walnuts, when I saw the man with the dark green eyes sitting two tables away. He was with a friend, watching us as he drank. Feridun noticed that I'd seen them.

"Your friend must have jumped into a car and followed us," I said.

"Tahir Tan is not my friend," said Feridun.

"Isn't he the man who asked to come with us as we were leaving the Pelür?"

"Yes, but he's not my friend. He poses for Turkish *photoroman*s, and he plays in blood-and-thunder films. I don't like him."

"Why has he followed us?"

For a moment no one spoke. Füsun, sitting next to Feridun, had heard what we'd said and was growing uneasy. Tarık Bey was lost to the music, but Aunt Nesibe had been listening to us, too. Just then I guessed from Feridun's and Füsun's expressions that the man was approaching us, so I turned around.

"Do excuse me, Kemal Bey," Tahir Tan said to me. "I did not mean to disturb you. I wish to speak to Füsun's mother and father."

He assumed the demeanor of a handsome, well-mannered youth who has seen a girl he likes at an officer's wedding, and who has come to ask her parents for permission before inviting her to dance, following the advice given in newspaper etiquette columns.

"Excuse me, sir, there is something I want to discuss with you," he said as he approached Tarık Bey. "There's a film that Füsun . . ."

"Tarık, look, the man is trying to tell you something," said Aunt Nesibe.

"I'm addressing you, too, madam. You're Füsun's mother, are you not? And you, sir, are her father. Do you know about this? Sir, there are two important producers, Muzaffer Bey and Hayal Hayati—both prominent figures in the Turkish film industry—who have offered your daughter important roles. But we have been given to understand that you would not give your consent because the films included kissing scenes."

"It's nothing like that," Feridun said coldly.

As always in Tarabya, the noise level was very high. Tarık Bey had either not heard, or else—like so many Turkish fathers who find themselves in this situation—acted as if he hadn't.

"Nothing like what?" Tahir Tan said, his voice rough now.

It was clear to all of us that he'd had a lot to drink and was spoiling for a fight.

"Tahir Bey," Feridun said carefully, "we're out for a family dinner this evening, and we have no desire to discuss film business."

"But I do. . . . Füsun Hanım, why are you so afraid? Can't you just say you want a role in this film?"

Füsun looked away. She was smoking calmly and taking her time. I stood up. Feridun did likewise. We both stepped into the space between the man and the table. At the tables surrounding ours, heads began to turn in our direction. We must have assumed the fighting cock stance that Turkish men assume before a fight. No one wanted to miss the drama; all around us, curious, bored drunks settled in for a good show. Tahir's friend rose from their table to approach us.

An elderly waiter who'd seen many years of bar brawls intervened. "Come on now, gentlemen, let's not all crowd in here. Please move back." He added, "We've all had a lot to drink, and tempers will flare. Kemal Bey, we're bringing out your fried mussels and salted fish."

Lest they misunderstand, let me inform visitors who come to our museum centuries hence—those happy generations of the future— that in those days Turkish men seized even the tiniest excuse to come to blows wheresoever they found themselves—be it a coffeehouse, a hospital queue, a traffic jam, or a football match, and that huge dishonor attached even to the appearance of shrinking away from a confrontation. Avoiding a fight or cowering was regarded as dishonor without degree.

Tahir's friend came from behind and put his hand on Tahir's shoulder; he took him away, making as if he wanted them to "be the ones who kept their dignity." And Feridun took *me* by the shoulder, as if to say, "What's the use, anyway?" and he sat me down. I was very grateful to him for doing this.

As the north wind blew, and a ship's searchlight swept through the night, lighting up the choppy waves, Füsun carried on smoking, as if

nothing had happened. I looked into her eyes for the longest time, and not once did she look away. There was something challenging, almost haughty, about the way she looked at me; I was suddenly aware that the change she had undergone over the past two years was far bigger and more dangerous than this little trouble we'd had with some drunken actor—and so were her expectations.

Tarık Bey added his voice to the song floating over from the Mücevher Gazino, slowly swaying his head and his *rakı* glass as he intoned Selahattin Pınar's "Why Did I Ever Love That Cruel Woman." We all joined in, knowing that to share the sorrow of the song would do us all some good. Much later, around midnight, while driving home, singing all together in the car, singing still, it seemed as if we'd utterly forgotten the unpleasant incident.

61

To Look

BUT I had not forgotten Füsun's treachery. It was clear that having noticed her at the Pelür, Tahir Tan was besotted with her and had persuaded Hayal Hayati and Muzaffer Bey to offer her film roles. Or, even likelier, having noticed Tahir Tan's interest in Füsun, Hayal Hayati and Muzaffer Bey had offered her roles. After Tahir Tan had backed off, Füsun, acting like a cat that had just tipped over a bowl of milk, confessed that she had, at the very least, encouraged them.

After that night at the Huzur Restaurant in Tarabya in the summer of 1977, Füsun was banned from all the film world's Beyoğlu haunts, and most particularly the Pelür; and her resentment of this regime, whether imposed by her husband, her father, or both, precipitated a sullen fury when I next visited.

Afterward, at the Lemon Films offices, Feridun clarified that Aunt Nesibe and Tarık Bey both had been frightened by the episode. And so not only was the Pelür off limits; for a time they'd even restricted her contacts with her neighborhood friends. She could not go out without

asking her mother's permission, as if still unmarried. Feridun tried to soften Füsun's anger over this draconian but short-lived imprisonment by promising that he, too, would stay away from the Pelür. But it was clear to us that getting the art film under way was our only hope of restoring her spirits.

The film, however, was still in no fit state to pass the board of censors, and neither did it seem to me that Feridun could remedy the situation any time soon. In the back room, where she had now begun a painting of a seagull, Füsun revealed to me that she was perfectly and painfully aware of this fact, and I was sad for her, and yet the spectacle of her willfulness moved me to ask only rarely how her painting was going. It was only if I happened to spy her in a good mood, and thus felt certain our conversation would be of painting seagulls, that I followed her into the back.

Most of the time I would arrive to find a listless Füsun and sit down to feel her angry eyes on me. Sometimes she seemed convinced of being able to communicate in eloquent detail through looks alone, and she would fix me in a very particular way that I could only begin to decipher. Even if we'd spent four or five minutes in the back room, gazing at the painting, most of the evening would be devoted to those looks, and my efforts to make sense of them, to figure out what she thought of me, her life, and her feelings. I had once been quite disdainful of such games, but now I had given myself over to the subtleties of nonverbal communication, and before long, had become a very skilled practitioner.

As a young man, out with my friends at the cinema or sitting with them at a restaurant, in springtime on the top deck of a ferry, headed for the islands, I remember whenever one of us said, "Hey, look, those girls over there are staring at us," while the others became eager I was suspiciously indifferent, knowing that, in fact, girls only rarely dared to glance at men in crowded places, and if they happened to come eye to eye with a man, they would look away immediately, as one might avert one's eyes from the sun, never to cast their eyes again in that direction. During those first months after I'd begun to visit the Keskin household at suppertime, if we were all sitting at the table watching television and at some unexpected moment our eyes met, it was that very sort of aborted look Füsun gave me. It was, I thought, the way a Turkish girl

might encounter a stranger in the street, and I didn't like it. Later I began to see this as Füsun's effort to provoke me, but at the time I was still new to the art of exchanging glances.

In the old days, even in Beyoğlu, regardless of whether her head was covered or not, a woman walking in the streets of Istanbul or wandering its shops or markets would not merely avoid the direct gaze of a man, she could hardly be seen casting her eyes in a man's direction. On the other hand—apart from the majority who still lived by arranged marriages—I was young enough to know plenty of couples who having caught each other's eye had proceeded to become acquainted, and eventually got married. "In the beginning we communicated with our eyes," they'd invariably say. And even my mother insisted that before their marriage had been arranged, she and my father had first seen each other from afar at a ball attended by Atatürk, and that, having warmed to each other, they came to an understanding not by talking, but by looking. Though my father never contradicted her account, he once confided that while they had indeed both attended a ball with Atatürk, he sadly had no recollection of the sixteen-year-old in her fashionable dress and white gloves.

It was perhaps because of having spent part of my youth in America that it took me so long to understand what it meant for the sexes to come eye to eye in a world like ours, where tradition dictated that a woman should never meet or come to know a man outside her family circle. It wasn't until my thirties, when I'd met Füsun. . . . But when I'd discovered this reality I knew the worth of what I'd then come to understand, and how deep these currents were. The look Füsun gave me was the look women gave in the old Persian miniatures, and now to be observed in the love scenes and *photoroman*s of the day. When I was sitting across from her at the table, my attention was not on the television but on reading the looks that beauty cast in my direction. Perhaps because she'd discovered how much pleasure I derived from the exchange and wanted to punish me, but whatever the reason, after a time, whenever our eyes met, Füsun's eyes would dart away, as if she were some shy young girl.

At first I thought she was informing me that she had no desire to remember or to remind me of what we'd been through together, not during a family meal, and that her resentment at our having not yet

made her a star burned hot as ever. I felt she had every right to such feelings. But later I came to resent such strenuous avoidance of my gaze as absurd pretense: After all our happy lovemaking, how could she represent herself as a shy virgin confronting a man she did not know? If no one was paying attention to us as we ate supper, and having given ourselves over to television, we had been moved to tears by the spectacle of lovers in some sentimental series saying their last farewells, a chance meeting of our eyes would bring me great joy, and I would have gladly acknowledged having gone there that evening just to look into her eyes. But Füsun would pretend not to notice the happiness of that moment; she would avert her gaze, and this would break my heart.

Did she realize that I was there because I could not forget how happy we'd been together, once upon a time? Eventually I came to feel that she understood from my expressions that I was immersed in such thoughts, and feelings of hurt. Or perhaps I was just imagining this.

This ambiguous realm in the cleft between the felt and the imagined was my second great discovery under Füsun's tutelage in the intricate art of exchanging glances. Of course, staring was the only way to communicate when there were no words. Everything that was expressed, everything that was to be understood, though, was deeply rooted in an ambiguity we found entrancing. If I'd been unable to understand something Füsun had meant to say with her look, in time I would come to see that the thing the look meant to express was the look itself. There were, at first, those rare moments when a deep and powerful emotion registered on her face, and, sensing her anger, her determination, and her stormy heart, I would be thrown into confusion, feeling as if the ground had shifted beneath my feet. But later, when something on television evoked the happy memories we shared—for example, a couple kissing as we had once done—and my attempt to catch her eye was met with her looking away, and even turning her head, I would become enraged. Out of such emotion did I master the habit of staring at her insistently, stubbornly, without blinking.

I would gaze straight into her eyes and study her carefully, as if there were all the time in the world. Of course, at the dinner table these looks of mine could never last longer than ten or twelve seconds, with my boldest attempt persisting for half a minute. Modern generations may well consider what I was doing as a form of harassment. Because by my

insistent looks I was laying out on her family's dinner table the intimacy, the love we had formerly shared, and which Füsun now wished to hide, or perhaps even forget. I cannot excuse myself by saying that we would all have had something to drink, or that I myself had overindulged. In my defense I can say only that had I denied myself even this joy of staring, I might have gone mad, even lost the will to visit the Keskins.

Most nights Füsun could tell after the first few glances whether I was in that angry, obsessive mood, wherein I would resort to deep looks that evening, and ruthless prosecution of my claim, but she would never panic; rather, like all Turkish women schooled in this art, she would pretend not even to have noticed that a man was sitting across from her with menace in his eyes, and she would give me not so much as a glance in response. This maddening rejoinder would make me even angrier, and I would stare at her all the more fiercely. In his column in *Milliyet,* the famous columnist Celâl Salik had issued many stern warnings to the angry men who prowl our streets: "When you see a beautiful woman," he'd said, "please don't bore into her with your eyes as if intent on murder." And the thought that Füsun might take my intense staring as proof that I was one of those Celâl had addressed made me burn with further fury.

Sibel had talked to me at length about the way men recently arrived from the provinces harassed women; if they saw a beautiful woman wearing lipstick and without a scarf on her head, they would just stand and stare in vicious amazement. Often after a good, long stare, some of these men would stalk their quarry, while others would make their presence known in some more subtly menacing way, from a distance for hours, sometimes even days.

One evening in October 1977, Tarık Bey went upstairs to bed early, saying he was feeling "indisposed." Füsun and Aunt Nesibe were conversing tenderly, and I was watching them somewhat absentmindedly, I think, when suddenly Füsun looked me straight in the eye. I stared back in that careful way I had recently mastered.

"Don't do that!" Füsun said.

That threw me for a moment. Füsun had done a very good impression of my stare. At first I was too ashamed to answer.

"What are you trying to tell me?" I murmured.

"I am trying to tell you to stop doing it," Füsun said, and then she

mimicked me again, this time exaggerating. Her imitation of me made me see my distasteful resemblance to the heroes in *photoromans*.

Even Aunt Nesibe smiled at this. Then she took fright. "Stop imitating everybody and everything like a child, my girl!" she said. "You're not a child anymore."

"Don't worry, Aunt Nesibe," I said, gathering all my strength. "I understand Füsun very well."

Did I really? It's important, no doubt, to understand the person we love. If we cannot manage this, it's necessary, at least, to believe we understand them. I must confess that over the entire eight years I only rarely enjoyed the contentment of the second possibility, let alone the first.

It was threatening to become one of those evenings when I could not rise from my chair. Deploying my willpower, I finally did, and murmuring that it had gotten very late, I removed myself. At home, drinking myself into oblivion, I resolved never to visit the Keskins again. In the next room my mother was snoring—a painful-sounding moan, but it was perfectly healthy.

The reader will already have guessed that I then sank into deep indignation. But it didn't last long. Ten days later I rang the Keskins' doorbell, as if nothing had happened. Stepping inside, I could see, from the moment our eyes met, that Füsun's were shining, saying she was glad to see me. At that moment I was the happiest man on earth. We sat down at the table, where we continued to exchange looks.

As the months and years went by, and I was still sitting and talking at the Keskin table, watching television with Tarık Bey and Aunt Nesibe, aimlessly gabbing about this and that—with Füsun joining in at the odd tangent—I tasted pleasures I'd never known before. You could say I was creating a new family for myself. Those nights sitting across from Füsun, taking part in the Keskin family's conversations lifted my spirits and made the world look so bright to me, I almost forgot the sorrow that brought me here.

So it was when in such a mood, late in the evening, at some unexpected moment, I would meet her eye by chance and suddenly I would remember my undying love, and I would bolt upright in excitement, as if having awakened, as if suddenly resurrected. I'd want Füsun to share my elation. For if she could for only a moment awaken as I had from

this innocent dream, she would remember the deeper, truer world we'd once inhabited, and in no time she would leave her husband and marry me. But when I saw no such "recollection," no such "awakening" in Füsun's eyes, I would be far too dejected to rise from my chair.

For the whole while our film plans were in limbo, she somehow managed almost never to look at me in a way to suggest any memory of how happy we once were. She looked blandly, pretended to be fascinated by whatever was on television or by the gossip she'd just heard about a neighbor, acting as if her life had found its fulfillment sitting at her parents' dinner table, as if her quest for meaning ended there; it was in effect the abrupt halt of my quest, too—this impression of desolation, betokening no shared future, no hope that Füsun would ever leave her husband.

Years after these events I saw how much Füsun's indignant glances and the rest of her coded pantomime owed to the expressions of Turkish films. But it was no mere mimicry, for Füsun, like those heroines, was unable to explain her troubles to her mother, her father, or any man, so she channeled all her anger, her desire, and other emotions into those looks of hers, laden with meaning.

62

To Help Pass the Time

SEEING FÜSUN on a regular basis allowed me to impose some order on the rest of my life as well. Because I was getting enough sleep, I'd get to the office early in the morning. (Inge was still drinking Meltem soda and smiling down mysteriously from the wall of that apartment in Harbiye, but according to Zaim, her effect on sales had abated.) Freed of the need to think obsessively at all times of Füsun, I was even working productively: I could spot people's tricks and make sound decisions.

As expected, it wasn't long before Tekyay, the company to which Osman had appointed Kenan manager, became Satsat's competitor. But its success was not owing to the way Kenan and my brother ran

it. Rather it was that the textile mogul Turgay Bey (my spirits plunged whenever I thought of his Mustang, his factory, and his infatuation with Füsun, though for some reason, I no longer felt jealous of him) had signed over the distribution rights of some of his key products to Tekyay. Being a man of fine feelings, Turgay Bey had forgotten all about the snub of the engagement party; he and his family were now on sound terms with Osman and his family. Subscribing to the same travel magazines, they'd go skiing together on Uludağ in the winter, and on shopping trips to Paris and London in the spring.

I was taken aback by Tekyay's aggressive tactics, though I could do little to counter them. Kenan went after the eager young managers I'd brought into the firm, as well as the two middle-aged ones whose hard work and honesty had been the mainstays of Satsat for many years; lured by the recklessly large salaries he was offering, they defected.

More than once over supper with my mother I complained that Osman was so greedy and keen to seize advantage that he was competing with the firm his own father had founded, but in reply my mother only said, "I really don't want to come between you two, my son." I think Osman had encouraged her to believe that my separation from Sibel, my strange new private habits, and my visits to the Keskins'—of which I was certain she was somewhat aware by now—had rendered me incompetent to run my father's business anyway.

Over the first two and a half years, individual visits to the Keskins' shed their singularity—the looks I exchanged with Füsun, the meals we shared, our conversations, and our excursions to the Bosphorus, which now extended into winter—without exception, each reenacted an event that had happened before; amassed they evoked a sense of the quotidian (with its own beauty) that was out of time. If we couldn't get Feridun's art film into production, the commencement of shooting was forever only months away.

Füsun had resolved, or was acting as if she had resolved, that the art film would take longer than she'd hoped, and that venturing on her own into the commercial film business would leave her vulnerable; however, the anger expressed in her looks was not entirely dissipated. Some nights, if our eyes chanced to meet, instead of looking away like a shy girl, she would bore into me with a fury reminding me of all my faults. I would become despondent at this sudden display of all the

anger she had suppressed, but knowing that this made her feel closer to me, I'd rejoice.

By now I'd resumed asking, as the evening drew to a close, "Füsun, how is your painting going?" regardless of whether Feridun was at home or not. (After that evening at the Huzur Restaurant, Feridun was going out less frequently, and having supper with us instead, as the film business was in trouble by now anyway.) I remember once the three of us got up from the table together to consider the painting of a pigeon that Füsun was then working on, and afterward we discussed it at length.

"I really admire how slowly and patiently you work, Füsun," I whispered.

"I've been saying the same thing. She should have an exhibition!" said Feridun, also in low tones. "But she's too shy. . . ."

"I'm doing these to help pass the time," said Füsun. "The hardest part is getting the feathers on the pigeon's head to shine. Do you see?"

"Yes, we see," I said.

A long silence followed. Feridun had stayed home that night also to watch the sports roundup, I think. When he heard someone scoring a goal, he ran out to the television.

"Füsun, let's go to Paris one day to visit all the museums, and see all the paintings. I'd like that so much," I said.

This was bold: a crime punishable by pouts, frowns, indignation, and the silent treatment for many visits, but Füsun took my words very naturally: "I'd like to go, Kemal."

Like so many children, I'd had a passion for painting during my school years, and for a time, when at middle school and lycée, I had used the Merhamet Apartments to paint "by myself," even dreaming of becoming a painter one day. It was in those days that I'd first indulged in childish dreams of going to Paris to see all the paintings. From the 1950s until the early 1960s, there was not a single museum in Istanbul in which you could see paintings; there weren't even any art books or catalogs that one could leaf through for pleasure. So neither Füsun nor I knew much about the art of painting. It was enough for us to enlarge black-and-white photographs of birds and other things and color them in.

As one visit to the Keskins' followed another, the streets of Istan-

bul, the world beyond the house, took on an eerie cast. To look at Füsun's paintings, to witness their slow progress, poring over the photographs of Istanbul's birds that Feridun had taken for her, and musing in hushed voices about which she should paint next—the hawk, the dove, or the swallow—this intimation of security, continuity, and the pleasures of home seemed to fix things for all eternity. It lifted up my heart to behold that we lived in a universe both simple and good. The peace I felt came from the place, the room, our mood, and what we saw around us; it came from Füsun's slow progress painting birds, and the brick red dye in the Uşak carpet on the floor, the pieces of cloth, the buttons, the old newspapers, Tarık Bey's reading glasses, the ashtrays, and Aunt Nesibe's knitting—in my mind they were all one piece. I would inhale the room's fragrance, and later, back in the Merhamet Apartments, the thimble or button or spool I'd pocketed before leaving would help me remember all this, and so prolong my happiness.

After clearing the plates at the end of the meal and putting the big serving platters with the leftover food into the refrigerator (visitors to the museum should pay special attention to the Keskins' refrigerator, which always struck me as possessing supernatural qualities), Aunt Nesibe would go to fetch her knitting set, which she kept in a capacious old plastic bag, or more typically ask her daughter to fetch it. This was the time when we would retire to the back room. Aunt Nesibe would say, "My daughter, could you bring my knitting when you come back?" Then she would settle in to enjoy knitting and chatting in front of the television. It was because she feared Uncle Tarık, I think, that Aunt Nesibe, who didn't mind our being alone together in the back room, would not let a suspicious length of time elapse before following us into the room and saying, "Where's my knitting? *The Winds of Autumn* is about to begin. Don't you want to watch it?"

We would watch it. During those eight years I must have watched hundreds of films and television series with Füsun and her family; but I, who can remember even the smallest, most trivial details of anything connected to the Keskin household, can recall not a thing about the films and series we saw, and even less of those discussion programs aired to mark national holidays (with titles like *The Conquest of Istanbul: Its Place in World History; Turkishness: What Must It Reflect?;* and *Coming to a Better Understanding of Atatürk*).

Most of what I recall of the things we watched on television were discrete moments (Aristotle, the theorist of time, would have approved). Such moments would combine with an image and remain engraved in my memory. Half of this indelible memory would be made of the image on the screen or even just a fragment of it. The shoe and the trouser cuffs of an American detective racing up the stairs; an old building's chimney, which was of no interest to the cameraman, but which had nevertheless slipped into the frame; a woman's hair, tucked behind her ear, during a kissing scene (while silence reigned at the table); or a timorous girl clinging to her father at a football match, surrounded by thousands of mustached men (probably there was no one at home to look after her); or the socks worn by the closest of the men bent over in prayer at a mosque in Ramadan, on the Night of Measures; or the Bosphorus ferry in the background in a Turkish film; or the tin from which the villain had eaten *dolma*s; and a good many other things. In my mind these images would combine with a detail of Füsun's face as she watched that scene: a corner of her mouth, her raised eyebrows, the placement of her hand, the way she left her fork on the side of her plate, or her eyebrows suddenly aloft as she stubbed out her cigarette. Often these images would fix themselves in my mind like the dreams we can never forget. In an effort to make them visible in the Museum of Innocence, I provided artists with detailed instructions, which assumed the form either of questions or of images, but to the questions I never found an exact answer. Why was Füsun so moved by that scene? What was it that had pulled her so far into the story? I would have liked to ask her myself, but when a film ended the Keskins were not inclined to discuss how it had affected them, preferring to discuss the denouement in moral terms.

For example, Aunt Nesibe would say, "That filthy brute got what he deserved, but I still pity the boy."

"Oh, come on, they don't even remember the child," Tarık Bey would say. "Men like that worship money and nothing else. Turn it off, Füsun."

When Füsun pressed the button, all those brutes—the strange European men, the American gangsters, that odd, feckless family, and even the despicable writer and director who had created the film—

would be sucked into the dark eternity beyond the screen like swirls of cloudy water flushing down a bathtub drain.

Immediately, Tarık Bey would say, "Oh, that feels much better, to put all that behind us!"

"All that" could have been a Turkish film or a foreign one, a panel discussion, the sly emcee of a quiz show, or the idiotic contestants! Those words would add to the peace I felt, and the very phrase seemed to confirm that the most important thing was that I stay here keeping company with Füsun and her family. And so I would realize that I wanted to remain, not just for the pleasure of sitting at the same table in the same room as Füsun, but out of my profound attachment to this house, this building, and every member of the Keskin family. (It is through my reproduction of that enchanted space that museum visitors can wander, as if through Time.) I would particularly like them to note the way my love for Füsun slowly radiated outward to encompass her entire world, and every moment, every object connected with her.

This feeling I had of being outside Time while watching television, the deep peace that made it possible to visit the Keskin family faithfully, and to love Füsun for eight years—it was broken only when the news came on, repeating how the country was sliding fast into civil war.

By 1978, bombs were going off at night even in this neighborhood. The streets leading to Tophane and Karaköy were controlled by nationalist factions, and in the papers it was claimed that many murders had been planned in the local coffeehouses. At the top of Çukurcuma Hill, on the crooked cobblestone streets heading toward Cihangir, by contrast, the residents were petty bureaucrats, workers, and students sympathetic to the Kurds, the Alevis, and various left-wing factions. They were no less fond of weapons, and on occasion militants from both sides would engage in armed combat to take control of a street, a coffeehouse, or a little square; sometimes, following the explosion of a bomb planted by gangsters controlled from afar by the secret services or some other arm of the state, a fierce pitched battle would ensue. It took quite a toll on Çetin Efendi, who was often caught in the crossfire, and never sure where to park the Chevrolet or at which coffeehouse to wait, but whenever I suggested that I could go to the Keskins' alone, he adamantly refused. By the time I left the Keskins, the streets of Çukur-

cuma, Tophane, and Cihangir were never safe. Along the way as shadows tacked up posters, plastered notices, and scrawled slogans across walls, we'd exchange fearful looks in the mirror.

With the evening news relaying the details of the bombings, killings, and massacres, the Keskins felt the peace of being safe at home, thank God, but they were worried about the future. The news was so awful, we were disinclined to discuss it, preferring to talk about the charms of Aytaç Kardüz, the host of the day. Unlike the relaxed women newscasters in the West, Aytaç Kardüz sat like a statue, never once smiling, and rushing through her reports as she read from the copy in her frozen hands.

"Slow down, my girl, take a breath, you're going to choke," Tarık Bey would say from time to time.

Although he had made this joke hundreds of times, we would all still laugh as if he were saying it for the first time, because Aytaç Kardüz, so disciplined and devoted to her work, could be quite amusingly terrified of making a mistake; she would race to the end of a sentence without once stopping to breathe, and in the event of a very long sentence she would sometimes turn red before she had got it all out.

"Oh no, she's going red again," Tarık Bey would say.

"Slow down, my child, at least stop to swallow," Aunt Nesibe would say.

Then Aytaç Kardüz would take her eyes off the page from which she was reading, as if having heard Aunt Nesibe's plea; glancing at all of us sitting at the table watching her with a mixture of panic and joy, she would exert the effort of a child who has just had her tonsils out, to swallow, whereupon Aunt Nesibe would say, "Well done, my girl!"

It was from this newscaster that we heard that Elvis Presley had died in his mansion in Memphis, that the Red Brigade had kidnapped Aldo Moro, and that Celâl Salik had been shot and killed outside Alaaddin's shop in Nişantaşı, together with his sister.

There was another way the Keskins had of distancing themselves from the care of the world, and I found it very soothing: They would look for resemblances between the people on the screen and their own friends and relations, and, as we ate, they would remark on the similarities with great attention.

At the end of 1979, as we watched the Soviet invasion of Af-

ghanistan, I recall discussing how Babrak Karmal, the new Afghan president, was virtually the double of a man who worked in the neighborhood bakery, so similar that the two could have been brothers. It was Aunt Nesibe who first mentioned it. She enjoyed the search for resemblances at least as much as Tarık Bey. At first no one could tell whom she meant, but because I had Çetin regularly stop the car in front of the bakery long enough for me to run in and buy a few loaves still hot from the oven, I knew the faces of the Kurds who worked there and could pronounce Aunt Nesibe's observation absolutely right. My endorsement notwithstanding, Füsun and Tarık Bey stubbornly insisted that the man tending the till bore no resemblance whatsoever to the new Afghan president.

Sometimes Füsun seemed to be contrary just to spite me. She refused, for example, to accept that Anwar Sadat, the Egyptian president who was killed by Islamists while reviewing a military procession from the box of honor, just as our staff officers do, was the spitting image of the newsagent on the corner of Çukurcuma Hill and Boğazkesen Avenue; and if you ask me, it was because I was the one who made the comparison. As the coverage of Sadat's assassination went on for several days, there ensued a war of nerves between me and Füsun that I did not care for at all, and it went on for days, too.

If the majority at the Keskin table agreed on a resemblance, we could, from then on, without dissent, allude to the eminent person on the screen not as Anwar Sadat but as Bahri Efendi the newsagent. By the time I entered my fifth year of eating supper at the Keskins', I too had agreed that Nazif Efendi the quilt seller resembled the famous French actor Jean Gabin (whom we'd seen in many films); and that the awkward weathergirl who sometimes appeared on the evening news resembled Ayla, who lived downstairs with her mother and was one of the friends Füsun hid from me; while the late Rahmi Efendi was a dead ringer for the elderly head of the Islamist party, who would fulminate on the evening news; and Efe the electrician recalled the famous sportswriter who summarized the week's goals on Sunday evenings; and it was I who (mainly on account of his eyebrows) likened Çetin Efendi to President Reagan.

Once pegged, the appearance of one of these famous faces on the screen was the signal to see who among us would crack the first joke.

"Hurry over and look at this, children!" Aunt Nesibe would say. "See how beautiful Bahri Efendi's American wife is!"

But there were instances, too, when we struggled to work out a match for the famous person on the screen. For example, when Kurt Waldheim, the Secretary-General of the UN who was so busy trying to make peace between Israel and Palestine, appeared, Aunt Nesibe would say, as if calling for help, "So let's see, who does this man look like?"; as we all searched our experiences, the table would fall silent for a very long time. These silences could continue long after the famous person faded from the screen, to be replaced by other scenes, news items, or commercials.

Then suddenly I'd hear a ship coming from the direction of Karaköy and Tophane blowing its whistle, and I would remember the noise of the city, and its crowds, and as I tried to conjure up the image of the ferries approaching the piers, I would reluctantly realize just how involved I'd become with the Keskin family, how much time I'd spent eating at this table: As these ships had gone by, blowing their whistles, I'd not even noticed how many months and years had passed us by.

63

The Gossip Column

AS THE country slid toward civil war, the exploding bombs and the pitched street battles resulted in fewer people going to the cinema, which absence had devastated the film industry. The Pelür Bar and other industry watering holes were as crowded as ever, but by now, with families no longer even venturing out into the streets in the evening, the film people were all struggling to get by doing commercials or skin flicks and fight films now flooding the market. In just the past two years, big producers had stopped investing in the sorts of films we'd enjoyed over the summer, a development that suddenly elevated me among the habitués of the Pelür Bar, in whose eyes I was the wealthy backer of Lemon Films, and potentially an investor in their ventures.

Though I was managing for the most part to stay away from the Pelür, one evening, at Feridun's insistence, I went and saw that the crowd was larger than ever, a fact explained later when I heard from the drunks that unemployment had been a boon to the bars and that "all of Yeşilçam" was "hitting the bottle."

That evening I, too, drank until morning with the miserable film crowd. I even recall chatting amiably with Tahir Tan, the man who had once pursued Füsun all the way to the Huzur Restaurant. By the end of the same evening, Papatya, one of the most charming of the new generation of young actresses, had claimed me as a "friend." Only a few years earlier Papatya had been starring in family films as the innocent girl who sold *simit*s and looked after her blind mother, or continually dissolved into tears as her stepmother, played by Conniving Sühendan, plotted her ruination; now she, like the others, was out of work and forced to take on dubbing domestic porn films; but there was a screenplay that Feridun had also found interesting, and she was hoping for my backing to produce it. Drunk as I was, I could see that Feridun found Papatya interesting, too—there was what film magazines called a "certain intimacy" between them—and yet I was rather amazed by his annoyance at the attention I paid her. Toward morning, when the three of us left the Pelür, I remember walking together through the dark backstreets, past walls on which drunks had relieved themselves and leftists had scrawled radical slogans, making our way to Cihangir, where Papatya lived with her mother, who worked as a singer in low-rent nightclubs. As menacing packs of dogs followed us down the cold streets, I left it to Feridun to see Papatya home and returned to Nişantaşı, where I lived peacefully with my mother.

After drunken evenings like this, as I drifted in and out of sleep, I was beset by painful thoughts: that my youth was well and truly over; that (as was the case for all Turkish men) my life was taking its ultimate shape before I had even reached the age of thirty-five; that I would— could—never again know great happiness. At times, remembering the love and longing that filled my heart, I would console myself thinking that if my future seemed darker with each passing day, this could only be an illusion induced by the political assassinations, the never-ending street battles, the spiraling prices, and the bankruptcies that filled the news.

But if I had been to Çukurcuma to see Füsun, if we had looked into each other's eyes and spoken, if I had stolen from the Keskins' house a few objects that would remind me of her later, and if back at home I had a chance to play with them, it would seem to me as if I could never feel unhappy again. There were times when I would survey the knives and forks that Füsun had used, and that I had secreted away from the Keskins' dinner table, as if they formed a single picture, in themselves a complete memory.

Sometimes, convinced of the possibility of a better life elsewhere, beyond the circumscribed world of my obsession, I would struggle to dwell on other things. But if by chance I'd seen Zaim, his report on all the latest society gossip was enough to remind me that I was not missing much by avoiding the company of rich friends, whose lives seemed increasingly boring.

Though they had been seeing each other for three years by now, Mehmet and Nurcihan had (according to Zaim) still not made love, and were telling people that they planned to marry. This was the biggest piece of news. Even though everyone, Mehmet included, knew of Nurcihan's love affairs with French men during her years in Paris, she was determined not to make love with him before marriage, and she made light of this decision, saying that in Muslim countries, the foundation of a true and long-lasting, happy and peaceful marriage was not wealth but premarital abstinence. Mehmet seemed to appreciate this joke; it was part of the tapestry of their common outlook, which they articulated in one voice, telling stories illustrating the wisdom of our ancestors, and the beauty of our old music, and the contentment of the old masters, with their dervish temperaments. Neither the jokes they liked to make, nor their interest in our Ottoman ancestors, had led to their being branded in society as devout or reactionary. Zaim believed that one reason for this was the amount they both drank at parties, which, however excessive, never compromised their manners or their elegance. When he'd had some wine to drink, Mehmet would proclaim with some excitement that the wines mentioned in Divan poetry were not metaphorical but real libations, and he would recite lines from Nedim and Fuzuli—the accuracy of which no one could judge—and looking carefully into Nurcihan's eyes, he would lift his glass to toast the love of God. There was a reason that society had not been put off

by such an exhibition and indeed had even accepted it respectfully: There were far worse things, a lesson that could be traced to the panic among young girls following the dissolution of my engagement to Sibel. This episode had served as potent warning to girls of our generation in Istanbul society not to put too much trust in men before marriage, and, if the rumors were to be believed, inspired terrified mothers with marriageable daughters to urge extreme caution. But lest one attach too much importance to my own experiences, I beg the reader to remember that Istanbul society was such a small and fragile circle that the deep shame of any member was no less universally felt than in a small family.

Especially after 1979 I'd grown well accustomed to the comforts of my new life, and moving between my home and my office, Füsun's house and the Merhamet Apartments, I felt at one with its spirit. I would go to the Merhamet Apartments, and, reflecting upon the happy hours Füsun and I had spent there, I would lose myself in daydreams, admiring my slowly growing "collection" with ever renewed wonder. As these objects accumulated, so did the manifest intensity of my love. Sometimes I would see them not as mementos of the blissful hours but as the tangible precious debris of the storm raging in my soul. Sometimes I felt ashamed at their very existence, alarmed at the idea that someone else might see them, and a bit afraid that at this rate, my collection would soon fill the rooms in the Merhamet Apartments from floor to ceiling. For I had not begun taking these things from the Keskin household with an eye to what the future might hold, but only that I might be returned to the past. It did not occur to me that there might one day be objects enough to fill rooms and whole houses, because for the better part of those eight years I sustained myself with the conviction that it would be only a few more months, six at most, before I could bring Füsun around to marry me.

Here I exhibit a cutting from *Akşam,* a column from the "High Society" page, dated November 8, 1979:

SOCIETY AND THE CINEMA: A MODEST WARNING

We all like to boast that Turkey's film industry is the third largest in the world after Hollywood's and India's. Sadly, the situation is chang-

ing: The new sex films and our citizens' growing reluctance to go out-
side in the evening, in view of the terror wrought by militants of the
left and right, has kept our families away from the cinema. Even the
most esteemed Turkish cineastes are now unable to find the audiences
or the backers to make their films. The Turkish cinema has never had
as great a need as it has today for rich businessmen to come to
Yeşilçam to make "art films." In the past, artistic-minded cineastes
tended to come from new money—families recently arrived from the
provinces—and their aim would be to make the acquaintance of beau-
tiful actresses. Of the many "art films" that our critics praised so lav-
ishly, not a single one has gone on to be shown to the intellectuals of
the West, despite what has been claimed, nor have any of them
received an honorable mention in the bland small-town festivals of
Europe; instead they have served as vehicles for any number of scions
of the nouveau riche to meet and engage in amorous affairs with
female "artists." But that was in the old days. Now there is a new fash-
ion. These days our wealthy art lovers don't come to Yeşilçam to have
love affairs with beautiful actresses; they come to make girls they
already love into stars. As a consequence, we now find the bachelor
son of one of the most illustrious families of Istanbul society (having
chosen to withhold his full name, we shall call him Mr. K) is so infat-
uated with a young married woman he describes as a "distant relation"
and so jealous of anyone who comes near her that he cannot even
bring himself to arrange for the "art film" (for which he has commis-
sioned a screenplay) to go into production. This reporter's sources tell
him that Mr. K has gone so far as to admit, "I could not bear to see her
kissing someone else!" And such is his jealousy that he shadows the
young woman and her director husband, crawling after them in
Yeşilçam bars and Bosphorus restaurants, a glass of *rakı* in his hand,
and apparently he gets upset if the married would-be actress so much
as steps outside her house. According to these sources, our society
bachelor—who not so long ago celebrated his engagement to a gradu-
ate of the Sorbonne, the adorable daughter of a retired diplomat, with
a fabulous party at the Hilton attended by all society and described in
lavish detail in this space—was irresponsible enough to break off the
engagement, all for the sake of the beautiful relative to whom he has
now said, "I am going to make you a star!" We, meanwhile, are reluc-
tant to stand by while this feckless rich boy, who has already done so
much harm to the diplomat's lovely young daughter, goes on to
blacken the name of F, the beautiful would-be actress, to whose
charms a great many philandering gentlemen are particularly suscepti-
ble. So, after apologizing in advance to readers who have tired of lec-
tures, we would like to pass on the following wisdom to society's Mr.
K: Sir, in this modern age, when the Americans have gone to the

moon, it is simply not possible to have an "art film" without kissing scenes! You must decide once and for all, and either marry a headscarf-wearing peasant girl and put Western art and films out of your mind forever, or give up on this fantasy of making stars out of young girls you guard so closely that you can't bear anyone else even looking at them. That is, if making stars is what you're really after.—WC

My mother read the two newspapers delivered daily to our house from cover to cover, never missing the society gossip. As we were having breakfast the morning that column appeared, I waited until she had gone to cut out the offending page, fold it up, and slip it into my pocket. "Something's bothering you again—what is it?" my mother asked me as I left the house. "You're so gloomy!" At the office, too, I tried to feign high spirits, telling Zeynep Hanım an amusing anecdote, whistling as I walked down the hallway, and jovially making the rounds of the aging and ever more idle employees of a moribund Satsat who whiled away their time by doing the *Akşam* crossword.

By the time everyone came back from lunch, it was clear from the expressions on their faces and in particular the compassion—and fear—in Zeynep Hanım's eyes that the entire staff of Satsat had read the column. Maybe I'm just imagining things, I told myself afterward. My mother rang me to say that she'd been expecting me for lunch, and also asked, "How are you, darling?" straining not to let concern inundate her normal voice, from which I could tell all the same that she'd heard about the column, sent out for another copy of the paper, and had a good cry over it (her "normal" voice now full of that gravitas people acquire after they've cried); just as she could tell from the torn-out page that I'd read it, too. "The world is full of people with monstrous souls, my child," said my mother. "You are not to let anything upset you."

"What are you talking about, Mother?" I said.

"It's nothing, my child," she said.

I was tempted to pour out my heart to her, but I was certain that if I did, she would, after ample expression of love and understanding, feel obliged to tell me that I was at fault, too, and then press me for all the details of the Füsun story. She might even have burst into tears and

told me I'd been bewitched. She might have said, "In some corner of the house, inside a jar of rice or flour, or at the back of one of your drawers at work, there's an amulet hidden—someone's cast a spell on it, and breathed on it, to make you fall in love—so find it and burn it at once!" But I sensed that she was downcast because she'd been unable to share my sorrow, unable even to broach the subject. It was all she could do to show respect for my predicament. Was this an indication of how bad my situation was?

At this moment, I wondered about the readers of *Akşam:* How contemptuously were they regarding me, how heartily were they laughing or raging at my passion, and how many of this report's details did they believe? I couldn't dislodge these questions from my mind, nor the thought of how upset Füsun would be when she read the column. After my mother's phone call, it occurred to me to warn Feridun to keep *Akşam* away from Füsun and everyone else in our family. But I didn't place the call. My first reason was fear that I might be unable to explain things to Feridun in such a way that he wouldn't get so upset as to feel compelled to act. But my second reason was deeper: Despite the humiliation and being made out to be a fool, I was still glad about the column. I hid this satisfaction even from myself, but when I look back now, so many years later, I can see it perfectly well: My relationship with Füsun, my closeness to her by whatever name, had been reported in the papers, and thus, in some sense, society had accepted it! This column was read by absolutely everyone with an interest in Istanbul society; malicious columns like this one were discussed for months on end. And so I tried to convince myself that this gossip augured my return to my former place in the social order, with Füsun at my side—or, at the very least, to imagine that our story might arrive at this happy resolution.

But such was the hopelessness to which I'd been delivered that I could entertain such sweet dreams. It would not be long before I felt that society gossip and mendacity and innuendo were slowly turning me into a different sort of man. I was no longer the one who had, by force of his own will and passion, embarked on an unconventional course, but someone who had been ostracized after being featured in a gossip column.

The initials over which the column appeared left no room for doubt

that it had been written by White Carnation. I was annoyed at my mother for having invited him to the engagement party, and incensed by Tahir Tan, whom I suspected to be the source of many of the man- ufactured details ("I could not bear to see her kissing someone else!"). How I longed to sit down with Füsun, to curse our enemies together, so that I could console her, and she me. We would need to go to the Pelür Bar and defy them all with our determination. Feridun would have to come, too! Only this could prove the gossip a degrading lie, and silence the slurring drunks of the film world—not to mention our friends in society, who were now reading the column with relish.

But the evening after the column appeared, I could not—hard as I tried—bring myself to visit the Keskins. I was sure that Aunt Nesibe would do her best to put me at ease, and Tarık Bey would affect to know nothing of what had happened, but when I tried to imagine the moment when my eyes met Füsun's, my mind went blank. In that moment there would be no denying that we were both feeling the same turmoil within, and for some reason, this frightened me. Then I had the following insight: What we would both understand the moment our eyes met was not that there were tempests raging in both our souls, but simply that the false reports were actually true!

Yes, as the reader well knows, quite a few details in White Carna- tion's column were wrong: I had not broken off my engagement with Sibel to make Füsun a star; I had not commissioned Feridun to write a screenplay. But these were trivial errors. What newspaper readers and all the gossips in the city would take from the column was this simple truth: My love for Füsun and the things I had done for her had led me to disgrace myself! All of them were mocking me, laughing at every- thing I'd done; even the most well-meaning pitied me. Though I reminded myself that Istanbul society was very small, and that none of these people was seriously rich or genuinely principled, my shame was unrelieved. Rather I felt the sting of my stupidity and ineptitude all the more. Here I was, living in a poor country, yet lucky enough to have been born into a wealthy family; offered such opportunity as God offers so few in this corner of the world—an honest, civilized, and happy life—and I had idiotically thrown it all away! I knew that the only way out of this predicament was to marry Füsun, put my business affairs in order, make my fortune, and then return, victorious, into soci-

ety, but by now I could not find the strength to realize this plan, and indeed I'd come to hate that tiny set into which I might seek readmittance. Above all, I knew that, once they'd read the offending column, the Keskin household would neither entertain nor abet my dreams.

My love and my shame had brought me to this place where my only inclination was to turn inward and live in silence. For a week I went to the cinema every night: I went to the Site, the Konak, and the Kent and saw American films. Especially in a world as miserable as ours, the point of films is not to offer verisimilitude but a different new universe to amuse us and make us happy. Particularly, in identifying with the hero, it would seem to me that I was exaggerating my troubles. And at such moments I would castigate myself for having been inept enough to become the idle gossips' object of derision; I even began to believe some of the lies they'd told about me.

Of all the lies, the one that bothered me most was the claim that I had said, "I could not bear to see her kissing someone else!" At moments of greatest discouragement I would become convinced that it was this charge that was chiefly provoking laughter, and it became the center of my obsession to correct the lies. I was also irked to be portrayed as a spoiled rich boy irresponsible enough to break off an engagement, but I assured myself that those who knew me would not fall for that one. That I might have said I didn't want her kissing anyone, however, was credible, because despite all my Western airs, there was something in me of a man who might say such a thing, and I wasn't even sure I hadn't said as much to Füsun, either in jest or in drunkenness. Because, in truth, even for art's sake, I definitely did not want Füsun kissing anyone else.

64

The Fire on the Bosphorus

In the early hours of the morning of November 15, 1979, my mother and I were awoken by the sound of a huge explosion; we

jumped from our beds and ran into the hallway to embrace each other in terror. For a moment the entire apartment rocked from side to side, as if caught in a severe earthquake. Accustomed as we were to bombs going off in coffeehouses, bookstores, and the city's squares, we assumed that yet another had been detonated near Teşvikiye Avenue, but then we noticed the flames rising near the other side of the Bosphorus, just off the Üsküdar shore. Figuring this was some act of political violence, for a while we watched the fire with the red clouds rising from it in the far distance, and then we went back to bed.

A Romanian tanker loaded down with crude oil had collided with a small Greek ship just off Haydarpaşa; oil had gushed into the water, causing explosions within and without the tanker hull and then the fires. The papers rushed to put out special editions, and the next day the whole city was abuzz with talk of the Bosphorus set ablaze and the clouds overhanging Istanbul like a black umbrella. At Satsat that day I could almost feel the fire inside me, and I sensed it was the same with all the lady clerks in the office, and the bored managers, and so I tried to see the conflagration as a good excuse to go to the Keskins' for supper that evening. The event would utterly preempt the gossip column, which I wouldn't even have to mention as we sat at the table talking incessantly about the fire. But, still, like everyone else living in Istanbul, I associated the Bosphorus fires with all the other disasters that were contributing to the general misery: an ensign of the political assassinations, breadlines, hyperinflation, and the impoverished, abject appearance of the entire country. And as I read the latest editions, it seemed to me that I was fascinated by the fire because it spoke to me about the disasters in my own life.

That evening I went to Beyoğlu; as I walked the length of İstiklal Avenue I was surprised to see it so empty. Outside the big cinemas like the Palace and Fitaş, where they now showed sex films, there were only a few fidgety men. When I passed through Galatasaray Square, I realized how close I was to Füsun's house. Sometimes, on summer nights, the whole family would stroll up to Beyoğlu for ice cream. Perhaps we might cross paths. But I could not see a single woman in the streets, or a single family. When I reached Tünel, I again became uneasy about being so close to Füsun's house, so I walked in the opposite direction to resist its pull. Passing alongside the Galata Tower I walked down to the

bottom of Yüksekkaldırım. At the corner where Yüksekkaldırım crossed the street of the bordellos, there was the usual crowd of wretched men. Like everyone else, they were looking up at the play of the orange light against the black clouds.

I crossed the Galata Bridge with the crowd watching the fire in the distance. Even those trawling for mackerel from the bridge could not take their eyes off the flames. Without my willing it, my feet followed the crowd as far as Gülhane Park. The lights in the park were out—because either, like most of Istanbul's streetlamps, they had been shattered by stones hurled in rage, or because there'd been a power cut—but the flames rising from the tanker were so intense that the whole of this large park, and Topkapı Palace, to which it had once belonged, together with the mouth of the Bosphorus, and Üsküdar, Salacak, and Leander's Tower, were as bright as day. The light in the park, coming directly from both the fire and the orange light reflecting off the clouds, provided the cozy glow of a lampshade in a European sitting room, making the large, restless crowd of onlookers seem happier and more peaceful than they really were. Or else the pleasure of watching a spectacle had lifted their spirits. This throng had come from all parts of the city—by bus, by foot, and by car, rich and poor, some obsessively and others simply curious. I could see grandmothers in headscarves; young mothers with their sleeping children in their arms, clinging to their husbands; unemployed men hypnotized by the fire; drivers sitting in their cars and their trucks, listening to music; and street vendors who had rushed in from all quarters to hawk *helva,* stuffed mussels, fried liver, and *lahmacun;* as well as tea vendors darting among the crowd with their trays. Arranged around the base of the Atatürk statue were the men who sold meatballs and hot sausages stuffed in bread; they had lit the grills in their glass-covered carts, and the pleasant aroma of grilled meat filled the air. The boys hawking *ayran* and soda (but not Meltem) had turned the park into a market. I bought a tea from one street vendor, and, finding a place on one of the benches, next to a poor, old, and toothless man, I felt my own happiness as I watched the flames.

I returned each day until the end of the week, by which time the fire was beginning to die. Sometimes the faint flames would flare up again, rising in a wave to the height we had seen on the first day, again casting

an orange glow on the faces of those watching the fire with such fear and awe, as the flames bathed not just the mouth of the Bosphorus, but Haydarpaşa Station, the Selimiye Barracks, and Kadıköy Bay in shades of orange, and sometimes gold. At such moments I would stand motionless with the rest of the crowd, entranced by the view. A while later we would hear an explosion and watch the embers fall, or try to listen as the flames silently shrank. It was the spectators' cue to settle in for eating and drinking and chatting.

During one of these evenings at Gülhane Park, I spotted Nurcihan and Mehmet, but I ran off before they could see me. That I longed to see Füsun there with her parents, and that this had perhaps been my reason for joining this crowd every evening—it was only after seeing a family whose three shadows resembled theirs that I realized this. It was just as it had been during the summer of 1975, now four years past: Every time I saw anyone who looked like Füsun, love would make my heart race. The Keskins were, I thought, just the sort of family to believe most sincerely in the power of disasters to bind us together. I had to visit their house before the fire on the *Independenta* was extinguished; we would live through this catastrophe together, and their fellowship would help me put all the bad things behind me. Could this fire mark the beginning of a new life for me?

There was another evening when as I was looking for a place to sit in the crowded park I ran into Tayfun and Figen. To my great relief, they did not mention the column in *Akşam,* or indeed any other society gossip; they did not even seem to be aware that there was any talk about me, which so pleased me that I left the park with them, as the flames were beginning to die down; we got into their car and went to one of the new bars that had opened up in the backstreets of Taksim, where we drank until morning.

The next day—on Sunday evening—I went to the Keskins'. I had slept all day and eaten lunch with my mother. By evening I was feeling optimistic, hopeful, even happy. But the moment I walked into the house and came eye to eye with Füsun, all my dreams were destroyed: She was joyless, hopeless, hurt.

"What's new, Kemal?" she said, mimicking a carefree and well-satisfied woman of the world—or rather, her idea of one. But my beauty's heart wasn't in it; even she knew she was faking.

"Nothing much," I said brazenly. "I haven't had time to come over; there's been so much happening at the factory, and the firm, and the business."

In a Turkish film, when a certain intimacy has been established between the young hero and heroine, an understanding matron will cast a certain glance of contentment their way, so that even the most inattentive viewer will appreciate the development and share in the emotions. . . . Well, that is how Aunt Nesibe gazed upon Füsun and me. But soon afterward I could tell from the way she averted her eyes that the gossip column had caused a great deal of pain in this house, and that Füsun had spent many days crying, just as she had done after the engagement party.

"Why don't you bring out some *rakı* for our guest, my girl?" said Tarık Bey.

For three years now Tarık Bey had been acting as if he knew nothing of the situation, always greeting me with warm sincerity, treating me like a relation who'd simply come to supper, which I had always respected. But now it grieved me to see him show so little interest in his daughter's anguish, my own helplessness, and our shared predicament. Let me now make the heartless observation that I refrained from making, even to myself: Tarık Bey had almost certainly deduced what I was doing there, but his wife had prevailed upon him to accept that it was better "for the family" for him to pretend to know nothing.

"Yes, Füsun Hanım," I said, assuming her father's contrived manner. "Why don't you give me my usual *rakı,* so that I can savor the full happiness of coming home."

Even today I cannot explain why I said this, or what I meant by it. Let us just say that my misery came to my lips. But Füsun understood the sentiment behind the words, and for a moment I thought that she would begin to cry. I noticed our canary in its cage. I thought about the past, and my life, the flow of time, the passing years.

We lived through our most difficult moments during those months, those years. Füsun had not risen to stardom, and I had not succeeded in coming any closer to her. Our impasse had become a public disgrace; we'd been humiliated. It was just as it had been on those evenings when I could not stand up—I saw us unable to stand up and remove ourselves from this predicament. For as long as we continued to see each

other four or five times a week, it would be impossible for either of us to start a new life, and this we both knew.

That evening, toward the end of supper, I uttered the usual invitation with more sincerity than ever. "Füsun," I said, "it's been so long since I've seen what's happening to your painting of the dove."

"The dove has been finished for ages now," she said. "Feridun found a lovely picture of a swallow. I've started on that now."

"This swallow is by far the best one yet," said Aunt Nesibe.

We went into the back room. Staying with the formula of the other Istanbul birds perched on various parts of the house—balustrades, windowsills, and chimneys—she had placed a dainty swallow in the bay window of our dining room, overlooking the street. In the background you could see the cobblestones of Çukurcuma Hill, depicted in a strangely childish perspective.

"I'm so proud of you," I said, my voice heavy with defeat despite my best efforts. "One day everyone in Paris should see these!" I said. As always, what I really longed to say was something like "My darling, I love you so much, and oh, how I've missed you. It was so painful being far away from you, and what bliss this is, to see you!" But it was as if the painting's flaws had become the flaws of the world in which we lived, and it was while examining the dove painting, sadly noting its simplicity, innocence, and lack of sophistication, that I understood this.

"It's turned out beautifully, Füsun," I said carefully, inside me nursing a deep pain.

If I say that the painting contained elements recalling Indian miniatures painted under British influence, and Chinese and Japanese bird paintings, with Audubon's attention to detail, and even the bird series that came packaged with a brand of chocolate biscuits sold in stores across Istanbul, please bear in mind that I was a man in love.

We looked at the views of the city that served as backgrounds for Füsun's paintings of Istanbul birds, but far from lifting my heart, this exercise brought me sorrow. We loved our world very much, we belonged to it, and that meant we ourselves were part of the picture's innocence.

"Maybe you could paint the city and the houses in more vibrant colors one of these days. . . ."

"Never mind, my dear," said Füsun. "I'm just passing the time, you know."

She picked up the picture she'd been showing me and put it to one side. I looked at her lovely art supplies—the tubes of paint, the brushes, the bottles, and the cloths stained with all sorts of colors. Like the bird paintings, these things were neatly arranged. Near them were Aunt Nesibe's thimbles and materials. I slipped a colored porcelain thimble into my pocket, and an orange pastel pencil that Füsun had been fiddling with a short time before. It was during these, our darkest days, and most especially the last months of 1979, that I stole the most things from the Keskin household. By now these objects were no longer just tokens of moments in my life, nor merely mementos; to me they were elemental to those moments. For example, the matchboxes on display in the Museum of Innocence: Füsun touched every one of them, leaving behind the scent of her hands with its hint of rosewater. As with so many other things on exhibit in my museum, whenever I held any of these matchboxes back at the Merhamet Apartments, I was able to relive the pleasure of sharing a table with Füsun, and gazing into her eyes. But even before that, whenever I dropped a matchbox into my pocket, pretending not to notice what I had done, there was another reason to rejoice. I may not have "won" the woman I loved so obsessively, but it cheered me to have broken off a piece of her, however small.

To speak of "breaking off" a piece of someone is of course to imply that the piece is part of the worshipped beloved's body. But three years on, every object and person in that house in Çukurcuma—her mother, her father, the dining table, the stove, the coal carrier, the china dogs on the television, the bottles of cologne, the cigarettes, the *rakı* glasses, the sweets bowls—had merged with my mental image of Füsun. I managed to see Füsun three or four times a week, and as happy as this made me, with each week I still took ("stole" would be the wrong word) from her house (from her life) three or four things, sometimes as many as six or seven, and during the most miserable phases, between ten and fifteen, and having got them to the Merhamet Apartments, I felt triumphant. What bliss it was to hold a saltshaker with which Füsun had so daintily salted her food without taking her eyes off the television—to slip it into my pocket, to know that it was

there while I chatted and sipped my *rakı,* to know that I had taken pos-
sesion of this trophy was to find the strength to stand up and leave
when the evening had drawn to its conclusion. After the summer of
1979, an object in my pocket was the key to prying me out of my chair.

Years later, when I fell in with Istanbul's weird and obsessive collec-
tors; when I visited their houses packed to the rafters with paper, rub-
bish, boxes, and photographs, every time trying to understand how
these soul mates of mine felt about their soda bottle caps or pictures of
film stars, and what meaning a new acquisition held—I would remem-
ber how I'd felt every time I took something from the Keskins' house.

65

The Dogs

MANY YEARS after the events I am relating here, I set out to see all the
museums of the world; having spent the day viewing tens of thousands
of strange and tiny objects on exhibit in a museum in Peru, India, Ger-
many, Egypt, or any number of other countries, I would down a couple
of stiff drinks and spend many hours walking the streets of whatever
city I was in. Peering through curtains and open windows in Lima, Cal-
cutta, Hamburg, Cairo, and so many others, I would see families joking
and laughing as they watched television and ate the evening meal; I
would invent all sorts of excuses to step into these houses, and even to
have my picture taken with the occupants. This is how I came to notice
that in most of the world's homes there was a china dog sitting on top
of the television set. Why was it that millions of families all the over
world had felt the same need?

I first asked myself a more modest version of this question at the
Keskin house. As I would come to know later, the china dog that I
noticed upon first walking into the family's apartment on Kuyulu
Bostan Street in Nişantaşı had, before television came to Turkey, sat
atop the radio around which the family gathered every evening. As in
so many houses I saw in Tabriz, Tehran, the cities of the Balkans, in the

East, in Lahore and even Bombay, at the Keskins' house, the dog was set on a handmade lace doily. Sometimes a small vase would sit along-side it, or a seashell (once Füsun picked up the television shell and, smiling, put it to my ear, so that I, too, could listen to the oceanic mur-muring trapped inside it), or the dog would be propped against a ciga-rette box, as if standing guard. Sometimes it was these cigarette boxes and ashtrays that determined where the dog was placed. It was, I thought, Aunt Nesibe who saw to these mysterious arrangements, which might make one think the dog was about to nod—or even to pounce on the ashtray—though there was one evening in December 1979, when, while admiring Füsun, I saw her change the position of the china dog on the television. At a moment when nothing would draw notice to the dog or the television set, when we were all sitting at the table, waiting for her mother to serve the food she had prepared, she had shifted it with an impatient flick of the wrist. But this does not explain the dog's presence in the first place. In later years it would be joined by another dog guarding another cigarette box. For a time there was a fashion for plastic dogs that really did nod their heads; you often saw them in the back windows of private cars and shared taxis; the fashion came and went in the blink of an eye. Little was said about these dogs; if the Keskins began to remark on the comings and goings of these dogs, it was because my interest in their belongings was now evident to them. By the time the dogs sitting on the television set began to change with regularity, Aunt Nesibe and Füsun had either guessed or knew for a fact that I was taking them away, as I did so much else.

Actually, I had no desire to share my collection with others, nor did anyone know I was hoarding things—I was ashamed of what I was doing. After having taken all those matchboxes, and Füsun's cigarette butts, and the saltshakers, the coffee cups, the hairpins, and the bar-rettes—things not difficult to pick up, because people rarely notice them missing—I began to set my sights on things like ashtrays, cups, and slippers, gradually beginning to replace them with new ones.

"You know that doggie on top of the television, the one we were talking about the other day? Well, it ended up at my house. Our Fatma Hanım was just putting it away when she dropped it on the floor and broke it. I've brought this to replace it. Aunt Nesibe, I was in the Spice

Bazaar, buying birdseed and rapeseed, and I saw it in one of the shops there. . . ."

"Oh, what lovely black ears it has," Aunt Nesibe would say. "He's a real street dog. . . . Come here, old black ears! Now sit. The poor creature brings us peace!"

She took the dog from my hand and placed it on the television set. Sometimes the dogs set there brought us peace by their mere presence, much as the clock ticking on the wall did. Some looked threatening, others ugly and utterly charmless, but even these dogs made us feel as if we were sitting in a place guarded by dogs, and perhaps to feel thus protected was what brought us peace, as the neighborhood echoed with the militants' gunfire and the outside world seemed more surreal with every passing day. The black-eared dog was the most charming of the scores of dogs that came to rest on the Keskins' television during those eight years.

On September 12, 1980, there was another military coup. By instinct I'd woken up before everyone else that morning; seeing that Teşvikiye Avenue and the streets leading off it were all empty, I knew at once what had happened: In those days, coups came every ten years. From time to time army trucks came down the avenue, filled with soldiers singing martial songs. I turned on the television at once, and after watching the images of flags and military parades and listening to the generals who had seized power, I went out onto the balcony. I liked seeing Teşvikiye Avenue so empty, and the city so silenced, so the rustling leaves of the chestnut trees in the mosque courtyard soothed me. Exactly five years earlier I had stood on this balcony with Sibel after our end-of-summer party, at exactly this hour in the morning, and admired the same view.

"Oh good, I'm so glad. The country was on the brink of disaster," said my mother as she watched the frontier folk singer with the handlebar mustache sing of war and heroism. "But why have they put this ugly brute on television? Bekri won't be able to make it in today, so Fatma, you'll have to cook. What do you have for us in your refrigerator?"

The curfew lasted all day. From time to time we'd see an army truck hurtling down the avenue; from this we knew that politicians, journal-

ists, and many others were being picked up from their houses and taken into custody, and we were thankful that we never had involved ourselves in politics. The newspapers had all produced special editions, welcoming the coup, and all day long I sat with my mother, reading them and watching the generals announce the coup, a recording played many times over, interspersed with old images of Atatürk. From time to time I went to stand by the window and admire the beauty of the empty streets. I was curious to know how things were with Füsun—how everyone was feeling at the house in Çukurcuma. There were rumors of house searches in certain neighborhoods, as had been done during the 1971 coup.

"From now on we'll be able to go out into the streets in peace," my mother said.

With the imposition of the ten o'clock curfew, the military coup cast a long shadow over my evening meals at the Keskins'. During the evening news broadcast on the country's only television channel, the generals not only railed against politicians and dissident intellectuals but lectured the entire nation about the bad habits that had led them astray.

But it wasn't just politicians and dissident intellectuals—they were also jailing common swindlers, brothel keepers, tombala men who sold black market cigarettes, and anyone who'd violated a traffic ordinance, written a slogan on a wall, or been involved in a porn film. A large number of people linked with terrorism were summarily executed as examples to others. Whenever word of one of these events reached the Keskin table, everyone would fall silent. At such times I would feel closer to Füsun: part of the family. They no longer seized young, long-haired "hippie types" from the streets to shave off their beards, as in the previous coup, but they did immediately fire a slew of university lecturers. The Pelür Bar was emptied out with other such places. In the wake of the coup, I resolved that I, too, would put my life in order: I would drink less, mitigate the disgrace my love had caused, and, if nothing else, tame my urge to collect things.

Less than two months later I found myself alone in the kitchen with Aunt Nesibe just before supper. I'd started coming to the house earlier, so that I could see more of Füsun.

"My dearest Kemal, you know that street dog with the black ears

that you bought us—the one on the television? Well, it's gone missing. . . . Your eyes grow accustomed to things, so the moment they're gone, you notice. Whatever happened has happened; it doesn't matter to me—maybe the poor beast decided it was time to get up and go," she said. She let out a sweet little laugh, but when she saw the harsh expression on my face, she became serious. "What shall we do?" she asked. "Tarık Bey keeps asking what happened to the dog."

"Let me take care of this," I said.

That evening I was too upset to speak. But in spite of my silence—or because of it—I was also unable to stand up and leave, a paralysis that intensified as it got close to the curfew hour. I think that Aunt Nesibe and Füsun were both aware of my predicament. Aunt Nesibe was obliged to say, "Oh please don't be late!" several times. Only at five past ten was I able to leave the house.

No one stopped us on the way back, and after we were home safe I spent a long time thinking about the meaning of these dogs, and why I kept bringing them to the Keskins' only to remove them later; in fact, despite Aunt Nesibe's insistence that she'd noticed the disappearance immediately, it had taken them an astonishing eleven months to see that the dog was gone; it seemed to me that it had happened now only because of the coup, and the prevailing sentiment that we should all put our houses in order. Almost certainly, most of those dogs sitting on lace doilies atop the television were holdovers from the days when dogs sat on radios. As people listened to the radio, their heads would naturally turn toward it, and then their eyes would seek out something for distraction, something that offered solace. After radios gave way to televisions as the altars for family meals, the dogs were transferred to the tops of television sets, but now, with all eyes glued to the screen, no one noticed these little creatures anymore. I could take them away whenever I pleased.

Two days after that evening, I brought two china dogs to the Keskins.

"I was walking through Beyoğlu today when I saw these in the Japanese Market," I said. "It's almost as if they were designed to sit on our television."

"Oh, what a lovely pair they make," said Aunt Nesibe. "But why did you go to such trouble, Kemal Bey?"

"I was sorry about the one with the black ears going missing," I said. "Actually, I used to worry that he was lonely, sitting up there on the television. When I saw how happy these two were together, I said to myself that it would be nice to have a frisky pair of dogs up there on the television."

"Were you really worried the dog was lonely up there, Kemal Bey?" said Aunt Nesibe. "What a curious man you are. But that's why we love you."

Füsun was smiling tenderly at me.

"I get upset to see things thrown away and forgotten," I said. "They say the Chinese used to believe that things had souls."

"Before we Turks came here from Central Asia, we spent a huge amount of time with the Chinese; there was something about this on television just the other day," said Aunt Nesibe. "You weren't here that evening. Füsun, do you remember the name of the program? Oh, you've put the dogs where they belong, and don't they look lovely. But do you think they should be facing each other, or looking at us? Right now I just can't make up my mind."

"The one on the left should face us, and the one on the right should face his friend," Tarık Bey said suddenly.

Sometimes, at the strangest moment in a conversation, when we all thought he wasn't even listening, Tarık Bey would suddenly make a judicious comment that showed how he grasped the details even better than we did.

"If we do it like that, the dogs can be friends, and they won't get bored, but they'll also keep an eye on us, and be part of the family," he continued.

As much as I longed to touch them, I kept my hands off those dogs for more than a year. By 1982, the year I finally took them away with me, I had begun to leave money in a discreet corner to cover the cost of the things I took, or else I would bring over some quite expensive replacement the very next day. During those last years, many strange objects of the same form but different function—dogs that were also pincushions, and dogs that were also tape measures—had their time on top of the television.

66

What Is This?

FOUR MONTHS after the coup we were on our way home from the Keskins' one night when, fifteen minutes before curfew, Çetin and I were stopped by soldiers checking people's identity cards on Sıra-selviler Avenue. I was stretched out comfortably on the backseat, and as all my papers were in order I had nothing to fear. But as he took my identity card from me, the soldier gave me a dubious look. When I saw his eyes light upon the quince grater at my side, I grew nervous.

By instinct, or by force of habit, I'd picked up the grater at the Keskins' when no one was looking. It made me so happy that I'd been able to leave early without making too much of an effort, and, just before this, I'd taken the prize out of my coat pocket, like a hunter wishing to cast a proud look over a woodcock he'd just bagged, and I'd left it sitting on the seat beside me.

The moment I'd arrived at the Keskins' house that evening, I'd breathed in the lovely fragrance of quince jelly. While we were talking about this and that, Aunt Nesibe mentioned that she and Füsun had been boiling the fruit all afternoon over a low flame, and that they'd had a nice mother-daughter chat. It pleased me to imagine how, while her mother was busy with something else, Füsun had slowly stirred the jelly with a wooden spoon.

After inspecting their occupants' identity cards, the soldiers let some cars continue on their way. In other cases they ordered all the passengers out of the car and subjected them to careful body searches.

Çetin and I got out of the car as ordered. They studied our identity cards carefully. We complied when directed to place our hands on the Chevrolet, like culprits in a film. The two soldiers searched the glove compartment and looked under the seats and everywhere else. The sidewalks of Sıraselviler Avenue, hemmed in on both sides by apartment houses of some height, were wet, and I remember, too, that quite a few passersby turned to look at us. As the curfew drew closer and no

people remained in the streets, I could see just ahead that the lights were out in the windows of Sixty-Six, the famous brothel that took its name from its street number, and that, in our last year of lycée, everyone in my class had visited. Mehmet knew quite a few of the girls.

"Whose is this?" asked one of the soldiers.

"It's mine," I said.

"What is it?"

I suddenly realized that I would be unable to say that it was a quince grater. If I did, it seemed to me they would instantly understand that I was obsessed with Füsun and had for years been visiting four or five times a week the house she shared with her family, such a hopeless and humiliating situation as to oblige them to see me as a man with strange inclinations, harboring evil. My head was foggy after an evening of clinking *rakı* glasses with Tarık Bey, but when I think back on this episode so many years later, I do not believe this was the reason for my miscalculation. Only a few minutes earlier this quince grater had been part of the Keskins' kitchen, and now it seemed so incongruous in the hands of this well-meaning officer from (I thought) Trabzon, that it unexpectedly sounded a deeper chord—something to do with living on this earth, and being human.

"Is this thing yours, sir?"

"Yes."

"What is it then, brother?"

Again I fell silent, surrendering to despair—a new symptom of paralysis; I wanted this soldier, this brother of mine, to understand the wrong I had done without my telling him, but it wasn't to be.

I'd had a classmate in primary school who was odd and rather stupid. Whenever the teacher called him up to the blackboard to ask if he'd done his math homework, he would fall silent just as I had done now, refusing to say yes or no; so weighed down was he by guilt and failure that he could only stand there, shifting his weight from one leg to the other, until the teacher went mad with fury. What I did not understand as I watched him with such amazement in that classroom was that if a person were to fall into such a silence even once, it would never again be possible for him to open his mouth; he would remain silent for years, even centuries. When I was a child, I was happy and

free. But that night on Sıraselviler Avenue, so many years later, I discovered what it meant to be unable to talk. I had already had intimations that my passion for Füsun would ultimately turn into such a story of stubborn introversion. My love for her, my obsession, or whatever one could call it—it had rendered me incapable of diverting myself onto a path that would lead me to sharing this world freely with another. Even in the early days I'd known deep in my heart that mutuality could never happen in the world I've been describing, and so I'd turned inward, to seek Füsun there. I think that Füsun knew, too, that one day I would find her inside me. In the end everything would be fine.

"Officer, that is a grater," said Çetin Efendi. "An ordinary quince grater."

How had Çetin recognized the grater?

"So why couldn't he tell me that himself?" He turned to me. "Look, we're under martial law here. . . . Are you deaf or what?"

"Officer, Kemal Bey is so sad these days. . . ."

"Why is that?" asked the officer, though his job left no room for compassion. "Get back in the car and wait!" he barked. Then he walked away holding the quince grater and our identity cards.

The grater sparkled for a moment in the glare of the bright lights of the cars waiting behind us, before I saw it disappear inside the small army truck just ahead of us.

Inside the Chevrolet, Çetin and I began to wait. The closer it got to curfew, the faster people were driving by, and in the distance we saw cars racing around the corners of Taksim Square. The silence between us was further laden with the fear and guilt that I felt whenever I was searched or my card was being checked or I was simply in the presence of the police. We listened to the car clock ticking, and to keep the silence we remained perfectly still.

I imagined the grater being pawed by a captain inside the truck, and it made me uneasy. As I sat there waiting in silence, I was slowly swamped by anxiety, imagining the pain I would suffer should those soldiers confiscate the quince grater; even years later I would vividly remember how intense this anxiety was. Çetin turned on the radio. Announcers were reading out various bulletins related to the state of

martial law: the wanted list, the prohibitions, the list of suspects who had been caught. . . . I asked Çetin if he could change the station. After a bit of crackling we were able to find a more agreeable program from a distant country. As we tried to distract ourselves, a few drops of rain fell onto the windshield.

Twenty minutes after the beginning of the curfew, one of the soldiers came back and handed us our identity cards.

"It's all settled. You can go," he said.

"What if someone stops us for being out after the curfew?" Çetin asked.

"You can say we stopped you," said the soldier.

Çetin started the engine. The soldier cleared the way for us. But I stepped out of the car and went over to the army truck.

"Sir, I think you still have my mother's quince grater. . . ."

"Now look at that, it turns out you aren't deaf and dumb after all, and look how beautifully you speak."

"You can't keep this on your person, sir, it could be used as a weapon and cause serious injury!" said another soldier, one of higher rank. "But fine, take it, just be sure you don't bring it out with you again. What line of work are you in?"

"I'm a businessman."

"Do you pay your taxes on time?"

"I do."

They didn't say anything more. I'd suffered a little heartbreak, but I was glad to be reunited with the grater. As Çetin drove us home, slowly and carefully, I realized I was happy. These dark, empty streets that now belonged to Istanbul's dog packs, these avenues so ugly by daylight, hemmed in by concrete apartment buildings in such dreadful condition that it sapped my will just to look at them—now they looked alluringly mysterious, like poems.

67

Cologne

IN JANUARY 1981, over lunch at Rejans, Feridun and I talked business as we drank our *rakı* and ate our bluefish. Feridun was making commercials with Yani, a cameraman he knew from the Pelür, and while that caused me no misgivings, he was upset about doing such work "for the money." Having observed the precocious ease with which Feridun had mastered the art of always looking comfortable and taking life's pleasures as they came, I might at one time have found it hard to understand his moral qualms; but because suffering had caused me to mature beyond my years, I had come to realize that most people are not what they appear.

"I have a screenplay that's ready to go," Feridun said then. "If I'm going to work for the money, it would be better to be working on that. It's a little crude but it has good prospects."

It was at the Pelür Bar that I'd first heard screenplays described as "ready" or "absolutely ready" to be filmed; it meant that the screenplay had passed the board of censors or had been granted all the permissions from the state that would guarantee its safe passage. In times when very few screenplays with popular appeal passed the censors, directors and producers whose livelihood depended on making one or two films a year were prepared to shoot screenplays they'd not even considered, provided they were "ready." Over many years of the board's smoothing over the edges, and cutting the prickly bits out of everything that was interesting or original, films had assumed a dreary uniformity, and so for most directors it was no hardship to make a film about which they knew nothing.

"Is the plot suitable for Füsun?" I asked Feridun.

"Not in the slightest. It's a very suggestive role, perfect for Papatya. The actress will have to wear revealing clothing, and she also has to strip. Plus the leading man has to be Tahir Tan."

"It can't be Tahir Tan."

We bickered for some time about Tahir Tan, as if the heart of the matter were not our using Papatya instead of Füsun in our first film together. "Let us not be ruled by emotions!" Feridun said, insisting the time had come to forget the incident at the Huzur Restaurant. Suddenly our eyes met. How much was he thinking of Füsun at that moment? I asked what the film was about.

"A rich man seduces a beautiful girl who happens to be his distant relation, and then he abandons her. The girl, having lost her virginity, takes her revenge by becoming a singer. . . . As it happens, the songs were written for Papatya. . . . Hayal Hayati was going to make this film, but when Papatya refused to become his slave he got angry and pulled out. The screenplay was left in the lurch. It's a great opportunity for us."

The screenplay, songs, and all else about this film were so bad as to be not just unsuitable for Füsun but a discredit to Feridun. Though my beauty had been sulking through every supper, bolts of lightning flashing in her eyes whenever she looked at me, I thought there might be a virtue in making Feridun happy, at least, and so before the lunch was over, encouraged by the *rakı,* I agreed to back the film.

In May 1981 Feridun began to shoot his "ready screenplay," called *Broken Lives,* after the eighty-year-old novel of the same name by Halit Ziya; but there the resemblance ended, for this tale of love and family ties in the Ottoman mansions of the Westernized bourgeoisie and the imperial elite was a world away from the screenplay set in the muddy streets and *gazino*s of 1970s Istanbul. Sustained only by rage and pure will, our heroine (played by Papatya, who earnestly threw herself into the part) becomes famous for the love songs she performs in the *gazino*s as she devotes many patient years to plotting her revenge against the man who took her virginity; unlike the heroine of the novel, she is miserable not because she is married but because she cannot marry.

We began filming in the old Peri Cinema, in those days the location favored for all films with scenes in nightclubs offering traditional music. The theater seats had been taken out and tables put in to make the place look like a *gazino.* The cinema's stage was wide and deep, if not quite as large as the one at Maksim's, the largest indoor *gazino* of the day, or the Çakıl Gazino, which was housed in a large tent in Yeniköy. From the 1950s through the 1970s there were many such

places, modeled on French cabarets, where patrons might eat and drink while being entertained by a lineup of singers, comics, acrobats, and magicians; they featured Turkish singers with Western as well as traditional repertoires, and many musical melodramas were filmed in them. Typically it was in the *gazino* that the heroine would first make a florid confession of her consuming pain, and when, years later, she drew wild applause and tears from another audience, it would be understood that she had achieved victory in the *gazino* as well.

Feridun had explained to me the various ploys Yeşilçam used to avoid paying the extras in scenes where wealthy spectators applauded impoverished singers pouring their hearts out; in the old days, real singers like Zeki Müren and Emel Sayın would usually play themselves in such musicals, and the filmmakers would admit anyone in a jacket and tie who knew how to sit quietly and politely at a table. The *gazino* would be packed with people eager for a free show, in return serving free as extras. But in recent years filmmakers had begun to use lesser-known actresses like Papatya in musicals. (These young starlets would play singers much more famous than they themselves were, but after one or two films the gap between the film and real life would close, whereupon they could begin to star in films about impoverished singers much less famous than they now were. Muzaffer Bey had once told me that Turkish audiences would quickly tire of anyone who was as rich and famous in real life as represented in films; a film's secret power derived from the discrepancy between the star's real-life circumstances and her character in the film. The very point of the film being, after all, to show how that gap was closed.) As we could find no one willing to put on their best clothes to come to the dusty Peri Cinema and see a minor singer they'd never heard of, free kebabs were offered to any man who turned up wearing a tie and to any woman not wearing a headscarf. In the old days, whenever we were together with our friends or out on the town, Tayfun had always enjoyed making fun of the Turkish films he'd seen over the summer in garden cinemas; after mimicking the affectations and phony gestures of poor extras trying to play the rich spectators with full stomachs, he would, with the genuine pique of someone wronged, insist that rich people in Turkey were nothing like that.

Before we even began filming, I knew from Feridun's stories of his

days as an assistant that cheap extras caused problems far more serious than misrepresenting the rich. Some would try to leave once they'd finished their kebabs, while others sat at their tables reading the newspaper, or carried on joking and laughing with their fellow extras even as the singer star uttered her most affecting lines (though this last detail was at least true to life); some simply grew tired of waiting and fell asleep at their tables.

When I visited the set of *Broken Lives* for the first time, the set manager, his face flushed with anger, was scolding the extras for looking into the camera. For a time I was surveying the proceedings from a distance, like any film producer, when I heard Feridun shout "Action!" Then there was a flash of the crude magic—half fairy tale, half vulgarity—that you see so often in Turkish films, as Papatya stepped down the catwalk, microphone in hand, flanked on either side by the audience.

Five years earlier I had gone with Füsun and Feridun to a garden cinema near İhlamur Palace to see a film also starring Papatya, this time as a golden-hearted little girl who, being also shrewdly diplomatic, finds a way to reconcile her parents, who'd separated following a misunderstanding; now (with a speed indicating the fate of all Turkish children) she had been transformed into one of life's angry, long-suffering victims. Papatya had slipped into the traditional role of the tragic woman—luckless and robbed of her innocence, and destined only for death—as she might slip into a dress that had been tailor-made for her. It was when I remembered Papatya's former childish innocence that I could understand her now, just as I could recognize that childish innocence when I saw the tired, angry woman she had become. Accompanied by a nonexistent orchestra—Feridun would fill in with clips from other films—she walked through the scene with the certainty of a model, with a hopelessness that seemed almost to rebel against God, and a lust for vengeance so great that we could not but share in her grief, recognizing that, rough as she was, Papatya was a jewel. Dozing extras came back to life, and when the filming began even the waiters who had been bringing out the kebabs stopped to watch her.

In those years, every star held the microphone in a particular way meant to express their personality; that Papatya had found her own new and original way, which made her fingers look like pincers, was

proof, according to one journalist I'd met at the Pelür, that she was destined for stardom. *Gazino*s had stopped using fixed microphones, preferring the newer ones connected to long cords that allowed singers to mingle with the audience. But this improvement presented its own problems: Though divas were able to be more expressive, enhancing the lyrics with defiant and bitter gestures, and sometimes even with real tears, they had to yank at the long cord like housewives struggling with a vacuum cleaner. In fact, Papatya was just lip-synching, and the microphone wasn't attached to anything, but still she had to pretend that the cord kept getting stuck in order to show herself adept at managing this little difficulty with small, elegant gestures. It was the same admiring journalist who later likened these gestures to those of young girls swinging a jump rope for their friends.

The filming was progressing fast, and at the next break I congratulated Feridun and Papatya. Even as I uttered these words I heard myself sounding like the producers I'd read about in newspapers and magazines. Maybe this was because journalists took notes! Meanwhile, Feridun had begun to resemble the directors one read about: The chaotic speed of filming having robbed him of his childish air, in two months it was as if he'd aged ten years, and he now looked every bit the strong, resolute, and even merciless sort of man who always finished what he started.

That day also brought my first intimation that Feridun and Papatya might be in love, or at least involved in a serious relationship, though I wasn't absolutely certain. Whenever journalists were around, all stars and starlets made as if they were conducting secret love affairs. Or was there perhaps something about the gaze of magazine journalists that was so suggestive of sin, guilt, and the forbidden as to compel actors and filmmakers to transgress? When they started taking pictures, I kept my distance, and as scarcely a week went by without Füsun picking up a copy of *Ses* or *Hafta Sonu*, which gave so much coverage of film news, I predicted that she would soon be reading something about Feridun and Papatya. Papatya might just as likely imply that she was having an affair with her leading man, Tahir Tan, or even with me—the producer! Anyway there was no need for independent insinuations: Magazine and film page editors having decided what version would sell best would invent an intrigue, embroider it, and gleefully write it up. Sometimes

they would propose their false story to the actors openly, and the actors would gamely help them by providing a suitable "intimate pose."

I was glad to have kept Füsun away from the sordid ambience of such people, but at the same time it saddened me somehow that she would be deprived of the excitement of working on the set, which she craved almost as much as fame. And because, in fact, after a woman had played many variations on the fallen woman, in films and in real life—for audiences, the two were one, after all—after life had knocked her about a bit, a famous film star could settle down to play respectable matriarchs and conduct the rest of her career like a lady. Could Füsun have been dreaming of some such course? If so, would she first need to find herself a sugar daddy from the underworld or some equally tough, moneyed adventurer inclined to that sort of liaison? The moment such men began affairs with stars, they would prohibit them from all kissing in films, and likewise from exposing too much skin. Lest readers and visitors in future centuries misunderstand, let me clarify that by "exposing" I mean the baring of their shoulders and lower legs. Once a sugar daddy took a star under his wing, he also imposed an immediate ban on all rude, degrading, or snide news pieces about her. Once a younger reporter was shot in the knees because, unaware of the ban, he wrote a story about a large-breasted star then under such august protection, claiming that when still young enough to be a schoolgirl, she had worked as a dancer and had been the mistress of a famous industrialist.

It was painful to remember that, less than ten minutes from the Peri Cinema, Füsun was sitting idle at home in Çukurcuma, even as I enjoyed watching the filming, which would go on all day, right up until the curfew. It alarmed me to think that if my place at the Keskins' table remained empty, Füsun would infer I preferred being in the film world to an evening in her company. So in the evenings, after leaving the Peri Cinema, I would walk down the cobblestone hill to the Keskins' house, urged on by guilt and the promise of happiness. Füsun would be mine in the end, I reasoned; I'd done well to keep her out of films.

Sometimes it would occur to me that ours was a companionship of knowing shared defeat: This made me even happier than love did. Whenever I felt this, everything—the shafts of evening sun on the city streets; the odor of dust, age, and mildew wafting from the old Greek

apartment buildings; the vendors selling fried liver and pilaf with chick-peas; the football bouncing between the boys playing on the cobble-stones; and the mock applause when I recovered a strong ball for them on my way down to the Keskin house—everything in the world made me happy.

In those days, everyone in the city—whether on the film set or in the hallways of Satsat, at the coffeehouses or at the Keskins' dinner table—was talking about the exorbitant interest rates being offered by opportunists setting themselves up as "bankers." With the inflation rate nearing 100 percent, everyone wanted to invest his money some-where. Just before we sat down to eat, Tarık Bey told me that at the neighborhood coffeehouse he visited on occasion, there were a few who had bought gold at the Covered Bazaar, and others who had deposited their savings with bankers promising as much as 150 percent interest, but that everyone else was selling their gold and closing their bank accounts; gingerly, uneasily he sought out my counsel as a busi-nessman.

What with the filming and the curfew, Feridun was seldom home, and he gave Füsun none of the money I'd put into Lemon Films. It was around this time (about a month earlier I'd taken away an old deck of cards belonging to Tarık Bey, scarcely concealing my action) that I stopped replacing the things I took and instead began to leave money.

I knew that Füsun read her fortune with those cards to pass the time. When Tarık Bey played bezique with Aunt Nesibe, he used a dif-ferent deck, as did Aunt Nesibe when, once in a blue moon, she played cards with a guest (poker with peas, or even seven jacks). A number of cards in the deck I "stole" were dog-eared, and their backs were stained; some of the cards were even bent and broken. Füsun was amused to admit that because she could recognize some of these cards by their marks and stains, she could make her fortune come up accord-ing to her wishes. I'd sniffed the deck, breathing in the mixture of per-fume, mildew, and dust particular to old cards, picking up the scent of Füsun's hand. The deck and its scent made my head spin, and as Aunt Nesibe had noticed my interest, I slipped it into my pocket in plain view.

"My mother tries to read her fortune, but it never works out," I said. "This deck seems to offer more favorable results. Once she gets to

know the stains and creases, perhaps my mother will have better luck. She's been very low lately."

"Please send my best regards to Sister Vecihe," said Aunt Nesibe.

After I'd promised to buy a new deck from Alaaddin's shop in Nişantaşı, she spent a good while insisting that I "should not go to all that trouble." When I insisted, she did allow that a certain new set had caught her eye in Beyoğlu.

Füsun was in the back room. Feeling very ashamed, I took a roll of cash from my pocket and hid it on the sideboard.

"Aunt Nesibe, would you please buy two of those sets, one for yourself and one for my mother? She will be happy to receive a deck of cards if they come from this house."

"Of course," said Aunt Nesibe.

Ten days later, and again feeling strangely ashamed, I left another wad of bills in the place from which I'd taken a new bottle of Pe-Re-Ja cologne.

During the first few months I was sure that Füsun had no idea that I was replacing objects with money. In fact, I'd been taking cologne bottles from the Keskin household for years and storing them at the Merhamet Apartments. But these were either empty or almost empty bottles, and so bound to be discarded soon anyway. No one but the children who played with them in the street had any interest in empty bottles.

Whenever I was offered cologne after supper, I would eagerly, even hopefully, rub it into my hands, my forehead, and my cheeks, as if anointing myself with some unction. When Füsun or her parents were offered cologne, I would watch enchanted as they each performed their own rituals. Never taking his eyes off the television, Tarık Bey would slowly and noisily unscrew the heavy bottle's cap, and we all knew that soon, at the next commercial break, he would hand the bottle to Füsun saying, "See if anyone would like some." First Füsun would pour cologne into her father's hands, and Tarık Bey would rub it into his wrists with therapeutic purposefulness, inhaling the fragrance deeply, like someone recovering from shortness of breath, a relief renewed for the rest of the evening by sniffing now and again the tips of his long fingers. Aunt Nesibe would take only a few drops, and with dainty ges-

tures reminiscent of my mother's, she would make as if she were lathering an imaginary bar of soap between her palms. If he was at home, it would be Feridun who took the most cologne when his wife offered it, cupping his hands like a man dying of thirst, slapping it on his face as if intending to gulp it down. This range of gestures led me to feel that cologne had a meaning beyond its pleasant smell and cooling effect (especially since the same rituals were performed on cold winter evenings).

Like the cologne the driver's assistant offered each and every traveler at the beginning of a bus journey, our cologne reminded us that as we gathered around the television we belonged to one another, that we shared the same fate (a sentiment also suggested by the evening news), that even though we were meeting together in the same house to watch television every evening, life was an adventure, and there was a beauty in doing things together.

I sat impatiently when my turn came, waiting for Füsun to pour cologne into my hands, and for our eyes to meet. We would look deeply into each other's eyes, like two who had fallen in love at first sight. As I smelled the cologne in my hands, I would never look at them, but continue to look deep into her eyes. Sometimes the intensity, determination, and love visible in mine would make her smile, a hint of a smile that would not soon leave the corners of her lips. In that smile I saw a tenderness as well as a derision inspired by my ardor, my evening visits, and life itself, but it didn't break my heart. Rather I would feel more love for her than ever, and so I'd want to take the cologne, this bottle of Altın Damla, Golden Drops, home with me, and a few visits later, when the bottle was almost empty, I would walk over to my coat, hanging near the door, and without stealth slip the bottle into my pocket.

During the filming of *Broken Lives,* as I walked from the Peri Cinema to Çukurcuma at around seven in the evening, just before nightfall, I sometimes felt as if I were reliving a little piece of a former life. In the first life that I was now repeating exactly, there had been no great sorrow, nor any great happiness, and a heavy melancholy was blackening my soul. Perhaps this was because I'd seen the end of the story and knew that no great victory or extraordinary bliss awaited me. Six years after falling in love with Füsun, I was no longer someone who thought

of life as a pleasurable adventure, indeterminately full of possibility: I was on the verge of becoming a sad and dejected man. I was slowly being overtaken by the fear of having no future.

"Füsun, shall we look at the stork?" I asked during those spring evenings.

"No, I haven't touched it since last time," said Füsun listlessly.

Once Aunt Nesibe interrupted us to say, "Oh, how can you say such a thing? Why, when last I saw it that stork took off from our chimney and flew so high into the air—Kemal Bey, from where it is now you could see all of Istanbul."

"I'd love to take a look."

"I'm just not in the mood tonight," Füsun would say sometimes, in all honesty.

Then I would sense Tarık Bey's beating heart, and in his longing to protect his daughter, his sadness. It grieved me to think that when she uttered these words, Füsun was talking about not just that night, but about the dead end that was her whole life, and it was then that I decided to stop going to watch the filming of *Broken Lives*. Füsun's answer had also served as a reminder of the war she had been waging against me for many years; in Aunt Nesibe's looks, I could see that she was concerned for me as well as Füsun. The woes and worries of life had blackened our hearts, no less than the dark rain clouds gathering over Tophane had blackened the sky; feeling this, we would sink into a silence we had only three ways to remedy:

1. We'd watch television.
2. We'd pour more *rakı* into our glasses.
3. We'd light another cigarette.

68

4,213 Cigarette Stubs

DURING MY eight years of going to the Keskins' for supper, I was able to squirrel away 4,213 of Füsun's cigarette butts. Each one of these had touched her rosy lips and entered her mouth, some even touching her tongue and becoming moist, as I would discover when I put my finger on the filter soon after she had stubbed the cigarette out; the stubs, reddened by her lovely lipstick, bore the unique impress of her lips at some moment whose memory was laden with anguish or bliss, making these stubs artifacts of singular intimacy. For nine years Füsun smoked Samsuns, for which brand I gave up Marlboros soon after beginning to dine at the Keskins'. I used to buy Marlboro Lights from tombala men and the black market vendors in the backstreets, and I can recall a conversation with Füsun one night about how both Marlboro Lights and Samsuns were full-flavor cigarettes of a similar taste. Füsun claimed that Samsuns made one cough more, but I said that as we had no way of knowing how many poisons and other chemicals the Americans put into their tobacco, it was possible that Marlboros were even more harmful. Tarık Bey had not yet sat down at the table when, looking deeply into each other's eyes, we each produced a pack to offer the other a cigarette. For eight years I followed Füsun, chain-smoking Samsuns, but as I have no wish to set a poor example for future generations, let me not dwell lovingly on those seductive details that feature so prominently in old novels and films.

Once they'd been lit, our fake Marlboros, which were produced in the Socialist Republic of Bulgaria and smuggled into Turkey on ships and fishing boats, would burn—just like the real Marlboros produced in America—all the way to the end. But Samsuns would always flame out before that. The tobacco was coarse and moist, not ground well enough, and the cigarettes often contained what looked to be chips of wood, as well as undried lumps of the plant and thick-veined leaves. For this reason, Füsun was in the habit of softening the cigarette

before she smoked it by rolling it between her fingers, and over time I had acquired this habit, too, rolling my cigarette between my fingers, just as she did, before lighting up, and I loved it when our eyes met as we were both doing this.

During my first years with the Keskins, Füsun would smoke in a way as if to suggest she was half trying to hide it from her father. Covering her cigarette with the curved palm of her hand, and not using the Kütahya ashtray that her father and I used, but tipping her ashes onto the small saucer of a coffee cup, "without anyone seeing." Her father and Aunt Nesibe and I were heedless of where our smoke went, but when she had to exhale, Füsun would suddenly turn her head to the right, as if about to whisper a secret into the ear of the classmate sitting beside her, directing the fast cloud of dark blue smoke to a point far from the table. I loved to see her face clouding with guilt, panic, and affected shame: It reminded me of our math lessons, and I believed then that I would love her all my life.

The anxious adherence to the forms of deference that we associate with traditional families—sitting straight and never crossing one's legs or smoking or drinking in front of one's father—had over time slowly disappeared. Tarık Bey certainly saw his daughter smoking, but he didn't respond as one might expect a traditional father would, seeming content with the other gestures by which Füsun showed her respect. It was a great joy to study the myriad social refinements of which anthropologists seem to have so little understanding, and most especially these rituals that allowed families to act "as if" they were respecting tradition, even as they broke with it. This "as if" culture did not seem to me duplicitous: Whenever I watched Füsun making these sweet and lovely gestures, I would remind myself that I was only able to see the Keskins at all because every time I visited we all acted "as if" I wasn't sitting there as the suitor, as I truly was. I was able to see Füsun by reason of acting as if I were merely a distant relation come to visit, however frequently.

When I was not at the house, Füsun would smoke her cigarettes almost down to the filter, as I could tell from those butts she'd left around the house before I arrived. I always knew which ones were hers, not by the brand but rather by the way she'd stubbed them out, which bespoke her mood.

When I came for the evening, she would smoke her cigarettes as Sibel and her friends smoked their long, thin, stylish American "ultra-lights"—never smoking the whole cigarette but putting it out midway.

Sometimes she would stub it out with evident anger, sometimes with impatience. I had seen her stub out a cigarette in anger many times, and this caused me disquiet. Some days she would put out her cigarette against the surface of the ashtray with a series of short, insistent taps. And sometimes, when no one was looking, she would press it down hard, and very slowly, as if crushing the head of a snake, so that I would think that the collected resentment of her whole life was being expressed with this cigarette stub. At times, when watching television, or listening to the conversation at supper, when her mind was clearly elsewhere, she would snuff the cigarette without even turning her head to look. Quite often, if she needed to free her hand to pick up a spoon or a large pitcher, I would see her doing the job with one quick movement. When she was feeling joyous or glad, she would sometimes press what was left of the cigarette against the ashtray, extinguishing it with the sudden force of her forefinger, as if trying to kill an animal without causing it pain. If she was working in the kitchen, she would do as Aunt Nesibe did, removing the cigarette from her mouth and holding it for a moment under the tap before throwing it into the bin.

This variety of methods ensured that every cigarette to leave her hand had its special shape, and its own soul. Back in the Merhamet Apartments I would retrieve the butts from my pocket for careful examination, likening each to some other form. For example, I would see some as little black-faced people with their heads and necks smashed, their trunks made crooked by the wrongs others had done them; or I would read them as strange and frightening question marks. Sometimes I likened the cigarette ends to crayfish or the smokestacks of City Line ferries; sometimes I saw them as exclamation marks, one warning me to take heed of lurking danger of which another was an omen; or as just so much foul-smelling rubbish. Or I would see them as expressions of Füsun's soul, even fragments of it, and as I lightly passed my tongue over the trace of lipstick on the filter, I would lose myself in communion with her.

When those visiting my museum note that beneath where each of the 4,213 cigarette butts is carefully pinned, I have indicated the date of

its retrieval, I hope they will not grow impatient, thinking I am crowding the display cases with distracting trivia: Each cigarette butt in its own unique way records Füsun's deepest emotions at the moment she stubbed it out. See, for example, the three cigarette butts I collected on May 17, 1981, when the filming of *Broken Lives* began at the Peri Cinema: All are roughly bent, folded upon themselves, and compacted, perfectly recalling the terrible awkwardness of Füsun's silence that day, her refusal to say what was upsetting her, and her vain attempts to pretend nothing was wrong.

As for this pair of well-crushed butts, I trace one of them back to the evening we saw a film called *False Bliss,* which aired on television around that time, with our friend Ekrem from the Pelür (better known as Ekrem Güçlü, the famous star who had once played the prophet Abraham) as the hero. Füsun had stubbed out that cigarette just after he had intoned, "The greatest mistake in life, Nurten, is to want more, to try to be happy," while Nurten, his poverty-stricken beloved, cast down her eyes in silence.

Some stains on a few of the straighter butts come from the cherry ice cream Füsun ate on summer evenings. Kamil Efendi, the ice cream vendor, would trundle his three-wheeled pushcart through the cobblestone streets of Tophane and Çukurcuma on summer evenings, shouting *"Eye-es Gream!"* and slowly ringing his bell; in the winters he would sell *helva* from the same cart. Once Füsun told me that she'd seen Kamil Efendi's cart being repaired by Beşir, the man to whom she'd taken her own bicycle when she was a child.

When I look at another pair of cigarette butts and read the dates recorded beneath them, I think of other warm summer evenings, of fried eggplant with yogurt, of standing together with Füsun at the open window, she holding a small ashtray in one hand, repeatedly tapping her ash into it with the other. Whenever Füsun chatted with me in front of the window she would always affect this pose, and I would imagine her as a woman at a stylish party. Had she wished, she could have tapped the ash into the street, as I, like all Turkish men, did, or she could have stubbed out the cigarette on the windowsill before shooting it like a dart through the window; she could even have tossed it out still burning, with one flick of the hand, to watch it spiral down through the darkness. But no, Füsun would do none of these things, and I followed

her example of poise and elegance. Someone viewing us from afar might take us for a couple enjoying polite conversation in a European country, where men and women could be at ease together; he might imagine us at a party and assume we had retired to a quiet corner to get to know each other better. We would not look into each other's eyes; we would look through the open window, laughing as we chatted about the film we had just seen on television, or remarked on the oppressive summer heat, or the children playing hide-and-seek in the street below. Just then a light breeze would blow in from the Bosphorus, bringing a strong whiff of seaweed, which blended with the overpowering scent of honeysuckle, the fragrance of Füsun's hair and skin, and the pleasing smoke from this cigarette.

Sometimes, when Füsun was stubbing out her cigarette, our eyes would unexpectedly meet. If she was watching a love story, or engrossed in the endless succession of shocking events in a documentary about the Second World War, with a dirge playing in the background, Füsun would stub out her cigarette without ceremony, and without showing much intent. However, if, as in the case of this specimen, our eyes happened to meet, a charge passed between us, jolting us both, as we remembered at the same time why I was sitting at that table, and her stub would reflect the particular confusion she was feeling, thereby endowing the butt with an unusual shape. Hearing a ship blow its horn from a very great distance, I would then imagine the universe, and my life, as those aboard the ship might view it.

Some nights I would take only one cigarette butt away with me, and some nights I would take away a few; then at the Merhamet Apartments, picking them up one by one, I would recall various "moments" belonging to the past. Of all the objects I collected, it was the cigarettes that I found to correspond most truly to Aristotle's moments.

By now I no longer needed to pick up the objects accumulated in the Merhamet Apartments; I had only to see them once and I could remember the past Füsun and I had shared, the evenings we had spent together at the dinner table. I had associated each and every object—a porcelain saltshaker, a tape measure in the form of a dog, a can opener that looked like an instrument of torture, a bottle of the Batanay sunflower oil that the Keskin kitchen never lacked—with a particular moment, and as the years passed, it seemed as if these remembered

moments expanded and merged into perpetuity. And so looking at any of the things gathered in the Merhamet Apartments, even only to remember them, was like looking at the cigarette butts: one by one, they would recall the particles of experience until I had summoned up the entire reality of sitting at the dinner table with Füsun and her family.

69

Sometimes

SOMETIMES WE'D do nothing but sit there in silence. Sometimes Tarık Bey, tiring of the show—we all did on occasion—would begin to peer at the paper from the corner of his eye. Sometimes a car would clatter noisily down the hill, blowing its horn, and there would be a hush as we listened to it pass. Sometimes it would rain and we would listen to the raindrops against the windowpanes. Sometimes we would say, "How hot it is." Sometimes Aunt Nesibe, forgetting that she'd left a cigarette burning in the ashtray, would light up another in the kitchen. Sometimes I would discreetly stare at Füsun's hand for fifteen or twenty seconds, and feel my adulation grow. Sometimes, during the commercials, a woman would appear on the screen to acquaint us with something that we at the table were eating at that very moment. Sometimes there would be an explosion in the distance. Sometimes Aunt Nesibe would rise from the table to throw one or two more pieces of coal into the stove, or sometimes Füsun would do it for her. Sometimes I'd think that on my next visit I should bring Füsun a bracelet instead of a hair clip. Sometimes I would forget what a film was about even as we were watching it, and though I continued to watch, I would think about my primary school days in Nişantaşı. Sometimes Aunt Nesibe would say, "Why don't I brew some linden tea?" Sometimes Füsun yawned so beautifully that I would think that she had forgotten the entire world and that she was drawing from the depths of her soul a more peaceful life, as one might draw cold water from a well on a hot

summer day. Sometimes I would say to myself that I should not stay there a moment longer, that I should get up and leave. Sometimes, after the barber who worked until all hours in the shop on the ground floor across the street had sent off his last customer, he would lower his iron shutters very fast, and in the silence of the night the echo would reverberate throughout the neighborhood. Sometimes they'd cut off the water, and for two days we'd go without. Sometimes we would notice something other than flames flickering inside the coal stove. Sometimes I would come for supper two nights in a row, because Aunt Nesibe said, "You liked my beans in olive oil, so why don't you come again tomorrow, before they all get eaten up?" Sometimes conversation turned to the Cold War between America and the USSR—the Soviet warships that passed through the Bosphorus by night, and the American submarines that plied the Marmara. Sometimes Aunt Nesibe would say, "It's turned very hot this evening!" Sometimes I could tell from Füsun's expression that she was daydreaming, and I would long to visit the country in her imagination, although everything seemed hopeless—my life, my lethargy, and even the way I sat there. Sometimes the objects on the table looked to me like mountains, valleys, hills, depressions, and plateaus. Sometimes a funny thing happened on television, and we would all burst out laughing at once. Sometimes it would seem ridiculous the way we all got sucked into whatever was happening on the screen. Sometimes I was bothered by the way Ali the neighbor's child climbed onto Füsun's lap and nestled up to her. Sometimes Tarık Bey and I would discuss the vagaries of the economic situation, man to man, and in low voices that suggested conspiracies, deceptions, and dirty tricks. Sometimes Füsun would go upstairs and linger, which was upsetting. Sometimes the phone would ring, and it would be a wrong number. Sometimes Aunt Nesibe would say, "Next Tuesday I'm going to make candied squash." Sometimes a gang of three or four men would hurtle down the hill, yelling and singing football songs as they continued in the direction of Tophane. Sometimes I would help Füsun pour coal into the stove. Sometimes I would see a cockroach scurrying across the kitchen floor. Sometimes I would sense that Füsun had taken off her slipper underneath the table. Sometimes the watchman would blow his whistle right in front of the door. Sometimes Füsun would get up to tear off the forgotten pages of the *Saatlı Maarif Takvimi*

one by one, and sometimes I would. Sometimes, when no one was looking, I would take another spoonful of semolina *helva*. Sometimes the picture on the television would go fuzzy, and Tarık Bey would say, "Could you see what you can do, my girl?" and Füsun would fiddle with a button on the back of the set, while I watched the back of her. Sometimes I would say, "I'll smoke one more cigarette, and then I'll go." Sometimes I would forget Time altogether, and nestle into "now" as if it were a soft bed. Sometimes I felt as if I could see the microbes, bugs, and parasites inside the carpet. Sometimes Füsun would go to the refrigerator between programs and take out cold water, while Tarık Bey paid a visit to the bathroom upstairs. Sometimes they'd cook stuffed squash, tomatoes, eggplant, and peppers in clarified butter and eat it two nights in a row. Sometimes when supper was over Füsun would rise from the table, go over to Lemon's cage, and speak to him like a friend, and I would fantasize that she was really talking to me. Sometimes on summer evenings a moth would fly in through the open bay window and flutter faster and faster around the lamp. Sometimes Aunt Nesibe would mention an old piece of neighborhood gossip that she had only just heard, telling us, for example, that Efe the electrician's father was a famous gangster. Sometimes I would forget where I was and think we were alone together; I would forget myself and show Füsun all my love, gazing at her lovingly for the longest time. Sometimes a car passed so quietly its presence was announced only by the shuddering of the window. Sometimes we heard the call to prayer coming from Firuzağa Mosque. Sometimes, for no apparent reason, Füsun would rise from the table and go over to the window that looked down the hill, and stand there for a long while, as if waiting for someone she missed very deeply, and this would break my heart. Sometimes, while watching television, I would think of something very different, imagining, for example, that we were passengers who had met in the restaurant aboard a ship. Sometimes on summer evenings, after spraying the whole top floor with Temiz İş, Clean Work, Aunt Nesibe would come downstairs with the insecticide, to give those rooms "a quick once-over" and kill more flies. Sometimes Aunt Nesibe spoke about Süreyya, the former queen of Iran, of her anguish when the Shah divorced her for failing to give him an heir, and of her life in high society in Europe. Sometimes Tarık Bey would cry, "How could they put a disaster like

that man on television again?" Sometimes Füsun would wear the same outfit two days in a row, though to me it still looked different. Sometimes Aunt Nesibe would ask, "Does anyone want ice cream?" Sometimes I saw someone in the apartment across the way go to the window to smoke a cigarette. Sometimes we ate fried anchovies. Sometimes I observed that the Keskins sincerely believed there was justice in the world, and that the guilty were punished, if not in this life, then in the next. Sometimes we would fall silent for a long time. Sometimes we would not be the only ones: It would be as if the entire city had gone quiet. Sometimes Füsun would say, "Father, please don't pick at the food like that!" and then I would feel as if they couldn't even feel at home at their own table, because of me. Sometimes I would think the exact opposite, and I would delight in noticing that everyone seemed at ease. Sometimes, after lighting her cigarette, Aunt Nesibe would get so involved with whatever was happening on television that she would forget to blow on the match until it had burned her hand. Sometimes we would eat baked macaroni. Sometimes a plane would fly overhead in the black sky, headed toward the airport at Yeşilköy. Sometimes Füsun would wear a blouse that revealed her long neck and a bit of cleavage, and as I watched television it was all I could do not to stare at the whiteness of her lovely throat. Sometimes I would ask Füsun, "How's the picture going?" Sometimes the television would say "Snow tomorrow," but it wouldn't come. Sometimes an oil tanker would blow its mournful, anxious horn. Sometimes we'd hear gunshots in the distance. Sometimes the next-door neighbor slammed his front door so hard that the cups in the cupboard behind me rattled. Sometimes the phone would ring and Lemon, mistaking it for a female canary, would begin to sing with joy, and we would all laugh. Sometimes a couple would come to visit, and I would feel a bit shy. Sometimes when the Üsküdar Musical Society Women's Chorus was performing old Turkish songs on television, Tarık would join in without leaving his seat. Sometimes two cars would meet nose to nose in the narrow street, and with both drivers too stubborn to give way, an argument would begin, with curses flying, and before long the two would have stepped out of their cars to fight. Sometimes there would be a mysterious silence in the house, the street, the entire neighborhood. Sometimes I brought them salted fish as well as cheese pastries and smoked fish. Sometimes we

would say, "It's awfully cold today, isn't it?" Sometimes, at the end of a meal, Tarık Bey would reach into his pocket with a smile and bring out a few Ferah brand peppermint sweets and offer them to us all. Sometimes two cats at the door began to wail wildly, and then they would screech and begin to claw at each other. Sometimes at supper Füsun would wear the earrings or the brooch I had brought her that very day, and I would tell her in a low voice how well she looked. Sometimes we were so affected by the reunions and kisses in love stories that it was as if we had forgotten where we were. Sometimes Aunt Nesibe would say, "I put very little salt in this, so, please, whoever wants more, add more if you wish." Sometimes we'd see lightning in the distance, and the sky would rumble. Sometimes while we were watching a film, or a series, or a commercial, someone we knew from the Pelür would appear, someone we'd joked about, and I'd want to exchange looks with Füsun, but she would avert her eyes. Sometimes there'd be a power outage and we could see our cigarette embers in the dark. Sometimes someone would pass the front door whistling a familiar tune. Sometimes Aunt Nesibe would say, "Oh, I've smoked too many cigarettes this evening." Sometimes my eyes would fix on Füsun's neck, and for the rest of the evening I would make a point of not looking at it again, without too much trouble. Sometimes we'd suddenly fall silent, and Aunt Nesibe would say, "Someone has just died somewhere." Sometimes Tarık Bey would be unable to get one of his new lighters to work, and I could tell it was time to bring him a new lighter as a present. Sometimes Aunt Nesibe would bring out something from the refrigerator and ask us what had happened in the film while she'd been away. Sometimes, just across Dalgıç Street, we'd hear a domestic quarrel, and the screams as the husband beat the wife would upset us. Sometimes on winter nights we'd hear the *boza* seller ringing his bell, crying, "Genuine *vefaa!*" as he passed our door, and I would have the urge to drink some. Sometimes Aunt Nesibe would say, "Aren't you a bundle of joy today!" Sometimes I'd try very hard not to reach over and touch Füsun. Sometimes, especially on summer evenings, a breeze would stir, slamming the doors. Sometimes I thought about Zaim, and Sibel, and all my old friends. Sometimes flies would land on our food on the table, annoying Aunt Nesibe. Sometimes Aunt Nesibe would take mineral water out of the refrigerator for Tarık Bey and ask me, "Would you like some, too?"

Sometimes, before it had even turned eleven, the watchman would pass by blowing his whistle. Sometimes I was overcome by an unbearable longing to say, "I love you!" when all I could do was offer Füsun a light. Sometimes I would notice that the lilacs I had brought on my last visit were still sitting in a vase. Sometimes amid a silence someone in one of the neighboring houses would open a window and toss out rubbish. Sometimes Aunt Nesibe would say, "Now who is going to eat this last meatball?" Sometimes while watching the generals on television I would remember my army days. Sometimes I would be utterly convinced that I was not the only inconsequential one; it was all of us. Sometimes Aunt Nesibe would say, "Who can guess what we have for dessert today?" Sometimes Tarık Bey would have a coughing fit and Füsun would get up to fetch him a glass of water. Sometimes Füsun would wear a pin I'd bought her years earlier. Sometimes I'd begin to think what I was watching on television had a subtext. Sometimes Füsun would ask me a question about an actor, literary luminary, or professor we saw on television. Sometimes I helped take the dirty plates into the kitchen. Sometimes there was a silence at the table, because all our mouths were full of food. Sometimes one of us would yawn, somehow inducing another of us to do the same, until having all caught the contagion we would laugh. Sometimes Füsun would become so engrossed in the film on television that I'd long to be that film's hero. Sometimes the smell of grilled meat would linger in the house all evening. Sometimes I thought I was abundantly happy, just to be sitting next to Füsun. Sometimes I would say, "It's about time we went out to eat on the Bosphorus one evening," to encourage the making of plans. Sometimes I was absolutely positive that life itself wasn't somewhere else, but right there, at that table. Sometimes we'd argue about something—the lost royal cemeteries of Argentina, the gravity on Mars, how long a person could hold his breath underwater, why it was dangerous to ride motorcycles in Istanbul, the shape of chimney rocks in Capadocia—prompted by nothing more than something we'd seen on television. Sometimes a harsh wind would blow, and the windows would moan, and the stovepipes would clank ominously. Sometimes when Tarık Bey recalled how, five hundred years earlier, Mehmet the Conqueror's galleys had passed Boğazkesen Avenue, only fifty meters from where we were sitting, on their way to the Golden Horn,

he would say, "And the man was only nineteen years old!" Sometimes Füsun would rise from the table after supper and go over to Lemon's cage, where after a moment I would join her. Sometimes I would say to myself, "It's good that I came here tonight!" Sometimes Tarık Bey would send Füsun upstairs to fetch the newspaper, the lottery ticket, or his spectacles, or whatever else he had forgotten there, and Aunt Nesibe would call up the stairs, saying, "Don't forget to put out the lights!" Sometimes Aunt Nesibe said we could go to Paris to attend a distant relation's wedding. Sometimes Tarık Bey would say, "Quiet!" in a forceful voice, and, gesturing with his eyes, direct our attention to a noise coming through the ceiling, and we would be unable to tell whether the creaks we had heard were from a mouse or a burglar. Sometimes Aunt Nesibe would ask her husband, "Is it loud enough for you, darling?" because as time went on, Tarık Bey was slowly losing his hearing. Sometimes the silence that consumed us would have a mysterious air. Sometimes it would snow, and it would stick on the window frames and on the sidewalk. Sometimes there were fireworks, and we would all rise from the table to see whatever we could of the colors streaming across the sky, and later, the smell of gunpowder wafted through the open window. Sometimes Aunt Nesibe would ask, "Shall I fill your glass, Kemal Bey?" Sometimes I would say, "Shall we have a look at your painting, Füsun?" and we would go into the back room, and as Füsun and I looked at her painting, I realized this was the time when I was always happy.

70

Broken Lives

A WEEK after the curfew was pushed back to eleven o'clock, Feridun made it home with just half an hour to spare. For some time he had not been coming home at night, saying the shooting had run late and he had slept on the set. That night he came in drunk, and very obviously miserable. Seeing us sitting at the table, he forced himself to utter a few

pleasantries, but he couldn't keep it up for long. When his eyes met Füsun's, he took on the air of a soldier just returned from a long and disastrous campaign, and saying little more he went upstairs to his room. Füsun should have risen from the table and followed her husband up, but she didn't.

I had fixed my eyes on hers and was watching her carefully. She knew my eyes were on her. She lit a cigarette, smoking it casually, as if nothing had happened. (She no longer took care to blow the smoke to one side, having lost the old pretense of shame to be smoking in front of her father.) She stubbed it out without much expression. I suddenly found myself unable to stand up, an affliction from which I thought I'd recovered, but here it was as if it had never left me.

At nine minutes to eleven, as Füsun placed a new Samsun between her lips, a bit more deliberately than usual, she gave me a long, cautious look. We told each other so much with our eyes at that moment that I felt as if we had been talking freely all evening. Of its own accord, my hand reached out, and I lit the cigarette between her lips. For a moment Füsun did what Turkish men only see in foreign films, touching the hand that was holding the lighter.

I, too, lit a cigarette, smoking it slowly, as if nothing out of the ordinary had happened. With every moment I felt the curfew drawing closer. Aunt Nesibe was fully aware of what was going on, but, frightened by the seriousness of the situation, she didn't say a word. As for Tarık Bey, he, too, almost certainly realized how strange a turn things had taken, but he couldn't quite figure out whether he needed to pretend he hadn't noticed. I left the house at ten past eleven. I think this was the night that the idea dawned on me that Füsun and I would in fact marry. I was so ecstatically happy to realize that Füsun would prefer me in the end that I forgot what great jeopardy I had put myself in, and Çetin, too, by going out into the streets after the curfew. After dropping me off in front of the house in Nişantaşı, Çetin Efendi would leave the car at a garage on Nigâr the Poetess Street, only a minute's drive away, and from there he would have to walk through the backstreets to his home in the old shantytown nearby, trying to avoid detection. But I was too happy that night to worry, and like a child I couldn't sleep.

Seven weeks later, during the premiere of *Broken Lives* at the Palace

Cinema in Beyoğlu, I was with the Keskins at the house in Çukurcuma. As the wife of the director, Füsun should naturally have attended the premiere, as I should have done, being the producer and owning more than half of Lemon Films, but neither of us did. Füsun needed no excuse, as she and Feridun weren't talking, her husband having scarcely been home that summer: Almost certainly he was living with Papatya. He'd drop by the house in Çukurcuma every other week to collect a few things from his room—a shirt, or a book. I would hear of these visits only indirectly, from Aunt Nesibe's hints and asides, but despite my extreme curiosity, I dared not raise this "forbidden" subject. From the looks she gave me, and her general demeanor, it was clear that Füsun had prohibited any mention of the matter in my presence. But it was Aunt Nesibe who eventually informed me that a fight had broken out during one of Feridun's visits.

I calculated that if I went to the premiere, Füsun would read about it in the papers and, getting upset, would certainly punish me. Still, as the film's producer, I would be conspicuous by my absence. Just after lunch that day I had Zeynep Hanım ring Lemon Films to say that my mother was very ill, and that I would therefore be unable to leave home.

That evening, around the time that *Broken Lives* was to be shown for the first time to the cineastes and journalists of Istanbul, it was raining. When Çetin picked me up in Nişantaşı, I told him to take me to the Keskins' via Taksim and Galatasaray instead of Tophane. As we passed in front of the Palace Cinema I peered through the raindrops on the windows and saw a few well-dressed people walking to the premiere holding umbrellas, and the fancy posters and announcements paid for by Lemon Films, but it was not at all like the Palace Cinema premiere I had imagined for Füsun's first film.

No one mentioned the premiere over supper. Tarık Bey, Aunt Nesibe, Füsun, and I chain-smoked as we ate macaroni with meat sauce, yogurt with cucumbers and garlic, tomato salad, white cheese, and then the ice cream I'd brought from Ömür in Nişantaşı and put straight into the freezer on arrival. We kept rising from the table to look out the window at the rain, the water pouring down Çukurcuma Hill. As the evening dragged on I was tempted on several occasions

to ask Füsun how her bird painting was going, but from her harsh expression and her frowns I deduced that this was not an opportune moment.

Though the critics belittled *Broken Lives* in vicious terms, it met with such enthusiasm among audiences in both Istanbul and the provinces that it was pronounced a box office hit. During the last scenes, when Papatya sings two bitter, anguished songs about her misfortune, it was women in the provinces who cried hardest, but people of all sorts, young and old, left the humid, airless cinemas with puffy eyes. In the penultimate scene, when Papatya kills the evil rich man who had tricked her, staining her honor when she was still a child, but who now stands before her, pleading for his life, there was universal exultation. This scene made such an impression, becoming so familiar that the actor playing the part of the evil rich man (Ekrem Bey, our friend from the Pelür, who typically played Byzantine priests and Armenian militants) stopped going out for a time, tired of being punched and spat upon in the streets. The film was also praised for bringing back the crowds that had stayed away from cinemas during the "terror years"—as people now alluded to the period preceding the military coup. And with the revival of the cinemas, the Pelür Bar had filled up again, too: Sensing the resuscitation of the film business, its former regulars were again coming every day to strike deals or just to be seen. On a windy, rainy night at the end of October, two hours before the curfew, when—at Feridun's insistence—I dropped by the Pelür, I saw that my reputation there was much enhanced; to use the expression of the day, I was in my element. The commercial success of *Broken Lives* had transformed me into a prominent producer to whom many were also prepared to attribute a quick wit and slyness, and everyone from cameramen to famous actors sought to sit for a while at my table and befriend me.

By the end of that evening, though my head was swimming from the compliments, the attention, and the drink, I remember sitting down with Hayal Hayati, Feridun, Papatya, and Tahir Tan. Ekrem Bey, at least as drunk as I was, kept needling Papatya with mischievous jokes about the photographs of the rape scene that the papers had been reprinting incessantly; but Papatya responded with a good-natured smile, saying that she would never sleep with a penniless, decrepit rooster. At the

next table was a dandified critic who had ridiculed her for appearing in such a "vulgar melodrama"; Papatya tried for a time to provoke Feridun into giving him a good thrashing, but the effort was fruitless.

After the film, Ekrem Bey received numerous invitations to appear in bank commercials, though he confessed that he could not understand why: Evil men weren't supposed to be in demand for commercials. But in those days, with everyone talking about the bankers offering 200 percent interest, and these bankers fanning the flames with big advertisements in newspapers and on television using Yeşilçam's most famous faces, the film community was well disposed toward them. Still, as I was in the drunken eyes of the Pelür's clientele a modern businessman (by Hayal Hayati's definition, "A businessman who loves culture is modern"), whenever such subjects came up there was a respectful silence, which, it was hoped, I would fill with my opinion. In the wake of the box office success, I had been credentialed a farsighted "ruthless capitalist"; and everyone forgot that I had first come to the Pelür years ago to make Füsun a star, just as they had forgotten Füsun herself. Just reflecting on how fast Füsun had been forgotten caused my love for her to flare up inside me, and I would want to see her at once, and then thinking about how she had been able to resist being drawn into this tawdry world to the point of staining her reputation, I loved her all the more—and once again I would congratulate myself on keeping her away from these malevolent people.

It was an aging unknown, a friend of Papatya's mother's, who had dubbed the songs for Papatya in the film. Now, thanks to the success of *Broken Lives,* Papatya was going to make a record in which she sang the songs herself. That October evening we agreed that Lemon Films should back this venture, too, and also get started on a sequel to *Broken Lives.* Actually, the decision to do the sequel was not ours; it was what the cinemas and distributors of Anatolia called for unanimously, and so insistently that any refusal by Feridun would have been seen as "spitting in the face of success," to use another expression of the day. Whatever her intentions, by the end of the film Papatya's character had, like all girls, good or evil, who had lost their virginity, died without realizing her dream of a happy family life. We decided that the best solution was to reveal that Papatya had not really died at all, that having

been wounded, she had feigned her death to keep herself safe from other evil men. The sequel's first scene would be in the hospital.

It was three days later that *Milliyet* ran an interview with Papatya in which she announced that shooting was soon to begin. By now there was an interview with her in the papers every day. When *Broken Lives* had first opened, the papers had dropped hints that Papatya and Tahir Tan were having a secret affair in reality, but the life had gone out of this rumor, and now Papatya was denying it. When we spoke on the phone at around this time, Feridun informed me that all the most famous actors now wanted to play opposite Papatya, and that, anyway, Tahir Tan wasn't suited for the part. For in her latest interviews Papatya had begun revealing that, though she had kissed men, she'd of course never been truly intimate with one. Her fondest and truly most indelible memory remained her first kiss, this with her teenaged sweetheart on a summer's day, in a vineyard buzzing with bees. Sadly, the youth had been martyred while fighting against the Greeks in Cyprus. And after that Papatya had considered intimacy with any man inconceivable, concluding that only another lieutenant might be able to mend her heart. Feridun allowed that he didn't approve of such lies, but Papatya insisted that she'd only told them to help get the sequel past the censors. Feridun made little effort to conceal his relationship with Papatya from me; it was in keeping with his nature as one who picked no fights and had no quarrels, only carrying on, forever the naïf, never bitter or less than sincere—and for this I genuinely envied him.

"Broken Lives," Papatya's first single, came out the first week of January 1982, and though it was not as big a hit as the film, it was much beloved. Posters appeared on the city's walls, so many of which had been whitewashed after the coup, and advertisements, however small, in the papers. But because the censorship board of Turkey's only television channel (actually, it had a more elegant name: the Inspectorate of Music) found the song lacking in moral fiber, Papatya's voice was on neither television nor radio. The record, nevertheless, afforded her another round of interviews, and spurious stories about beatings and other controversies that she fabricated for these occasions made her more famous still. Papatya began to take part in cultural discussions along the lines of "Should a modern Turkish Kemalist girl think first

about her job or her husband?"; posing in front of her bedroom mirror (having bought a traditionally Turkish furniture set, adorned with a few pop features), she would frolic with her teddy bear while musing on what a shame it was that she had yet to meet the man of her dreams; making spinach pastry with her mother in the kitchen, in which there was an enameled pot identical to one at Füsun's, she played the honest housewife to prove that she was far more respectable than Lerzan, the angry, wounded heroine of *Broken Lives*. Her honor had not been stained, and she was perfectly happy, though, she allowed, "Certainly there is something of Lerzan in all of us," hoping to have it both ways. Feridun expressed pride that Papatya was such a professional, never taking the interviews and articles about her to heart. So many of the harebrained stars and starlets at the Pelür had reacted amateurishly, worrying that the lies propagated about them might damage their public image, but Papatya took control of the matter, telling her own lies from the start.

71

You Hardly Ever Come Here Anymore, Kemal Bey

WHEN MELTEM, now struggling to compete with Coca-Cola and other foreign brands, decided to use Papatya in its early summer advertising campaign, directed by Feridun, I had a final falling-out with my old circle of friends, for whom, though we had grown estranged, I felt no rancor—and it broke my heart.

Zaim was, of course, aware that Papatya was contracted by Lemon Films, and so, planning to discuss this matter amicably, we met for a long lunch at Fuaye.

"Coca-Cola is extending credit to distributors, and giving them huge Plexiglas shop signs for free, as well as calendars, and promo-

tional gifts, and we just can't compete," said Zaim. "The young are like butterflies: Once they've seen Maradona [the greatest footballer of his day] holding a Coca-Cola, they couldn't care less about a Turkish-made drink, even though it's cheaper and healthier."

"Don't take offense, but on those very rare occasions when I have a soda, I drink Coca-Cola, too."

"So do I," said Zaim. "It doesn't matter what *we* drink. . . . Papatya will help us increase sales in the provinces. But what sort of woman is she? . . . Can we trust her?"

"I don't know. She is an ambitious girl who comes from nothing. Her mother is a former nightclub singer. . . . There's no sign of a father. What are you worried about?"

"We're investing so much in this. If she went off and did a belly dance in a porn film afterward, or if—I don't know—she got caught with a married man . . . the provinces wouldn't be able to take it. I hear she's involved with your Füsun's husband."

I didn't like the way he said "your Füsun," and neither did I care for his knowing expression, which I read to imply unspoken awareness of my intimacy with the people in question. Somewhat spitefully I said, "So do they really like Meltem better in the provinces?" Zaim, who had pretension to modern and European sophistication, bristled at the fact that, despite his Western ad campaign with Inge, his product's cachet with the rich and the urban had proved ephemeral.

"Yes, we're more popular in the provinces," admitted Zaim. "Because people in the provinces haven't corrupted their palates yet, because they're pure Turks, that's why! But don't get hostile and tetchy with me. . . . I understand perfectly your feelings for Füsun. In this age of ours, your love is perfectly respectable—whatever anyone might say."

"Who's saying what?"

"No one's saying a thing," said Zaim cautiously.

This meant "Society has written you off." The thought caused us both disquiet. I loved Zaim both because he could be counted on to tell me the truth and because he didn't want to hurt me.

And Zaim saw affection in my eyes. With a friendly and encouraging smile, he raised his eyebrows and asked, "So what's going on?"

"Things are going well," I said. "I'm going to marry Füsun. I'm going to reenter society and bring her with me. . . . Assuming, of course, I can see past those disgusting gossips."

"Just forget them, my friend," said Zaim. "And very soon the whole thing will be forgotten. You look so well, and it's clear you're in good spirits. When I heard the Feridun story, I knew at once that Füsun would come to her senses."

"Where did you hear the Feridun story?"

"Just forget that, too," said Zaim.

"Sooo, what about you? Is there marriage on the horizon?" I asked, reluctantly changing the subject. "Is there someone new in your life?"

"Hilmi the Bastard's just walked in with his wife, Neslihan," Zaim said, looking at the door.

"Oooooh . . . hey, look who's here!" Hilmi said, approaching our table. Neslihan was very fashionably turned out, and that suited Hilmi the Bastard well, for he had no confidence in the tailors and seamstresses of Beyoğlu, and wore only Italian clothes, which he selected with much consideration. It was pleasing to see a pair so well dressed, so affluent, but I knew I would not be able to join in their general disdain of all things and persons not up to their standards. As I shook hands, there was a moment when I thought I saw fear in Neslihan's eyes, and so I remained reserved in their presence, a stance that suddenly seemed all-important. I couldn't believe that a moment ago, speaking to Zaim, I had used that peculiar word "society," an expression lifted from the magazines and celebrity pages my mother perused—and having declared a hope to return to it once I had redeemed myself, I now felt ashamed, and longed to return to Çukurcuma and the world I'd shared with Füsun.

Fuaye was as crowded as ever, and as I surveyed the vases of cyclamen, the plain walls, and the modish lamps like so many pleasant memories, the place looked time-worn, as if it had aged ungracefully. Would I be able to sit here with Füsun one day with an untroubled heart, sustained purely by the happiness of being alive and together? I let myself believe so.

"Is something on your mind? You have that faraway look. You've floated off into your daydreams," said Zaim.

"I was thinking about your dilemma concerning Papatya."

"Remember this summer she'll be the face of Meltem—this woman has to appear at all our parties and so on. So what do you think?"

"What are you asking?"

"Will she be presentable? Will she know how to act?"

"Why wouldn't she? She's an actress, a star, in fact."

"Well, that's what I mean. . . . You know how those Turkish film types carry on, the poor ones who play rich people. We can't have that sort of thing, can we?"

Zaim owed his turn of phrase to his well-mannered mother, but what he meant was "we won't." Papatya was not the first person to stir up such concerns, which beset him whenever it was a matter of anyone he viewed as lower class. Put off though I was by his bigotry, I nevertheless saw nothing to be gained by showing my friend anger or disappointment as we sat there at Fuaye.

I asked Sadi, the headwaiter at the restaurant for many years, which fish he was recommending.

"You hardly ever come here anymore, Kemal Bey," he said. "Your lady mother doesn't come here, either."

I explained that after my father died, my mother had lost interest in going out.

"Why don't you bring the lady here yourself. Please, Kemal Bey—we could cheer her up. When the Karahans' father died, they brought their widowed mother out to eat three times a week, and we put her at the table next to the window, where the lady would eat her steak and enjoy watching the passersby in the street."

"Did you know that the lady in question came out of the last sultan's harem?" said Zaim. "She's Circassian, green-eyed, and still beautiful even in her seventies. What sort of fish have you got for us?"

Sometimes Sadi would affect an undecided air and recite the names one by one: "Whiting, bream, red mullet, swordfish, sole," he would say, raising his eyebrows in approval or frowning to indicate the freshness or quality of each. Other times he'd cut it short: "I'm going to give you fried sea bass today, Zaim Bey."

"What will you serve with it?"

"Mashed potatoes, arugula, whatever you like."

"And to start?"

"We have this year's salted bonito."

"Bring red onions with it," said Zaim without raising his eyes from the menu, and then turning it over to the beverage list. "God bless, you have Pepsi, Ankara soda, and even Elvan, but still no Meltem!" he blurted.

"Zaim Bey, your people bring one delivery, and then we never see them again. Cases of empties have been sitting in the back for weeks."

"You're right, our Istanbul distributors are useless," said Zaim. He turned to me. "You know this business. How is Satsat managing? What can we do about our distribution problem?"

"Forget about Satsat," I said. "Osman set up a new firm with Turgay, and he's done us in. Since my father died, Osman cares only for money."

Zaim did not care for Sadi hearing us talk about our private failures. "Bring us each a double Kulüp *rakı* with ice on the side, would you? That would be best," he said. When Sadi left he frowned as if waiting for an answer. "Your beloved brother, Osman, wants to do business with us, too."

"I'd rather stay out of that," I said. "I'm not about to take it amiss if you choose to do business with Osman. Business is business. What other news, Zaim?"

He knew at once that I meant society news, and hoping to cheer me up, he offered quite a few amusing stories. Güven the Ship Sinker had run a rusty cargo ship aground, this time between Tuzla and Bayramoğlu. Güven specialized in rotting, polluting derelicts that had been decommissioned. He would buy them abroad at scrap prices and with the help of his contacts in the government and the state bureaucracy fiddled the paperwork to make them seem valuable and seaworthy vessels; by bribing the right people he could then take out interest-free loans from the Turkish Maritime Development Fund, putting the ships up as collateral, and soon thereafter he'd sink them and receive big payouts from the state-owned Başak Insurance. And so by the time he'd sold the beached cargo ship to his scrap yard friends, he'd made himself a pot of money without ever getting up from his desk. Plied with a few drinks, Güven would brag to his friends at the club that he was "the biggest shipowner who'd never been aboard a ship."

"The scandal erupted not because of this chicanery, but because he

ran the ship aground just next to the summer home he had bought his mistress, so that he wouldn't have to travel far to see the shipwreck. But the residents of those beach and summer homes raised an awful hue and cry over his having polluted the water. Even his mistress couldn't stop crying, apparently."

"What else?"

"The Avunduks and the Mengirlis invested everything with Deniz the Banker and were wiped out, and that, by the way, is why the Avunduks have pulled their daughter out of Notre Dame de Sion and are trying to marry her off."

"That girl is hideous. Good luck to them," I said. "On top of that— who would trust somebody called Deniz the Banker? I've never even heard of him."

"Do you have any money with brokers?" asked Zaim. "Is there a reputable one you know and trust?"

Having arrived at this new profession after running kebab restaurants, truck tire depots, and even lottery shops, these bankers were offering such ludicrously high interest rates that it was clear they would not stay in business indefinitely. But so ubiquitous and seductive was their advertising that they'd taken in enough cash to stay afloat temporarily, because even those who derided and exposed them in the press—among them even economics professors who saw them clearly as con men—were apparently dazzled enough by the advertised rates to invest their own money, "just for a month or two."

"I don't have any money with brokers," I said. "Our companies don't either."

"With those returns it seems idiotic to put money into an ordinary business. To think if I'd given Kastelli the money I've sunk into Meltem, I'd have doubled my investment by now and avoided these headaches."

Whenever I remember that conversation we had among the crowd at Fuaye, it seems to me as empty and meaningless as it did that day. But then as now I did not blame the general idiocy—or more politely, the general unreflectiveness—of the world in which my story takes place, but rather I imputed a sad want of seriousness, which could never trouble me unduly, and more typically moved me to laugh, to embrace it with pride.

"Is Meltem really not making money?"

I'd said this without intending a dig, but Zaim took offense.

"It's all riding on Papatya—what else can we do?" he said. "I just hope she doesn't embarrass us. I've arranged for her to sing Meltem's jingle accompanied by the Silver Leaves at Mehmet and Nurcihan's wedding. All the press will be there at the Hilton."

I fell silent for a moment. I had heard absolutely nothing about Mehmet and Nurcihan's impending wedding at the Hilton, and I was crushed.

"I know you won't be coming," said Zaim. "But I figured you'd have heard about it by now."

"Why wasn't I invited?"

"Oh, there were endless discussions. As you might have guessed, Sibel doesn't want to see you: 'If he's going to be there, I'm not coming' is what she said. And after all, Sibel is Nurcihan's best friend. She's even the one who introduced Nurcihan to Mehmet, don't forget."

"I'm a good friend of Mehmet's," I said. "You could also say that I had as much to do with introducing them."

"Don't make too much of this—it will only upset you."

"Why do Sibel's feelings take precedence?" I said, knowing even as I spoke that I had no right.

"Look, my friend, everyone sees Sibel as a woman wronged," said Zaim. "You got engaged to her, and after living with her in a Bosphorus *yalı,* and sharing the same bed, you abandoned her. For the longest time there was talk of nothing else, and you'd have thought they were speaking of some evil djinn the way mothers discussed the scandal with their daughters. Sibel really did not mind, but everyone felt very sorry for her all the same, and naturally they were very angry at you. You can't be indignant that they're on Sibel's side now."

"I'm not indignant," I said indignantly.

We downed our *rakı*s and began to eat our fish, and it was the first time Zaim and I had eaten a meal at Fuaye and fallen silent. I listened to the waiter's hurried footsteps, the steady crackle of laughter and conversation, the clatter of knives and forks. I angrily vowed never to come back, even as I thought how much I loved this place, and how I had no other world.

Zaim said that he wanted to buy a speedboat that summer but that

before doing so he needed to find a suitable outboard motor, though there were none to be found in the stores in Karaköy.

"That's enough, now. Stop looking so glum," he said suddenly. "Nobody should get this upset over missing a wedding at the Hilton. I'm sure you've been to one?"

"My friends have turned their backs on me because of Sibel—I don't like that."

"No one's turned their back on you."

"Fine, but what if the decision had been up to you? What would you have done?"

"What decision?" said Zaim, in a way that seemed disingenuous. "Oh, now I see what you mean. Of course, I would have wanted you to come. You and I always have such fun at weddings."

"This is not about fun; it's something much deeper."

"Sibel is very lovely; she's a very special girl," said Zaim. "You broke her heart. Not only that—in front of everyone, you put her in a very precarious situation. Instead of pulling a long face and glaring at me, why don't you just accept what you did, Kemal? Take it on the chin and then it will be much easier for you to return to your real life, and before you know it, all this will be forgotten."

"So you consider me guilty, too?" I said. I knew it wouldn't be long before I began to regret persevering in this, but I couldn't help myself. "If we insist virginity is still so important how can we pretend we're modern and European? Let's be honest with ourselves, at least."

"Everyone is honest about this. . . . Your mistake was imposing your view on someone else. It might not be important to you, or to me. But it goes without saying that in this country a young woman's virginity is of the utmost importance to her, no matter how modern and European she is."

"You said Sibel didn't care. . . ."

"Even if Sibel didn't care, society did," said Zaim. "I'm sure you didn't care either, but when White Carnation wrote those awful lies about you, everyone was talking. And even though you say you don't care, now you're upset about it—am I right?"

I decided that Zaim was choosing his words—expressions like "your real life"—just to inflame me. Two could play at that game, I thought, yet a voice inside me still counseled prudence, reminding me

that I might regret something said in fury after two glasses of *rakı,* but unfortunately I was angry, too.

"Actually, my dear Zaim," I said, quite superciliously, "this plan of yours to get Papatya to sing the Meltem jingle with the Silver Leaves at the Hilton—it really is rather crass. What makes you think it would work?"

"Come on, don't goad me. We're about to sign a contract, for goodness' sake. You don't have to take your anger out on me."

"It's going to look pretty coarse. . . ."

"Well, if that's what you think, don't worry. We chose Papatya for that very reason—because she's coarse," Zaim said with assurance. I thought he was going to tell me that her coarseness had become marketable thanks to the film I'd produced, but Zaim was a good man; such a thing would never cross his mind. He merely preempted further discussion by saying he and his associates would find a way to manage Papatya. "But let me speak to you as a friend," he said. "Kemal, my friend, those people didn't turn their backs on you; you turned your back on them."

"Now how did I do that?"

"By turning in on yourself, and taking no joy or interest in our world. I know you believe you went your own way, in pursuit of something deep and meaningful. You followed your heart; you made a stand. Don't be angry with us. . . ."

"Might it be something simpler than that? The sex was so good that I became obsessed. . . . That's what love is like. Maybe you're the one finding some deep meaning in all this, something projected from your own world. Actually, our love has nothing to do with you and yours!"

Those last words came out of my mouth of their own accord. Suddenly I felt as if Zaim was regarding me from a great distance; he had already given up on me a long time ago, and was only now accepting that he couldn't be alone with me anymore. As he listened to me he was thinking not of me, but of what he would tell his friends. I could read his absence in his face now. And because Zaim was an intelligent man such signals as I had just given were not lost on him, and I could tell that he was angry at me in return. And so the distance was perceptible from either perspective: Suddenly I, too, was seeing Zaim, and my entire past, from a point very far away.

"You're a man of real feeling," said Zaim. "That is one of the things I cherish about you."

"What does Mehmet say about all this?"

"You know how much he cares about you. But he's happy with Nurcihan in a way beyond anyone else's understanding. He's walking on air, and he doesn't want anything—any trouble—to bring him down."

"I understand," I said, resolving to drop the matter.

Zaim read my mind. "Don't think with your heart—use your head!" he said.

"Fine, I'll be rational," I said, and for the rest of the meal we said nothing of any consequence.

Once or twice Zaim offered another serving of society gossip, and when Hilmi the Bastard and his wife stopped at our table on their way out, he tried to relieve the tension with a few jokes, but without success. Those fine clothes on Hilmi and his wife suddenly looked pretentious, even false. Yes, I'd cut myself off from my entire crowd, and all my friends, and perhaps this was cause for sadness, but there was also something more, I felt—a grudge, a rage.

I paid the bill. Saying our good-byes at the door, Zaim and I suddenly threw our arms around each other and kissed each other on the cheeks, like two old friends who knew that one was on the verge of a long journey that would part them for many years. Then we walked off in opposite directions.

Two weeks later Mehmet telephoned Satsat to apologize for having been unable to invite me to the wedding at the Hilton. He added that Zaim and Sibel had been a couple for some time now. He'd assumed I knew, considering everyone else did.

72

Life, Too, Is Just Like Love. . . .

ONE EVENING at the beginning of 1983 I was about to sit down to supper at the Keskins' when, sensing something strange, something

missing, I carefully surveyed the room. The chairs were all in their usual places, and there was no new dog on top of the television, but the sense of something peculiar in the room persisted, as if the walls had been painted black. In those days I'd ceased to think of my life as something I lived in wakeful consciousness of what I was doing: I'd begun instead to think of it as something imagined, something—just like love—that issued from my dreams, and as I had no wish either to fight my growing pessimism about the world or to surrender myself to it unconditionally, I acted as if no such thoughts had entered my mind. It might be said that I had decided to leave everything as it was. I applied the same logic to the unease awakened in me by the dining room as I had to that stirred by the sitting room: I resolved not to dwell on it, to let it pass.

TRT 2, Turkey's arts and culture channel, was at the time showing a series of films starring Grace Kelly, who had just died. It was our old friend Ekrem the famous actor who presented the "Art Film" feature every Thursday evening, reading from the script in his hands, which the alcoholic Ekrem Bey hid behind a vase of roses, so as to hide his shaking hands. His comments were written by a young film critic, who had been an old friend of Feridun's before they fell out over a scathing review of *Broken Lives*. And Ekrem Bey read the critic's convoluted, intellectualized prose with little comprehension; finally he raised his eyes from the page, and just before saying, "and so here is tonight's feature . . ." he announced that he had met "America's elegant 'princess star' at a film festival many years ago," adding, almost as if it were a secret, that she had a deep love for Turks, his dreamy expression implying that he might even have enjoyed a grand romance with the enchanting star. Füsun, who had heard a great deal about Grace Kelly from Feridun and his film critic friend during the early years of her marriage, would not miss a single one of these films, and since I would not miss a chance to watch Füsun watch the fragile, helpless, but still radiantly beautiful Grace Kelly, I would make sure to take my place at the Keskin table every Thursday.

That Thursday we watched Hitchcock's *Rear Window*, but far from putting my troubled mind at ease, it heightened my anxiety. It was this film I'd gone to see eight years earlier, when, skipping out on my usual lunch with the Satsat employees, I took refuge in a cinema to contem-

plate Füsun's kisses in solitude and peace. But now it was no consolation to see from the corner of my eye how engrossed Füsun was in the film, nor did it help to remark on something of Grace Kelly's purity and refinement in her. Either in spite of the film or because of it, I had sunk into that stupor that afflicted me, if not often then at regular intervals, during suppers in Çukurcuma. It was like being caught in a suffocating dream, trapped in a room whose walls were advancing toward me. It was as if time itself was getting steadily narrower.

I struggled for a long time to convey for the Museum of Innocence this sensation of being caught in a dream. The condition has two aspects: (a) as a spiritual state, and (b) as an illusory view of the world.

(a) The spiritual state is somewhat akin to what follows drinking alcohol or smoking marijuana, though it is different in certain ways. It is the sense of not really living in the present moment, this now. At Füsun's house, as we were eating supper, I often felt as if I were living a moment in the past. Only a moment before we would have been watching a Grace Kelly film on television, or another like it; true, our conversations at the table were more or less alike, but it was not such sameness that invoked this mood; rather it was a sense of not abiding in those moments of my life as they were occurring, experiencing these moments as if I were not living them. While my body lived out the present on the screen, my mind was watching Füsun and me from a slight distance, and my soul watched from a greater one. So the effect of that moment I was living was of something I was remembering. Visitors to my Museum of Innocence must compel themselves, therefore, to view all objects displayed therein—the buttons, the glasses, the old photographs, and Füsun's combs—not as real things in the present moment, but as my memories.

(b) To experience this present moment as a memory is to experience a temporal illusion. But I also experienced a spatial illusion. Exhibited here are a pair of optical illusions. Try to detect the seven differences between these two pictures, or decide which one is smaller; this puzzle is of the type that induced a similar disquiet when I was a boy and came across them in magazines for children. When I was a child, games like "Help the king find his way out of the labyrinth!" or "What burrow should the rabbit take to get out of the forest?" amused me as much as they unnerved me. Likewise, during my seventh year of

dining with the Keskins, the supper table slowly became less an amusing and more a stifling place. That evening, Füsun sensed my state of mind.

"What's wrong, Kemal? Didn't you like the film?"

"No, I liked it."

"Maybe you didn't like what it was about," she said cautiously.

"On the contrary," I said, and I fell silent.

It was so unusual for Füsun to show interest in my mood, or ask how I was when we were still at the table, in her parents' earshot, that I was moved to say a few admiring things about the film and Grace Kelly.

"But I know you're feeling low this evening, Kemal, don't try to hide it," Füsun said.

"Fine, then, I'll talk. . . . It's just that it seems as if something has changed in this house, but I can't figure out what it is."

They all burst out laughing.

"We've moved Lemon to the back room, Kemal Bey," said Aunt Nesibe. "We were wondering why you hadn't mentioned it."

"Is that so?" I said. "How could I not have noticed? I mean, I love Lemon. . . ."

"We love him, too," said Füsun proudly. "I've decided to paint his portrait, so I've moved the cage into the other room."

"Have you started painting yet? Could I have a look, please?"

"Of course."

It had been some time since Füsun had given up on her bird series, for which she could no longer summon up the enthusiasm. Entering the room, before looking at Lemon himself, I inspected Füsun's painting of the bird, only just begun.

"Feridun doesn't take bird photographs anymore," said Füsun. "And so I've decided to paint from life instead."

Füsun's mood, her poise as she talked about Feridun as if he were someone from her past—it all set my head spinning. But I kept my calm. "You've made a good start on this, Füsun," I said. "Lemon is going to be your best painting yet. After all, you know your subject so well, and it's by drawing on the subjects one knows best that one makes the most successful art."

"But I'm not aiming for realism."

"What do you mean?"

"I'm not going to paint his cage. Lemon will be perched in front of the window like a wild bird who has alighted there of his own free will."

That week I went three more times to the Keskins' for supper. Each night, when the meal was over, we went into the back room to Lemon's emerging portrait. He seemed happier and livelier outside his cage, and when we went into the back room, we were now more interested in the painting than the bird itself. After an oddly serious but perfectly sincere discussion of the challenges of this project, we would speak of going to see the museums of Paris.

On Tuesday evening, as we gazed at the painting of Lemon, I uttered the words I had prepared in advance, though I was as nervous as a lycée student: "Darling, the time has come for us to leave this house, this life, together," I whispered. "Life is short, and in our stubbornness we have lost many days, many years. What we need is to go to another place to be happy." Füsun acted as if she had not heard me, but Lemon answered with an abbreviated *chk, chk, chk*. "There's nothing to fear anymore, nothing to hold us back. Let's you and I, the two of us, leave this house together, for another place, another house, our own house, and let us live happily from then on. You are only twenty-five years old—we have half a century of life ahead of us, Füsun. We have suffered enough over these past six years to deserve those fifty years of happiness! Let's leave together now. We've been stubborn with each other for long enough."

"Have we been stubborn with each other, Kemal? That's news to me. Don't put your hand there, you're scaring the bird."

"I'm not scaring him. Look, he's eating from my hand. We can give him the best place in the house."

"My father will be wondering where we are," she said, warmly, as if we were sharing a secret.

The next Thursday, we saw *To Catch a Thief*. Instead of watching Grace Kelly, I watched Füsun watching her, from start to finish. In everything—from the pulsing of the blue veins in my beauty's throat to the way her hand fluttered across the table, straightened her hair, or held her Samsun—I saw her fascination for the screen princess.

When we went into the back room, Füsun said, "Do you know what, Kemal? Grace Kelly was bad at mathematics, too. And she got

into acting by working as a model first. But the only thing I really envy her is that she could drive a car."

In his introduction that week, as if he was giving inside information about a very close friend, Ekrem Bey informed Turkey's art film enthusiasts of the odd coincidence: that a year earlier the princess had died in a car accident on the same road she had driven down in this film.

"Why were you jealous?"

"I don't know. Driving made her look so powerful, and free. Maybe that's why."

"I could teach you, if you like."

"No, no, that would be impossible."

"Füsun, I know that in two weeks I can teach you enough for you to get your license and drive comfortably around Istanbul. There's nothing to it. Besides, Çetin taught me how to drive when I was your age [this wasn't true]. All you need to do is to be calm, to have a little patience."

"I'm patient," Füsun said confidently.

73

Füsun's Driving License

IN APRIL 1983 Füsun and I began to prepare for the drivers' licensing examination, our first tentative plans having been followed by five weeks of indecision, feigned reluctance, and silence. We both knew there would be more at stake than a license since the intimacy between us was to be put to the test, once again in a tutelary setting. We had been given our second chance, and being quite sure that God would not give us a third, I was tense about it.

Still, I was jubilant at Füsun's ultimate agreement and so I nurtured real hope of becoming steadily more relaxed, cheerful, and confident. The sun was emerging from behind the clouds after a long, dark winter.

It was on the afternoon of one such sunny, glistening spring day (April 15, to be exact, three days after we had celebrated her twenty-

sixth birthday with a chocolate cake I'd bought at Divan) that I picked up Füsun in the Chevrolet in front of Firuzağa Mosque for her first driving lesson, and off we went, with me at the wheel and Füsun sitting beside me. She'd asked me not to pick her up in front of the house in Çukurcuma but on a corner higher up the hill, five minutes away from the curious eyes of the neighborhood.

It was the first time in eight years that we were going out alone together, though I was too tense and excited to notice my elation. I was meeting this girl after an agonizing eight-year wait—I had been put to so many tests, endured such pain—yet that is not how it felt. Rather it was as if I was meeting for the first time a splendid young girl who had been found for me by others, and who was, in their view, a perfect match.

Füsun was wearing a becoming print dress of orange roses and green leaves on a white background. It was the same elegant dress—with its V-shaped neckline and its skirt falling just below her knees—that she would wear to each driving lesson, as a sportswoman might wear the same tracksuit for every training session, and by the end of the lesson, her dress would be as dampened as any athlete's suit. Three years after we had begun our lessons, when I spotted it in Füsun's chest of drawers, I would pluck it out, instinctively sniffing its sleeves and its front for her unique scent, longing to remember the pleasure of those tense and dizzying lessons of ours, in Yıldız Park, just above Sultan Abdülhamit's palace.

The underarms of Füsun's dress would be the first to become moist, before the damp patches spread slowly and adorably over her breasts, her arms, and her abdomen. Sometimes the engine would stall in a bright spot in the park, and—just as eight years earlier, when we were making love—we would perspire lightly, feeling the sun on our skin. But it was not so much the sun that made Füsun and me perspire as the fact of being alone in that car, trapped in our own air, our own shame, tensions, and jangled nerves. When Füsun made a mistake, for example, rolling the right-hand front tire over the curb, grinding the gears, or causing the engine to stall, she would redden with anger and begin to perspire, never more profusely than when she bungled the clutch.

Füsun had made a careful study of all the traffic regulations, mem-

orizing the books at home, and her steering wasn't bad, but—as with so many new drivers—the clutch was her downfall. She'd drive carefully at a low speed down the learner's lane, and slow down for the intersection, approaching the sidewalk as carefully as a captain landing at an island pier, and just as I said, "That's wonderful, my lovely, you're really catching on," she'd take her foot off the clutch too fast and the car would lurch forward and strain for breath like a rasping old man. As the car stumbled on like a coughing invalid, I would cry, "The clutch, the clutch, the clutch!" But in her panic Füsun would hit the accelerator or the brakes instead. When it was the accelerator, the car would rock more menacingly before stalling. I'd observe the sweat pouring down Füsun's red face, her forehead, the tip of her nose, and her temples.

"That's it, I've had enough," she'd say, wiping her face with the back of her hand, full of embarrassment. "I am never going to learn this. I give up! I wasn't put on this earth to be a driver, after all." Then she would step out of the car and storm off. Sometimes she would bolt from the car without a word, and fishing a handkerchief from her handbag, walk away as she wiped off the perspiration, and when she had reached a point forty or fifty paces away, she would stand there by herself, furiously smoking a cigarette. (On one such occasion, two men who thought she'd come to the park alone descended on her within seconds.) Other times she'd light her Samsun without getting out of the car, and it, too, would be saturated with her damp rage as she angrily stubbed it out into the ashtray, saying she was never going to get her license and, anyway, never really wanted it.

Naturally, I would panic, for it seemed not just the license that she was brushing away, but our future happiness, and I would almost beg Füsun to be patient and calm.

With her wet dress clinging to her shoulders, I would gaze at her lovely arms, the panic on her face, her frown, her anxious stretching, and her lithe frame, drenched in perspiration, as it had been during those spring days of making love. Not long after taking the driver's seat, Füsun would become flushed, and in short order she would undo the top button of her dress, and perspire all the more profusely. Seeing the moisture on her neck and temples and behind her ears, I would try to remember, to glimpse those wondrous pear-shaped breasts that, eight years earlier, I had taken into my mouth. (And that night, back at

the house, after downing a few glasses of *rakı* in my room, I would dream I had seen her nipples, red as strawberries.) Sometimes when Füsun was driving I would sense her awareness of my intoxication at the sight of her, and feeling that she didn't mind it, even liked it, in fact, I would grow more desirous still. When I'd lean over to show her how to shift gears smoothly in one sweet stroke, and my hand would brush against hers, or against her lovely arm, or her thigh, it would occur to me that before any physical union took place in this car, our two souls had become one. Then Füsun would remove her foot from the clutch too soon again, and my father's '56 Chevrolet would quiver like a poor, feverish horse, trembling violently until it passed out. With the engine stalled, we would notice the deep silence reigning in the park around us, in the summer villa before us, in the world everywhere. We would listen enchanted to the whirring of an insect beginning vernal flight before the onset of spring, and we would know what a wondrous thing it was to be alive in a park on a spring day in Istanbul.

It was in these gardens and villas that Abdülhamit had once hidden from the entire world, governing the Ottoman state from seclusion and playing like a child with the miniature ship in the great pool (the Young Turks had planned to blow him up with this ship, too); after the founding of the Republic, the grounds had become a public park favored by rich families taking a leisurely spin and equally unhurried student drivers. I had heard from Hilmi the Bastard, Tayfun, and even Zaim that brave couples with nowhere else to go would come here, taking refuge behind the hundred-year-old plane and chestnut trees, to kiss. Whenever we caught sight of them embracing behind the trees, Füsun and I would fall into a long silence.

A lesson would last two hours at most, though to me it would seem as unending as our hours of lovemaking at the Merhamet Apartments; when the lessons were over, we would succumb to the silence that had become our default.

"Shall we go to Emirgân and drink tea?" I would say as we drove through the park gates.

"Yes, all right," she would whisper, like a bashful young girl.

I would be as delirious as a young man who, having acceded to the arrangement of his marriage, found cause only for delight and gratitude following his first meeting with his intended. We drove along the

Bosphorus road, parking beside the sea, and sat in the car, sipping tea, and I would be speechless with happiness. It was all we could do following our exhaustion from the emotional undercurrents of our lesson. Füsun would either stay silent or talk about driving.

The windows would sometimes fog over, and once or twice I tried to use that opportunity to touch her, or kiss her, but like any honorable girl disinclined to any sort of physical intimacy before marriage, she politely pushed me away. Yet even having done so, she lost none of her chirpy good humor—and what a joy it was to see that she wasn't angry at me. There was, I think, something in my glad response at being rebuffed that called to mind a provincial suitor discovering that the girl he is thinking of marrying is "principled."

In June 1983 we drove through almost every neighborhood in Istanbul gathering together the necessary documentation for the driving test. One day, after waiting half a day in a line outside the administrative office of Kasımpaşa Military Hospital, to which all driving applicants were referred owing to the emergency measures in effect, and, following that, an interminable interval at the door of an irritable doctor, we emerged with a report confirming the fitness of Füsun's nervous system and her reflexes and took a triumphal walk around the neighborhood, venturing as far as Piyalepaşa Mosque. Another day we had waited for four hours in a queue in the Taksim First Aid Hospital, only to find the doctor had gone home; to cool our tempers, we ate an early supper at a small Russian restaurant in Gümüşsuyu. On yet another day, after being informed that an ear, nose, and throat specialist we needed to see was on vacation, after we had been sent off to a hospital in Haydarpaşa, we whiled away the time throwing *simit*s to the seagulls from the back deck of the Kadıköy ferry. It was at the Istanbul University's Çapa Hospital that we handed in our collected documents, and, as we waited for them to be processed, took a long walk, wandering through narrow cobblestone streets, going right past the Fatih Hotel. I had suffered such anguish for Füsun in this place, and it was here I had heard the news of my father's death, but now the hotel seemed part of another city.

Whenever we had secured another necessary document, and placed it in the folder that accompanied us everywhere and that by now was covered with stains of tea, coffee, ink, and oil, we would leave the hos-

pital in high spirits, and go celebrate our success at a simple neighborhood restaurant. Füsun would smoke openly, without feeling nervous, or trying to be discreet; sometimes she would lean toward the ashtray and—as if we were friends from the army—brazenly take my cigarette to light her own, and then cast her expectant, playful gaze about her, looking for the next source of amusement. It stirred me to see my unhappily married beloved enjoying life on the go: watching people, visiting new neighborhoods, beguiled by the surprises of urban life, and keen to make new friends.

"Did you see that man? The mirror he's carrying is taller than he is," Füsun would say. After standing with me on a cobblestone street watching children play football, with a joy more sincere than mine, she would buy us two bottles of soda from the Black Sea Grocer (who, as if to make Zaim's point, had no Meltem!). When a laborer bearing pumps and a huge iron rod came down the street, looking up at the wooden houses' latticed windows and shouting "Sewerman!" to those on the concrete balconies and upper stories, Füsun would seem as fascinated as a child; on the Kadıköy ferry, when a vendor was hawking a kitchen utensil that could peel squash, squeeze lemons, and even slice meat, she would make a careful study of the tin gadget in his hand. "Did you see that boy?" she would say of someone as we walked down the street. "He is practically strangling his little brother." At a crossroads, where a crowd was gathering just in front of a muddy children's playground, she would cry, "What's going on? What are they selling?" and rush over, with me in tow, to a place where we would watch the gypsies and their dancing bear, the schoolchildren in their black smocks, rolling across the middle of the street as they fought, and the sad eyes of two dogs locked in coitus while some cheered in derision and others looked on sheepishly. If two cars had collided and the drivers got out of them, spoiling for a fight, or if an orange plastic ball escaped from a mosque courtyard to bounce gracefully down a hill, or if an excavator was digging the foundations of an apartment on a large avenue, or a television was on in some shop window, we would stop and look on with everyone else.

To become reacquainted with each other as we explored the city, to see an undiscovered part of Istanbul each day, and an unknown side of Füsun—it was a pleasure that continually renewed itself. When we wit-

nessed the poverty and chaos that reigned in the hospitals, the desperate old people who had to queue outside the entrances in the early hours of the morning to have any chance of seeing a doctor, or when we happened on black market butchers cutting up carcasses in the empty lots of the backstreets, far from the supervising eyes of the city council, it seemed to me that in life's shadowy precincts we were drawn even closer. Though our own story had its own vexing shadows, they were as nothing to the fearsome darkness in the lives of the city and its dwellers that we glimpsed while walking these streets. The city was teaching us to see the ordinariness of our lives, teaching us, too, a humility that banished guilt. There was a consoling power I felt mixing with the city crowds in shared taxis and buses, and admiring Füsun as she conversed with a headscarfed auntie sitting in the next seat, her grandchild asleep in her lap.

With her, I was able to discover all the awkwardness and pleasure of a stroll through Istanbul in the company of a beautiful woman whose head was uncovered. If we entered a hospital reception area, or the office of a state bureaucracy, all heads would turn toward her. Old functionaries accustomed to peering down indifferently on the impoverished and the elderly would perk up, presenting themselves as diligently devoted to duty, and without first inquiring her age would address her as "young madam." There were those who, habituated to the careless use of the familiar with other patients, pointedly adopted the formal "you," and there were others who didn't dare even to look at her face. Young doctors would approach like urbane gentlemen in European films, to ask, "Might I be of any assistance?" Crusty professors who seemed not even to notice me tried to charm her with quips and courtesies. All this disruption on account of a beautiful woman appearing without a headscarf in the office of a state bureaucracy, sowing momentary alarm, even panic. Some clerks could not bring themselves to discuss the business at hand in her presence, others would stammer, still others fall silent, obliged to seek out a man who could act as intermediary. When they finally saw me, and took me for her husband, they would relax, as would I, in much the same helplessness.

"Füsun Hanım needs a report from the ear, nose, and throat specialist to take to the office of drivers licensing," I'd say. "We were sent here from Beşiktaş."

"The doctor isn't in yet," the orderly in charge would say. Opening the file in our hands, he would glance quickly at the documents inside and say, "Please sign in and take a number." When we noticed how long the line of patients was, he would add: "Everyone is waiting in line. There's no one who doesn't wait."

Once I spied an opportunity to grease the orderly's palm, but Füsun objected, saying, "No, we're going to do this like everyone else."

As we waited in line, chatting with patients and clerks, everyone assumed I was her husband, and this pleased me. I did not see the mistake as reflecting the assumption that a woman would never go to a hospital with a man who wasn't her husband, but as proof that our growing intimacy was now clear to all. Once we went for a stroll in the backstreets of Cerrahpaşa, while waiting for our number to be called at the University's Çapa Hospital, and at some moment I had lost Füsun, whereupon a window in a ramshackle wooden house opened, and a headscarf-wearing auntie informed me that "your wife" had stepped into the grocery story around the corner. We attracted some notice in these backstreet neighborhoods, but no alarm. A few children might follow us; some adults mistook us for tourists who'd lost their way. Sometimes a smitten youth might shadow us, just to admire Füsun from afar, but when a few streets farther on I would catch his gaze, he would politely retreat. Heads were often to be seen poking out of doors and windows, the women asking Füsun whom we were seeking or what address, and the men asking me. Once, seeing Füsun about to eat a plum she'd bought from a street vendor, an old woman reached out, crying, "Wait a minute, my girl. Let me wash that for you first!" The woman washed our plums in her stone-paved kitchen on the ground floor, made us coffee, and asked us what we were doing in the area; when I said that my wife and I were searching for a beautiful wooden house to live in, the old woman relayed this information to all the neighbors.

All the while, our laborious driving lessons in Yıldız Park continued, and we were also preparing for the written exam. If we were sitting in a tea garden with some time to kill, Füsun would sometimes take a booklet from her bag with a title like *Driving Made Easy* or *Driving Exam Questions Complete with Answers,* and, smiling mischievously, she would quiz me.

"What is a road?"

"I give up."

"The lanes and zones open to traffic for public use," Füsun would say, reciting half from memory and reading the rest. "All right then, what is traffic?"

"Traffic refers to the presence and movement of pedestrians and animals—"

"There is no 'and,' " Füsun would say. "Traffic refers to the presence and movement of pedestrians, animals, vehicular machinery, and tractors with tires on roads."

I enjoyed these question-and-answer exchanges, which caused us to reminisce about middle school, and the curriculum, which relied so heavily on memorization, and our report cards, which included marks for "comportment," and soon I would find myself asking her a question.

"What is love?"

"I don't know."

"Love is the name given to the bond Kemal feels with Füsun whenever they travel along highways or sidewalks; visit houses, gardens, or rooms; or whenever he watches her sitting in tea gardens and restaurants, and at dinner tables."

"Hmmm . . . that's a lovely answer," Füsun would say. "But isn't love what you feel when you can't see me?"

"Under those circumstances, it becomes a terrible obsession, an illness."

"What has this got to do with the driving examination?" Füsun would say. Then she would behave as if this sort of dalliance could not be allowed to go on if a couple was unmarried, and I would take care not to make any more such jokes for the rest of the day.

The written exam took place in Beşiktaş, in a small palace where Numan Efendi, one of Abdülhamit's crazy princes, had listened to harem girls play the ud as he whiled away the hours doing impressionist paintings of the Bosphorus. After the founding of the Republic the building had been converted by the state into offices that were never properly heated, and as I waited at the entrance, I regretfully remembered, as I had countless times, that I should have waited outside the

Taşkışla Building, where she had taken her university entrance exam eight years earlier. Had I broken off the engagement to Sibel and sent my mother to ask for Füsun's hand, we could have had three children by now. But there would still be time for three children, or even more, once we'd married. I was so sure of this that when Füsun came out of the exam looking elated, and announcing, "I answered all the questions!" I was on the verge of informing her how many children we would have, but I held back, mindful of how, in the evenings, we were still sitting, quite solemnly, at the family table, watching television as we ate.

Füsun passed the written exam with a perfect score, but she failed her first road test miserably. They flunked everyone on the first attempt, just to emphasize what a serious business it was to operate an automobile, but we were unprepared for how it turned out. Füsun got into the Chevrolet with the three-man examination committee, and though she had successfully started up the car and put it into motion, she had not gone far before a deep-voiced examiner in the backseat declared, "You didn't look in the mirrors!" and when Füsun turned around to ask, "What did you say?" they instructed her to stop the car at once and get out. Drivers, the regulations clearly stated, were never to look behind them while they were driving. The examiners bolted from the Chevrolet, as if truly frightened to be in a car with such a reckless driver, a degrading show that Füsun found demoralizing.

They scheduled her for a retake four weeks later, at the end of July. Those familiar with the modus operandi of the drivers licensing agency could only laugh to see us so downcast and humiliated, and they lectured us amicably about bribes and how we might go about procuring a license at a particular shantytown teahouse (with four pictures of Atatürk and a clock on its walls) that was frequented by everyone in Istanbul who had a hand in the drivers licensing business. If we were to enroll in one of the pricey driving schools where retired traffic policemen taught (and attendance wasn't compulsory), we were certain to pass, because the examination committee and many policemen were partners in that business.

Paying for this course also afforded one the privilege of taking the test in an old Ford specially modified for the purpose: This vehicle had

a huge hole in the floor next to the driver's seat, so that when the driving candidate was called upon to park in a tight space, he could see the colored markings on the road; and if he would but refer to the written guide hidden behind the sun visor, he would know which colored marking indicated that he should turn the wheel as far as it could go to the left, and exactly when he should go into reverse, so as to park the car flawlessly. It was also possible, for a larger sum, to avoid enrolling in a school altogether, a custom which I, as a businessman, knew only too well was sometimes unavoidable. But as Füsun was adamantly opposed to the smallest enrichment of the policemen who had callously failed her, we continued our lessons at Yıldız Park.

The examination guide contained hundreds of minor regulations of which a driver needed to show awareness on the road. It was not enough to operate the car properly in the presence of the examining committee; one also had to demonstrate, sometimes by exaggerated gestures, mastery of these regulations—for instance, looking into the rearview mirror as required counted for nothing unless you also showed consciousness of doing so by gripping the mirror. A fatherly policeman with long experience of the licensing process explained this to Füsun in a most affable way, saying, "My girl, it's not enough to drive a car during your exam. You also have to look *as if* you're driving. The first you do for your own benefit, and the second for the benefit of the state."

After our driving lessons in the park, when the sun was low in the sky, we would go to Emirgân for coffee and soda on the edge of the Bosphorus, or to a coffeehouse in Rumelihisarı for tea from a samovar, and these pleasures never failed to neutralize the aggravations of the lessons. But let no reader infer from this that we carried on like giddy lovers.

"We're making better progress at these lessons than we did with mathematics!" I said once.

"We shall see," Füsun replied cautiously.

Sometimes we would sit at the table and drink our teas in silence, like some long-married couple who had run out of things to say to each other; as we admired the Russian tankers passing by, or the City Line ferries on their way to Heybeliada, or (as happened once) the *Sam-*

sun heading out on its tour of the Black Sea ports, we seemed lost in misery, in dreams of other lives and other worlds.

Füsun didn't pass her second test either. This time they set her the very difficult task of maneuvering into an imaginary parking space while driving up a hill in reverse. When she made the Chevrolet tremble and judder again, they ordered her out of the car in the same humiliating way.

I had been watching from a distance with a mixed crowd of retired policemen, applicants, letter writers, teaboys, and various gawkers; when one of them saw a bespectacled examiner once again take the wheel from Füsun, he said, "They flunked that chick," and a couple of others laughed.

As we drove back toward the house, Füsun was too upset to speak. Without asking her first, I parked the car in Ortaköy and sat down in a little *meyhane* in the market, where I ordered us some *rakı* with ice.

"Life is short but very sweet, Füsun," I said after a few swigs of *rakı*. "The time has come to stop letting these fiends get the better of you."

"How can they be so vile?"

"They want money. So let's pay them."

"Do you believe women can never be good drivers?"

"It's not what I think, but it is what they think."

"It's what everyone thinks."

"Darling, I beg you, don't be so stubborn about this as well," I said, hoping almost at once that Füsun had not heard me say this.

"I'm not stubborn in anything, Kemal," she said. "But when your pride or your honor is being trampled on, you can't just bow your head. Now I'm going to ask something of you, and I would like you to listen, please, and take it seriously. I am going to get my license without paying a bribe, Kemal, and on no account are you to interfere. Don't you dare pay a bribe behind my back, and don't try to pull any strings, either, because I'll know if you do, and I will be extremely upset."

"All right," I said, looking down.

We drank our *rakı*s saying little more to each other. It was almost evening, and this *meyhane* in the middle of the market was empty. Impatient flies were perched uncertainly on its trays of fried mussels and little meatballs with thyme and cumin. Years later I went back for another

look at that ramshackle *meyhane* whose memory is so dear to me, but the entire building had been razed and in its place were now shops selling evil eyes, trinkets, and other tourist souvenirs.

That evening, after we'd left the restaurant and were getting back into the car, I took Füsun by the arm.

"Do you know what, sweetheart? That was the first time in eight years we have eaten in a restaurant, just the two of us."

"Yes," she said. The light that flickered for a moment in her eyes made me inordinately happy. "I have something else to say to you. Give me the keys, I'm going to drive the car."

"Of course."

The junctions and hills of Beşiktaş and Dolmabahçe made her perspire a little, but even though she'd had a bit to drink, she was able to steer the Chevrolet as far as Firuzağa Mosque without incident. When I picked her up three days later from the usual spot, she wanted to drive the car again, but the city was crawling with police and I talked her out of it. Despite the hot weather, our lesson went amazingly well.

As we were driving back I looked at the whitecaps on the windy Bosphorus and said, "If only we'd brought our swimsuits!"

The next time we went out, when Füsun left the house in the usual floral print dress, she was wearing underneath it the blue bikini displayed here. After our lesson, at Tarabya Beach, she did not take off her dress until just before she jumped off the seawall into the water. For one brief moment of embarrassment, I could see my beloved's body, and then she swam away, so fast you might have thought she was fleeing me. The bubbles and the churning water in the wake of her plunge, the beautiful light, the midnight blue of the Bosphorus, her bikini—all this gathered in my mind to form an indelible image, a feeling. I spent years searching out that sentiment, and those wondrous colors, in the old photographs and postcards of Istanbul's troubled collectors.

I jumped into the sea right after her. A strange voice inside warned of monsters and evil creatures perhaps lurking underwater, waiting to attack her. I needed to reach her in time and protect her from the depths of the waves. I remember that I was giddy as I searched for her in the choppy sea, that I swam as fast as I could, panicked at the

thought that happiness might escape my grasp, and that at one moment at the height of my panic I couldn't breathe. Füsun had been carried away by the Bosphorus currents! At that moment I wanted to die with her; I wanted to die at once. Just then the capricious waves of the Bosphorus opened up and there was Füsun right in front of me. Both of us breathless, we faced each other with the smiles of happy lovers. But when I tried to get closer, so that I might touch her, kiss her, she pulled a long face, like some modest girl with scruples; without further dallying, she did a cool breaststroke away from me. I swam after her, doing the same stroke. As I swam I admired the movement of her beautiful legs, the sweet roundness of her buttocks. Only much later would I notice how far we were from shore.

"Enough!" I said. "Stop running away from me. This is where the currents begin. They could sweep us both up, and we could die."

I turned around, and when I saw how far away the shore was, I was afraid. The city surrounded us, the European shore now seeming almost as distant as the Asian shore behind us. There was Tarabya Bay, and the Huzur, the restaurant where we'd eaten on so many occasions, and all the other restaurants lining the shore, and the Tarabya Hotel, and the cars, minibuses, and red buses snaking along the shore road, and the hills rising above it, and the shantytowns above Büyükdere—the entire city had receded.

It was as if I were looking at a panoramic miniature painting, not just of the Bosphorus and the city, but of the life I'd left behind. It felt like a dream, this sense I had of being far from the city and my own past. To have reached the middle of the city, in the middle of the Bosphorus, to be so distant from everyone else but together with Füsun, felt like the chill of death. When a wave larger than the others hit Füsun unexpectedly and she let out a shriek, and wrapped her arms around my neck and shoulders to hold on, I knew then that only death would part us.

Just after this fiery touch—we can call it an embrace—she used the excuse of an approaching coal freighter to swim away. She swam gracefully and very fast, so fast I had a hard time keeping up. As soon as she had climbed to the shore, Füsun left me for the bathhouse. None of this called to mind two lovers without shame about each other's bodies.

We were as shy, quiet, and prudish as if we'd just been introduced by our families with marriage in mind: We couldn't even look at each other unclothed.

By driving to and from her lessons, and sometimes to the city proper, Füsun had soon learned to drive well. But she did not pass the road test in early August either.

"I flunked, but never mind. Let's forget about those evil men," said Füsun. "Shall we go to the seaside?"

"Let's go."

Like so many applicants who came to the road test with friends, and had their photos taken as if departing for their military service, only to fail the test, Füsun left the scene at the wheel, smoking and honking like an oafish truck driver. (When I went back many years later, those once ugly, bald, garbage-strewn hills had been transformed into luxury housing estates, complete with swimming pools.) We continued our lessons at Yıldız Park until the summer's end, but by now the driver's license was just an excuse for going to a restaurant or the beach. A few times we rented a rowboat from the wharf next to the Bebek ferry station, and together we'd row out to a place far from the jellyfish and the oil slicks, where the bay met with the currents, and there we'd jump into the sea. One of us would keep hold of the rowboat, to keep it from being swept away by the currents, holding the other with his—or her— free hand. I loved renting a rowboat in Bebek, not least for the pleasure of holding hands with her.

This love finally flowering between us after eight long years was not something we embraced with joy; rather we approached it with great caution, like a friendship that beckons but is nevertheless exhausting. The eight years we'd lived through had buried our love deep within, yet it still made itself felt even at moments when we were paying it least attention. But when I saw that Füsun had no taste for risking the dangers of any greater intimacy before marriage, I, too, resisted my never absent desires to embrace or kiss her. I had begun to entertain the idea that couples who lost their heads and capitulated to desire before they wed, heedless of the consequences, were not likely destined for marital bliss, but rather for disillusionment and depression. As for Hilmi the Bastard, Tayfun, and Mehmet, whom I ran into now and again, I had begun to grow disdainful of these friends of mine, who still patronized

brothels and bragged about their womanizing. At the same time, though, I dreamed that after Füsun and I were married I would find release from my obsessive thoughts and reunite with my friends, and everyone in my old circle, with the contentment that only maturity can confer.

At the end of the summer Füsun took another test with the same examiners and failed once more. This unleashed the usual tirades about male prejudice against Istanbul's women drivers, and she railed against them with that same expression on her face I remembered from so many years earlier, when she'd told me about the sleazy "uncles" who had pawed and molested her.

Early one evening, following our driving lesson, we went to Sariyer Beach, and as we sat there drinking Meltem (an indication that Zaim's campaign with Papatya had worked somewhat) we saw a friend of Mehmet's named Faruk, together with his fiancée, and at that moment I felt a strange sort of shame. This was not on account of Faruk's having paid many visits to the *yalı* in Anadoluhisarı during the summer of 1975 or his having witnessed the sort of life Sibel and I had led there; I was ashamed because Füsun and I showed no joy as we sat there silently drinking Meltem. The silence stemmed from our awareness that this would be our last trip to the beach. The first storks flying past us in the evening sky overhead announced to us that this beautiful summer would soon come to an end. One week later, when the beaches closed with the first rains, neither Füsun nor I had any urge to go to Yıldız Park to practice driving.

After failing three more times, Füsun finally passed her road test in early 1984. They had tired of her, and they understood by then that she was never going to pay a bribe. To celebrate the occasion, that night I took her and Aunt Nesibe and Tarık Bey to the Maksim Gazino to hear Müzeyyen Senar sing old Turkish songs.

74

Tarık Bey

THAT EVENING we all went out to Bebek Maksim, all of us got drunk, and after Müzeyyen Senar came out on stage, everyone at the table began to sing along. As we joined in with the refrains, we would look into one another's eyes and smile. Looking back so many years later, I imagine it had the aura of a farewell ceremony. Actually, it was Tarık Bey, and not Füsun, who most loved Müzeyyen Senar's singing, but I'd thought it would delight Füsun to see her father drinking and blissfully harmonizing with Müzeyyen Senar as he did renditions of songs like "There's No One Else Like You." The most memorable thing about the evening for me was noticing for the first time that Feridun's absence had become ordinary. That evening I reflected happily on how much time I'd spent alone with Füsun and her parents.

Sometimes the passage of time would be marked by seeing a building torn down, or discovering that a little girl had become a high-spirited, buxom woman with children of her own, or I'd notice that some store to which my eyes had grown accustomed had been boarded up, and I would feel anxious. When I saw, at around this time, that the Şanzelize Boutique had closed, I was pained not only at the loss of my own memories, but equally by a sudden feeling that life had gone on without me. In the window where Sibel had spied the counterfeit Jenny Colon handbag nine years earlier, coils of Italian salamis were now hanging, and wheels of hard yellow cheese, as well as the European brands of bottled salad dressings, the pastas and soft drinks just entering the Turkish market.

And whereas before I had always enjoyed sitting with my mother at the dinner table and listening to her gossip about children, families, and weddings, it was at around this time that such reports began to unsettle me. As my mother, displaying her customary hyperbole, told of how my childhood friend Faruk the Mouse already had his second child— "a strapping boy!"—though he'd been married for only a short time—

"three years!"—and as I thought about having been unable to share my life with Füsun, my joy would drain away, but my mother, noticing nothing, would just keep talking.

Ever since Şaziment had (at last) managed to marry off her elder daughter to the Karahan boy, they'd stopped going to ski in Uludağ every February, preferring to spend a month in Switzerland with the rest of the Karahan clan, and taking Şaziment's younger daughter with them. This younger daughter had found herself a rich Arab prince who was staying in the same hotel, and Şaziment had almost succeeded in marrying her off as well when it emerged that the prince had another wife back in his own country—a harem, even. As for the Halis family of Ayvalık, their eldest son—"You remember, the one with the longest chin," said my mother with a laugh, which I could not help sharing— my mother had heard from Esat Bey, her neighbor in Suadiye, that the boy had been caught on a winter's day at their summer house in Erenköy with the German nanny. The eldest son of Maruf the tobacco king—when we were children, we'd played together with shovels and pails in the sandboxes of city parks—had been kidnapped by terrorists, a development my mother was shocked to learn I had not heard about, not even when he was released following the payment of a ransom. Yes, they'd managed to keep the matter from the press, but because the family had been so slow to cough up the money, everyone had been "scandalized" for months on end by the matter—so how could I not have heard?

I was worried that my mother might have intended this question as a dig about my visits to Füsun's family; maybe she was remembering that whenever I came home on summer evenings with wet swimming trunks, and both she and Fatma Hanım would ask whom I'd gone swimming with, how I'd reply, "I'm working very hard, Mother dear," and try to change the subject (as if it had eluded my mother what dreadful shape Satsat was in). It made me sad that after nine years I'd still found no ways of intimating to my mother my obsessive love for Füsun, let alone confiding in her; I would long for her to tell me another pointless story so that I could forget my troubles. One night she described in great detail about how Cemile Hanım, whom I'd seen at the Majestic Garden Cinema with Füsun and Feridun many summers ago, being no longer able to afford the upkeep on her eighty-year-

old mansion, had, like Mükerrem Hanım, another of my mother's friends, taken to renting it out to producers of historic melodramas, only to see "that huge, lovely mansion" burned down, ostensibly due to faulty electrical equipment during filming, though everyone knew the family had deliberately set the fire to erect an apartment building in the mansion's place. The narrative was so vivid that I was in no doubt about my mother's full awareness of my close ties to the film world, the particulars of which Osman must have furnished her.

Though I'd been amused to read in the papers about Melikhan, the former foreign minister, who had taken a fall having caught his foot on a carpet at a ball and died two days later of a brain hemorrhage, my mother didn't mention it, fearing perhaps that it might remind me of Sibel and the engagement. There were other pieces of news that my mother saw fit to withhold, but that I'd heard from Basri, the Nişantaşı barber. It was he, for instance, who informed me that my father's friend Fasih Fahir and his wife, Zarife, had bought a house in Bodrum; that Sabih the Bear was actually a very decent person "underneath it all"; that gold was actually a foolish investment right now; that prices were bound to fall; that there would be a lot of fixing at the horse races that summer; that even without a hair left on his head, the famously wealthy Turgay Bey, out of attachment to the habits of a gentleman, still came in for regular haircuts; that two years ago Basri had been offered the Hilton concession, but being a "man of principle" (the meaning of which he did not elaborate) he had declined—and in this same spirit proceeded to ply me for any information I might have on this and that. It would irritate me to realize that Basri and all his rich Nişantaşı clients knew all about my obsession for Füsun, and lest I give them more to gossip about, I would sometimes go to Cevat, my father's old barber in Beyoğlu, and from him I would hear tales of the Beyoğlu hoodlums (by now referred to as the mafia) and the film world. It was from him, for example, that I heard of Papatya's involvement with Muzaffer, the famous producer. None of my sources, however, talked to me about Sibel or Zaim, or about Mehmet and Nurcihan's wedding. From this, if nothing else, I should have deduced the universal awareness of my sorrow and suffering, but I didn't: My informants' tact seemed as natural to me as their oft-repeated indiscreet accounts of all the bankers going bankrupt, stories I always welcomed.

It was two years earlier, at the office and also from friends, that I'd begun to hear about all the bankers who'd gone bankrupt, and all the investors who'd lost their fortunes—stories I enjoyed because they proved the utter brainlessness of the Istanbul rich, not to mention their slave masters in Ankara. For her part, my mother relished saying, "Your dear departed father always did insist that no one should trust those conniving bankers!"—a subject she warmed to since, unlike so many others in our circle, we'd not fallen prey to them. (Though I sometimes suspected that Osman had secretly invested some of the profits from his new ventures with them.) My mother felt bad for any friends who'd been fleeced—Kadri the Sieve, whose beautiful daughter she had once hoped I would marry, Cüneyt Bey and Feyzan Hanım, Cevdet Bey and his family, the Pamuks—but when it came to the Lerzans, she would profess amazement that they should have consigned their entire fortune to a "so-called banker" who was the son of an accountant in one of their own factories (and who had worked his way up from security guard), a man who had only recently risen from the shantytowns with no financial credentials, but with an office of some sort, an advertisement on TV, and a checking account with a reputable bank. Closing her eyes as if she would faint and shaking her head half in jest, she would say, "They could at least have gone to someone like Kastelli, who's so close to those actor friends of yours." I would never dwell on the subject of my actor friends; when she marveled that "sensible, reasonable people" (including, as readers will recall, Zaim) could be so harebrained, I would enjoy chiming in.

Tarık Bey numbered among those my mother dismissed as stupid. He had invested money with Kastelli the banker, who had hired so many of the famous actors we knew from the Pelür to appear in his commercials. When Tarık Bey had admitted losses two years earlier, I'd assumed them to be small, as he gave no indication of serious suffering or hardship.

On Friday, March 9, 1984, two months after Füsun got her driver's license, when Çetin dropped me off at the house in Çukurcuma at suppertime, I saw that all the windows and curtains were open, and the lights were on upstairs and downstairs, this despite Aunt Nesibe's perennial upset at the waste of electricity when a single light was left on upstairs at suppertime; without fail, she would say, "Füsun, my girl, the

bedroom light's still on," and without delay Füsun would go straight upstairs to turn it off.

Steeling myself for a family quarrel between Feridun and Füsun, I went upstairs. No one was seated at the table where we'd eaten supper for so many years, nor could I see any food. The television was on, and sitting before it were two neighbors—an old lady and her husband—who seemed at a loss as to what to do. Out of the corners of their eyes they were watching our actor friend Ekrem Bey, who, dressed as the grand vizier, was making a speech about infidels.

"Kemal Bey," said the neighbor, Efe the electrician. "Tarık Bey has passed away. Please accept our condolences."

I ran upstairs, instinct taking me not to the master bedroom but to Füsun's room—the little bedroom I had dreamed of for so many years.

My lovely was lying doubled up in bed and crying. When she saw me she straightened herself, and I sat down beside her. We instantly threw our arms around each other, embracing with all our strength. She rested her head between my neck and chest, weeping convulsively.

Dear God, what great happiness it was to hold her in my arms! I felt the world's profundity, its unbounded beauty. With her head resting on my shoulder, her chest pressed against mine, I felt as if it were not just she but the entire world in my arms. Her shaking upset me, grieved me deeply, in fact, but what bliss it brought me, too! I stroked her hair with care and tenderness, combing it gently with my fingers. Every time my hand returned to her roots so my fingers could pass once more through her hair, her entire body quaked as she burst into tears once more.

I called to mind my own father's death so that I might better share in her grief. But much as I'd loved my father, there'd always been a tension between us, a rivalry of sorts. Füsun, by contrast, had loved her father deeply, tirelessly, and without effort or reservation, just as one might love one's home, and one's street, and the sun that shone down on them. And it seemed to me that her tears were shed not just for her father but also for the state of the world, and the course of life.

"Don't worry, my darling," I whispered into her ear. "Everything will be fine from now on. From now on everything will work out. We are going to be very happy."

"I don't want anything anymore!" she said, wailing more fiercely. As I felt her shudder in my arms, I looked long and hard at the furniture,

the drawers, the little nightstand, Feridun's film books, and so much else. For eight years, how much I had longed to come into this room where Füsun kept all her dresses, and all her other belongings.

As her sobbing intensified, Aunt Nesibe came in. "Oh Kemal," she said, "what are we going to do? How can I live without him?" Sitting down on the bed, she, too, began to cry.

I spent the night in Çukurcuma. Sometimes I would go downstairs to sit with the friends and acquaintances who had come to offer condolences, and then I would go back upstairs to comfort Füsun, still crying in her room; I would stroke her hair and give her a fresh handkerchief. As her father's body lay in the next room, and the friends and acquaintances gathered together downstairs sat drinking tea and smoking cigarettes and watching television in silence, Füsun and I lay side by side, locked in an embrace, for the first time in nine years. I breathed in the scent of her neck, her hair, her skin perfumed with the scent that the exertions of crying had released. Then I would go back downstairs to serve the guests.

Feridun was unaware of what had happened, and that night he did not come to the house. It is only now, years later, that I can fully appreciate the thoughtfulness of the neighbors in acting as if it was entirely natural that I be there, indeed as if I were Füsun's husband. I'd met them all in the course of my visits to Çukurcuma, sometimes in the street, and sometimes when they called at the house, and to offer them tea and coffee, to empty their ashtrays, to offer them pastries hurriedly acquired from the corner bakery was for me a welcome distraction, as it was for Füsun and Aunt Nesibe. At one point three men—the Laz carpenter whose shop was just up the hill, the eldest son of Rahmi Bey (whose artificial hand will be familiar to all museum visitors), and an old friend who often came to play cards with Tarık Bey in the afternoons—embraced me each in turn, repeating the traditional entreaty not to die with the dead. But as I grieved for Tarık Bey, there was also inside me a boundless will to live; as I considered the new life now awaiting me, I felt deeply happy, and on this account ashamed.

After the banker he'd invested with went bankrupt and fled the country, Tarık Bey began to spend time at an association set up by a number of other "banker victims" (as the newspapers liked to call them). The association had been established to find a legal means of

recovering the money that the retirees and petty clerks had lost to the bankers, but in this it had been unsuccessful. As Tarık Bey would some-times relate to us, barely containing his laughter, the members (whom he sometimes described as a "brainless rabble") were so fractious that planning discussions would typically degenerate into argument, with victims kicking and punching one another. Sometimes, after a great deal of shouting, they would force through a petition, which they'd submit to the ministry or leave at the door of a bank or a newspaper with no professed interest in helping them. Some members would pelt banks with rocks, bellowing their grievances, sometimes assaulting bank clerks. After several unsavory incidents in which bankers' doors had been kicked down and their homes and offices looted, Tarık Bey distanced himself from the association, but that summer, while Füsun and I were sweating for her driver's license and swimming in the sea, he'd begun attending meetings once again. That afternoon some devel-opment at the association had particularly annoyed him, and he'd gone home complaining of chest pains; as the doctor who'd come hours too late was able to confirm with one look, he'd died of a heart attack.

Füsun was all the more distraught at not having been at home when her father died. Tarık Bey must have lain in bed for a long time, waiting for his wife and daughter. Aunt Nesibe had taken Füsun along that day to a house in Moda to finish a dress that was a rush order. In spite of all the assistance I had given the family, from time to time Aunt Nesibe still went off with that sewing box with the picture of Galata Bridge on it, to work at various houses at a daily rate. In no way was I insulted, as other men might have been, by Aunt Nesibe's persistence; rather, I was impressed that she still sewed, even though she knew she could count on me for support. Still, I was troubled whenever I heard that Füsun had accompanied her, asking myself what my beauty, my one and only, could be doing in those strangers' houses; but she went only rarely, and even more rarely spoke to me about those sewing day trips, though when she did she always described them as pleasant excursions, in terms reminiscent of her mother's visits to Suadiye so many years ago, with such joy in her voice as she told me of drinking *ayran* on the Kadıköy ferry, and of throwing *simits* to the seagulls, that I hadn't had the heart to tell her that when we were married and living among the

rich, neither of us would enjoy meeting those people whose houses she'd visited as a seamstress.

Long after midnight, when everyone had left, I curled up on the divan in the back room downstairs. To sleep in the same house with Füsun, for the first time in my life . . . this was the greatest happiness. Before drifting off to blissful sleep, I listened first to Lemon rattling about in his cage, and then to the ships sounding their whistles.

I woke up with the morning call to prayer; by now the ships on the Bosphorus were more insistent, and in my dream Füsun's ferry ride from Karaköy to Kadıköy had merged with Tarık Bey's death.

From time to time, I heard foghorns, too, and the whole house was bathed in the pearly white that was particular to foggy days. Passing in silence through the white dreamscape, I made my way up the stairs. There, on the bed where she and Feridun had spent the first happy nights of their marriage, I found Füsun fast asleep, with her arms draped around her mother. I sensed that Aunt Nesibe had heard me. I gave the room one last careful peek: Füsun really was asleep, and Aunt Nesibe was pretending.

Going into the other room, I gently lifted the sheet they'd draped over him, and looked for the first time at Tarık Bey's body. He was still wearing the jacket he'd put on to attend the meeting at the banker victims' association. His face was ashen, the blood having gathered at the nape of his neck. It was as if the stains and moles and wrinkles on his face had grown larger in death. Was this because his soul had left him, or because his body had already begun to decay and change shape? Death's terrifying presence was much stronger than the love I felt for Tarık Bey. Rather than feel for him, or put myself in his shoes, I wanted only to flee. But I did not leave the room.

I'd loved Tarık Bey because he was Füsun's father, because we'd spent so many years at the same table, drinking *rakı* and watching television. But as he'd never really opened himself up to me, I'd never felt truly close to him. In truth, we'd never been fully satisfied with each other, but in spite of that we still managed to get along.

As I thought all this over, I realized that Tarık Bey, like his wife, had known from the beginning that I was in love with his daughter. Or rather, I did not so much realize this as confess it to myself. He'd

almost certainly known very early on that I'd been so irresponsible as to sleep with his daughter when she was but eighteen years old, and, inevitably, dismissed me as a heartless rich man, a boorish philanderer. As I was the one who had forced him to marry his precious girl off to a penniless boy with no prospects, he could not but have hated me! But he had never once shown his resentment; or perhaps I had never once wanted to see it. I might say he had both resented and forgiven me, as thieves and gangsters keep company by turning a blind eye on one another's iniquities and disgraces. This was why, after the first few years, he'd ceased to be the man of the house, just as I had ceased to be the guest: We had become partners in crime.

As I looked at Tarık Bey's frozen face, a long-suppressed memory surfaced: I was reminded of the fear and awe that had printed itself on my father's face as he faced death. Tarık Bey's heart attack had lasted longer: He'd met death and struggled with it, and so on his face there was no awe. He'd bitten his lips on one side, as if to fight the pain, and the other side of his mouth was open, as if grinning. At the table he'd always had a cigarette in that corner of his mouth, and a *rakı* glass in front of him. But in the room there was no charge issuing from the objects that had surrounded him in life; there was only the fog of death and the void.

The white light flooding the room came mostly from the left-hand side of the bay window. Looking outside I saw the narrow street was empty. Because the bay window extended as far as the middle of the street, I could imagine myself suspended above it in midair, in fog so thick that I could only just see the corner where the street met Boğazkesen Avenue, the entire neighborhood asleep in the fog, a cat confidently slinking slowly down the street.

Just over his bed, Tarık Bey had hung a framed photograph from his days as a teacher at Kars Lycée: It showed him standing with his students at the end of a play they had performed in the famous theater that dated back to the time when the city had belonged to the Russians. The top of the bedside table and its half-open drawer also brought back strange memories of my father. It emanated a sweet fragrance, a mixture of dust, medicine, cough syrup, and yellowing paper. Above the drawer I saw a water glass containing his false teeth and a book by his beloved Reşat Ekrem Koçu. Inside the drawer there were old med-

icine bottles, cigarette holders, telegrams, folded doctors' reports, newspaper articles about bankers, electric and gas bills, coins now gone out of circulation, and many other odds and ends.

Before any of the day's visitors gathered at the Keskin house, I left for Nişantaşı. My mother was up and having breakfast in bed, eating from a tray Fatma Hanım had brought her and propped on a pillow: boiled eggs, marmalade, black olives, and toasted bread. She perked up when she saw me. When I told her about Tarık Bey, her face dropped, and she looked genuinely sorry. I could tell that she felt Nesibe's grief. But beneath that I sensed something else.

"I'll be going back there," I said. "Çetin can bring you to the funeral."

"I'm not going to the funeral, my son."

"Why not?"

First she gave two ridiculous excuses. "There's been no announcement in the papers. Why are they in such a big hurry?" and "Why aren't they having the funeral at Teşvikiye Mosque? Everyone else started their funeral processions there." I could see that she felt deeply for Nesibe, whom she'd liked so much, and with whom she'd had such good fun during the days when Nesibe had come to the house to sew. But underneath there was something else, something unyielding. When she saw how unsettled I was by her refusal, and how determined to know the true reasons for it, she lost her temper.

"Do you want to know why I'm not going to the funeral?" she said. "Because if I do, you'll marry that girl."

"Where did you get that idea? She's married already."

"I know. It will break Nesibe's heart. But my son, I've known all about this for years. If you insist on marrying her, it won't be a pretty picture to most people."

"Does it really matter, Mother dear? People will always talk."

"Please, I beg of you, don't take offense." Looking very serious, she set her toast on the tray, and next to it, her knife, smeared with butter; and she looked intently into my eyes. "At the end of the day, what other people say has no importance whatsoever. Of course, what's important is the truth, the honesty of our feelings. I have no complaints about that, my son. You fell in love with a woman. . . . And that's wonderful, my son. I can't complain about that. But has she ever loved you? What

has she done over the past eight years? Why has she still not left her husband?"

"She's going to leave him, I am certain of it," I lied ashamedly.

"Look, your dear departed father was smitten with a poor woman young enough to be his daughter. . . . He was obsessed with her. He even bought her a house. But he kept everything hidden; he didn't make a fool of himself as you have done. Even his closest friend had no idea." She turned toward Fatma Hanım, who had just entered the room, and said, "Fatma, we're having a little talk." When Fatma had withdrawn, shutting the door behind her, my mother continued. "Your dear departed father was a man of character and intelligence, and a gentleman, too, but even he had his weaknesses and desires. Years ago you asked me for the key to the Merhamet Apartments and I gave it to you, but knowing you to be your father's son, I warned you. 'For goodness' sake, be careful,' I said. Didn't I? My son, you didn't listen to me at all. All right, you say to me that if it's your fault, where is Nesibe's sin in all this? What I can never forgive is this torture she and her daughter have subjected you to, these ten long years."

I did not say, It's been eight, not ten, Mother. "All right, Mother," I said. "I know what to say to them."

"My son, you can't find happiness with that girl. If you could, you'd have found it by now. I don't think you should go to the funeral either."

I did not infer from my mother's words that I had ruined my life: Quite to the contrary, she'd reminded me, and I felt this all the time now, that I was soon to share a happy life with Füsun. And so I was not in the least angry with her; I even smiled as I listened to her lecture, my only wish being to return to Füsun's side at once.

Seeing she'd made no impression on me, my mother was incensed. "In a country where men and women can't be together socially, where they can't see each other or even have a conversation, there's no such thing as love," she vehemently declared. "By any chance do you know why? I'll tell you: because the moment men see a woman showing some interest, they don't even bother themselves with whether she's good or wicked, beautiful or ugly—they just pounce on her like starving animals. This is simply their conditioning. And then they think they're in love. Can there be such a thing as love in a place like this? Take care! Don't deceive yourself."

Finally my mother had succeeded in angering me. "All right then, Mother," I said. "I'm off."

"When they hold funerals in neighborhood mosques, the women don't even attend," she called after me, as if this had been her real excuse all along.

Two hours later, as the crowd at Firuzağa Mosque dispersed after funeral prayers, I saw women among the mourners embracing Aunt Nesibe, though admittedly they were few. I remember seeing Ceyda and also Şenay Hanım, proprietor of the now defunct Şanzelize Boutique, as I was standing beside Feridun in his flashy sunglasses.

In the days that followed, I went to Çukurcuma early every evening. But I sensed a great uneasiness in the house, and at the table. It was as if the gravity and contrivance of the situation had now been uncloaked. It had always been Tarık Bey who was best at pretending not to see what was going on between us: It was he who'd excelled at acting "as if." Now that he was gone, there was no acting naturally, nor could we fall back into the comfortable, half-rehearsed routines of the past eight years.

75

The İnci Patisserie

ON A RAINY day at the beginning of April, after chatting with my mother for most of the morning, I went to Satsat at around noon. As I was drinking my coffee and reading the paper at my desk, Aunt Nesibe phoned. She asked me not to come to visit for a while, saying that there'd been some unpleasant gossip going around the neighborhood, and that though she couldn't go into detail over the phone, she had good news for me. With my secretary, Zeynep Hanım, listening in the next room, I did not inquire how things were going, not wishing to make my concern for Aunt Nesibe too obvious.

For two days I waited, eaten alive by curiosity, until—once more, just before noon—Aunt Nesibe came to see me at Satsat. Despite all the time we'd spent together over the past eight years, it was so strange

seeing her at the office that I stared at her blankly as if at some visitor from the provinces or the outskirts of the city, who, having come to exchange a defective Satsat product or to collect her complimentary calendar or ashtray, had found her way upstairs by mistake.

By then Zeynep had figured out that the stranger was someone very important to me; perhaps she could tell from my awkwardness or Aunt Nesibe's ease, or perhaps she'd already heard a few things. When she asked us how we'd like our Nescafés, Aunt Nesibe said, "I'll have Turkish coffee, my girl—if that's possible."

I closed the connecting door. Aunt Nesibe sat down across from me at my desk and looked me straight in the eyes.

"Everything's settled," she said, her manner suggesting not so much a happy outcome as life's tendency to put things aright in the simplest way. "Füsun and Feridun are separating. If you let Feridun have Lemon Films he'll be very accommodating. This is what Füsun wants, too. But first the two of you will have to talk."

"Do you mean me and Feridun?"

"No, I mean you and Füsun."

After watching the first glow of happiness spread across my face, she lit herself a cigarette, crossed her legs, and told me the story, not in a needlessly dilatory way, but enjoying every bit just the same. Two days earlier, Feridun had come to the house having drunk a good deal; telling Füsun that he and Papatya had split, he said he wanted to come back to the house, and to Füsun. But, of course, Füsun wouldn't have him back, and a terrible row ensued, and what a pity, what a shame it was that the neighbors, the entire neighborhood, had heard them shouting (this was why Aunt Nesibe had asked that I not visit for a while). Later on Feridun telephoned, and after he and Aunt Nesibe arranged to meet in Beyoğlu, both husband and wife agreed to a separation.

There was a silence. "I've changed the locks on the front door," said Aunt Nesibe. "Our house is no longer Feridun's house."

For a moment it was as if all the traffic clattering past Satsat had fallen silent, along with the wider world. Seeing me transfixed by what she'd said, my cigarette burning down unnoticed in my hand, Aunt Nesibe retold her story from the beginning, this time lavishing more detail. "To tell the truth, I could never feel any anger toward that boy,"

she said, in a worldly-wise tone of voice that implied she had known from the start how all this would turn out. "Yes, he has a good heart, but he's also very weak. What mother would want a bridegroom like that?" she said, and then fell silent. I was expecting her next to say something like, Of course, we had no choice, but she said something utterly different.

"I've experienced a bit of this in my own life. It's very difficult, being a beautiful woman in this country especially a divorcée—more difficult, even, than being a beautiful girl. . . . When men can't get what they want from a beautiful woman, they do evil things to her—you know this, too, Kemal; and Feridun protected Füsun from all those evils."

For a moment I wondered whether I was one of the evils Feridun had protected her from.

"Of course, it shouldn't have taken this long to sort things out," she continued.

Calm but amazed, I said nothing: It was as if I had never noticed before what a strange shape my life had taken.

"Of course, Feridun has a right to Lemon Films," I said after some time. "I'll speak to him. Is he at all angry with me?"

"No," said Aunt Nesibe, frowning. "But Füsun wants to have a serious talk with you. There is so much inside her that has gone unsaid. You'll talk."

We decided that Füsun and I should meet at two in the afternoon three days hence, at the İnci Patisserie in Beyoğlu. Aunt Nesibe did not prolong the conversation; she pretended to be uncomfortable speaking in such strange surroundings, but, good woman that she was, she did not try to hide her contentment when she left.

On the afternoon of Monday, April 9, 1984, I went to Beyoğlu as happy and excited as a teenager going to see the lycée girl he had been dreaming about for months. At first I was too restless to sleep and then too impatient to get through the morning. So I'd asked Çetin to drop me off at Taksim early. It was sunny there, while İstiklal Avenue was as always in shadow, and I sought the refuge of its cool shade, its shop windows, its cinema entrances; even the smell of damp and dust in the passages I had visited with my mother as a child was inviting. I was dizzy with blissful memories and the promise of a happy future, the

contagious optimism of the crowds swirling past me in search of a nice meal, a diverting film, a few things to buy.

I went into Vakko, Beymen, and a couple of other stores in search of a present for Füsun, but I couldn't decide on anything. To work off nervous energy, I walked all the way to Tünel, and exactly half an hour before the appointed time, in front of the Mısırlı Apartments, I saw Füsun. She was clad in a lovely spring dress, large, bright polka dots on a white background with a pair of provocatively glamorous sunglasses and was looking at a shop window. She hadn't noticed me, but I noticed her, and in particular that she was wearing my father's earrings.

"What a coincidence" were my first clumsy words.

"Oh . . . hello, Kemal! How are you?"

"It's such a beautiful day, I had to get out of the office," I said, as if we'd had no plan to meet in half an hour, and had run into each other by chance. "Shall we walk?"

"First I have to find a particular type of button for my mother," said Füsun. "She is under a lot of pressure completing an urgent dress order, and so after you and I have spoken, I'm going back to the house to help her. Shall we go to the Passage of Mirrors to find her a wooden button?"

We went not just to the Passage of Mirrors but to several other passages, too. How lovely it was to watch Füsun talk to the shop assistants, looking over samples of all colors, rummaging through trays of old buttons, chatting away as she searched for a set.

"What do you say to these?" she said, having found some buttons.

"They're beautiful."

"All right, then."

She paid for the buttons that I would find nine months later, in her chest of drawers, still in their wrapping paper.

"Come on now, let's walk a little," I said. "I spent eight years dreaming about meeting one day in Beyoğlu and walking along together."

"Really?"

"Truly."

We walked for a while without speaking. From time to time I, too, would look into a shop window, though it wasn't the merchandise that drew my eye, but her beautiful reflection in the glass. Men were not the

only ones noticing her in the Beyoğlu crowds; it was the women, too, and Füsun liked that.

"Let's sit down somewhere and have a piece of cake," I said.

Before Füsun could answer, a woman broke through the crowd and crying with delight threw her arms around her. It was Ceyda, and her two children: a boy of eight or nine and his younger brother, both in short pants and white socks, both healthy-looking and vivacious; as their mother spoke to Füsun, they eyed me curiously: They had Ceyda's huge eyes.

"How lovely to see you two together!" said Ceyda.

"We ran into each other just a few minutes ago," said Füsun.

"You look so nice together," said Ceyda. They lowered their voices to continue their conversation inaudibly.

"Mother, I'm bored, can we please go?" said the older child.

I remembered sitting with Ceyda in Taşlık Park eight years ago, when this child was in her belly; as we'd gazed down at Dolmabahçe, we'd talked about the pain I was in. But recalling that time I was neither sad nor overcome by emotion.

After Ceyda had left us, we slowed down in front of the Palace Cinema where they were showing *That Troublesome Song,* starring Papatya. During the past twelve months, Papatya had (if the papers were to be believed) broken some world record by playing the lead in no fewer than seventeen films and *photoroman*s. The magazines were peddling a lie about her being offered starring roles in Hollywood, and Papatya had kept the story line bubbling by posing with Longman's textbooks and telling lies about taking English lessons, and her willingness to do whatever she could to represent Turkey abroad. As Füsun examined the film stills in the lobby, she noticed me paying close attention to her expression.

"Come on, darling, let's go," I said.

"Don't worry, I'm not jealous of Papatya," she said sagely.

We continued along in silence, gazing into shop windows.

"Sunglasses are very becoming on you," I said. "Shall we step inside for a profiterole?"

We'd arrived at the İnci Patisserie at the exact time her mother and I had arranged for the rendezvous. Without hesitation we went inside:

An empty table beckoned at the back, just as in my dreams of the past three days. We ordered the profiteroles, for which the patisserie was famous.

"I'm not wearing sunglasses to look good," said Füsun. "Whenever I think of my father, it brings me to tears. You do understand that I am not jealous of Papatya, I hope?"

"I understand."

"Still, I'm impressed by what she's done," she continued. "She put her mind to something, and she refused to give up, and she succeeded, just like a character in an American film. If I regret anything, it's not having failed to become a successful actress like Papatya; it's having failed to fight for what I wanted in life, and for that I have only myself to blame."

"I've been pressing my case for nine years, but that is not always the best way to get what you want in life."

"That may be true," she said coldly. "You spoke to my mother. Now it's time for you and me to speak."

Exuding self-assurance, she took out a cigarette. As I leaned forward with my lighter, I looked into her eyes and—in a whisper, so that no one in this tiny patisserie could hear me—I told her once again how much I loved her, how our bad days were over, and how, despite all the time we'd lost, a great happiness awaited us.

"I feel the same way," she said in a measured, cautious voice. Her gestures were tense, her expression anything but natural, from which I concluded there was a tempest raging inside her that required all her strength to suppress. Seeing how forcefully she was exerting herself to do the right thing, I loved her more than ever, but I also feared the intensity of what was brewing inside her.

"After I'm officially divorced from Feridun I want to meet all your family, your friends, everyone," she said, sounding like the pupil at the head of the class, laying out her future. "I'm not in any hurry. We can take our time. . . . After I've divorced Feridun, of course your mother has to come to us to seek permission. She and my mother will get along fine. But first she has to telephone my mother and apologize for not coming to my father's funeral."

"She was very unwell."

"Of course. I know."

We fell silent, and for a time picked at our profiteroles. As I watched her mouth, now filled with sweet chocolate and cream, it was not desire I felt, but love.

"There is something you must believe, and I expect you to behave accordingly. At no point during my marriage with Feridun did we have marital relations. You absolutely must believe this! In this sense I am a virgin. I shall be with only one man in my life, and that man is you. We can draw a veil over those two months that preceded the past nine years." (Actually, dear reader, it was a month and a half, less two days.) "It will be as if we've just met. So it will be just as in those films—I married someone, but I remained a virgin."

She smiled slightly as she uttered the last two sentences, but having grasped the seriousness of her demands, I only frowned soberly and said, "I understand."

"We'll be happier if we do it this way," she said as one would utter any judicious pronouncement. "There's one more thing I want. Actually, this was not my idea—it was yours. I want us all to tour Europe together in your car. My mother will come to Paris with me. We can go to the museums, look at all the pictures. Before we marry, I also want to buy things there that I can take to our house, as my trousseau."

Hearing her speak of "our house" I broke into a smile. Even as she issued her commands she smiled slightly as she spoke, as a chivalric commander emerging victorious might declare his righteous terms at the end of a long war. Later, when she said, "We'll have a big, beautiful wedding at the Hilton, like everyone else," she frowned gravely. "Everything will be as it should be, down to the last detail," she said, without affect, as if having no memories, good or bad, of my engagement party there nine years earlier, and simply wanting all to be correct.

"That's how I want it, too," I said.

For a time we were silent.

The İnci Patisserie had been an important landmark of my childhood excursions to Beyoğlu with my mother, and in thirty years it hadn't changed a bit, though it was more crowded than I remembered, and that made it harder to speak.

When, for a moment, a mysterious silence fell over the whole patisserie, I whispered that I loved her very much and would obey her every wish, desiring nothing else in the world than to spend the rest of my life with her.

"Really?" she said, in the same childish manner as when doing her math homework.

She was confident and determined enough to laugh at her own words. Carefully lighting another cigarette, she enumerated her other demands: I was never to hide anything from her, I would share all my secrets, and whatever question she asked about my past, I was to answer it truthfully.

As I listened, everything I saw engraved itself upon my memory: Füsun's stern, willful expression, the patisserie's ancient ice cream machine, and the framed photograph of Atatürk, whose frown so closely resembled Füsun's. We decided that the engagement should happen before we went to Paris, and that it should be a small family affair. We spoke of Feridun with respect.

Returning to the subject of sexual relations, she expressed her clear wish to wait until after marriage in the following terms: "Don't try to force me, okay? It won't work anyway."

"I know," I said. "Actually, I'd prefer this to be an arranged marriage."

"It can almost count as one!" she said, sounding so very certain.

She went on to say that without a man in the house anymore, the neighbors might jump to conclusions if I continued coming to supper every night. (Every night?) "Of course, I don't really care about the neighbors; they won't be my neighbors for long," she said later. "I just can't have those same sweet conversations without my father there. It's so painful."

For a moment I thought she was going to cry, but she held herself together. The patisserie had swinging doors, but now a great influx was holding them open. A crowd of lycée students in navy jackets, their thin ties askew, were pushing their way in, laughing boisterously and jostling one another. Before long we rose to leave. Taking no end of pleasure from escorting Füsun through the Beyoğlu crowds, I walked silently by her side as far as Çukurcuma Hill.

76

The Cinemas of Beyoğlu

WE MANAGED to honor the spirit of the conditions Füsun had set out at the İnci Patisserie. I immediately arranged for an army friend of mine, a lawyer who lived in Fatih—a world away from Nişantaşı—to represent Füsun in what was, after all, a straightforward case, since the couple had made a mutual decision to divorce. Füsun had told me with a smile that Feridun had also considered asking me to recommend him a lawyer. Though I could no longer visit her in Çukurcuma, we met every other day in Beyoğlu and went to see a film.

Even as a child, I'd always treasured the coolness of the Beyoğlu cinemas as the streets grew warmer with the progress of spring. Füsun and I would meet in Galatasaray, and after considering all the posters we would select a theater, buy our tickets, and step into the cool, dim, and mostly empty seats, where, by the light reflected off the curtains, we would find a secluded place at the back, to hold hands, and watch the film at leisure, like people with all the time in the world.

At the beginning of summer, when the cinemas began to show two or three films for the price of one, I remember a day when I'd sat down, adjusting my trousers to be as comfortable as possible, setting my newspapers and magazines on the empty seat beside me, thus deferring my blind search for Füsun's hand, and before I could act, it landed on my lap like an impatient sparrow, opening expectantly on my belly for a moment, as if to ask, Where are you? And at that moment, moving faster than my soul, my hand wrapped itself longingly around hers.

Those Beyoğlu theaters with summertime double features (the Emek, the Fitaş, and the Atlas) and even those showing three films (the Rüya, the Alkazar, and the Lale) did away with the traditional five-minute intermission midfilm; and so it would not be until the lights went up between features that we would see what sort of an audience we'd been sitting with. During these intervals, as we watched the lonely

men in wrinkled clothes, holding wrinkled newspapers, sprawled or reclining or doubled over in the seats of these huge, mildewy, dimly lit halls, and the elderly dozing in corners, and those desirous souls who had such a hard time wrenching themselves from the dream world of the film back to the reality of the dusty, murky theater, Füsun and I would exchange our news in whispers, though never holding hands. It was at one such interval, in a box at the Palace Cinema, that Füsun whispered the words I'd been awaiting for eight years: She and Feridun were officially divorced.

"The lawyer has the papers," she said. "Now I am legally a divorcée."

In that instant the gilded ceiling of the Palace Cinema, its faded glamour and its peeling paint, and its curtains, and its stage, and its drowsy slouching patrons, engraved itself forever in my memory. Even as recently as ten years ago, couples still used theater boxes at the Atlas and the Palace as they used Yıldız Park, to hold hands and kiss in private; while Füsun wouldn't let me kiss her while we were sitting in a box, she did not stop me from resting my hand on her legs or petting her knees.

My last meeting with Feridun reached the necessary resolution, but contrary to my hopes and expectations, it left me with a bad taste in my mouth. I'd been shocked by Füsun's insistence at the İnci Patisserie that they'd never made love, and by her demand that I believe this, because, after all, I (like so many men in love with married women) had been secretly clinging to this idea for eight long years. This is, in fact, the crux of our story, for it explains why I had been able to stay in love with her so long.

Had I dwelled long and hard and openly on the notion of Füsun and Feridun's enjoying full marital relations (a painful proposition I'd tested once or twice with no desire to repeat the experience), my love could not have survived. Yet, when, following years of successful self-deception, Füsun had commanded that I had no choice but to believe it, I immediately and unequivocally told myself that it couldn't be true, and indeed even bristled at the thought that she was tricking me. But as Feridun had in fact left her after six years of marriage, the deception clung by a reed of hope, though a moment's thought to the contrary would make me unbearably jealous and also angry at Feridun, keen to humiliate him. We had muddled through eight years without conflict

precisely because I'd felt no anger toward this man. Eight years on, it was easy to understand how their happy sex life had permitted Feridun to tolerate me, especially at the beginning. Like any man who is happy with his wife but also enjoys the company of friends, Feridun had wanted to spend the evenings in the coffeehouse relaxing and talking about work. As I looked into Feridun's eyes, I was obliged to accept another fact I had long hidden from myself: that my presence had curtailed the happiness Füsun might have shared with her husband during the early years of their marriage.

It was during my last meeting with Feridun that I first heard the murmurings of the jealousy that had been lying voiceless and dormant for eight years, in the oceanic depths of my consciousness, and I decided then and there, as I had with certain old friends of my circle, that I would never see him again. Those who knew how, for many years, Feridun had been like a brother to me, and those who had pined for Füsun before I even knew her, may find it inscrutable that I should have borne him such ill will just as things were going my way. Suffice it to say that after so many years of seeing Feridun as an enigma, I was coming to understand him, and with that, let us close the subject.

Feridun's eyes betrayed his own jealousy, though small, of the happiness Füsun and I had before us. But during that long final lunch at the Divan Hotel, we plied ourselves with enough *rakı* to relax us; and so after ironing out the details of transferring full rights to Lemon Films to Feridun's name, we were able to turn to another subject that soothed and charmed us both: Feridun was soon to start shooting his art film, *Blue Rain*.

I'd drunk so much that with an unsteady gait I went straight home, without even stopping off at Satsat, and immediately fell into bed. I remember remarking to my worried mother when she came to check on me, before dropping off, "Life is beautiful!" Two days later, on an evening when the skies were ripped open by thunder and lightning, Çetin drove my mother and me to Çukurcuma. My mother pretended to have forgotten her refusal to attend Tarık Bey's funeral, and being agitated, as she always was on such occasions, she did not stop talking the whole way. "Oh, look how nicely they've done those sidewalks," she said as we came closer to Füsun's house. "I've always wanted to see this neighborhood. What a lovely hill that is. What nice snug places

they seem to have here." As we entered the house, a cool wind swept up the dust from the cobblestones, presaging rain.

My mother had previously telephoned Aunt Nesibe with her sympathies, and the two women had met a few times. And yet this visit to ask for Füsun's hand seemed at first to be a condolence call, the occasion to express our regrets at Tarık Bey's passing. But everyone felt that the regrets expressed went far deeper. After the requisite pleasantries and formalities ("How lovely it is here. Oh how I've missed you. I can't tell you how sad we were to hear . . .") Aunt Nesibe and my mother embraced and began to cry, whereupon Füsun fled the room, running upstairs.

When a lightning bolt struck somewhere nearby, the two women released each other and straightened up. "Dear God!" my mother said. Then, as the rain came pouring down and the sky continued to rumble, the twenty-seven-year-old divorcée brought us coffee on a tray that she carried as daintily as any eighteen-year-old who has just entered society. "Nesibe, Füsun is your spitting image!" said my mother. "How clever and knowing she looks when she smiles. What a beauty she's become!"

"No, she is much more intelligent than I am," said Aunt Nesibe.

"Mümtaz, may he rest in peace, he always used to say that Osman and Kemal were more intelligent than he was, but I was never sure he believed it. Who says the younger generation must have more brains than we do?" my mother said.

"The girls are certainly smarter," said Aunt Nesibe. "Did you know, Vecihe"—for some reason, she was unable to, or wouldn't, address her as "Sister Vecihe" in her old reverential way—"what I regret most in life?" She went on to tell how for a long time she'd dreamed of opening a shop and making a name for herself, but could never find the courage, only to live to see "people who don't even know how to hold a pair of scissors or sew a stitch now own the finest fashion houses."

Together we went to the window to watch the rain and the runoff pouring down the hill.

"Tarık Bey, may he rest in peace, was very fond of Kemal," said Aunt Nesibe as she sat down at the table. "Every evening he'd say, 'Let's wait a little longer. Kemal Bey might be coming.'"

I could tell that my mother did not care for these words at all.

"Kemal knows his mind," said my mother.

"Füsun knows what she wants, too," said Aunt Nesibe.

"They've already made their decision," said my mother.

But that was as close as my mother got to asking Aunt Nesibe for her daughter's hand.

Aunt Nesibe and Füsun and I each drank our usual glass of *rakı;* my mother drank only rarely, but she asked for a glass, too, and after two sips turned cheerful—not so much because of the effect of ingesting the *rakı* itself, but because of the fragrance, as my father used to say. She recalled the days when she and Nesibe had stayed up until dawn to complete an evening gown. They both enjoyed reminiscing about the weddings and dresses of that era.

"Vecihe's pleated dress was so celebrated that afterward other women in Nişantaşı asked to have an identical one made for them. Some of them even bought the same material in Paris, placing it right on my lap, for me to sew, but I refused," said Aunt Nesibe.

When Füsun rose ceremoniously from the table and went over to Lemon's cage, I got up, too.

"For God's sake, don't bother with that bird while we're still eating!" my mother cried. "Don't worry, you have plenty of time left to spend together. . . . Stop, stop right there, I'm not letting either of you back at the table until you've washed your hands."

I went upstairs to wash, and Füsun, who could have washed her hands downstairs in the kitchen, followed me up. At the top of the stairs I took her by the arms and kissed her passionately. It was a deep and mature kiss, lasting ten or twelve seconds. Nine years ago we had kissed like children. But there was nothing childish about this kiss, with its slow, powerful soulfulness. Then Füsun went downstairs ahead of me, at a run.

We got through supper with little further merriment, and keeping a close watch on what we said; as soon as the rain had let up, we left.

"Mother dear, you forgot to ask for the girl's hand," I said, as we were driving home in the car.

"How often did you go over there, all these years?" my mother asked. When she saw me at a loss for words, she snapped, "Whatever is done, is done. . . . But Nesibe said one thing that really hurt. Maybe it's because you hardly ever stayed in to eat supper with your mother that it broke my heart to hear it." She stroked my arm. "But don't worry, my

son, I didn't mind. Even so, I just couldn't bring myself to ask for her hand, as if she were still a lycée girl. She's been married and divorced; she's a full-grown woman. She has a head on her shoulders, and she knows what she's doing. You two have talked everything over and agreed on everything. So why the need for all the pomp and ceremony? If you ask me, even an engagement is unnecessary. . . . Stop prolonging things and creating fodder for gossips—just get married. . . . Don't bother going to Europe, either; these days you can find everything you want in the shops in Nişantaşı, so what's the point of trudging over to Paris?"

Seeing my determined silence, she closed the subject.

When we got home, before going to bed, my mother said, "You were right, though. She's a beautiful woman, and intelligent. She'll be a good wife for you. But be careful, she looks as if she's suffered a great deal. I may not know the half of it, but take care not to let the anger, the grudge, whatever it is she's harboring inside her, poison your life."

"It won't!"

Quite to the contrary, with every day, the bond between us grew stronger, and with it our attachment to life, to Istanbul, its streets, its people, and all else. Sometimes while holding hands in a cinema, I would feel a light shiver passing through her. Sometimes she would lean into me, or even rest her head gently on my shoulder. She would sink into her seat to get closer, and I would take her hands between mine, sometimes stroking her leg, like a feather's touch. During the first weeks Füsun had not liked sitting in a box, but now she didn't object. Holding her hand allowed me to measure her reflexive responses to the film, just as a doctor might with the tips of his fingers probe a patient's innermost parts, and I drew enormous pleasure from taking the pulse of her emotional responses to the film.

During intermission, there was cautious talk about the preparations for our trip to Europe, and about beginning to appear together in public, but I never mentioned my mother's thoughts on an engagement party. I, too, had slowly come to see that an engagement party would bring only trouble, encouraging a lot of gossip, and causing disquiet even inside the family: If we invited a great many the gossip would be of how many we'd invited; if we invited fewer the gossip would be of

how few. It seemed to me that Füsun was slowly coming to the same awareness, or at least I thought this was why she, too, avoided talk of the engagement. So it was without discussion that we somehow agreed to skip the engagement and marry at once after our return from Europe. As we smoked our cigarettes during the intervals between films, and at the Beyoğlu patisseries we'd gotten into the habit of visiting afterward, our greatest pleasure was dreaming up things we'd do on our trip. Füsun had bought a book written for Turks called *Europe by Car* and always took it along to the cinema, and as we turned the pages we would plan our itinerary. We would spend our first night in Edirne, then drive straight through Yugoslavia and Austria. I bought my own guidebooks, as well, and Füsun especially liked to look at the photographs of Paris in them. "Let's go to Vienna, too," she would say. Sometimes staring at the pictures of Europe in a book, she would fall into a strange, mournful silence as she drifted off into a daydream.

"What's wrong, darling? What are you thinking?" I would ask her.

"I don't know," Füsun would say.

Because Aunt Nesibe, Füsun, and Çetin had never been outside Turkey before, they were applying for their first passports. To save them from the torture of visiting the various state bureaucracies and the torment of waiting in all those long lines, I brought in Selami, the police chief who took care of such matters for Satsat. (Careful readers will remember that it was this same retired constable whom I had asked to track down Füsun and her family eight years before.) Anchored by love, I had not been outside Turkey for nine years, and so it was I came to discover that I no longer felt the need for travel, where before, if I'd been cooped up in this country for more than three or four months, I'd be out of sorts.

It was a hot summer day when we went to sign papers at the Security Services Passport Office at the Governor's Headquarters in Babıali. This old building, once home to prime ministers, pashas, and grand viziers, had since been the scene of numerous raids and political murders described in lycée history books, but as with many great Ottoman buildings that had survived into the Republican era, its former gilded splendor had worn away, as thousands of weary souls entered it daily to spend hours standing in line, first to acquire documents, then to have them stamped, and then signed, an eternity that inevitably led

to arguments and scuffles, the whole scene suggesting Judgment Day. In the heat and humidity, the documents in our hands quickly turned soggy.

Toward evening we were sent to the Sansaryan Building in Sirkeci for another document. As we walked down Babıali Hill, just before the old Meserret Coffeehouse, Füsun stepped into a small teahouse without asking permission of any of us and sat down at a table.

"What is it with her now?" said Aunt Nesibe.

While she and Çetin Efendi waited outside, I went in.

"What's wrong, darling, are you tired?"

"I've had it. I don't want to go to Europe anymore," said Füsun. She lit a cigarette, inhaling deeply. "The rest of you can go, by all means—get your passports—but I've run out of energy."

"Darling, hang on, we're almost there."

She held out for a while longer, showing a bit of temper, but in the end, inevitably, she came with us, my beauty. We endured a similar tantrum when applying for visas at the Austrian Consulate. Hoping to save them from the queues and humiliating interviews, I'd prepared documents describing Aunt Nesibe, Füsun, and also Çetin Efendi as highly paid "specialists" in Satsat's employ. They granted us all visas, all but Füsun, who because of her young age, looked suspicious, and was called for a visa interview. I went in with her.

Six months earlier, an angry applicant who had been repeatedly denied visas over many years had shot an employee of the Swiss Consulate in the head four times; following that incident the visa sections of consulates had instituted strict security measures. Now applicants were no longer permitted to converse face-to-face with European visa officials, but rather, like death row prisoners in American films, were separated from the officials by bars and bulletproof glass, and obliged to converse by phone. Still people would crowd the entrance, prodding and pushing as they struggled to reach the visa section, or to enter the garden or courtyard. Turkish staffers (particularly in the German Consulate, where it was said that in the space of two days they became "more German than the Germans") would scold the crowd for failing to line up decorously, shoving them around and singling out the ill-attired to say, "You're wasting your time here," by way of thinning the herd. And so most applicants were practically jubilant to be granted

interviews, taking their place nervously before the bars and the bullet-proof glass, like so many students sitting down to a difficult exam, peaceful and compliant as lambs.

Because we'd pulled strings, Füsun had no need to wait in any queue, and went into the interview smiling; but when, shortly, she emerged, she was purple in the face, and without so much as looking in my direction she went out to the street. I followed her out, catching her when she paused to light a cigarette. She wouldn't tell me what had happened, but went into the National Sandwich and Refreshment Palace, where, having taken a seat, she announced, "I don't want to go to Europe anymore. I give up."

"What happened? Aren't they giving you a visa?"

"They asked me about my whole life. They even asked why I got divorced. Even how did I support myself. They even asked me that. So I'm not going to Europe. I don't want visas from any of them."

"I can find another way to arrange things," I said. "Or we could take a car ferry straight to Italy."

"Kemal, believe me, I no longer want to take this trip to Europe. I can't even speak the languages, and it makes me ashamed."

"Darling, we could still see just a bit of the world. . . . In other places, there are people who live differently, and more happily. We can walk down their streets holding hands. There's more to this world than Turkey."

"Ah, to be worthy of you I need to see some of Europe, is that it? Well, I've also given up on the idea of marrying you."

"We'll be so happy in Paris, Füsun."

"You know how stubborn I can be, Kemal. Don't pressure me, you'll only make me dig in."

But I did press her, and years later, whenever I recalled how I'd insisted and felt the sting of remorse, I also remembered that it had been my fantasy for years to make love to Füsun in a hotel along the journey. With the help of Selim the Snob, who imported paper from Austria, Füsun's visa came through one week later. It was around the same time that we were also able to obtain the documentation to take the car abroad. We were sitting in a box at the Palace Cinema when I gave Füsun her passport, whose pages were now covered with colorful visas for all the countries we'd be visiting en route to Paris; at that

moment I felt a strange pride at being a good husband. Years before, when I was seeing ghosts of Füsun on every corner, I'd encountered her apparition at the Palace Cinema, too. Taking her passport, she smiled at first, before assuming a dour expression as she turned the pages, inspecting each visa in turn.

Through a travel agency I booked three large rooms at the Hôtel du Nord in Paris, one for me, one for Çetin Efendi, and one for Aunt Nesibe and Füsun. I'd stayed at other hotels in Paris during the years Sibel was at a university, but like a student who dreams of the places he'll go when he's rich, I had a fantasy of the happy days I would spend one day in that venerable hotel, which seemed a place out of old films and memories.

"There's no need for this. Get married and then go," my mother kept saying. "Come on, if you're going to travel with the girl you love, why not make the most of it? . . . Why drag Nesibe and Çetin Efendi there with you? First get married; that way the two of you can fly to Paris and honeymoon by yourselves. . . . I could talk to White Carnation and have the whole thing written up as the sort of romantic story that everyone loves, and then in two days it will be forgotten, yesterday's news. That old world is gone, anyway. Everywhere you look it's all parvenus from the provinces."

For my part, I kept saying: "And how am I supposed to manage without Çetin? Who's going to drive me around? . . . Mother dear, you've only left the Suadiye house twice all last summer. Don't worry, we'll be back before the end of September. When you return to Nişantaşı at the beginning of October, Çetin will be there to drive you, I promise. . . . And Aunt Nesibe will find you a dress for the wedding."

77

The Grand Semiramis Hotel

ON AUGUST 27, 1984, at a quarter past twelve, Çetin parked the car in front of the house in Çukurcuma, ready to drive to Europe. It had been

exactly nine years and four months since Füsun and I had met at the Şanzelize Boutique, but I did not give this coincidence much thought, nor did I dwell upon the ways in which my life and my character had changed in the intervening years. We had been delayed by my mother's tears and ceaseless flow of advice, and also by the traffic, but none of it could dull my determination to end this chapter of my life and set out on our journey at once. After waiting endlessly for Çetin Efendi to load Aunt Nesibe's and Füsun's suitcases into the trunk, I grew outwardly petulant at the sight of smiling, waving neighbors and the children swarming around the car, but inside I felt a pride that I did not wish to acknowledge. As we headed down to Tophane, Füsun waved at Ali, returning from football practice. I told myself that soon Füsun and I would have a child like Ali.

As we drove over the Galata Bridge, we opened the windows, happily breathing in that familiar Istanbul smell of sea and moss, pigeon droppings, coal smoke, car exhaust, and linden blossoms. Füsun and Aunt Nesibe were sitting in the back. I was in front with Çetin—just as in my dreams—and as we drove through Aksaray past the city walls, past one poor neighborhood after another, rumbling over the cobblestone streets, in and out of potholes, I would occasionally throw my arm over the back of the seat and turn around to give Füsun a contented smile.

Outside the city limits, beyond Bakırköy, moving past little factories and depots, new neighborhoods and motels, I caught sight of Turgay Bey's textile mill, which I'd visited nine years earlier, but now I could barely remember the jealousy that had stung me that day. Once the car had crossed the limits of Istanbul, all the suffering I'd endured for the love of Füsun was suddenly reduced to a sweet story that could be told in one breath. After all, a love story that ends happily scarcely deserves more than a few sentences! Perhaps this is why we became increasingly quiet once we'd left Istanbul behind. Even Aunt Nesibe—though full of mirth at the outset, and asking questions like, "Oh, we didn't forget to lock the door, did we?" and admiring everything she saw through the window (even the emaciated old nags grazing in an empty lot)—had by the time we'd reached Büyükçekmece Bridge, fallen asleep.

As Çetin was filling the tank at the Çatalca exit, Füsun got out of the car with her mother. After buying a packet of the local fol cheese from

an old lady selling her wares beside the road, they went into the tea-house next door, ordered tea and *simit*s to accompany the cheese, and tucked into their makeshift feast. As I sat down with them, it occurred to me that if we continued at this pace, our European tour would last months, not weeks. Did I complain? No! As I sat across from Füsun, silently watching her, I felt the same sweet ache spreading through my chest and my stomach as I'd felt in early adolescence at a dance party, or upon meeting a beautiful girl at the start of summer. It was not the deep and corrosive agony of thwarted love that had once been so familiar, but a requited lover's sweet impatience.

At 7:40 the sun shone into our eyes before sinking below the line of the sunflower fields. Not long after Çetin Efendi had turned on the headlights, Aunt Nesibe said, "For the grace of God, everyone, let's not drive in this darkness!"

On the two-lane road the trucks bearing down on us from the opposite direction did not even bother to dim their lights. Just past Babaeski, my eyes were drawn to the blinking purple neon sign of the Grand Semiramis Hotel; it seemed a good place to stop for the night. I asked Çetin to slow down; making a turn in front of Türk Petrol, we heard the dog's *woof, woof, woof* warning us off. Çetin stopped in front of the hotel, where my heart began to beat wildly, bursting with feeling, and the awareness that at this place, after nine years of longing, my dreams would come true.

The three-story hotel was quite clean and, except for its name, a modest establishment; the retired army officer at the desk (a cheerful picture of him armed and in uniform hanging above reception) accommodated my request for three rooms, one for Füsun and Aunt Nesibe, one for Çetin Efendi, and one for me. When I found mine, I lay down on the bed and, gazing at the ceiling, it occurred to me that enduring this entire journey while sleeping alone in the room next to Füsun's might be even worse than having waited nine years.

Later, as she entered the small dining room downstairs, I noticed that Füsun's manner perfectly befitted the surprise I had prepared for her. It was the sort of entrance one might have made into the sumptuous salon hung with velvet curtains of a grand hotel in some glittering European seaside resort of the nineteenth century: She was beautifully made up and wearing a perfume that I had given her years earlier—Le

Soleil Noir (I display the bottle here)—and her lipstick shade matched the red of her dress (also in this exhibit), which brought out the lustrous undertones of her black hair. Sitting at the other tables were tired families—workers returning from Germany; from time to time curious children and lustful fathers would turn around to look at us.

"That red looks lovely on you tonight," said Aunt Nesibe. "It will look even better in the hotel in Paris, and when we go out. But, darling, don't wear it every night we're on the road."

Aunt Nesibe shot me a look requesting that I second her advice, but no words came from my mouth. It wasn't merely that, in fact, I wanted her to wear this dress every night, for in it she was so extraordinarily beautiful; it was also that I was as tense as a young lover who, sensing that his happiness is very close at hand, still fears what might go wrong; and so I was struck dumb. I sensed that Füsun, sitting just across from me, felt something of the same anxiety, as she avoided my gaze, and smoked awkwardly as a schoolgirl novice, turning away to exhale.

As we looked over the hotel's rather plain menu, which had been approved by Babaeski Council, there was a long, strange silence, as if this were the moment to review the last nine years of our lives.

When a waiter finally appeared, I ordered a large bottle of Yeni Rakı.

"Why don't you have a drink tonight, too, Çetin Efendi, so that we can make a toast," I said. "You won't be driving me home after supper."

"God bless you, Çetin Bey, you've spent enough time waiting," said Aunt Nesibe, full of appreciation. And then, still holding his attention, she looked at me and said, "If you have patience, and put yourself in God's hands, there is no heart you cannot win, no fortress you cannot capture—isn't that so?"

When the *rakı* arrived, I poured out a generous amount for Füsun—as I'd done for the others—adoring the way she smoked when she was nervous, staring at the tip of her cigarette. We'd all, Aunt Nesibe included, taken our *rakı* on the rocks, and as the liquid clouded, we drank it in like some potion. After a while I relaxed.

The world was a beautiful place, in truth. It was as if I were noticing this for the first time, though I had already known that I would be caressing Füsun's fine body, her long arms, and her beautiful breasts for the rest of my life, that resting my head against her neck and breathing in her scent I would sleep in peace for years to come.

I did as I'd done as a child, first concentrating to put out of my mind whatever the cause of my happiness, so that I might then look around me with fresh eyes and see the beauty of everything anew: on the wall a fetchingly elegant photograph of Atatürk in a frock coat, beside it a panorama of the Swiss Alps, a prospect of the Bosphorus Bridge, and—a souvenir of nine years ago—an image of Inge posing sweetly with a bottle of Meltem. I saw a clock showing the time to be twenty past nine, and a sign on the wall behind the reception desk warning that "couples will be asked to present a marriage certificate."

"*Withering Slopes* is on tonight. Should we tell them to find the channel?"

"There's still time, Mother," said Füsun.

A foreign couple in their thirties came into the dining room. Everyone turned around to look at them, and they greeted us politely. They were French. In those days very few tourists from the West came to Turkey, but those who did came mostly by car.

When the time came, the hotel owner sat down in front of the television with his wife, who was wearing a headscarf, and his two grown daughters—one of whom I'd seen earlier in the kitchen—whose heads were not covered; with their backs to their guests, they settled in to watch the latest episode in silence.

"Kemal Bey, you won't be able to see from there," said Aunt Nesibe. "Why don't you come sit next to us?" whereupon I wedged my chair into the narrow space between Füsun and her.

Withering Slopes was set in the Istanbul hills, but I cannot say that I took much of it in, with Füsun pressing against me with her bare arm! My left arm, especially my forearm, pressed against her, was aflame. My eyes were on the screen, but it was as if my soul had entered Füsun's.

A third eye, an inner one, feasted on Füsun's neck, and her beautiful breasts, and the strawberry nipples at the tips of those breasts, and the whiteness of her stomach. Füsun kept pressing against me, and she slowly increased the pressure, so that the Batanay Sunflower Oil ashtray into which she stubbed out her cigarette, even the lipstick-stained cigarette ends, escaped my notice.

When the episode had ended, the television was switched off for the night. The hotel owner's elder daughter turned on the radio and found some sweet, light music that the French couple appreciated.

Returning my chair to its rightful place, I very nearly tripped, having drunk so much. Füsun had had three glasses, by the report of my third eye, which kept count.

"We forgot to make a toast," said Çetin Efendi.

"Yes, let's make a toast," I said. "In fact, the time has come for us to have a small ceremony. Çetin Efendi, you are now going to officiate."

With a flourish, I produced the engagement rings I had bought a week earlier at the Covered Bazaar, and took them out of their boxes.

"This is the right way to do things, sir," said Çetin Efendi, warming at once to the situation. "You can't get married without first getting engaged. Let's see now, could you present to me your hands?"

Füsun had already offered hers, smiling excitedly.

"There's no turning back after this," said Çetin Efendi. "But then there will be no need. You are going to be very happy, I'm sure of it. . . . Now, give me your other hand, Kemal Bey."

He slipped the rings on us, without delay, and we heard clapping: the French couple, who had been watching us, and a few other sleepy guests who joined in. Füsun was smiling prettily, looking at the ring on her hand with the delight of someone choosing rings at the jeweler's.

"Does it fit, darling?" I asked.

"It fits," she said, making no effort to hide her utter satisfaction.

"It looks lovely on you."

"Yes."

"Dance, dance!" said the French couple.

"Yes, let's see you dance," said Aunt Nesibe.

The sweet music wafting from the radio was good for dancing. But was I able to stand?

We both got up at the same time, and I took Füsun by the waist, enfolding her in my arms, feeling under my fingers her hips, her ribs, her spine.

Füsun, less tipsy than I was, took the dance seriously, holding on to me with genuine emotion. I wanted to whisper into her ear, telling her how much I loved her, but I was suddenly struck shy.

Actually, we were both rather drunk, but something kept us from letting ourselves go. A little later, when we sat down, the French couple clapped again.

"I'd better be getting to bed," said Çetin Efendi. "We have a long

ride ahead of us. I should look the engine over in the morning before we go. We're setting off early, aren't we?"

If Çetin hadn't jumped up so abruptly, Aunt Nesibe might have lingered too.

"Çetin Efendi, could you give me the keys to the car?" I asked.

"Kemal Bey, we've all had a lot to drink tonight, so please, I beg you, don't even touch that steering wheel."

"I've left one of my bags in the trunk, and it has my book in it."

As I took the key from his extended hand, Çetin Bey pulled himself up straight, and then he bowed down in the exaggerated gesture of respect he had once reserved for my father.

"Mother, how am I going to get into the room without waking you?" Füsun asked.

"I'll leave the door unlocked," said Aunt Nesibe.

"Or I can come up with you now and take the key."

"There's no hurry. The key will be in the lock on the inside of the door," said Aunt Nesibe, "but I won't turn it. Come up whenever it suits you."

When Aunt Nesibe and Çetin Efendi had left, we were at once more relaxed and more agitated. Füsun was acting like a bride on her first night with a man, and she kept averting her eyes. But I sensed an emotion other than the accustomed bashfulness. I wanted to touch her. I reached out to light her cigarette.

"Were you going to go up to your room to read your book?" asked Füsun, as she started to get up.

"No, darling, I thought we could go for a spin in the car. The night is so beautiful."

"We've both had a lot to drink, Kemal. It's out of the question."

"But we could be together."

"Just go upstairs and go to bed."

"Are you afraid I'll wreck the car?"

"I'm not afraid."

"Then let's go; we can take a side road and get lost in those hills and forests."

"No, go upstairs and get to bed. I'm getting up now."

"Do you mean to leave me alone at the table on the night of our engagement?"

"No, I'll stay a bit longer," she said. "Actually, it's very nice sitting here."

As the French couple watched from their table, we must have sat at ours in silence for almost half an hour. From time to time our eyes met, but with each meeting our gaze was turned inward. There was a strange and eclectic film playing in my mind's cinema, splicing together memories, fears, desires, and so many other things whose meanings I could not decipher. Later on, a large black fly hovering between our glasses became part of the film, too. My hand, and the hand with which Füsun was holding her cigarette, and the glasses, and the French couple kept drifting in and out of the frame. Besotted though I was with drink and love, there was still a part of me that needed to find a logic in the film, that wanted the world to see that there was nothing between Füsun and me but love and happiness. I was as determined to work this out as the drowsy fly scampering among the plates. I smiled at the French couple to make a show of our happiness, and they smiled back in the same way.

"Why don't you smile at them, too?"

"I have smiled at them," said Füsun. "What more do you want—a belly dance?"

Because I kept forgetting Füsun was very drunk and because I took everything she said seriously, her remarks sometimes irked me. But my contentment was not to be shattered, as I'd succeeded in drinking myself into that state of mind wherein all the world is one, and there is but one world. This, I concluded, was the theme of the film starring the fly and my memories. Everything I had ever felt for Füsun, all the pain I had suffered for her, was now at one with the beauty and confusion of the world, and in this extraordinarily beatific feeling of unity and completion, my spirit found its long sought peace. But then, my attention turning to the fly, I began to wonder how it could walk so far without its legs getting tangled up. Then the fly vanished.

As I held Füsun's hand in mine on the tabletop, I could feel the peace and beauty within me passing through my hand to hers, and from hers to mine. Her beautiful left hand was like a tired hunted animal that my right hand had turned on its back, roughly mounting it, almost crushing it. The whole world aswirl inside my head, inside both our heads.

"Shall we dance?" I said.

"No . . ."

"Why not?"

"I don't feel like it right now!" Füsun said. "I'm happy just like this."

When I realized she was referring to our hands, I smiled. It was a moment outside of time, as if we'd been sitting there hand in hand for hours, or had only just arrived. I looked around and saw that we were the only ones left in the restaurant.

"The French have left."

"Those people weren't French," said Füsun.

"How could you tell?"

"I saw their license plate. They were from Athens."

"Where did you see their car?"

"They're about to close the restaurant, let's go."

"But we're still here!"

"You're right," she said in a voice of maturity.

We sat hand in hand for a while longer.

Taking a cigarette from the packet, and lighting it deftly, she smiled at me as she took a long drag. This too seemed to last hours. A second feature had just begun to play in my mind when she slipped her hand from mine and rose to her feet. I was walking after her and soon headed upstairs, paying close attention to the back of her dress, fortunately without stumbling.

"Your room is there," said Füsun.

"First let me escort you to yours, your mother's room."

"No, you go to your own room," she whispered.

"I'm so upset, you don't trust me. How will you be able to spend the rest of your life with me?"

"I don't know," she said. "Go on now—off to your room."

"What a beautiful night," I said. "I'm so very happy. For as long as we live, each and every moment will be as happy as this—I promise."

She saw me drawing nearer, to kiss her, but before I could, she had embraced me. I kissed her passionately, almost forcing myself on her. For the longest time we kissed, at one point my eyes opening to see in the narrow, low-ceilinged corridor a picture of Atatürk. And I remember between kisses pleading with Füsun to come to my room.

Someone in one of the rooms coughed politely. A key turned in a lock.

Füsun pulled away from me and, turning in to the corridor, vanished.

I looked forlornly after her, before going to bed still wearing my clothes.

78

Summer Rain

THE ROOM was not pitch-dark; there was light coming in from the gas station and the Edirne road. Was that a forest in the distance? I could just make out a flash of lightning in the far-off sky. My mind was open to the entire universe, and everything in it.

A long time had passed when there was a knock on the door. I answered it.

"My mother seems to have locked me out," said Füsun, peering through the darkness, trying to see me.

I took her hand and pulled her in. Lying down on the bed still in my clothes, I pulled her down beside me, and I embraced her, drawing her still closer. She nestled up to me, like a cat come in from a rainstorm, resting her head on my chest. She pulled me toward her with all her might, as if our happiness could only grow the nearer we drew to each other; and I noticed she was shivering. I felt that, as in a legend, we would die then and there unless we kissed. I remember how we kissed, before I pulled off her now very rumpled red dress, and how long and deeply we kissed after that, how the embarrassing report of the bedsprings would cause us to slow down, and how aroused I became when her hair swept over my chest and face; but if I particularize, let no one imagine that we lived these moments in full consciousness, or that I remember each and every one. The whiplash of living at once what I had been awaiting for years, the sheer disbelief at finding happiness in

this world, had reduced the pleasures to a series of luminous moments, discrete and without measure, like so many fireflies, beaming and vanishing in an instant. But the images entering my head beyond my control, as in a dream, molded into one general impression.

I remember that we climbed in between the sheets and that whenever my skin touched hers, it burned. I was in a trance, immersed in nine-year-old memories that, unbeknownst to me, I'd forgotten, but which now revived, animated by other details of those happy days that I was reliving in my enchantment. As the long-suppressed hope for happiness mingled with the joy and triumph of wishes fulfilled (I had already swallowed each of her breasts whole), the lived moment became a blur—a confusion of pleasures and emotions. Even as I rejoiced at having in the end mastered her, I could not but feel for her, admire everything about her—her moan of pleasure, her childlike way of clinging to me, the sudden sparkle of her velvet skin. One sublime moment I remember clearly: She was sitting on my lap, her face lit up by the headlights of the trucks rumbling past (their tired engines echoing our low, deep moans), when, looking joyously into each other's eyes, we were surprised; a strong, unexpected gust of wind rattled everything for a moment, and somewhere in the distance a door slammed, and the leaves on the trees shook as if sharing a secret with us. A far-off flash of lightning filled the room with an instant of purple light.

As we made love with fervor that only grew and grew, our past, our future, and our memories became as one with that moment's ecstatic escalation. Trying to stifle our cries, and bathed in sweat, we continued to consummation. Afterward, Füsun nestled up close, and I—utterly content with life, and the world, and everything in it, radiant with beauty and meaning—buried my head in her neck, and breathing in her dizzying scent, drifted off to sleep.

Much later, in a dream, I was visited by images of happiness. Here, for the benefit of visitors to the museum, I display images from my reverie. The sea in my dream was indigo, like the sea of my childhood. And like our arrival in Suadiye at the beginning of summer, our outings in rowboats, the happy days when I would water-ski, the evenings I'd gone fishing just for sport—memories that always awakened in me a sweet impatience—the stormy sea of my dream seemed to stir such

contented restlessness of early summer. Just then I saw soft little clouds passing slowly overhead, one resembling my father. In the ocean, amid the storm, I saw a ship slowly bobbing and disappearing, as well as black-and-white images reminiscent of my childhood comics, and other dark, faint, yet frightening pictures and memories. They had the feel of memories long lost and recently recovered. Images of Istanbul in old films, snowy streets, monochrome postcards passed before my eyes.

These dream images taught me that the happiness of being alive could never be separated from the pleasures of seeing this world.

Then a strong gust swept over me, bringing all these images to life, and chilling my still sweaty body. The leaves of the acacia trees seemed to radiate light as they swayed back and forth, rustling sweetly in the wind. When the wind grew stronger, the rustling of leaves and branches turned into an ominous moan, and with it a long rumble of thunder crackled, so loud that I woke up.

"How beautifully you were sleeping," said Füsun, and she kissed me.

"How long was I asleep?"

"I don't know. The thunder woke me just now."

"Were you afraid?" I asked, wrapping my arms around her, and drawing her close.

"No, I wasn't at all afraid."

"It will begin to rain in a moment. . . ."

She rested her head in the crook of my neck, and for a long time we lay there in the darkness, gazing out the window. In the distance the cloudy sky glowed intermittently with a pink and purple light. The passengers in the noisy trucks and buses tearing down the Istanbul–Edirne road seemed not to see this far-off storm, as if only we were aware of that strange corner of the world.

Before we heard the passing traffic, the high beams would shine into the room, silently widening on the wall on our right until they'd lit up the entire room, and by the time we heard the rumble of an engine, the light would change shape and disappear.

Now and then we kissed, when not watching the play of the lights upon the wall, fascinated as children discovering a kaleidoscope. Under the sheets our legs lay stretched out side by side, like husband and wife.

We began to explore each other again with caresses, lightly at first, exercising caution, finding even more beauty and meaning in our coupling, now that we were not quite so drunk. I kissed her breasts and her sweet-smelling throat at length. When first becoming aware in my early youth of the brute, implacable force of sexual desire, I remember calming myself with this wishful thought: A person married to a beautiful woman could make love to her from dawn till dusk, wasting no time on anything else. Now the same childish thought crossed my mind. An infinity stretched out before us. The world though half shrouded in darkness had come close to paradise.

When the powerful lights of a bus shone into the room, I looked at Füsun's face, at her alluring lips, and I saw that her thoughts had drifted far away. My sensation stayed with me long after the lights had vanished. I kissed Füsun's stomach. From time to time the road fell silent, and I could hear the buzzing of a cicada. And was it the croaking of frogs far away, or was it the world's fine inner music, the susurrus of the grass, the deep, low hum that came from the earth itself, and nature's steady breathing, too soft to be heard when in the midst of life? I continued to kiss her stomach, my tongue traveling idly over her smooth skin, even as a mosquito bit my back and continued to make its annoying whine heard. As a cormorant happily diving in water will come up for air, so would I lift my head from time to time, to search the ever changing light for Füsun's eyes.

As we made love, drinking in at length the pleasures of discovering each other anew, we repeated the things we had done before; and in one part of my mind I was recording every moment, never to be erased, and classifying it methodically:

1. The joyful recognition of some of Füsun's gestures, first identified during the forty-four days we had spent making love nine years earlier, in 1975. Her moans, the innocent tenderness that illuminated her face—the way she frowned when intrigued to find me grasping her powerfully by the waist to reverse our positions; the felicitous fit of our various appendages, as if the elements of our respective anatomies were pieces of a single instrument ordinarily disassembled; the way, when we were kissing, her lips would open up like a flower—these were the details

I'd recalled and dreamed of for nine years, longing to relive each one.

2. The many little particulars that I had forgotten and so had been unable to dream about, now recalled with surprise as I watched Füsun enacting them: the way she'd use two fingers like a pair of tongs to take my wrist, the twitch of the mole right below her shoulder (many other moles were just where I'd left them); the way her eyes would cloud over at the height of pleasure before refocusing on the little things around her (the watch left on the tabletop, or the electric wires running the perimeter of the ceiling); the way she would relax her grip after holding me tight, making me think that she was about to pull away, only to grab me all the more forcefully—that night I remembered all these forgotten little mannerisms that now gave our lovemaking an earthy quality that rescued it from becoming some surreal fantasy fed by nine years of dreaming and imagining.

3. A number of habits, manifestly new, of which I had no recollection, which surprised and unsettled me to the point of jealousy. The digging of her fingernails into me; her way of becoming lost in thought at the most intense moments of lovemaking, as if to ponder her bliss or its meaning; the habit of going suddenly limp, as if having fallen off to sleep, or of sinking her teeth into my arm or my shoulder, as if to cause me real pain—these things made me think that she was not the old Füsun. I was content at one point to put it all down to the novelty of this experience: During our forty-four days together nine years ago we had never spent a night together in the same bed. Still, I was troubled no less by the ferocity of her lovemaking than by her tendency to passively withdraw into private thought.

4. The simple fact of her being someone else now. The eighteen-year-old girl I had known and made love to was still living within her, but as the years passed, she had been buried deeper and deeper within, like the sapling encased in the bark of the tree. I loved the Füsun now lying at my side far more than I'd ever loved the young girl I'd met so many years before. Time had favored us both with growth of wisdom, and of depth, it pleased me to see.

Giant raindrops began to fall on the windowpanes and windowsills. As the sky thundered, the downpour began. And as we listened to the heavy summer rain, wrapped in each other's arms, I fell asleep.

When I awoke the rain had stopped. Füsun was not beside me but on her feet, putting on her red dress.

"Are you going back to your room?" I said. "Please don't go."

"I'm going to look for a bottle of water. We seem to have had a lot to drink. I'm terribly thirsty."

"I'm thirsty, too," I said. "Stay, I'll go. I saw some bottles in the restaurant refrigerator."

But by the time I had got out of bed, she'd quietly opened the door and left. So I got back into bed, and happily imagining that she would soon return, I fell asleep.

79

Journey to Another World

MUCH LATER, when I awoke, Füsun had still not returned. Thinking she had gone to her mother's side, I got out of bed and lit a cigarette at the window. The sun had not yet risen, but in the gloom I could make out just the hint of daylight and the fragrance of wet earth. The neon signs of the gas station up the road, and of the Grand Semiramis Hotel, were reflected in the puddles on the edge of the asphalt and in the polished chrome bumpers of the Chevrolet in the adjacent parking lot.

I saw that the restaurant where we'd had dinner and performed our engagement ceremony the night before had a small garden, its chairs and cushions now sopping wet. Just beyond, a naked lightbulb was strung to the branch of a fig tree, and in the light filtering through its leaves I could see Füsun sitting on a bench. She was half turned toward me, smoking as she awaited sunrise.

I threw on my clothes and went straight down. "Good morning, my beauty," I whispered.

She said nothing, lost in thought and shaking her head like someone preoccupied with great troubles. On the chair right beside the bench I saw a glass of *rakı*.

"While I was getting the water, I noticed there was an open bottle of this, too!" Her impish expression reminded me that she was Tarık Bey's daughter.

"Assuming we aren't going to spend the most beautiful morning the world has ever seen drinking, what are we going to do?" I said. "It will be hot on the road. We can sleep all day in the car. . . . Is this seat taken, young lady?"

"I'm not a young lady anymore."

I did not answer, but sat down beside her, and taking her hand just as I'd done in the Palace Cinema, I settled in to admire the view with her.

Sitting there in silence we watched the world around us slowly brighten. There were still purple lightning bolts in the distance, and orange clouds shedding their rain on some part of the Balkans. An intercity bus rumbled past. We gazed at its red taillights until they disappeared.

A dog with black ears approached us with care from the gas station, wagging its tail amicably. It was a dog of no distinction, an ordinary mutt. After sniffing me, and then Füsun, he rested his head on her lap.

"He's taken a shine to you," I said.

But Füsun didn't answer.

"Yesterday as we were coming in, he barked at us three times," I said. "Did you notice? There was once a china dog just like him on top of your television."

"You stole that one, too."

"I wouldn't say 'stole.' Your mother, your father, all of you knew about it from the first year."

"True."

"What did they say about it?"

"Nothing. It upset my father. My mother would act as if it didn't matter. And I wanted to become a film star."

"You still can be."

"Kemal, that's a lie you've just told me. You don't even believe it yourself," she said in a serious voice. "That really makes me angry— how good you are at telling lies."

"What makes you say that?"

"You know perfectly well that you have no intention of helping me become a film star. There's no longer any need, after all."

"What do you mean? If it's what you really want, it's perfectly possible."

"It's been what I really wanted for years, Kemal. And you know that."

The dog nestled up to Füsun.

"It's the spitting image of that china dog. Especially those ears, half black, half wheaten—they're identical."

"What did you do with all those dogs, and combs, and watches, and cigarettes, and everything else?"

"I took comfort from them," I said, now a little resentful myself. "The whole collection resides in the Merhamet Apartments. I could feel no shame about it with you, my lovely. When we get back to Istanbul, I'd like you to see it."

She looked at me and smiled. There was compassion in that smile, and, at least in my opinion, just as much mockery as my story, and my obsession, merited.

"So you want to take me back to that dusty *garçonnière*, is that it?" she said.

"There's no longer any need for that," I said in some pique, throwing her words back at her.

"That's right. Last night you tricked me. You robbed me of my greatest treasure without benefit of marriage. You took possession of me. And people like you never marry what they've already had. That's the kind of person you are."

"You're right," I said, half angry, half playful. "This is the one and only thing I've been waiting for all these years. Why should I get married now?"

At least we were still holding hands. Hoping to smooth it over before the game turned serious, I kissed her passionately on the lips. Füsun submitted at first, but then she drew away.

"I could kill you," she said, standing up.

"Because you know how much I love you."

I wasn't sure she'd heard me. My beauty, truly angry now, walked off in a drunken huff, her high heels clicking furiously.

She did not go back into the hotel. The dog was following her, and together they headed out to the highway, turning in the direction of Edirne, Füsun in the lead, and the dog trailing. I finished the *rakı* left in Füsun's glass (as I'd sometimes done at the house in Çukurcuma, when no one was looking). For a long while I watched them from behind. The Edirne road stretched out straight ahead of them to the horizon, almost into infinity, and with Füsun's dress ever easier to spot as the sky brightened, there seemed no danger of her vanishing from sight.

But after a time I could no longer hear her footsteps across the fields. And when I could see no more the red speck that was Füsun, when she had vanished into infinity, like a heroine at the end of a Yeşilçam film, I became uneasy.

A few minutes later I saw the red speck again. She was still walking on, my angry beauty. A great tenderness was born in me as I considered it: We would spend the rest of our lives making love as we had done last night and having tiffs as we'd done this morning. Even so, I longed to make the arguments fewer, the rough patches smoother, and Füsun happy.

Traffic was building on the Edirne–Istanbul road. A pretty woman in a red dress with such beautiful legs was bound to be harassed. I got into the '56 Chevrolet and set off down the road to find her.

A kilometer and a half on, I spotted the dog under a plane tree. He was sitting there waiting for Füsun. I felt a sharp pang inside me, and my heart knocked against my chest. I slowed down.

ALTAT TOMATOES, a large billboard proclaimed, amid gardens, fields of sunflowers, little farmhouses. The *O*s had been peppered with bullets, target practice for bored passengers driving past. The holes had had time to rust.

One minute later, seeing the red speck on the horizon again, I laughed giddily. I slowed, as I drew closer to her, still stalking angrily along the right side of the road. She didn't stop when she saw me, or when I reached across to open the passenger-side window.

"Come on, darling, hop in and let's go back. It's getting late."

But she didn't answer.

"Füsun, please believe me, it's going to be a very long drive today."

"I'm not coming. The rest of you can go on without me," she said, like a rebellious child, still not slowing.

I'd reduced speed to keep pace with her and was calling to her from the driver's seat.

"Füsun, my darling, look at how beautiful the world is—open your eyes to this glory," I said. "Why poison life with anger and arguments?"

"You don't understand at all."

"What don't I understand?"

"Because of you, I haven't had the chance to live my own life, Kemal," she said. "I wanted to become an actress."

"I'm sorry."

"What do you mean, you're sorry?" she said, furious.

Sometimes I wasn't able to keep the car abreast of her, and we couldn't hear each other.

"I'm sorry," I said again, shouting this time, thinking she hadn't heard me.

"You and Feridun, you deliberately kept me from having my chance in films. Is this what you're sorry for?"

"Did you really want to become like Papatya and all those drunken women at the Pelür?"

"We're all drunks now, anyway," she said. "And I would never have been like them, I assure you. But you two were so jealous, so afraid I might find fame and leave you, that you had to keep me at home."

"You were always a bit timid about going down that path alone, Füsun, without a powerful man at your side. . . ."

"What?" she said, now palpably enraged.

"Come on now, darling, jump into the car. We can argue about it as much as you like over drinks tonight," I said. "I love you with all my heart. We have a wonderful life ahead of us. Please just get in."

"On one condition," she said, in the same childish voice she had used so many years before, the time she asked me to return her child-hood tricycle to the house.

"Yes?" I asked.

"I'm driving."

"The Bulgarian traffic police are even more corrupt than ours. I hear there are lots of roadblocks, just so they can take bribes."

"No, no," she said. "I want to drive it now, back to the hotel."

I stopped the car at once and opened the door. As I was changing places, I pinned Füsun to the hood of the car and kissed her with all my

might. And wrapping her arms around my neck, squeezing with all her strength, and pressing her beautiful breasts against me, she set my head spinning.

She slid into the driver's seat. Starting the engine as carefully as she had done during our first lessons in Yıldız Park and deftly releasing the handbrake, she crawled out into the road, propping her left arm on the open window, just like Grace Kelly in *To Catch a Thief*.

We moved ahead slowly, searching for a place to make a U-turn. She tried to make a full U at the junction of the main road and a muddy country lane, but she couldn't manage it, and the car came to a shuddering halt.

"Watch the clutch!" I said.

"You didn't even notice the earring," she said.

"What earring?"

She'd started the car up again, and we lurched forward.

"Not so fast!" I said. "What earring?"

"The one on my ear . . . ," she moaned, like someone just coming out of anesthesia.

Dangling from her right ear was her lost earring. Had she been wearing it while we were making love? Could I have missed such a thing?

The car was gathering speed.

"Easy does it!" I shouted, but she'd pressed the accelerator right down to the floor.

In the far distance, her friend the dog seemed to have recognized Füsun and was coming out into the middle of the road to meet the car. I was hoping he would take note of the speed and get out of the way, but he didn't.

Now going even faster, ever faster, Füsun honked the horn to warn the dog.

We jerked to the right, and then to the left, the dog still far ahead of us. Suddenly the car began moving in a straight line, as a sailboat will cut straight through the waves without listing when the wind has died. But this line, though straight, deviated from the road. It was when I saw we were speeding not toward the hotel, but right for a plane tree on the side of the road, that I realized an accident was inevitable.

Truly I knew then, in the depths of my soul, that we had come to

the end of our allotted portion of happiness, that our time had come to leave this beautiful realm, by way of racing toward the plane tree. Füsun had locked onto it, as onto a target. And so it was I felt, my future could not be parted from hers. Wherever we were going, I would be there with her, and we were never to enjoy the happiness one could find on this earth. It was a terrible shame, but it seemed inevitable.

All the same, I shouted, "Watch out!"—a pure reflex, as if Füsun could not see what was happening. In fact, it was the instinctual shout of someone trying to escape a nightmare and return to the beauty of ordinary life. If you ask me, Füsun was a little drunk, but driving at 105 kilometers an hour, headed for the 105-year-old plane tree, she seemed to know exactly what she was doing. And so I understood we had reached the end of our lives.

My father's twenty-five-year-old Chevrolet went hurtling with impressive speed and power into the plane tree on the left-hand side of the road.

Beyond the tree amid a field of sunflowers was a house—a small factory, actually, that produced Batanay sunflower oil, the very brand the Keskins used for cooking, as we had both noted when speeding along the road, just before the accident.

Months later I found the wreck, and I remembered, as I touched the various parts of the ruined Chevrolet, what I had recalled in my dreams: that just after the crash, Füsun and I had looked into each other's eyes.

Füsun knew she was about to die, and during those two or three seconds she told me with her pleading eyes that she didn't really want to, that she would cling to life as long as she could, hoping for me to save her. But I could only smile at my beautiful fiancée, still so full of vitality, the love of my life to the last, and believing I was about to die as well, I felt glad of being under way to a different world.

All memory of what happened next eluded me during my months lying in a hospital and for years thereafter; so what follows is based on the report of others, and on what I was able to glean when I returned to the site of the accident many months thereafter.

Six or seven seconds after the crash, Füsun died of injuries sustained when the car crumpled like a tin can and the steering column pierced her chest. Her head smashed with full force against the wind-

shield. (It would be another fifteen years before seatbelts became compulsory in Turkish cars.) According to the accident report displayed here, her skull was crushed, tearing the meninges of the brain whose wonders had always surprised me, and she'd suffered a severe laceration of the neck, as well as several broken ribs and glass splinters in her forehead. All the rest of her beautiful being—her sad eyes; her miraculous lips; her large pink tongue; her velvet cheeks; her shapely shoulders; the silky skin of her throat, chest, neck, and belly; her long legs; her delicate feet, the sight of which had always made me smile; her slender honey-hued arms, with their moles and downy brown hair; the curves of her buttocks; and her soul, which had always drawn me to her—remained intact.

80

After the Accident

I WOULD now like to offer a brief account of the twenty-odd years that followed, bringing my story to a close without undue delay. Eventually I would be told that my surviving the accident was the fortuitous result of having opened the passenger-side window, so that I could converse easily with Füsun while driving beside her, and of my having instinctively shot my arm out just before the crash. The impact had caused a few small hemorrhages in my brain, and the swelling that resulted left me in a coma. In that state I was transported by ambulance to Istanbul University's Çapa Hospital, where I was placed on a respirator.

For a month I lay in intensive care, unable to speak. Words did not enter my head; the world had frozen over. I will never forget when Berrin and my mother came to visit, tears in their eyes at the sight of the tube in my mouth. Even Osman showed an unaccustomed compassion, though from time to time there was something in his expression that said "I told you so."

If Zaim, Tayfun, Mehmet, and various other friends eyed me with

similar expressions—half reproach and half sorrow—it was because the police report attributed the accident to driving under the influence of alcohol (the role of the dog having gone unnoticed) and because the press had embellished the story with a dose of scandal. The Satsat employees were as respectful as ever, and touchingly empathetic.

After six weeks they got me started on physical therapy. Learning to walk again felt like starting life over, and as I embarked on my new existence, I thought about Füsun constantly. But thinking about her now had no connection to the future, or to the desire I'd once felt; slowly Füsun became a dream of the past, the stuff of memories. This was unbearably painful, now that suffering for her no longer took the form of desiring her, but of pitying myself. I was at this point—hovering between fact and remembrance, between the pain of loss and its meaning—when the idea of a museum first occurred to me.

I sought consolation in Proust and Montaigne. I would sit across the table from my mother at supper, the yellow pitcher resting between us, and as we ate I would pay little mind to the television. My mother felt that Füsun's death was something akin to my father's, and that since we'd each lost our most beloved, we had unlimited license to sigh and brood to our hearts' content and apportion blame together. Vaporous *rakı* glasses had figured prominently in both deaths, and so, too, had the secret world that each of the departed harbored within, until the pressure grew so great that there was no choice but to tell the secret. My mother didn't care for this second similarity, but I wanted to lay everything out for consideration.

During the first few months after my release from the hospital, whenever I went to the Merhamet Apartments to sit down on the bed and smoke a cigarette and view the surrounding objects, a feeling awoke in me that if I could tell my story I could ease my pain. But to do so I would have to bring my entire collection out into the open.

I longed to patch things up with Zaim and have him again as my confidant. But in January 1985 I heard from Hilmi the Bastard that he and Sibel were very happy together and expecting a child. Hilmi the Bastard also told me that Nurcihan and Sibel had fallen out over something trivial. There was no reconnecting with them. Nor could I go to the new clubs and restaurants frequented by the old clientele of the Pelür and Garaj; my story was important to me and I did not wish to

see it reflected in other people's eyes, or to be seen as a broken wretch. For this reason, during a first and last visit to Şamdan, I laughed and joked and teased Tayyar, the aging waiter, whom I knew from the Pelür, making sure everyone noticed my high spirits, thus leaving the gossips to conclude that "in the end" I had "saved" myself from "that girl."

One day I ran into Mehmet on a corner in Nişantaşı, and we agreed to meet for a meal on the Bosphorus, "just us men." The Bosphorus restaurants had ceased to be places people saved for special occasions; now one went any day of the week. Sensing my curiosity, Mehmet began by telling me what all my old friends were up to. He said that he and Nurcihan had gone to Uludağ with Tayfun and his wife, Figen; that Faruk (the same Faruk whom Füsun and I had run into at Sariyer Beach) had been effectively bankrupted by high inflation, on account of dollar loans, but had fended off ruin by taking out more bank loans; and that though there was no ill feeling between Mehmet and Zaim following Nurcihan and Sibel's falling-out, he no longer saw Zaim. Before I could ask why, Mehmet explained that Sibel had been needling Nurcihan for becoming too "à la Turca," going to *gazino*s to hear classical singers like Müzeyyen Senar and Zeki Müren, and fasting during Ramadan ("Is Nurcihan really fasting?" I asked with a smile). But I recognized at once that this was not the real reason for the rift between these two old friends. Mehmet, imagining I wished to return to my old world, wanted to pull me back to his side. But he'd misread my intentions. Six months after Füsun's death, I knew categorically that I could never return to that world.

After drinking a little *rakı,* Mehmet confessed that while he loved Nurcihan dearly and had the utmost respect for her (this second feeling having assumed recently elevated importance), he did not find her as attractive as he had before she'd given birth. After enjoying a long and romantic courtship, getting married, and starting a family, they had quickly reverted to their former selves, with Mehmet resuming old habits. Sometimes leaving the children with his mother, he and Nurcihan would go out together, but more typically he would go out to new clubs and bars alone, the sort of places favored by advertisers and the rich, to which in his determination to lift my spirits and regain my camaraderie he was now introducing me, as he would the city's up-and-coming neighborhoods.

Another evening, Nurcihan came out with us. We went to a big new part of town just beyond Etiler that had sprung up in the space of a year, to eat a strange menu of dishes presented as American cuisine. Nurcihan did not mention Sibel, nor did she inquire about my feelings in the wake of Füsun's death. One thing she said I took to heart, however; in the middle of the meal, apropos of nothing, she said she knew "deep in her bones" that I would one day be very happy. I had never more keenly felt that the chance for happiness in this life was forever lost to me. Perhaps this is why, although Mehmet seemed very much the old Mehmet, with Nurcihan I felt as if I were meeting a new person, as if all those memories in common no longer existed. It also occurred to me that the restaurant's atmosphere, and these new city streets, which didn't agree with me at all, may have also contributed to my feeling.

There were more of these new streets, these strange new concrete neighborhoods with each passing day, and they served only to reinforce my impression since getting out of the hospital that with Füsun's death, Istanbul had become a very different city. Let me say now that this feeling was my most important preparation for the many years of wandering that lay ahead.

It was only when calling on Aunt Nesibe that I could feel the old Istanbul, the city I had so loved. One evening, after the first tearful visits, she, dispensing with formalities, told me I could go upstairs to look at Füsun's room whenever I wished, and take away with me as much as I wanted.

Before going upstairs I performed what had been our ritual: I went over to Lemon's cage to check his food and water. This, like any recollection of our suppers together, of our conversations while watching television, of everything else we had shared sitting at the table, was enough to bring tears to Aunt Nesibe's eyes.

Tears . . . Silences . . . Because memories of Füsun were too painful for either of us to bear, I would be quick about the requisite preliminaries before going up to her room. Once a fortnight I would walk down to Çukurcuma from Beyoğlu, and as Aunt Nesibe ate supper we would watch television in silence, and after paying some attention to Lemon, who was slowly growing older and more quiescent, I would go look through Füsun's bird pictures, one by one, after which review,

announcing the need to wash my hands, I would head upstairs, my heart beating ever faster as I entered Füsun's room and opened up her drawers and cupboards to go through her things.

All the presents I'd brought her over the years—the combs and brushes and little mirrors, and butterfly brooches and earrings—she had arranged in the drawers of the little cabinets. There were things I had forgotten ever having given her—socks for the tombala sack, the wooden buttons I had thought I was buying for her mother, hair clips, as well as the toy Mustang Turgay had given her, and the love letters I had sent via Ceyda—to find these artifacts weighed on me so that I could never linger more than half an hour among these drawers and cupboards that still bore her scent. Sometimes I would sit on the bed and relax with a cigarette, sometimes, to stem my tears, I would stand at the window, or on one of the balconies on which she had painted her birds, before picking up a sock or a comb or two to take away with me.

By this time I had realized that I would have to find a place to gather together all the objects that connected me to Füsun, from the first things collected on impulse to the items now retrieved so deliberatively from her room—perhaps the entire contents of the house—but I had no idea where such a place could be. It was only after I had begun my travels, visting the world's smaller museums one by one, that I could at last answer this question, and understand its full significance.

One snowy evening during the winter of 1986, when we had finished our supper, I was sifting through the butterfly brooches, earrings, and pins that I'd bought for Füsun over all those years, though to no avail, when I happened on a box at the back of a drawer, and within it I found the pair of butterfly-shaped earrings, each bearing the initial *F,* that she had been wearing at the time of the accident, despite having insisted for years that she'd lost one of them. I took the earrings and went downstairs.

"Aunt Nesibe, these seem to have been put into Füsun's jewelry box very recently," I said.

"Kemal, my boy, whatever Füsun was wearing that day—her red dress, her shoes, everything—I hid from you, because I didn't want to add to your grief. Then I said to myself that I'd better put them where they belonged, and here you have noticed at once."

"Was she wearing both the earrings?"

"Before she went to your room that evening, my darling girl was still planning to come sleep in our room. I was just pretending to be asleep, when suddenly she pulled these earrings from her handbag and put them on. When she left the room, I said nothing. I wanted you to be happy at long last."

I had never told Aunt Nesibe that Füsun had told me her mother had locked the door.

How could I have failed to notice the earrings as we were making love? Then another question occurred to me.

"Aunt Nesibe, years ago I told you that I'd left one of these earrings by the mirror in the bathroom, the very first time I visited this house. I even asked you, 'Have you seen them?' "

"I have no idea, my son. Don't delve into these things and make me cry. I do remember that she wanted to surprise you by putting on a certain pair of earrings in Paris—she had said something like that, but I never knew which earrings she meant. Ah, she so wanted to see Paris, my dear Füsun."

Aunt Nesibe began to cry, for which, afterward, she apologized.

The next day I booked a room at the Hôtel du Nord. In the evening I told my mother that I was leaving for Paris, that a trip would do me good.

"Oh, I'm so glad," said my mother. "And you can do some good for the business, for Satsat. Your brother shouldn't take over everything."

81

The Museum of Innocence

I HAD NOT said, This trip to Paris is not on business, Mother. For if she'd asked my reason, I could not have offered her a proper answer, having concealed the purpose even from myself. As I left for the airport, I considered my journey in some sense the atonement I had obsessively sought for my sins, among them, my having failed to notice Füsun's earring.

But as soon as I had boarded the plane, I realized that I had set out on this voyage both to forget and to dream. Every corner of Istanbul was teeming with reminders of her. The moment we were airborne, I noticed that outside Istanbul, I was able to think about Füsun and our story more profoundly. In Istanbul I'd always seen Füsun through the prism of my obsession; but in the plane I could see my obsession, and Füsun, from the outside.

I felt such consolation, the same deep understanding, as I wandered idly around museums. I do not mean the Louvre or the Beaubourg, or the other crowded, ostentatious ones of that ilk; I am speaking now of the many empty museums I found in Paris, the collections that no one ever visits. There was the Musée Édith Piaf, founded by a great admirer, where by appointment I viewed hairbrushes, combs, and teddy bears; and the Musée de la Préfecture de Police, where I spent an entire day; and the Musée Jacquemart-André, where other objects were arranged alongside paintings in a most original way—I saw empty chairs, chandeliers, and haunting unfurnished spaces there. Whenever wandering alone through museums like this, I felt myself uplifted. I would find a room at the back, far from the gaze of the guards who paid close attention to my every step; as the sound of traffic and construction and the urban din filtered in from outside, it was as if I had entered a separate realm that coexisted with the city's crowded streets but was not of them; and in the eerie timelessness of this other universe, I would find solace.

Sometimes, thus consoled, I would imagine it possible for me to frame my collection with a story, and I would dream happily of a museum where I could display my life—the life that first my mother, and then Osman, and finally everyone else thought I had wasted—where I could tell my story through the things that Füsun had left behind, as a lesson to us all.

On visiting the Musée Nissim de Camondo, whose founder I knew to have come from one of Istanbul's most prominent Jewish families, I was emboldened to believe that in the Keskins' set of plates, forks, knives, and my seven-year collection of saltshakers, I, too, could have something worthy of proud display, and the notion set me free. The Musée de la Poste made me realize I could display the letters I had written to her, and the Micromusée du Service des Objets Trouvés legiti-

mated the inclusion of a wide range of things, so long as they reminded me of Füsun, for example, Tarık Bey's false teeth, empty medicine boxes, and receipts. It took me an hour in a taxi to reach the Musée Maurice Ravel, formerly the famous composer's house, and when I saw his toothbrush, coffee cups, china figurines, various dolls, toys, and an iron cage that immediately called to mind Lemon, with an iron nightingale singing within it, I very nearly wept. To stroll through these Paris museums was to be released from the shame of my collection at the Merhamet Apartments. No longer an oddball embarrassed by the things he had hoarded, I was gradually awakening to the pride of a collector.

I did not, however, invoke such concepts at that time, gauging my spiritual alteration instead by the simple awareness that I felt happy the moment I entered one of these places, and began to dream of telling my story through objects. One evening while drinking alone in the bar of the Hôtel du Nord, gazing at the strangers around me, I caught myself asking the questions that occur to every Turk who goes abroad (if he has some education and a bit of money): What did these Europeans think about me? What did they think about us all?

Eventually I thought about how I might describe what Füsun meant to me to someone who knew nothing about Istanbul, Nişantaşı, or Çukurcuma. I was coming to see myself as someone who had traveled to distant countries and remained there for many years: say, an anthropologist who had fallen in love with a native girl while living among the indigenous folk of New Zealand, to study and catalog their habits and rituals, how they worked and relaxed, and had fun (and chatted away even while watching television, I must hasten to add). My observations and the love I had lived had become intertwined.

Now the only way I could ever hope to make sense of those years was to display all that I had gathered together—the pots and pans, the trinkets, the clothes and the paintings—just as that anthropologist might have done.

During my last days in Paris, with Füsun's birds on my mind, and a bit of time to kill, I went to the Musée Gustave Moreau, because Proust had held this painter in such high esteem. I couldn't bring myself to like Moreau's classical, mannered, historical paintings, but I liked the museum. In his final years, the painter Moreau had set about

changing the family house where he had spent most of his life into a place where his thousands of paintings might be displayed after his death, and this house in due course became a museum, which encompassed as well his large two-story atelier, right next to it. Once converted, the house became a house of memories, a "sentimental museum" in which every object shimmered with meaning. As I walked through empty rooms, across creaking parquet floors, and past dozing guards, I was seized by a passion that I might almost call religious. (I would visit this museum seven more times over the next twenty years, and each time as I walked slowly through its rooms I felt the same awe.)

On returning to Istanbul, I went directly to see Aunt Nesibe. After telling her about Paris and its museums, and sitting down to eat, I went straight to the matter foremost in my mind.

"You know that I've been taking away things from this house, Aunt Nesibe," I said, with the ease of a patient who can at last smile about an illness he was cured of long ago. "Now I'd like to buy the house itself—the entire building."

"What do you mean?"

"I'd like you to sell me the house and all its contents."

"But what will happen to me?"

We talked it through in a way that was only half serious. I spoke almost ceremoniously: "I would like to find a way to commemorate Füsun in this house." I also suggested to Aunt Nesibe that she would not be happy in this house, lighting the stove on her own, though, if it was her wish, she could stay. Aunt Nesibe cried for a time at the thought of spending her life alone. But then I told her that I had found her an excellent apartment in Nişantaşı, on Kuyulu Bostan Street, where she'd once lived.

"Which building is it in?" she asked.

A month later we'd bought Aunt Nesibe a big apartment in the nicest part of Kuyulu Bostan Street, just a little way beyond her former apartment (and right across the street from the tobacconist, the newsagent, and the shop owned by Uncle Sleaze the child molester). She deeded to me the whole building in Çukurcuma, including the ground-floor flat and all the movables. On the advice of my lawyer friend who had handled Füsun's divorce, we made an inventory of the building's entire contents and had the document duly notarized.

Aunt Nesibe was in no hurry to move to her new home in Nişantaşı. With my assistance, she had new lighting installed and bought furniture as carefully as a girl might build her trousseau, and every time we saw each other she would tell me with a smile that there was no hope of her ever being able to leave the house in Çukurcuma.

"Kemal, my son, I can't leave this house and all its memories. What are we to do?" she would say.

"We will turn the house into a place where we can display our memories, Aunt Nesibe," I would reply.

As my journeys gradually became longer, I saw her less often. Because I still did not really know what to do with the house, its contents, and all those things of Füsun's, which were so precious to me I hardly dared to look at them, for fear my gaze might do them harm.

My visit to Paris served as the model for my subsequent travels. On arriving in a new city I would move into the old but comfortable and centrally located hotel that I had booked from Istanbul, and armed with the knowledge acquired from the books and guides read in advance, I would begin my rounds of the city's most noteworthy museums, never rushing, never skipping a single one, like a student meticulously completing an assignment. And then I would scan the flea markets, the shops selling trinkets and knickknacks, a few antique dealers; if I happened on a saltshaker, an ashtray, or a bottle opener identical to one I'd seen in the Keskin household, or if anything else struck my fancy, I would buy it. No matter where I was—Rio di Janeiro, Hamburg, Baku, Kyoto, or Lisbon—at suppertime I would take a long walk through the backstreets and far-flung neighborhoods; peering through the windows, I would search out rooms with families eating in front of the television, mothers cooking in kitchens that also served as dining rooms, children and fathers, young women with their disappointing husbands, and even the rich distant relations secretly in love with the girl in the house.

In the morning, after a leisurely breakfast at the hotel, I would kill time on the avenues and in the cafés until the little museums had opened; I'd write postcards to my mother and Aunt Nesibe, peruse the local papers, trying to figure out what had happened in Istanbul and the world, and at eleven o'clock I would pick up my notebook and set out hopefully on the day's program.

One cold and rainy day, while walking through the galleries of the Helsinki City Museum, I happened on just the sort of medicine bottles I'd found in Tarık Bey's drawers. Prowling the mildewy rooms of a museum in the small city of Cazelles, near Lyon in France (a converted former hat factory with no visitors but me), I saw hats exactly like those my mother and father had once worn. As I was viewing the playing cards, rings, necklaces, chess sets, and oil paintings of the State Museum of Württemberg, located in a tower of the old castle in Stuttgart, I was inspired by the belief that the Keskins' possessions (like my love for Füsun) deserved display in comparable splendor. The smallest detail demanded the most exacting investigation: I spent an entire day in the Musée International de la Parfumerie in the South of France, some distance from the Mediterranean, in Grasse, the world capital of perfume, struggling to identify Füsun's scent. At Munich's Alte Pinakothek (whose stairs would serve as a model for those in my own museum) the sight of Rembrandt's masterpiece *The Sacrifice of Abraham* reminded me of having told Füsun this story many years earlier, and of the moral of giving up the thing most precious to us while expecting nothing in return. I gazed at length at George Sand's lighter, her jewels, her earrings, and locks of her hair, which were stapled to a piece of paper, until there, in the Musée de la Vie Romantique in Paris, I shivered. In the Göteborgs Historiska Museum, which narrates the history of that city, I sat patiently before the china tiles and plates imported by the East India Company. In March 1987 a suggestion by a former classmate now working at the Turkish Embassy in Oslo brought me to the Brevik Town Museum; on finding it closed, I went back to Oslo for the night, returning the next day to view the exhibits, which included a three-hundred-year-old post office, a photographer's studio, and an old pharmacy. It was in Trieste, where the Civico Museo del Mare is housed in an old prison, that I first realized what many other museums would remind me of: being awash with memories of Füsun, the Bosphorus ferries (for example, the *Kalender*) would need to be represented by some model alongside other totems of my obsession. In Honduras, for which I had a hard time acquiring a visa, the Museum of Insects and Butterflies in La Ceiba, where I walked among tourists in shorts, led me to imagine that I could display all the butterfly barrettes I'd bought for Füsun over the years as if they were real but-

terflies; and that, by extension, I could organize and show all the mosquitoes, blackflies, horseflies, and other insects from the Keskin household. In the Chinese city of Hangzhou, in the Museum of Chinese Medicine, I felt that I had come face-to-face with one of Tarık Bey's very own medicine boxes. I would note with pride at the Musée du Tabac, just opened in Paris, that its collection was not nearly as extensive as the one I had built up over eight years. One bright spring day in Aix-en-Provence, I remember gazing with boundless happiness and admiration upon the shelves of pots and pans and other objects in the sun-drenched rooms of the Musée de l'Atelier de Paul Cézanne. At the pristine and perfectly maintained Rockox House in Antwerp I had occasion to remember that in small museum houses the past is preserved within objects as souls are kept in their earthen bodies, and in that awareness I found a consoling beauty that bound me to life. But still I wonder if I could ever have learned to appreciate my own collection in the Merhamet Apartments, let alone nurtured any hope of showing it proudly to others, had I not first gone to Vienna to see the Sigmund Freud Museum, crammed with the statues and the furniture of the famous psychoanalyst. Was a visit to the old barbershop in the Museum of London on every London trip during my first traveling years merely an expression of nostalgia for my Istanbul barbers, Basri and Cevat the Chatterbox, or something more? At the Florence Nightingale Museum, housed in a London hospital, I was hoping to find a painting or an object that the famous nurse had brought back from Istanbul, where she'd run a hospital during the Crimean War, but the memento I found was not just from Istanbul—it was a barrette identical to one of Füsun's. In the Musée de Temps in Besançon, France, formerly a palace, as I wandered among the clocks, listening to the deep silence, I thought about museums and time. In Holland, gazing at the minerals, fossils, medals, coins, and old utensils in the old wood-framed display cupboards, amid the silence of the Teylers Museum in Haarlem, I had an intimation that I would be able to say what it was that gave life meaning, and offered me the greatest solace, but as with the first blush of love, I couldn't at first express what bound me to such places. In Madras, at the Fort St. George Museum, situated in the first fort built by the English in India, it was hot and very humid; and as I stood beneath an overhead fan, surrounded by letters, oil

paintings, coins, and everyday objects, I felt the same elation. It was while strolling through the Castelvecchio Museum in Verona, ascending its staircases to marvel at how the architect Carlo Scarpa had arranged for the light to drape like silk over the statues, that I first came to understand how my pure contentment flowed not just from these museums as collections, but from the harmony in the arrangement of their pictures and objects. But it was not until I visited the Museum der Dinge in Berlin, once accommodated in the Martin Gropius Building and later made homeless, that I saw this truth another way: One could gather up anything and everything, with wit and acumen, out of a positive need to collect all objects connecting us to our most beloved, every aspect of their being, and even in the absence of a house, a proper museum, the poetry of our collection would be home enough for its objects. When I first set eyes on Caravaggio's *The Sacrifice of Isaac* at the Uffizi in Florence, first tears came to my eyes, at the thought of never having had the chance to see this painting with Füsun, and then I saw in the painting that the unremarked lesson of Abraham's sacrifice was that it is possible to substitute for one's most cherished object another, and that this was why I felt so attached to the things of Füsun's that I had collected over the years. Every time I went to London I visited Sir John Soane's Museum; after walking through its gorgeously cluttered, crowded rooms and admiring his arrangement of the paintings, I would sit alone in a corner, listening for many hours to the noise of the city, thinking that one day I would exhibit Füsun's things in just this way, and that when I did, she would smile down on me from the realm of the angels. But not until I found myself in the sentimental collection which was on the top floor of the Museu Frederic Marès in Barcelona, perusing its romantic assortment of barrettes, pins, earrings, playing cards, keys, fans, perfume bottles, handkerchiefs, brooches, necklaces, handbags, and bracelets, did I realize at last what I could do with Füsun's things. And on my first tour of America—where I spent more than five months visiting 273 museums—I recalled that same emotional experience while visiting New York's Glove Museum. Then at the Museum of Jurassic Technology in Culver City, California, I remembered again why some museums had the power to make me shudder: They induced the feeling that I had become suspended in one age while the rest of humanity lived in another. In the town of Smith-

field, North Carolina, at the Ava Gardner Museum, from which I stole a charming exhibition plaque reproducing a tableware advertisement in which she appeared, at the sight of Ava's yearbook picture, her night-gowns, her mittens, and her boots, I so ached for my lost Füsun that I very nearly aborted my journey and returned to Istanbul. Fortunately, after two days of studying the collection of soda and beer cans at the recently opened and soon to close Museum of Beverage Containers and Advertising near Nashville, while still longing to go home, I found the will to carry on. It was five weeks later, in Saint Augustine, Florida, at the (soon to close) Tragedy in U.S. History Museum, where, upon seeing the chrome-plated gauges and the rusting, crumpled wreck of the 1966 Buick in which Jayne Mansfield had been crushed to death, I at last decided to return to Istanbul. As it happens, I had by then con-cluded that the true collector's only home is his own museum.

I did not remain for long in Istanbul. Following Çetin's directions, I drove to the garage owned by Şevket Usta, who specialized in Chevro-lets, in the streets behind Maslak; in the empty lot behind the garage one look at our '56 Chevrolet under a fig tree produced a paroxysm of emotional turmoil. The trunk was open, with chickens from the adja-cent coop wandering through the wreck, and around it children were playing. According to Şevket Usta, some parts had been salvageable, among them the gas cap, the gearbox, and the handle of the rear win-dow, all sold to owners of other '56 Chevrolets, a sizable market as most of the city's taxis were now the same model. When I poked my head into the wreck, to peer at where the fuel gauge and the speedome-ter had once lodged in mint condition, and the radio knobs, and the steering wheel, I caught the scent of leather rising from the seat cover-ings in the gentle heat of the sun, and my head began to swim. By instinct, I touched the steering wheel, which seemed almost as old as I was. And soon the intensity of the memories compressed into these remains overwhelmed me and I broke down.

"Kemal Bey, what happened? Why don't you sit down over there," said Çetin, his voice full of understanding. "Children, could you bring us a glass of water?"

For the first time since Füsun's death, I'd been on the brink of cry-ing in public. A boy apprentice, sooty as a coal digger and covered in axle grease, but with immaculately clean hands, brought us tea on a tray

with the logo CYPRUS TURK (I record this by force of habit; visitors should not waste time looking for it in the Museum of Innocence); as we drank our teas, after a bit of bargaining, we bought back my father's car.

"So where are we going to put this, Kemal Bey?" asked Çetin Efendi.

"I want to spend the rest of my life under the same roof with this car," I said with a smile, but Çetin Efendi understood at once that I was earnest, and unlike the others, he did not say, "Oh, please, Kemal Bey, life must go on—you can't die with the dead." Had he done so, I would have explained that the Museum of Innocence was to be a place where one could live with the dead. Though I had prepared this answer in advance, the words now stuck in my throat: Prompted by pride, I said something altogether different.

"There are lots of things stored in the Merhamet Apartments. I want to bring them together under one roof and spend the rest of my days among them."

I had many heroes in mind, who, during the last years of their lives, like Gustave Moreau, had arranged for their homes to be turned into museums posthumously. I loved the museums they'd created, and so I continued my travels, revisiting the hundreds I'd come to know and cherish and going to the thousands of others I still longed to see.

82

Collectors

THIS IS what I observed while traveling the world, and wandering through Istanbul. There are two types of collectors:

1. The Proud Ones, those pleased to show their collections to the world (they predominate in the West).
2. The Bashful Ones, who hide away all they have accumulated (an unmodern disposition).

The Proud regard a museum as a natural ultimate destination for their collections. They maintain that whatever a collection's original purpose, it is, in the end, an enterprise intended for proud display in a museum. This view was common in the official histories of small, private American museums: For example, the brochure for the Museum of Beverage Containers and Advertising describes how the collector Tom picked up his first soda can on the way home from school. Then he picked up another, and a third, keeping what he found until after a time his ambition was to "collect them all" and exhibit them in a museum.

But the Bashful collect purely for the sake of collecting. Like the Proud, they begin—as readers will have noticed in my own case—in pursuit of an answer, a consolation, even a palliative for a pain, a resolution of difficulty, or simply out of a dark compulsion. But living in societies where collecting is not a reputable act that contributes to learning or knowledge, the Bashful regard their compulsion as an embarrassment that must be hidden. Because in the lands of the Bashful, collections point not to a bit of useful information but rather to a wound the bashful collector bears.

I would come upon these dark sentiments in many places over the years, but it was in the early months of 1992, among those in Istanbul who specialized in film paraphernalia, that I caught my first glimpses of "collectors' embarrassment," while hunting for posters, lobby photographs, and ticket stubs from films we'd seen in the summer of 1976, to display in the Museum of Innocence.

It was after having haggled at length that Hıfzı Bey sold me an assortment of lobby photographs from films like *Love's Agony Ends in Death* and *Caught in the Crossfire,* and after he had told me again and again how pleased he was by my interest in his collection, he turned wistful.

"It saddens me, Kemal Bey, to part with things that are so dear to me," he said. "But how I wish that the people who mock my hobby, and make fun of me—the ones who ask, 'Why do you cram the house with this filth?'—how I wish they could see someone like you, a cultured man from a good family, finding something to value in my collection. I don't drink, or smoke, or gamble, or fool around with women. My only vice is collecting photographs of stars and films. . . . Might you

be interested in stills from scenes on the *Kalender* in *Hear My Mother's Lament,* in which Papatya played when still a young girl? She's wearing a pinafore, and her shoulders are bare. . . . If you would care to come to my humble abode this evening, I could show you photographs taken during the filming of *Black Palace,* which was never completed, due to the suicide of its lead, Tahir Tan. Until now, no one but me has seen them. I also have pictures of Inge, the German model who appeared in the advertising campaign for Turkey's first domestic fruit-flavored soda—she went on to play a kindly, Turk-loving German aunt in *Central Station,* which was part of the first wave of Turkish-German film productions. I have lobby photographs of her with the man she falls in love with in the film; he is played by Ekrem Güçlü, and they are kissing on the lips."

When I asked about other lobby photographs I was seeking, Hıfzı Bey told me that there were quite a few collectors whose homes were packed to the rafters with photographs, films, and posters. When their rooms were so full of photographs, posters, newspaper cuttings, and magazines that no room remained to live in, their families would abandon the house (most had never married anyway), and the collectors would be free to begin to pick up everything they could get their hands on, until their houses turned into such rubbish dumps that no one could even enter them. Doubtless some of these famous collectors would have what I was after, but they would never be able to extract the items from the heaps that were their homes—it was hard enough for them to get through the front door.

Even so Hıfzı Bey proved helpless in the face of my entreaties, and he was able to get me into some of the rubbish dens that had become legendary among the Istanbullus during the 1990s.

Sifting through the detritus in these houses I was able to find most of the lobby photographs that I would go on to display in my museum, along with the Istanbul views, quite a few postcards, cinema tickets, restaurant menus that it had not occurred to me to save at the time, rusty old tin cans, pages from yellowed newspapers, paper bags with company logos, medicine boxes, bottles, photographs of film stars and other celebrities, and also pictures of ordinary, everyday Istanbullus that spoke more eloquently than anything of the place where Füsun and I had once lived.

The owner of an old two-story house in Tarlabaşı looked relatively normal, but sitting on a plastic chair surrounded by piles of paper and odd objects, he declared with a reticent pride that he had amassed 42,742 items.

I felt the same shame while inspecting the holdings of a retired meter reader, having only just managed to enter the house in which he and his bedridden mother lived in a room heated by a gas stove. (The rest of the place was as frigid as it was inaccessible, though at some remove I glimpsed old lamps, Vim cans, and a few toys familiar from childhood.) What made me feel ashamed was not the retired meter reader's mother, who berated and humiliated her son incessantly: It was knowing that all these things, saturated with memories of people who had once walked the streets of Istanbul, and lived in its houses, and were now mostly dead, would eventually disappear without ever having been brought together in a museum, or sorted, or set within a frame. I had recently heard the drama of the Greek photographer who had, for forty years, been taking pictures at weddings, engagement parties, business meetings, and restaurants in Beyoğlu; having run out of space, and knowing his pictures were no longer wanted, he set about burning his entire stock of negatives in an apartment furnace. There was simply no demand for these photographs and negatives recording the weddings, festivities, and other gatherings of an entire city, not even free of charge. The owners of the rubbish dens would be objects of ridicule in apartment houses and neighborhoods, feared as much for their being solitary cranks as for combing trash bins and consorting with junk dealers. Hıfzı Bey had already told me, without undue bitterness, in a tone more suggestive of one imparting life's verities, that after these solitaries died, their piles of accumulated objects would, with a quasi-religious ferocity, be consigned to an empty neighborhood lot (where lambs were sacrificed on holidays)—to be burned or left for the junk man or the rubbish collector.

In December 1996 a lone hoarder ("collector" would be the wrong word) named Necdet Adsız, who lived in Tophane, a mere seven-minute walk from the Keskins' house, was crushed to death beneath the accumulated piles of paper and old objects in his little house, not to be discovered, let alone mourned, until four months later, when in summer the stench coming from the house grew unbearable. With

the piles pressing up against the front door, the firemen were obliged to enter through the windows. By describing the incident in half-mocking, half-scaremongering terms, the papers sowed among the people of Istanbul even more apprehension than already existed concerning all manner of collectors. There is a further strange detail that I hope the reader will not find superfluous, and that comes to me owing to my ability in those days to think about all things connected to Füsun at the same time. Necdet Adsız, the man crushed to death beneath his hoard, whose body was left to rot, was the same Necdet whom Füsun had mentioned at the end of the engagement party at the Hilton, when the subject of séances came up—the friend she'd assumed to be dead.

That their life's work was an embarrassment to be kept secret and hidden, and that beneath it they felt a shame with even deeper roots, I saw in the eyes of my fellow collectors, whom I would like to thank here for their contributions to my museum and to Füsun's memory. I have already mentioned Halit Bey the Invalid, the celebrated postcard collector, whom I sought out between 1995 and 1999, fired by the ambition to acquire postcards of every street and neighborhood I had ever visited with Füsun. There is another (with no wish to be named) whose collection of doorknobs and keys I was delighted to exhibit after he explained that every resident (by which he meant every male) of Istanbul touched about twenty thousand door handles in his lifetime, and so it was virtually certain that "the hand of the one I loved" had touched a great many of his specimens. Then there is Siyami Bey, who spent the last thirty years of his life collecting photographs of every ship to pass through the Bosphorus since the invention of photography, and who was kind enough to give me copies of those photographs for which he had doubles. I would like to acknowledge him here, first for providing the means to show my visitors the ships whose whistles I heard while thinking of Füsun, or walking through the city with her, and second for being, like a Westerner, free of shame about exhibiting his collection.

It was from another collector who, more typically, preferred anonymity, that I acquired the assortment of little paper portraits of the dead that mourners would pin to their collars at funerals between 1975 and 1980: After driving a hard bargain for each and every one of

them, he asked the essential question I so often heard from these types, often in a demeaning tone, to which I recited my usual answer.

"I'm setting up a museum, you see. . . ."

"I'm not asking what you're going to do with them. What I'm asking is, why do you want these things?"

He was giving expression to the understanding that anyone obsessed with collecting objects and storing them away must be in the grip of heartbreak, deep distress, or some ineffable psychological wound. So what was my problem? Was I troubled at the loss of someone dear whose picture I had been unable to pin to my collar at the funeral? Or was I, like the man asking the question, suffering from something deep, unmentionable, and shameful?

As personal museums were almost nonexistent in the 1990s, the collectors of Istanbul were secretly contemptuous of themselves and of their obsessions, and no less so of one another, whom they excoriated openly, the tirades only worsening if complicated by jealousy. When Aunt Nesibe had moved to Nişantaşı and the architect İhsan began work on the Keskin house, aiming to turn it into a real museum, it was bruited about scornfully that I was "making a private museum, just as in Europe!" and in the same breath that I was rich. My hope was that this might soften their disdain and let them see not someone driven by a deep unspoken psychological wound—not half cracked, in other words, as they were—but someone collecting things for a museum as one might in the West, simply on account of being rich and inclined to celebrate his collection.

At the insistence of Hıfzı Bey, and in the hope of chancing upon a few reminders of Füsun that might have a place in my story, I attended a meeting of the Lovers of Collectible Objects Association, the first such group in Turkey, then recently established. There, in a little wedding salon rented for the morning, I felt myself a leper among society's lepers.

There were those familiar to me by name as collectors (including seven already known to the reader, such as Cold Suphi, the matchbox collector), and they treated me even more shabbily than they might have done a regular Istanbul collector or one of their own. The mostly silent stares of suspicion, as if I were a spy, an interloper, broke my heart. Hıfzı Bey's subsequent and apologetic explanation suggested

that to see even a rich man driven to soothe his troubled heart by acquiring objects awoke in them feelings of revulsion and hopelessness. For they were simple folk, so innocent as to imagine that their sin, their mania for collecting things, was an illness that wealth would surely have cured. But in time, as the gossip about my love for Füsun became common knowledge, these first serious collectors of Istanbul not only helped me but also shared their stories of struggle to emerge from underground and bring the fruits of their labors into the public domain.

Before transporting to Çukurcuma one by one the objects I'd stored at the Merhamet Apartments, I took a panoramic photograph of the collection that now filled most of the room where Füsun and I had made love twenty years earlier. (By now, too, the cries of children playing football in the back garden had been supplanted by the roar of an air conditioner.) When I brought these things together with the objects already assembled in the Çukurcuma museum house—those I had found during my travels, the Keskins' old possessions, the things I had extracted from the rubbish dens, and from members of the Association, as well as those received from various witnesses of my story—a thought that had occurred to me during my travels abroad, especially my visits to flea markets, took form before me, vivid as a painting.

All these objects—the saltshakers, china dogs, thimbles, pencils, barrettes, ashtrays—had a way of migrating, like the flocks of storks that flew silently over Istanbul twice a year to every part of the world. In the flea markets of Athens and Rome I had seen lighters identical to one I had bought for Füsun—and there were others almost exactly like it in Paris and Beirut. This saltshaker, made in a small Istanbul factory, which sat on the Keskin table for two years, was to be seen in restaurants in the poorer parts of Istanbul, but I also noticed it in a Halal restaurant in New Delhi, in a soup kitchen in an old quarter of Cairo, among the wares the peddlers set out on the canvases they spread on the sidewalks of Barcelona every Sunday, and in an unremarkable kitchen supply store in Rome. What is certain: Someone somewhere had produced the first of these saltshakers, and then others made molds from them for mass production in many other countries, so that over the years, millions of copies had spread out from the southern Mediterranean and the Balkans, to enter the daily lives of untold fami-

lies. To contemplate how this saltshaker had spread to the farthest reaches of the globe suggested a great mystery, as great as the way migratory birds communicate among themselves, always taking the same routes every year. Another wave of saltshakers would always arrive, the old ones replaced with the new, as surely as a south wind deposits its debris on the shore, and each time people would forget the objects with which they had lived so intimately, never even acknowledging their emotional attachment to them.

I brought my entire collection to the newly converted museum, along with the bedframe, the musty mattress, and the blue sheet on which Füsun and I had made love in the Merhamet Apartments, storing these last three objects in the attic. When the Keskins had lived in the house, the attic had been the domain of mice, spiders, and cockroaches, and the dark, mildewy home of the water tank; but now it had become a clean, bright room open to the stars by a skylight. I wanted to sleep surrounded by all the things that reminded me of Füsun and made me feel her presence, and so that spring evening I used the key to the new door on Dalgıç Street to enter the house that had metamorphosed into a museum, and, like a ghost, I climbed the long, straight staircase, and throwing myself upon the bed in the attic, I fell asleep.

Some fill their dwellings with objects and, by the time their lives are coming to an end, turn their houses into museums. But I, having turned another family's house into a museum, was now—by the presence of my bed, my room, my very self—trying to turn it back into a house. What could be more beautiful than to spend one's nights surrounded by objects connecting one to his deepest sentimental attachments and memories!

Especially in the spring and summer, I began to spend more nights in the attic flat. İhsan the architect had created a space in the heart of the building, which I could see through a great opening between the upper and lower levels; I could pass the night in the company of each and every object in my collection—commune with the entire edifice. Real museums are places where Time is transformed into Space.

My mother was uneasy about my living in the attic of my museum, but because I ate lunch with her regularly and had reconnected with some of my old friends (though never with Sibel and Zaim), and went on summer yacht trips to Suadiye and the Princes' Islands, and because

she, too, had come to believe in this as the only way I could bear the pain of having lost Füsun, she did not say a word; contrary to everyone she knew, she was prepared to regard my creation of a museum in the house where the Keskins had lived, exhibiting things that told the story of my love for Füsun, and the life we had shared, as perfectly normal.

"And oh, of course you must take all the old things in my wardrobe, too, and in my drawers. . . . I'll never have a reason to wear those hats again, and the same goes for those handbags, and your father's old things. . . . Take my knitting set, too, and the buttons and swatches. There's no point in spending money on seamstresses now that I'm in my seventies," she would say.

Whenever I was in Istanbul, I would pay monthly visits to Aunt Nesibe, who seemed happy with her new apartment and her new circle of friends. It was upon returning from my first visit to the Museum Berggruen in Berlin that I told her excitedly about the agreement I'd heard about between the founder, Heinz Berggruen, and the municipal government, a pact whereby he would be allowed to spend the rest of his days in the garret of the house he'd bequeathed to the city, to display the collection he had accumulated over a lifetime.

"While strolling through the museum, visitors can walk into a room or climb the stairs and find themselves face-to-face with the person who created the collection, until the day he dies. Isn't that strange, Aunt Nesibe?"

"May God ordain that your time will be late in coming," said Aunt Nesibe as she lit a cigarette. Then she wept a bit for Füsun, and with the cigarette still in her mouth, and the tears still streaming down her cheeks, she gave me a mysterious smile.

83

Happiness

IN THE middle of one moonlit night passed at the house in Çukur-cuma, I awoke in my little curtainless attic room, bathed in a sweet

glow, and gazed down at the empty space of the museum below. The silvery moonlight pouring through the windows into my museum, which sometimes seemed as if it might never be completed, gave the building and its empty center a frighteningly vacant aspect, as if it were continuous with infinite space. My entire collection of thirty years stood nestled in the shadows on the lower floors, encroaching like the gallery of a theater upon this emptiness. I could see it all—the things that Füsun and her family had used in this house, the rusting wreck of the Chevrolet, every fixture from the stove to the refrigerator, from the table on which we ate supper for eight years to the television we had watched while eating; and like a shaman who can see the souls of things, I could feel their stories flickering inside me.

That was the night I realized that my museum would need an annotated catalog, relating in detail the stories of each and every object. There was no doubt that this would also constitute the story of my love for Füsun and my veneration.

In the light of the moon, each and every thing tucked into the shadows, as if part of the empty space, seemed to point to an indivisible moment, akin to Aristotle's indivisible atoms. I realized then that just as the line joining together Aristotle's moments was Time, so, too, the line joining together these objects would be a story. In other words, a writer might undertake to write the catalog in the same form as he might write a novel. But having no desire to attempt such a book myself, I asked: Who could do this for me?

This is how I came to seek out the esteemed Orhan Pamuk, who has narrated the story in my name, and with my approval. Once upon a time his father and uncle did business with my father and the rest of us. Coming as he did from an old Nişantaşı family that had lost its fortune, he would, I thought, have an excellent understanding of the background of my story. I had also heard that he was a man lovingly devoted to his work and who took storytelling seriously.

I went to my first meeting with Orhan Bey well prepared. Before I spoke of Füsun, I told him that over the previous fifteen years I had traveled the world, visiting 1,743 museums in all, saving all of my admission tickets, and to pique his interest, I told him about the museums devoted to the memory of his favorite writers: When he heard that the only genuine piece in the F. M. Dostoevsky Literary-Memorial

Museum in Saint Petersburg was a hat kept under a bell jar, with a caption saying "This truly belonged to Dostoevsky," perhaps he would give me a smile. What would he have to say about the Nabokov Museum in the same city, which during the Stalin era had served as the office of the domestic board of censors? I told how, having visited the Musée Marcel Proust in Illiers-Combray and having seen the portraits of those who had served as models for his works, I left none the wiser about his novels, though possessing a clearer idea of the world in which the author had lived. No, I did not find the idea of a writer's museum absurd. For example, at Spinoza's house in the small city of Rijnsburg in Holland, I thought it was fitting that they had gathered together all the books in his library which were enumerated in an official report issued after his death, ordering them from largest to smallest, as was customary in the seventeenth century. And what a happy day I had walking through the labyrinth of rooms at the Tagore Museum, gazing at the author's watercolors, and recalling the dusty, musty scent of the first generation of Atatürk Museums, all the while listening to Calcutta's unending roar! I talked of visiting Pirandello's house in the city of Agrigento, Sicily, and seeing photographs that might have been of my own family; of the city views from the windows of the Strindberg Museum in the Blue Tower in Stockholm; and of the gloomy little four-story house in Baltimore that Edgar Allan Poe had shared with his aunt and his ten-year-old cousin Virginia, whom he would later marry. I found it so familiar: Of all the museums I visited, it was this tiny four-story Baltimore Poe House and Museum, which now sits in the middle of a poor, outlying neighborhood, that reminded me most of the Keskin household, its forlorn air, its rooms, and its shape. But as I told Orhan Bey, the most magnificent writer's museum I had seen was the Museo Mario Praz on Giulia Street in Rome. If he ever managed to make an appointment to visit, as I had done, the home of Mario Praz, the celebrated historian and author of *The Romantic Agony,* who had an equal passion for visual art as for literature, he must, I advised, read the book in which the great author told the story of his wondrous collection like a novel, room by room, object by object. By contrast, the house in Rouen where Flaubert was born was full of his father's medical books, so there was no need for a writer to visit the Musée Flaubert et d'Histoire de la Médecine. Then I looked carefully into our author's

eyes: "While Flaubert was writing *Madame Bovary,* inspired by his beloved Louise Collet, to whom he had made love in horse carriages and provincial hotels, just as in the novel, he kept in a drawer a lock of her hair, as well as a handkerchief and a slipper of hers, and he would, from time to time, take these things out to caress them, looking in particular at the slipper to recall how she walked—as you certainly know from his letters, Orhan Bey."

"No, I didn't know that," he said. "But I love it."

"I once loved a woman so much that I, too, hid away locks of her hair, and her handkerchiefs, and her barrettes, and everything she ever owned, and for many years I found consolation in them, Orhan Bey. May I, in all sincerity, tell you my story?"

"Of course, go right ahead."

So it was during our first meeting, at Hünkar (the restaurant that had replaced the now defunct Fuaye), that I told him my whole story— not in a disciplined way, but jumping back and forth—in the space of three hours. I was overexcited, and had drunk three double *rakı*s, and I think my elation got the better of me, making my story sound to some degree ordinary.

"I knew Füsun," said Orhan Bey. "I remember her from the engagement party at the Hilton. I was so very sorry to hear she had died. She used to work at that boutique down the road. I even danced with her at your engagement party."

"Is that true? She was such an exceptional person, wasn't she. . . . I'm not talking about her beauty, but her soul, Orhan Bey. When you were dancing with her, what did you say to each other?"

"If you really have all of Füsun's things in your possession, I would like to see them."

First he came to Çukurcuma, showing a genuine interest in this collection I'd assembled and this museum I'd made from an old house, an admiration he made no effort to conceal. Now and then he would pick up an object, for example, the yellow pump that Füsun was wearing the first time I saw her in the Şanzelize Boutique, and he'd ask me to tell him its story, and so I would.

Later on we began to work in a more organized fashion. Whenever I was in Istanbul he would come to my attic once a week, always asking me why the objects and photographs I had recalled and organized in a

row had to appear in the same order in the boxes and display cases of the museum and why each had to be mentioned in its particular chapters. With the greatest pleasure I would tell him. He listened very carefully to everything I said, and when I saw him taking notes I was pleased—and proud.

"Please finish this novel now, so that people who are interested can tour the museum with the book in hand. As they walk from case to case in my museum, seeking a better understanding of my love for Füsun, I'll come down from my attic room in my pajamas and wander among them."

"But you haven't finished your museum either, Kemal Bey," Orhan Bey would say by way of reply.

"There are many museums in the world I have yet to see," I would say with a smile. And then I would try, yet again, to explain the spiritual effect that the silence of museums had on me, what sublime happiness it was to be in a far corner of the world on an ordinary Tuesday morning, strolling through a forgotten museum in an out-of-the-way neighborhood, and evading the scrutiny of the guards. Whenever I returned from my travels I would ring Orhan Bey at once, and tell him about the museums I'd seen, bringing tickets and brochures out of my pocket, as well as the little trinkets and directional signs that I had pocketed in the museums I most liked.

It was just after my return from one such journey that, after telling him my story, and describing the museums I'd visited, I asked him how the novel was progressing.

"I am writing the novel in the first person singular," said Orhan Bey.

"What do you mean?"

"In the book you are telling your own story, and saying 'I,' Kemal Bey. I am speaking in your voice. Right now I am trying very hard to put myself in your place, to be you."

"I understand," I said. "So tell me, have you ever been in love this way, Orhan Bey?"

"Hmmmmm . . . We aren't talking about me," he said, and he fell silent.

After working together for a long while, we had some *rakı* in my garret. Talking about Füsun and our life together had tired me. After he left, I stretched out on the bed where Füsun and I had once made love

(more than a quarter century ago) and thought about why I felt so strange about his telling the story from my point of view.

Though I had no doubt that it would remain my story, and that he would treat it respectfully, the idea of his speaking in my voice was disturbing. It seemed a failure of courage, a sort of weakness on my part. While I thought it perfectly normal to tell the story to visitors myself, pointing out relevant objects along the way, for Orhan Bey to put himself in my place, for him to make his own voice heard in place of mine—this annoyed me.

I was feeling that way two days later, when I asked him about Füsun. That night we again met in the attic of my museum, and had already polished off our first glass of *rakı,* when I said, "Orhan Bey, could you please tell me about your dance with Füsun the night of my engagement party?"

For a while he was reluctant—I think he was embarrassed. But when we'd each had another *rakı,* Orhan Bey described with such feeling how he'd danced with Füsun a quarter century ago that he immediately won my trust as the ideal person to tell my story to museum visitors in my voice.

It was around then that I decided my voice had been heard too much anyway, and that it was time I left it to him to finish my story. From the next paragraph until the end, it will, in essence, be Orhan Bey who is telling the story. Having paid Füsun such sincere, detailed attention during their dance, he will, I am sure, do no less in these last pages. Farewell!

HELLO, THIS IS ORHAN PAMUK! With Kemal Bey's permission I shall begin by describing my dance with Füsun: She was the most beautiful girl there that night, and there were many men waiting their turn to dance with her. I was not handsome or flamboyant enough to catch her eye, and, though five years older than her, I was not, how shall I put it, mature enough, and in those days I didn't have much self-confidence, either. My mind was crammed with moralistic thoughts and books and novels that made it impossible for me to enjoy the evening. That her mind was occupied with very different matters you will already know.

Yet despite all this, after she had accepted my invitation to dance, as

I followed her to the dance floor, I entered into a reverie at the sight of her tall form, her bare shoulders, her magnificent back, and her fleeting smile. Her hand was light but warm to the touch. When she put her other hand on my shoulder there was a moment when I could not have been prouder had she been my own, and not merely my momentary dance partner. As we swayed lightly across the floor, I was driven to distraction by the closeness of her skin, her perfect posture, the liveliness of her shoulders and her breasts, and though I did my best to resist her attractions, I was unable to stop the fantasies racing through my mind: We left the dance floor hand in hand, going upstairs to the bar; we were falling madly in love; we were kissing under those trees just over there; I was sure we would be getting married!

Just to get the conversation going, I said the first thing that came into my head ("When I'm walking down the street in Nişantaşı, I sometimes see you in the shop"), but my dull words only reminded her that she was a very beautiful shopgirl, and she was unimpressed. Anyway, by the middle of the first dance, she had already worked out that I wasn't up to much, and had begun looking over my shoulder at the people sitting at the tables, and trying to see who was dancing with whom, keeping track of the many men who had shown an interest in her, to see whom they were laughing and talking with now, and sizing up the most charming and beautiful women, to plan her next move.

I had respectfully (but also with delight) placed my right hand just above her beautiful hip, and with the tips of my first two fingers could feel every movement of her spine, down to the merest flutter, as if taking her pulse. Her curiously erect posture set my head spinning, and for years I would be unable to forget it. There were moments when I could feel in my fingertips the blood coursing through her body, the very life, and then suddenly she would fixate on something new, causing her organs to flinch, a frisson through her elegant frame, and it was all I could do not to embrace her with every bit of my strength.

As the dance floor became crowded, another couple bumped into us from behind, and for a moment our bodies were pressed together. After that shockingly intimate instant, I remained silent for some time. As I gazed upon her neck and her hair, I was so swept up in the fantasy of happiness with her that I would have gladly abandoned my books and my dreams of becoming a novelist. I was twenty-three years old

and quick to anger when the bourgeoisie of Nişantaşı, even my own friends, would laugh at my decision to become a novelist, snidely telling me that no one my age could possibly have enough understanding of life for that. Exactly thirty years later, as I revise these lines, I would now like to add that I believe these people were right. Had I had any understanding of life then, I would have done everything in my power to intrigue her during our dance, I would have believed that she could take an interest in me, and when she slipped out of my arms, I would not have stood there so helplessly watching her go. "I'm tired," she said. "Would you mind if I sat down after the second dance?" I was walking her back to her table, a courtesy I had learned from films, when I suddenly couldn't hold myself back.

"What a boring lot," I said priggishly. "Shall we go upstairs and find a comfortable place to sit and talk?" It was so noisy that she couldn't really hear me, but she understood immediately from my expression what I was after. "I have to sit with my mother and father," she said, as she politely drew away.

When he realized that I had chosen to end my story there, Kemal Bey congratulated me. "Yes, that would be just like Füsun. You understood her very well!" he said. "I would also like to thank you profusely for resisting the urge to omit those details damaging to your pride. Yes, that is the crux of it, Orhan Bey—pride. With my museum I want to teach not just the Turkish people but all the people of the world to take pride in the lives they live. I've traveled all over, and I've seen it with my own eyes: While the West takes pride in itself, most of the rest of the world lives in shame. But if the objects that bring us shame are displayed in a museum, they are immediately transformed into possessions in which to take pride."

This was the first in a series of didactic pronouncements that Kemal Bey delivered himself of in his small attic chamber as we drank into the night. I was unfazed, mostly because everyone who runs into a novelist in Istanbul feels moved to edifying declarations and suchlike, but (as Kemal Bey so often suggested to me) I, too, was becoming confused about what to include in the book, and how to go about it.

"Do you know who it was that taught me the central place of pride in a museum, Orhan Bey?" Kemal Bey asked me during another late-night session in the attic. "The museum guards, of course. No matter

where I went in the world, the guards would answer my every question with passion and pride. At the Stalin Museum in Gori, Georgia, an elderly woman guard spoke for almost an hour of what a great man Stalin was. And it was thanks to an amiable guard at the Museum of the Romantic Era in the city of Oporto in Portugal, who proudly talked with me at length, that I discovered in Carlo Alberto, the exiled king of Sardinia, who spent the last three months of his life in that building in 1849, a profound influence on Portuguese romanticism. Orhan Bey, if someone asks a question at our museum, the guards must describe the history of the Kemal Basmacı collection, the love I feel for Füsun, and the meanings invested in her possessions, with the same dignified air. Please put this in the book, too. The guards' job is not, as is commonly thought, to hush noisy visitors, protect the objects on display (though of course everything connected to Füsun must be preserved for eternity!), and issue warnings to kissing couples and people chewing gum; their job is to make visitors feel that they are in a place of worship that, like a mosque, should awaken in them feelings of humility, respect, and reverence. The guards at the Museum of Innocence are to wear velvet business suits the color of dark wood—this being in keeping with the collection's ambience and also Füsun's spirit—with light pink shirts and special museum ties embroidered with images of Füsun's earrings, and, of course, they should leave gum chewers and kissing couples to their own devices. The Museum of Innocence will be forever open to lovers who can't find another place to kiss in Istanbul."

I would sometimes tire of this declamatory style so reminiscent of the more outspoken political writers of the seventies, which Kemal Bey would adopt after two glasses of *rakı,* that I would stop taking notes, and in the days that followed I would have no wish for his company. But the twists of Füsun's story, and the singular atmosphere created by the museum's objects, were such that after a time I would always be drawn back, again want to visit the attic, to listen to this time-worn man deliver long monologues about Füsun, becoming more animated the more he drank.

"Never forget, Orhan Bey, that the logic of my museum must be that wherever one stands inside it, it should be possible to see the entire collection, all the display cases, and everything else," Kemal Bey would say. "Because all the objects in my museum—and with them, my entire

story—can be seen at the same time from any perspective, visitors will lose all sense of Time. This is the greatest consolation in life. In poetically well built museums, formed from the heart's compulsions, we are consoled not by finding in them old objects that we love, but by losing all sense of Time. Please write this in the book, too. Let us not conceal the way in which I had you write it, or how you went about your work. When it is done, please give me all the drafts and your notebooks, so that we can display them, too. How much longer will it take? Those who read the book will certainly wish to come here to see locks of Füsun's hair, her clothes, and her other belongings, just as you have. So please put a map at the end of the novel, so that anyone who cares to can make their way by foot through Istanbul's streets. Those who know the story of Füsun and me will certainly remember her as they walk those streets and see those prospects, just as I do, each and every day. And let those who have read the book enjoy free admission to the museum when they visit for the first time. This is best accomplished by placing a ticket in every copy. The Museum of Innocence will have a special stamp, and when visitors present their copy of the book, the guard at the door will stamp this ticket before ushering them in."

"Where shall we put the ticket?"

"They should put it here, of course!"

THE MUSEUM OF INNOCENCE

SINGLE ADMISSION ONLY

"Thank you. And at the end, let's put an index of names, Orhan Bey. It is thanks to your account that I remembered how many people witnessed our story or were otherwise acquainted with it. Even I have a hard time keeping all the names straight."

In fact, Kemal Bey did not like my seeking out the people mentioned in the story, but he tolerated my novelist's ways. Sometimes he

was curious to know what the people I'd tracked down had said, or what they were doing now; sometimes he had no interest in them whatsoever, and could scarcely understand my interest in them.

For example, he could not begin to comprehend why I wrote a letter to Abdülkerim Bey, Satsat's distributor in Kayseri, or why I met him during one of his visits to Istanbul. As for Abdülkerim Bey, who left Satsat to become the Kayseri distributor for Tekyay, the firm Osman founded with Turgay Bey, he regarded Kemal Bey's story as the tale of love and disgrace that had brought down Satsat.

I was able to locate Sühendan Yıldız (also known as Conniving Sühendan), the actress who perennially played the she-devil and who had observed our lovers' first months at the Pelür. She told me that while she had known Kemal Bey as a desperately lonely man, and though like everyone else she'd been well aware of how besotted he was with Füsun, she felt little pity for him, generally disapproving of rich men who prowled the film world for beautiful girls. Sühendan had, in fact, pitied Füsun, "whose impatience to play in films and be a star was something akin to panic." Had she succeeded, surrounded by all those wolves, she would have come to a sad end anyway, Sühendan supposed, never understanding why Füsun had married "that fatso" (Feridun). As for the grandson for whom she was knitting a tricolor jumper in those days, he was now exactly thirty years old, and whenever he saw on television an old film in which his grandmother had starred, he could barely contain his laughter, but was also shocked to see how poor Istanbul had been in those days.

Basri the Nişantaşı barber had once been my barber, too. He was still working, and was inclined to speak with love and respect more about Mümtaz Bey than about Kemal Bey. Mümtaz Bey had been an affable, generous, good-hearted man, always ready with a joke. I discovered nothing noteworthy from Basri the barber, or indeed from Hilmi the Bastard and his wife, Neslihan, Hayal Hayati, or Salih Sarılı (another Pelür regular) or Kenan. Ayla, the downstairs neighbor whom Füsun hid from Kemal, now lived in a side street in Beşiktaş with her engineer husband and her four children, the eldest of whom was now at university. She told me that she had valued Füsun's friendship, and had loved everything about her—her joie de vivre, her wit, the way she spoke—to the point of adopting Füsun as her role model, but sadly

Füsun had never reciprocated her desire for close friendship. The two girls would get dressed up and go out together to Beyoğlu, to the cinema. A neighborhood friend who worked as an usher at the Dormen Theater would let them into rehearsals. Afterward they would stop somewhere for a sandwich and an *ayran,* protecting each other from the men who bothered them. Sometimes they would go into Vakko or some other fashionable shop, pretending to be paying customers, and have great fun trying on clothes, looking at themselves in the mirror. They would be laughing and talking when suddenly Füsun would become fixated on something and all the joy would drain out of her— as it would sometimes in the middle of a film—but she never told Ayla what was bothering her. Everyone in the neighborhood had been aware of Kemal Bey's comings and goings—they knew he was rich, and not quite right in the head—but no one had said anything about love. Like everyone else in Çukurcuma, Ayla had known nothing about what had happened between Füsun and Kemal in earlier years, and "anyway" she no longer knew anyone in the neighborhood.

The White Carnation had, in the course of twenty years, risen from gossip columnist to editor of the daily celebrity supplement in one of the country's leading newspapers. In addition, he edited a monthly gossip magazine focused on the scandals and love affairs of stars in domestic films and television series. Like so many journalists whose false reports had hurt people or even shattered their lives, he had forgotten what he had written about Kemal, asking me to pass on his greetings, along with his deepest respects to his esteemed mother, Vecihe Hanım, whom he had been in the habit of ringing for news now and again, until very recently. Imagining I had approached him about a book I was writing set among film stars and therefore likely to enjoy brisk sales, he was friendly and more than obliging in his offer of help: Did I know that the child resulting from Papatya's failed marriage with the producer Muzaffer now, though still quite young, owned one of Germany's leading tourism agencies?

Feridun had severed all ties with the film world to found a highly successful advertising firm. On hearing that he had called it Blue Rain, I was reminded that he had not abandoned the dreams of his youth, but I dared not ask him anything about his film that had never been

made. Feridun shot commercials full of Turkish flags and football matches that advertised great pride in the modest international success of Turkish biscuits, Turkish blue jeans, Turkish razors, and Turkish hoodlums. He had heard about Kemal Bey's plans for a museum, but it was I who informed him that I was writing a book "telling Füsun's story": With extraordinary candor, carefully choosing his words, he told me how he had loved only once in his life, but that Füsun had never paid him any heed, and so he'd been careful not to relive that sorrow by falling in love with her again once they were married, particularly since he knew that Füsun married him only because she'd been "obliged" to do so. I liked his honesty. When I was leaving his stylish office, he asked me with the same cautious courtesy to convey his greetings to "Kemal Bey," after which he warned me, with a frown: "If you write anything bad about Füsun, Orhan Bey, rest assured that I will come after you." Then regaining the light and easy manner that suited him so well he asked a favor: Could he use the first sentence of my novel *The New Life* in a campaign for Bora, a new product from the soft drinks giant that used to make Meltem, with which his firm had long-standing ties?

With his retirement settlement, Çetin Efendi had bought a taxicab, which he rented to another driver, though sometimes, despite his advanced age, he would take it out himself into the streets of Istanbul. When we met at a taxi stand in Beşiktaş, he told me that Kemal had never changed since boyhood: In essence, he was one who relished every moment of life, ever open to the world and to other people and possessed of a childlike optimism. In this sense, wasn't it strange, I asked, that his life had fallen prey to such a black passion. But if I had ever met Füsun, Çetin Efendi explained, I would have understood why Kemal Bey had fallen so hard for this woman. They—Füsun and Kemal—were essentially good and innocent souls who suited each other perfectly, but as God had been unwilling to let them be together, we mortals were in no position to question the outcome too closely.

On our first meeting after his return from a long journey, after Kemal Bey had told me about the museums he had visited, I told him about my conversation with Çetin Efendi, repeating word for word what he had said about Füsun.

"Visitors to my museum will learn of our story one day, and any-how, will know in their hearts what sort of person Füsun was, Orhan Bey," he said. We started drinking at once—by now I truly enjoyed drinking with him. "As they go from display case to display case, and box to box, looking at all these objects, visitors will understand how I gazed at Füsun at suppertime for eight years, and when they see how closely I observed her hand, her arm, the curl in her hair, the way she stubbed out cigarettes, the way she frowned, or smiled, her handker-chiefs, her barrettes, her shoes, and the spoon in her hand" (I did not say, "But Kemal Bey, you failed to mention the earrings.") "they will know that love is deep attention, deep compassion. . . . Please finish the book now, and also write that each and every object in the museum must be softly lit from within the display cases in a way that conveys my close and devoted attention. When visitors to our museum view these objects, they should feel respect for my love and compare it with mem-ories of their own. The premises should never be crowded, so that the visitor can examine unhurried each object, and view the pictures of the Istanbul neighborhoods we visited hand in hand, getting a leisurely feel for the entire collection as a totality. In fact I hereby declare that no more than fifty at a time should be admitted to the Museum of Inno-cence! Groups and school classes must make appointments to visit our museum! In the West museums are getting more and more crowded, Orhan Bey. European families go out together on a Sunday to visit a great museum, just as we used to get into our cars for a Sunday drive down the Bosphorus. And they sit in the museum restaurants and laugh, just as we do in Bosphorus restaurants. Proust wrote of how the furnishings of his aunt's house were sold to a brothel after her death, and how every time he saw her chairs and tables in this place he felt as if every object was crying. When the Sunday crowds pour through museums, the collected objects cry. In my museum, they won't be ripped from their own house, at least. I'm afraid that this museum craze in the West has inspired the uncultured and insecure rich of this coun-try to establish ersatz museums of modern art with adjoining restau-rants. This despite the fact that we have no culture, no taste, and no talent in the art of painting. What Turks should be viewing in their own museums are not bad imitations of Western art but their own lives.

Instead of displaying the Occidentalist fantasies of our rich, our museums should show us our own lives. My museum comprises the life I shared with Füsun, the totality of our experience, and everything I've told you is true, Orhan Bey. Perhaps some things will not be clear enough for every reader or visitor, for even though I have told you my story, described my life with utmost sincerity, even I cannot know how much I have understood it as a whole. We can leave that job to future scholars, and the articles they will write for *Innocence,* the museum magazine. Let them be the ones to establish the structural relations between Füsun's barrettes and brushes and the deceased canary Lemon. If future generations find the account of our life exaggerated, if they are nonplussed by the pain I suffered in love's name, or by Füsun's suffering, or the way we diverted ourselves from all this by looking into each other's eyes at supper, or found happiness holding hands at the beach and the cinema, the guards must impress upon the incredulous that everything as represented is true. But don't worry, I don't doubt that future generations will understand our love. The contented university students who travel here from Kayseri by bus fifty years from now, the Japanese tourists lined up at the door clutching cameras, the single women who end up in the museum having lost their way in the street, and the happy lovers of tomorrow's happy Istanbul will—upon studying Füsun's clothes, and the saltshakers, the clocks, the restaurant menus, the old Istanbul photographs, and our shared childhood toys and other objects—find a profound understanding of our love and our lives virtually inescapable. I hope the crowds will also visit our temporary exhibitions, devoted to the ship photographs, soda caps, matchboxes, clothespins, postcards, pictures of stars and celebrities, and earrings gathered together by my obsessive collector cohort, my strange brethren, whose acquaintance I've made in their rubbish dens or through their Association. These exhibitions, and the stories behind them, should also in due course have their own catalogs and novels. As visitors admire the objects and honor the memory of Füsun and Kemal, with due reverence, they will understand that, like the tales of Leyla and Mecnun or Hüsn and Aşk, this is not simply a story of lovers, but of the entire realm, that is, of Istanbul. Would you like another *rakı,* Orhan Bey?"

In the early hours of April 12, 2007—Füsun's fiftieth birthday—Kemal Basmacı, the hero of our novel and the founder of our museum, was asleep in a large room overlooking the Via Manzoni in the Grand Hotel et de Milan, the establishment in which he stayed every time he visited that city, when he suffered a heart attack and died, age sixty-two. Kemal Bey would take every opportunity to go to Milan, to "experience" (as he put it) the Bagatti Valsecchi Museum, which he esteemed "one of the five most important museums in my life!" (By the time of his death he had visited 5,723 museums.) "Museums are (1) not to be strolled around in but to be experienced, (2) made up of collections expressive of the soul of that 'experience,' (3) not in fact museums but merely galleries when emptied of their collections." These are the last thoughts of his that I recorded. What most enchanted Kemal Bey about this house (renovated by two brothers in the nineteenth century to replicate a sixteenth-century Renaissance palazzo, and then converted to a museum in the twentieth century) was that its wondrous, historic collection comprised nothing but the ordinary everyday appurtenances of the brothers' lives (the old beds, lamps, Renaissance mirrors, pots and pans).

Most of the people whose names I have listed in the index attended his funeral in Teşvikiye Mosque. Kemal's mother, Vecihe, observing from the balcony as was her wont, was wearing a headscarf. We who stood tearfully in the courtyard could hear her crying as she bade farewell to her son.

Many of Kemal Bey's relatives and close associates had refused to see me while he was alive, but in the first few months after his funeral they began to seek me out, one after the other, an orderly progression that, though strange, had its logic. The reluctance to approach me I attribute to the false but widely held impression that my books set in Nişantaşı denigrated everyone mercilessly. Sadly, there had been so much gossip, and so many accusations, that it was generally believed I had misrepresented not just my mother, my older brother, my uncle, and the rest of my family, but many other Nişantaşı notables as well, including the celebrated Cevdet Bey, his sons, and his family; my poet friend Ka; and Celâl Salik, the famous assassinated columnist, whom I had so admired; the well-known shopkeeper Alaaddin; as well as high-

ranking state dignitaries, religious leaders, and military commanders. Zaim and Sibel were fearful of me without ever having read my books. Zaim was much richer than he'd been as a young man. Meltem soda had fizzled out, but the firm itself was going strong. They entertained me very graciously in their magnificent house in the Bebek hills overlooking the Bosphorus, honored, they said, to receive the one who had undertaken to write Kemal's life story (those closer to Füsun would call it Füsun's story). But I was not to make my story one-sided: I was to listen to them as well.

First of all, they wanted to tell me about a huge coincidence: Half a day before his death, on the afternoon of April 11, they had run into Kemal Bey on the streets of Milan. (At once I felt that they had invited me over expressly to tell me this.) Zaim and Sibel and their two pretty, clever daughters, who joined us for supper, twenty-year-old Gül and eighteen-year-old Ebru, had gone on a three-day trip to Milan, just for pleasure, *un petit séjour*, as Sibel said. When Kemal had set eyes on the family enjoying their multicolored cones of orange, strawberry, and melon ice cream, and peering into shop windows, and laughing jovially as they strolled down the street, he at first saw only Gül, and her resemblance to her mother was so great that he went up to her and said, "Sibel! Sibel! Hello, this is Kemal."

"Gül looks so much like I did in my twenties, and that day she just happened to be wearing an old knitted stole I'd worn in those years," said Sibel Hanım, beaming with pride. "But poor Kemal, he looked so tired, so disheveled, broken down, and deeply unhappy. Orhan Bey, I felt so bad to see him that way. I wasn't the only one—Zaim was heartsick, too. The man to whom I'd become engaged at the Hilton, who so loved life, who was always so charming, and so full of fun—he'd vanished, and in his place was an old man cut off from the world and life itself, with a long face, and a cigarette hanging from his mouth. If he hadn't recognized Gül, we would never have known him. He hadn't just aged; he'd fallen apart. I felt so sorry for him. Especially since this was the first time I'd seen him in who knows how many years."

"It would have been thirty-one years after your last meal together at Fuaye," I said.

There was an eerie silence.

"So he told you everything!" Sibel said a short while later, her voice full of pain.

As the silence continued, I realized what it was that they really wanted to tell me: They wanted readers to know how much happier their life together was compared to the story I was telling, and what a beautiful and normal life it was.

But after the girls had gone to their rooms, when we were drinking our cognacs, I realized that there was another thing that the couple was struggling to express. On her second glass, Sibel explained herself in a forthright way that I appreciated, without beating around the bush as Zaim had: "At the end of the summer of 1975, after Kemal had confessed to me that he was badly smitten by the late Füsun Hanım, I pitied my fiancé and wanted to help him. With the best of intentions, we moved together to our *yalı* in Anadoluhisarı so that I could nurse him back to health, Orhan Bey, and we stayed there for a month." (In fact, they stayed for three.) "Actually, this is no longer important. . . . Today's young people don't worry about things like virginity." (This wasn't true, either.) "But even so, I am going to ask you especially to make no mention of those days in your book, because they are humiliating for me. . . . This might not seem so important, but it was expressly because she'd gossiped about this matter that I fell out with my best friend, Nurcihan. The children wouldn't care, but their friends, and all those gossips. . . . Please don't let us down. . . ."

Zaim told me how much he'd loved Kemal—such a sincere person he was, whose friendship he'd always sought—and how much he missed him. "Is it true that Kemal collected all of Füsun Hanım's possessions? Is there really going to be a museum?" he asked, half in awe, half in fear.

"Yes," I said. "And with this book, I shall be the museum's chief promoter."

When I took my leave of their house, rather late though still laughing and carrying on with them, for a moment I put myself in Kemal's shoes. If he were still alive, if he had taken up again with Sibel and Zaim (this was indeed possible, contrary to what he imagined), Kemal would have left their house that night feeling as I felt—both content and guilty about his solitary life.

"Orhan Bey," said Zaim at the door. "Please don't forget Sibel's

request. We at Meltem Enterprises, of course, wish to make a donation to the museum."

That night I also realized it was pointless speaking to other people: I did not want to tell Kemal's story as others saw it; I wanted to write it the way he had told it to me.

It was out of simple doggedness that I went to Milan, where I discovered what had upset Kemal so on the day he had run into Sibel, Zaim, and their daughters: Just before that chance encounter he had gone to the Bagatti Valsecchi Museum, finding that it was in terrible disrepair, and that in an effort to raise funds, a part of it had been rented out as a boutique of the famous designer Jenny Colon. The women who worked as guards in the museum, in black uniforms, were in tears on receiving my report of his death, and the directors, who confirmed that a Turkish gentleman came to visit them without fail every few years, had also been distraught.

This alone convinced me that I had no need to hear any more gossip to finish my book. I would only have wished to see Füsun, and to hear her. But before I could visit the ones who knew her best, there were the invitations from those who feared my book and insisted on receiving me in their houses preemptively, which invitations I accepted just for the pleasure of some company and sharing a meal.

And so it was that in the course of a very quick supper I was advised by Osman not to write this story at all. Yes, it might be true that it was his late brother's negligence that had plunged Satsat into bankruptcy, but all his late father's other firms were now engines of Turkey's export boom. They had many vicious competitors, and a book like this, beyond causing heartbreak and endless gossip as well, would only make Basmacı Holding a laughingstock and by association give Europeans just another excuse to laugh at us and put us down. Even so, I was able to leave the house with a lovely souvenir, a marble from Kemal's childhood that Berrin Hanım handed to me in the kitchen, out of her husband's view.

As for Aunt Nesibe, to whom Kemal had introduced me, she told me nothing new when I went to see her in her apartment on Kuyulu Bostan Street. Now she wasn't crying just for Füsun, but also for Kemal, whom she described as her "only son-in-law." She mentioned the museum but once: She used to have an old quince grater, and hav-

ing got it into her head to make quince jelly, she wondered whether the grater she could find nowhere had perhaps wound up in the museum. I would surely know. If it was there could I bring it with me on my next visit? As I said good-bye at the door, she said, "Orhan Bey, you remind me of Kemal," and she burst into tears.

Six months before his death, Kemal had introduced me to Ceyda, Füsun's closest confidante, who in my view not only knew all Füsun's secrets but understood Kemal best, too. This introduction had come about partly because Ceyda Hanım liked novels and had wanted to meet me. Her sons, now in their thirties and engineers both, were married, and their lovely brides, whose pictures she showed me, had already given her seven grandchildren. Her rich husband (he was the Sedircis' son!), who was much older than Ceyda, looking slightly drunk and slightly senile, showed no interest in us or our story, even when Kemal and I admitted our overindulgence with *rakı*.

Ceyda told me with a sweet smile how Füsun had discovered the earring Kemal had left in the Keskins' bathroom on the evening of his first visit, and how though she'd told Ceyda about it right away, they'd decided together that Füsun should feign ignorance, just to punish Kemal. Like so many of Füsun's secrets, that story Kemal Bey had already extracted from Ceyda years earlier. He had smiled painfully when he told it to me, pouring us each another glass of *rakı*.

"Ceyda," said Kemal later, "when I came to you for news of Füsun, you and I would always meet in Maçka, Taşlık. As you were telling me about Füsun, I would admire the view of Dolmabahçe from Maçka. When I checked recently, I discovered that I have accumulated many pictures of that view."

As we'd been talking about photographs, and perhaps also to honor her visitors, Ceyda Hanım allowed as how just the other day she'd happened on a photograph that Kemal Bey had never seen. "This had us all excited," she said. The photograph, taken during the finals of the 1973 Milliyet Beauty Contest, was of Hakan Serinkan whispering to Füsun the cultural questions that she would be asked to come on stage. The famous crooner, now a deputy for an Islamist party, had been very much taken with Füsun.

"It's a shame neither of us made it through, Orhan Bey, but to the

end we behaved like the good lycée girls we were, though we laughed ourselves to tears that night," said Ceyda. In a flash, the pale photograph appeared on the wooden coffee table; the moment he saw it, Kemal Bey's face went as white as ash, and he fell into a long silence.

Because Ceyda's husband had no taste for the beauty contest story, we would not be looking much longer at Füsun's old photograph. But at the end of the evening Ceyda, understanding as ever, offered it to Kemal Bey as a present.

After leaving Ceyda's house in Maçka, I walked toward Nişantaşı with Kemal Bey, through the silence of the night. "I'll walk you as far as the Pamuk Apartments," he told me. "Tonight I won't be staying at the museum, but with my mother in Teşvikiye."

But five buildings before we reached the Pamuk Apartments, just in front of the Merhamet Apartments, he stopped and smiled.

"Orhan Bey, I read your novel *Snow* all the way to the end," he said. "I don't like politics. So please don't be offended if I say I found it a bit of a struggle. But I liked the ending. And at the end of our novel I would like to do the same as that character in *Snow* and address the reader directly. Do I have this right? When will your book be finished?"

"After your museum," I said. By now this had become a standard joke between us. "What are your last words for the reader?"

"I'm not going to say, as your character did, that readers cannot possibly understand us from afar. On the contrary, visitors to the museum and people who read your book will most certainly understand us. But there is something else I want to say."

He took Füsun's photograph from his pocket and in the pale light of the streetlamp in front of the Merhamet Apartments he looked lovingly at her. I drew up beside him.

"She's beautiful, isn't she?" he said to me, just as his father had said to him thirty-odd years ago.

There we stood, two men, gazing with love, admiration, and respect at the photograph of Füsun in a black swimsuit embroidered with the number nine—at her honey-hued arms, and her face (betraying no joy, only sadness), and her splendid body, both of us struck by the depth of her humanity, the radiance of her soul, despite the thirty-four years that had elapsed since the photograph had been developed.

"Please put this photograph in your museum, Kemal Bey," I said.

"My last words in the book are these, Orhan Bey, please don't forget them. . . ."

"I won't."

He kissed Füsun's photograph lovingly, and placed it with care into the breast pocket of his jacket. Then he smiled at me, victorious.

"Let everyone know, I lived a very happy life."

2001–2002, 2003–2008

INDEX OF CHARACTERS

A NOTE ON THE TYPE

This book was set in Garamond, a type named for the famous
Parisian type cutter Claude Garamond (ca. 1480–1561). Garamond,
a pupil of Geoffroy Tory, based his letter on the types of the Aldine
Press in Venice, but he introduced a number of important differ-
ences, and it is to him that we owe the letter now known as "old
style." The version of Garamond used for this book was first intro-
duced by the Monotype Corporation of London in 1922. It is not a
true copy of any of the designs of Claude Garamond, but can be
attributed to Jean Jannon, a Protestant printer working in Sedan in
the early seventeenth century.

Composed by North Market Street Graphics,
Lancaster, Pennsylvania
Printed and bound by Berryville Graphics,
Berryville, Virginia
Designed by Virginia Tan